KU-611-541

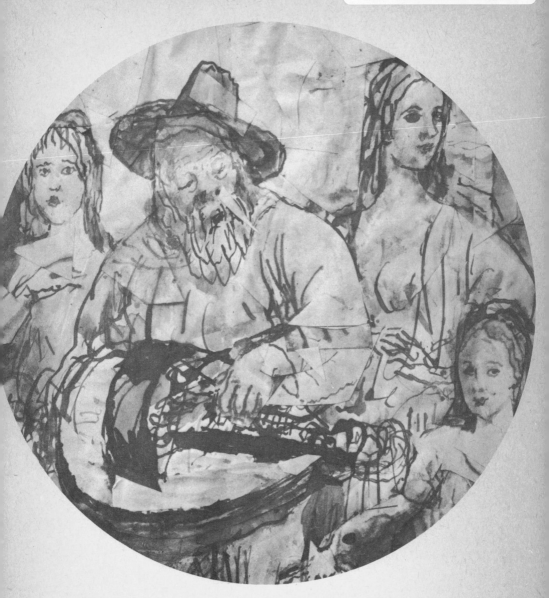

Augustus John
A Biography

Volume I
The Years of Innocence

BOOKS BY MICHAEL HOLROYD

Hugh Kingsmill: A Critical Biography
Lytton Strachey: A Critical Biography (2 vols)
Lytton Strachey by Himself (edited by Michael Holroyd)
The Best of Hugh Kingsmill (edited by Michael Holroyd)
Unreceived Opinions (essays)
Lytton Strachey: A Biography
Lytton Strachey and the Bloomsbury Group (criticism)
Augustus John: A Biography (2 vols)

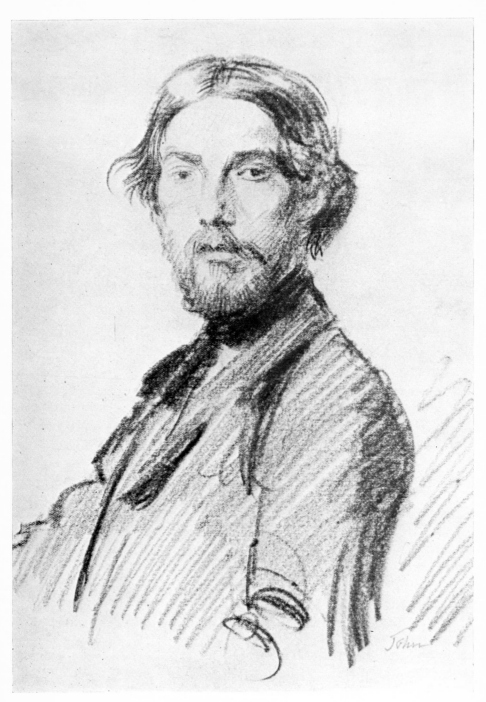

Augustus John. Self-portrait, about 1901 (chalk)

AUGUSTUS JOHN

A BIOGRAPHY
by
MICHAEL HOLROYD

VOLUME I
The Years of Innocence

'Some account of your innocence could be most interesting.'
(Daniel George to Augustus John, 10 June 1957)

HEINEMANN : LONDON

William Heinemann Ltd
15 Queen Street, Mayfair, London W1X 8BE

LONDON MELBOURNE TORONTO
JOHANNESBURG AUCKLAND

First published 1974
© Michael Holroyd, 1974

SBN: 434 34574 1

Contents

Illustrations

The endpapers show 'Family Group with Dorelia, Ida and Children' *c.* 1906; and sketch for 'Les Saintes-Maries' *c.* 1960.

Preface

This is a biography: it is not an art-book. Those who wish primarily to read about Augustus John's pictures should turn to Lord David Cecil, to Sir John Rothenstein and especially to Dr Malcolm Easton. 'What justifies a biography at all?' demanded Marghanita Laski recently in *The Times*; and answer came there none. To the *Lives* of artists and writers there has long been a standard objection. 'L'homme c'est rien,' wrote Flaubert, 'l'œuvre c'est tout.'

The practice of seeking truth through the individual has always attracted suspicion. But for biographers the man is their work. To accuracy, to plain facts there attaches virtue even when these facts may not be employed for other purposes, such as literary or artistic criticism. We do not insist that a landscape painting improves our agriculture, nor should we look blindly for such benefits in biography. If the work contains merit, it is its own justification.

Between portrait painting and the writing of biography there is an obvious analogy. The subject need be neither saintly nor even commercially successful. He or she must be stimulating to the painter or writer. It has been argued by Professor George Steiner that 'it is the minor master . . . whose career may be important in that it has crystalized the manners of a period, the tone of a particular milieu' who makes the best biographee. In so far as many of the greatest artists appear miraculously to translate all their energy into work, leaving little for the biographer to use, there may be truth in this.

The aim, I believe, of all biographers, who live so long and close to their subject, is to establish, out of loneliness perhaps, a true relationship, and give it literary form. If new information is discovered of cultural or historical value; if readers are enabled to see the subject's work in an original way: these are bonuses. But the biographer's real purpose is to re-create a world into which readers may enter, where they may experience feelings and thoughts, some of which may remain with them after the book is closed.

It is an ambitious aim and doomed to some degree of failure. Yet by admitting this I do not impugn biography as a branch of literature. In the present case, I would plead in mitigation that to write about painters is notoriously difficult, since they tend neither to talk nor to think in concepts. But this has been part of the challenge: in a work of

transliteration to use literary devices, sometimes very simple ones, to echo the pictures and to form some parallel with the art of Augustus John.

<div align="right">

MICHAEL HOLROYD

February 1974

</div>

Note

In the second volume I shall provide a select bibliography of the books I have used. Most of my information has been taken from unpublished material that, uncatalogued, still privately owned and widely scattered, has no permanent place to which I may usefully refer readers. The location of those letters in public collections I have given in my notes.

Acknowledgements

In my second volume I shall thank those who helped me in writing this biography. But at the outset I must record my indebtedness to the John family, without whose co-operation this book could not have been written. It was authorized in 1968 by Dorelia John and, after her death, this authorization was confirmed by her executors, Sir Caspar John and Mr Romilly John. As representatives of the family they have read through my typescript, checked it for facts, and provided me with valuable suggestions; naturally they should not be held responsible for my own opinions or interpretations.

I must also record my indebtedness to the late David John who lent me many important letters, in particular those of his mother Ida John; to Mr Edwin John who allowed me to borrow his father's correspondence to him, empowered me to see those letters of Gwen John's in private and public collections, and enabled me to collaborate with Mrs Mary Taubman who is working on the biography of Gwen John. I am grateful also to Mr Robin John, Mme Poppet Pol and Mrs Vivien White, all of whom patiently answered my questions and lent me material in their possession. In addition my thanks are due to Mrs Igor Vinogradoff for kindly allowing me to quote from *Ottoline: The Early Memoirs of Lady Ottoline Morrell* edited by Robert Gathorne-Hardy.

A Winston Churchill Fellowship made it possible for me to go to Europe; and a grant from the Phoenix Trust helped me to complete my researches in America. I record both with gratitude.

I inherited a vile melancholy from my father, which has made me mad all my life, at least not sober.

Dr Johnson. Boswell's *Tour of the Hebrides*, 16 September 1773

So must pure lovers' soul descend
　To affections, and to faculties,
Which sense may reach and apprehend,
　Else a great prince in prison lies.

John Donne. *The Ecstasy*.

FOR
PHILIPPA

Little England Beyond Wales

Who *am* I in the first place?

Augustus John
Finishing Touches

I. 'MAMA'S DEAD!'

A regiment of women, monstrously feathered and furred, waited at Tenby railway station. The train that pulled in from Haverfordwest one autumn day in the year 1877 carried among its passengers a young solicitor and his wife, Edwin and Augusta John. With his upright figure, commanding nose, his trimmed whiskers and brave moustaches, he had more the bearing of a soldier than lawyer. She was a pale woman of twenty-nine, with small features, rather fragile-looking, her hair in ringlets. She was expecting their third child.

The train stopped, and the landladies of Tenby fell upon it, jostling over the new arrivals. But the Johns stood aloof from this mêlée. By prior arrangement the most regal and fantastic of all the beldames swept across, escorted them to her carriage and drove them up the Esplanade to a large mauve building on the edge of South Cliffs: No. 50 Rope Walk Field.* From their windows they looked over the sea to Caldy Island with its white monastery and the monks' green fields, and to a smaller island, then a bird sanctuary, that at low tide seemed, like a long umbilical cord, to attach it to the mainland of Wales.

Augusta's other children were all born at home in Haverfordwest. But she and Edwin had decided that, for perfect safety, she should give birth to their third child in Tenby, Haverfordwest having recently been hit by an epidemic of scarlet fever. Soon after the New Year her labour pains began, and at 5.30 on the morning of 4 January 1878 the new baby was born. It was a boy, and they named him after both of them: Augustus Edwin John.

Victoria Place, Haverfordwest, had been built in 1839 to commemorate the opening of the new toll bridge. The houses were narrow, and all had small square windows with wooden sides that sloped inwards, and windowsills you could sit on.

* This lodging house was Corporation property owned by Ancient Grant. Its lease was assigned to William John on 23 October 1877. Two years later, on 27 December 1879, the lease was devised to William Williams.

The John family lived at No. 7.* Almost immediately behind the front door rose a steep staircase. Small alcoves had been cut into the wall. From the second floor it was possible to see into Castle Square opposite, one side of which was formed by the Castle Inn with its ramparts and its archway down which coaches drove to the stables. Above this towered the ruined Norman castle, its jagged stone windows gaping at the sky. All around the uneven slate roofs of the houses stretched, now high, now low, undulating away to the perimeter of the town. And beyond the town lay green hills that on summer evenings grew blue and hazy, and in winter, when there was frost, stood out hard.

In the eleven years of their marriage Edwin and Augusta John had two boys and two girls. Thornton was nearly three years older than Augustus; Gwen eighteen months older; and Winifred was born almost two years later.†

For all of them, Haverfordwest was a strangely exciting town in which to grow up. While they were still very young they used to play in the back garden of Victoria Place and along the right-of-way that led from it to their father's old law offices in Quay Street. But later, accompanied by their nurse Mimi and occasionally by her follower, a burly police-man named 'Mr Simpson', they were allowed to explore the town. She would take them up the steep High Street, flanked with Regency houses built by the rich families who, during the season, had flocked there to give balls in the assembly rooms and to be carried in sedan chairs over the cobble stones to call on other rich families for gossip.

By the 1880s Haverfordwest had become a less sophisticated resort, though some of the earlier English influence persisted, the more snobbish of the English-speaking inhabitants preferring to call them-selves 'Pembrokeshire Men' rather than Welsh. It was now a market town, and on market days the streets and square heaved with a pande-monium of country folk and animals – women from Langwm in short

* After Augustus John's death in 1961 a plaque commemorating the place where he spent his early years was affixed by the Haverfordwest Council at No. 5 Victoria Place. On neither his brother's nor his sisters' birth certificates had any number been given. Winifred, who was still alive in America, could not remember the number; Thornton, nearing ninety and living in Canada, appears to have accurately copied down number 5 from the address (5, Tower Hill) of the solicitor who wrote to him asking after his birthplace.

No. 7 Victoria Place is now part of Lloyds Bank. The John family never bought the house, leasing it from a Mr Joseph Tombs. But the number is confirmed by several directories of the period in the National Library of Wales. No. 7 Victoria Place is also given on the birth certificate of Augustus's youngest uncle Frederick Charles John, born on 20 September 1856.

† The exact dates of their births were: Thornton, 10 May 1875; Gwendolen Mary, 22 June 1876; Winifred Maud, 3 November 1879.

skirts, bright shawls and billy-cock hats carrying baskets of oysters on their backs; philosophical-looking tramps wandering through with an air of detachment and no obvious motive; and gypsies, mysterious and aloof, shooting down sardonic glances as they rode by in their ragged finery on horse and cart. And from this continuous perambulation arose a cacophony – barking dogs, playing children, the perpetual lowing of cattle, screaming of pigs and the loud vociferation of the Welsh drovers.

For Augustus it presented a compelling spectacle to which was added the irresistible lure of danger. For Papa had warned them all against walking abroad on market days in case they should be kidnapped by the gypsies and spirited away in their caravans, no one knew where.* It was a warning Augustus never forgot.

Regularly, on week-ends, Edwin John would lead out his children on well-conducted expeditions in the outskirts of the town. Augustus, who never liked remaining indoors for long, loved these walks. One of his favourites was along a path known as 'the frolic' which ran southeast, parallel to the river Cleddau where barges were pulled in over the marshy ground to dilapidated wharves. This walk boasted a phenomenon at which he never ceased to marvel. For, beyond the tidal flats, in the middle distance, a railway train would sometimes seem to issue, as if by magic, from the ruins of an ancient priory and rumble industriously onwards under its white banner till, with a despairing wail, it hurled itself into the hillside: and vanished.

Another popular walk was along a right-of-way called 'the scotch-wells'. Under a colonnade of trees this path followed the millstream past the booming flour mill from which the terrifying figure of its miller, white from head to toe, would occasionally emerge. Sometimes, too, Papa would take them along the Gyle, or the Parade, high above the Cleddau valley and perilously close to the cottage of a known witch.

On all these walks Edwin John marched in front, preserving a moderate speed – the pace, he believed, of a gentleman and an officer – only halting, in primrose time, to pick a few of his favourite flowers, to make a nosegay against the frightful exhalations of the tannery, or, when on the seashore, to gather shells for his collection. Behind him, heard but not seen, the children crocodiled out in an untidy line, darting here and there in a series of guerrilla raids.

On Sundays, invariably, they were led or sent to Church. Augustus much preferred being sent with the servants to their humble Bethels, Zions and Bethesdas. The sonorous unintelligible language, the fervour and harmony of their singing, the obstinacy of their prayer, the surging and resurging crescendos of the orator who, like one possessed, worked

* Until 1850 the abominable crime of 'associating with gypsies' was punishable by hanging.

himself up to that divine afflatus with which all good Welsh sermons must terminate, were awe-inspiring.

The religious atmosphere of Victoria Place was for several years fortified by two of the children's aunts, Rosina and Leah Smith.* They were younger sisters of Augusta, both in their twenties, and both ablaze with zeal for God. They had come to Haverfordwest from Brighton where they lived, when Augusta's health began to fail. After the birth of Winifred, Augusta seldom seems to have been well, and was often away for long periods. She suffered from chronic rheumatism which the damp climate of Haverfordwest was thought to aggravate, and she travelled much of the country in search of a cure. A photograph of her with the children, taken about the year 1882, shows that a surprising change had come over her. No longer is she the timid, withdrawn, delicate-looking girl at the time of her marriage. Perversely, she looks more alert and vigorous, her mouth hard-set, a brow like thunder, eyes quick as a bird's. She has put on weight, and the severity of her expression is probably a sign of struggle against pain.

In her absence Rosina and Leah quickly took charge of the children's upbringing. One of their first demands was for the dismissal of their nurse, on the grounds that she had permitted the children to grow too fond of her. They had been allowed, for instance, to go to her cottage in the Prescelly mountains north of Haverfordwest, where they would sit wide-eyed over their bowls of *cawl*, stare at the dark-bearded woodmen with their clogs, thin-pointed and capped with brass, and argue on the way home whether their feet were the same shape. Few of these men knew a word of English. Old pagan festivals, long-forgotten elsewhere, still flourished, and on certain dates the children were given sprigs of box plant and mugs of water, and told to run along the stone flags of the streets asperging, with complete impunity, any stranger they met. These were practices of which Aunts Rosina and Leah could not approve.

The new regime under aunts was a bewildering experience for everyone. Both were Salvationists, held rank in General Booth's army, and abominated Roman Catholicism on account of its heretical worship of the Virgin Mary. These were the two fixed points on their religious horizon round which all else revolved. Aunt Leah, a lady of ruthless cheerfulness and an alarming eloquence, had once 'tried the spirits' but found them wanting. Also found wanting was a young man who had had the temerity once to propose marriage to her: she had rejected him,

* In *Chiaroscuro*, Augustus refers to these aunts as Rose and Lily. Whether in fact the children did call them by these names or whether he misremembered them many years later, one cannot be certain, but in the first draft of his autobiography he does name the elder aunt Rosina.

she explained simply, because of his *wickedness*. But she had been seduced by the Princess Adelaide's Circle, of which she soon became a prominent member.

Aunt Rosina was a more lugubrious character with a curious ferret-like face. Her choice of religion seemed to depend on her digestion, which was erratic. 'At one time it might be "The Countess of Huntingdon's Connexion", with raw beef and hot water, at another Joanna Southcote and grapes, or again, The Society of Friends plus charcoal biscuits washed down with Rowntree's Electric Cocoa.'[1]

In their quest for truth, and for the promotion of truth, the two aunts toured the neighbourhood of Haverfordwest in a wicker pony-trap known locally as 'the Hallelujah Chariot', bringing souls to Jesus. Their success was phenomenal. Strong men, it was said, pickled in sin, fell prostrate to the ground before them, weeping miserably. Edwin John, a man of violent moods rather than strong opinions, was certainly no match for them, and their presence dominated Victoria Place. Each day began with morning prayers, and continued with the aid of such improving tracts as *Jessica's First Prayer* and *The Lamplighter*.

Yet there were some elopements from this wholesale atmosphere. Although, very naturally, the theatre was out of bounds, the children were permitted without scruple to attend an entertainment called 'Poole's Diorama'. This was a precursor of the cinema. It consisted of a vast historical picture, or series of pictures which, to music and other sound effects, was gradually unrolled on an apparently endless canvas across the stage. At one corner a man with a wand pointed to features of interest and shouted out his explanations to the audience, who could thereby make these informed journeys through time and space from the comfort of their seats. But when The Bombardment of Alexandria was depicted the aunts judged matters had gone far enough and, fearing that the infernal din would do permanent damage to the children's nerves, they bustled them outside.

Even more exciting, though viewed with some family misgivings, was the children's first visit to the circus. Though later in life Augustus used to object to 'that cruel and stupid convention of strapping the horses' noses down to their chests',* this circus, he claimed, corrupted him for life. It wasn't simply a question of the animals, but the dazzling appearance of a beautiful woman in tights, and of other superb creatures, got up in full hunting kit and singing 'His moustache was down to heah, Tiddy-foll-ol' and 'I've a penny in my pocket, La-de-dah'.

In summer the family used to go off to Broad Haven, twelve miles

* 'This damnable practice makes me as uncomfortable as the horses, and I don't want to see any more circuses.' *Horizon*, Vol. III, No. 14, February 1941, p. 100.

away, where Edwin had had a one-storey house specially built for him out of the local stone.* And the aunts came too. But here the regime was less strict and the children happier. Their house was on St Bride's Bay, had a large lawn and faced the sea, in which the children spent much of their time. Yet even in the waves they were not wholly beyond the religiosity of the Welsh which extended offshore with their dangerous ceremonies of Baptism by Total Immersion.

The Johns at this time were an isolated family. The uncompromising reputation of the aunts, the formidable respectability of Edwin, and their rather dubious origins, limited their number of friends while failing to win them entry into the upper reaches of Haverfordwest society. The children, from an early age, were obscurely aware of this insularity. They were at ease in the sea or roaming the wilds on their doorstep at Broad Haven, but in the company of other people they were, even for children, abnormally nervous. 'Our invincible shyness,' Augustus later recorded, 'comparable only to that of the dwarf inhabitants of Equatorial Africa, resisted every advance on the part of strangers.' Their grandfather, William John, used to exhort them: 'Talk! If you can't think of anything to say tell a lie!' And: 'If you make a mistake, make it with authority!' But the children stayed speechless and staring as before.

With his grandfather Augustus appears to have made no contact at all; while of his father, who was of remote and uncertain temper, he was much in awe and even afraid. Once, at the age of four, he was violently kicked upstairs by him – an incident of which he was to be poignantly reminded twenty-five years later. Between all the family the failure in communication seemed almost complete.

The only adults with whom Augustus appears to have formed any real contact were the servants. At Victoria Place the one room where he felt at home was the kitchen, and he passed many hours sitting on a 'skew' by the kitchen fire, listening to all the quick chatter and watching the comings and goings. Sometimes an intoxicated groom would stagger in, and the women would dance and sing to him till his eyes filled with tears of remorse. Unlike the upper storeys of the house, there was always warmth and laughter here, the spectacle of human companionship, a sense of natural life going on.

Probably all the children needed the influence of their mother. But she was absent more and more. One day, in the second week of August 1884, the servants were lined up in the hall of Victoria Place, and Edwin John informed the household that his wife had died. The

* This house, though altered and now precariously named 'Rocks Drift', still stands. It has a large entrance hall and stair well, drawing-room, dining-room and six bedrooms. It was built using the stone from Settlands, the next little bay.

servants stood in their line, some of them crying quietly; but the children ran from room to room, like newsvendors, chanting with senseless excitement: 'Mama's dead! Mama's dead!'.

2. THE RESPONSIBLE PARTIES

'We come from a long line of professional people,' Edwin John would tell Augustus when questioned by him about their antecedents. Since he was then seeking to enter the freemasonry of fashionable Pembrokeshire society, Edwin, who probably knew this to be untrue, had his reasons for not being more explicit. But Augustus, who had little sense of belonging to his parents' unknown families, feared it might be true and was discouraged from probing further.* They couldn't *all* have been middle-class lawyers, he thought; then he would glance at his father again and reflect that perhaps, after all, they had been and it was better to remain in the dark. At least *he* would be different.

In view of the many legends and speculations that were to camouflage Augustus's origins – some of them amiably spread by himself – it is important to establish the facts. Both his paternal great-grandfathers, William John† and David Davies, were Welsh labourers living in Haverfordwest; while on his mother's side he came from a long line of Sussex plumbers, all bearing the name Thomas Smith. William John's son, who was named after him, was born in 1818. At the age of twenty-nine he married a local sempstress, Mary Davies, the same age as himself. On the marriage certificate he described himself as a 'writer', though whether this was a euphemism for clerk (as seems probable) or an indication of some literary aspirations is not now known. That he had cultural interests, however, is certain. By the end of his life he had collected a fair library including, most prominently, leather-bound volumes of Dickens, Scott, Smollett and an edition of Dante's *Inferno* with terrifying illustrations by Gustave Doré; and he had done something rather unusual for a man of his class in the mid-nineteenth century:

* 'I think his [Edwin's] father and perhaps his grand-father too, practised at Haverfordwest, as solicitors and my earliest years were spent there,' Augustus wrote to the Haverfordwest historian G. Douglas James (17 August 1960). In another letter one week later, he added: 'I have the impression that one of my forebears was Town Clerk of H-West.'

† Besides being a labourer, William John had abilities as a violin player. 'I am hoping that the musician will turn out to have been a wandering minstrel,' Augustus wrote to H. W. Williams on discovering this fact (16 May 1952). '. . . His musical gifts reappeared in one or two of my descendants'. Perhaps the most celebrated musician among these descendants is the 'cello player Amaryllis Fleming. Augustus's sister Winifred played the violin, and her daughter Muriel Matthews is a respected 'cellist in America. Augustus's son David was for many years an oboist in the Sadler's Wells orchestra, and another son Edwin played the flute.

he had travelled through Italy, bringing back with him a fund of Italian stories and a counterfeit Van Dyck to hang in his dining-room.

If William John ever had ambitions to be an author, they were soon extinguished by his marriage, and on the birth certificate of their first child, Joanna, nine months later, his occupation is given unequivocally as 'attorney's clerk' – a job that was not to vary over the next fourteen years. But these years were far from idle. They had begun their married life in a workman's cottage in Chapel Street, moved shortly afterwards to Prendergast Hill and in 1850 were living at 5 Gloster Terrace. Each move, though only a few hundred yards, denoted a rise in the world, and the climax was reached when, in 1855, they transferred to Victoria Place. On a modest scale, the career of William John was a considerable success story. His life appears to have been one of blameless, unremitting diligence of a kind that would have horrified his grandson. In the Michaelmas Term of 1854 he was admitted as a solicitor and following this there was no holding back. He started his own legal firm in Quay Street, served for several years as town clerk of Haverfordwest, bought a number of properties and, on his death, left a capital sum of nearly eight thousand pounds. In politics he was a Liberal, and had acted as Lord Kensington's agent in all his contests up to the late 1870s. He had established himself as a much-respected figure in the district, well known for his eloquent speeches in Welsh at the Quarter Sessions. But although, in the various directories of the time, he is listed among the attorneys, he is not among the gentry.*

Between 1840 and 1856 William and Mary had six surviving children, three sons and three daughters. Edwin William John, the fourth child and second son, was born on 18 April 1847. No. 5 Gloster Terrace, where his earliest years were spent, was a tall thin house into which were crammed five children,† William and Mary, Mary's sister Martha Davies, fourteen years younger than herself, who helped to look after her nephews and nieces, and, rather confusingly, another Martha Davies of about the same age, who acted as a general servant.

In later years Edwin John let it be known that he was an old Cheltonian. In fact he was at Cheltenham only three terms and, according to his younger sister Clara, this single year produced a devastating effect upon him. His disposition, tolerable before he attended public school, was 'impossible' ever afterwards. He became a victim to the cult of

* His obituary in the *Haverfordwest and Milford Haven Telegraph* (9 July 1884) notes that 'the remains of the deceased gentleman were interred this (Wednesday) morning in St Mary's Cemetery. The funeral was largely attended by the principal professional men, as well as the leading tradesmen of the town and neighbourhood.'

† Joanna (b. 1840), Emma (b. 1842), Alfred (b. 1884), Edwin, and Clara Sophia (b. 1849).

appearances, in particular respectable appearances. He quickly forgot all he knew of the Welsh language and greatly exercised himself on the subject of his social reputation.

Edwin's main education, however, had been conducted locally in Haverfordwest. He knew Lloyd George's father, William George, a Unitarian schoolmaster who ran a private school in rooms he rented in Upper Market Street, and here Edwin went for several years. William George 'was a severe disciplinarian', he afterwards recalled, ' – rather passionate, sometimes having recourse to the old-fashioned punishment of caning'. His wife, whom he married while Edwin was at the school, was 'a sweet lady whom the boys liked very much'.

It was the eldest son Alfred, not Edwin, who had originally been intended for the law.* Alfred had married a Swansea girl and had had three children in three years, but after a period working in his father's law office his spirit suddenly revolted. While still in his twenties he ran away to London – and eventually to Paris – to play the flute, first in an orchestra, later on in bed. He was pursued, like some Pied Piper, across the country by his father, but to no avail. So, since he seemed determined to prove a black sheep,† the burden of family responsibility was passed on to Edwin. He filled this role impeccably. Leaving Cheltenham at the age of sixteen, he was immediately articled to his father and, in the Easter term of 1870, admitted a solicitor. For a further two years he was employed as an assistant, after which, on his twenty-fifth birthday, William John made him a partner, and the practice became known as William John and Son. When William John retired seven years later, Edwin took it over entirely. He had done all that could have been expected of him, perhaps more.‡

*William John used to describe Alfred as a solicitor, though in fact he never passed the law exams, and probably acted as managing clerk, a position he could hold without legal qualifications.

† By reason of his sense of humour, unyielding incompetence in managing practical affairs and an almost complete dissimilarity to his younger brother Edwin, Alfred John came to fulfil Augustus's ideal of an English gentleman. His haggard good looks proclaimed an invincible innocence, unconquered by lifelong poverty. Visiting his nephew one hot summer day, he accidentally revealed by a spontaneous gesture that, underneath his mackintosh, he wore no clothes at all. With such poverty and innocence, he judiciously added to his family's name a 'St' and, as Alfred St John, was rewarded with a very fine funeral service, free of charge, by the clergy of St David's Cathedral.

‡ Edwin was made the main beneficiary of William John's Will, which is dated 14 June 1881. From this document it appears that his two eldest daughters Joanna and Emma had already died, and that his youngest son, Frederick Charles John (then aged twenty-four), had, like Alfred, turned out in his father's opinion a ne'er-do-well. Each of them was left a small annual income provided that, at the time of William John's death, he was not 'an uncertified bankrupt or through his own act

He had even married with his father's 'lawful consent'. The legal
atmosphere appears to have been so thick that, on the marriage certifi-
cate, his wife accidentally gave her own profession as that of solicitor.*
Her father Thomas Smith's profession she described as 'Lead Merchant',
a delicate euphemism for plumber.

Thomas and Zadock Smith had been born at Chiddingly in Sussex,
the sons of Thomas Smith, a village plumber. The elder son, who
inherited his father's business, moved to Brighton and in 1831, at the
age of twenty-two, married Augusta Phillips. They lived in Union
Street, and between 1832 and 1840, produced three children, Sarah
Ann, Emily and Thomas who was later himself to inherit the Smith
plumbing business. That there may have been other children who did
not survive seems probable. In any event, early in 1843, Augusta was
again pregnant and her condition must have been serious. She was
given an abortion, but afterwards was attacked by increasingly violent
fevers. On 25 May, at the age of thirty-two, she died.

A year later Thomas Smith married again. His second wife was a
twenty-six-year-old girl, Mary Thornton, the daughter of William
Vincent Thornton, a cupper† from Cheltenham. Before her marriage
she was living in Ship Street, Brighton, and it was here that Thomas
Smith and his three children now moved. In the next fourteen years
they had at least ten children,‡ but the mortality rate among the boys
was high, four of them dying before their twelfth birthday. As befitted
the grandfather of Augustus John, Thomas Smith was 'a person of full
habit of body' and outlived nine of the seventeen children he had by
his two wives.

In its way Thomas Smith's career was comparable to that of William

* It was not until the removal of the Sex Disqualification Act in 1919 that women
were permitted to qualify as solicitors. The first woman was admitted in 1922.

† A cupper was someone professionally skilled in blood-letting by the applica-
tion of cupping-glasses, as opposed to leeches or venesection. Air was expelled
from the glass which adhered closely to the surface of the skin. When this had
swollen and blackened, the cupper prised his glass off, scarified the skin, then
re-exhausted and re-applied the glass, into which the blood flowed.

‡ Benjamin died on 12 January 1856 of hydrocephalus and convulsions, aged
two months; William had died six days earlier from the same cause, aged one year
and eleven months; Sydney died after fourteen days of diarrhoea on 13 August
1861, aged five weeks; and Thornton, on 15 May 1861, aged eleven years, died of
congestion of the brain, fever and debility.

or default or by operation or process of law or otherwise disentitled personally to
receive or enjoy the same during his life or until he shall become bankrupt' etc.
Frederick Charles John died on 9 April 1896, aged 39.

John, and from humble beginnings he became a successful and much respected local figure. By the age of fifty he was not merely a plumber, but a Master Plumber, glazier and painter, employing ten men and three boys in the painter's shop he had bought next door in Ship Street, and in the home a cook, housemaid and nursemaid. His will is a chauvinistic document that might well have drawn a word of approval from the Town Clerk of Haverfordwest. In one respect at least it is superior to William John's: he left a sum of almost fourteen thousand pounds.

Mary Smith's third child, born on 22 September 1848, was named Augusta after her father's first wife. From a comparatively early age she appears to have shown a talent for art. She was sent to 'Mrs Leleux's Establishment' at Eltham House in Foxley Road, North Brixton, and here, in December 1862, she was presented with a book, *Wayside Flowers*, as a 'Reward for Improvement in Drawing'.

She continued drawing and painting up to the time of her marriage, and to some extent afterwards. The few examples of her work that still remain show that her subjects were mostly pastoral scenes, done in the dry watercolour method. A study of Grasmere Church, seen across a tree-lined river and delicately executed in soft cool colours, is signed Augusta Smith and dated 1865; a picture of cattle with friendly human faces, painted three years later when she was nineteen, is signed 'Gussie'. It is meticulously done, the colours rich and warm. Both these are privately owned in Wales; but a charming Landscape with Cows painted after her marriage and simply signed 'A. John' is part of the celebrated Dalton Collection in Charlotte, North Carolina, where, attributed to her son, it hangs happily in company with Constables, Rembrandts, Sickerts and Turners.

But for Augusta painting was only a pastime,* and she had no thought of any professional career. Her father's taste for biblical christian names, and the fact that almost none of his daughters married before his death, suggests an Old Testament view of women's place in the scheme of things to which, while he lived, Augusta was obedient. But on the night

* Her subjects were typically nineteenth-century (children playing 'oranges and lemons' for example, or a mother and two children arranged among sheaves of corn) and may sometimes have been copied from other paintings. Perhaps the most striking of her watercolours is a head and shoulders of a Tyrolean shepherd boy, in the collection of Mr J. F. Thomas of Bognor Regis, who wrote: 'The watercolour that I have is about 18" × 14". It appears to represent a rustic lad – maybe a Tyrolean shepherd boy (no English boy would wear such a hat!). It shows the head and shoulders. The draughtsmanship is delicate and assured. The blue in the outer jacket (and reflected in the subject's chin) probably accounts for the fact that Mr E. W. John, father of Augustus, called the picture "The Blue Boy". Thirty odd years ago it hung in the housekeeper's room in E. W. John's home, 5 Lexden Terrace, and she said he had told her it was painted by his wife.'

of Thursday, 20 February 1873, Thomas Smith suffered a stroke. His intellect was unaffected, and for five days he lay paralysed on his bed, gradually sinking under the attack until, at four o'clock on the following Thursday afternoon, he died.

His relatives filled three mourning coaches at the cemetery. Such was his reputation as an honest plain-dealing tradesman that, despite appalling weather, a great concourse of people gathered at the grave, while in Brighton itself nearly every shop in his part of the town had one or two shutters up. 'In fact,' the *Brighton Evening News* (4 March 1873) commented, 'so general a display of shutters is seldom to be seen on the occasion of a funeral of a tradesman, only but honourably distinguished by his strict and uniform integrity during a long business career.'

Four months later, on 3 July, Augusta married Edwin John at St Peter's Church in Brighton. It was said to be a love match. One of the tastes they held in common was for music: she would play Chopin on the piano, while he preferred religious music and in later life wrote a number of 'chaste and tuneful compositions' for the organ, including a setting for the Te Deum and a Berceuse. The three eldest children, who were unmusical, were all encouraged to draw, and a large pencil drawing of a dog by Thornton John testifies to the fact that he too inherited his mother's ability.

But the strongest reaction Augusta produced on all her children came through her absence. She died, apparently among strangers, at Ferney Bottom, Hartington, in Derbyshire. The cause of her death was given as rheumatic gout and exhaustion. She was thirty-five years old;* and Augustus was six-and-a-half.

3. DEATH WITH FATHER

The year 1884, which was for Edwin John a particularly unhappy one, marked a turning-point in his life. Everything had gone wrong. His marriage, ruined latterly by his wife's ill-health, was at an end; and his father, who had been suffering from what the locals called 'water on the brain', had died the previous month.† He had four children, two fanatical sisters-in-law, few friends, but an army of voluble neighbours who, with eager pessimism, would point, particularly to Winifred, and exclaim: 'Is this the poor little motherless child? She doesn't know yet how terrible it is – *but she will later*!'

That autumn Edwin made a great decision, gave up his practice in Victoria Place, sold his house at Broad Haven and, taking with him

* The death certificate inaccurately gives her age as thirty-four.

† William John died of cerebral softerina on 6 July 1884.

two Welsh servants from Haverfordwest, moved to Tenby where, for a short spell, he had enjoyed unclouded happiness with Augusta. Leah and Rosina left too, transferring their proselytizing zeal to the wider horizons of the New World,* and leaving Edwin to lapse back into the Bosom of the Church-in-Wales.† He was thirty-seven years of age – not too late to start another life.

Victoria House, 32 Victoria Street, into which he and his young family now moved was a very ordinary mid-nineteenth-century terrace house, with three main floors, a basement for servants and an attic for children. It stood just round the corner from Belgrave House.

Augustus disliked his new home almost from the beginning. Dark and cube-like, with a peeling false façade, it was like a cage and he a bird caught within it, unable to use his wings, to escape. Set in a dreary little street off the Esplanade, from where you could hear but not see the Atlantic, it was furnished without taste or imagination, its dull and uniform mahogany tables and chairs, its heavy shelves of law tomes and devotional works, its appalling conglomeration of unauthentic Italian pottery, pseudo-ivory elephants and fake Old Masters – all tourist souvenirs from William John's European wanderings – contributing to the atmosphere of mediocrity and gloom. In the twelve years he lived here, Augustus came to feel that it was not a proper home nor was Edwin John a real father. Existence there was a sort of death. 'I felt at last that I was living in a kind of mortuary where everything was dead,' he records,[2] 'like the stuffed doves in their glass dome in the drawing-room, and fleshless as the abominable "skeleton-clock" on the mantelpiece: this museum of rubbish, changing only in the imperceptible process of its decay, reflected the frozen immobility of its curator's mind.'

The key to Edwin John's character was a form of acute anxiety that,

* Aunt Leah went straight to America where she picked up a slight American accent and a large band of marching American disciples. Aunt Rosina's travels were more circuitous, and her destinations always preceded by a series of brown paper parcels. Sustained by a diet of over-ripe fruit and protected by a dense fur muff, she set off for Switzerland from where she wrote a number of indecipherable letters in purple ink testifying to her brief enthusiasm for Dr Coué, a gentleman who had propounded the theory that if everyone repeated 'Every day in every way I am getting better and better' many thousands of times, the world might become a more cheerful place. From here she went to Japan, where she collected a miniature Japanese maid, and later, improbably passing through Mason, Nevada, married Owen H. Bott, a druggist with two sons. Under the pitiless blue of the Californian skies, she caught up with Winifred, terrifying her children with her severe cotton-wool hair and pale grey eyes that seemed to glare at them with ceaseless displeasure, her extreme age, humped back and restless scuttling from place to place.

† Gwen, Augustus and Winifred were baptized at St Mary's Church, Tenby, on 21 January 1886.

apart from stifling his intellectual curiosity, dammed up his unexhausted physical passions and diverted them along the narrower channels of avarice. For what he had lost with the death of his wife, for all he had seemed prevented from attaining by his terrible reserve, he found solace in the contemplation of a stubbornly unspent bank balance.

The regime at Victoria House was a direct expression of this financial and emotional stringency. Sometimes, at night, the children were so cold that they would pile up furniture on their beds. During the day-time, too, the atmosphere was scarcely warmer. Meals were particularly grim. Though timid in public, Edwin was something of an authoritarian at home and demanded of his children an unquestioning obedience. He was determined to do the right thing – and the right thing, it seemed, so often combined unpleasantness with parsimony. Gwen, who abhorred rice pudding, was required to swallow it to the last mouthful; Winifred, who was rather fragile when young, was specially fed on a diet of bread-and-butter pudding full of raisins which she was convinced were dead flies. The children's tastes were never consulted. Certain food was bought because it was cheap, and eaten because it was there.

But more awful than anything else were the silences. Whether because of his shyness or of some deep vein of melancholia, Edwin seemed shut off from his children, as from all other people, unable to mix or communicate with them. Breakfast, lunch and eventually dinner were eaten sometimes without a word spoken. Once, when Winifred hazarded some whispered remark, Edwin turned on her and asked sarcastically: 'Oh, so you've found it at last, have you?'

'Found what?'

'Your tongue.'

After which the silence plummeted deeper.

When they were very young Gwen and Winifred invented a touch and facial expression language, but were forbidden to use it in the house since it made them look so hideous. So they would go upstairs before each meal and try to decide in advance what each would say.

'I'm going to say . . .'

'No. I want to say that.'

'I thought of it first.'

'Well, I'm the eldest.'

Augustus's method of non-communication was at the same time more simple and more sophisticated. On one occasion, at a fairground, he had seen a boy of about his own age fall off a roundabout and be led away bleeding at the mouth. This scene had so impressed him that he later transferred it to himself and was afflicted with strong vicarious symptoms. When called upon to answer some question he would

struggle gallantly with his partly amputated tongue but be quite unable to enunciate anything beyond a few grunts. This handicap left him at last when he became a self-elected son of the Antelope Comanche Indians, by which time he could seldom be persuaded to utter more than 'Ugh! Ugh!'

In this bleak inarticulate atmosphere, small occasions assumed a grand importance. Games, birthday parties, Christmases gave rise to moods of almost unbearable excitement. Though excessively formal, Edwin John was not an unkindly man and, his parental prerogative once set aside, he could be humane and even playful. At night, the children would tell him what to play on the piano, and the sound of his scrupulous rendering would float up to their icy bedrooms. He also read to them in the evenings from *Jane Eyre* and Mme Blavatsky's *Isis Unveiled*, from carefully bowdlerized versions of *The Arabian Nights* and, more haltingly, from the complete works of an obscure Belgian author, Henri Conscience, in the original French – a language in which Edwin was being tutored by Monsieur de Berensburg, a Belgian exile in Tenby. All his children had a quick ear for languages, and Gwen and Winifred were for a time taught by a French governess who was so delighted by their progress that, in a moment of modest abandon, she told their father it must be due to some French ancestry. This intended compliment so shocked Edwin that he discontinued the lessons and substituted in their place instruction in German grammar – the declensions of which, Winifred later claimed, turned her against the whole nation for life.

Nurses, housemaids and governesses came and went fairly rapidly, but with none of them do the children seem to have formed any deep attachment. As at Haverfordwest, it was the servants who enjoyed themselves most and they were much envied by the other servants in Tenby. Shrieks of laughter were often to be heard rising from the basement and invading the funereal stillness of Edwin John's rooms. Occasionally relatives called, and the children would be dragged out from behind furniture and under beds to deliver a cold kiss.

But it was not an unhappy life, and their emotions were chiefly directed to their animals, the sea, wild countryside and to the occasional best friend. Gwen had a cat, Mudge, who fought. Out walking, Edwin would meet him on the town wall, torn, bleeding and looking so disreputable that he refused to recognize him and would hasten his pace to shake him off. But when Winifred lost her spaniel Floss, Edwin arranged for the town crier to walk through Tenby ringing his bell and shouting out the news. And once Floss was found, he hurried round, accompanied by a maid, to interrupt her lessons and tell her.

Thornton grew into a small quiet boy, more at home in the sea than

on land. Rather slow and very precise in his speech, with an air of unblinking naïvety, his conscientious calmness would provoke Augustus into all sorts of exasperating tricks to discover the limits of his endurance. Then, once his religious patience was at an end, Thornton would advance upon his younger brother with plodding Old Testament determination, only to be met with acts of buffoonery so extreme as to reduce him to powerless laughter. Destined by his father to be an engineer, he cherished a romantic ambition to live the life of a gold prospector, and before the age of twenty left luggageless for Canada, sprouted a moustache and spent the next seventy years happily, though with complete unsuccess, digging.*

The two girls, Winnie with long fair hair down her back, and Gwen who was dark, used to walk about Tenby alone, which was regarded then as very peculiar. Both were intensely shy, but whereas Winnie was gentle and timid, with a self-deprecating sense of humour, Gwen's unobtrusiveness contained a far more intractable nature. Together they used to go for long bicycle rides along the green Pembrokeshire lanes, climbing on to the stone walls whenever they met a flock of sheep. Once they encountered a company of soldiers, whose officer gave a word of command as they approached so that the columns of men separated, allowing them just room to ride down the centre, at full speed, blushing furiously.

Winifred, who was to become an accomplished violinist in America,†

* Either he would discover a good partner and no gold, or gold and a partner who ran off with it. But, except for a brief period when he dreamed of starting a tobacco factory in Ireland, he seemed to have found what he really loved – mountains, prairies, horses and empty spaces. Among the trappers, cowboys and prospectors he soon earned the honourable title of 'the rider from away back', and, in company with a band of these wild and woolly fellows, crossed Canada on horseback, fording rivers and bathing in hot springs till his skin turned orange. Above all he relished solitude and for some years before 1914 went to live beside an Indian encampment, whose inhabitants would suddenly appear outside his tent, sit for hours silently smoking their long pipes, then vanish. He also travelled through Montana 'and always on horseback'; he wrote: 'I used to make my bed on the ground without a tent, and the dawn was the most important part of the day.' He married late in life a woman who had had two previous husbands and whom he discovered after her death to have been twenty years older than he thought. He had no children, but one foster daughter. He died in British Columbia on 19 March 1968, aged 92.

† From Paris, where she stayed with Gwen, Winifred crossed the Atlantic while still in her early twenties. By the summer of 1905 she had reached Montana, living some months with Thornton surrounded by Indians, 'rattle-snakes and all sorts of wild animals'. The two of them planned to travel to Mexico, by boat, along the Mississippi. 'The idea of orange groves and sunlight is *enchanting*,' Augustus wrote to her, ' – but too remote from *my* experience to be anything but a lovely dream. But depend on it, you have only to perjure yourselves to its reality to bring this family

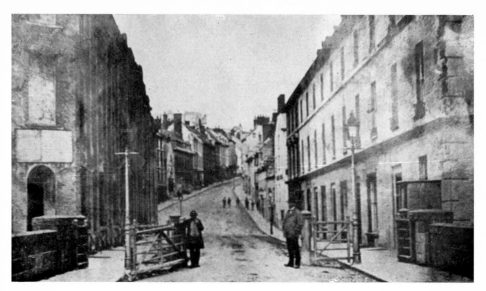

Victoria Place, Haverfordwest, 1870s

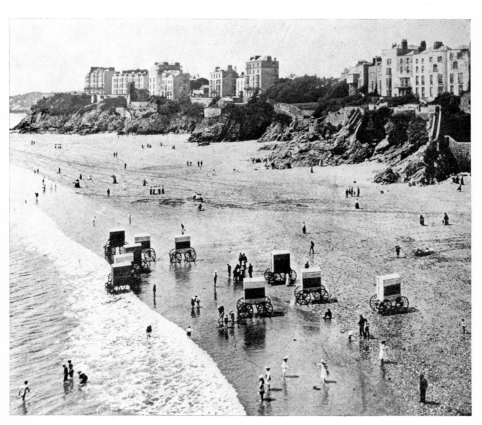

South Sands, Tenby

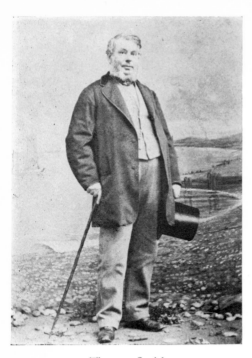

Thomas Smith

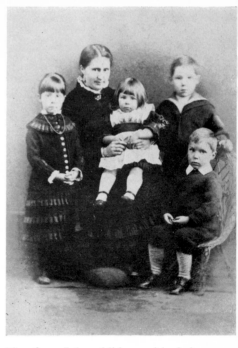

The four John children with their nurse.
Left to right: Gwen, Winifred, Thornton
and Augustus.

Augusta and Edwin John

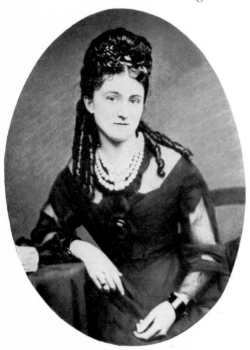

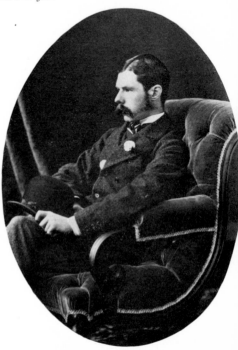

and who also loved dancing, shared many of her sister's tastes, in particular her strange affinity for the sea and passion for flowers. But Gwen's need for these things, nurtured by greater solitude, was more obsessive. She used to dream of flowers as others dream of people, and she would spend the last halfpenny of her pocket money on them if she could not pick them. Out of sight of her father and the well-dressed persons of Tenby, she loved to throw off all her clothes and run along the beaches for the sheer joy of being free.

In this wildness, and the quick switchback of her emotions, Gwen resembled Augustus much more closely than Winifred or Thornton* who were both softer personalities. Gwen was naturally independent. She and Augustus would stage elaborate arguments as to who was the elder, neither of them appealing for judgement to Papa because, they explained, they would then have to find something else to argue about.

More than half of Augustus's life at this time was fantasy. He would ransack his father's library for books and, poring over them, seem to leave his body and hover on the threshold of other worlds. When he read the story of Gerda and Little Kay, he was overcome by ungovernable tears, and had to shut himself away in his room. But his favourite author was Gustave Aimard, whose tales of Red Indians utterly absorbed him. So strong was his feeling for these books that he took to studying his father's features in the hope of discovering in them some trace of Antelope blood.

But it was outside Victoria House that Augustus came fully alive.

* But to some extent Thornton certainly shared the melancholia that affected Gwen and Augustus. Writing to Augustus on 18 March 1947 he refers to Gwen's 'moods of sadness' and adds: 'It is not for me to pry into this but I fully understand her for I have felt the same tendency myself – perhaps it is hereditary.'

at any rate helter skelter on your tracks . . . I can just *see* you and Thornton installed on the top of some crumbling teocalli with the breath of the Pacific in your nostrils.' Eventually this plan was abandoned, and Winifred journeyed instead to Vancouver where 'the weather was perfect: it rained every day', and to San Francisco, 'a beastly town'. For a number of years she gave violin lessons in California, and on 30 January 1915 married one of her pupils, Victor Lauder Shute, a failed painter who had turned engineer and worked mostly for the railroads. They had three children, Dale, Betty and Muriel, a fourth child being still-born in 1924. Although she claimed to have developed 'such strong nerves I have played to a room full of people and forgot everybody', she always preserved her extreme John shyness. When, during the First World War, she wanted to write to her friend Irene about the birth of one of her children, she felt it was so delicate a matter that she would have to use code – with the result that her friend was arrested by Scotland Yard.

She never returned to Wales or England, but died in Martinez on 12 April 1967, aged 87.

Beyond that enclosed atmosphere and the inhibitions of adult authority his fantasies flourished. Striding through the streets of Tenby on the tallest stilts, diving off rocks and swimming far out into the cold Atlantic, gathering wild strawberries that overhung the cliff tops, exploring hidden ways, gazing fearfully down disused coal pits or up through the terrifying blow-holes that bellowed out volumes of yellow sea-spume over the fields, or wandering alone across the salt-marshes up to the rock-pools in the hills where the snow outlasted the winter, listening to the larks in the long summer evenings, chasing the butterflies, building castles in the open air – Augustus was in his element.

Outdoors he seemed completely fearless. One day, coming across an untethered horse, without a word or thought he jumped on it bareback. As it started to gallop along, he fastened his arms about its neck but slowly began sliding off until he was soon hanging down in front of it. So this odd pair hurtled towards the horizon. But in the end, when the horse had finally come to a halt, Augustus was still clasped to it. His climbing exploits were unrivalled. He would descend the dizzy perpendicular rock-cliffs between Giltar and Lydstep to wet shingle beaches untrodden by human foot, and, like Gwen, fling off his clothes and perform wild antics in and out of the water while the tide advanced giving him that special thrill which came from not being quite sure of getting back again.

In particular he loved the harbour at Tenby with its fleet of luggers and fishing-smacks, and the russet sails of the trawlers in Tenby Bay; and he loved the long expanse of Tenby beach, its sand spongy like light flat cake – a golden playground two miles long. Here, while still very young, Augustus would play all day with his brother and sisters, catch shrimps in the tidal pools where sea-urchins delicately flowered, paddle through the shallow waves that gently broke seething and criss-crossing across the shore, dig, fill and elaborately haul buckets of sand up the blue, slate-coloured cliffs. Where the sea had worn these cliffs away tunnels and devious caves had been hollowed out, as if gnawed by giant sea-mice – dark, dangerous and exciting. Great slabs of slate rock lay bundled at the entrances, covered with barnacles and emerald sea-weed.

This beach was the fashionable meeting place for all Tenby. Under the cliffs a band played patriotic airs and nigger minstrels sang and danced; donkeys, led by donkey-boys and ridden by well-dressed infants, trotted obediently to and fro; gentlemen in boaters or top hats and ladies in long skirts with wasp waists carrying parasols promenaded the sands, inspecting from a safe distance the calm and superficial sea. Every week-day, bathing – a complicated procedure in voluminous

serge costumes – was permitted before 8 a.m. and after 8 p.m. Between these hours horse-drawn bathing machines, strewn along the sands, had to be used – and bathing from boats was not lawful within two hundred yards of the shore. These bathing-machines were upright carriages on wheels, advertising the benefits of Beecham's pills and Pears soap. They were looked after by a company of boys, celebrated for their vulgarity, who shocked Augustus by whispering unheard-of swear words – 'Bloody Bugger!' – into his ears. A frantic man, summoned by the shouts of these boys, would canter up and down the sands harnessing horses to the vehicles which were pulled out deep into the ocean. The occupants could then enter the water with the least possible hazard to modesty. Once they had completed their swimming, they would re-enter their horse-drawn dressing-room, regain their clothes, then raise a flag as a signal that they were ready to be towed back on to land.

As he grew older, Augustus began to avoid this beach, roaming beyond North Cliff Point where he and his companions could bathe from the rocks and bask naked in the sun. He longed for a wider, freer world than that symbolically enclosed by the town walls of Tenby, and was never so happy as when he and his brother and sisters were invited to stay at Begelly, in a house on the hill overlooking an infertile common populated by geese, cattle and the caravans of romantic-looking gypsies. Here, and with the Mackenzie family at Manorbier, the rules and repressions of Tenby were forgotten, Papa was left behind, and the strangely brooding children of Victoria Street were transformed into a turbulent troupe of Johns, running wild.

One of Augustus's best friends at this time was a boy, eighteen months younger than he, called Arthur Morley. 'We used to go for walks together, sometimes to a place known as Hoyle's Mouth, a cave in a limestone cliff about 1½ miles from the town near a marsh where flew many orange-tip butterflies,' Morley later recalled.[3] 'On the floor of the cave we used to dig pre-historic animals . . . We found that leading out of this cave there was a second which we could reach by crawling along a very small passage with a lighted candle. One day at the end of one of these visits we were preparing to return by one of the two possible ways back to Tenby [when] I said "Let's go by this route!" He said, "No, we'll go by the other." We could neither of us give way at this point, so we solemnly turned and walked away each by his chosen route. There was no ill feeling on either side and we never referred to this episode.'

Carrying butterfly nets, the two boys spent much of their time wandering along the dunes. 'One evening at dusk, when we were standing by a mass of white campion frequented by moths, close to what

appeared to be a storehouse, two boys turned on us obviously in no friendly mood. One of them shouted: "Go away! This building belongs to my father and you are trespassing." Gussie replied loudly and emphatically "Prove it," a phrase he used every time the boy said anything, until at last the two boys went off in disgust.'

His greatest friend was Robert Prust, whose family occupied, with their parrot, a fine house on the south cliff. Robert Prust was keen on Red Indians, and for a long time Augustus hero-worshipped him. The two of them would lead out a pack of braves along the rough grass tracks, across the sand-dunes known as 'the Burrows' to advance upon the army encampment at Penally. No one took his Indian life more seriously than Augustus. 'Under the discipline of the Red Man's Code,' he wrote,[4] 'I practised severe austerities, steeled myself against pain and danger, was careful not to betray any emotion and wasted few words.' Such a Spartan regime was eventually too much for his companions who, one by one, abandoned the warpath to chase instead the paleface Tenby girls. At last only the two of them were left. The final betrayal came when, having helped Augustus set fire to a wood, Robert Prust revealed a most un-Indian lack of stoicism by breaking down before the face of things to come. So Augustus was left to roam the Burrows alone, attended by a phantom tribe of Comanches.

The cult of the Red Indian was, for Augustus, more than a game: it gave him an alternative world to Tenby. Yet everywhere there were encroachments. His hunting-ground, the Burrows, was soon converted into a golf-links; the nigger minstrels under the cliffs were replaced by a refined troupe of Pierrots who could be invited with impunity to tea; even the annual fair, with its blaring cacophony of roundabouts spinning away late into the night, was removed from under the old town walls to a field on the outskirts.

Tenby, in the last two decades of the nineteenth century, had become a town much favoured by relatives of the county landowners of Pembrokeshire, by retired colonels and elderly sea-dogs. It was also a fashionable holiday resort for the upper-middle class who arrived each summer to play their golf, badminton and high-lobbing lawn tennis, to shoot, to hunt foxes and otters. There were regattas, much blowing of marine music, balls in the Royal Assembly Rooms and, in the evening, the twilight ritual of the slow promenade along the margin of the cliffs.

Everywhere the strictest rules of snobbery were observed. Edwin John much applauded this scheme of things and was determined to become a part of it. One of the first things he did was to throw away his professional brass plate – though he continued intermittently and on the quiet to practise law from his home as if it were a not quite reputable occupation or, at best, merely a gentleman's whim or hobby, like his

amateur shell collecting. He associated himself ever more intimately with the church, and was appointed assistant organist at St Mary's. Every Sunday morning he would insist on lining up his children, like small soldiers, in the hall, to be inspected before they set off, two by two, for the service. He himself, in a top hat and frock coat, led the way, and drew many curious glances. He did more: he took up photography; he played the harmonium; he entered cold baths in the early morning; above all he did – and was conspicuously seen to do – absolutely nothing whatsoever. He saw to it that his manner was never less than frigidly unapproachable: and no one approached him. It was very odd. He redoubled his efforts. His hair grew white, his cheeks turned pink, his collection of cowries multiplied, his walks became longer and longer, his collars, always of the stiffest, stiffened even further: everywhere throughout the district his gentility and rectitude were freely acknowledged. But with the elite of Tenby – the Prusts and Swinburnes, the Morleys and Massays and Hannays and de Burghs, whose children were Augustus's companions, Edwin was never on visiting terms. For although his propriety was unexampled, curious rumours persisted of some scandal back at Haverfordwest – rumours fanned into life by Augustus's lively imagination.

The conformist who sacrifices all for his conformity usually achieves the unconventional. Edwin John was an eccentric who detested eccentricity. He longed for the superior decorum of polite society, yet the drawing-rooms of Tenby remained closed to him, and he took his place, quite unaware, among the town's most bizarre characters – with the gentleman who tied a rope to his topmost window and, shunning stairs, swarmed up and down it; and with another who wore socks on his hands; with the lady who struggled to keep an airless house, stuffing paper into every crevice of window and door; with Cadwalladyr, the speechless shrimper, massive and hairy and never less than up to his waist in water; and with Mr Prydderch, bank manager and Captain of the Fire, who, 'swaggering fantastically, his buttocks strangely protuberant', paraded the town to the music of a brass band until captured and confined to Carmarthen Lunatic Asylum.

From the start, Edwin John made sure that his children were seen to be educated in the most proper manner. Nothing excessive was required; in particular the girls' education was so reticent as to be almost invisible. As soon as the family had settled into their house at Tenby, Gwen and Winifred were sent to what was referred to as a 'private school' a few yards away in Victoria Street. This school took its privacy almost to the point of secrecy. It consisted, *en masse*, of three pupils, the mother of the third one, a German lady married to a sequestering philosopher named Mackenzie, acting as teacher. This arrangement combined for Edwin

the advantages of cheapness with those of social prestige in claiming for his daughters a foreign 'governess', optimistically described as 'Swiss'. Mrs Mackenzie was a kind and homely woman who, to a limited extent and more especially with Winifred, took the place of their mother. Her daughter Irene became a particular friend of Winifred's – the two of them laughed so much together that if one caught sight of the other even on the horizon she would be convulsed with giggles. Gwen, at this time, suffered from a type of back trouble that gave Mrs Mackenzie's lessons a drastic appearance. On doctor's advice Gwen would spend hours stretched out on the schoolroom floor, where both Irene and Winifred insisted on joining her.

When they were older both of them attended Miss Wilson's academy, a school that placed more emphasis on impeccable conduct than on scholarship. Miss Wilson herself was an ice-cold woman of unguessable age, who wore an expression of unrelieved sternness and who later committed suicide by striding off into the sea. On one occasion she took Gwen, Winifred and some of their friends on an excursion to Manobier Castle, and on the way home it was proposed they give three cheers for her. 'Hip, hip . . .' they began, as Miss Wilson stood stonily facing them – but halfway through the cheer died out into a series of frantic whispers: 'Why didn't you go on?' – 'I was waiting for you . . .'

Augustus's education was equally unusual. Late in 1884 he went to an infant school in Victoria Street, and at the age of ten was sent to join his brother at Greenhill, a rambling building set on a plateau on the slopes of lower Tenby.* This school catered both for the sons of tradesmen and of the middle classes, and its pupils, faithfully mimicking the ways of their parents, segregated themselves into two classes: 'gentlemen' and 'cads'. It was run by Mr Goward, a tiny man with a large spectacled face topped by a flame of hair, and invariably dressed in frock coat, button boots, mock-clerical neckwear and curiously short turned-down trousers. An ardent Liberal and Congregationalist, he began each day with a Gladstonian homily, followed, according to his mood, by hymns or, more secularly, a rendering of 'Scots, wha hae!' A theoretical champion of liberty, in practice he wielded a heavy ruler and was assisted in this by a staff that included two daughters and an ever-changing company of unkempt, ill-paid undermasters.

Gussie, as everyone called him, was a mutinous pupil. The local games, into all of which he entered with zest, failed to absorb his energy, and he was always getting into trouble for breaking school

* This building has now been converted into a public library. In the cemented grounds are two trees, an oak planted in memory of Augustus, and a birch in memory of Gwen. Greenhill School carries on, but has moved to the outskirts of Tenby.

rules, libellously caricaturing the masters and retaliating when corrected. With the other boys he seems to have been popular. It was here that he won his first serious stand-up fight, collapsing into uncontrollable tears after his victory as if in sympathy with the loser.

It was here, too, that he received from the drill master a smashing blow on the ear that, for the rest of his life, made him partially deaf.

Regularly, every term, his misdeeds were reported to his father who meticulously committed them to paper. Then, one day, something shocking happened: Augustus struck the second master – instead of the other way about – and Edwin felt he could ignore these delinquencies no longer. Having entered this last enormity in his ledger, he summoned Augustus to his study, read out the full catalogue of his crimes stretching over the years and with an impassioned cry of 'Now, sir!' had, to use his own words, 'recourse to the old-fashioned punishment of caning'. The decline in Edwin's authority began from that day. Essentially a passive man, whose chief ambition for his children was that they should cause no trouble for him, he was unable to inject any conviction into his performance as irate paterfamilias: he simply didn't care enough. And Augustus, sensing this, began to lose respect for him.

When, shortly after this incident, Mr Goward left Greenhill for America, Thornton and Augustus were sent to boarding school at Clifton, near Bristol. This choice is, at first sight, rather curious. Edwin had not planned for either of his sons to go to his own school; possibly he was not anxious for them to find out just how tenuous his connection with Cheltenham had been. The new school, however, took a number of pupils from Pembrokeshire and was well thought of in Tenby. Edwin, at any rate, was glad to be released from the perpetual company of his sons, and may well have looked for a change in them to a manner similar to his own. If so, he was disappointed.

Augustus never fitted into this school. The top hat, Eton jacket and collar uniform made him feel uncomfortable and faintly ridiculous. At football, which he liked, he played centre forward and achieved some success. But cricket, by which his father set great store, left him cold – it was so elaborately unspontaneous: he could never bowl, the long drudgery of fielding bored him unutterably, and at batting, which seemed more promising, he was always being given out. It was while day-dreaming on the cricket field that a ball struck him on his ear and did for that one what the drill instructor's baton had successfully done for the other at Greenhill.

In the foreign atmosphere of the English preparatory school Augustus was strangely shy and undemonstrative. Though strong for his age he seldom entered into the tribal games of the other boys and he made no

lasting friendships. The only boy for whom he cared at all was, like himself, an outcast from the community, being a half-wit, but so sweet-natured that Augustus at once befriended him.

Everything that appealed to him at this time seemed to lead him away from Clifton – the river Avon flowing westwards under wooded cliffs towards the Golden Valley and the sea; the docks of Bristol where, for a few pence, it was possible to watch a platoon of rats being mauled to death by a dog or ferret; and, in the dark autumn evenings, while he was at prep., the distant wail of an itinerant street vendor, stirring in him a peculiarly painful longing, like despair.

'Gloom, boredom and anguish of mind'[5] were his predominant moods at Clifton, but they did not last for long. Early in 1891 he left to continue his schooling back at Tenby which, for all its disadvantages, was still the only home he knew.

St Catharine's, where he passed the next two-and-a-half years, was a brand new spick-and-span school which had recently opened in the road next to, and parallel with, Victoria Street. It had just one class-room and only seven pupils – though this number doubled later on – and the atmosphere was like that of a family party, far happier than at Clifton.

'A lonely adolescent' was how Augustus later described himself up to the age of sixteen. But to the other boys he seemed out of the ordinary, someone it was impossible to overlook. Sometimes he was rebellious, at other times rather staid – but at all times conspicuous. When out walking in convoy along the sands he would display embarrassing initiative, break off and, on the spur of the moment, strip naked before everyone. Dashing up and down, splashing into the sea, jumping and somersaulting like one possessed, he would suddenly come to a halt, quietly dress, then rejoin the convoy which, led by their headmaster, would resume its speechless progress. No one commented on these exhibitions, and Augustus was never reprimanded for them. At the other extreme he could be very prim, sedulously avoiding all swear words, and hurrying out of earshot of the improper stories exchanged by the other boys. There appeared to be two sides to his character that set up within him a curious tension. From time to time he claimed to be a descendant of Owen Glendower, and was readily believed. But when one boy, Peel minor, expressed scepticism, Augustus marched up to him glaring terrifically and waving his fists before his nose. This argument had a devastating effect, and the doubter retired in confusion.

The school was so small it could not raise a full team for any game, and they devised all sorts of ingenious miniature variations – hockey on roller skates on a concrete rink; four-a-side football; golf on the sand dunes with one club; and a game with wooden sticks with which you

endeavoured, without being hit yourself, to hit your opponent's elbow. Augustus enjoyed all these sports without going out of his way to excel in them. But there was one game at which he was in his element. 'We each had to make a shield of some sort and were given six tennis balls,' Arthur Morley remembered.[6] 'We were then divided into two sides. . . . The idea was to attack the other side with the tennis balls. Anyone who was hit was out. Gussie naturally was captain of one side, but instead of trying to take his enemies by surprise he stood on the highest dune challenging them all loudly – he had, I think, been studying The Lady of the Lake. He was a striking figure.'

With such small numbers and a wide diversity of ages, little teaching in class was practical, and the boys worked on individual lines under the headmaster's supervision. Augustus was almost completely innumerate, steadily maintaining his place in arithmetic at the bottom of the school. But his reading and writing improved greatly. He devoured almost every book he could lay his hands on, especially any volume of poetry, and his stories and essays were so vividly written that the headmaster, who thought he might become a novelist, often used to read them out loud to the class. One of them, done at the age of fourteen, began:

' "He's dead," said Jones.
' "Who's dead?" said I.
' "Moses," said he.
' "I know," said I.'

It turns out at the end that Moses is the name of a tame owl.

It was not long before Augustus established himself as the star pupil. With the headmaster, Allen Evans, a clever Welshman who had passed his written examination for the Indian Civil Service but failed to pass the medical, he was an obvious favourite. On one occasion Evans delivered to the class a triumphal address in which he expatiated on the boldness and idealism of Augustus's aspirations, picturing him with one foot on Giltar Point and the other on Caldy Island, and in effect comparing him to the Colossus of Rhodes.

To these encomiums, which might have embarrassed another boy, Augustus responded like a bud in the sun. He had longed for encouragement from his father, but Edwin's unyielding lack of interest affected him like a winter blight. The hero-worship he had wanted to fix upon his father he now transferred to Allen Evans. This halcyon period lasted for over a year. But their relationship, extremely warm at first, later became the subject of speculation and was eventually terminated in the most painful way. 'One day when we were at work in the classroom the headmaster and Gussie stood together in a quiet but very bitter argument,' Arthur Morley recalled. 'I think that the former was

accusing the latter of some offence which Gussie was vehemently denying. In the end the headmaster no doubt feeling that the argument had gone beyond the bounds of reason turned towards me and said: "Morley, did you hear what we were saying?" This was embarrassing, but I said: "I could not help hearing, sir." He then turned to Gussie and said: "There is a boy who talks the truth." '

For Augustus, the effect of this scene was out of all proportion to the trifling incident from which it arose. He had been accused of dishonesty and his plea of absent-mindedness over a new school regulation, though exactly true, was brushed aside as a lie. Charged publicly with deceit by the one man whom he trusted and idolized, he was unable to find words to defend himself and, in a paroxysm of grief, broke down before the whole school.

He had been badly bruised, and the marks never left him. Incidents – disappointments – in later life would press upon this point and unaccountably cause him pain, giving rise to blasts of anger, moods of sarcasm. He never forgot it and, fifty years later, when writing the first draft of an autobiography, he castigated this 'amateur pedagogue', long since dead, for his 'intellectual weakness' and 'appalling meanness of soul'.

Not long after this episode he left the school. He was just sixteen and about to start on a career that would take him far from Tenby and all its associations. Once his tears had dried and the shock passed, resentment purged all feelings of misery. A little later, while he was away, he heard that Allen Evans had committed suicide – and began to wonder, half-seriously, whether he possessed the evil eye. In his fragmentary autobiography, *Chiaroscuro*, he alludes briefly to the headmaster's 'unhappy end'.[7] But there is a sentence, not eventually included in that book, of terrible deliberate insensitivity, obliquely poignant in its parenthesis, that expresses his deep sense of retribution: 'Not long did my master (whom I had loved) enjoy his satisfaction and when he had punctiliously cut his throat, I grieved no more.'

4. A CRISIS OF IDENTITY

'I am visiting my father,' Augustus John wrote to William Rothenstein during a stay in Tenby over thirty years later,* 'and suffering again from the same condition of frantic boredom and revolt from which I escaped so long ago. My antecedents are really terrifying.'

Yet he loved Pembrokeshire; and since he was never cruelly treated and the conditions of these first sixteen years were in many ways out-

* The letter is undated, but part of it, quoted in John Rothenstein's *Modern English Painters*, is wrongly dated 6 May 1939. It was probably written in the 1920s.

wardly agreeable, some other factor must have accounted for this extreme sense of 'boredom and revolt'.

The presence of his father saturated the home and dominated these years. In *Chiaroscuro* Augustus gives a brilliantly amusing portrait of Edwin John:[8] 'Too shy to be sociable, he made few friends; and these few he often found an embarrassment. Walking at his side through the town, I would be surprised by a sudden quickening of pace on his part, while at the same time he would be observed to consult his watch anxiously as if late for an important appointment: after a few minutes' spurt he would slow down and allow me to catch up with him. This manoeuvre pointed to the presence of a friend in the vicinity . . . he was delighted when a bemused soldier from Penally Barracks, mistaking him for a retired officer of high rank, saluted him. In reality he lacked every martial quality, except, of course, honour. Excessively squeamish, he would never have been able to accustom himself to the licence of the camp; even the grossness of popular speech shocked him as much as would have done the politer bawdry of the smoking-room.'

Perversely, Edwin John was the single most influential person in Augustus's life, and their relationship shaped the pattern of his adult behaviour. But to what extent is this picture of his father accurate? Winifred, who was probably Edwin's favourite but who saw less of him than any of the others, told her daughters she felt Augustus had been unfair; and some critics have suspected that he deliberately caricatured him in *Chiaroscuro*. But both Gwen and Thornton's attitude to their father exactly supports Augustus. In about 1910 Edwin John visited Gwen in Paris. 'My father is here,' she wrote to her friend Ursula Tyrwhitt, ' – not because he has wished to see me or I to see him, but because other relations and people he knows think better of him if he has been to Paris to see me! And for that I have to be tired out and unable to paint for days. And he never helps me to live materially – or cares how I live. Enough of this. I think the Family has had its day . . . We don't go to Heaven in families now – but one by one.'

Thornton, who specifically endorsed Augustus's treatment of their father,* added (3 February 1959): 'He seemed to live in a fantastic world where everybody has a price, respects wealth and asks no questions.' At about the same time (23 February 1959), in a letter to his foster-daughter, Thornton remarks that Augustus is still 'trying to solve the mystery of our father's character and wants me to help him . . . It is not rare for a family to have a "skeleton in the cupboard".' He gave no

* 'The bubble of a life-time of respectability burst without a trace,' Thornton wrote to Augustus (25 June 1959). 'There seemed no answer to it [Edwin's character] but ridicule. That was your answer and I approve of it – that or silence. There may still be obscurities – penalties perhaps – who knows!'

details of what this skeleton might have been, but its presence was also sensed by Augustus. Their suspicions may have been a form of wishful-thinking, but there are two clues indicating that they could be founded on fact.

The first of these concerns Edwin's younger brother Frederick Charles John. In 1871, at the age of fourteen, he was living in Victoria Place with the rest of the family. Ten years later he had disappeared. The records and old editions of the Law List show that he never became a solicitor. Nor is he ever mentioned by any of Edwin's children, none of whom, it appears, met him. Although he was certainly alive at the time, he was not at his father's funeral. He died on 9 April 1896, but there is no death certificate in Somerset House and no record of his death abroad. What had happened to him? In an unguarded moment, Edwin once revealed that Frederick had served a term in prison. It seems probable, therefore, that after his imprisonment Frederick left Britain, probably with the encouragement of his family, and died somewhere abroad at an early age under circumstances that were not reported to the British consulate.

The second dubious affair involved William John, and latterly Edwin's relationship with him. The prevalence in Pembrokeshire of the surname John, exceeding in quantity even the Sussex army of Smiths, makes some genealogical mystery almost obligatory. From various censuses and certificates, it is possible to establish that William John had been born between April 1818 and April 1819 in the parish of St Mary, Haverfordwest. His father's name, as we already know, he lists as being the same as his own – a violin-playing labourer. But a search of the St Mary parish register between 1813 and 1823 has revealed no one who could have been he.* Unless he was baptized after his sixth year, the only candidate whose date is exactly right and whose father is not necessarily wrong is William, baptized on 25 November 1818 in the parish of St Mary, son of Anne John, single woman.

This speculation over the birth of William John is complemented by certain rumours surrounding his final illness and death. His fortune had been made largely from an investment in a new bank that had turned out unexpectedly well. In 1879, at the age of sixty, he retired; and two years later, on 14 June 1881, in London, he made a new will. This will, which

* Since an examination of the other Haverfordwest parishes over the same period has also failed to uncover any positive or even likely identification, the nearest possibility seems to be William, only son of William John, servant, and Anne, his wife, of Hoinslane, parish of St Mary, baptized on 26 January 1818. This, however, assumes that William John was consistently inaccurate, by one year, about his own age.

allowed Alfred and Frederick a small annual income subject to certain conditions, also discriminated against Clara* and left the bulk of the fortune to Edwin.

By this time, William John was already suffering from the cerebral softerina which would eventually kill him and, according to Thornton, this illness was making him increasingly 'childish and ready to do as he was told'. Clara believed that Edwin, manufacturing an excuse from her recent marriage, persuaded the old man who was incapable of looking after his own interests to make this new will. A rift quickly opened up between them. Clara's feeling for Edwin – a financial passion of jealousy and injustice – matured over many years of comparative poverty to a settled hatred. She cut herself off from Edwin and (since it was he who looked after their father) she seldom saw William during his last years. When he died in Edwin's house at Broad Haven, Thornton and Gwen, Augustus and Winifred were taken in to be shown his body, and later they stood by his grave on a hill outside Haverfordwest. But Clara, Alfred and Frederick were absent.

It was this atmosphere of family feuding that Edwin hoped to mask in an odour of respectability at Tenby. He had two alternative ambitions. The first and least likely of these was the revival of an old day-dream: to enter the church. All his life he entertained a great admiration for churchmen, and had once considered preparing himself for the priesthood. This dream was fractionally realized when, in his fifties, he became organist at Gumfreston, a tiny inaccessible church two miles from Tenby. Every Sunday morning, wet or fine, dressed in his best suit and tallest collar, he would walk there alone, play the hymns and psalms in a style curiously deliberate – loud and slow: then walk back. This he persisted in doing for over thirty years, until he was almost ninety – a feat that can only be appreciated by those who have trodden the precipitous route in Welsh weather.

His other ambition was to remarry. For a short time he became engaged to Alice Jones-Lloyd, and on another occasion proposed marriage to Teresa George. Both girls were considerably younger than himself, very handsome and of good family. There is also evidence to show that in a rather diffident manner he kept company with a number of girls nearer in age to his own children than to himself. These matrimonial skirmishes were always most proper and discreet, but news of them eventually leaked out bringing down on him the combined rage of Gwen and Winifred. 'I was furious at this heartless and extravagant

* Unlike Alfred and Frederick, Clara had never quarrelled or broken with her father, even after her marriage to Francis Temple-Allen, a 'foreign merchant'. He names her as an executrix in his Will, and there is no mention of her income being imperilled by possible bankruptcy.

outburst, and took his part,' Augustus records:⁹ 'but my overheated intervention only earned me the disapproval of all three.'

The ordinary people of Tenby liked Edwin – they liked the look of him. 'I am not clever,' he once boasted, 'but I am independent, and I believe in a good appearance all the time. With a good appearance I can accomplish much.' His chief accomplishment was to convert this good appearance into the appearance of goodness. His unflagging church-going, his cast-iron empty routine, above all his unrelenting loneliness and longevity excited much admiration. Stranded by his peculiar temperament from adult companionship, he was attended in later life by a succession of well-behaved cats in the home, while outside he made several friendly overtures, assisted by money, to children. He offered to pay for the education of his housekeeper's son; he taught a number of local children to play the organ; and when he wished to try out some new air he would call on a young chorister and present him afterwards with the princely sum of one shilling for his trouble. Another of the children in the neighbourhood, John Leach, remembers that 'my own father in spring and summer often took my sister and me to evensong . . . and usually we walked home with Edwin John through the woods and lanes. It came about through these walks that he asked my sister and me to go with him to the cinema, of which he appeared to be very fond. These were the days of the early Chaplins, the Keystone cops and the serial with its weekly threat to the life or virtue of the heroine. Perhaps Edwin John was fortified by the presence of children on these occasions . . . Besides being generous, one recalls [him] as a quiet, gentle, soft-voiced courteous man, who talked to children without condescension.'

But for his own children he could find no love. He was faced with the obstacle of their existence: an obstacle to re-marriage, to the church and to almost any ambition he may have had. Out of this stalemate there developed the cult of appearance, the parsimony, the solitude, all reinforced by his natural timidity. 'He became an object only,' commented Thornton (3 February 1959). 'Is it any wonder we felt the effects of this?'

The effect of this loveless climate on Augustus was like that of a poison that remains in the human system for life. It was more lethal to him than to the others because they extricated themselves early on from their father's influence and set up separate lives in foreign countries: Thornton in Canada; Gwen in France; Winifred in America. 'I hold no grudge against him [Edwin],' Thornton remarked towards the end of his life. But Augustus, who never wholly escaped, did hold a grudge. He had needed a hero, and the hope that his father might somehow reveal himself as this hero had died a lingering death. Following the disillusion, his desire to become absolutely independent was to be effected by a

traumatic experience at the age of seventeen that weakened his will-power, making it subject to upheavals of hysteria. He once described his father to Darsie Japp as 'a revolting personage',[10] and their many points of similarity made him over-anxious to destroy every particle of this involuntary attachment and develop into someone utterly different. To this refractory spirit must be attributed many of his shortcomings and much of the ill-fortune that was to befall him. 'I wanted to be my own unadulterated self, and no one else. And so, taking my father as a model, I watched him carefully, imitating his tricks as closely as I could, but in reverse. By this method I sought to protect myself from the intrusions of the uninvited dead.'[11]

Very many of his adolescent actions represented not simply a wish to be different from his father, but to be someone other than his father's son. His claim to be a descendant of Owen Glendower; his vivid fantasy life, nourished by books, which developed into the cult of the Red Indian; even the vicarious symptom of dumbness that afflicted him when he saw another boy bleeding from the mouth: all these were signs of his identification with non-John people. The great kinship he felt for the gypsies, too, and which later became so close that many people actually took him to be a gypsy, arose not just from the fact that Edwin John disapproved of them but from his having warned Augustus they might capture him and bring him up as one of their own children. This was a fate better than life as he knew it. At home he felt an outcast, and at school it was with the outcast he grew most sympathetic – the half-wit at Clifton, even the boy he beat in a fight at Greenhill.

This drive to be someone else did not cease after adolescence, but grew more complicated. To know Augustus John was to know not a single man, but a crowd of people, all different, none of them quite convincing. His reaction against the paternal environment of his early years was in perpetual conflict with the strongly-marked charac-teristics he inherited from his father. Between the two opposing forces in this civil war there existed a barren No Man's Land where Augustus uncertainly drifted. At first he hovered very near the rebel camp, but the genetic pull of the Johns dragged him gradually away, ever nearer the forces of tradition. This battling against part of himself produced a state of crisis: a crisis of identity. In later years everyone else would recognize readily enough the manly and melodramatic form of Augustus John – but he himself did not know who he was. His lack of stylistic conviction as a painter, the frequent changes of handwriting and signature in his letters, his surprising passivity and lack of direction in everyday matters, the abrupt changes of mood, the sense of strain and vacancy, the acting: all these point to this central lack of identity. 'When I am in Ireland I'm an Irishman,' he told Reginald Pound, and it was

partly true. He was Chameleon. He had half turned his back on Wales
and, while continuing to revisit it, chose to live fifty years of his life
amid the lushness of Hampshire and Dorset – a green-tree country he
never painted and to whose beauty he was not particularly responsive.
His wholesale dismissal of the past went even further. He claimed not to
know the date of his birthday, and boasted that he never celebrated it.
In 1946 he told a *Time* interviewer, Alfred Wright, that his mother's
name was Augusta Petulengro; and six years later (14 May 1952) he
wrote to John Rothenstein: 'As for Gypsies, I have not yet encountered
a sounder "Gypsy" than myself. My mother's name was Petulengro,
remember, and we descend from Tubal-Cain via Paracelsus.' What he
did not tell Alfred Wright or John Rothenstein was that Petulengro
was the Romany version of Smith.* It was a deliberate teasing, a
fantasy that was irresistible to him but in which he did not actually
believe. His real state of mind concerning who he was seems to have
been a genuine bewilderment. 'I am in a curious state,' he confessed to
Lady Cynthia Asquith in 1918, ' – wondering who I am. I watch myself
closely without yet being able to classify myself. I evade definition –
and that must mean I *have* no *character*. Do you understand yours?'

This void seems to have come about through the deliberate rejection
of all Augustus knew of his background. He could not remember his
mother; he knew nothing of his origins; he abominated his father and
their home. The antipathy he felt for Victoria House was reinforced by
an instinctive fear of the one indisputable genetic strain he had inherited
from Edwin John: melancholia. It was a disease compounded of
extreme shyness, anxiety and a feeling of 'alienation', of being irretriev-
ably segregated from other people. This quality of soundless isolation
persisted very strongly in many of the John family, especially the men,
and affected their lives in one of two ways. Either they would stylize
their companionless state by the most painstaking methodicity; or else
be driven to extreme wildness by their impatience to touch and com-
municate with others. Gwen, who believed 'it isn't pious to suffer long'[12]
and who made solitude part of her religion, was to adopt the first
course; her uncles Alfred and Frederick seem to have fallen into the
second. Edwin was a supreme example of the first type, and, partly
in reaction to him, Augustus became the archetypal rebel, incapable of
coming to terms with his legacy of melancholia, endeavouring always
by sheer force of energy to hurl it from him, to escape from this
spectre of boredom, depression and loneliness simply by outpacing it,
like a boy running against his shadow. To many who, like William
Rothenstein, believed that Augustus had been born 'with a whole

* The word Petulengro means horseshoe-maker or smith. It was T. W. Thompson
who first identified Borrow's Jaspar Petulengro with a certain Ambrose Smith.

series of silver spoons between his gums',[13] this stampeding through life seemed just a thoughtless squandering of his natural gifts and creative energy. But Augustus, though seldom introspective, took a more sombre view of himself: 'I am not so perverse as unfortunate,' he told Mrs Meynell (15 September 1899). All the children had, of course, been unfortunate in losing their mother and in having to contend with the John melancholia. But Augustus was particularly unfortunate in having been afflicted while still at school by a partial deafness that magnified his sense of exile and raised up an invisible barrier between him and the rest of the world.

'If our mother had lived it would have been different,' Thornton wrote to Augustus over seventy years after her death (3 February 1959). From her the children had inherited their artistic talent, and while she was still alive she had encouraged them to draw. Afterwards, at Tenby, Gwen and Augustus had continued drawing and painting, using the attic at Victoria House as their studio. 'Wherever they went their sketch-books went with them,' their father liked to recall later on.[14] 'In their walks along the beach . . . on excursions into the country, wherever they went the sketch-books went too, and were used. They sketched everything they saw – little scenes, people, animals . . . I can remember when they were a little older, and I sometimes used to take them to the theatre in London, how, even here, the inevitable sketch-books turned up as well. Then in the few minutes interval between the acts they worked feverishly to draw some person who had interested them.' Although he conceded that 'it is possible that I was a less keen observer of the boy's work than his mother would have been', Edwin later on (especially after Augustus was elected an R.A.) took pride in having failed to put a stop to all this sketching. He had, as he put it, 'left' his children's talent to 'develop freely and naturally'. He neither encouraged nor discouraged them until, one day on Tenby beach, Gwen, who 'was always picking up beautiful children to draw and adore',[15] came across Jimmy, a twelve-year-old boy with a pale, haunting face and corkscrew curls down to his shoulders, dressed in a costume of old green velvet. Having made friends with him, she would invite him back to her attic, and, in the hope of some payment for these sessions, his mother came too – much to Gwen's disgust. Edwin quickly grew alarmed. He disapproved of strollers, and the sight of this woman wanderinging into his house was, he felt, open to misinterpretation. He therefore decided to put his foot down and forbid Gwen inviting such 'models' home. But already it was too late. He objected; Gwen insisted; and he gave way. It was the pattern of things to come.

From these earliest days there are – at least in retrospect – indications that Augustus saw life in terms of pictures. 'Once when we were walking

together over the sand dunes and saw a piece of hard perpendicular sand,' Arthur Morley recalled,[16] 'Gussie pulled out his penknife and very rapidly carved out an attractive hand and face. On another occasion when he was sitting on my right in class he seized my Latin Grammar book and on the first empty page drew in ink with amazing speed two comic faces very different from each other, face to face.'

At Greenhill there had been special art classes in which the pupils, armed with coloured chalks, copied lithographs of Swiss scenery and drew likenesses of Greek and Italian acanthus leaves. But Augustus also practised drawing from life, discovering from among the masters some challenging models. Great caution was necessary, for this extra-curricular study was severely punishable. One day, for example, while hard at work, he was observed by his favourite subject, the headmaster, who called him up, examined some caricatures of himself and, after permitting himself a wry smile, viciously attacked the artist's hand with a ruler.

At Clifton he had been given no encouragement and no instruction. 'Philosophy was eschewed,' he afterwards wrote, 'Art apologized for, and Science summarized in a series of smelly parlour tricks.'[17]

But back at Tenby, while studying at St Catharine's, he endured a course of 'stumping' under the tuition of a Miss O'Sullivan. 'Stumping' was a substitute for drawing prescribed by the State Art Education Authorities. The stumps were stiff spiral cones of paper, and the stumping powder a box of pulverized chalk. With these curious instruments and a sheet of cartridge paper, he would reproduce the objects placed before him by means of a prolonged smudging and stippling process that gave him a method of representing form without risking the use of line. At first he copied simple cones, pyramids and cylinders, then gradually advanced, via casts of fruit and flowers, to Graeco-Roman statuary until he finally arrived at the Life Room where he spent several months studying a fully clothed model almost as bored as himself. At this stage his work was submitted to the Central Authority, since each successful student received a certificate qualifying him to indoctrinate others in the Theory and Practice of Stumping, while the school received a grant from the Exchequer. Augustus was awarded such a certificate and at the age of sixteen became a Master Stumper, Third Class.

A series of nude studies, done from the imagination at about the same time, were quickly confiscated by the headmaster's brother, a muscular ex-policeman turned teacher with the reputation of a Celtic Casanova. But a portrait of the Devil was more successful and received high praise from the Catholic priest, Father Bull, who declared that he was able to discern under its Mask of Evil the beauty of a Fallen Angel.

Father Bull was a dandified young man who used to mince about the streets of Tenby awakening in the girls vague feelings of religious doubt. He was also employed as tutor to a few pupils and soon became especially friendly with Augustus. He would join him and some of the other boys at a secluded bathing place formed by a little promontory on the north shore of Tenby, and was quick to encourage him with his drawings, especially his nudes. Augustus responded eagerly, but once again his feelings of gratitude and hero-worship were to be turned back. At a formal luncheon to celebrate the dedication of the new Church at St Teilo, Augustus, who was unused to such social grandeur, became more and more embarrassed by the ribaldry, so misplaced, he felt, in the circumstances. He grew silent and his complexion ripened to a deep crimson. Noticing this, Father Bull inquired pointedly if he *painted* – a sally that brought the house down. It was a tiny incident, but Augustus never again trusted his friend.

He was more than ever anxious by this time to escape from Tenby. But what was he to do? He had relinquished his dreams of becoming a trapper on the Red River, or of leading a revolt of the Araucanian Indians, and his mind now explored the exotic possibilities of China. He would join the Civil Service perhaps, if that would carry him to such enchanted lands: he would do *anything* to get far enough away from this stagnant little backwater which was slowly suffocating him. He still loved parts of Tenby and the wild sea-coast and rocky country round it, but the meanness of his life at home constricted him unbearably, and his hunger for a larger world and fresh horizons was every day growing more acute. His father, who would have preferred to launch him on a barrister's career, had to acknowledge that he was unfitted by nature to such a profession, and for a short time it was agreed between them that he should join the army. Augustus began his army training locally, and in the evenings the respective merits of Sandhurst and Woolwich would be duly weighed.

Then, all at once, he changed his mind. He had decided, he told his father, not to join the army after all, but to study art. In spite of both Augustus and Gwen's enthusiasm, Edwin had never, he later admitted, 'taken their drawing seriously'. But for some months Augustus had been going to an art school in Tenby run by Edward J. Head, a Royal Academician, who had reported very favourably on his progress. Edwin was impressed by these reports. As a lover of Nature, he was an unfailing annual visitor to the Royal Academy. Fully alive to the claims of culture when officially sponsored, he read with appreciation in *The Times* accounts of various sales and successes in the art world. Landscape painting in particular recommended itself to him as a gentlemanly pursuit. Admittedly his own choice of bedroom pictures testified to a

strange susceptibility to the lure of fleshly beauty, but then he knew how to restrict his emotions to the academic field, while for others landscape was undoubtedly safest. These days, it seemed, the artist's profession might be tolerably respectable, provided of course it was practised with sufficient financial success. Mr Head himself, if not exactly a gentleman, hardly ever got drunk and managed to live very comfortably. When a number of his pictures had first been hung at the Academy, Edwin's civic pride had swelled noticeably – it was an example his son might well strive to emulate some day. Naturally he would have preferred him to go for a soldier, but since Augustus seemed resolved to study art he had better do so – for the sake of peace and quiet as much as anything. After all he was such a temperamental fellow, so moody, so rebellious and with no head for serious business: it might be just the job for him. One thing only bothered him: had he been sufficiently discouraging? Certainly he had failed very ably to encourage his son, but was that by itself enough? He had no wish to appear dilatory in the way of putting up difficulties: that would be irresponsible. In his own account of this time, Edwin explained his sanction by means of paradox:[18] 'Obstacles put in his [Augustus's] way would only have strengthened his determination to become an artist,' he wrote. ' . . . He suggested being allowed to attend the Slade School in London. The earnestness he put into this request made me first think he might after all make an artist . . . he could display plenty of determination when necessary, and his whole childhood had proved that he could give untiring application to either drawing or painting. This, combined with his obvious eagerness, made me give my consent quite willingly.'

It was Mr Head who had recommended the Slade. The fees, Edwin discovered, were pretty stiff, but a legacy of forty pounds from Augusta would see to his son's upkeep – and there was always the possibility of a scholarship. Besides, it would take them out of each other's sight for a while and put an end to the domestic ructions that were now breaking out every day more and more seriously. On the whole, things could have turned out worse.

So, in the autumn of 1894, Augustus left Tenby for London, with his father's cautionary advice ringing in his ears: 'Be a Michelangelo if you like, but first make your living.'

Also, of course, landscape was safest.

'Slade School Ingenious'

What a brood I have raised!

Henry Tonks

The Slade continues to produce geniuses, we turn them out every year.

Henry Tonks to Ronald Gray (November 1901)

1. NEW STUDENTS – OLD MASTERS

On his first day at the Slade, in October 1894, Augustus was led into the Antique Room, presided over by Henry Tonks – and almost at once a rumpus broke out. Some of the new students, who had already worked for several months in Paris, were objecting at not being allowed straight into the Life Class. Professor Tonks however was adamant: the students' taste must first be purified and elevated by Graeco-Roman sculpture before it could be judged fit to deal with the raw materials of life itself. And from this judgement there was no appeal.

Augustus was not one of those who objected. To him the absence of stumping was in itself wonderful enough. Far from having been to Paris, he had scarcely been to London before, and he felt keenly his immense ignorance of everything. To the others he appeared a very spruce and silent figure, white-collared, clean-shaven, shy, formal and guarding his dignity with great care. Tonks sat him down on one of the wooden 'donkeys', next to another new student, Ethel Hatch. 'I found myself sitting next to a boy about sixteen', she later recalled,[19] 'with chestnut hair and very brown eyes who had the name "John" written in large letters on his paper. It was the young Augustus John. He was very neatly dressed, and was very quiet and polite, and on the following mornings he never failed to say good morning when he came in.'

He seemed an unremarkable personality, out of the ordinary only in so far as he was quieter than the other students, and perhaps more timid. But one of them, Michel Salaman, noticed that, when he called for an india-rubber one day and someone threw it to him, he caught it and began rubbing out all in a single movement. He was superbly well-coordinated.

Every student had been instructed to provide himself with a box of charcoals, some sheets of *papier Ingres*, and a chunk of bread. Their first task was to make what they could of the Discobolus. Augustus fixed it with an intent stare, then using a few sweeping strokes, polished it

off, as he thought, in a couple of minutes. Tonks, however, thought differently. It was bold, certainly, he admitted, but it was far too summary. Yet he was obviously surprised by Augustus's sketch – and interested.

The atmosphere at the Slade was unlike anything Augustus had encountered in Wales. He was dazzled by almost everything. The beauty and the spirit of dedication by which he felt himself to be surrounded, thrilled and abashed him. He hardly knew where to look. Obscurely he thought he could recognize that he was in the presence of *genius*, and the knowledge of this, though wonderful, was intimidating. The girls were so ornamental and the men apparently so self-assured that whatever imperfections he observed in their work he attributed to his own lack of understanding. He felt humble, determined to succeed, yet willing for the moment to be led.

The Slade, and in particular the teaching of Tonks, gave Augustus the sense of direction he had so far lacked. In such an environment he seemed to know who he was and the part he had to play, so that, whatever successes he gained later in his career, he remained to a certain extent a Slade student all his life. In its strengths and limitations, this was the single most complete influence on him as an artist.

When Augustus John came to London, the Slade School was just twenty-three years old, and about to enter one of its most brilliant periods. Its tradition, to which Augustus responded so deeply, was founded upon the study of the Old Masters, and laid special emphasis on draughtsmanship – on the interpretation of line as the Old Masters understood line, of action and anatomical construction. 'Drawing is an explanation of the form,' he was told. This was the Slade motto, and he never forgot it.

The school had opened in its apparently unique form in 1871, at a time when British art was at a low ebb. Cut off by its indifference from the exciting new developments that were taking place on the Continent, the Royal Academy was all-powerful, steeped in the English literary tradition which, by the last third of the century, had degenerated in artists like Frith and Alma-Tadema into pure illustration. In such a climate, art schools were at their nadir, and the time was ripe for some form of revolution.

The new school took its name from Felix Slade, a wealthy connoisseur of the arts, who, on his death in 1868, had left £35,000 to found professorships of art at Oxford, Cambridge and the University of London. The Oxford and Cambridge chairs – the former taken by Ruskin – were to be solely for lecturing. In London the executors were asked to found a 'Felix Slade Faculty of Fine Arts', and University

College voted £5000 for building the Slade School as part of the College quadrangle off Gower Street.

The first professor, Edward Poynter, was a most unlikely choice. A fellow student in Paris of Du Maurier, he was portrayed in *Trilby* as Lorimer, the 'Industrious Apprentice'. In his inaugural address he attacked the system then almost universally taught in the schools with its months spent upon a single elaborate drawing substituting, George Charlton has explained,[20] 'the "free and intelligent manner of drawing" (. . .) of the French ateliers, of which he had considerable experience as a pupil of Gleyre' There were other shocking novelties: students were not examined on admission, and all the teachers had to be practising artists.*

Poynter did not remain long at the Slade. The very essence of Victorianism, which he had first rejected so categorically, soon seeped into his blood stream: he subsided into success, consented to be knighted, was made President of the Royal Academy, and in 1876 handed over the Slade torch to Alphonse Legros. Much in the condition of British art over the next sixty years is symbolized by his career.

At a time when almost all English art students were fixed in the stippling of one drawing for months on end,[21] Legros taught his students to draw freely with the point, and to build up their drawings by observing the broad planes of the model. A friend of the great French artists of the period, he was himself a considerable draughtsman, a disciple of Raphael and Rembrandt, of Ingres and Delacroix. One of his pupils, William Rothenstein, has described his methods of teaching drawing:[22] 'As a rule we drew larger than sight-size, but Legros would insist that we studied the relations of light and shade and half-tone, at first indicating these lightly, starting as though from a cloud, and gradually coaxing the solid forms into being by superimposed hatching. This was a severe and logical method of con-

* In his inaugural lecture, *Systems of Art Education*, Poynter had attacked the current methods of English art teaching in which 'a trivial minuteness of detail [was] considered of more importance than a sound and thorough grounding in the knowledge of form', and only at the end of the course was the student allowed to do what he should 'have been set to do the first day he entered the school, that is to make studies from the living model'. He himself intended to adopt the methods used in France. 'I shall impress but one lesson upon the students, that constant study from the life-model is the only means they have of arriving at a comprehension of the beauty in nature, and of avoiding its ugliness and deformity; which I take to be the whole aim and end of study.' In his later lectures, Poynter's academicism becomes increasingly evident. He concentrates on the problems of style, and recommends the student to study not any contemporary painter, but the Italians of the fifteenth century, Titian, Velasquez and Michelangelo. See *Lectures on Art* (1879) by Edward Poynter and also *The Slade 1871–1960* by Andrew Forge.

structive drawing – academic in the true sense of the word. . . . He urged us to train our memories, to put down in our sketch-books things seen in the streets. We were also encouraged to copy, during school hours, in the National Gallery and in the Print Room of the British Museum. . . . Legros, as a student of Lecoq, had no doubt of the wisdom of this. He used to say "Si vous volez, il faut voler aux riches, et pas aux pauvres." '

Neither Poynter nor Legros were revolutionaries: they were traditionalists rather than experimenters. But Legros, whose own work displayed a measure of realism compounded with morality, took no trouble to hide his hostility to the Royal Academy which, he believed, represented neither tradition nor scholarship, and he invariably encouraged his students to be independent of Burlington House. He became, an isolated figure; even to his wife he spoke not a syllable of English, and his instruction in painting came to be interpreted by Walter Sickert as 'almost a model of how not to do it'.

Legros retired from the Slade a year before Augustus John arrived there, but by this time the principles which he had helped to introduce were firmly established. The key to the school's independent character lay in the fact that none of its professors had been taken up by the École des Beaux Arts, or the Royal Academy schools, or the Royal College of those days. Basically, Poynter and Legros had been trained in the studio schools of Paris, and were consequently links in a chain of studio teachers (as opposed to teachers of academics) stretching back to the Renaissance. This was the atmosphere in which Augustus found himself at the age of sixteen – that of a mediaeval-Renaissance workshop school, which launched him on his Renaissance life.

By the time Legros retired, the Royal Academy had apparently become aware of the Slade's growing strength, but despite its efforts to get one of its men appointed, the chair was offered to Frederick Brown. Brown was then forty-two, 'a gruff, hard-bitten man, of great feeling, with something of the Victorian military man about him, such as the colonel who had spent his life on the North-West Frontier, surrounded by savages, which indeed his life as a progressive artist and teacher during the 'seventies and 'eighties must have rather resembled'.[23] This rather grim figure, with his greying hair, moustache and chin-tuft, his prognathous jaw and grave bespectacled eyes, was invariably dressed in a black frock coat. His massater muscles were especially prominent, as if his teeth were permanently clenched, giving him the appearance of a man who would stand no nonsense – nor would he. His physical energy was manifest – at an advanced age he still often walked home from Gower Street to Richmond. The son of an artist and teacher, he had studied in Paris under Robert-Fleury and Bouguereau, and for the past

fifteen years had been head of the Westminster School of Art, which he expanded from evening classes and ran on the lines of the French school. Brown's ability as a teacher laid a hold on his pupils, many of whom followed him from Westminster to the Slade. His severe expression and high standards were complemented by a great, if rather obvious, patience. But he endeared himself to many of them by his wonderful memory – he would often refer to drawings they had done years before – and he became a great collector of their work.

One of these students who was to follow Brown to the Slade was a young Fellow of the Royal College of Surgeons, Henry Tonks. Tonks had become increasingly attracted to the artist's life and very eloquent in persuading his patients to pose as models, and, when obliged to fall back on the dead, seized every opportunity to draw the corpses that were dissected in his class. In about 1890, while Senior Resident Medical Officer at the Royal Free Hospital, he had started to attend the Westminster School of Art as a part-time student, hurrying off to its evening classes once his medical duties were over, smelling strongly of carbolic.

Tonks was exactly the person Brown felt he needed to support him at the Slade. He was well-educated and businesslike, had a gift for teaching and an expert knowledge of anatomy that gave him an almost divine insight into the process of figure-drawing. Like Brown, he was dissatisfied with the mechanical methods of instruction employed in most art schools. If Brown resembled a Victorian colonel, Tonks had the commanding presence of a nineteenth-century cardinal – immensely tall and gaunt, with a fierce expression, vehement tongue and opinions most tenaciously held.

In the late autumn of 1893 Brown offered Tonks the post of his assistant. Tonks was 'amazed, almost beside myself with pleasure'. Without hesitation he forsook surgery and, a few months before Augustus arrived there, took up his new career at the Slade. So began the famous partnership of Brown and Tonks, those two lean and rock-like bachelors, which was to carry on the teaching reforms of Legros, establish the Slade tradition of constructive drawing, of which Augustus would shortly be the star, and produce a crucial effect on succeeding generations of British Art.

From morning till late afternoon, day after day, Augustus toiled over the casts of Greek, Roman and Renaissance heads. Then, initially for short twenty-minute poses, he and the new students were allowed down into the Life Class. Augustus entered this studio for the first time with feelings of awe which deepened into something like panic when he

saw, seated on the 'throne', a girl, Italian and completely naked. 'Perfect beauty always intimidates,' he wrote.[24] 'Overcome for a moment by a strange sensation of weakness at the knees, I hastily seated myself and with trembling hand began to draw, or pretend to draw this dazzling apparition.' Looking round, he was astonished to observe that the other students appeared almost indifferent to the spectacle: and his respect for them mounted even higher.

The regime at the Slade during this time was still austere. Men and women worked together in the Antique Rooms only, were carefully segregated elsewhere and rarely met in the evenings. 'This is not a matrimonial agency,' Brown told Alfred Hayward, a student whom he had come across saying good morning to a young girl in one of the corridors. Models and students were forbidden to converse, communication being restricted to short barks of command.* Older students in the Life Rooms had little to do with the new pupils, for the hierarchy was almost that of the public school. There was no drinking – certainly no womanizing. It was a life of the purest ideals, a lyrical time, full of painstaking sincerity. Augustus seemed fixed in his work all day long and half the night. Wherever he went he took his sketch-book, which was filled with rapid drawings of his fellow students. 'Once when I was working in front of him,' Ethel Hatch remembered, 'I suddenly turned round, and caught sight of a drawing of my back view with outstretched arm, and in a long overall. I shifted my place, but John also moved, and seemed determined to get my back view.'

In criticizing their monthly compositions one day, Tonks had said he wanted his students to study the National Gallery more, and the *Yellow Book*, with its *avant-garde* drawings by Aubrey Beardsley, less. 'I cannot teach you anything new,' he told them; 'you must find that out for yourselves. But I can teach you something of the methods of the Old Masters – if that will be of any use to you.' Augustus took this lesson to heart, spending much of his free time at the National Gallery, the British Museum and other permanent collections. What he saw in these places awed and overwhelmed him. Immensely stimulated, he was at the same time very confused. There was so much – he could not sort out his ideas, could not decide what excited him most, what suited his own talent best – Rubens, Michelangelo, Rembrandt, Watteau, Ingres: the pickings of all Europe were before him at the end of a bus ride to Trafalgar Square. He flitted from

* Even so, as Randolph Schwabe later noted in *The Burlington Magazine* (No. CDLXXXIII. June 1943, p. 142) 'we had progressed from the days when Sir Edward Poynter could not be seen with students in the women's Life Room while a nude female was posing. They had to file out when he came in, and he wrote his criticisms, in their absence, around the margins of their drawings.'

picture to picture like a butterfly. Should he be a Pre-Raphaelite or a latter-day disciple of Rembrandt? Or both – or something else again? Looking back at this period years later, he concluded:[25] 'A student should devote himself to one Master only; or one at a time.'

All London stimulated and confused him during these first months. The pervading smell of chipped potatoes, horse-dung and old leather; the leaping naphtha flames along the main roads; the wood-blocks of the streets looking like squares from some strange Battenberg cake; the glittering, multicoloured theatres and music halls; the costermongers with their barrows of fruit and flowers; the vendors of pickled eels, ices and meat pies; the jugglers and conjurers who performed for pennies; the whole crowded cosmopolitan atmosphere: it was all too foreign and bewildering for him to absorb. He walked everywhere – from Bermondsey to Belgravia, from the narrow streets of cobblestones where chickens scavenged, the shabby slum children played and their mothers, reeking of treacle-and-opium, strung out their wash to dry, to the fashionable promenading in Hyde Park where men and women, glossily hatted, rode to and fro, their horses gleaming with health, their drivers decked out in authoritative livery. To Augustus it seemed that no encounter was impossible, and every adventure for the asking – if only he had the courage to find his voice.

But he was boorishly shy and very poor. Most evenings he would return after dark to a dreary little villa, 8 Milton Road, in Acton where he lived with one of his 'Jesus Christ Aunts'; and every morning he would leave early on his long day's journey into town. But occasionally his father would send him a small cheque, and then he would hurry off to the music halls. This was life! – or as close as he could get to it for the time being. The Alhambra, the Old Mogul, the Metropolitan, the Bedford, Collins', Old Sadler's Wells with their variety shows and their Victorian melodramas held him in thrall.* They were more real than reality itself. He went whenever he could afford it, and sometimes when

* Some of John's Music Hall sketches at the Alhambra, of Buskers, singers and dancers (among them Cissy Loftus, Cadieux and May Belfont) were exhibited at the Mercury Gallery, London (15 January–10 February 1968). John also made a portrait of Arthur Roberts dated, almost certainly inaccurately, 1895, now in the National Portrait Gallery. 'I consider him [Arthur Roberts] about the most important buffoon England has ever produced – a born comedian and a most accomplished artist,' he wrote to the National Portrait Gallery (14 May 1929). On 3 June 1929 he wrote again: 'Roberts I hear is appearing on the Music Hall at East Grimsby at present – so there's life in the old man yet. If I kept the drawing I might of course pre-decease him, so I think it had better hang along with Kipling etc. in the Board Room en attendant.' In Henry Savage's autobiography, *The Receding Shore*, there is a brief mention of John doing a portrait of Arthur Roberts in about 1922, which

he could not: and once or twice was ignominiously thrown out. When he was by himself he preferred the pit at the Empire where, for a shilling, he could watch the ballet and gaze in rapture and despair at the exquisite Adeline Genée.

He was alone a lot to begin with, but it was a crowded loneliness. On Sundays he would often wander round Speakers' Corner, listen to the orators, watch the crowds, grow excited at all the outlandish sights – then, bursting with nervous energy, march all the way home. Often he travelled great distances, resolutely and in no fixed direction until late at night, staring into people's faces, carrying under his arm one or other of his two favourite books – Walt Whitman's *Leaves of Grass* and *Hamlet* – as if they were guide books to the town.

Increasingly during this first year, he sought the company of two other Slade students, Ambrose McEvoy and Benjamin Evans. McEvoy was a fearfully short-sighted youth, with a low dark Phil May fringe, an oddly cracked voice and spare muscleless body supported by twin spindles tipped with patent leather. He was none the less something of a dandy, and cultivated an arresting, rather sheep-like appearance that incorporated, besides his dancing pumps, a monocle, high collar of modulated white and a pitch-black suit. He was further distinguished, this naïve and gentle youth, by knowing the legendary Whistler, in deference to whom he converted himself into an almost perfect 'arrangement in black and white'. From under his extraordinary fringe and through the monocle with which, his eyes on pivots, he myopically peered out, the world too seemed a black-and-white place – a simple two-dimensional right-or-wrong arena where men and women acted out the mild melodrama of their enchanted lives. His natural amiability, his talent for quick design (which led to early employment as comic-strip draughtsman for a paper called *Nuts*), and his gift for comedy all endeared him to the solitary Augustus.* For a time he believed his friend might marry Gwen, but instead he became secretly engaged to another painter, Mary Edwards, eight years older than himself, to whom Augustus had introduced him in the National Gallery. In later

* In the National Portrait Gallery there is a red chalk drawing by John of Ambrose McEvoy belonging to this Slade period that is almost expressionist in its exaggeration. The look on the face, the pose, position of the hands, all emphasize those aspects of McEvoy's character that especially appealed to John. His sympathy and responsiveness to McEvoy are very evident, but he preserved a detachment that allowed both irony and humour as part of his attitude.

was to have been the cover or frontispiece to a book of reminiscences which Henry Savage and Randall Charlton were going to ghost. But the authors fell out and the book was never written. Roberts was born in 1852, and so was nearly eighty when he appeared at East Grimsby.

years Augustus fell rather out of sympathy with him.* It wasn't simply that he was unspeculative or that his childlike curiosity about life was held in check by childish timidity: it was that, like Augustus, he was taken up by society as a fashionable portrait painter, but, unlike Augustus, seemed wholly content. His easy and delightful temperament bobbed happily within the circle of the *beau monde*; he longed for no wider seas, was never subject apparently to squalls of discontent. His ambition, it was said, was to paint every holder of the Victoria Cross and every leading debutante, and by the time he died at the age of forty-eight, he was well on the way to achieving this.

Benjamin Evans, who had been at the same 'frightful school' as Augustus at Clifton, was an altogether different character, an intelligent and witty draughtsman, deeply versed in Rembrandt. His disconcerting style of humour, seemed to spring from some abysmal lack of self-confidence that, when not directed to amuse, enabled him to exceed in dullness anyone Augustus had met. Yet these stolid and facetious qualities seemed to answer some alternating current of melancholy in Augustus and were a good counterfoil to his romanticism and to McEvoy's blandness.

The three of them went everywhere together. Sometimes they would start out in the small hours of the morning and walk to Hampton Court, or Dulwich; then, after breakfasting at some cabman's pull-up, spend the rest of the day at the picture gallery. At other times they would take their sketch-books to the anarchist clubs off the Tottenham Court Road. In the mild climate of England, the foreign desperadoes who gathered here seemed to have grown curiously genial, as if in constant attendance at some underground cocktail party. Augustus saw many of their most sinister celebrities including Louise Michel, 'the Red Virgin', who had once fought on the Barricades during the Commune in the uniform of a man, now a little old lady in black; and that doyen of revolutionaries, Peter Kropotkin, dressed in a frock coat and radiating goodwill to everyone. Most innocent of all were the American anarchists – not a bomb, not an ounce of nitro-glycerine between the lot of them. The leader of the English group was David Nichols, founder of 'Freedom', whose rashest act was to recite some passages from Swinburne in cockney. Despite a vehement Spanish contingent, the general atmosphere was one of sturdy handclasps, singing and dancing, and voluble monologues in subdued voices and indecipherable dialects.

* 'McEvoy has had great successes lately which has completely turned his head,' William Orpen wrote to a friend (undated), '– he now goes about abusing John and saying he's down – his day is over – etc. which is hardly nice of Mr Mc. and very untrue.'

Augustus's natural tendency still was to hero-worship those whom he immediately liked, but since few people are natural heroes, this generous idolatry was often replaced by an aggressive disillusionment. Friendship with him was a dangerous business. If McEvoy became the wrong type of success, Evans turned out the wrong sort of failure. Augustus had looked up to him as immensely gifted, had predicted for him a great future. But when Evans gave up art to become, of all things, a sanitary engineer, Augustus felt personally betrayed. So far as he was concerned, his friend had 'gone down the drain'.

Almost the only person who seemed capable of sustaining Augustus's adulation was Tonks himself. He looked forward to his visits with excitement and some alarm, for Tonks was a scathing critic, his drastic comments, like amputations, cutting off many an unpromising career. 'What is it?' he would ask after closely examining some student's drawing. ' . . . *What is it?* . . . Horrible! . . . It is an *insect?*' Mere accuracy never satisfied him. 'Very good,' he remarked of one competent drawing – then added with a deep sigh: 'But can't you see the *beauty* in that boy's arm?' Pretentiousness exasperated him and, much to his own consternation, he would reduce many of the girls to tears. But behind the forbidding Dantesque mask lay a benevolent nature. Sometimes he would have brief flirtations, even love-affairs, with the girl students, but his lasting passion was for the teaching of drawing and, as Augustus wrote,[26] 'the Slade was his mistress'. A fine drawing, he would say, should have a bloom on it like a peach.

Augustus never felt discouraged by Tonks, and responded well to his fanatical zeal. Since Tonks's personality was not one to welcome over-familiarity, Augustus did not lose his awe of him and for several years was much influenced by Tonks's fondness for the Pre-Raphaelites – 'the intense study of natural appearances', as Evelyn Waugh has described that movement, 'devoted to the inculcation of a lofty theme'.

In Augustus's second term at the Slade two new teachers arrived. Both taught painting. Wilson Steer was already one of the most celebrated artists in the country, and one of the worst art teachers in the world. He was built upon a pattern very dear to his fellow Englishmen – a large, genial, small-headed, slow-moving man, thoroughly inarticulate, incurious and easy-going. People loved him for his modesty. When he was awarded the O.M. he took it along to show Tonks and asked: 'Have you received one of these?'* Although he was England's most distinguished living painter, there was no nonsense about him: you'd never guess he painted – or at least he hoped you wouldn't. He

* John was awarded the O.M. shortly after Steer's death. 'I was delighted his [Steer's] O.M. shd. have gone to John,' William Rothenstein wrote to his brother Albert Rutherston (13 June 1942); 'this is right and proper.'

travelled the country with his painting materials locked up in a cricket bag, explaining: 'I get better service that way.' There was something reassuring about his bulky and obvious presence, with its bulwarks of English insularity. It was true that he had studied in Paris, but he'd never troubled to learn the language, simply repeating himself very slowly in English, as if there were something deficient in French ears. He was loved, too, for the untroubled paradox of his character and for his monumental calm. As England's most revolutionary artist, he was a deeply conservative man, opposed to all change; he had gained a reputation for immense wisdom yet scarcely ever spoke; of his own fame he seemed unaware and would refer to his job (if there were no avoiding it in front of strangers) as 'muddling along with paint'. Yet he could be unexpectedly witty and had a keen sense of human character. 'Will Rothenstein paints pretty well like the rest of us,' he once murmured, ' – but from higher motives, of course.' Asked one evening what was wrong with some artist who had recently been accused of an attempt upon the virtue of a servant girl, and who now entered his drawing-room leaning upon a stick, he replied briefly: 'Housemaid's knee, I suppose.' At the same time he disliked being startled by anything the least unexpected in his friends' conversation, and, sitting with his hands folded across his stomach, would enjoy nothing better than to hear some old jokes retold again and again, mouthing them contentedly to himself like some silent echo. A complete conformist, he was beset by baffling eccentricities. He was an avid collector of Greek coins and Chelsea china, an impassioned valetudinarian. His chief enemy was draughts, and to outwit them he would dress, at the height of summer, in a heavy overcoat, yachting cap and policeman's boots. So effective was this disguise that he evaded death until his eighty-third year. Cosy and lethargic, he was English to the core: triumphantly unromantic despite his eye for painting pretty girls; purposefully uncompetitive while acknowledged to be superior to all his contemporaries; his greatest ambition, to lead a quiet life.

To the young Augustus, Steer was largely a figure of fun. When Steer grew a beard, possibly to help with the draughts, Augustus's letters became filled with the vicissitudes of this growth which, by all accounts, was a remarkable object. In his correspondence with Ursula Tyrwhitt* he traces its history with a wealth of illustrative detail, leading up to a final caricature, 'The Shearing of Mr Steer' and a reflection: 'Mr Steer has no doubt made brushes from his ill-fated beard.'

In his teaching at the Slade, Steer gave full expression to his inertia.

* These letters are in the National Library of Wales, Aberystwyth, No. N.L.W. MS 1964–5. See also *The National Library of Wales Journal*, Vol. XV, No. 2, Winter 1967, p. 236.

Students awaiting his criticism as he sat behind them would turn at last to find him fast asleep. The result of such methods, so far as Augustus was concerned, was that he was never taught to paint, only to draw, and he benefited from Steer's early impressionist work only very indirectly, some twelve years later, through his friend J. D. Innes.

This lack of instruction in painting was reinforced by the other new teacher, Walter Russell, a dry uninformative man, scrupulously dressed, and unique for his unmemorable qualities. Russell's career, however, which in a minor way ran parallel to that of Edward Poynter, provides a vital index to the condition of English painting at the turn of the century and explains the peculiar predicament in which almost all British artists of Augustus's generation were soon to find themselves, especially perhaps those trained at the Slade.

Only three years after joining Brown's team, Russell, a member of the New English Art Club, was exhibiting his work at the Royal Academy. Since the New English was the chief rallying ground for opposition to the Academy, and since the Slade of Brown and Tonks was a nursery for this opposition, Russell's career seems to embody an extraordinary paradox.* Increasingly he became a link between the Royal Academy and the forces that had set themselves up violently to oppose it. In 1910, the year of Roger Fry's revolutionary exhibition 'Manet and the Post-Impressionists', Russell held his first one-man show at the Goupil Gallery. He remained at the Slade another seventeen years – totalling thirty-two years altogether – was knighted, fossilized into a senior academician, trustee of the Tate and National Gallery.

The close ties that Russell quietly formed between the Slade and the Royal Academy enabled an injection of new blood to be pumped into the academic tradition of art in Britain at a time when the rhythm and mood of the age were no longer behind that tradition. It was an artificial stimulus that helped to keep alive this form of art well beyond its normal life span, conferring upon it the unnatural bloom of ante-diluvian youth. So when at last the 'Roger Fry rabble', as Tonks captioned them, advanced across the country with their rallying cry of 'Cézanna!' they were opposed not just by the old diehards at the Royal Academy, but by alert and combative reformers such as Tonks, who had behind him some of the most brilliant young artists in the country and who, for the next twenty years, fought a vigorous defensive

* By 1933, the connection between the N.E.A.C. and the Slade, for many years under stress, was soon to be broken. 'I am automatically cut off the N.E.A.C. Jury this year by the new rule,' wrote Randolph Schwabe (who succeeded Tonks as head of the Slade) to Albert Rutherston (7 October 1933). 'I would not have served anyhow, having had so much abuse for my efforts in the past, and having heard so much of the Club being "run by a lot of Art-Masters".'

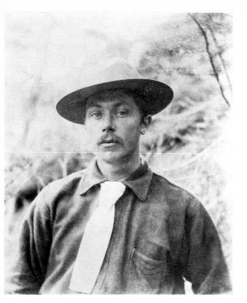

Thornton

Winifred

St Catharine's School, Tenby, 1893. Augustus John top left.

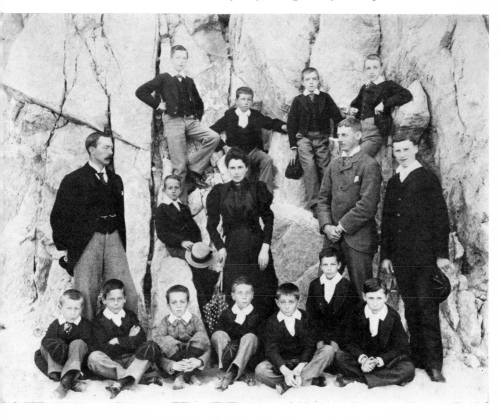

Ida Nettleship and her parents

campaign against the invasion of post-impressionism, futurism and all abstract art.*

Those who, like Augustus, owed their loyalty to Tonks, soon found that the solid ground under their feet was no longer connected to the mainland of contemporary art. To the few individuals who were self-sufficient – J. D. Innes, Gwen John and Stanley Spencer – this isolation made no difference: they went their own way. But Augustus, who had little sense of personal identity or of what his style might be, was cut adrift and, disdaining the trades of fashion, steered a blind and desperate course, never reaching home. In his seventies, tired and deeply disappointed at not yet having fulfilled the inexhaustible promise with which so many had burdened him, he wrote in explanation: 'I was never apprenticed to a master whom I might follow humbly and perhaps overtake.' Tonks, remarkable man though he was, could only act as go-between, pointing his way back to the Old Masters. But the Old Masters were many, and all of them were dead. Because of his insupportable loneliness, Augustus needed a living master, someone moving and breathing near him. With patience, with calculation and foresight, he might then have attained some equilibrium between life and art, some method of discovering himself and expressing what he had discovered, even the search itself, in paint. But in the summer of 1895 he suffered a bad accident, the long-term effects of which, unappreciated at the time, were to remove beyond his reach those very qualities of patience, calculation and foresight, making him an empty house for passing moods that, like the convulsions of the weather, seemed uncontrollable.

2. WATER-LEGEND

Augustus was happy at the Slade,† but at home he was increasingly discontented. Never had Tenby seemed more provincial, Victoria House more mean and squalid. Whenever possible he would avoid staying

* 'I think Manet from a very rapid glance at the exhibition comes out best among the moderns,' Tonks wrote to Albert Rutherston (5 January 1932). 'It is interesting to observe, and this is a fine lesson, how degradation sets in at once with the coming in of contempt for Nature. We are no good without it, we are like children without guardians. The last twenty years have been I believe the worst on record, speaking generally, and because of this Roger Fry has upset the applecart.'

† In his second year he won a certificate for figure drawing, a prize for advanced antique drawing and, much to his father's gratification, a Slade scholarship of thirty-five pounds per annum for two years. The next year (1896–7) he was awarded a £3 prize for a study of a nude male figure, standing; and a certificate for advanced antique drawing. In his final year he won a certificate for Head Painting, a £6 prize for figure painting, and another £10 for the figure composition prize ('Moses and the Brazen Serpent').

there, and go off on expeditions, at first in Britain, later to Belgium and Holland, with his two friends Ambrose McEvoy and Benjamin Evans.

But sometimes it was not possible to escape, and then he occasionally invited a friend down to share his exile. One winter Michel Salaman came for a week. It was an alarming holiday. Salaman was a Slade student of the same age as Augustus and belonged to a very large red-haired fox-hunting family that had made its fortune in ostrich feathers. The atmosphere of Victoria House was unlike anything he had experienced. Edwin, very dry and upright, hardly spoke at all, and made all conversation by the others, even their whispers, sound a vulgarity. Thornton appeared to be a sort of hobbledehoy, utterly miserable when not playing cards. Winifred was at all times extraordinarily dull and musical except in the presence of Gwen, when the two girls would giggle continuously, much to Salaman's dismay. Gus, he thought, was quite out of place in this strange environment. Between dismal meals, the two boys would hurry off to the caves where Gus leapt from rock to rock in the most agile and death-welcoming way. They also penetrated deep into the blackness of these caves, using up all their matches and unnerving Salaman with the thought that they'd be discovered, two heaps of bones, fifty years later. On another occasion, seeing a navvy who was bullying a child in the street, Augustus strode up without hesitation and, while Salaman looked on in horror, put a stop to the affair by challenging the navvy to a fight. By the end of his visit Salaman was exhausted. He never returned.

At the beginning of the summer holidays of 1897 Augustus set off on a camping trip round Pembrokeshire with McEvoy, Evans and a donkey. It was a journey full of adventures and misadventures, in keeping with his zeal, culled from Whitman's *Leaves of Grass*, for Freedom and the Open Road. At Haverfordwest they fell in with a party of Irish tinkers 'rich in the wisdom of the road'; at Solva they were taught by a tramp how to snare rabbits; they drank beer in wayside inns, made friends with villagers, entered themselves unsuccessfully in regattas, joined with more success in old-fashioned village games 'which included a good deal of singing and kissing',[27] and, in the intervals, painted 'the Rape of the Sabine Women'. It was an exhilarating time, perhaps more charming than heroic. 'My friends and myself are encamped in a place called Newgale with two cottages and one partially built and a stretch of sand two miles long,' Augustus wrote to Ursula Tyrwhitt. 'The Atlantic continually plays music on the beach. Outside browses the Donkey, our hope and pride. On this animal we depend to draw our cart and baggage. . . . Outside the tent the odour of the fragrant onion arises on the summer air, it is McEvoy who cooks. One

night we slept out under the eternal stars, one of which alone was visible – Venus – and that I regret was placed exactly over my head.'

When they arrived back in Tenby, McEvoy and Evans left for London. Augustus expected to join them again shortly at the Slade. Meanwhile he had to steel himself for a week or two of filial duty at Victoria House. The boredom was excruciating. He felt tempted to do all manner of wild things, but did nothing – there was nothing to do. One afternoon towards the end of his vacation he went to bathe on the South Sands with Gwen, Winifred and their friend Irene Mackenzie. The tide was far out but on the turn, and he decided to go off on his own and practise diving from Giltar Point. He climbed the rock and looked down. The surface of the water was strewn with seaweed but seemed deep enough for a dive. At any rate it was worth a try. He stripped off his clothes and plunged in. 'Instantly I was made aware of my folly,' he later recorded.[28] 'The impact of my skull on a hidden rock was terrific. The universe seemed to explode!' Possibly because of the cold water he did not lose consciousness and somehow managed to drag himself to the shore. Part of his scalp had been scissored away and lay flapping over one eye. The ebb and flow of his blood was everywhere. He did what first aid he could, dressed slowly, turbaned his towel round his head and set off back to the South Sands. 'Presently he came running back,' Irene Mackenzie recalled,[29] 'with blood pouring from his forehead.' Edwin, who had joined his daughters on the beach, was greatly alarmed. They must get him back to the privacy of the house as speedily and discreetly as possible. At all costs, short of death itself, publicity must be avoided. Augustus was already feeling very weak. Supported and camouflaged on all sides by his family, he was hurried back by a curious zig-zag route to the safety of his bed. Here he seems to have lost consciousness for a time. The next thing he knew was that he was being examined, rather to his gratification, not by the family's usual practitioner, but by Dr Lock, a far more eminent and romantic figure. Dr Lock stitched his wound, told him that he probably owed his life to his uncommonly thick skull, and left. There was no concussion, though some element of shock, and, since the stitches held, little more needed to be done. It was essential, however, that he rest and endure a long period of convalescence in Victoria House. Soon this 'durance vile'[30] as he called it grew almost insupportable. It was by far the worst part of his accident. 'As my brain clears I find my confinement here more galling,' he complained to Ursula Tyrwhitt. 'But I'm healing like a dog – the doctor is amazed at the way I heal. The wound is the worst of its kind he has had to deal with. If I appear at all cracked at any time in the future, I trust you will put it down to my knock on the head and not to any original madness. The worst part of it is the beef tea, I think.

I am not allowed to remain long in peace without the slavey bearing in
an enormous cup of that beverage. . . . Man cannot live by beef tea
alone.'

The Slade students went back, but Augustus was not among them.
Even Gwen had gone to London. He perspired with impatience. His
wound healed, it seemed, by the sheer force of his willpower. Even so
it was a slow business and the doctors were taking no chances. For a
time Augustus tried working on his own. 'I have been doing sketches
for a Poster for cocoa,' he told Ursula Tyrwhitt. ' . . . It's great fun,
but difficult – like everything else.' Then suddenly he tired of this: 'I'm
sick of doing comic sketches . . . I don't feel in a comic mood at all.'
His feelings were of colossal tedium, colossal revolt. Once he was free
from this appalling imprisonment he would do such things – what they
were he was not yet sure, but they would be the wonders of the world.
In the meantime: 'I am horribly dull. I was hoping for some signs that
my brain was affected – a little madness is so enlivening. I do hope this
dullness is not permanent.'

His handwriting in these letters to Ursula Tyrwhitt grows increas-
ingly wild and is interrupted by drawings of himself, like a wounded
soldier, with a bandage round his head and the beginnings of a beard.
From everything worthwhile he felt cut off. He was buried alive. 'You
must have lots of news to tell me, if only you would,' he pleads. 'I am
insatiable.' And when Ursula does write to him he calls her 'an angel'
and replies: 'Your letter did more for my head than tons of that other
stuff [beef tea]. In fact I got up this morning before the doctor came and
he was quite annoyed . . . they've cut away a great patch of my hair
which will look funny I daresay. I'm longing to see a good picture
again. . . . I'm going to paint next term. Hurrah! How exciting it is
. . . I feel sure *another* letter would complete the cure.'

His own letters also contain a rather tentative declaration of romantic
love. He recalls, with nostalgia, the last day of the summer term. 'How
the strawberries sweetened one's sorrow! – how the roses made one's
despair almost acceptable! How you extinguished everybody at the
Soirée! Before you came it was night – a starry beautiful night, but you
brought as it were the dawn which made the stars turn pale and flee,
remaining alone with its own glorious roseate luminescence. Selah!'

At first he is merely in love with love, with the melody of the words
themselves. But later he alters key to a more urgent, more practical tone.
He wants to hear from her precisely what she is doing, to extract from
her 'like a tooth' the pledge that he may keep company with her once
he returns. Is he to be allowed 'to take you home', he asks. 'I mean to
accompany you?' In return he will lend her his Rembrandt book. They
must have a definite understanding.

When he does go back to the Slade that autumn he is transformed. Upon his head he wears a defunct smoking-cap of black velvet and gold embroidery produced by his father to conceal his wound from public gaze; and round his cheeks and chin sprout small tufts of red hair, like fungus. He had become, Ethel Hatch noticed, very untidy – quite unlike the spruce, clean-shaven youth whom she had met three years ago.

In this way the Augustus John legend was conceived.

This legend, which stalked his life like a shadow, is a perfect example of how a remarkable man may be simplified into a myth by popular fancy acting through suggestible minds. In the public imagination he was to represent the Great Artist, the Great Lover, the Great Bohemian Enjoyer of Life. It was a cruelly ironic comment on his actual career, one which he did not accept himself but never effectively contradicted, and from the pressures of which he constantly suffered.

The story is perhaps most succinctly told on the back of a Brooke Bond Tea Card, as one of a series of fifty Famous People.[31] Here Virginia Shankland writes that Augustus John 'hit his head on a rock whilst diving, and emerged from the water a genius!* He became a magnificent draughtsman; this mastery later spread to painting. John was a fiery personality with a passion for independence and personal liberty, which he expressed in his paintings, especially those of gypsies. He felt great affinity with their roving lives and often lived among them.' To this brief account must be added one further ingredient of the legend, perhaps not palatable to Brooke Bond tea drinkers. This was what a *Daily Telegraph* leader writer gallantly referred to as his 'prowess with the fair sex'.†

Like many fables, this picture does partake a little of the reality out of which it grew, but the truth has been coated with accretions of those popular sentiments that flourished so lavishly in the climate of late Victorian and Edwardian England. To judge from the facts, it seems clear that from 1897 onwards Augustus was a changed man. He was changed not just in appearance, but also in his work and behaviour. In his first two years at the Slade, Tonks had described his work as 'methodical'. Now the drawings he began to do were passed from hand to hand, everywhere exciting admiration. They were extraordinarily precocious, remarkable for their firm, fluent, lyrical line, executed with

* In 1930 Augustus's second son Caspar dived on to a rock and emerged from the water an Admiral!

† 'As a man he was larger than life-size. Even while still young his prowess with the fair sex was legendary and the stories about him legion. He attacked everything with vigour.' *Daily Telegraph*, 1 November 1961.

the point of the pencil and with astonishing vigour and spontaneity. They seemed to promise a new force in British art. Suddenly his genius was manifest. Even his rejected sketches were eagerly snatched up by other students between easel and waste-paper basket.

His personality, too, seemed different. As his beard grew, so his clothes grew shabbier, his manner more unpredictable. For long periods he was still very quiet: but suddenly there would be an outburst of high spirits, some outrageous exploit; then silence again. In his earlier years, according to Edwin,[32] he had been 'a happy healthy child, not at all given to brooding or moodiness, who loved games and in every way was much the same as other children . . . a docile tractable child not subject to passionate outbursts'. Edwin, very characteristically, was eager to present a picture of a family that was ordinary to an extraordinary degree, united and respectable to the extreme of banality. His son's docile manner may often have been a symptom of the moodiness he denies to have existed, but which Augustus had undeniably shared with him. From about the age of eighteen Augustus's energies were directed against those factors he held in common with his father – that is, almost all the first seventeen years of his upbringing – and much that he had inherited. He grew intermittently less docile and more to resemble what Wyndham Lewis was to call 'a great man of action into whose hands the fairies had stuck a brush instead of a sword'.

Augustus disliked this description, and for much the same reason that he disliked the magnificent portrait painted of him in 1900 by William Orpen.* Both, he felt, degraded him; neither showed any trace of the shy, uncertain, dreamy person he knew himself to be. But the outer man had already begun to eclipse that vague unrealized inner being: he was a moon that was paling to invisibility in the sunlight of the John legend. 'I am just a legend,' he once said. 'I'm not a real person at all.'

The essence of all such legends is the substitution of the private by a public self. Very often this substitution is made as a deliberate act of will, an early resolve to detach oneself and rise superior to life. Of all Augustus's near-contemporaries, probably the example of Bernard Shaw illustrates this self-myth-making principle best. Much of his childhood and youth, before he had formed a protective covering, was

* This portrait is now in the National Portrait Gallery, London. Many years after it was painted John described it in *Finishing Touches* as 'most regrettable'. Orpen had painted it in frank, romantic imitation of Whistler's 'Carlyle', and at the time John wrote of it to Michel Salaman: 'Orpen's portrait of me extracts much critical admiration. It is described in one notice as a clever portrait of Mr John in the character of a French Romantic.

'One far-seeing gentleman hopes that I will emerge from my Rembrandtine chrysalis with a character of my own! I have just been to the Guildhall and return exalted with the profound beauty of Whistler's Carlyle.'

spent in tears. But at the age of fifteen he had seen Gounod's *Faust*, been profoundly impressed, and begun to model his personality on Mephistopheles. He clothed himself in a powerful and invulnerable detachment from human emotions, and by sheer willpower achieved a kind of Mephistophelian immortality on earth, an icing of the soul.

The John and Shaw myths were bubbles blown by the unsatisfied desires for power and pleasure. But Augustus, unlike Shaw, never 'decided' to become a legend, never modelled his life on anyone, neither planned nor carried through any fabled programme. He did not even grow a beard, he once told John Freeman;[33] it just grew of its own accord. But, like Shaw, he adopted a simple military slogan: the best method of defence is attack. It is a technique that accounts for many paradoxes: why it is the shy who make the most outrageous statements, the timid who are suddenly bold, the frightened who attack, the doubtful who act most decisively.

The clue to Augustus's performance at the Slade, which was to nourish his larger-than-life legend, was *impatience*. His bang on the head had not infected him with a genius for draughtsmanship. His sister Gwen, a no less remarkable artist, though certainly quite capable of cracking her head on any rock,* somehow completely failed to do so. Augustus himself described the theory of a rock releasing hidden springs of genius as 'nonsense', and he added:[34] 'I was in no way changed, unless my fitful industry with its incessant setbacks, my woolgathering and squandering of time, my emotional ups and downs and general inconsequence can be charitably imputed to that mishap.'

This common-sense denial, however, does admit some change obscurely connected with the incident. Almost certainly, it seems, the claustrophobia of his convalescence was what most strongly affected him. Like alcohol, it did not confer on him any quality he did not already possess. But it greatly magnified certain traits, leaving him with an obsession against being confined, a terrible impatience, a sense of walled-in isolation from the human race, and a rising revolt against the surroundings of his imprisonment and all they represented. He was unable now to tolerate stress, but had simply to outpace his anxieties. The assurance of his early drawings testifies to the speed with which he did them rather than to any deep self-confidence. His natural doubts and

* When staying at Pevril Tower, Swanage, in 1899, Gwen wrote to Michel Salaman: 'I bathe in a natural bath 3 miles away, the rocks are treacherous there, and the sea unfathomable. My bath is so deep I cannot dive to the bottom and I can swim in it – but there is no delicious danger about it, and yesterday I sat on the edge of the rock to see what would happen – and a great wave came and rolled me over – which was humiliating and *very* painful – and then it washed me out to sea – and that was terrifying – but I was washed up again.'

hesitations had no time to crowd in on him:* he would not let them. By the time they had caught up, he had finished; he was somewhere else. It was a way of life that served him magnificently while he was still young. He actually raised the standard of work at the Slade, lifted other students to a level they might otherwise not have reached. But later on, as his lyrical inspiration faded, it was replaced by nothing, by emptiness, or sentimentality masquerading as lyricism. The anxieties, half-smothered then with boredom, easily overtook him and reached the canvas while he was still at work on it.

It was his vitality and restlessness that gave Augustus such tremend-ous initial impetus. To those near him, he seemed endowed with a more than human brilliance. People worshipped him. Everything con-tributed to his God-like aspect: his very name, Augustus, suggested the deified Roman Emperor.† By his eighteenth birthday he had already grown into an imposing figure: a picturesque giant nearly six feet tall, with a Christ-like beard, roving eyes and beautiful hands with long nervous fingers that gave a look of extreme intelligence to everything he did. He was not talkative. He kept himself perfectly still, listening with an absent-minded air. But sometimes his eyes would light up, his whole being come alive and he would speak eloquently in a deep, rumbling, Welsh voice.

Physically he was the stuff from which heroes are made, and the age was right for heroes. England was on the decline. Over the next thirty years psychic forces that would earlier have gone into politics or art seem to have turned inwards and inflated the personality. From Oscar Wilde, who put his genius into his life and only his talent into his work, to the Sitwells, English civilization threw up a fantastic gallery of 'characters' – dandies and eccentrics, prophets and impresarios of the arts. The age was becoming more mechanical, personal liberty more restricted, attitudes and behaviour more uniform. The collective frustration of Edwardian England was soon to focus upon Augustus

* In a letter Charles Morgan wrote to D. S. MacColl, he recalls some words of Wilson Steer's: 'Do you remember that drawing by John? It was done at a time when he drew with many lines and many of those lines were superfluous or even wrong, but then at the last moment, he would select among them and emphasize those which were right, and so, by an act of genius, save a drawing which, in the hands of any other man, would have become a mess and a failure.'

† '*Augustus Caesar,*' *so the poet said,*
 '*Shall be regarded as a present god*
 By Britain, made to kiss the Roman's rod.'
 Augustus Caesar long ago is dead,
 But still the good work's being carried on:
 We lick the brushes of Augustus John.
 Punch, 27 February 1929.

and elect him as the symbol of free man. Through him people lived out their fantasies; for what they dared not do, it seemed he did instinctively. There was nothing mechanical, nothing restricted or uniform about him: there was *wildness*. Wyndham Lewis, who got to know him at an early age, caught this reverence for the Celtic warrior perfectly when he described[35] Augustus as 'the most notorious nonconformist England has known for a long time. Following in the footsteps of Borrow, he was one of those people who always set out to do the thing that "is not done", according to the British canon. He swept aside the social conventions, which was a great success, and he became a public lion practically on the spot. There was another reason for this lionization (which is why he has remained a lion): he happened to be an unusually fine artist.

'Such a combination was rare. The fashionable public found as a rule that it had been leo-hunting some pretentious jackal. Here was one who had gigantic ear-rings, a ferocious red beard, a large angry eye, and who barked beautifully at you from his proud six foot, and, marvellously, was a great artist too. He was reported to like women and wine and song and to be by birth a gypsy.'

3. FADED PRIMROSES AND STRAW

No one could have been more different from this exterior vision of Augustus than his sister Gwen. If he seemed all circumference and no centre, she was all centre. Physically, she appeared fragile. Her figure was slender, with tiny hands and feet; her oval face very pale; her soft Pembrokeshire voice, much to her irritation, almost inaudible. She dressed carefully in dark colours, and latterly in black. Her hair was brown, neatly arranged, with a big bow on top. But this modest impression was corrected by a look of extreme determination, by eyes that, though grave and sometimes sad, were rock-steady. The receding John chin, which Augustus had camouflaged so redly, seemed to symbolize Gwen's withdrawn nature. Socially ill at ease, she preserved beneath this timid front an air of majestic aloofness.

At opposite poles both their personalities were elusive: hers, in its stern reticence, manifestly so; his, more deceptively, behind the smoke-screen of his 'reputation'. Despite appearances, they had much in common* – an essentially simple attitude to life, a passionate response

* In a letter to Sir John Rothenstein (14 May 1952) written after having read Rothenstein's essay on Gwen John in *Modern English Painters*, Augustus sent some notes on himself and his sister: 'With our common contempt for sentimentality, Gwen and I were not opposites but much the same really, but we took a different attitude. I am rarely "exuberant". She was always so; latterly in a tragic way. She

to beauty: the beauty of nature and of people, especially women, some-
times the same women. They had also inherited the same sense of
isolation from other people. But the isolation of Augustus had been
intensified by his partial deafness and made hysterical by the aftermath
of his bathing accident. Unlike Gwen, he could not bear to contain his
emotions, could never absorb and sublimate them on to his canvas.
Instead, he had to disburden himself at once, dissipate them into
the thin air about him. So, although they were confronted by many
identical problems, their methods of dealing with them were entirely
different.

Before Augustus had been at the Slade many months, he was urging
Gwen to join him. She needed little encouragement and, as he later
implied,[36] would have done so anyway: '*She* wasn't going to be left out
of it!' Her need to escape from Victoria House was as urgent as his. She
had no energy in Tenby, she once confided to Ursula Tyrwhitt (30 July
1908): 'So if you feel as I did in Tenby you cannot work much.' She
wanted to work. She had only to travel three or four miles from home
and she would feel marvellously revitalized. It was 'strange' – she
attributed it to the local weather.

On coming to London, Gwen put up at first at 'Miss Philpot's
Educational Establishment' at 10 Princes Square, Bayswater. But during
the autumn of 1895, when she started to attend the Slade, she moved to
23 Euston Square,* very near University College. By this time Augustus
had left Acton, his growing paganism having proved too much for his
aunt, and was living at 20 Montague Place, a superior lodging house in
a street of temperance hotels, private apartments and the occasional
bootmaker or surgeon. In *Chiaroscuro* he described himself and Gwen
sharing rooms together and, like monkeys, living off fruit and nuts.
Very early in 1897 they did take the first floor flat of 21 Fitzroy Street, a
house that had recently been bought by a Mrs Everett, mother of one
of their friends at the Slade, who hurriedly converted it from a brothel†
into a series of flats and studios. Here they seem to have lived inter-
mittently for over a year, sharing it with Grace Westry, another Slade
student, and with Winifred John who had come up to London to study
music. Apart from this, and a flat over a tobacconist's in which they lived

* On the University College, London, form she filled in, '10 Princes Square' has
been crossed out and '23 Euston Square' substituted.
† The proprietress described herself as a 'feather dresser'.

wasn't chaste or subdued, but amorous and proud. She didn't steal through life
but preserved a haughty independence which people mistook for humility. Her
passions for both men and women were outrageous and irrational. She was never
"unnoticed" by those who had access to her.'

very briefly after leaving the Slade, the only rooms they shared were other people's. They were fond of each other, but incompatible, and it was not practicable for them to remain together very long. He felt that she dangerously disregarded her health in a way that could not benefit her work. His objections to her policy of self-neglect were exactly those expressed a few years later on her behalf by Rodin, who was always insisting that she ate well and took proper exercise. But whereas Rodin sounded sympathetic, Augustus's sympathy was often mixed with irritation. Her indifference to physical conditions and to what people thought of her seemed like a family parody of his own unconventionalism, and it was difficult for him to be detached.

Although Gwen never took Augustus's advice and sometimes ridiculed his opinions, she was worried by him, for she was not strong enough to retain her single-mindedness while he was near. He did not belong to that part of her heart and mind – the same part where her love of art lay – which remained undisturbed by the events and difficulties of life. This part, perhaps, could only be shared by those, mostly women, whose sensibility came directly from the soul, not the nerves. Augustus, she felt, was hostile to her desire for a more interior life. He could not share her solitude, was not part of her atmosphere. Until she removed herself beyond its influence, his forceful character dominated her. His life, where so much energy was squandered on *doing things*, dissipated her mind, led into a whirlwind of impressions that tore chaotically through her and away again before she had time to catch hold of them, make them her own. In order to realize her feelings, express her thoughts, she had to confine them to a small private area she could control. In a crowded life this was impossible, and the enervation and waste left her exhausted. 'I should like to go and live somewhere,' she told Ursula Tyrwhitt (undated), 'where I met nobody I know till I am so strong that people and things could not affect me beyond reason.'

People especially were always threatening to affect her beyond reason. Though chaste and even puritanical in her attitude, her relationships were sometimes extraordinarily passionate, and she did not get over them easily. While at the Slade she formed a particularly intense attachment to another girl* there. When this girl started a love-affair with a married man, Gwen was appalled and decided that it must be stopped. After failing to persuade her by argument she declared an ultimatum:

* Possibly Grace Westry, the Slade student who lived with Gwen for a year or two and whom Gwen painted as 'Young Woman with a Violin' and Augustus drew (the drawing is in the Fitzwilliam Museum, Cambridge. P.D. 942). Though attractive she appears not to have married, her various addresses up to at least 1912 showing a startling similarity to those of Ambrose McEvoy and his wife.

either the affair must cease – or she herself would commit suicide. There was no doubting her sincerity. 'The atmosphere of our group now became almost unbearable,' Augustus records,[37] 'with its frightful tension, its terrifying excursions and alarms. Had my sister gone mad? At one moment Ambrose McEvoy thought so, and, distraught himself, rushed to tell me the dire news: but Gwen was only in a state of spiritual exaltation, and laughed at my distress.' The girl's love for Gwen had now turned to hate, and she was quite obdurate. Something would have to be done. Augustus, very shocked, decided upon an athletic solution. He sought out the man and declared his own ultimatum: either the affair must cease – or he would fight him. Confronted in this way, the man retreated to his wife and the drama came to an end.

From dreadful involvements of this kind Gwen had to protect herself. Only then could she put all this energy of loving into her work. Once she had developed her ideas, begun to achieve something, then she could endure any misfortunes that might engulf her, not threaten suicide, but still go on in her search for 'the strange form'.[38]

To pursue this search without hindrance she forced herself to develop certain habits that counterbalanced what she considered to be her inherent weaknesses. 'One must be patient,' she counselled,[39] and this was the refrain to many of her letters. She had to fight a terrible tendency towards 'impatience and angoisse';[40] she had to make sure, in the face of all her instincts, that everything went slowly; she had to harness her extraordinary inner excitement to an equally extraordinary painstaking and methodicity. For a picture she would prepare endlessly – then paint it with great rapidity. 'I think a picture ought to be done in 1 sitting or at most 2,' she told Ursula Tyrwhitt (2 August 1916). 'For this one must paint a lot of canvases probably and waste them.' In this lifelong acquiring of patience, struggle for composure, lay her strength. 'I cannot imagine why my vision will have some value in the world – and yet I know it will,' she wrote. ' . . . I think it will count because I am patient and recueillé in some degree.'[41]

She was not naturally sombre – Augustus testifies to her 'native gaiety and humour' – nor did solitude altogether suit her. In time she developed a rather sickly obsession about 'God's little artist' as she liked to refer to herself. The detachment which she cultivated to modify her passion for beauty, to transfer it from 'people and things' to paint, was never complete. Ruthless towards those who bothered her – 'I will not be troubled by people'[42] – she remained poignantly vulnerable to those whom she loved and admired. While, for example, she was begging Vera Oumançoff, Jacques Maritain's niece, for some answer to her letters, she would make use of her father's poignantly unanswered correspondence simply for pencilling out small prayers.

'Prayer is asking and receiving,' she scrawled without any sense of irony or of the impartial truth suggested by Coleridge's lines:

O Lady! we receive but what we give,
And in our life alone does Nature live.

Like a plant, Gwen was nourished by Nature and by those few people, like Rodin, who were in spiritual communion with Nature. From the rest she guarded herself with her Catholicism (which she adopted in 1913) and her cats. Of her faith she tried without complete success to make a substitute for relationships with people; while her quarantine of cats provided the practical excuse why she could never leave, for any extended period, her solitary rooms. They were also the knife that kept so painfully sharp her dislike of that mass of human beings who together made up what Augustus called 'life', by reminding her constantly of their cruelty to animals. She was a weak person ('I am ridiculous. I can't refuse anything that is asked of me'[43]) magnificently armed.

About Augustus's pictures Gwen said very little – neither of them talked painting. But in a letter to Ursula Tyrwhitt written in the winter of 1914–15 she wrote: 'I think them rather good. They want something which perhaps will come soon!' Of her work Augustus was the staunchest admirer from the very earliest days, believing her to be a more talented painter than himself, though possibly less accomplished as a draughtsman. In his last years, after Gwen had died, this admiration curdled into a sentimentalized concoction – 'Fifty years after my death I shall be remembered as Gwen John's brother.' – but his appreciation was genuine, often expressed and acted upon during her lifetime. 'I have seen him peer fixedly, almost obsessively, at pictures by Gwen as though he could discern in them his own temperament in reverse,' John Rothenstein recalls;[44] 'as though he could derive from the act satisfaction in his own wider range, greater natural endowment, tempestuous energy, and at the same time be reproached by her single-mindedness, her steadiness of focus, above all by the sureness with which she attained her simpler aims.'

Round Gwen and Augustus there soon gathered a group of young artists whose talent appeared extraordinarily precocious. A new spirit of comradeship, unknown in Legros' time, invaded the school. Within its small pond these students created an enormous wave. There was Edna Waugh, very pretty and petite and with long hair down to her waist, who had gone there at the age of fifteen, won a scholarship and in 1897 scored a dramatic triumph with her beautiful watercolour 'The

Rape of the Sabines'. She was proclaimed an infant prodigy, a Slade school 'genius'. The flexibility of her talent and the strange poetic imaginings with which she filled her notebooks particularly impressed Tonks, who informed her that she was going to be a second Burne-Jones, to which she immediately replied: 'No, the first Edna Waugh'. But to many people's dismay she did not remain Edna Waugh for long, and when only nineteen was married off to [Sir] William Clarke Hall. Even her best-known work, a series of haunting illustrations to *Wuthering Heights*, stayed unfinished.

There was Gwen Salmond, who later married Matthew Smith,* a very self-possessed and outspoken girl, whose 'Descent from the Cross' was spoken of as a masterpiece. But already by the time she left the Slade she seemed to have lost any illusions about her future and that of most of her contemporaries: 'Of course, we've gone down in art,' she wrote to Michel Salaman, ' – I wish we hadn't – and I shan't bring up the average anywhere near. My four years show me that – a sort of technicality is the wall I break myself against . . . I am really deeply ashamed of having done nothing for so long. I wish you'd try and do something you think beautiful and work it out – all you men go in for "pleasant effect" or "something good".'

Most brilliant of all was William Orpen. With his arrival at the Slade in 1897 from the Metropolitan School of Art in Dublin, a new force made itself felt in Gower Street. It was the force, primarily, of tireless industry and tireless material ambition. Orpen was a gnome-like and exuberant figure, very popular with the other students. Slim and active, he had high cheek-bones given prominence by sunken pale cheeks, light grey eyes, and thick brown hair, very unkempt. Invariably he wore a small blue serge jacket without lapels – of a type usually worn by

* In his obituary notice (*The Times*, 1 February 1958) of Lady Smith, Augustus wrote: 'The death of Lady (Matthew) Smith has removed one of the last survivors of what might be called the Grand Epoch of the Slade School. Gwen Salmond, as she then was, cut a commanding figure among a remarkably brilliant group of women students, consisting of such arresting personalities as Edna Waugh, Ursula Tyrwhitt, my sister Gwen John, and Ida Nettleship.

'Gwen Salmond's early compositions were distinguished by a force and temerity for which even her natural liveliness of temperament had not prepared us. I well remember a Deposition in our Sketch Club which would not have been out of place among the *ébauches* of, dare I say it, Tintoretto!

'. . . In what I have called the Grand Epoch of the Slade, the male students cut a poor figure; in fact they can hardly be said to have existed. In talent, as well as in looks, the girls were supreme. But these advantages for the most part came to nought under the burdens of domesticity which . . . could be for some almost too heavy to bear . . . "Marriage and Death and Division make barren our lives". Gwen Smith had reason to know this but she also had the pluck to face it bravely, which is what made all the difference.'

engineers. In 1899, his last year at the Slade, he became the hero of the hour by winning the coveted Summer Composition Prize with his outstanding 'The Play Scene in *Hamlet*'. But his father, a rather stuffy solicitor, had by now had enough of his son's painting and gave him the alternative of taking up some serious business or being cut off with a hundred pounds. Orpen took the hundred pounds and never looked back. There seemed nothing he could not accomplish. He was already a devoted disciple of William Rothenstein and by a successful proposal of marriage was promoted to be his brother-in-law. Stationed back in Ireland with the rank of art-teacher, he met a rich American patron, a specimen comparatively rare before the transatlantic jet. This American wanted his wife's portrait done, wearing a leopard skin topee and heavy pearls, in the early morning. Orpen did it with immense success and was paid a sum of money he had heard mentioned before but of which he had formed no accurate numerical notions, all figures beyond a hundred pounds being to him indistinct visions, clouds and darkness. From this moment onwards he was overwhelmed by lucrative commissions. The Rolls Royce had entered into his soul.

At first Augustus took to Orpen. He was an easy companion, very spontaneous, whimsical, high-spirited. But in due course, after Orpen had become what Augustus called 'the protégé of big business', their ways diverged. He succumbed very eagerly to those social and financial pressures that afflict the professional artist. These pressures Augustus also felt, but whereas in him there was always some struggle between the 'pull duchess' and 'pull painter' forces, Orpen seemed to experience no struggle, and organized his career with the very un-John-like efficiency of a tycoon. The result, which revolted Augustus by its vulgarity, was a degree of material success to rival Van Dyck and Reynolds and, in his own time, Sargent. Even in these early days at the Slade, people, it was said, came to praise John's pictures but went away with Orpen's.* He had cut his hair short as a soldier's, perched on its shaven dome a small bowler hat and encircled his neck with a stiff white collar. The artist was lost to sight. A sentimental Irishman in England, he was typically English when in Ireland, and though he claimed to have been brought up on 'the Irish Question', he confessed that he had never found out what it was.

Orpen cultivated ignorance, pursued superficiality with extreme zeal. There was not a single serious topic of which he could not claim to be unaware, not one good book he had not omitted to read. He had few

* Hence E. X. Kapp's masterly clerihew:

When Augustus John
Really does slap it on,
His price is within 4d.
Of Orpen's.

prejudices, no opinions. His rapid-fire, staccato conversation had about it the suggestion of epigrams but was almost unintelligible and strenuously confined to subjects of microscopic triviality. If the talk threatened to turn to more adult topics, he grew scared and would fall into the most extravagant feats of horseplay. It was not beyond him to get down on all fours at dinner and bark like a dog, or to produce from his pocket some new mechanical toy and set it spinning across the table. He also developed, his nephew John Rothenstein remembers,[45] a 'habit of speaking of himself, in the third person, as "little Orps" or even as "Orpsie boy". It would be difficult to imagine a more effective protection against intimacy.' There was to his life an inarticulate pathos. Money, fame, success – these were like delicious coloured sweets to him: he simply could not resist them.

Before Orpen had dwindled into success, he and Augustus were often together, and in 1898 they were joined by a third companion, Albert Rutherston.* 'Little Albert', as he was called, was the younger brother of William Rothenstein, very pink and small and regarded as rather a rake. 'Not content with working all day,' William Rothenstein recorded,[46] 'they used to meet in some studio and draw at night. They picked up strange and unusual models; but I was shy, after seeing John's brilliant nudes, of drawing in his company.'

Above the studio† in which they worked lived Mrs Everett, an improbable woman in her forties, very fat and vigorous, her cheeks aflame, her eyes very blue, unevenly dressed in widow's weeds and men's boots. Her son Henry and niece Kathleen Herbert had recently gone to the Slade where she now attempted to join them, arriving there fully equipped with a Gladstone bag containing one large bible, a loaf of bread, a Spanish dagger, spirit lamp and saucepan, and a dilapidated eighteenth-century volume on art. She presented a phenomenon unique in Tonks's experience. In desperation he banished her to the skeleton room in the cellar of the Slade which, interpreting as a privilege, she garishly transformed by introducing there various brass Buddhas, stuffed peacocks and a small organ, two grandfather armchairs loosely covered with gold-encrusted priests' vestments and a slowly-dying palm tree, like a monstrous spider, from which she suspended religious texts decorated on cardboard. Some nights she slept there; some days she entertained her pack of dogs there; sometimes, night or day, her voice could be heard among the skeletons singing lustily: 'Oh, make those dry bones live again, Great Lord of Hosts!' – to which the

* Albert Rothenstein changed his name to Rutherston during the First World War, and is generally now remembered by that name. To avoid unnecessary complication I have called him Rutherston throughout.
† 21 Fitzroy Street.

students above would add their refrain, clapping wildly and chanting ribald choruses.

Exiled at last from the Slade, Mrs Everett started what she called her 'Sunday School' in the converted brothel at Fitzroy Street. Here, and later at 101 Charlotte Street, she encouraged the art students to gather for bread and jam, hot sweet tea and intimate talk of the Almighty. These teas or 'bun-worries', as they were called, were lively affairs, especially when Augustus and Orpen turned up, and would last late into the night, culminating in the singing of 'Are you washed?' with its confident refrain: 'Yes, I'm washed!' For Augustus the atmosphere was uncomfortably like that of his Salvationist aunts, but Mrs Everett was a fascinating subject to draw from all angles and so he often came. 'One lovely day early in May,' Ethel Hatch recalls,[47] 'Mrs Everett invited us all to a picnic in the country . . . she met us with a large yellow farm cart, she herself wearing a sun-bonnet, and the driver a smock . . . After lunch we wandered about in the lovely park and grounds, and some of them ran races round the trees; John was a very good runner, and most graceful. I can see him now, chasing a red-haired girl through the trees at the bottom of the lawn.

' . . . afterwards a photograph was taken of the party in the wagon, with John sitting astride a horse. I shall never forget the journey home in the train, when John and Orpen entertained us by standing up in the carriage singing all the latest songs from Paris, with a great deal of action . . . Unfortunately John had lost his railway ticket and when the ticket collector came round, he asked John to give his name. John kept repeating the name John, to the annoyance of the collector, who kept saying: "But what's your other name?" '

At another of her gatherings, Mrs Everett, drawing on the full extent of her artistic knowledge, extolled John's great talent, and informed him: 'God loves you.' But Augustus, acutely embarrassed, mumbled: 'I don't think he has bestowed any particular favours on me.' He was overwhelmed during this period by an avalanche of flattery, but kept his head. When Tonks on one occasion declared that he was the greatest draughtsman since Michelangelo, he replied simply: 'I can't agree with what you said.' It was this modesty that helped to endear him to his fellow students. One summer big baskets of roses were imported to decorate the gaunt walls of the Slade, and the students set about binding them into festoons. 'Several of us were standing about outside the Portrait Room with baskets of festoons,' Edna Clarke Hall remembered.* ' . . . We were considering a pedestal, from which the

* Unpublished reminiscences. But see 'Edna Clarke Hall: Drawings and Watercolours 1895–1947'. Slade Centenary Exhibition at the d'Offay Couper Gallery, October 1971.

statue for some unknown reason had been removed, when Professor Tonks came suddenly out of the Portrait Class. He stopped and from his height looked down on me, and with one of his sardonic smiles and indicating the empty pedestal asked "Is that for John?" '

Already, by 1897, it seemed clear to many that something of a phenomenon had come among them.* He excelled *au premier coup* and could draw the nude from any angle upon a single inspiration. What gave the work its quality was the way it went for its mark, its intensity and virtuosity. Sargent, the American portrait painter then at the height of his fame in London, exclaimed when he visited the Slade that Augustus's drawings were beyond anything that had been seen since the Italian Renaissance. And William Rothenstein, in his memoirs,[48] wrote: 'Not only were his drawings of heads and of the nude masterly; he poured out compositions with extraordinary ease; he had the copiousness which goes with genius, and he himself had the eager understanding, the imagination, the readiness for intellectual and physical adventure one associates with genius.'

He was extremely industrious. After leaving the Slade in the late afternoon, he and his friends would go back to his rooms and continue drawing and painting and acting as one another's models. On one occasion Augustus lost his key. No amount of knocking fetched anyone and, becoming quickly impatient, he leapt on to the railings in front of the house and then, like a monkey, scaled up the outside of the building to the top floor, hanging on by his fingernails. Having got through an attic window, a minute later he was opening the door to the other students standing there terrified by his acrobatics.

In 1897, when Augustus was nineteen, Tonks offered his students a prize for copies after Rubens, Watteau, Michelangelo and Raphael. Augustus won it easily with a charcoal study after Watteau. His sheer manual dexterity was dazzling. Whatever style he adopted he did it supremely well and his work acted on the other students as a powerful catalyst. Before joining the Slade he had studied reproductions of Pre-Raphaelite paintings in magazines and been enormously impressed by them. Now this influence was passing. Gainsborough had become his favourite British artist; but he had also developed an admiration for Reynolds, in particular his power of combining fine design with psychological insight. The more he saw, the more he admired. He would, he told William Rothenstein, have given 'five years to watch Titian paint a picture'. But at the same time he claimed that 'J. F. Millet was a master I bowed before'. But by 1897 Watteau, probably, was the

* Gwen John was also successful at the Slade. In her second year (1896-7) she won a certificate for figure drawing, and the following year was awarded the Melvill Nettleship Prize for figure composition.

chief influence upon him, though he was about to be introduced by William Rothenstein to the work of Goya whom he later considered superior to all these. Rothenstein's book on Goya opened up for Augustus a world where, to the accompaniment of guitars, the artist lived dangerously with the athleticism of a bull-fighter, coquetted with death under the affrighted eyes of his favourite *maja*. It was a life on which he would have liked to model his own career.

'We may say that the whole of the art which preceded it has influenced the work of John, in the sense that he has continued a universal tradition,' wrote T. W. Earp. But although he was an amalgam of so many Old Masters, he was beginning to produce unmistakable 'Johns'. After fifty years of painstaking Victorian pictures, his lightning facility was extraordinarily refreshing. His best work appeared to possess an almost baroque splendour. There seemed no reservations in his attitude, and the immediacy of his drawings was marvellously invigorating. He wanted to register his first conception of beauty, his excitement, the mood of a passing moment. He wanted to fix all this with an almost spontaneous impact on the canvas. Draughtsmanship was in no way for him an intellectual exercise, but a matter of passionate observation involving the animal co-ordination of hand, eye and brain.[49] He had learnt Brown's method of rendering the human form by a succession of rhythmical lines following the surface and explaining its structure; he had mastered Tonks's lesson on the contour. His own drawings were largely dependent upon their sensuous line. He was bowled over not by his emotional involvement with people, but by his appreciation of their physical beauty; and it was his unfading response to their beauty that he set down. 'Does it not seem,' he once asked, 'as if the secret of the artist lies in the prolongation of the age of adolescence with whatever increase of technical skill and sophistication the lessons of the years may bring?'[50]

But while his drawings and pastels improved, his paintings remained uncertain. He found it difficult to control his palette. The Slade had taught him little of the relation of one colour to another and he had no natural sense of tone. Sometimes he would ruin a picture for the sake of a gesture, stamping down an attitude or splashing on some band of colour – a red scarf or green hat – because, on the spur of the moment, it took his fancy. But occasionally he gave promise of astonishing work.

In the autumn of 1898 he set off with Evans and McEvoy for Amsterdam, where a large Rembrandt exhibition was being held.* 'This was a great event,' he recorded.[51] 'As I bathed myself in the light of the Dutchman's genius, the scales of aesthetic romanticism fell from

* At the Stedelijk Museum from 8 September to 31 October 1898.

my eyes, disclosing a new and far more wonderful world.' Having very
little money, they slept in a common lodging house, wandered by the
canals of old Amsterdam, lived off herrings and schnapps, and every day
visited the museums. It was now that the last vestigial wraiths of Pre-
Raphaelitism, the sorcery of Mallory's dim and lovely world, faded in
his imagination, to be replaced by the poetry of common humanity.
Not long afterwards, he travelled through Belgium with the same
companions, immersing himself in the Flemish masters for whom he
now felt a deep and natural sympathy. 'Bruges, Anvers, Gand, Bruxelles
have seen me and I have beheld them,' he wrote to Will Rothenstein.
'Rubens I have expostulated with, been chidden by, and loved. Jack
Jordaens has been my boon companion and I have wept beside the
Pump of Quinton Matzys.'

At other times he was condemned to Tenby. Edwin had recently
moved from 32 Victoria Street to a house just round the corner in
South Cliff Street. Southbourne, as it was called, was almost exactly
identical to Victoria House: the same narrow, dark, cube-like prison.
Augustus felt all the old sensations of claustrophobia, the panic and
emptiness. 'An exile in my native place I greet you from afar and tear-
fully,' he wrote to Will Rothenstein (18 June 1898). 'Rain has set in and
I feel cooped up and useless. What we have seen of the country has been
wonderful. But it is ten minutes walk to the rocky landscape with
figures.*

'Pembrokeshire has never appeared so fine to me before, nor the
town so smugly insignificant, nor the paternal roof so tedious and
compromising a shelter. Trinkets which in a lodging house would be
amusing insult my eye here and the colloquy of the table compels in me
a blank mask of attention only relieved now and then by hysterical and
unreasonable laughter.

'The great solace is to crouch in the gloom of a deserted brick kiln
amongst the debris of gypsies and excrete under the inspiration of lush
Nature without, to the accompaniment of a score of singing birds.

'I hope to quit this place shortly and come home to London where I
can paint off my humours.'

In a letter to Michel Salaman of about the same date Augustus wrote:
'I intend coming up to London in a week or so when I shall start that
Holy Moses treat.' He had chosen, from among the alternatives set for

* 'I have been blown upon by the wind, peppered with sand, moistened by
spray – indeed borne all the rough handed caresses of the air, earth and water – not
ungratefully,' he wrote from South Cliff Street to Michel Salaman this summer.
'To-day I had a glorious bathe in a little bay some distance away on the coast. The
sun tho' far away shone hot and uninterrupted by clouds which however ranged
themselves exquisitely in their right places.'

the Slade summer competition that year, Poussin's theme 'Moses and the Brazen Serpent'. The bustling bravura composition he now produced was by far his most ambitious painting as a student. Heavily influenced by the Italian Renaissance, it also owed something, especially in its volume and colour, to Venetian aesthetics, and it exemplifies Augustus's affinity with a painter such as Tiepolo. The anatomy and posing of the foreground figures seem to be adapted from the ceiling of the Sistine Chapel. But the whole painting derives most clearly from Rubens and from Rembrandt. In the handling of light, pose, rhythm and paint texture it compares with Rubens's 'Betrothal of St Catherine' and the Allegories Augustus must so often have seen at the National Gallery. He makes great use of dramatic chiaroscuro, and the standing figure on the left, with its heavy impasto, is extraordinarily similar to Rembrandt's etchings and drawings of Jews. The whole composition is very obviously an exercise – 'an anthology of influences' Andrew Forge described it – and, though far from being purely imitative, it lacks the true originality of, say, Stanley Spencer's prize paintings a few years later, 'The Apple Gatherers' and 'The Nativity'. Possibly because of this, it is in one literary respect more satisfactory than many of Augustus's other group studies: there is greater individual characterization, a far closer inter-relation of figures, a better control of drama, movement and balance. Eyes focus, gestures mean something; there is no emptiness, the group is alive, each person in it reacting to another. This *tour de force* of eclecticism won Augustus the summer prize and he left the Slade in a blaze of glory.

Two years before, while he was at work in the Life Class, he had seen Brown usher in a jaunty little man in black, wearing a monocle: James McNeill Whistler. 'It is difficult to imagine the excitement that name aroused in those days,' Augustus recalled.[52] They had all heard and read so much about this Mephistopheles in miniature; had spent so many hours in the Print Room of the British Museum studying his etchings of the Thames and of Venice; had seen in the galleries from time to time some reticent new stain from his brush – the image of a tired old gentleman sitting by a wall, or a young one obtruding no more than cuffs and a violin; or of a *jeune fille* poised in immobility, or some dim river in the dusk, washed with silver. No wonder such a stir went through the students. 'An electric shock seemed to galvanize the class: there was a respectful demonstration: the Master bowed genially and retired.' By the end of the century Whistler's predominance had begun to wane, and Augustus himself was becoming the idol of the Slade. The students loved him for his bad drawings, for his willingness to destroy so much that he did, for his exhortation to them to take risks. There arose among them a veneration for the stylish, elegant

vitality of his line – for his facility, spontaneous avoidance of pro-
fundity, his air of Greek classicism. For those in need of a hero, here
was the obvious choice, and his entrance into the Life Class at the Slade
in 1901 was at least as galvanizing as that of the formidable butterfly
with the sting five years before. 'When I first saw this extraordinary
individual was while I was a student at the Slade school,' Wyndham
Lewis remembered.[53] ' . . . He had had the scholarship at the Slade,
and the walls bore witness to the triumphs of this "Michelangelo". He
was a legendary "Slade School *ingenious*", to use Campion the door-
keeper's word. A large charcoal drawing in the centre of the wall of the
life-class of a hairy male nude, arms defiantly folded and a bristling
moustache, commemorated his powers with almost a Gascon assertive-
ness: and fronting the stairs that lead upwards where the ladies were
learning to be Michelangelos, hung a big painting of Moses and the
Brazen Serpent . . .

' . . . One day the door of the life-class opened and a tall bearded
figure, with an enormous black Paris hat, large gold ear-rings decorating
his ears, with a carriage of the utmost arrogance, strode in and the
whisper "John" went round the class. He sat down on a donkey – the
wooden chargers astride which we sat to draw – tore a page of banknote
paper out of a sketch-book, pinned it upon a drawing-board, and with
a ferocious glare at the model (a female) began to draw with an indelible
pencil. I joined the group behind this redoubtable personage. . . . John
left as abruptly as he had arrived. We watched in silence this mytho-
logical figure depart.'

4. FLAMMONDISM

And women, young and old, were fond
Of looking at the man Flammonde.
 Edwin Arlington Robinson

Augustus's growing renown in the late 1890s and early 1900s was based
not simply on his gifts as a draughtsman but upon his extreme visibility.
The exhibitionism he seemed to cultivate – a kind of inverted Dandyism
– made it impossible to overlook him. His shoes, created specially to his
own design, were meticulously unpolished; the gold ear-rings he was
soon to pin on were second-hand; he wore no tie or collar and was
contemptuous of those who did – in their place he fastened a black silk
scarf with a silver brooch that came from ancient Greece; he did wear a
hat but, far from being a respectable one, it was of gypsy design,
patina'd with age; his eyes were restless, his hair alarmingly uncut.

He walked the streets with a terrific military stride, bolstering himself
up like some non-commissioned officer, as if constantly to raise his own
morale and to protect himself from other people. And when he broke

his silence he could be formidable. One day a gang of children fell in behind him and began shouting: 'Get yer 'air cut, mister.' Augustus halted, turned on them, and growled: 'Get your throats cut!'

Part of his reputation at this time depended on deliberate neglect. He neglected to shave; he neglected middle-class proprieties and conventional attitudes; he even neglected using very much common sense. By many he was regarded with a respect that was agreeably tinged with horror. There was no telling what he would say or do next – though very often he said and did nothing at all. He seemed a mass of inexplicably changing moods that might have appeared pretentious had they not been so awe-inspiring, so obviously authentic. The barometer of these moods shot up and down with extraordinary rapidity. Periods of great charm and tenderness would vanish suddenly before violent convulsions of temper; days of leaden gloom would all at once disperse, and he would glow with wonderful geniality. But often there seemed nothing to account for these alterations, or to connect them.

The romantic fable that had begun to spin its cocoon round his real self arose in part from this mysterious unpredictability, and partly from his picturesque appearance. A vivid example of how others, who were themselves affected with romanticism, saw Augustus at the age of twenty-one is given by William Rothenstein:[54] 'He looked like a young fawn; he had beautiful eyes, almond-shaped and with lids defined like those Leonardo drew, a short nose, broad cheek-bones, while over a fine forehead fell thick brown hair, parted in the middle. He wore a light curling beard (he had never shaved) and his figure was lithe and elegant. I was at once attracted to John. . . . A dangerous breaker of hearts, he would be, I thought, with his looks and his ardour. He talked of leaving the Slade, and was full of plans for future work; but he was poor and needed money for models.'

Although not materialistic, Augustus was ambitious. He felt naturally eager to develop his talent, and he was anxious also for success partly as a vicarious means of fixing his own identity. Unable to exist within himself, he used an echo principle for defining his personality, seeing himself in other people's looks, hearing himself in their replies, recognizing himself in their attitudes to him. Many of his portraits are in this way strongly autobiographical.

Under the flamboyant exterior there was always much uncertainty. But his sense of ambition, and the impatience that had accumulated since his bathing accident, made him determined to outmanoeuvre his disadvantages and convert them into positive-looking qualities. To achieve this, he invented a part, complete with theatrical costume, that fitted only a fraction of the real Augustus John and, for the rest, acted as a form of concealment.

Hesitant, unsure of so much, he was dynamic in one thing: the pursuit of beauty, in particular of beautiful women. This was his inspiration as an artist, affording him what Wyndham Lewis called his epileptic 'fits of seeing'. A beautiful girl would act upon his eye like a lighted match upon a Catherine-wheel. Gone would be the fearful melancholy, the faltering indecision; banished the furred hesitation of speech, as there rang out the old commanding cry: *'Come on then, let's go!'* 55

It is impossible to disconnect Augustus's work from his passionate response to the beauty of women – 'these magnificent goddesses', as Lord David Cecil described the John girls, 'who, with kerchiefed heads and flowing, high-waisted dresses, stand gazing into the distance in reverie or look down pensively at the children who run and leap and wrestle round their feet. Wild and regal, at once lover, mother and priestess, woman dominates Mr John's scene.'

Like his maternal grandfather Thomas Smith, Augustus was a man 'of full habit of body'. But his view of women was idealistic rather than simply sensual, and had been formed of its particular kind by the early death of his mother. At first, back in Tenby, he had been drawn towards the full-bosomed majesty of maturer women, admiring from afar and usually while in church their rich proportions that seemed to offer all he most desired: warmth and consolation. Typical of these women had been the headmaster's wife at his unsympathetic school near Bristol, on whose generous bosom, he remembered, 'in great distress, I once laid my head and wept'. 56

With the onset of adolescence his world had become invaded by new and disturbing forces. Whether upon the beach or in the streets of Tenby, by wood or field or mere, it seemed his fate to encounter at every turn the mocking glance of some fair girl, to gaze in wonder at her flashing limbs and flowing hair, catch some breath of fern-like fragrance as she passed. Under the eyes of such beauty his awkwardness was painful, the old-fashioned clothes his father made him wear an unspeakable insult. He would have felt less of an ass if, while wandering alone on the marshes, he had come across some faery's child lingering disconsolately amid the sedge. For she, like him, would have been silent, would not have laughed, but taken him perhaps into the cool ritual of her embrace. Such phantoms peopled his imagination in an atmosphere of hazy eroticism. Prevented by his abnormal timidity from making contact with actual girls, he consorted with imaginary creatures who had travelled from the languid reveries of Burne-Jones and Rossetti. Only with the governess who mainly looked after Winifred could he feel any assurance, and this because she was an alien, as he felt himself to be.

The conflict between the world of reality and his fastidiously

romantic dreamland gradually intensified. On Sunday afternoons in the early 1890s Geraldine de Burgh, her elder sister and a friend of theirs used to walk from Tenby over the sand dunes and rough grass tracks of the Burrows towards Penally and Giltar. And almost every Sunday they were secretly met by 'Gussie', Thornton and their friend Robert Prust. Geraldine was partnered by Gussie – the routine was invariable – though she would have much preferred Robert Prust. Gussie, she thought, was terribly backward: they did not even hold hands. But as the youngest, it was not hers to choose. Over sixty-five years later (1959), Augustus wrote to her: 'You are one of the big landmarks of my early puberty. I was intensely shy then, besides you generally had your brother with you to add to my confusion.* Perhaps your noble name intimidated me too. But I was always afraid of girls then – girls and policemen. . . . Yes, I have been honoured with the Freedom of the Burrough [*sic*] – Freedom for what? We all had the Freedom of the Burrows long ago and I greatly regret I made so little use of it as far as you were concerned.'

By this time Augustus had experienced what he called 'the dawn of manhood'. The sexual facts of life, the biological mysteries of reproduction were explained to him not by his father or at school, but with much raucous humour by the other boys in Tenby. He was horrified and could not share their crude levity. Gloom, terror and bewilderment mounted in him. So this was how his father, in his salt hours, had amused himself with his mother; to these wanton appetites and motions did he owe his very existence! An indefinable horror gripped him from within. It seemed as if he would never be free from it.

But, when all the exaggerations and dubious anecdotes of Augustus John's life are set aside, he remains a man of astonishing virility. Therefore, inevitably, acclimatization to the real world came with time. 'Further investigations both in Art and Nature,' he wrote,[57] 'completing the process of enlightenment thus begun, brought me down from cloud cuckooland to the equally treacherous bed-rock of Mother Earth.'

Having loosed this knot, he would never again be tied up by sexual mores and taboos. Homosexuality did not shock him; incest held no fears: both were part of village life, protected by winter and bad roads. It was modern society, with its sophisticated network of rules and regulations that complicated what was, in the first place, a simple matter.

* It seems possible that John invented this extra obstacle to help account for his extreme bashfulness. Mrs Violet Crowther, Geraldine de Burgh's daughter, in a letter to the author (13 January 1969), wrote: 'He would have known my mother's brothers, of course, even if only by sight, but he is, I feel sure, mistaken in saying one was present on the occasion of these meetings.'

To Augustus, all women were mothers, with himself either as child or God-the-father. Not long content to figure in the public eye as doubtful or baffled, he produced himself, like Meredith, as a robust pagan with a creed that personified Nature as a mother. She was an object of desire, but also a goddess of fertility, a symbolic yet physical being capable of answering all the needs of man: a woman to be celebrated and enjoyed. This pagan simplicity Augustus expressed most lyrically in the glowing figure-in-landscape panels he painted with Innes in the years before the First World War. Here women and children appear as part of the wild country – a connection Augustus specifically makes in some of his letters. 'This landscape,' he wrote to Wyndham Lewis[58] (October 1946) from Provence, 'like some women I have heard of, takes a deal of getting into. I am making the usual awkward approaches – soon I hope to dispense with these manoeuvres and get down to bed-rock, but the preliminaries are tiresome.'

The Victorian preliminaries he found increasingly tiresome after his third year at the Slade. Impetuosity – assisted by the occasional glass of wine or whisky or, when in France, of *absinthe* or calvados or even, at the Café Royal, hock-and-seltzer or crême de menthe frappé – was always helping him to accelerate past his awful shyness. His first serious girl friend was Ursula Tyrwhitt, who allowed him to walk her home every day after school. A bird-like, ecstatic creature, she soared on flights of astronomical vagueness, being very friendly one day and quite cool the next, as if she could never recall what state their relationship had reached. When they were together they drew and painted each other's portraits;* and wrote love-letters to each other when they were apart. 'How is it, pray, that your letters have the scent of violets? Violets that make my heart beat,' Augustus asked her, ' . . . Write again sans blague Ursula Ursula Ursula Ursula.' By mystifying him with her vagueness she continued to attract him, but any idea they may have had of marrying was scotched by her father, a crusty old gentleman, very averse to Tyrwhittless† unconventionality. In one of his last letters to her, while they were both still students, Augustus enclosed a charming

* In the Ashmolean Museum, Oxford, there is a portrait by John of Ursula Tyrwhitt, drawn in soft pencil on mottled brown-ochre paper. It is done with great economy of line, the contours fading out, the features suggested not stated, giving an evanescent quality to the face. John depicts her as a rather idealized figure, matriarch and goddess combined. Handled with delicacy and tenderness, the drawing avoids sentimentality by virtue of its understatement and pleasing design. Also at the Ashmolean is an early John self-portrait smoking a pipe, done in red conté on off-white paper, which he gave Ursula Tyrwhitt. It is an objective record of external features, with emphasis on good drawing, rather than any attempt at self-analysis. The variety of pressure on the pencil gives the effect of strong light.

† She later married a man named Tyrwhitt – a cousin.

little self-portrait, pen and brush in black ink, inscribed 'Au Revoir, Gus'. Their love-affair had already come to an end, and Ursula was soon far closer to Gwen, with whom she kept in touch for almost thirty years.

Before leaving the Slade, Augustus had taken up with another student, Ida Nettleship, one of Ursula's best friends. Ida was a very sexually attractive girl, with slanted Oriental eyes, a sensuous mouth, dark curly hair and a dark complexion. There seemed some wild untamed quality about her, yet for the time being these fires were damped down, smouldering. She was very quiet – 'tongueless' she called herself – her manner enigmatic; and when she did speak it was with a low, cultivated accent. She had been brought up in a strongly Pre-Raphaelite atmosphere and, at the age of four, was once snatched from the nursery floor to be kissed by Robert Browning – an experience she was instructed never to forget. By her mother, a martinet and dressmaker – an expert with the needle who made clothes for many of the smartest ladies connected with the theatre, from Ellen Terry to Oscar Wilde's wife Constance – Ida was worshipped and perhaps a little spoilt. Her father, Jack Nettleship, once the creator of imaginative Blake-like designs depicting lost spirits, had by now turned painter of melodramatic zoo-animals in conflict, mostly lions, leopards and polar bears, all lavishly reproduced in *Boy's Own Paper*. He had preferred painting to a career as writer* and, after being taught at Heatherley's and the Slade, became one of a group known as 'the Brotherhood' which included Jack Yeats, Edwin Ellis and George Wilson. 'George Wilson was our born painter,' Yeats used to say, 'but Nettleship our genius.' As the Pre-Raphaelite spirit ebbed out of British art, he had lost his confidence however and painted only what Rossetti called 'his pot-boilers'.

He had sent Ida to the Slade in 1892; in 1895 she won a three-year scholarship and remained there altogether six years. From most of the students she held aloof, cultivating a small circle of devoted friends – Ursula Tyrwhitt, Gwen Salmond and Edna Waugh. These last two and Ida were known collectively as 'the nursery' because they were, or behaved as if they were, younger than the other students. The Kipling *Jungle Book* had recently come out, and Ida named each of her special friends after one of the animals, she herself being Mowgli, the man cub. Her early letters seem exaggeratedly fey and child-like, but have about them a certain intensity. She is frequently exchanging with 'Baloo' the

* He wrote a biography of Browning. One of his brothers, Henry, was Corpus Professor of Latin at Oxford; another, Richard, was a Fellow and Tutor at Balliol, and a great friend of Benjamin Jowett; and the third, Edward, a prominent oculist. He always regretted not having done the lions in Trafalgar Square, of which, he claimed, he could have made a far better job than Landseer.

big brown bear (Dorothy Salaman) tokens of 'friendship for always' which took the form of rosaries made from eucalyptus, pin cushions, ivy leaves and lavender and all manner of flowers and plants 'rich in purple bells, a joy to the eyes'. And she terminates these letters on a crescendo of jungle euphoria: 'Bless you with jungle joy, Your bad little man cub, Mistress Mowgli Nettleship'. When 'Bagheera', the pantheress (Bessie Cohen) marries, Ida writes: 'I think you are a charmer – but oh you *are* married – never girl Bessie again. Do you know you are different? . . . Mowgli will be so lonely in the jungle without the queen panthress. Oh you're worth a kiss sweet, tho' you are grown into a wife.'

Ida herself carefully avoided growing into a wife. All her most intimate friends were girls, and they lived together in a golden world of Victorian emotionalism, a timeless place with the prospect of being girls eternal. Their mood was that of Polixenes in *The Winter's Tale*:

> *We were as twinn'd lambs that did frisk i' the sun*
> *And bleat the one at the other: what we chang'd*
> *Was innocence for innocence; we knew not*
> *The doctrine of ill-doing, no, nor dream'd*
> *That any did.*

Men had no place in this sexless paradise, and about the only creature to be credited with some degree of masculinity was Ida herself, the man cub. The tone is perfectly caught in a letter she wrote one summer from Aldeburgh:

'My dearest Baloo – Mowgli begs forgiveness for his cheek and ingratitude in not answering your letter or thanking you for the sweet scent. Dear old bear, sweetest teacher of naughty man cubs – I, Mowgli, take my face between your two hands and kiss you, bearling and teacherling that you are.

'. . . I have been away with Gwen and that young child Edna – we had a life fit for queens and princesses. Except that they don't do work, do they? We ran into the sea without garments. Hush, whisper it not – it is considered by mentrap people shocking and unseemly. Nevertheless we sported with the waves – oh in the early morning in the sunshine – it was most beautiful. There was a bower all grown with sweet convolvulus where we undressed and hid (the convolvulus was *not* animally and full of flies, but very clean and sweet like honey and the sea).'

At this time Ida could not have been younger than nineteen. Her soft voluptuous beauty was of a kind that is at its finest in the late teens and early twenties. At the Slade she had many admirers, but all of them she shrugged off – except one. This was Clement Salaman, elder brother

of Augustus's friend Michel Salaman, who became friendly with her through his sisters. It was not long before he fell passionately in love and, for a short time, they were engaged to be married. Ida seems to have consented to this partly for his sisters' sake and, since she was not in love with him, she could not really believe he was in love with her. Love, surely, was a mutual experience – so he *must* be mistaken. Naturally she would like to be his friend always, as she was with Baloo. In February 1897 she formally broke off the engagement, explaining in a letter to the panthress Bagheera that this was 'a good and pleasant thing for both'. 'Don't you think a great friendship could come out of it?' she queried. 'The soft side surely can be conquered – indeed I think he has conquered it. It would be a life joy, a friendship between us. Think how splendid. No thought of marriage or softness to spoil.'

Shortly before their engagement was broken off, Ida's sister Ethel 'happened to go into the room where they were spooning and I roared with laughter', she recalled,[59] 'and afterwards Ida said to me: "You mustn't laugh at that, it's holy" '. From both parents she had inherited a strong vein of religiosity; Jack Nettleship had once confessed: 'My mother cannot endure the God of the Old Testament, but likes Jesus Christ; whereas I like the God of the Old Testament, and cannot endure Jesus Christ; and we have got into the way of quarrelling about it at lunch.'[60] Ida herself was very High Church when young. In vermilion and black inks she prepared an exquisite, tiny manual for use at Mass and Benediction, 'The Little Garden of the Soul', seventy-five pages long and done with scrupulous care: 'Ida Nettleship her book'. In everyday matters she was not above sermonizing to her friends. Girls still at school were earnestly warned to beware of 'affections', advised to walk a lot and play plenty of tennis. She herself, she once explained, had taken to practising the fiddle as a means of avoiding temptation. 'My dear, my sweet, go thro' life aiming for the highest you know,' she instructed Bessie Salaman who had just become engaged. '– Oh don't fall from what is possible for you, keep a brave true heart and be brave and kind to all other people – And think of making happiness and not taking it . . . don't slip – strive high for others – that is all.'*

* Perhaps the most eloquent testimony to Ida's religion is given in a letter she sent, about the year 1900, to her aunt Margaret Hinton. In its confident rallying cry to one depressed we may see something of the semi-pantheist strength on which she may have later drawn during periods of great adversity. 'As to feeling that your life is useless,' she wrote, '– that is nonsense – we are not in the world for *use* – it is a mistake people are always making – we are here to live and be – we are here because God is life and each breath of His gives more life more spirit – and men and trees and worlds are only the different forms His Spirit takes . . . To live up to oneself, whatever one is, that is living up to the greatest thing, God – because each of us is God. God is the spirit of Life and we are full of that

In March 1897, immediately following the break-up of her engage-
ment, Ida left England for Florence, moving among various *pensions* and
reassuring her 'dear sweet mother' (18 March 1897) that she must not
'let the proprieties worry you – I do assure you there's nothing to fear'.
Superficially there did seem cause for anxiety since here, as at the Slade,
Ida quickly attracted about her a swarm of young admirers, poets and
Americans, who brought her almond blossom, purple anemones and
full-blown roses; and a red-haired student, less romantic and with a
funny face, 'who began talking smart to me – and ended by being
melancholy and thirsty'. Most persistent of all was a musician called
Knight, 'very friendly and very boresome', who, she explained to her
sister Ethel, 'plays the piano, and reads Keats and cribs other people's
ideas on art. He looks desperately miserable. . . . His complaints and
sorrows weary my ears so continually – and "oh, he is so constant and
so kind". They all are.' Her virtue vanquished all comers and spread
much disappointment. 'Something very funny happened to-day,' she
told Ethel. 'I was sketching, and a curious Jew-looking youth with a
book under his arm appeared greatly interested in me. That is nothing
uncommon; but I found he followed me everywhere. I wandered far
and wide, often making a circle and coming back to where I started
from, because I don't keep count of where I'm going when I sketch, and
always the youth at my elbow. After about ¾ of an hour I said "Non
siete stance" – which means you are not tired? He looked very shame-
faced, and next time I looked he was gone. Poor youth!'

Ida's letters from Italy reveal much about her character. On the whole,
the girls in the *pensions* took her fancy more than the men – one very
beautiful 'like a Botticelli with great grey eyes'; and a pretty American
one, 'dark eyed and languid in appearance', who sat next to her at meals
and 'says sharp things in a subdued trickle of a voice'; even 'the little
chambermaid here with little curls hanging about her face and great
tired dark eyes' who 'takes a great interest in me'. Almost the only
woman she did not find sympathetic was the fidgety nervous little
Signorina who gave her lessons in Italian and self-control, and who
'says eh? in a harsh tone between every sentence – I pinch myself black

spirit, tho' some only cultivate the bodily part of the spirit . . . tho' you may not
see the use of your being alive, neither does a rose or any flower. I know it is harder,
because a flower has no consciousness – but you must be necessary because you
came – and just to live on doing your best, your *real inward* best, is your life. And
when you have conquered all hindrances to the holy spirit in you you will hear the
sons of God shouting for joy. No – you will not hear for you will be amongst them,
one of God's voices singing, not in praise with harps and white garments, but simply
as the bird sings, because it has life . . . in the end it will be alright – and life in-
stead of being a means to do things, will be an end in itself – just to be will be all.'

and blue to keep from dancing round the table in an agony of exaspera-
tion'.

When she was not learning Italian she was drawing and painting –
'dashing my head against an impenetrable picture I am attempting to
reproduce in the Pitti', as she described it. ' . . . I am so bold and un-
afraid in the way I work that all the keepers and all the visitors and all
the copyists come and gape . . . they think I am either a fool or a
genius'. Every day she worked six or seven hours, copying Old Masters
or sketching out-of-doors. But, she warned her mother, '*don't* expect
great things – it's fatal . . . it's no easier to do in Italy than in England'.

Yet Italy intoxicated her: the bells on the mules and horses passing
below her window; the chatter of carts and of people that carried along
the stone streets on the warm evening air; the sight of a dazzling green
hill under the olive trees; the boisterous river that careered down by
the *pension*, swollen and yellow with rain – all these sights and sounds
stirred longings in her, she scarcely knew for what. 'I simply gasp
things in now, in my effort to live as much as possible these last weeks,'
she wrote towards the end of her time there. 'I can't believe I shall ever
be here again in this life – anyway it's not to be counted on. And it's
like madness to think how soon I shall be away, and it going on just the
same . . . I suppose Italy must have some intoxication for people –
some remarkable fascination. She certainly has converted me to be one
of her lovers.'

On her return to England, Ida felt curiously flat. Even her drawing
and painting left her dissatisfied. 'We have a model like a glorious
southern sleek beauty, so hard it is to do anything but look,' she wrote
to her friend Bessie Cohen. 'To put her in harsh black and white – ugh,
it's dreadful.' Although, between 1894 and 1896, she had been awarded
a number of prizes and certificates, now she was winning nothing, and
Tonks had become rather discouraging. She grew uncertain in a way
she had never experienced before. 'Some days I look and wonder and
say "Why paint?"' she admitted to Dorothy Salaman. 'There are such
beautiful things, are they not enough? It seems like fools' madness to
ever desire to put them down.'

Before this she had always been swept upwards by gushes of enthusi-
asm that were generous and romantic. Now she felt herself being
slowly enfolded by what she called an 'eternal ennui' that seemed to
come between her and the actual experience her vigorous nature
needed. Womankind cannot stand very much unreality. There must be
more to life, Ida felt, than copying Old Masters and exchanging
flowers, admirable as these habits were. She began to feel sluggish. Her
boredom – 'a giant who is difficult to cope with' – stood over her,
overshadowing everything.

It was about this time that she started seriously to become involved with Augustus. His personality was so strong that it tore through her morbid self-consciousness, banishing the giant of boredom. He was made for open spaces. The least calculating of men, he strode capaciously through the streets, taking her arm with a sudden thrust of initiative, as one who might say: 'Come on now, we'll show them what we can do!' Never had she known such a companion – a great, sensitive, ebullient being, refreshing as a sea breeze. The stale familiarity of so much in London was peeled away in his presence; outward impressions intensified – even her faltering belief in art revived. He was, she thought, a wonderfully romantic creature with just that trace of feminine delicacy which made his invigorating influence so sympathetic. When they were together she felt swept along by his unaffected air of confidence; it was as if they were discovering life for themselves for the first time as no one else had ever done. Without him existence grew doubly tedious: she had to force herself into being occupied, doing and learning things, in order to lift herself over these dull parts of living. Her romanticism, tempered by practical experience, was beginning to recognize certain frontiers. 'There are myriads of things one can give oneself to,' she told Dorothy Salaman, ' – one can make oneself a friend of the universe – but talking is no good. A want is a want – and when one is hungry it's no good – or not much – to hear someone singing a fine song.' Only Augustus, it seemed, could assuage her real hunger. Once, when she was playing with her sisters the game of 'What-do-you-like-doing-best-in-the-World', Ida gave her choice in a low whisper: 'Going to a picture gallery with Gus John.'

Among the many men who fell in love with her Augustus was now her obvious favourite, the first and only man with whom she was herself ever to fall in love. They did not become engaged. Their situation was awkward, for her parents disapproved of Augustus and of her friendship with him. His introduction into their Victorian household had been an unmitigated disaster. It was Ada Nettleship,* Ida's mother, who chiefly objected to him: and her objections were not easily to be overcome. Since her husband's lions and tigers did not sell, she had become the 'business person' in the family. Her flourishing dress-making trade provided for the lot of them and took up almost the whole of their house – a barrack-like building without bathrooms, No. 58

* Her maiden name was Hinton, and she was the sister of James Hinton who wrote an enormous philosophical work in three volumes and then, according to David John, went off his head. 'I had an idea of "discovering" him,' Romilly John records (1 August 1972), 'but have always been completely baffled after reading two sentences and had to start again, and so on indefinitely. James Hinton's son was the author of a book on the fourth dimension, involving the construction by the reader of hundreds of cubes with differently coloured surfaces and edges.'

Left to right: Ida Nettleship, Ursula Tyrwhitt and Gwen John.
Drawing by Augustus John about 1899.

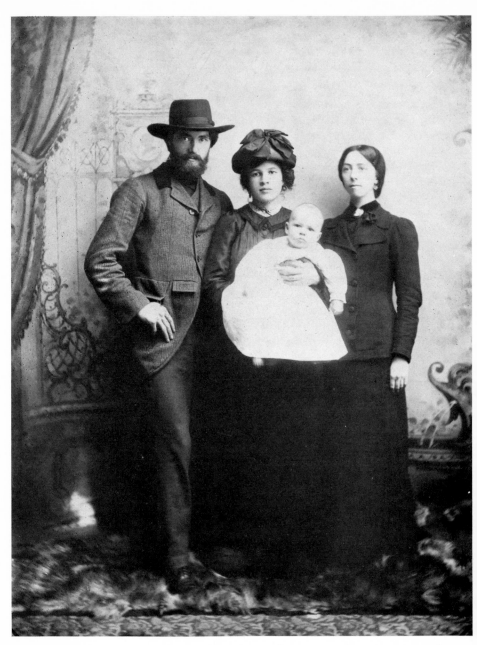

Augustus, Ida (holding David) and Gwen

Wigmore Street. Her husband and daughters inhabited only the fourth floor, ill-lit by gas-jets, and her domestic life was likewise thinly sandwiched in between her business pursuits.

Ada Nettleship was fat and soft and contrived to look older than her age. For many years she had been careful to take no exercise and moved, when she had to, with extreme slowness. She was a formidable dumpling of a woman, with short grey hair, a round face, retroussé nose and plump, capable Queen Victoria hands. Invariably she wore a robe of heavy black brocade made in one piece from neck to hem, with a little jabot of lace and a collar of net drawn up and tied under her chin with a narrow black velvet ribbon. Her voice was high-pitched and rather flat; her expression full of 'character'; her temper certain, but bad – except towards her family for whose welfare she was solely responsible. She worked her staff of skirt-girls, pin-girls and the embroideresses whom she had imported from the Continent very hard and, before the hours were altered by Act of Parliament, very long. Her Spartan discipline was peppered with fines and instant dismissals. But though feared, she was respected by her girls for she was an imaginative dressmaker and competent business woman, her one peccadillo being a weakness for society people, who, however extravagantly titled, perpetually postponed paying her bills.

Ada Nettleship was frankly horrified by Augustus. It is doubtful whether, in her opinion, anyone would have been good enough for her favourite daughter, but Augustus was too bad to be true. She had no use for him at all. The person she saw was no melodramatic Christ-like figure, simply a lanky, unwashed youth, shifty-eyed and uncouth to the point of rudeness, with a scraggy, reddish beard, long hair, and scruffy clothes. She could not understand what Ida saw in him. Had it been anyone else he came to call on, she would not have let him in the house. She was confident, however, that her daughter's peculiar affection for him could not last. He was obviously not right for her in any way. Jack Nettleship was more dismayed than horrified. 'I do wish he'd clean his shoes,' he kept complaining, ' – it's so bad for the leather.' But he spoke with little authority, generally going about the house himself barefoot.

Augustus was at his worst in Wigmore Street. His developing and very painful love for Ida, combined with her mother's unconcealed antagonism, made him increasingly ill-at-ease. Max Beerbohm, who once saw him there, noted that he was 'pale – sitting in window seat – sense of something powerful – slightly sinister – Lucifer'. Old Nettleship, though everyone agreed he was the salt of the earth, only added to this embarrassment. With bald head, heavily grey-bearded chin and nose 'like an opera-glass',[61] he presented an eccentric spectacle within this conventional setting. 'Years before he had been thrown from his

horse, while hunting, and broke his arm, and because it had been badly set suffered great pain for a long time,' wrote another visitor to the house, W. B. Yeats.[62] 'A little whisky would always stop the pain, and soon a little became a great deal and he found himself a drunkard.' Having put himself into an institution for some months, he emerged completely cured, though still with the need for some liquid to sip constantly. This craving he assuaged by continual cocoa, hot or cold, which he drank at all times from a gigantic jorum eight inches in diameter and eight inches deep. An alarmingly modest man, he would show Augustus his carnivorous pictures, begging for criticism. These pictures left Augustus cold, but if he ventured the least remark Nettleship would rush for his palette and brushes and begin at once the laborious business of repainting. Although he had a way of accepting absolutely other people's judgements, his admiration for Augustus's work was, to use a masterly word of William Rothenstein's, 'hesitating'. Their appreciation of art was very different: it was like blasphemy for Augustus to hear him describe Beardsley's charming and corrupt moppets as 'damned ugly women'. Yet it was in this house that he first met many celebrities, from the old William Michael Rossetti to the young Walter Sickert, 'the latter just emerging from the anonymity of *élève de Whistler*'.[63]

In a rough synopsis* for his autobiography, scribbled on Eiffel

* This synopsis was done for Hubert Alexander, whose family had been friendly with the McNeills, and who had got to know Augustus through Dorelia McNeill. In the 1920s Hubert Alexander had turned publisher and approached John for his memoirs. 'I've been thinking of the book and will send you shortly a provisional synopsis,' John wrote to him on 21 February 1923. 'Bye the bye I've been approached by another firm on the subject of my memoirs.' But six months later the position was roughly what it had been six months before. 'When in New York I got a note for an appointment from a member of your Firm of Publishers asking for an appointment to meet me,' John wrote to Alexander on 1 September 1923. 'Unfortunately this letter was lost or thrown away by my servant so I could not answer it. I am very sorry to have seemed so discourteous; I would have been glad to have arranged a meeting. I have done little else about the book but think about it – which however is after all a necessary preliminary. Still I'll get on with the synopsis and let you have it.' Alexander believes he may have got the synopsis about 1927, but since there is a holograph synopsis among Augustus's papers, it seems likely that it was never sent. Certainly by 1932 negotiations were still continuing and Sir Charles Reilly remembered that year 'a publisher came down [to Fryern Court] and offered him great sums for his autobiography, finally reaching £13,000, the sum I heard him say Lady Oxford got for hers, but he nobly turned it down.' By the summer of 1938 he had got as far as signing a contract – with Little, Brown of America who did not finally publish his book. By April 1950 he had changed his literary agent to Pearn, Pollinger and Higham, and informed his British publisher, Jonathan Cape, that he would finish the book by the end of the month – it was published by them over two years later. A second volume was published three years after his death (Cape 1964).

Tower Restaurant paper some time during the 1920s, Augustus introduces Ida's name together with the word 'torture'. He was violently attracted to her. Her mature body, so chaste and erotic, the muted intensity of her nature half-concealed beneath its calm exterior, her quiet deep manner that hinted at unexplored mysteries, those strangely slanting eyes, that ingenuous mind: all this excited him frantically. His happiness seemed to depend upon the secret of her beauty, upon his possessing it, and he pursued her with a wild intermittent persistence. One day, for example, he turned up at St Albans, where she had gone to a party of Edna Clarke Hall's, who remembered[64] what happened.

'Ida and I had not seen each other for some time, so, to get away from the others, we climbed up a ladder to the top of a great haystack . . . We had hardly settled there when up the ladder came Augustus John.

'Ida told John very definitely that we wanted to be alone and he told us no less definitely that he wanted to be there, and to put an end to the matter he gave a great heave and it fell to the ground. And there we were! Ida was extremely vexed and told him so in no uncertain terms. John took umbrage and said that if we did not want him he would go. He flung himself on to the steep thatch and proceeded to slide down head first. We were horrified! The stack was a very high one, and the ground seemed a long way off. Securing ourselves as best we could, we both got hold of a foot – his shoes, then his socks came off, – we frantically seized his trousers. He wriggled like an eel and his trousers began to come off. Then we cried aloud for help and some of the party came running, put up the ladder and rescued the crazy fellow!

'But the peace of our solitude was completely shattered.'

Augustus was tortured not by unrequited love but unconsummated sex. Although Ida loved him, she refused to live with him, less perhaps for her own sake than for that of her parents who, she hoped, would come to like him. Meanwhile their love-affair, for all its passion, seemed to have reached a stalemate. Augustus was not faithful. Sight was mind, and out of sight was largely out of mind. On his journey through the Netherlands he grew excited as much by the surprising character and beauty of the people he saw as by the Flemish masters. The two were jumbled together in his letters as if there were no difference. He writes, for example, of Rembrandt's wife, Saskia van Uylenborch: 'She was sweeter than honey, more desirable than beauty, more profound than the Cathedral. And in Brussels lives an old woman with faded eyes who made me blush for thinking so much of the young wenches.

'But there was one in Antwerp I think Rembrandt would have cared for, Gabrielle Madeleine by name. She had azure under her eyes and her veins were blue and such a good stout mask withal, and she spoke French only as a Flamande can. Unfortunately she wore fashionable

boots of a pale buff tint. (Besides which her room lay within that of her white haired bundle of a Mama.) You will shrug your shoulders hearing of my aberrations but I feel more competent for them, and that is the main thing.'

Women continued to inspire Augustus only while they remained mysterious. As custodians of a happiness he could divine but never completely enjoy, they symbolized for him an ideal state of being that formed the subject of his painting. Yet his most immediate need was for a physical union that would dissolve momentarily the loneliness locked up within him. From external troubles and from his innate melancholy he sought release through multifarious love-affairs. These were affairs of the body, but while his body was comforted his spirit could no longer be illumined as it was by longing. Sex was solace and sensation; but longing was limitless, lyrical. The penalty he paid for being unable to endure this isolation was a theft from his artistic imagination of its essential stimulus. For his ideal concept of 'beauty', once divested of its symbolic majesty and enigmatic life, became empty, almost meaningless: beauty embalmed, beauty unalive.

5. AMONG THE LIVING

'I am taking a studio with McEvoy,' Augustus had written to Michel Salaman in the summer of 1898. This was 76 Charlotte Street, once used by Constable, and now, over the next two years, to be shared inter-mittently with Orpen, Benjamin Evans and Albert Rutherston. All of them were desperately poor, but full of plans for future work. Most helpful to Augustus was Albert's elder brother William Rothenstein. His admiration for Augustus's work was tireless – 'a sight of some of John's drawings has taken any vanity I might have had out of me', he once wrote to his wife Alice. To his many friends, including Sargent, Conder and Charles Furse, Rothenstein began showing Augustus's drawings, and a number were sold in this way – though Furse was greatly taken aback at the price of two pounds apiece. It was mainly on this money, together with what he received each quarter through Thomas Smith's will, and very little help from his father, that Augustus subsisted.

'John – Orpen – McEvoy and myself are going to get up a class,' Albert Rutherston wrote to his father (20 January 1899), 'and have a model in John's studio once a week at night – it will come to about 7d each.' Augustus himself had found the model late one night in the Tottenham Court Road – a young girl with hair of flaming red and a pale mask of a face who, having no work, willingly agreed to sit. As the sittings progressed she and Augustus grew increasingly friendly,

but one day when she dropped off to sleep on the divan he suddenly realized that her gleaming head of hair, now curiously misplaced, was – a wig! Congenital baldness was no crime, neither was it contagious; yet great was the disenchantment and he felt strangely incapable of finishing her portrait. He turned the picture to the wall, and soon she ceased to come.

Because the studio was small, Augustus spent a good deal of time roaming about the town with his sketch-book. He had been reading Heine's *Florentine Nights* and was particularly drawn to a tattered band of strolling players he met in Hyde Park who would give song-and-dance performances full of Elizabethan charm and crudity. He often saw them and eventually succeeded in persuading the principal dancer to pose for him. 'Those flashing eyes, that swart mongolian face (the nose seemed to have been artificially flattened), framed in a halo of dark curls, made an impression not to be shaken off lightly.'[65]

Having left school and gained a studio, Augustus had set himself up, he felt, as a real artist. His first commission in portraiture was to paint an old lady living in Eaton Square for a fee of forty pounds, half of which was paid in advance. 'As the work went on I began to tire of the old lady's personality,' he wrote:[66] 'she too, I could see, was bored by mine, and getting restless. She even spoke rather sharply to me now and then. This didn't encourage me at all. One day, having made a date for the next sitting, I departed never to return. I had got her head done pretty well at any rate and the old lady got her picture at half price.'* Looked at today, the picture seems very close in style and feeling to some of Gwen John's portraiture, and indicates that their development began on parallel lines. The colour has been toned down – monochrome with silvery-white flesh tones and slight touches of warm ochre. In the middle of an area of black dress, the old lady holds a red book. An orange frill on the cushion behind her head gives colour to her face and follows the line of her smile. Augustus's treatment conveys the impression of decaying beauty. Despite the atmosphere of sadness, the suffering is contained and the old lady's personality clearly comes through.

About the same time, through the mediation of a fashionable lady in Hampstead, Augustus was also commissioned to do two drawings in the

* In 1941 Sir John Rothenstein came across this picture in a dealer's gallery and brought it to John's studio for identification. At first John failed to recognize it, but later did acknowledge it to be his, and it was hung in the Tate Gallery. In his *Modern English Painters*, Rothenstein described it as a rather fumbling and pedestrian essay and, though probably a fair example of his painting at this time, very laboured, niggling in form, hardly modelled at all. But John himself, on reading this, objected: 'The "Old Lady's" head is very well modelled: the hands unfinished yet expressive. She couldn't move them easily.'

West of England. His first destination was a large mausoleum of a
house set in parklands that resembled a cemetery – altogether a monu-
ment to boredom. On arriving there, he was awestruck by the beauty of
his young hostess, which seemed, after a cocktail or two, very visibly
to increase. They felt shy with each other and after the drawing was
done she took him upstairs to show him her home-made chapel fitted
into the attic. Her husband was away shooting, she explained – he often
was – and during the dull days of his absence she would seek consolation
here. Within the wall, Augustus spied a recess – perhaps a confessional,
or a boudoir, or both. . . . But soon he had to be on his way for the
next assignment. Here, too, there was much embalmed magnificence
and beauty, though the atmosphere seemed less tense with melodrama.
His new hostess, unencumbered with religiosity, was as amiable as the
first. There seemed to be an epidemic of 'shooting' in the district, for her
husband also had been carried off by it. When the drawing was done,
Augustus returned to London with two cheques in his pocket, but
richer in more ways than one.

Largely because of the emotional deprivation of his mother, Augustus
had grown up without any inner source of self-esteem. But now, to his
surprise and delight, other people were finding him to be a marvellous
proper man. He began to sniff some of the power that his personality
could exert, especially on women. So much that he had missed at Tenby,
even at the Slade, seemed at last within his grasp. It was dangerous
knowledge. In the heyday he was now entering, such was the devastat-
ing charm of his presence that old ladies on buses, it was said, would get
up blushing to offer him their seats; and young girls in the Café Royal
had to be led away fainting when he made his entrance there.

The letters that Augustus and his friends wrote at this time show them
drawing and painting all day – self-portraits, portraits of one another or
of some shared model – often in the hope of having their work accepted
by the New English Art Club. In the evening they would hurry off to
the Empire to listen to Yvette Guilbert, or go to the Hippodrome to
see a splendid troupe of Japanese acrobats, tight-rope walkers,
nightingale-clowns and swimmers. But best of all, Augustus loved the
Sadler's Wells music hall in Islington, London's oldest theatre. He went
almost every week, taking there for a shilling a box from the very front
of which he would fling his hat in the air whenever he approved of a
turn. The crowd in the stalls, believing him to be a tremendous swell,
often took more notice of him than they did of the stage. Because of his
baggy corduroy trousers, large black hat, the red tie round his neck and
hair down to his shoulders, they nicknamed him 'Algy' under the
impression he must be some aristocrat incognito. One night, when their
teasing became too personal, Augustus rose and delivered an abusive

speech. The crowd, after listening for a minute, went for him, but he emptied his beer over them and, like the Scarlet Pimpernel, escaped.

After such breathless entertainments, whenever they could afford it, Augustus and his friends would go to the Café Royal, eat sandwiches, drink lager beer and sit up late gazing in awe at the celebrities. Orpen, Albert Rutherston and Augustus were together so much of the time that they became known as 'the three musketeers'; but on less rowdy evenings they would be joined by McEvoy and Gwen John, Ida Nettleship and some of her special friends. Sometimes, too, by Mrs Everett, her hair decorated with arum lilies, anxious to spirit them away to Salvationist meetings where men with sturdy legs and women with complexions shared a chorus of loud laughter and jokes.

On 14 September 1898 Ida and Gwen Salmond crossed over to Paris, Gwen to stay there for six months, Ida for three. They put up temporarily at what Ida called a 'very old lady style of pension' at 226 Boulevard Raspail on the outskirts of the Latin quarter: 'such a healthy part of Paris!' she exclaimed in a letter to her mother (15 September 1898). They had invited Gwen John to join them, but when she mentioned the plan to her father, Edwin automatically opposed it. She was, however, undeterred; went round the house singing 'To Paris! To Paris!'; and wrote to Ida in the third week of September announcing that she was on the way. 'Gwen John is coming – hurrah,' Ida told her mother (18 September 1898). '. . . We *are* so glad Gwen is coming. It makes all the difference – a complete trio.'

Gwen arrived punctually carrying a large marmalade cake, and the three of them set off to look at flats – 'such lovely bare places furnished only with looking-glasses'[67] – soon finding what they wanted on the top floor of 12 Rue Froidveau, or 'Cold Veal Street' as Ida called it. In a letter to her mother (20 September 1898) she described the moral architecture of the place, which was 'on the 5th floor – overlooking a large open space – right over the market roof. It has 3 good rooms, a kitchen and W.C. and water and gas – and a balcony. Good windows – very light and airy. Nothing opposite for miles – very high up. The woman (concierge) is very clean and exceedingly healthy looking. The proprietress is rather swell – an old lady – she lives this end of Paris and we went to see her. She asked questions, and especially that *we received nobody* – "Les *dames* – oui. Mais les messieurs? Non! *Jamais!*" . . . She wants to keep her apartments very high in character. All this is rather amusing, but it will show you it is a respectable place. It *is* over a café – but the entrance is right round the corner – quite separate . . . We want all the paper scraped and the place whitewashed – otherwise it is alright – *not* Seine water . . . It is near the Louvre and Julian's – and is very open.'

Gwen Salmond had sixty pounds and wanted to study at the *Académie Julian* under Benjamin Constant. Ida had thirty pounds and thought of going to either Delécluze or Colarossi, both of whom were less expensive. Gwen John had less money still and could afford to attend no school. But by a fortunate chance another studio was just opening in Paris that autumn – the extraordinary *Académie Carmen* in the Rue Stanislas. It was to be run by the luxuriant Italian beauty Carmen Rossi, a one-time model of Whistler who, it was announced, would himself attend twice a week to instruct the pupils. The price was the same as Julian's – too expensive for Ida: but Gwen Salmond, changing her mind at the last moment, decided to go there. 'Whistler has been twice to the studio – and Gwen finds him very beautiful and just right,' Ida wrote to her mother. '. . . [he] is going to paint a picture of Madame la Patronne of the studio, his model, and hang it in the studio for the students to learn from. Isn't it fine? He's a regular first rate Master and, according to Gwen, knows how to teach.' So enthusiastic was Gwen Salmond that she insisted that Gwen John accompany her, and by a benevolent act of intrigue smuggled her in as an afternoon pupil.

Whistler's name was enough to ensure the early success of the *Académie Carmen*, which was thronged when he first appeared there with palpitating pupils, but which, by the beginning of 1901, had shrunk to a grand total of two ladies. The rules, which made it an unpopular institution with the men, were stricter than those of the Slade. Smoking was prohibited; singing and talking disallowed; charcoal drawings on the walls absolutely forbidden; studies from the nude in mixed classes banned – and the sexes quickly segregated into different *ateliers*. Whistler himself made a point of being received not as a companion in shirt-sleeves, but as the Master visiting his apprentices. Against all expectation he offered no magical short cuts: on the contrary he would have liked to teach his students from the very beginning, even the grinding and mixing of the colours. Tintoretto, he enjoyed reminding them, had never done anything for himself until he was forty, and that was the way he wished them to work for him. His high larks, which always contained some serious matter, very often bewildered them. The palette, not the canvas, was the field of experiment, he insisted, and he would frequently ignore their pictures altogether, earnestly studying their palettes to detect what progress was being made. His magisterial passions, monocled sarcasms, his old-fashioned romantic susceptibilities, and the need which his rootless nature felt for a band of dedicated disciples, antagonized the men, whose male competitiveness it aroused. But the women students adored him, understanding far better the poignancy and kindness of his character and responding to his courtesy and wit. 'Whistler is worth living for,' Gwen Salmond declared

simply in a letter to Michel Salaman. At the least breath of criticism she and the others rushed to his defence. 'I hear there is a blasphemous letter about Whistler's teaching in one of the English papers,' Ida fulminated to her mother (December 1898). 'It is very stupid and unkind.'

In Augustus, too, Whistler inspired the prescriptive veneration due to one who has been a famous rebel victorious against the social conventions, and a great Master in his own right. With the thirty pounds he had won for 'Moses and the Brazen Serpent',* he followed the three girls to Paris that autumn, and in the Salon Carré of the Louvre the two painters met formally for the first time: Whistler a small, neat, erect old gentleman in black, with crisp, curly hair containing one white lock, and a flashing monocle; Augustus a tall, dishevelled tramp. After some ceremony and a contest of compliments on behalf of Gwen, Augustus ventured to suggest that his sister's work showed a sense of character. 'Character? What's character?' Whistler demanded. 'It's *tone* that matters. Your sister shows a sense of tone.'

Augustus seems to have spent only a short time in Paris on this occasion, and much of this was passed with the two Gwens and Ida in the Louvre, looking at Rembrandt, Leonardo, Raphael and Velasquez. His sister also took him to meet Carmen, and together they went to see Whistler in his studio, then at work on an immense self-portrait – a ghostly face set upon a body hardly discernible in the gloom. To explain her attendance at the *Académie Carmen*, Gwen had written home to announce that she had won a scholarship there. By this imaginary triumph she may have hoped to reconcile Edwin to the notion of giving her a small allowance. But Edwin decided to do better than this – that was, to come and see how she was getting along for himself. His arrival most likely accounted for Augustus's quick departure from Paris. To welcome him, Gwen arranged a small supper party, putting on a new dress designed by herself from one in a picture by Manet. 'You look like a prostitute in that dress,' Edwin greeted her. To which she haughtily replied: 'I could never accept anything from someone capable of thinking so.' Despite this setback, she continued going to Whistler's school and, in order to earn enough money, posed regularly as an artist's model.

Whistler's teaching was a perfect corrective to that of Brown and Tonks at the Slade. Painting, not drawing, came first. 'I do not teach art,' Whistler declared. 'I teach the scientific application of paint and brushes.' In this laboratory atmosphere, to which Augustus never

* We have now the news of John's prize,' Ida wrote from 12 Rue Froidveau to Michel Salaman. 'He sent a delicious pen and ink sketch of himself with 1st Prize £30 stuck in his hat as sole intimation of what had befallen him. We were so awfully glad.'

subjected himself, where students could paint in the dark if need be, Gwen developed her methodical technique 'to a point of elaboration undreamt of by her Master'.[68] It was a short period of vital importance in her career, but, as always, much of her work was done independently. 'Gwen John is well and has not been lonely,' Ida reported to her mother. 'She has many more friends – one Alsatian girl [Mlle Marthe] whom we are painting in the mornings. Such a beauty she is.'

Breakfast in Cold Veal Street was given over to reading *King Lear* and *King John*; while in the evenings the three of them sometimes ate at an anarchists' restaurant where beautiful, grubbily-dressed girls fetched their own food to avoid being waited upon. Between these times they painted. 'Gwen S. and J. are painting me,' Ida told her mother, 'and we are all 3 painting Gwen John.' Their life together, with all its excitements and difficulties, dedication and triviality, is charmingly described in a letter of Ida's to Michel Salaman: 'We are having a very interesting time and working hard. I almost think I am beginning to paint – but I have not begun to really draw yet. We have a very excellent flat, and a charming studio room – so untidy – so unfurnished – and nice spots of drawings and photographs on the walls – half the wall is covered with brown paper, and when we have spare time and energy we are going to cover the other half. . . . Gwen John is sitting before a mirror carefully posing herself. She has been at it for half an hour. It is for an "interior". We all go suddenly daft with lovely pictures we can see or imagine, and want to do – as usual . . . We want to call Gwen John "Anne" – but have not the presence of mind or memory. And I should like to call Gwen Salmond Cynthia. These are merely ideals. As a matter of fact we are very unideal, and have most comically feminine rubs, at times; which make one feel like a washerwoman or something common. But as a whole it is a most interesting time . . . '

This interesting time came to an end early in 1899. Ida returned to Wigmore Street and Gwen John established herself in a little cellar below the dressmakers and decorators of Howland Street. Augustus, who disapproved of most places in which his sister chose to live, tried to include her in some of the invitations he was now receiving and in the spring of this year the two of them went down to stay at Pevril Tower, a boarding house which Mrs Everett had opened at Swanage. Suffering from conjunctivitis, Augustus could do little work; and Gwen too was listless, wandering along the cliffs by moonlight, catching fire-flies and putting them in her hair and in Mrs Everett's. 'I have not done anything,' she confided to Michel Salaman, 'but have been tramping into the country – around by the sea. Yesterday I came to an old wood – I walked on anemones and primroses – primroses mean youth, did you know?

' . . . To-day the sky is low, everything is grey and covered with mist – it is a good day to paint – but I think of people.'

Augustus, too, seemed much involved with people. Together with Orpen, Albert Rutherston and others he was helping to organize a revolutionary campaign against the desecration of St Paul's by the mosaicist Sir William Richmond. During April and May he was busy dragooning students from all the art schools round London into meetings, trying to raise funds for the printing of notices and arranging for a public petition to be presented to the Dean and Chapter of the cathedral. 'Sir William Richmond R.A. has for five years been decorating St Paul's Cathedral and last year the mosaics were discovered to the Public,' Albert Rutherston explained to his father. 'The place has been utterly spoilt and looks now like a 2nd rate Café – it is a mass of glittering gold etc. – he has also had the cheek to cut away pieces of Wren's sculpture and replace it by his own mosaics . . . Even Sir Edward Poynter P.R.A. has asked Richmond to stop his decorations.'*

The other excitement of these months was Augustus's first one-man show at the Carfax Gallery in Ryder Street off St James's. This gallery had recently been opened by John Fothergill, a young painter, archaeologist and author, famous for his dandified clothes and later as a pioneer amateur innkeeper.† Arthur Clifton had been put in charge of the business side; Robert Sickert, younger brother of Walter, acted as manager; and the choice of artists was left to William Rothenstein. Rodin, Conder, Orpen, Max Beerbohm all held exhibitions there as well as Rothenstein himself. By the spring of 1899 it was Augustus's turn. 'There is to be a show of my drawings at Carfax and Co.,' he had written from Swanage to Michel Salaman. 'I hope to Gaud I shan't have all back on my hands. There is however not much fear of that as Carfax himself would probably annex them in consideration of the considerable sum advanced to me in the young and generous days of his debut.' Singled out for praise by the didactic New English Art critic D. S. MacColl, the show was a success, earning Augustus thirty pounds.

With this sum in his pocket he set off to join a large painting party that had congregated at Vattetot-sur-Mer, a fishing village near Étretat on the Normandy coast. William Rothenstein and his new beautiful wife, the former actress Alice Kingsley; Albert Rutherston, now curiously nicknamed 'All but Rothenstein'; Orpen and his future wife

* See Appendix One, 'Desecration of Saint Paul's'.

† His inn was the Spread Eagle at Thame in which, for a time, Augustus's son Romilly worked, and for which Carrington painted an inn sign (now gone). He was the author of *Confessions of an Innkeeper*, *John Fothergill's Cookery Book*, *The Art of James Dickson Innes*, *My Three Inns*, etc.

(Alice Kingsley's sister)* Grace Knewstub, unfortunately known as 'Newslut'; Arthur Clifton and his red-haired wife: all these Augustus knew already. But in Charles Conder he was to meet, according to Will Rothenstein, a kind of bull-necked athlete of intimidating vitality. He was surprised to be introduced to a charming but in no way physically formidable person, a wistful, tentative, ailing man, his hair luxuriant but lifelessly hanging, a brown lock perpetually over one malicious blue eye, who admitted, in a voice exhausted to the point of inaudibility, to being a little 'gone at the knees'.

Industry was the order of the day. Every morning they rose at half-past seven, drank a cup of chocolate, and worked until eleven. Conder did his fans; Rothenstein painted his 'The Doll's House'; † Augustus did no painting, but drew, mostly landscapes which Rothenstein described as remarkable. 'As for us,' Augustus wrote to Michel Salaman, 'we grow more delighted with this place daily. The country is wonderfully fine in quality. In addition we have a charming model in the person of Mrs R's sister who serves to represent Man in relation to Nature. Orpen and I have been drawing with a certain industry, I think. Albert reads Balzac without cessation. Occasionally his brother drives

* 'Hugh Lane says Orpen has married a woman who looks about ninety, simply because Rothenstein, who[m] he admired immensely, married her sister. Now he doesn't admire Rothenstein so much as he did, but the wife remains.' Undated letter from Lady Gregory to W. B. Yeats (New York Public Library).

† Rothenstein had first heard of Ibsen through Conder, and in his *Men and Memories* (Vol. I, p. 56) writes: 'We were all mesmerised by Ibsen in those days.' The picture, now in the Tate Gallery, for which John and Alice Rothenstein posed, expresses the tension of Act III of *The Doll's House* when Mrs Linden and Krogstad are listening for the end of the dance upstairs. Subsequently it became famous as a 'problem picture' mainly perhaps on account of its dark colour. 'I am portrayed standing at the foot of a staircase upon which Alice has unaccountably seated herself,' John wrote in his Introduction to the catalogue of the Sir William Rothenstein Memorial Exhibition at the Tate Gallery (5 May–4 June 1950). 'I appear to be ready for the road, for I am carrying a mackintosh on my arm and am shod and hatted. But Alice seems to hesitate. Can she have changed her mind at the last moment? . . . Perhaps the weather had changed for the worse. . . .'
For some 'The Doll's House' stands at the summit of William Rothenstein's art. It 'has impeccable form and a perfect contrast of light and shade', wrote his biographer Robert Speaight, '. . . *The Doll's House* suggests an anecdote and conceals a mystery; and the mystery is deeper than the anecdote – whatever the anecdote may have been. It was a strange picture to have come out of a honeymoon summer. The shadows of a native melancholy seem to have chequered the sunshine of personal happiness, and thrown out a hint of disillusionment. For one thing is clear about *The Doll's House* – this man and this woman, though they are so nearly touching, are each alone in the prison of their own thoughts.'
The picture, painted between June and October 1899, was finished at Kensington in January 1900. It was exhibited in the British section of the Paris Exhibition in 1900 where it won a silver medal.

him out into the fields with a stick but he returns in good time for the next meal with half a tree trunk gradated with straight lines to show.'

Surrounded by farms and orchards, old barns and byres, enclosed by double and triple lines of trees to shield it from the cold winds, Vattetot was a quarter of a mile from the sea. At eleven o'clock on most mornings, the colony would lay down its brushes, make for the rocky white cliffs, and dive into the breakers. Augustus was a fearless swimmer and would crawl far out into the English Channel – a speck in the distance. 'Albert and I were seduced by that old succubus the Sea – the other day,' he wrote to Michel Salaman. 'The waves were tremendous and the shore being very sloping there was a very great backwash – it required all our virtue to prevail in the struggle.'

Everything Augustus did appealed to Rothenstein's romanticism and penchant for the dramatic. His drawings proclaimed an amazing genius, his actions a Byronic recklessness. One day, out of sheer exuberance, he jumped into a bucket at the top of a deep well and went crashing down to the bottom. It was all that the others could do – Rothenstein perspiring with admiration among them – to haul him back to the surface. And when he sprinted, stark-naked, along the beach, it seemed to Rothenstein, paddling and prawn-catching near by, that he had never seen so faun-like a figure. The coastguards, too, ogled these antics through their envious binoculars, and especially keenly when the girls undressed in a cave under the Monet cliffs to race him. Once they threatened court action – but the pagan goings-on went on.

After lunch at midday they resumed working until dinner. 'Under this discipline we all ripened steadily,' Augustus recorded.[69] In the evening they sat, Orpen, little Albert and himself, in the café singing, smoking, drinking their calvados, and listening to Conder, a bottle of Pernod at his elbow, telling his muffled stories. But Orpen, who was now planning his ambitious Summer Composition on *Hamlet*, would steal away early, while Augustus was always last to leave. Conder's reliance on Pernod, which he used both as a drink and as a medium for his brush, filled Augustus with apprehension and he told the Rothensteins that, in the event of his ever feeling tempted to drink, Conder's example would act as a valuable disincentive. As for calvados, that was rather different: he felt bound to impregnate himself with its quickening properties so as to draw nearer the soil and, by a kind of chemical magic, grow fruitful. As a counter measure, seeing the way things were going, Alice Rothenstein began to import quantities of restorative tea from England.

In August, Orpen returned to complete his 'Hamlet' and Augustus spent a few days with him on the way in Paris. They stayed close to Montparnasse station, spent their nights on the town, their days

half-asleep in the Louvre. 'It was so pleasant there,' Augustus wrote to Ursula Tyrwhitt. 'I wish you had been with us to wander in the Louvre, after the hot sun and dazzling light outside to be in the cool sculpture galleries. . . . I envy the sleeping Hermaphrodite its frozen passion, its marble self-sufficiency, its eternal languor.'

Augustus's own passions were sleepless. 'Mr Augustus is very well,' Orpen reported to Michel Salaman on his return from France. 'I left him with a lady! He was to come to the station to see me off (myself and Miss Knewstub) but did not turn up.' Everything seemed to be going wrong for Orpen. 'My Hamlet would kill high morality,' he wrote in another letter to Salaman that September, ' – Hamlet ought to be treated like a "Day of Judgement". Miss John is settled in 172 Gower Street. She is a most beautiful lady! Miss Nettleship I have seen but she has not posed yet, to tell the truth I am afraid to ask her to take the pose as she has seen my Hamlet – I will wait till Gus comes back I think – Miss John says she would not take it.'

Any hopes Orpen may have had of Gwen John changing her mind were dashed when a day or two later she broke her nose. Ida, however, without waiting for Augustus's sanction, agreed to take the pose which involved a man and a girl leaning together, with their arms round each other. At last everything was ready – then Orpen fell ill. 'The wretched Orpen has got jaundice or verdigris or something horrible,' Augustus informed Ursula Tyrwhitt. According to Orpen his complaint was more complicated still, and not unconnected with Augustus. 'My illness [jaundice] has been very severe. I was not able to eat for nearly ten days, but everything has started going down now! – I am still yellow – I have also got some nasty animals on a certain portion of my body – Gus's doing – Dog that he is – this is my judgement for Paris! Tell him not!'

Augustus himself seemed unaffected by these adventures. The laws of cause and effect appeared, in his case, to have become magically suspended. 'How he escaped getting the Ladies Fever we couldn't make out,' John Everett noted with irritation in his journal (1899). 'Tonks used to say it must be his natural dirt.'

He seemed protected, spiritually, by his natural innocence. 'The country here becomes still more beautiful with the arrival of autumn,' he told Salaman. With Rothensteins of various sorts he would go for long walks – to Fécamp, for the sake of the incomparable *pâtisserie*; to the little Casino at Vaucottes, Conder always leading; to Étretat,* a

* 'A charming place, very small but immensely smart – none of the demi-riche – but a great number of the French nobility stay there, also a good many Americans,' Albert Rutherston described Étretat (1 August 1899). 'It is delightfully amusing to watch the men and women bathe together – the women all wear black silk stockings with their bathing costumes.'

charming place full of smart people and mixed bathing; and to Yport, four miles away, where lived a tailor who decked Augustus out in a dazzling green corduroy suit with tight jacket and wide pegtop trousers.* 'He [John] looks splendid,' Orpen had reported to John Everett, 'and is acting up to his clothes' – much to the terror of Alice Rothenstein who, fearful that he or Conder would seduce her sister, dispatched her back to London in what she supposed to be the more harmless company of Orpen. Late at night, and chaperoned by the Rothensteins, they would wander back from Yport along the beach, sometimes bathing again by moonlight: 'wonderful days and wonderful nights these were,' remembered Will Rothenstein,[70] who had begun his honeymoon with hay fever and ended it with jaundice.

At the end of September, Augustus, Conder, Alice and the convalescent Will left for Paris where, over the next ten days, they passed a good deal of time in company with that 'distinguished reprobate' Oscar Wilde. Wilde had recently been released from prison and was living in a small hotel on the Left Bank. Though appreciative of him as 'a great man of inaction' and a 'big and good-natured fellow with an enormous sense of fun, impeccable bad taste, and a deeply religious apprehension of the Devil',[71] Augustus felt embarrassed by his elaborate performances of wit, not knowing how to respond. 'I could think of nothing whatever to say. Even my laughter sounded hollow.' The unnatural deference, the trained astonishment put on by the rest of his audience, sickened him. Never had the face of praise looked more foolish. Despite this, Wilde seems to have been much taken with 'the charming Celtish poet in colour'[72] as he described Augustus. Alice Rothenstein, noticing this friendliness, grew fearful for his reputation and hurried him along to the hairdresser. Next day Oscar looked grave. 'You should have consulted me,' he told Augustus, laying a hand reproachfully on his shoulder, 'before taking this important step.'

Augustus felt stifled by these long, unspontaneous lunches at the Café de la Régence and the Café Procope, and was always on the lookout to escape with Conder and seek 'easier if less distinguished company'. The two of them would go off 'whoring', as Conder called it, visiting a succession of *boîtes de nuit* in Montmartre until the first pale gleams of the Parisian dawn showed in the sky, and each with his companion went his own way. 'He [John] was drunk,' Will Rothenstein gushed, 'with excitement.' Once again much of his waking and sleeping day was spent in the Louvre, of which he never seemed to tire. 'Imagine,' he

* 'The harvest is nearly over with us now,' John wrote to Ursula Tyrwhitt (undated). 'Do you bathe much? I should very much like to have a swim with you. Come over and stay with us – with me – eh what? . . . Yes, everybody assures me I look very fine in green corduroys.'

wrote to Ursula Tyrwhitt, 'we were on the top of the Louvre yesterday! On the roof, and grapes and flowers are there. The prospect was wonderful – Paris at one's feet!'

Two painters in particular seem to have made a special impression on him. The first of these was Daumier who, John Rothenstein has written,* 'reinforced with immense authority the lesson he had begun to learn from Rembrandt, of seeing broadly and simply, and who taught him to interpret human personality boldly, without fearing to pass, if need be, the arbitrary line commonly held to divide objective representation from caricature'. The second was Puvis de Chavannes whose impressions of an idealized humanity and of the beauty of the relationship between figures and landscape was to be an inspiration to him.

Having spent all his money from the Carfax exhibition, Augustus now borrowed a further twenty from Michel Salaman.† He had intended to travel back via Brussels and Antwerp, but the life in Montmartre held him enthralled until the last moment. 'I've had a fantastic time here,' he told Ursula Tyrwhitt (October 1899) ' – we spent all our money and can't go to Belgium so we're off home tonight.'

6. 'MORAL LIVING'

The legend that had been conceived when Augustus dived on to a rock at the age of seventeen was by now fully grown. Only after he left the Slade, and the exterior discipline of Tonks and Brown had been removed, did he, in Michel Salaman's words, 'kick over the traces'. The extent of this change in his personality has been vividly recorded by John Everett,‡ who had first met Augustus in October 1896, shared

* *Modern English Painters*, Vol. I, 'Sickert to Grant' (Arrow Books), p. 200. Rothenstein instances 'The Rustic Idyll' of about 1903 as having been done under the immediate impact of Daumier. This work – possibly watercolour on dampened cartridge – is now in the Tate Gallery, and is called 'Rustic Scene'. It has an unusual texture – soft, blurred contours – and gives a more dramatic sense of atmosphere than is usual in John's work. '"The Rustic Idyll" I remember well,' John wrote to the Tate Gallery (16 March 1956). 'It is one of several pastels I did soon after leaving the Slade. Though hardly an Idyll, it has dramatic character . . . I don't consider it has merit as a *pastel*.'

† Five pounds of this was a loan, and the rest payment in advance for a portrait of Michel Salaman's mother.

‡ Everett, who had been baptized Herbert, registered at the Slade as Henry Everett, but he always called himself John Everett. He added to the confusion by marrying his cousin – Mrs Everett's niece – Kathleen, who altered her Christian name fractionally to Katherine. A marine painter all his life, John Everett never sold a marine painting during his life, but bequeathed them all (1,700 oils and an even larger number of drawings and engravings) to the National Maritime Museum, which held a memorial exhibition of his work in 1964.

21 Fitzroy Street with him during part of 1897, and who had left England for a year at sea in 1898. On his return to London in 1899 the first person he met was Orpen, who eagerly apprised him of all the scandalous things Augustus was up to: how he went pub-crawling and got gloriously drunk; how he kept a prostitute who would always go back to him if she could not pick up anyone in the streets; how he had careered all over the flower beds in Hyde Park with the police in hot pursuit – and so on. Remembering his friend of two years ago – 'a poor physical specimen [who] never played any games . . . a very quiet boy, a great reader, a studious youth' who used 'to sit up late reading and get to the Slade about 11', when everyone else began at nine, who avoided all the organized rags and tugs-of-war and was thought by some to be 'a nonentity' – Everett was astonished. 'If you had told me that of any man at the Slade I'd have believed you,' he replied to Orpen. 'But not John.'

Shortly afterwards Everett met Augustus again and over the next year saw a lot of him. 'All the things Orpen had told me about John were true,' he recorded in his journal. 'His character had completely changed. It was not the John I'd known in the early days at the Slade.' In some ways he was very like the sailors Everett had rubbed shoulders with during his voyages. He was getting commissions for portraits and drawings and the quality of his work had never been higher. He seemed however quite irresponsible. He would make an appointment with some sitter for the following morning, go off drinking half the night with his friends, then wake up grumpily next afternoon. Yet, Everett observed, he was not really a heavy drinker. Very little alcohol made him drunk and he could quickly become morose; unlike Conder, who drank far more, always remained cheerful, but had a tendency to see yellow-striped cats. Sometimes Augustus stayed out all night, and more than once he was arrested by the police and only released on bail next day. Despite his broken appointments, he was making a very reasonable income, though often obliged to borrow from his friends to get a meal. Money had only one significance for him: it meant freedom of action. To his friends he was spontaneously open-handed, and when in funds it was generally he who at restaurants demanded the bill, or was left with it. Other bills, such as the rent, he omitted to pay altogether. 'Gus says you need never pay Mrs Everett!' Orpen assured Michel Salaman. Some landladies were more exigent. 'I want to talk to you about this studio [76 Charlotte Street],' Orpen wrote in another letter to Salaman on his return from Vattetot. 'There is great trouble going on about Gus. I'm afraid he will not get back here.' Mrs Laurence, who kept the house, had grown increasingly alarmed by what she called 'Mr John's satur-nalias'. One night, simply it appears in order to terrify her, he had

danced with abandon on the roof of St John the Evangelist church next door. Other times he was apparently more conscientious, working late into the night with a nude model over his composition of 'Adam and Eve', and, in the heat of inspiration, stripping off his own clothes. Woken from her sleep by sounds of revelry, Mrs Laurence, chaperoned by her friend Mrs Young, went to investigate and, without benefit of art-training, was shocked by what she found. When Augustus left suddenly for France with the Carfax money in his pocket, he paid her nothing; and so, when he returned in October, she refused him entry. He retreated, therefore, to old territory: 21 Fitzroy Street – 'comfortless quarters', as Will Rothenstein described them, but economical.

Here was Will Rothenstein's cue, once more, to hurry to the rescue. Having been invited to stay at Sale with his brother-in-law, he gener-ously offered his house, No. 1 Pembroke Cottages,* to both Augustus and Gwen. Augustus used the house only spasmodically, preferring to sleep in Orpen's bed in the cellar of Fitzroy Street rather than make his way back to Kensington late at night. The springs of this bed had collapsed at the centre, so whoever reached it first and sank into the precipitous valley of the mattress was alone comfortable. Neither liked early nights, but Orpen was eventually driven by lack of sleep to extraordinary ingenuities, going to bed in the afternoon twilight, bolting doors, undressing in the dark, anything, to win a restful night. Augustus would then mount the stairs to John Everett's room, drink rum in front of his fire till half-past twelve, then jump up exclaim-ing: 'My God! I've missed the last train!' For weeks on end he slept on two of Everett's armchairs.

The following month Will Rothenstein returned from Sale. 'When I reached Kensington I found the house empty and no fire burning,' he wrote.[73] 'In front of a cold grate choked with cinders lay a collection of muddy boots . . . late in the evening John appeared, having climbed through a window; he rarely, he explained, remembered to take the house-key with him.' This was testing Rothenstein's hero-worship to the full. 'There were none I loved more than Augustus and Gwen John,' he admitted,[74] 'but they could scarcely be called "comfortable" friends.' As for Alice she was adamant: the walls must be white-washed and the floors scrubbed before their little home would again be habitable.

Will Rothenstein had now finished, for the New English Art Club, a portrait of Augustus† that won the difficult approbation of Tonks and, more difficult still, avoided the disapprobation of Augustus himself. It shows a dreamy, soft person whose exterior efforts to roughen and

* Off Edwardes Square in Kensington.
† Now at the Walker Art Gallery, Liverpool.

toughen himself are visibly unconvincing – the beard fails even to cover the chin. Yet the life he was now leading was certainly rough. After making one last effort to recapture 76 Charlotte Street – from which he was repelled 'with a charming County Court summons beautifully printed' [75] – he took up a fresh position at 61 Albany Street, by the side of Regent's Park. 'I've abandoned my kopje in Charlotte Street,' he told Will Rothenstein, 'trekked and laagered up at the above, strongly fortified but scantily supplied. Generals Laurence and Young hover at my rear . . . the garrison [is] in excellent spirits.'

He had briefly taken up with a new girl-friend, a Miss Simpson who, dismissing him as hopelessly impoverished, now decided to marry a bank clerk – and invited Augustus to her wedding. Except for his green corduroys he had nothing to wear. What happened was described by Orpen in a letter to John Everett: 'I met John last night – he had been to Miss Simpson's wedding, drunk as a lord. Dressed out in Conder's clothes, check waistcoat, high collar, tail coat, striped trousers. He seemed to say he was playing a much more important part than the bridegroom at the wedding and spoke with commiseration at the thought of how bored they must be getting at each other's society. . . . He almost wept over this, gave long lectures on moral living, and left us.'

Augustus's aversion to 'moral living' had strained his relationship with Ida almost to breaking point. He was painting a portrait of her which 'has clothed itself in scarlet', she told Michel Salaman (1 February 1900), adding: 'Gwen John has gone back to 122 Gower Street.* John sleeps, apparently, anywhere.'

The break between them came after an eventful trip Augustus made with Conder that spring to Mrs Everett's boarding house at Swanage. Augustus had had his hair cut short, trimmed his beard and now went everywhere in part of Conder's wedding equipment – tail coat, high collar and cap. After the dissipations of London, both painters tried hard to discipline themselves.† Conder seemed to have perfected a

* Gwen John seems to have been living at 122 Gower Street illegally and possibly even without furniture. The house was officially inhabited by a woman called Annie Machew, who since October 1899 had paid no rates. The rating authorities who attempted to collect the money owing to them throughout 1900 reported that there were 'no effects' there. For this reason the house does not appear in Kelly's Post Office Directory until three years later, when it had been taken over by the National Amalgamated Union of Shop Assistants, Warehousemen and Clerks.

† Conder, in a letter to Will Rothenstein from Swanage, wrote: 'I have nearly finished Harrison's decoration and John is working on a large decoration that promises very well – that seems to be his forte – a decoration 8 ft by 6 is no easy matter with a score of figures half life size, but he seems to work away with great

technique for investing simultaneously in life and work. He would sit
painting a watercolour of some Arcadian fan at the very centre of a
rowdy group of friends. 'There would be a whole lot of us smoking,
talking, telling good stories,' Everett optimistically recorded. 'Conder
would join in the conversation, talk the whole time, yet his hand would
go on doing the fan. At times it really seemed as if somebody else was
doing the watercolour.'

'We drink milk and soda and tea in large quantities,' Augustus
confided to Orpen. 'I must confess to a pint of beer occasionally on
going into the town.' As at Vattetot, they worked hard. 'Conder is
getting on with his decoration which becomes everyday more beautiful,'
Augustus told Will Rothenstein. 'The country here is lovely beyond
words. Corfe Castle and the neighbourhood would make you mad with
painter's cupidity! . . . I have started a colossal canvas whereon I depict
Dr Faust on the Brocken. I sweat at it from morn till eve.' Not even an
attack of German measles could interrupt such work. 'Conder had
them some weeks ago,' he reported to Will Rothenstein. 'I had quite
forgotten about it when I woke up one morning horrified to find my-
self struck of a murrain – I have been kept in ever since, shut off from
the world. In the daylight it isn't so bad, but I dread the night season
which means little sleep and tragic horrors of dreams at that. I mean
in the day I work desperately hard at my colossal task. I can say at any
rate Faust has benefited by my malady. In fact it is getting near the
finish. There are about 17 figures in it not to speak of a carrion-laden
gibbet.'*

If illness benefited their painting, the renewal of robust good health,
seasoned by the salt air, imposed ever-increasing obstacles. Mrs
Everett, protected from a knowledge of their world by her harmonium,
had invited down two fine-looking Slade girls, Elie Monsell and Daisy

* What became of the large decoration is not known, though a number of smaller
versions of the subject exist, showing the influence of Goya and Delacroix. One is
an oil belonging to Mr Humphrey Brooke; another, a wash drawing in the Quinn
Collection in New York, was sold by the Fine Art Society at the Slade Centenary
Show (autumn 1971); a third, a pen and wash drawing, is in the Tate Gallery (re-
produced in *Tate Gallery. Modern British Paintings, Drawings and Sculpture*, volume I,
plate 51).

ease. I found my decoration a great change and pleasure after smaller work and
think it is quite equal to the latter.

'I am quite well now and had almost a providential attack of measles which left
me undisturbed for some days to do my work.'

Not since his early days in France had Conder worked so consistently out of
doors. He painted at least nine views of Swanage, all in a more robust style than
hitherto. Three of these are now in the Tate Gallery.

Legge, to keep Conder and Augustus company. John Everett, who visited Pevril Tower during week-ends, watched the danger approaching with puritan *déjà-vu*. It seemed inevitable that a love-affair would develop, and before long Conder, to his dismay, found himself engaged to the Irish art-student Elie Monsell. Hauled up to London for a difficult interview with Mrs Monsell (who seems to have been considerably younger than himself), he shortly afterwards fled across the Channel to join Orpen and his mistress-model Amelia at Cany. The engagement then lapsed, fell into decay, and the following year Conder married Stella Maris.

Augustus, too, was experiencing what he called 'the compulsion of sea-air'[76] directed, not towards Daisy Legge, but to 'a superb woman of Vienna',[77] Maria Katerina, an aristocrat employed by Mrs Everett in the guise of parlourmaid. 'A beautiful Viennese lady here has had the misfortune to wrench away a considerable portion of my already much mutilated heart,' was how he broke the news to Orpen. 'Misfortune because such things cannot be brooked too complacently. . . . Conder is engaged on an even more beautiful fête galante.'

In a letter written nearly twenty years later (2 February 1918) to his friend Alick Schepeler, Augustus was to make a unique admission. 'The sort of paranoia or mental hail storm from which I suffer continually,' he told her, ' . . . means that each impression I receive is immediately obliterated by the next girl's, irrespective of its importance. Other people have remarked upon my consistent omission to keep appointments but only to you have I ever confessed the real and dreadful reason.'

The mental hail storm that now sprang up within him obliterated all feelings and thoughts of Ida. It was as if he had never met her, as if he had been blinded by this Viennese girl and could no longer see her. Possibly his confinement with measles – '*German* measles please!' he reminded Will Rothenstein. 'I did not catch them in Vienna.' – had helped to bring about the dreadful impatience of his emotions; and this impatience was exacerbated by the girl's elusiveness. The letters he wrote to his friends throb and reverberate with the echoes of this new passion. 'Marie la belle Viennoise has indeed captured a large proportion of my already much mutilated heart,' he admitted to Michel Salaman. 'She is the most distinguished woman in Swanage, but she "*haaates* work". It was without surprise I learnt she was descended from the old nobility of Austria. Her uncle, the familiar of Goethe, was Count von Astz. This damnably aristocratic pedigree, you will understand, only goes to make her more fatally attractive to my perverse self. . . . She wears patent leather shoes with open work stockings and – '

On, of all people, Conder's advice, he bought her a ring and presented it to her one dark night at the top of a drainpipe that led to her bedroom window. This overture had a magical effect upon Maria Katerina's defences which, Augustus later acknowledged,[78] 'proved in the end to be not insurmountable'. She 'has sucked the soul out of my lips', he boasted to Will Rothenstein. 'I polish up my German lore. I spend spare moments trying to recall phrases from Ollendorf and am so grateful for your lines of Schiller which are all that remain to me of the *Lied von der Glocke.*' But with the very instant of success, perhaps even fractionally preceding it, came the first encroachment of boredom. 'Sometimes when I surprise myself not quite happy tho' alone I begin to fear I have lost that crown of youth, the art of loving fanatically. I begin to suspect I have passed the virtues of juvenescence and that its follies are all that remain to me. Write to me dear Will and tell me . . . those little intimacies which are the salt of friendship and the pepper of love.'

On his last night in Swanage Augustus and Maria met secretly on the cliffs. She was wearing her ring and she promised to meet him in France where he was shortly to go with Michel Salaman. Back in London he felt desolate, and more than unusually un-self-sufficient. On 18 May, Mafeking Night, he strolled down to Trafalgar Square to see the fun. London had gone mad with excitement. Bells rang, guns were fired, streamers waved; people danced in groups, clapping, shouting, kissing. The streets were filled with omnibuses, people, policemen without helmets. As if by magic, whistles had appeared in everyone's mouth, Union Jacks in their hands, and amid all the tumult of tears, laughter and singing complete strangers threw their arms about one another's necks: it was, as Churchill said, a most 'unseemly' spectacle. Many were shocked by this 'frantic and hysterical outburst of patriotic enthusiasm', as Arnold Bennett called it. 'The Square, the Strand and all the adjacent avenues were packed with a seething mass of patriots celebrating the great day in a style that would have made a "savage" blush,' Augustus wrote.[79] 'Mad with drink and tribal hysteria, the citizens formed themselves into solid phalanxes, and plunging at random this way and that, swept all before them. The women, foremost in this mêlée, danced like Maenads, their shrill cat-calls swelling the general din. Feeling out of place and rather scared, I extricated myself from this pandemonium with some difficulty, and crept home in a state of dejection.'

'You have evidently forgotten my address,' Augustus remarked with surprise to Michel Salaman. Forgetfulness was not difficult. By June, shortly before he was due to join Salaman in France, he had reached the same point of crisis at Albany Street as he had achieved the previous

year in Charlotte Street, and by much the same methods.* 'I cannot come just yet,' he told his friend ' – I have some old commissions to finish amongst other deterrents to immediate migration. Yet in a little while I have hopes of being able to join you. I have had notice to quit this place. I think I will take a room somewhere in Soho if I can find one – a real "mansarde" I hope – I want to hide myself away for some time . . . I shall have to see my Pa before I would come as it is now a long while since I have seen him . . . It would be nice if Gwen could come too and good for her too methinks.'

Salaman had taken rooms at a house called Cité Titand in Le Puy-en-Verlay, a mediaeval Burgundian village built about a central rock and dominated by a colossal Virgin in cast iron. Augustus arrived here early in August. 'It is a wonderful country I assure you – unimaginably wonderful!' he wrote to Ursula Tyrwhitt (19 September 1900). ' . . . There are most exquisite hills, little and big, Rembrandtesque, Titianesque, Giorgionesque, Turneresque, growing out from volcanic rocks, dominating the fat valleys watered by pleasant streams, tilled by robust peasants bowed by labour and age or upright with the pride of youth and carrying things on their heads. I have bathed in the waters of the Borne and have felt quite Hellenic! At first the country gave me indigestion; used to plainer fare it proved too rich, too high for my northern stomach; now I begin to recover and will find a lifetime too short to assimilate its menu of many courses . . .

'We live in a pleasant flat with a pleasant garden without.'

To the golden-haired Alice Rothenstein, who had recommended Le Puy, he wrote with equal enthusiasm: 'Really, you have troubled my peace with your golden hills and fat valleys of Burgundy! . . .

'I work indoors mostly now. I am painting Michel's portrait. I hope to make a success of it. If when finished it will be as good as it is now I may count on that. I am also painting Polignac castle which ought to make a fine picture . . . †

'The very excellent military band plays in the park certain nights, and we have enjoyed sitting listening to it. It is very beautiful to watch the people under the trees. At intervals the attention of the populace is diverted from following the vigorous explanatory movements of the

* For example, Everett in his unpublished journal writes: 'We all went back to John's place in Albany Street. On the way they picked up an old whore, made some hot whisky. The result was John fell on the floor paralytic, the old whore on top of him in the same condition . . . Orpen and [Sidney] Starr tried to pull the old whore's drawers off, but she was too heavy to move.'

† John's drawing of the Château de Polignac is now in the Manchester Art Galleries. Very Flemish in its atmosphere, it provides an interesting demonstration of the diversity of his talent or, as detractors might claim, his ability to imitate.

conductor by an appeal to patriotism, effected by illuminating the flag by Bengal lights at the window of the museum! It is dazzling and undeniable! The band plays very well. Rendered clairvoyant by the music one feels very intimate with humanity, only Michel's voice when he breaks in with a laborious attempt at describing how beautifully the band played 3 years ago at the Queen's Hall that time he took Edna Waugh – is rather disturbing – or is it that I am becoming ill-tempered?'

Where Augustus went, could Will and Alice be far behind? They turned up, by bicycle, early in September and stayed two weeks at the Grand Hôtel des Ambassadeurs. 'Every day we met at lunch in a vast kitchen, full of great copper vessels, a true rôtisserie de la Reine Pédauque,' remembered Will Rothenstein,[80] 'presided over by a hostess who might have been mother to Pantagruel himself, so heroic in size she was, and of so genial and warm a nature.'

On their bicycles, the four of them pedalled as far south as Notre-Dame-des-Neiges, where Stevenson had once stayed on his travels with a donkey. Augustus on wheels was a fabulous sight, and Will Rothenstein noticed that the girls minding their cattle in the fields crossed themselves as he passed, and that the men in horror would exclaim: 'Quel type de rapin!' At Arlempdes, a village of such devilish repute it went unmarked on any map, they were entertained by the curé, who commented ecstatically upon Augustus's fitness for the principal role in their Passion play. 'Who does he remind you of?' he asked his sister. 'Notre Seigneur, le bon Dieu,' she answered without hesitation. 'I take it as a compliment,' Augustus remarked, but refused the part – understandably, since the previous year, in the heat of the occasion, Christ had been stabbed in his side. On reaching Notre-Dame-des-Neiges, Alice took sanctuary at an inn while the three men spent the night in a Trappist monastery where Will Rothenstein anticipated he might encounter Huysmans, but did not. Rising early he involved himself in the monastic rituals, but Augustus and Salaman lay abed, each in his cell where he was served by the silent monks with a breakfast of wine and cheese.

After returning to Le Puy, Will and Alice wheeled their machines over the horizon and were gone. 'Is it that I am becoming ill-tempered?' Augustus had queried. By this time he had been made extremely so by the failure of Maria Katerina to come to him. He had written long letters urging her to meet him in Paris, but these were intercepted by Mrs Everett who, after Augustus left Swanage, had discovered hairpins in his bed. With these instruments she had extracted from her servant a full confession. Her duty now was clear. From reading Augustus's letters it was a small step to writing Maria's, the tone of which, Augustus

noticed, suddenly changed. 'When you will no longer have me – what will I do then?' she asked. 'What will become of me then? Repudiated by my husband who loves me? Can you answer that?' Augustus did answer it according to his lights, but at such a distance, and screened by Mrs Everett, they were not strong enough to blind her doubts. 'Women always suspect me of fickleness,' he complained to Alice Rothenstein, 'but will they never give me a chance of vindicating myself? They are too modest, too cautious, for to do that they would have to give their lives. I am not an exponent of the faithful dog business.'

His leonine self-confidence had been badly shaken. Michel Salaman, who was financing their holiday, suffered grievously from his disappointment. Augustus, he observed, seemed to grow literally delirious about women. His temperature one evening shot up to 104, and almost every day he complained of numberless psychosomatic ailments from rheumatism to at least one completely new disease. His womanizing brought out in him a satyr-like quality. He would suddenly become violently attracted to some girl in a bar, and his whole nature changed. Some women were alarmed, others hypnotized. Michel Salaman was shocked.

Augustus did his best to pull himself together. He worked* – 'I am painting beyond Esplay,' he wrote to Will Rothenstein. ' . . . I want to travel again next year hitherwards and be a painter. I am, dear Will, full of ideas for work.' He read – in particular Balzac's *Vie Conjugale* which 'pains and makes me laugh at the same time'. He travelled – to Paris for a few days to see some Daumiers and Courbets and 'was profoundly moved'.†

When Michel Salaman left Le Puy, Augustus was joined by 'the Waif of Pimlico' as he now called his sister Gwen, and by 'the gentle Ambrose McEvoy'. 'I am conducted about by McEvoy and Gwen,' he told Salaman, 'who explain the beauties and show me new and ever more surprising spots.' Each evening they went for a long walk and would hurry back 'to cook a dinner which is often successful in some items'. Sometimes the two men – 'the absinthe friends' as Augustus dubbed them – would sit in a café where, he told Ursula Tyrwhitt, 'a young lady exquisitely beautiful, attired as a soldier, sings songs of dubious meaning'.

* Some pages from his sketch-book at this time were exhibited at the Mercury Gallery, London, 15 June–10 February 1968.

† 'I asked a gend'arme where the paintings by Daumier were to be found and he said "quelle paissance"!' John told Will Rothenstein. He had also been to see the Paris Exhibition in which Rothenstein's 'A Doll's House' won its silver medal, and reported: 'Your Maison des Poupées looked wonderful.'

By October Augustus seems to have recovered from his disappointment and had become, according to McEvoy, a 'demon' for work, refusing to budge from his easel. Vindictiveness, 'tempered with a regretful grain of salt', had succeeded his disillusion: then he dismissed her from his mind. He was quick to infatuation, as to anger: and quick to forget both. But for McEvoy and for Gwen it was a less happy time. McEvoy seemed in a dream, and could not settle down to work. 'After a strange period of mental and physical bewilderment I am beginning to regain some of my normal senses,' he eventually wrote to Salaman. ' . . . At first I felt like some animal and incapable of expressing anything. Drawing was quite impossible. I should like to live here for years and then I might hope to paint pictures that would have something of the grand air of the Auvergne – but now! Gus seems to retain his self-control. Perhaps he has been through my stage. He constantly does the most wonderful drawings. Oh, it is most perplexing.'

During this month at Le Puy, McEvoy's relationship with Gwen appears to have reached some sort of crisis. For much of the time he was silent, drinking himself gently into oblivion; while Gwen, who spent many days in tears, seemed inconsolable. Unlike her brother, she could not externalize emotional disasters and bounce them away. They lived on inside her until she suffocated them.

'It will be a frightful job seeking for rooms in London,' Augustus wrote to Salaman shortly before his return. But by November he had found what he wanted at 39 Southampton Street above the Economic Cigar Company. This was no 'mansarde', but it would serve for a time. Many of the drawings he had done at Le Puy were now put on exhibition at the Carfax Gallery. 'Glad to hear of MacColl's enthusiasm,' he wrote to Will Rothenstein. 'Tonks has bought 2 drawings. Brown thinks of doing so too. I have a great number if you like to come and amuse yourself.' It was again partly owing to Rothenstein's advocacy that the drawings sold so well. 'John is the great one at present,' Orpen assured Everett, 'making a lot of money and doing splendid drawing.' Augustus himself was delighted by this success – in a restrained way. 'The run on my drawings tho' confined to a narrow circle has been very pleasant,' he conceded in another letter to Will Rothenstein that autumn. 'People however seem better at bargaining than I am.'

People also seemed better, it occurred to him, at arranging their lives. He was growing increasingly dissatisfied by the quick rotation of pursuing landladies and girl-friends in retreat. Boredom and impatience constantly fretted him. Perhaps, after all, something a little more settled might suit him better, might even benefit his work.

He began to see Ida again. Although she had few illusions about the

sort of life he had been leading, she still loved him. In one of the limericks he was fond of composing, he scribbled:

There was a young woman named Ida
Who had a porcelain heart inside her
But she met a young card
Who hugged her so hard
He smashed up her crockery. Poor Ida!

It was more prophetic than he could have imagined. Soon the two of them were together again on the old basis. 'John is once more in the embrace of Miss Nettleship – the reunion is "Complet",' Orpen informed Everett. 'Marie (la Belle) has faded into the dark of winter, and disappeared in a dark back street.'

But the old basis was no longer enough for Augustus. Since the Nettleships would never agree to their 'living in sin', and since Ida would never consent to distressing them in this way, there was but one solution: 'moral living' as he had called it. Having, by devious routes, failed to avoid this conclusion, Augustus acted at once. He conceded the formality of a civil ceremony but, *en revanche*, insisted on an elopement, and set off with Ida early one Saturday morning for the Borough of St Pancras where they celebrated the event in secret. 'I have news to tell you,' he wrote the following week to his sister Winifred. 'Ida Nettleship and I got spliced at the St Pancras Registry Office last Saturday! McEvoy and Evans and Gwen aided and abetted us. Everybody agreed it was a beautiful wedding – there was a wonderful fog which lent an air of mystery unexpectedly romantic.' This letter he illustrated with a drawing of himself standing on his head.

Jack Nettleship, when he discovered what had happened, took the news philosophically: his wife less so. 'It might have been worse,' Augustus noted.[81] But it was less simple than he implied. That evening Ida went up to the bedroom of one of her mother's employees, Elspeth Phelps. 'I want to tell you something, Elspeth,' she said,[82] taking her friend's hand in both hers. 'I want to tell you – ' and then burying her face in her hands she broke into uncontrollable sobs. After a few moments she continued: 'I want to tell you I've married Gussie – and I think I'm a little frightened.'

She gave no sign of this fear in public. After the wedding they had gone round to tell Will and Alice Rothenstein the news. 'How pleased we were, and what mysterious things Ida and my wife had to talk over!' Will Rothenstein wrote[83] in his memoirs. That evening, to celebrate the wedding, the Rothensteins gave a small party. Ida looked 'exquisitely virginal in her simple white dress'. 'Mr and Mrs Nettleship, Mrs Beerbohm and Neville [Lytton], Miss Salmond, Misses John,

Salaman, Messrs Steer, Tonks, McEvoy, Salaman and myself were there,' Albert Rutherston wrote to his parents. But Augustus himself was not. The last anyone had seen of him was on his way that afternoon to a bath. Then, late at night, he turned up wearing a bright check suit and ear-rings. 'We were very gay,' wrote Albert Rutherston. 'We had scherades [*sic*] towards the end of the evening which were great fun. Mr and Mrs John were radiant.' One of these charades represented Steer teaching at the Slade – a long silence, then: 'How's your sister?' This, Augustus swore, was a perfect example of Steer's methods.

'I pray the marriage may be a splendid thing for both parties,' Orpen wrote to Will Rothenstein. Augustus himself had no doubts. At last someone had given him the chance of vindicating himself. Though Ida and he had undergone a more or less conventional marriage, neither of them were conventional people: they simply loved each other. He felt perfectly confident.

For their honeymoon, he took his wife to Swanage, and they stayed at Pevril Tower.

Love for Art's Sake

An artist is at the mercy of his temperament and his preferences
are apt to be purely personal, quite disproportionate and utterly
unhistorical.

Augustus John
(Willam Rothenstein Memorial Exhibition
Catalogue. Tate Gallery 1950)

What inconsiderate buggers we males are!
Augustus John to Mary Dowdall

I. EVIL AT WORK

The New English Art Club, by the time Augustus John officially became
a member in 1903, was seventeen years old and, in its influence, largely
French.* It was founded, after some half-dozen years of discussions, by
a number of artists who had worked in the Parisian schools and who
wanted an exhibiting society run on the lines of elective juries as against
the closed academic system of Burlington House. During the mid-
nineteenth century the Royal Academy had been perfecting its policy of
extreme caution. It had been slow to welcome the Pre-Raphaelites
until Pre-Raphaelitism became diluted – by which time it welcomed
little else. To many of its forty immortals, Paris was still a name of
dread, to be associated with lubricity, bloodshed and bad colour.

But to the mob of disgruntled outsiders Paris seemed an elysium, and
English Pre-Raphaelitism Gehenna. They found their inspiration in the
ennobling realism of Millet and Corot, in the pleinairism of Bastien-
Lepage and the school of Barbizon. This movement had come to a head
in 1886 when the New English Art Club was founded and its first
exhibitions held.

For perhaps a quarter of a century the club was to act as a *salon des
refusés*. Its members numbered many hardened sentimentalists. Chief
among them at the start was the 'Newlyn Group', whose watchword
was 'values'. They were not, in any exaggerated way, revolutionaries.
The pictures of Frank Bramley, in the matter of domestic sentiment,
could outdo those of any academician; while George Clausen, Stanhope
Forbes and H. H. La Thangue's large-scale, open-air paintings of
country and fisher folk, which excited much popular acclaim, contained
nothing to vex the Academy of Millais. It was not long before all these
artists drifted off to Burlington House.

* One of the first names suggested for the club had been 'the Society of Anglo-
French Painters'.

This dangerous contact with the open air, this accent upon 'realism' and concentration upon rustic themes seems at first sight to have something in common with Augustus's landscapes. But these *plein air* Victorian painters were *theatrical* realists, and their pictures were deliberately staged in an endlessly static way that was quite foreign to Augustus's work. Sickert put his finger on the weakness of the 'Newlyn Group' when he wrote: [84] 'Your subject is a real peasant in his own natural surroundings, and not a model from Hatton Garden. But what is he doing? He is posing for a picture as best he can, and he looks it. That woman stooping to put potatoes into a sack will never rise again. The potatoes, portraits every one, will never drop into the sack, and never a breath of air circulates around that painful rendering in the flat of the authentic patches on the very gown of a real peasant. What are the truths you have gained, a handful of tiresome little facts, compared to the truths you have lost? To life and spirit, light and air?'

Life and spirit, light and air were what Augustus would seek. He replaced social documentary with poetry, and abandoned story-telling altogether. His subjects do not act out special roles – the only parts they play are those they played in his life and in the fantasy of his imagination.

By the early 1890s control of the N.E.A.C. had passed to another group, sometimes called 'the London Impressionists', the leading figures of which were Steer and Sickert. They, too, looked to France for their inspiration – not to the humanitarian realism of Millet and Corot, but to Monet, Manet and Degas. London Impressionism had not a great deal in common with Monet's 1874 landscape entitled 'Une Impression', from which the name strictly derived. It was impressionism without colour, a puritan impressionism relying on line and tonality, and dominated by the influence of Whistler. Whistler himself had ceased to exhibit at the club in 1889, 'disapproving, perhaps, a society so less than republican in constitution as to have no president'. [85] But Sickert was still a faithful disciple and, moreover, a severe critic of Bastien-Lepage. Sentiment and invention were on the way out before a more impartial approach, an insistence upon 'the thing there'. When D. S. MacColl once praised Whistler on the aptness of a bit of wall-skirting in a portrait, he retorted severely: 'But it's *there*.' And Sickert, too, shared this principle. 'Supposing', he explained, 'that you paint a woman carrying a pail of water through the door, and drops are spilt upon the planks. There is a natural necessary rhythm about the pattern they make much better than anything you could invent.'

Torn by cliques and divisions, hampered by difficulties over galleries, the early exhibitions of the New English failed to make any great impact. But then, in 1890, D. S. MacColl became art-critic of the

Spectator, and shortly afterwards George Moore was appointed to a similar post on the *Speaker*. Both writers gave a leading place to the N.E.A.C. shows and incited rising anger among the ranks of the reactionaries. In headmaster tones Sir William Richmond was heard to say of such a dangerously *avant-garde* artist as John Singer Sargent: 'I should like to set him copying Holbeins for a year.' The climax came in 1893 over Degas's inaccurately named picture 'L'Absinthe', which was the occasion of one of the greatest aesthetic battles in the history of modern art, MacColl, Degas and the whole of the N.E.A.C. being abused 'from Budapest to Aberdeen'. This controversy had the result of placing the club at the forefront of non-academic painting, and its provoking nature was preserved by the election to membership of such unwholesome artists as Aubrey Beardsley. 'Degradation to suit a decadent civilization,' thundered the *Westminster Gazette*. 'No longer does nobility of idea dictate subjects to authors; sex is over-emphasized; the peak of abomination has been reached by the *Yellow Book*. . . . All this relates to the evil at work as expressed by the New English Art Club.'

By the turn of the century, when Augustus began to exhibit, the club was about to enter a new phase in its history. Alphonse Legros had disliked the aims of the N.E.A.C., but Brown was an original member, a close associate of Sickert's, and the man who had drafted the club's rules. Tonks, too, became a member in 1895 and was elected to the jury, on which he represented the revolutionary element in many an argument with Roger Fry – roles that were later drastically to be reversed. It was not extraordinary, then, that the Slade should emerge as the chief nursery of young talent, and that people should look to Augustus, as the spoilt child of this crèche, to lead the way.

He and Gwen were soon regularly exhibiting there. 'Gwen has had a portrait hung in the N.E.A.C.,' he wrote to Michel Salaman from Swanage (spring 1900). 'I don't know yet whether they have hung mine . . . Orpen has sent also and Everett so that there should be a healthy inoculation of new and Celtic blood into the Aged New English at last. The jurors have rejected both Mr Nettleship and Ida's works. I can't see why the former should wish to seek laurels in this direction . . .

'I have returned now . . . The New English has opened its doors on the flabber-gasted.'*

* For the summer show of 1899 Augustus exhibited two drawings – one of them a portrait of Miss Spencer Edwards – and a further two drawings in the winter show. In the summer of the following year both he and Gwen submitted pictures – Gwen a self-portrait that was later bought by Brown, and Augustus a Head of an Oriental and a portrait of William Morgan. Gwen's self-portrait is now in the Tate Gallery, No. 5366.

From this time onward a change began to pass over the appearance
of the N.E.A.C. exhibitions: more drawings and watercolours were
seen and the club became, in the words of D. S. MacColl, 'a school of
drawing'.[86] Then Roger Fry's appointment as art critic of the *Athenaeum*
gained for the New English another powerful platform. The Winter
Exhibition of 1904, Fry wrote, was its most important one yet. 'Mr
Sargent, Mr Steer, Mr Rothenstein, Mr John, Mr Orpen, to mention
only the best known artists, are all seen here at their best.' But the older
members belonged to a group, he continued, 'whose traditions and
methods are already being succeeded by a new set of ideas. They are no
longer *le dernier cri* – that is given by a group of whom Mr John is the
most remarkable member.'

There was nothing inimical in Augustus's work to Sickert's London
Impressionists whose pursuit was 'life' and whose object was to draw it
feverishly, Quentin Bell has explained,[87] 'capturing at high speed the
essentials of the situation'. Between Sickert and himself there was respect
tinged with irony. Sickert felt wryly amused by Augustus's moody
character, boasting that 'I am proud to say that I once succeeded in
bringing a smile to the somewhat difficult lips of Mr Augustus John.'[88]
Yet he knew the value of his work, describing him as 'the first draughts-
man that we have, . . . the most sure and able of our portrait painters'.[89]
And in the *New Age*[90] he paid generous tribute to Augustus's 'intensity
and virtuosity [which] have endued his peculiar world of women,
half gypsy, half model, with a life of their own. But his whole make-up
is personal to himself, and the last thing a wary young man had better
do is to imitate John . . . [he is] incessantly provisioning himself from
the inexhaustible and comfortable cupboard of nature.'

Perversely Augustus dismissed Sickert's writings as 'elegant drivel',[91]
feeling sceptical of that fashionably tailored figure so dissimilar to
himself. Though he respected Sickert's work, he was often impatient
of his aesthetic intrigues, for Augustus never interested himself in art
politics. While other painters held stormy meetings about New Rules
and Old Prejudices, the only record of Augustus invading their dis-
cussions is in the spring of 1903 when, so Orpen told[92] Conder (2
May 1903), he 'demanded to know why after accepting Miss Gwendolen
John's pictures – they [the N.E.A.C. committee] had not hung them.
But alas this question was out of order. . . . '

Gwen, however, was thankful to be free of the New English. 'I
think I can paint better than I used – I know I can,' she told Ursula
Tyrwhitt (8 July 1904); 'it has been such a help not to think of the
N.E.A.C. – and not to hurry over something to get it in – I shall never
do anything for an exhibition again – but when the exhibitions come
round send anything I happen to have.'

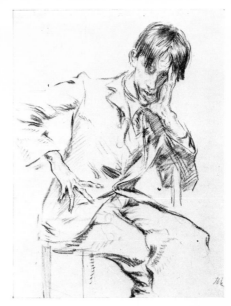

Wyndham Lewis

Ambrose McEvoy

William Rothenstein

John Knewstub

William Orpen

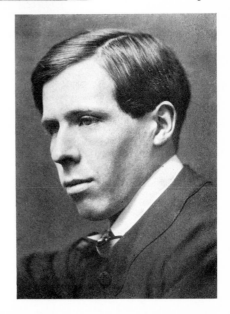

Augustus John

Gwen finally ceased altogether showing her pictures at the club in the winter of 1911,* while Augustus continued exhibiting there regularly until the large Retrospective Exhibition of 1925 – and even inter-mittently after that. His attitude towards the N.E.A.C. was exactly what his attitude to the R.A. would be: nothing theoretical – it was simply a place to show his work and a place to sell it. He deplored his sister's decision, largely because he wanted her to be an acknowledged success. Yet hers was an attitude that would ideally have suited his own temperament: only he could not afford to hold it. For she, in her little prisons of homes, was free; while he, patrolling the whole of Britain and the Continent, was to become more and more tied down by the claims of a voluminous family and by multitudes of hangers-on whom he frequently invited, then resented. The first knot was marriage, and he already needed more money for that.

2. LIVERPOOL

I become more rebellious in Liverpool.
Augustus John to Alice Rothenstein (December 1905)

'We have taken the most convenient flat imaginable in Fitzroy Street,' Augustus wrote to his sister Winifred a few days after his marriage. 'It has an excellent studio. The whole most cheap.'

By the time he and Ida returned from their honeymoon, this flat – three rooms and a huge studio in the top part of 18 Fitzroy Street – had been redecorated and was ready for them to move into.† But no sooner had they got there than Ida fell ill with the Swanage complaint – measles – and returned straightway to Wigmore Street, leaving Augus-tus bored and frustrated in their empty rooms. It was not a good omen.

Money was now their chief worry. Augustus had recently competed for a British Institute Scholarship, but failed to win anything. Well

* After this last show, Gwen wrote to Mrs Sampson (5 December 1911): 'I paint a good deal, but I don't often get a picture done – that requires, for me, a very long time of a quiet mind, and never to think of exhibitions.'

† One of Mrs Nettleship's girls, Edith Phelps, remembered that 'Very little was said in the house about Ida's marriage to Augustus John. The work girls said: "It's a shame; he's not half good enough for her." Though I never discussed it with her sisters, I don't think they were very pleased, and Ursula was disappointed there was no smart wedding, as Ida had several eligible admirers who wanted to marry her.

'Ida's great friend Gwen Salmond helped her at this time and went round to Fitzroy Street to tidy up the room, and Maginty the cook went too, and never stopped crying for two days when she came back. "My poor lamb, it's heartrend-ing," she kept on repeating. "I'm quite sure she'll get an infectious disease living in such a poor street".' *From Stomacher to Stomach: the Meanderings of a Dressmaker*, an unpublished autobiography by Edith Fox Pitt.

though his work had sold in exhibitions, it was not admired by everyone and could scarcely earn him enough to keep a wife let alone any children for some time. But that February, shortly after Ida had returned, a new opportunity for making a living suddenly presented itself. Albert Rutherston, staggering round to deliver his wedding present of a kitchen table, reported that 'the Johns . . . seem very comfortable in their flat which is the most charming one. There is just a chance of John going to Liverpool for a year to act as Professor in the school of art there during the absence of the present one – it would be very nice for him as he will get a studio free and at least £300 or £400 for the year.'

What had happened was that Herbert Jackson, the art instructor at the art school affiliated to University College Liverpool, had run off to the Boer War. D. S. MacColl, when asked to recommend someone temporarily to fill his place, had put Augustus's name forward;* and, since there was no time to be lost, his proposal was at once accepted.

Augustus arrived in Liverpool late that winter, 'a heartening sight', one student recalled'[93] '. . . striding across the drab quad to the studios in his grey fisherman's jersey and with golden rings in his ears'.† The academics were greatly fluttered by this spectacle, enhanced by the beard, long hair and large magnetic eyes, and by the sonorous voice with which he sang his repertoire of ballads romantic and bawdy – rollicking songs from the old troubadours and witty suggestive ones imported from Parisian cabarets, little verses from Villon and whining Cockney limericks with the cringing refrain:

I'm a man as done wrong to my paryents.

Liverpool, which he had been warned was an ugly commercial city, enthralled Augustus. 'The docks are wondrous,' he wrote to Will Rothenstein.[94] 'The college is quite young, so are its professors and they are very anxious to make it an independent seat of learning . . . The town is full of Germans, Jews, Welsh and Irish and Dutch.' Everything seemed to delight him. Whatever was new appeared exciting – and there was much that was new to him, much that smelt of adventure here. He explored the sombre district of the Merseyside with its migrant population of Scandinavians on their way to the New World, and reported to Alice Rothenstein, 'the Mersey is grand – vast –

* Herbert Jackson was Professor Walter Raleigh's brother-in-law, while D. S. MacColl was connected by marriage to Oliver Elton, who succeeded Raleigh as Professor of English Literature at Liverpool.

† Later on at Liverpool Augustus wore only one ear-ring, having, so the story goes, gallantly presented the other one to a lady who admired their design.

in a golden haze – a mist of love in the great blue eye of heaven'. He nosed round the Goree Piazza, still faintly reeking of the slave trade, on the lookout for superannuated buccaneers day-dreaming over their rum; he reconnoitred the Chinese Quarter off Pitt Street and Upper Frederick Street, with its whiff of opium, and penetrated the outlandish lodging-houses of the tinkers round Scotland Road. Even the art school – a collection of wooden sheds on Brownlow Hill – appealed to him. 'It is amusing teaching,' he told Will Rothenstein.

Over the first few weeks he and Ida put up at 9 St James's Street, and it was here that Augustus's only complaint lay. 'It has been impossible to do much work yet – living as a guest in somebody's house – a great bore.' He was hungry for work, especially since there was soon to be another show of his pictures at the Carfax Gallery. But already by April they had found 'very good rooms', he reported, 'in the house of an absent-minded and charming Professor, one Mackay'.

John MacDonald Mackay, Rathbone Professor of Ancient History, was the most flamboyant personality at University College – a wonderfully animating figure to whom Augustus at once responded. 'Mackay – Professor of History is delightful – the leading spirit of the College,' he wrote to Will Rothenstein shortly after moving into his house at 4 St James's Road. 'He avoids coming to the practical point most tenaciously – when arranging about taking these rooms he refused to consider terms but referred us to the Swedish Consul – who was extremely surprised when Ida spoke to him on the subject.'

Mackay combined two qualities that appealed very strongly to Augustus's divided nature: comedy and idealism. With his right hand raised, half to his audience, half to the sky visible through the nearest window, a far-away look in his eyes, he would discourse in a weird moustached chant, interrupting himself with bursts of sing-song merriment or New Testament indignation, often abandoning the line of his argument, yet always struggling back to First Principles, always stressing those ideals he believed his colleagues should follow. Under the chemistry of his strange, broken-back eloquence, Liverpool was transformed into a new Athens destined to save the country from materialism by the clearness of its thought, the quality of its work, the beauty of its art and architecture. Through sheer force of character, whatever nominal positions others may have held, he was the father of the university while Augustus lived there.

Mackay was important to Augustus for two reasons. First, he became the subject of one of his most successful portraits. He had a magnificent head, with fair unkempt hair, a powerful jaw and square chin, and the broad shoulders and strength of torso of someone altogether larger. Augustus's 'official' portrait – a three-quarter view of him decked out

in his red academic robes – catches in a remarkable way the spiritual energy of the man.*

Secondly, he introduced Augustus and Ida to many people whom, in their shyness, they might otherwise never have known. A number of these Augustus later drew and painted, and a few became close friends. 'We are to dine with the Dowdalls on Friday which I dread,' Ida wrote to her mother. 'They are very nice, but I would rather hide.' A little later she is writing: 'We had a nice little dinner with the Dowdalls on Saturday. He is a lawyer, I think, with a taste for painting – and he has a little auburn-haired wife who spends most of her time being painted by different people. Gus is to draw Dowdall's mother.'

Harold Chaloner Dowdall, later to become a County Court Judge and, as Lord Mayor of Liverpool, the subject of one of Augustus's most controversial portraits, was a pompous good-natured barrister, very loyal to the Johns but with a tendency to dilate, perhaps for an entire day, on the extreme freshness of the eggs that morning for breakfast, and other solemn topics. His wife Mary, nicknamed 'the Rani', was 'the most charming and entertaining character in Liverpool', Augustus asserted. She soon became one of Ida's most devoted confidantes. 'The Rani has beautiful browny-red hair and is quite exceptional, and reminds me of the grass and the smell of the earth,' Ida noted. As always with those she admired, Ida likened her to nature, and to an animal in natural surroundings. 'Certainly you belong to the woods and where creatures start and hide away at any alien sound.'

The daughter of Lord Borthwick, Mary Dowdall was Liverpool's one aristocrat; but she shocked Liverpool society dreadfully. It was shocked by her habit of walking barefoot through the mud – 'the gentle stimulant of cold mud welling between one's toes is a clarifier of thought,' she claimed, 'after a day's perfect irresponsibility'; it was shocked when, at the fashionable hour, she was to be seen seated, stockingless and swinging her legs, at the back of a gypsy caravan

* Mackay is depicted as a man of intuition rather than intellectuality, a kind of Wordsworthian poet more at home among daffodils than academics. But it is not simply a 'romantic' portrait; it combines John's usual force with a restraint that is less than usual. The V-shape of the robe at the neck gives firm support to the head; the point of the chin, breaking a fourth angle, increases the belligerence of the general attitude. The effect is monumental. D. S. MacColl, standing in front of it, declaimed: 'See a knight of the Holy Ghost.'

This portrait, which now hangs in Liverpool University Dining Club, was later the cause of a historic decision. First exhibited at the N.E.A.C. in the Winter Show of 1903, it was to have been awarded the Gold Medal for painting at the great International Exhibition at St Louis in the following year. Learning that this prize was to go to so young and relatively obscure an artist, the President of the Royal Academy and the English members of the international jury took the astonishing step of withdrawing, without explanation, the entire British section.

trundling down Bold Street; it was shocked by her 'goings-on', her involvement with the Repertory Theatre which dared to give theatrical performances on Good Friday, her frequent modelling improperly clothed for artists such as Shannon, by her awful wit, sheer attractiveness, her unaccountable failure to take Liverpool society seriously. They did not think it nice for the Hon. Mrs Dowdall to be on such familiar terms with the unfamiliar. Above all, Liverpool was appalled by the books she wrote – novels, with such uncompromising titles as *Three Loving Ladies* and, most notoriously, *The Book of Martha*, which, embellished with a frontispiece by Augustus, dealt with tradesmen and servants. She was also the author of *Joking Apart*, and her jokes, delivered in the mock-magisterial tones of her husband and an irresistible gamin's moue, were introduced by: 'All virgins will kindly leave the Court.' No wonder she emptied the drawing-rooms of Edwardian Liverpool.

Augustus's contacts with the university staff were not pushed to extremes, but among the exceptions were Walter Raleigh, who abashed him with the early morning brilliance of his mind – 'he shone even at breakfast!'[95] – Charles Bonnier, the French professor, a victim to the theory and practice of *pointillisme*, who 'has been producing a most astoundingly horrible marmalade of spots yellow, purple, blue and green in my studio';* and Herbert MacNair, instructor in Design and Stained Glass, a dawn dipsomaniac and, of an afternoon, a lusty bicyclist who, in later life, became a postman. He and his wife Frances, working in perfect unison, involved themselves with a peculiar form of *art nouveau*, producing, to Augustus's dismay, friezes of quaint mermaids designed after the MacNair crest, staircases encrusted in sheet lead, lamps of fancifully twisted wrought iron, symbolic watercolours done with much delicate debility upon vellum, embroideries depicting bulbous gnomes and fairies prettily arranged, and as their *pièce de résistance* a curly door-knocker eighteen inches long, the delight of small boys.† 'We dined with two artistic people called MacNair,' Augustus wrote to Will Rothenstein, 'who between them have produced one baby [Sylvan] and a multitude of spooks – their drawing-room is very creepy and the dinner-table was illuminated with two rows of nightlights in a lantern of the "MacNair" pattern. . . . However the MacNairs have a homely way of conversing which immediately sets people at their ease.'

* Augustus John to Will Rothenstein, 9 March 1902. He continues: 'I felt inclined to add my patch of home made sienna in reverence to the past.'
† 'The "MacNair" doorknocker is most popular with the children of the neighbourhood who by its means keep themselves in constant touch with the most advanced Art movement.' John to Rothenstein.

By far the most valuable new friend Augustus made was the uni-
versity librarian, John Sampson.* A portly man, twice Augustus's
age, ponderous in his speech and in his manner laboured, Sampson
was at heart a poet, a romantic and a rebel. His influence on Augustus
over the next two years was paramount: it changed his life. The two
men met in the late spring of 1901 and immediately struck up a close
friendship. There was much in Sampson for Augustus to admire † –
the monumental physique, the Johnsonian force of character and vast
accumulation of strange knowledge, the sardonic humour – and his
example contributed in time to Augustus's own *persona*.

'You are a learned man,' Walter Raleigh wrote[96] to Sampson (16 July
1908), 'and a rogue, one of the sort of fellows who think they can
conduct the business of life on inspirationist principles, and who run an
office pretty much the same way as they make love to a woman.' Both,
by all accounts, he did pretty effectively. He was a commanding
figure as he strode through the slums of Liverpool in his old velvet
jacket, disgracefully baggy trousers, his muff, gin-bottle and battered
old slouch hat set at an imposing angle, his chest thrust out, legs moving
powerfully. Despite much intimidating scholarship and overbearing
ways, there was something extraordinarily lovable about him – a
strange gentleness in his voice, a concealed but very vulnerable sen-
sibility and much boyish ardour. He was followed everywhere by a
battalion of devoted women who loved him and dedicated themselves
to helping him with his work. 'The majestic Sampson,' Augustus once
described him to the Rani, 'the large and rolling Rai – he reminds me of
a magnificent ship on a swelling sea.' Their relationship was subject to
several fiery quarrels and rivalries, but they made it up always and
without difficulty, for Sampson had a keen insight into character and
recognized that, sometimes contrary to appearances, there was no
malignity on Augustus's part. Besides, he was much younger.

Augustus was soon greatly in awe of Sampson. Here was a new kind
of hero for him to admire. For Sampson was a mine of curious know-
ledge. He had trained himself in Romany and Shelta, that mysterious
jargon of the Tinkers, had mastered both Back and Rhyming Slang,
cultivated Sanskrit, phonetics and philology, and would eventually
produce a *magnum opus* in his *The Dialect of the Gypsies of Wales*. Already
he was at work on an edition of William Blake that was to be acknow-
ledged everywhere as a noble monument of British scholarship; his

* Grandfather of (among others) Anthony Sampson the author.

† In a letter to her father (24 December 1901), Ida wrote: 'Sampson came in last
night and we talked till half past 12. He sits and says things in a heavy sort of way.
He is rather like a huge and charming Redcliffe Salaman – but don't tell Gus that!
he thinks Redcliffe is a mouse in comparison.'

experimental translations of Heine into Romany were in their eccentric way perfect and, when in 1901 he finished his Romany version of Fitzgerald's Omar Khayyám, he invited Augustus to contribute a frontispiece.

Augustus had a quick ear for languages and under Sampson's tutelage he soon learned the English dialect of Romany and later the deep inflected Welsh dialect. But if he venerated the gypsy scholar, it was the 'Rai of Rais', as Sampson was known outside the university, who enchanted him. By the gypsies themselves, Sampson had been admitted as one of their own, and they revealed to him some of their most secret customs. Augustus had been attracted to gypsies since childhood, but always safely from a distance. Now, as the Rai's close friend, he was welcomed by them as a fellow vagrant – and indeed, in certain moods, actually appeared to believe he belonged to this 'outlandish and despised people'. They seemed to possess for him some consuming attraction, so that he could not keep away. Time and again Sampson would take him to Cabbage Hall, a strip of wasteland beyond Liverpool where there was no hall and no cabbages, only the tents and caravans of the gypsy tribes who congregated there throughout the winter; and their visits were rich in adventures.

There was something strangely satisfying in this life of singing and dancing and odd journeys. The tents, the wagons, the gaily painted carts, the great shining flanks of the horses, the wild beauty of the women with their children, fired Augustus's soul in a way he could not explain. He had always felt an affinity with outcast people, those who were powerless and oppressed. Then, too, they were such a fine-looking lot, these open-air people, as they crowded round him and Sampson – their beauty somehow made more beautiful by a proud and enigmatic bearing. Carried away one evening at Cabbage Hall, he picked out an especially handsome Romany youth and, quoting Shakespeare – 'From fairest creatures we desire increase' – egged him on to choose the most beautiful *chai* (girl) he could find for his mate, so that they might produce the best-looking children in the world. The possibilities seemed endless. Noah, Kenza, Eros and Bohemia; Sinfai, Athaliah, Counseletta and Tihanna – their exotic names, and the mystery and antiquity of their origins conjured up a world that was remote yet oddly familiar, a world of which he should have been part.

And when he left them to return to the university and to Ida, he would try to reason out why he felt this incurable fascination, what the true significance of it might be. As a race they seemed to have much in common with him; they were natural exhibitionists, yet deeply secretive; they were quick-witted, courteous, gay yet temperamental and with a dark suspicion of strangers; they were essentially honest, almost

naïve, yet prevaricating; they loved children, yet without stifling sentimentality. All this he knew, and yet it still left unaccounted that painful hammering of his heart whenever he approached their camps, caught sight of their young women, so provocative, aloof. His excitement came from obscure but vital needs, from desires damped down in childhood now magically re-kindled. In the sun and wind, like the trees and fields around them, they were truly alive. There was nothing confined, nothing claustrophobic here: they did what they wanted, went where they wished – over the next hill, far away – and they were answerable to no man.

He was exhilarated.

Very different was the atmosphere in 4 St James's Road where life had now begun to follow a steady pattern. 'We have callers pretty often,' Ida informed Alice Rothenstein, 'University men and their wives. Our room is always in disorder when they come as Gus is generally painting – but they survive it.' Generally he was painting Ida, but she too found time to continue with her painting and 'have an old man model, who goes to lectures on Dante, and takes part in play readings. He sits like a rock, occasionally wiping his old eyes when they get moist.' Her sister Ethel* bravely came to stay for a week, and Ida contemplated going down to London for a few days, though 'I'm afraid Gussie won't come too. He works very hard.' It was an uneventful time, but not unhappy. 'I am afraid I haven't started a baby yet,' Ida apologized to Alice. 'I want one.'

The first disruptions in this gentle routine came that summer. Ida 'looks suspiciously pregnant,' Augustus suddenly remarked to Will Rothenstein. The doctor soon confirmed her pregnancy, but in these

* Ethel Nettleship was a 'cellist who, in the First World War, became an ambulance driver and nurse in Italy and Malta and who had such a bad time there that, on her return, she took to lace-making for her nerves. 'Untidy and gay,' Sir Caspar John remembers, 'always hard up – accessible and directly interested in all our lives.' Ursula, the third sister, was rather stern and aloof compared with Ethel. An adventurous mountaineer and skier, she became a singer and teacher of singing who, in an unobtrusive way, did an astonishing amount for music in England. She was for a long time closely connected with the Aldeburgh Festival, at which Benjamin Britten dedicated his 'Ceremony of Carols' to her. 'Her energy, her eagerness, her determination to be satisfied with nothing less than the best, forced those she taught to give of their best, and produced remarkable results,' wrote Ann Bridge (*The Times*, 7 May 1968); 'if she could not inspire she drove, inexorable as a tank, over such human frailties as slackness, timidity or lack of perseverance. Moving about, gesticulating, her greying hair wild, Ursula Nettleship conducting her choir was in fact an inspiring sight – lost in the music, utterly unselfconscious, dragging the sounds she wanted out of, often, very unpromising material.'

early months there was a rumour of complications and, so this doctor warned her, the possible risk of a miscarriage. For this reason she passed the summer months very quietly, first at Wigmore Street, then with Edwin and Winifred John in Tenby.

Liberated from domesticity almost on doctor's orders, Augustus felt he had been let out from a narrow place. He could go where he liked, be what he liked. The effect was magical. One morning he set out intending to go for a short walk 'but instead went to Bruges and stood amazed before the works of Van Eyck and Memling', he explained to Will Rothenstein. 'The Belgians are as shoddy as they were formerly magnificent. Maeterlinck needs all his second sight.'

His truancy over, he then joined Ida in Tenby 'feeling rather meta-grabolized', and carried her off for a month's rest-and-painting to New Quay in Cardiganshire. 'Now the child has quickened, I suppose there is very small fear of a miscarriage,' Ida reassured her mother that September. '. . . I have been very well here – no indigestion and very regular bowels. The baby moves from time to time – and I am growing very big and hard.' They were staying at 3 Prospect Place. Every morning Augustus would go bathing and, during the afternoons, he admitted, 'have models in a disused school room'. Ida sat at home, letting out her skirts and creating new clothes for the baby, and these she would take up to the schoolroom at tea time, when the painting had to stop.

In the last week of September they returned to Liverpool – but not to St James's Road, since Ida could no longer manage the stairs there. For two weeks they put up with John Sampson and his sentimental mouse of a wife, Margaret – 'delightful people', Ida promised her mother – at 146 Chatham Street, a semi-slum. Then they moved off to rather grander accommodation, 66 Canning Street, a three-storeyed, red-brick house, complete with *art nouveau* metalwork on the doors and railings, and a black projecting portico with Doric cornices.

So much, this autumn, augured well for Augustus. Ida's pregnancy had inflamed him with an intense excitement – a sense of power, massive tenderness and some curious feeling of fulfilment, almost as if it were he who was being born again. They had been fortunate in finding Canning Street, and Augustus himself had at last discovered a good studio* and was making it habitable.

The university, too, had 'raised my dole to a smug £200 and a day less in the week than last term'.[97] This increase reflected the excellent work he was doing at the Art Sheds. His predecessor, Herbert Jackson, had been an uninspiring teacher. He would slump down by a student's

* This building, which has now been destroyed, was between No. 2 Rodney Street and the hospital at the corner of Mount Pleasant.

drawing board, sketch an ear or a foot, examine it, then remark: 'It's not much good, I suppose, but it'll do.' Augustus's methods, though not especially orthodox, marked a great improvement. 'Alas, how many brilliant drawings have I done on the boards of my pupils!' he once commented. It was as though he was learning from his own instruction. Above all he stressed the importance of observation. 'When you draw,' he told his class, 'don't look at the model for one second and five minutes at your drawing, but five minutes at the model and one second at your drawing.' In the Slade School style, he could be severe. He developed a habit of standing in perfect silence behind students whose work was irredeemable. 'I think the nostril is a bit out,' one poor girl hazarded at last. 'The nostril!' Augustus snorted. 'The whole thing's a bit out.' But he was immensely pleased when one of his pupils did well, and he was responsible for several gifted young artists later leaving the School of Art and throwing in their lot with the Sandon Studios Society.*

Despite the incursion which teaching made into his time, his own work was also going well. Liverpool had stimulated him, made him more keenly responsive to the visible world. 'For my part a fine morning fills me with unspeakable joy,' he wrote to Will Rothenstein, ' – a tender sky tethers me to childhood, a joyous countenance is an obstacle on the road to old age.' Like Ruskin he felt that all Nature was a manifestation of beauty, that there was no bad weather, only different kinds of good weather. 'The weather keeps changing and our sensations with it,' he told Will Rothenstein. ' . . . Plus ça change, plus [c'est] la même chose.'

His letters during this first year at Liverpool are congested with joy, salted with the biological imagery he loved to use in relation to his work. 'It has seemed to me of late I've been passing through a transition stage,' he confided to Rothenstein (4 May 1901), 'taking my leave lingeringly and spasmodically, and with many runs backward, of old traditions. . . . Something stirs within me which makes me think so long and passionate company with so many loves as I have kept has not left me barren. Hitherto I have been Art's most devoted concubine, but now at length the seed takes root. I *am*, O Will, about to become a *mother* – the question of paternity must be left to the future. I suspect at least 4 old masters.

* The Sandon Studios Society, of which John was elected an honorary member, was later set up in opposition to the University School of Art, to encourage freer and more vigorous draughtsmanship and a less restrictive attitude to painting. It was officially opened at 9 Sandon Terrace on 5 December 1905, but 'any formality intended', records R. H. Bisson in his history of the society (p. 28) 'was dissipated by Augustus John, who got very cheerful and fell headlong down the stairs'.

'If you will stand godfather O how easy will be the parturition! how triumphant the deliverance! I have (with this new secret) got up at 5 this morning and walked in the Cemetery here – a wonderful place!'

Between the winter exhibitions of 1900 and 1902, greatly to Brown's disappointment, Augustus sent in nothing to the New English. Instead he relied on the Carfax Gallery and in particular on Rothenstein who seems to have set himself up as, in some respects, Augustus's London agent. To him Augustus would dispatch what he called his 'parcels of fancies' and 'pastels of sluts' – beggar girls, ballet girls and all manner of remarkable-looking models he had collided with in the streets of Liverpool. His purpose was to record the natural beauty he saw in life, as directly as possible, without any message or moral, any attitude or intervening glaze of intellectuality: simply the thing itself – almost as Wordsworth had expressed it in *Peter Bell*.

> *A primrose by a river's brim*
> *A yellow primrose was to him,*
> *And it was nothing more.*

With these pastels Rothenstein was extremely successful, especially in selling them to other artists – Ricketts and Shannon, Brown and Tonks. Augustus's gratitude, both to Rothenstein and to his models, swelled to its most rhapsodic vein:

'Beloved Will,

'You know how nothing delights my soul more than your laudation! you have made me tickle and thrill, and gulp tears to eye and water to lip. And have my poor girls served me so well! Blessing on you Maggie and Ellen Jones!* Daughters of Cardigan I thank ye! And you Quean of the Brook whose lewd leer captured me in my dreams, may your lusty honest blood be never denied the embrace it tingles for!

'. . . I pant to do a superb decoration . . .'

The most important development in Augustus's work during this Liverpool period was not in decoration but as an etcher. He had taken up etching at the suggestion of his friend Benjamin Evans, one of his first plates being a portrait of Evans[98]. Suddenly now he grew immensely enthusiastic over this new medium – 'I have been etching a good deal,' he informed Will Rothenstein. It was Rembrandt's example[99] that Evans had extolled and that now fired-off this burst of enthusiasm. Like Rembrandt, his first experiments included a number of portrait studies of himself in various poses and costumes – fur caps and wide-brimmed hats, bare-headed and in a black gown. But they also numbered several portraits of Ida, very plump and maternal, in a

* Two Liverpool models who later went 'to breed in the colonies. May they raise many a stalwart son to our Empire!' John wrote to the Rani.

fur-tipped cape or with a special necklace, or simply as 'a brown study': and pictures of drapers, chandlers, old haberdashers, young serving maids, children and all the curious cosmopolitan population of Liverpool whom he encountered on the waste ground of Cabbage Hall, within the university, at the working-men's dining-rooms and doss houses along Scotland Road – gypsies and mulattoes, the frock-coated bourgeois, the negresses, charwomen and old men with gnarled expressions, fierce and hopeless.

Augustus had made so close a study of Rembrandt's method, and assimilated it to such an extent, that a great many of his etchings have the appearance of being personal imitations. Yet however derivative his technique may be, these etchings do tell us a great deal about his aims as an artist, often by reason of their very imperfection. In his perceptive introduction to the Catalogue of Augustus's etchings, Campbell Dodgson wrote:

'There are certain features in his work which make it unlike that of his contemporaries. His choice of figure subjects in preference to the landscape or architectural motives which are so much in vogue to-day is one of them. His consistency in restricting the size of his plates to small, or even tiny, dimensions is another. Both are significant traits which link his work to the great tradition of the painter-etchers of four centuries . . . But a fault common to many of them is a fault that runs through Mr John's paintings and drawings as well, lack of concentration and acquiescence in an apparent finish, a facile substitute for true perfection. Or if we consider the subjects themselves, rather than the manner in which he treats them, is there not something unsatisfying, superficial, betraying lack of "fundamental brainwork" in most of the compositions containing two or more figures? There is no apparent motive for bringing them together, and Mr John, with all his intense interest in single types, and his power, unequalled among etchers of to-day, of expressing individual character, lacks the imaginative, constructive, or dramatic gift of showing several characters in action. Though more than one of his groups possess a certain degree of idyllic charm, which is seen at its best in *The Valley of Time*, he has produced nothing that makes him notable as an etcher of action, and he is too easily content with inventing groups of aimless women who sit doing nothing particular, in a world of shadows, or stroll, leading children by the hand, through vague meadows of dreamland.'

The fruit-sellers and philosophers, tramps and coster-girls who figure in so many of Augustus's visual lyrics were in fact very poor subjects – highly elusive, self-conscious, shy of being stared at. He had taught his students the value of observation – to look 'five minutes at the model and one second at your drawing' – but it was precisely this lesson he

was unable to practise. He could catch them all right, these reluctant sitters, but well before the five minutes were up they were off. He was therefore thrown back on his memory and on his imagination, and to some extent these failed him. Everything made its impact on him at once, and seemed to last only so long as it remained physically in front of him. In his imaginative work, based on memory or invention, there is a lack of substance. Most of these studies of gypsies or fisher folk lack atmosphere, a feeling for place, often even accurate recollection of detail: the oxygen has gone out of their world, and they wilt. They have become propaganda pictures advertising a recommended way of life, from which the initial vitality has had time to seep away. This seepage is sometimes particularly noticeable in the case of his etchings because the medium was so slow. To fill the emptiness, he overworked them with a turmoil of feathery cross-hatching, suffocating them in lines.* Perhaps because he realized how far short they fell of all he wanted to communicate he could not reconcile himself to leaving off at the right moment. 'It is only that I feel ever inclined to add a few scratches on the plate that I husband them in this way,' he told Will Rothenstein.

Campbell Dodgson's other chief criticism Augustus would have refuted. It was not his desire artificially to inject action or drama into these studies; it was not his wish to apply sophisticated 'brainwork' to these simple people. What action, what drama, what brainwork is there in a flower, a falling wave, the corner of a field, single tree, the look upon a half-averted face? What intellectual 'purpose' may be divined in such trivial shapes and ordinary sights? Augustus

* Undoubtedly some of the plates would have been better if they had been left in the pure etched state, without being carried to a finish by lavish use of dry-point, which sacrificed their original crispness, leaving them soft and veiled. Some of the very best ones are incomplete studies or sheets of studies, where the needle has been used like a pencil and the emphasis is on line; where, with a minimum of cross-hatching, the face has been left free from the rubberized pock-marks of dots and dashes intended to suggest variations of surface and of tone. These studies are often less self-conscious than the finished products, picked out more precisely in order to stress a curve or a fold, and they combine a more spontaneous execution with a regard for the personality of the model. Some of the series of heads form a natural design on the page, and some of the studies give the impression of a fine water-colour wash. But John is at his very best with single figures, and to his Liverpool period belong several extraordinarily fine portraits including the Mulatto; the Old Haberdasher; the Jewess with her shrewd suspicious gaze, her air of insolent coquetry, seated with her chin supported on a claw-like hand, her head sunk deep within her shoulders, and the shawl and feathers she wears suggesting a rococo touch in her character; and 'Old Arthy' where the effect of strong light behind the head creates a silhouette which the dense cross-hatching emphasizes without negating the figure, since the lines become part of the creases of the face and the shadows cast by it.

did not plot his pictures. His groups are deliberately motiveless. He etches them because they're there – and because he loves them. In a sense, the superficiality of which Campbell Dodgson accuses him is exactly what he sets out to achieve. His theme is the profundity of the superficial, an avowal that the look in an eye, a smile, a tone of voice – all these passing and unimportant things – have the power to move us beyond explanation or understanding, and become part of our lives. So far as the artist is concerned, the 'meaning' of his studies should be left, Augustus believed, to his unconscious. No critic makes a good artist, as the example of Roger Fry showed. Augustus's intention, in so far as he may be saddled with one, was to fix the passing moment for eternity, to transport us to a timeless but earthly paradise, 'a romantic world composed in the image of his desire'.[100] But where the magic of timelessness fails, time hangs heavy; and where the passing moment will not pose for him, his mood in retrospect shifts so that idealism is mixed with caricature, and the physical presence from which he derived his inspiration is confused with disembodied day-dreaming.

So much this autumn augured well, but so much seemed to trail, like a silhouette, its shadow of disappointment: and as the autumn changed to winter, these shadows began to lengthen.

The turning-point came in October. It was in the second week of this month that Augustus sustained a terrible bang on the head, reminiscent of his bathing accident at Tenby. Ida, in a letter to her mother (16 October 1901), explains what happened:

'Gus has broken his nose and put his finger out of joint by falling from a ladder in the studio. The doctor came – a splendid big red-brown man – and sewed up the cut on the nose in two exquisite stitches. Poor Gus was very white, and bloody in parts. He is now a lovely sight, very much swollen and one red eye. His profile is like a lion. They say the scar will not show, and he will be well in a fortnight. The bone was a little damaged but it won't make any difference – we think his nose may be straighter after! He goes about and has gone to the doctor now to have it dressed. His finger only needed pulling and bandaging. It was bent back! he thought it was broken.'

After the first shock had passed, Augustus resolved not to be pinned down by his injury. 'My dear!' he wrote to Will Rothenstein, 'a bang on the head has never and will never down me. Au contraire I feel double the *uebermensch* with a great patch on my nose! I have paraded it before my students with great effect. At the Sketch Club the other night it must have been grand to see me point a dislocated finger of scorn and turn up a broken nose at these purblind gropings in pictorial darkness.'

Such was the devastating effect of this patch and bandage, he claimed, that students hurried over from other art schools, and his class over- flowed. But what is evident from his letters is that this fall had resur- rected his accident at Tenby, and that he was now, in a theatrical way, over-reacting to it, as if to break up some pattern formed on the earlier occasion. He wore his misfortune, humorously enough, like some sartorial accomplishment. But an extra wildness entered into his behaviour, as if he were pushing frantically against a door he feared might close on him.

In this mood the value of things altered. Up till now he had seemed to share the biological adventure of Ida's pregnancy, but suddenly it threatened him with confinement. The whole process was too long – a nine *days'* wonder was what he would have liked. He felt hemmed in. 'I really must come to town and see what my contemporaries are about,' he wrote in October to Will Rothenstein. But the following month he was writing: 'I fear I cannot come to London before our baby has squeezed its way through the narrow portals of life.'

London, now that he could not reach it, was marvellously desirable to him; while over Liverpool, so fresh and enthralling only that spring, a cuticle of boredom had begun to spread. London bought his pictures – sometimes the very pictures which Liverpool had rejected. But the Liverpool Academy refused him membership. He felt himself fallen among Philistines. 'I come now shattered from a visit to the Walker Art Gallery,' he wrote to Will Rothenstein. 'It contains the Ox Bovril of the R.A. shambles.'*

Because of Liverpool's antipathy to his work and because of his own spendthrift ways, he was often pressed for money and, on one occasion, obliged to settle a huge milk bill by handing over to the disgruntled milkman a number of masterpieces. 'I would paint any man a nice big picture for £50, if he paid down 25 first,' he complained to Rothenstein this winter. 'That's to say a good big nude.' But no one wanted his nudes. They were big, certainly; but they were not good, Liverpool decided: they were *ugly*.

His teaching, he increasingly felt, prevented him doing the work he panted after. 'What output can be expected of one who works at a school for 3 days!' he expostulated.[101] In such a climate of restriction, Mackay's lofty ideals seemed peculiarly irrelevant. 'Mackay talks grandiosely of a great art school with 300 a year for me and studio

* The Walker Gallery was soon to return this compliment. When, in 1902, a group of subscribers gave William Rothenstein's portrait of John to the gallery, it was catalogued anonymously as 'Portrait of a Young Man', under which title it can be seen there today. When offered John's official portrait of Chaloner Dowdall as Lord Mayor of Liverpool, the gallery refused it in 1918. The first example of his work it bought was 'Two Jamaican Girls', in 1938.

and my own will to follow – But I trust him not,' he confided to Will
Rothenstein (16 April 1902). Blotting out Mackay's vision of a university
palace with cloud-capped towers and a studio for every face of the day
was Augustus's actual curriculum – a treadmill that grew more irksome
to him each week. 'The three days I prostitute to foul faced commodity
weigh on my soul terribly,' he confessed.[102] 'My conscience is awaken-
ing and I see the evil of my ways.' By the early spring of 1902 his
university career had reached a point of crisis. 'I am now expected to
examine *all* the work done by every student (50 or 60) during the past
Session and choose an example of *each* to send to the National Com-
petition S. Kensington,' he complained to Rothenstein (9 March
1902). 'You can imagine the brilliant result of such a rummage. I draw
the line at that.' But if he drew the line too firmly he would be out of a
job; and without a job he and his family would have no money. He was
trapped.

What particularly galled him was the way in which the most respec-
table, and therefore most despicable, elements of university life had
begun to infiltrate his home. The wives of professors – some of whom
he abominated – made it their duty to call regularly on Ida carrying
with them pieces of black net, flannel nightgowns, wool socks or torn
lace, disused blankets, second-hand pin-cushions, half the veil of a
deceased nun, a miniature redundant stove for preparing baby's food,
and all manner of ritual and nondescript items pulled out of old cup-
boards. Whenever Augustus returned from his studio, there they were,
these affable vague females, tousled, dusty and bespectacled, parading
their offerings and ceaselessly chattering about Ida's baby – when
would it arrive? Would it be a boy? Would it be born before, after or
even at the same time as the other College baby that winter, Mrs Boyce's?
Under this pressure Ida began to entertain fantastic nightmares about
her baby. 'I dreamt last night that the baby came – an immense girl, the
size of a 2 year old child – with thick lips, the under one hanging – little
black eyes near together and a big fine nose,' she wrote to her mother
(16 October 1901). 'Altogether very like a savage – and most astonishing
to us.'

Augustus's reaction to these Liverpool ladies was more realistic: he
avoided them. Instead, he spent more and more time with his gypsies.
That autumn there was a gypsy fair on Cabbage Hall. The place was
crowded with carts and wagons, booths and cheap jacks; and every-
where the animal – both horse and man – was magnificently exhibited:
turgid and strenuous. What utterly damnable things were towns and
town-dwellers compared to all this! And how tawdry the tea-party
wives who filled his home seemed when contrasted with the gypsy
fortune-tellers, the very pictures of sin and supernatural knowledge,

with their stately bearing and their wicked unreadable eyes like black coals burning internally with concentrated hate – terrible to behold! Mesmerized, as if by some witch's spell, he would linger on there all day and half the night, till the fields and hills grew dark, a heavy mist enshrouded the tents, and the fiddlers one by one stopped their playing.

Like a gypsy himself, Augustus was growing ever more elusive, so that Ida seldom knew where he was from hour to hour. It was not only Cabbage Hall that he preferred to his own home, but other people's homes – the Rani's at 28 Alexandra Drive which, according to Albert Rutherston*, 'is good for the moral tone of us all'; and the defunct Gothic school near Rodney Street where lived the 'Doonie', the artist Albert Lipczinski's generous blue-eyed wife to whom, in order to avoid trouble, Augustus wrote his letters in deepest Romany. Whenever duty called, in particular at times of birth, death or summonses upon loyalty, he felt himself being pegged in by the stakes of moral and social responsibility and would burst through this ring to assert his independence. For independence was oxygen to him, and without it he would surely suffocate.

Ida took all this very calmly – though her dreams grew more fantastic.† 'Unless anything unusual happens the baby will not come till the beginning of January,' she had told her mother. With very un-John-like punctuality it was born, weighing six pounds exactly, on 6 January. 'My wife gave birth to a little boy yesterday,' Augustus wrote to Albert Rutherston (7 January 1902), 'and seems none the worse.' But his casual tone concealed a real sense of excitement.

For this event the household had been reinforced by the presence of Mrs Nettleship and a nurse. While Ida rested upstairs in her bed and the nurse perambulated the infant out in the park, Augustus sat down-stairs listening to Mrs Nettleship strumming out cheerful tunes on the piano. They reminded him of his father. After a fortnight Ida was allowed up. 'It was lovely,' she wrote to her sister Ursula. 'But I felt as if I were too light to keep down on the floor.' Her letters over the next few weeks were full of baby-news in which Augustus took as

* Albert Rutherston to Max Beerbohm (undated, Merton College, Oxford). 'The hospitality of Liverpool is truly wonderful,' he added by way of explanation, 'the women more so.'

† She dreamt of a tiny man, 'the size of the 1st joint of a finger', immensely charming, who drank milk out of a miniature saucer, like a cat, and who had a little boat in which he sailed off alone. He was very plucky, but eventually got lost and exhausted, frightened by the prickly larch trees, until he came across a tent in which lived Jack Nettleship, who took him up and carried him home, quite naked. 'Do you think the baby will be a lunatic, having such a mother?' she asked her father (24 December 1901).

keen an interest as she did, noting each grunt, each ounce in weight. 'I cannot realise I have a little boy yet,' she told Ursula (21 January 1902). 'I *cannot* believe I am his mother. I love him very much. He has an intelligent little face – but looks, nearly always, perplexed, or contemplative. I do not think he has smiled yet. He is a wonderful mixture of Nettleship-John.'

What exercised Augustus's mind more than anything else was the choice of a name. It was another sign of his own lack of identity that, with all his children, this choice should be such a perplexing matter. By the time the child's birth had been registered, one name alone had been settled upon – and that one was compulsory: Nettleship. As a preliminary Christian name, Augustus had given a good deal of consideration to Lewis. But no sooner had he firmly decided upon this than the baby would physiognomically alter so as to resemble an Anthony or a Peter. Then a new conviction would seize him: he would fix upon his son a good Welsh name – Llewelyn or maybe Owen or even Evan . . . But which? Perhaps, since the child would after all be only one-quarter Welsh this too was wrong. Whichever way he looked at it, the problem appeared insoluble – yet it had to be solved correctly. He brought to bear upon it his utmost concentration. His eyes bulged, the veins stood out on his forehead, he strode off for long walks, he tried out names in the proximity of the baby as it slept, he read books. By March, Honoré was in the lead and seemed almost certain to win. But by May, Ida was writing to Alice Rothenstein: 'Really I cannot tell you the baby's name, as we can't decide. Gus has said Pharaoh for the last few days. But it changes every week. I don't mind what it is.' To meet the pressure of such inquiries, Augustus was eventually hurried into accepting David by the end of the year. But for much of his childhood David was called Tony, then reverted to David – with the occasional variant of Dafydd, being a quarter Welsh.

At the beginning of March, Augustus, Ida and 'Llewelyn De Wet Ravachol John' left Canning Street and moved to 138 Chatham Street, very near the Sampsons. Here, for five months, they endured the rigours of family life. 'I wish you would tell me something about your baby,' Ida asked Alice Rothenstein. 'Does he often cry? Ours *howls*. He is howling now. I have done all I can for him, and I know he is not hungry. I suppose the poor soul is simply unhappy.' Augustus too was not very happy. The birth of his son, with all its novelty and curiosity, had turned his attention back into their home, but now the noise began to drive him out again. He did little in the house and Ida sometimes felt that she had more to do than she could manage. But though the strain began to tell on her, she did not complain. 'Baby takes so much time – and the rooms we are in are not kept very clean, so I am always dusting

and brushing. Also we have a puppy, who adds to the difficulties,' she told Alice. But, she went on: 'I think I enjoy working hard really.'

Augustus's pictures of Ida often show her encompassed by children. But she was far from being a conventional mother-figure whose *raison d'être* was child-bearing. In a sense she represented more of a mother to Augustus than to his sons. She did not feel about her first-born, she told the Rothensteins, as they did about theirs. 'I have not had any ecstasies over him,' she confessed. 'He is a comic little fellow, but he grumbles such a fearful lot. I think he would very much rather not have been created.' She never enjoyed that intense physical and possessive love of her children that the Rothensteins bathed in, and it is doubtful whether Augustus would have wished her to. 'How wonderful it seems to me how you and others love their children,' she wrote again to Alice about three years later. 'Somehow I don't, like you do. I love only my husband and the children as being a curious – most curious – result of part of that love.'

Augustus's attitude was different again. Though eminently un-practical in the home, he was one of those fathers who, while his children were infants with little developed character of their own, felt towards them a mother's jealous passion, primitive and possessive. Whereas Ida could not believe she was their mother, Augustus in certain moods almost seemed to believe it was he who had given birth to them; and at the start his relationship was more physical than Ida's, almost more female. 'Honoré is becoming a surprising bantling with muscles like an amorillo,' he wrote proudly to Will Rothenstein that spring. His new role as parent had greatly fortified his self-confidence. 'The arrival of Honoré gives me to see I cannot dally and temporize with Fate.'

One thing delayed him from severing at once his connection with the University Art School, and that was the fittest method of pro-cedure. 'I am wondering,' he confided to Rothenstein, 'which is the best way to get out of this school, whether to be chucked out or re-sign . . . the former I think would look best in the end.' He had made a number of friends in Liverpool, but they were all rebels in the uni-versity or individualists outside it. The very qualities that provoked hero-worship also stimulated aversion in people such as Charles Allen who taught sculpture at the university, and F. M. Simpson who held the Chair of Architecture. 'I become more rebellious in Liverpool,' he was to tell Alice Rothenstein – and it was true. He did dreadful things there. Mustering his courage at an important dinner party, he completely failed to rise to his feet when the King's health was drunk – 'it took some doing'. His name acted as a litmus paper, identifying what category of person one was. It was also the trigger for all manner of

scandalous gossip. 'Mr [Wyndham] Lewis has been spreading very bad reports about everybody in London,' Orpen wrote a little later this year to Albert Rutherston, '. . . his last was that John had been kicked out of Liverpool and that he was going to leave his wife.'

Augustus was unrepentant. 'The school may go to hell,' he announced – and suddenly he felt much better. Even his work improved. 'I have started some startling pictures,' he claimed. 'Ah! if they would emerge triumphantly from the ordeal of completion.'

To make up for the loss of his salary, he had arranged to paint a series of portraits. 'I have some jobs on hand now, enfin, mon cher!' he told Rothenstein in May, 'les pommes de terre enterrées si longtemps commencent à pousser.' He had also made some rapid decisions about the art of portrait painting to fit in with these new commissions. 'Nowadays, I fancy, portraits should be painted in an hour or two,' he decided (16 April 1902). 'The brush cannot linger over shabby and ephemeral garments.' Of the intermittent series of Liverpool portraits he now began, three were to be outstanding – those of Mackay, completed in June this year, of Kuno Meyer and Chaloner Dowdall done several years later. Some of the other portraits* convey a feeling that he had made an effort to be interested in his subject, but failed. The significance of this Liverpool period however was that he experimented in several directions, and did not devote his energies to recording obvious prettiness or following fashion, but in searching out a personal form of beauty and celebrating some glimpse of it that was unique to himself.

But he was no longer painting Ida. 'I have not sat to Gus for ages,' she confessed to Alice. Although matters were far from being so bad as Wyndham Lewis reported, Ida felt very acutely the need of some sympathetic companionship. 'I long for Gwen [John],' she had written the previous summer. Now, at long last, Gwen arrived. Her life, too,

* These included a rather military portrait of Oliver Elton, the English Literature don; a curious King Lear impression of Dr Muspratt, emerging from the shadows of a flat dark background; a sombre Victorian impression of Sir John Brunner, the radical plutocrat, whom John credits with mother-of-pearl flesh tones, a white beard and a moustache slightly ginger on one side; a likeness of Sir John Sherrington, the scientist and a special friend of Ida's, a timid, gauche figure, his hands clasped together on his lap, his tie knotted for eternity in a stranglehold, his eyes distrustfully peering through weak spectacles; and a comfortable, spongy portrait of Charles Reilly, rather sadly wrapped in a black-and-white scarf.

The portrait of Chaloner Dowdall (1909) is now at the National Gallery of Victoria, Melbourne; of Kuno Meyer (1911), at the National Gallery, Dublin; those of Mackay, Elton, Muspratt, Brunner and Sherrington at the University College Dining Club, Liverpool; and that of Reilly at the School of Architecture in Abercrombie Square, Liverpool. John did not paint Sherrington till the mid 1920s, and Reilly till 1931.

had not been easy. In the summer of 1901 she had gone to live at 39 Southampton Street with Ambrose McEvoy; but in December McEvoy became engaged to Mary Edwards, a damp-looking woman, nine years older than himself, who lived near the river. 'We were quite surprised,' Everett noted with relish in his journal, 'as he'd been running round before with Gwen John.' They did not marry immediately however, and an awkward period ensued with Gwen living at 41 Colville Terrace, the McEvoy family home in Bayswater, where, as if in mourning, the shutters were always closed to avoid paying the rates. It was from here that she had come to Chatham Street; and it was from Chatham Street that she wrote to Michel Salaman a letter that indicates the direction in which her life was to move. 'As to being happy, you know, don't you, that when a picture is done – whatever it is, it might as well not be as far as the artist is concerned – and in all the time he has taken to do it, it has only given him a few seconds' pleasure. To me the writing of a letter is a very important event! I try to say what I mean exactly, it is the only chance I have – for in talking, shyness and timidity distort the very meaning of my words in people's ears – that I think is one reason I am such a waif . . . I don't pretend to know anybody well. People are like shadows to me and I am like a shadow.'

But with a few people, mostly women, Gwen was at ease – and one of them was Ida. She could trust Ida, she told Salaman, 'with all my thoughts and feelings and secrets'; and Ida felt the same way about her. Gwen had been hurt by McEvoy – 'Sister Gwen upset', Augustus noted.[103] But with him she did not welcome such closeness, for Augustus was one of those who made her feel a shadow. An etching he did of her probably during this visit[104] shows her as a very upright figure, bristling, on her guard, the daughter of Edwin John. Her expression is impassive, giving nothing away. On her head sits a pancake hat with a hedgehog on top; her hair is pinned into a tight bun; her dress firmly tied at the neck; her lips buttoned. Yet there is a feeling of sadness in the eyes, an impression of loneliness, of reserve and the inability to share emotion. There is no gentleness, no hint of passion. The etching is almost suffocated in lines.

'I have been very busy with the baby,' Gwen wrote to Salaman. She would take him out for 'air', and, quite unawares, scandalize the neighbourhood by sitting unconcernedly on the nearest doorstep whenever she felt like a rest.

After Gwen left, Ida felt her own isolation with a new sharpness. In the middle of April she went with the baby for a few days to London to see her father, who had not been well. 'I am left deserted,' Augustus exclaimed to Will Rothenstein (16 April 1902). 'As a consequence I lay abed last night with a moonlit sky in front of me and chased

infinite thoughts. Decidedly it is inspiring to lie alone at times. I fear continued cosiness is risky . . . I wish I had somebody to think with.'

He had never pretended to be an 'exponent of the faithful dog business' – it was not natural; certainly not natural for him. Ida knew this when she married him. She had made her bed, as it were, and sometimes she would have to lie in it alone. He trusted her to recognize that the overpowering attraction for other women which sometimes swept over him did not diminish his love for her. He loved her and would always love her – it was important she understood this – so long as they were not handcuffed together, so long as their ties were sufficiently elastic. He needed to play truant – she knew this – but he would always return to her, choosing the moment that best suited him. But if his freedom were curtailed, if he were criticized or prevented from acting as his energetic nature demanded, then a hot-and-cold madness would break out in him and instinctively he would say and do fearful things – things for which he was not responsible. It was as if another being had taken control and he was no longer 'himself'. The last thing he wanted to do was to hurt Ida, but too much 'moral living' might destroy them both

At the end of July they left Liverpool* and returned to live in Fitzroy Street. Both of them, for rather different reasons, were happy to be back in London. But the 'cosiness' of their married life was almost at an end.

3 · WHAT COMES NATURALLY

In the eighteen months since her marriage Ida had changed considerably. 'Ida with her shock of black hair, as wild as a Maenad in a wood pursued by Pan,' Arthur Symons[105] had romantically pictured her. 'Intractable, a creature of uncertain moods and passion. One never knew what she was going to say or do. . . . She had – to me – the almost terrible fascination of the Wild Beast. There was something almost Witch-like in her.' This had been her fascination for Augustus. But with the metamorphosis from Ida Nettleship to Mrs John she had developed into a more substantial figure – both physically, following the birth of David, but also in character. Gone was the feyness, the whimsicality of her early Mowgli letters; and gone too was much of her moralizing. Her intenseness had been the longing of a vigorous nature for those aspects of reality from which young Victorian ladies were

* 'I would subscribe to make Augustus John Director of a Public House Trust,' Walter Raleigh wrote to D. S. MacColl (27 May 1905). In fact John's time at Liverpool was later commemorated by a new public house, 'The Augustus John', which has been erected next to the postgraduate club.

hermetically protected. Now there was reality enough – she was glutted with it. Her character gained unexpected depths in grappling with the new problems that confronted her; she grew more resilient, more direct, at times more ironical. But, in Augustus's eyes, she lost something of her mystery. Her presence was more obvious; she grew more tired, and she was forced to give up painting in order to become a mother. It was a full-time job to which she could not easily resign herself – 'I certainly was not made for a mother,' she admitted to Alice Rothenstein (1903). She was made, she felt, for Augustus. She loved him, wanted to be his mistress. But the roles of mistress and of mother were often in conflict, and in the nature of things – though not in her nature – the mother began to eclipse the mistress.

'Look what a grand life she had,' her sister Ethel later wrote,[106] 'going full tilt.' But really it was life that had gone full tilt into her. The first blow came very shortly after her return from Liverpool. Her father had fallen seriously ill. Though having great difficulty in breathing, he would gasp out page after page of Browning day after day, until gradually he grew too weak. Ida and Augustus were with him during this final illness, though for much of the time he was barely conscious, could recognize no one, but liked the daylight and kept turning his head towards the window. After Browning was beyond him, he uttered very little. Once he called out: 'Are you there, Ethel?' and, after a silence, called back: 'Yes, I thought you might come and see us through this risk.' Every day Ida would go across to Wigmore Street to be near him. 'Old Nettleship is at his last,' Augustus told Will Rothenstein. 'He will die before the morning it is thought. Ida and I go round at midnight to see him. He has been in a high temperature . . . and his mind has not been clear.'

Somehow he survived that night, and in a moment of consciousness assured Augustus that God was 'nearer to me than the door'. Next morning his arm went up like a semaphore and could not be kept down until, quite suddenly, he died. 'The dear old chap was quite unconscious,' Ida wrote afterwards to Will Rothenstein (1 September 1902), and did not suffer, except in the struggle for breath, and at the end he was quite peaceful. He was so grand and simple.'

Besides Augustus, her father had been the only man who meant anything to Ida. Now she would have to rely on Augustus alone. As if sensing this extra responsibility, he grew wilder. He was meant to be hanging his pictures in the Carfax Gallery,* but this depressed him. To fling off his depression he drank more. 'I thank you sincerely for

* 'The Carfax directors are not inspiring companions and numerous other people came in with whom I could not feel fortunate,' John explained in a letter to Will Rothenstein.

bearing me home in safety,' he wrote to Will Rothenstein after one night's entertainment. 'I was utterly incapable. I had been imbibing a quantity of bad rum. I knew it to be poison yet drank it with relish. ... After having slept 3 hours I awoke perfectly well again.' His powers of recovery were truly remarkable – and he tested them to the full. 'John had the drinks,' L. A. G. Strong wryly noted in his diary,[107] 'and his friends had the headache.' One night Will Rothenstein received a telegram: 'Bail me out, Vine St, John.' Another night he came across him prostrate on the pavement – this while his father-in-law was dying.

The pattern that had established itself in Liverpool was now broadly repeated in London. By the autumn Ida was pregnant again. She was visited at Fitzroy Street by all her old jungle friends, and by her family, in particular her mother who brought along, brightly intact, all her old grievances against Augustus. It was as if the two of them were in a tug-of-war over the possession of Ida – but however deeply attached Ida was to her mother, she had given herself once and for all to Augustus. He sincerely tried to get on with Mrs Nettleship, but when she did not respond to him his temper would get the better of him and he would storm out of the house.

'Our life flows so evenly and regularly, I love it,' Ida wrote to the Rani soon after her return to London. 'But,' she added, 'I'm afraid Gus finds it rather a bore.' He had begun to find something of a home from home in the Café Royal. By the beginning of the century, the Café Royal had become the rendezvous of many artists and writers living in London. With its exuberant neo-classic ornament, its abundance of gilt, its ubiquitous flashing mirrors, its crimson velvet, it formed a cosily grandiose setting for such gatherings. It was unique in Britain, a café-restaurant on the French pattern where people could wander from table to table, sit drinking and talking with one group, move on to another. It was more popular with the *avant-garde* than the academic, and to be *avant-garde* meant, in some degree, to be an exile from Paris. 'If you want to see English people at their most English, go to the Café Royal,' Beerbohm Tree advised Hesketh Pearson, 'where they are trying their hardest to be French.' The atmosphere owed something to the 'nineties – *crème de menthe frappée* drunk through straws; and drawings done on menus with napkins plunged into Grand Marnier. In the opinion of Max Beerbohm, the Café Royal was 'life', and in such a world Augustus loomed even larger than life.

He liked the place for its casualness, for the easy coming-and-going, the undemanding companionship. He liked it because, to a large extent, and by sheer force of personality, he dominated it. His Shakespearian domed forehead; his beautiful eyes, observant, outstanding in the

literal sense that they stood far out, seeming to transfix his audience; his voice so soft and laconic, confiding, ruminating, rumbling; his noble manners, formal yet sympathetic; the hands which threw such a spell about his conversation; and that alarming residue of rage and outrage which could so innocently be stirred up: these ingredients contributed to a presence that could, almost physically, claw you into its orbit. 'Of all the men I have met,' wrote Frank Harris, who had a fine appreciation of such things and who claimed to have met everyone, 'Augustus John has the most striking personality.'

Though he tended to be morose at home and very silent, particularly when he was working hard, at the Café Royal he was a different person and, after a few drinks, wonderfully exuberant. Here, by popular acclaim, he was acknowledged a Bohemian king, with the waiters his courtiers, all his companions guests. In such a genial climate, his uncertainties dissolved, his morale shot up, and he inflated himself terrifically. He could be arrogant, childishly offensive to people, and he would grow sullen when others became too talkative. He liked to be at the centre of things, and because this suited him so well and he could exercise there such rare charm, people were generally happy for him to have the star role. He was unbelievably hospitable. Almost always he was left with the bill, and would pay it uncomplainingly with a huge fistful of notes that represented all the money he possessed. In a sense he paid friends to entertain him, and he valued them as entertainers rather than friends. His generosity contributed to the aura of his attraction, which was agreeably complicated by a vein of sardonic humour. One evening in the Domino Room, George Moore was denigrating him to Steer and Rothenstein – 'Why, the man can no more draw than I can!' – when Augustus himself walked in, apparently rather drunk, and sat down at their table. He took no notice of Moore, who tried to engage his attention, but in complete silence, Will Rothenstein recorded,[108] 'he took out a sketch book, and made as if to draw, doing nothing, however, but scribble. Moore, flattered, imagining John to be sketching him, sat bolt upright not moving a muscle. When John, tired of scribbling, shut up his book, Moore asked to see it, and turning over the pages, said unctuously, "One can see the man can *draww*." '

In the two most famous paintings of the Café Royal, those by Adrian Allinson and William Orpen, Augustus is prominently depicted. He liked best the company of other artists and of models – though he did not talk much about painting; of writers, preferably of the romantic school; and of eccentrics – magicians and bimetallists, Celtic gentlemen with a knowledge of archaeology, some philosophical or mathematical ambitions or perhaps a smattering of Sanskrit or Hindi, social

creditors, practical jokers, picturesque anarchists of the Kropotkin school, Flamenco dancers, Buddhists – and all those who had been stranded in some shallow tributary away from the mainstream of twentieth-century progress.

With such companions he felt a natural affinity – for was he not also an exile from the modern world, however loudly, in fits and starts, it might applaud him? Was he not a revolutionary in almost everything except his painting? 'Be regular and ordinary in your life, like a bourgeois,' Flaubert had advised artists, 'so that you can be violent and original in your works.' But Augustus could not husband his energies. He was extraordinarily prolific, but he squandered his vitality in acts of non-conformity. 'Perfect conformity,' he once remarked,[109] 'is perhaps only possible in prison.' His whole life was directed to avoiding, or escaping from, any form of imprisonment. In so far as he was revolutionary, it was not against the past but the foreseeable future, with its threat of rigid standardization and more implacable rule of law. Like many Celts, he hung back from entering the twentieth century. Perhaps the last person to manage this with complete success was W. B. Yeats, whom Augustus much admired. Both were untouched by industrialism and, being romantically involved in the mystery and poetry of life, shunned the arithmetical anonymity of our highly organized society with its accent on the enlargement of the social conscience, the betterment of civic existence. But Augustus's romanticism became contaminated by the tame and tidy modernity he abhorred. 'The flower of art blooms only where the soil is deep,' Henry James once wrote. In England, especially after the First World War, Augustus could find little depth of soil, could not achieve the full efflorescence of which he felt himself capable. 'The march of progress will leave the struggling artist behind,' he warned.[110] 'He is always an outsider, shunning the crowd, wandering off the beaten track and dodging the official guide and the policeman. Perhaps in a dream he has caught a glimpse of the Golden Age and is in search of it: everywhere he hits on mysterious clues to a lost world; sometimes he hears low music which seems to issue from the hills; the trees confabulate, the waters murmur of a secret which the sky has not forgotten.' Yeats had not lost this secret – policemen and official guides were no obstacles to him. His dream was a vision seen in twilight, a vision that held steady, not, as with Augustus, 'a passing light, a mere intangible, external effect . . . a dream that lingers a moment, retreating in the dawn, incomplete, aimless'.[111]

Augustus was seeing something of Yeats at this time at Will and Alice Rothenstein's house in Church Row, Hampstead. Alice was in the habit of entertaining a small elite of writers and artists that included,

besides Yeats, Max Beerbohm, with his immaculately tailored human nature, so amusing at a distance, so invisible near to; W. H. Hudson, hopelessly and eternally in love with Alice; Cunninghame Graham, delivering a string of improper stories all decently clothed in his impenetrable layer of Scottish dialect; Walter Sickert, decked out, with his determination not to be seen as aesthetic, in a roaring check shirt and leggings, looking like some farmer from a comic opera; Epstein, as innocent and truculent as Augustus himself, smelling like a polecat; and William Nicholson and James Pryde, the dandified Castor and Pollux of poster art.

With Wyndham Lewis, to whom the Rothensteins also introduced him, Augustus now struck up a lifelong precarious friendship.* Lewis had come from Rugby to the Slade, a good-looking, shy, gloweringly ambitious young man, who drew with thick black contours resembling the lead in a stained glass window. He could be relied on to act unpredictably, yet in Tonks's opinion had the finest sense of line of any of his students. Rothenstein took him to Augustus's top-floor flat, which he himself would later occupy, probably in the summer of 1902 – 'there was a noise of children', Lewis afterwards recalled, 'for this patriarch had already started upon his Biblical courses'.

Augustus had by now attracted a great deal of steam to himself, and for a time Lewis, made heady by this atmosphere, became his most formidable disciple. 'I was with John a great deal in those early days in London,' he wrote in *Rude Assignment*. '. . . Unlike most painters, John was very intelligent. He read much and was of remarkable maturity.' They stimulated and exasperated each other in about equal measures. Lewis was much impressed by all that Augustus had so rapidly achieved. His success in art and with women appeared phenomenal, and by associating with him, Lewis seems to have felt, some of this success might rub off on him. Augustus, on his side, was flattered by Lewis's veneration. Here was someone mysterious and remarkable, a poet hesitating between literature and painting, whose good opinion of him served to increase Augustus's self-esteem. He seemed a valuable ally. For whatever else he felt, Augustus was never bored by Lewis, whose dynamic progress through life was conducted as if to outwit some invisible foe. This involved a series of improbable retreats – to Scandinavia even, where he would find a letter from Augustus demanding: 'Tell me Lewis what of Denmark?' or – 'Is Sweden safe?' Such

* In January 1903 John did two etchings of Lewis, and in the same year an excellent drawing and one of his very best oil portraits 'full of Castilian dignity', as John Russell described it, 'displayed in a moment of repose'.
 Lewis did a drawing of John that is reproduced in his volume of memoirs, *Blasting and Bombardiering*.

places were not only safe, Lewis would hint in his replies, but the arenas of unimaginable conquests.

Very aware of his friend's superior education, Augustus strove to match Lewis's 'calligraphic obscurity' by what he called 'linguistic licence' – a fantastic prolixity that he thought the intellectual tenor of their relationship required. The result was an exchange of letters, part undiscoverable, part indecipherable, covering over fifty years, that is almost complete in its comic density. Both were flamboyantly secretive men with bombardier tempers, and their friendship, which somehow endured all its volcanic quarrels, kept being arrested by declarations that it was at an end – an event upon which they would with great warmth congratulate themselves and each other. Yet such was the good feeling generated by these separations and congratulations that they quickly came together again, when all the damning and blasting of their complicated liaison would start up once more.*

Their correspondence, on both sides, is extremely generous with offensive advice which they attempt to make more palatable by adding

* 'I called you poltroon for not daring to let me know before in what contempt you held me – when I had admitted you – fondly – almost to my secret places, for not honouring me so far as to be frank in this,' John wrote (June 1907) in a letter that gives the flavour of their explosive friendship. 'I called you mesquin for jesting at my discomfiture, for playing with words over the stricken corpse of our friendship, ever sickly and now treacherously murdered at a blow from you, poor thing! And I called you bête for so estimating me as to treat me thus – cavalierly – for though my value as a friend has not proved great, it is neither nil nor negligible. And I say this from the very abysm of humility. Nor am I one to be dismissed with a comic wave of the hand . . .

'You may not believe me when I say that the "temper" you have remarked in me so often of late (too often) was the *best* part of the "friendliness (not perfect) I showed towards you". Must I too confesss that on my side I have observed of late in you, *manners*, which would be more appropriate among strangers but which perfect friendship disallows. Will you be astonished to learn that a sensibility only less extravagant than your own has occasionally and inconsequently and involuntarily irked as at that subtle friction which subsists between two bodies that *are* not but which *have* been in contact? The wall you think fit to surround yourself with at times might be a good rampart against enemies, but its canvas bricks cannot be considered insurmountable to friends, and indeed (imagining them detachable) it would be an impertinence to level them in all seriousness at one's devoted head. I am as little inquisitive by habit as secretive by nature. I have never wished to, I have never committed the indecency of trespassing on the privacy of your consciousness, of which you are rightly jealous. But in a *friendly* relationship I expect, yes, I expect, a frankness of word and deed as touching that relationship – an honest traffic – within its limits – a plainness of dealing, which is the politeness of friends. *That* we have never practised – you have never – it seems to me – given the Index of friendship a chance. It would appear that you live in fear of intrusion and can but dally with your fellows momentarily as Robinson Crusoe with his savages before running back to his castle . . .'

the odd 'mon vieux' or 'old fellow'. Augustus frequently intends to return Lewis's letters by post in order to get him to 'admit [that] no more offensive statement could be penned'; but almost always he mislays the letter or, in his first fit of uncontrollable fury, flings it irrecoverably into some fire or sea. He is constantly being dumbfounded by Lewis's reminders to lend him money coupled with his forgetfulness in repaying it; and by his insistence that Augustus was influencing mutual friends to his discredit. His style grows more and more convoluted in grappling with these groundless charges until it becomes blameless of almost all meaning. Then, suddenly, the clouds clear and in a succinct moment of retaliation he announces that Lewis's drawings 'lack *charm*, my dear fellow'.*

* 'Now, as for your recent drawings of which you sent me photostats, I must at once admit my inability to discover their merits, qua drawings,' John wrote to Lewis (undated). 'They lack *charm*, my dear fellow (from my point of view that is).' In *Blast*, No. 2 (1915), Lewis wrote an article called 'History of the Largest Independent Society in England', in which he called John 'a great artist', adding that he was lacking in control and prematurely exhausted – 'an institution like Madame Tussaud's'. He also credits John with bringing some exotic subject matter into English painting, before going on to describe his gypsy cult as hothouse and *fin de siècle*. Shortly after this article appeared the two painters met one night at a restaurant. John, all smiles at first and with a 'woman-companion', invited Lewis to join them, but later in the evening, when the talk turned to *Blast*, he lost his temper.

Next day John wrote to apologize. 'I must have been positively drunk to assume so ridiculously truculent an attitude upon such slender grounds. Your thrusts at me in "Blast" were salutary and well-deserved, as to the question of exact justice – any stick will do to rouse a lazy horse or whore and the heavier the better. I liked many of your observations in Blast if I don't feel the particular charm of those designs which last night I characterized as "pokey". Probably "charm" is quite the last thing you intend. I think pokiness is an excellent and necessary element of design and I understand and admire your insistence on it. But I deplore your exclusion of all the other concomitants provided by an all too lavish creation – and with which I imagine none is better able to deal than you. But no doubt you have plans laid which, for all I know, may comprise a final emergence from a straight and disciplinary bondage to limitless caprices of Freedom.'

John concludes his painfully handsome apology by inviting Lewis to 'this bloody district [Chelsea]. I wish you'd call. I'd much like to see you.' But Lewis, in his answer, writes: 'We will not meet again in any friendly way, if you do not mind.' As to John's work, Lewis 'resented your stage-gypsies emptying their properties over your splendid painter's gift'. Along with tilting at John's 'Borrovian cult of the Gitane', he praises his substantial talent – 'I consider you had, pour commencer, as much talent as a man may comfortably possess.' But he had shipwrecked himself on 'all sorts of romantic reefs'. His work had become stagnant after too much buccaneering, though he was sure, Lewis conceded, to enter the history books as 'a figure of controversy, nevertheless'.

As to their patched and splintered friendship, Lewis affirms that he is reluctant to go on scrapping and that John had better believe him 'unless you want your head broken'. Being active and strong, he explains, he would certainly 'try and injure your head' if they met. So they had better not meet – though John must not attribute this 'gentleness' to lack of spirit.

The whole relationship is bedevilled by ingenious misunderstanding. Each credits the other with Machiavellian cunning, while assuming for himself a superhuman naïvety. Lewis is amazed that Augustus never invites him for a drink; Augustus is perplexed that Lewis is never able to visit him – when he does so, Augustus is always out; while Lewis, on principle, never answers his doorbell. They make elaborate plans to meet on neutral territory, but then something goes wrong – the wrong time, the wrong place, the wrong mood. Lewis becomes increasingly irritated that Augustus so seldom writes. Augustus becomes irritated because when he does write his letters go astray, Lewis in the meantime having moved in darkest secrecy to some new unknown address – such as the Pall Mall Safe Deposit. The letters which do arrive express very adequately this irritation fanned, in Lewis's case, by eloquent invective, and in Augustus's by a circumlocution that marvellously avoids answering the most innocent of Lewis's inquiries. It is a most stimulating exchange.

Life itself – beyond Fitzroy Street – was constantly stimulating; but at home it was the old routine. On 22 March 1903 Ida's second child was born. Augustus had confidently predicted a girl, but 'instead of Esther, a roaring boy has forced admittance to our household', he told Will Rothenstein. '. . . Ida welcomes him heartily.* But what will David say?' The boy, originally referred to as 'nice fat slug' or 'pig face' ('his face is like a pink pig's', Ida boasted to Mrs Sampson), was eventually called Caspar – and nicknamed Capper – and a gate was fitted at the top of the stairs outside their flat to prevent the children from falling. Suddenly their home seemed very crowded.

In a highly oblique passage of *Finishing Touches*,[112] his posthumous and unfinished volume of memoirs, Augustus refers to himself under the pseudonym of George. George, a new recruit of Will Rothenstein's and said to be on the threshold of a brilliant career, is 'only just recovering from the nervous breakdown following his recent marriage'. At the informal parties in Will Rothenstein's house he found 'an atmosphere no doubt very different from the climatic conditions of the home-life to which he was as yet uninured . . . he began to expand and blossom forth himself, in a style combining scholarship with an attractive diffidence and humour. He felt perhaps that here was a means of escape from the insidious encroachments of domesticity, and accordingly attached himself to Will Rothenstein with the desperate haste of a man caught in the quicksands.'

If he expanded here and at the Café Royal, he at once contracted

* 'It was *much* nicer to have Gussie than the doctor, and a gamp twice a day than a hovering nurse in a starched cap,' Ida wrote to the Rani. 'Lorenzo Paganini is quite lovely and so quiet.'

again when he got home. This concertina motion, to which Ida responded with a mixture of excitement and monotony, had by 1903 produced a strange fragmentation of himself. The delicate balance within us which we tend to take for granted had, in his case, been tilted to a critical angle. The pressures to which he felt himself increasingly subjected since marriage had made his condition more and more acute until it reached what he himself called 'a nervous breakdown'. His symptoms were several: maddening vagaries, fits of unexplained temper, sudden withdrawals from human contact, a lack of application or self-discipline, and perhaps most vital of all a tremendous difficulty in sustaining personal relationships. It seemed baffling that someone of such intelligence and physically strong physique could at times be so will-less. The only Will he had, apparently, was Rothenstein whose remedy was to send him off on marathon walks round Hampstead Heath, to lend a sympathetic ear to his difficulties, and sermonize upon the rewarding virtue of hard work.

Yet Augustus was not indolent. He could work well if tactfully organized. But to organize him without provoking his temper was a full-time operation of ruthless diplomacy that Will Rothenstein, for all his energy and enthusiasm, could not begin to do, and even Ida, continually pregnant and encompassed by domestic duties, was unable to manage. It needed a team to organize Augustus, and a team was precisely what he was about to assemble round him: a team of patrons and art-dealers and of women. He did not know why he needed all this, only that he must have it. His first steps to achieve what he wanted were to cause great anguish, imperil his marriage and bring him to a state which, in his autobiographical synopsis, he described as 'madness'.

4. TEAM SPIRIT

To the winter exhibition of the New English Art Club, late in 1902, Augustus had sent two major pictures. The first of these, 'Merikli',[113] was a portrait of Ida holding a basket of flowers and fruit painted as if by an Old Master: Rembrandt, with a helping hand from Velasquez. Ida's figure, touched by warm light, emerges enthusiastically from the dark shadows of the background. The colouring is sombre, the tone low; the handling is conventional and the pose very fixed, making the cumulative effect rather artificial. But there is a possible *double entendre* in the fact that, although her basket is full of roses and cherries, she proffers – a daisy. As a portrait, it lacks the monumental force of, say, 'The Smiling Woman' of a few years later; but it was voted Picture of the Year at the exhibition, and although contemporary opinion differed

as to its merits, it is generally regarded now as Augustus's first important portrait in oils.

The other portrait was of an Italian girl, Signorina Estella Cerutti. In the opinion of John Rothenstein,[114] this picture 'proclaimed him a master in the art of painting'. It 'is clearly stamped with that indefinable largeness of form characteristic of major painters'; it 'powerfully radiates a cool light'; it is modelled 'as plastically and as surely as a piece of sculpture'; it 'indefinitely holds the spectator's interest, without, however, yielding up the secret of the artist's power'. Estella Cerutti is a splendidly buxom creature. There is more than a hint of coquetry in her expression and the effect of foreignness has been well caught. Somehow one is given the sense of a figure, wonderfully pale, walking past a window – rather than held in a frame – and casting a backward glance.

It was a glance that Augustus followed. 'Esther' Cerutti, as he called her – the very name he was to have given his second child had it been a daughter – lived below them at Fitzroy Street. In the spring and summer of 1903 he made numerous drawings of her, at least one etching,[115] and painted 'several masterpieces', showing her rich statuesque appearance and a certain Italianate strangeness of manner. Two or three times a week she would come up to their flat, and he would sometimes descend to hers. But this proximity put an additional strain on married life. Ida admired, envied and was irritated by Esther in the most confusing way. What style she had – how languid, large! She was an accomplished pianist, dressed superbly well on all occasions and suffered from such interesting illnesses which she gracefully set to music. It was almost impossible not to be provoked.

Augustus seemed held in tension between the two of them, as if between two magnets, motionlessly suspended within their opposing fields of attraction. 'For days I have been inert and dejected,' he confessed to the Rani. 'I cannot account for the dejection except as the necessary complement of inanition, for my reasons to hope remain palpable and the same. Dearest Lady! how we married people need to cling and pull together and so make this holy state by union a force – for I begin now and then to suspect its weakening – or perhaps it is that I am a weak member, but then at least I am a link in the nuptial chain. But I think we ought to plan it so that we have the laugh of the others. . . . As to Miss Esther I don't know whether to be mühen again or not to be mühen, both courses being fraught with problems distant and immediate. At present I slumber in the studio surrounded by my works.'

To side-step his problems he went that summer on a 'short but brilliant campaign in Wales with the admirable Sampson'. When he

Ida John

Dear Miss Tyrwhitt I feel it is a
now return for you hereafter better
seen than have tattooed myself
throughout — but that I candidly
I have with else to tell you about.
My sister was here but
to take you home
I mean to accompany you —
that —
week
until I be
turn?

I will end my
Rembrandt book.
Has Miss Oliver distinguished herself?
Your friend A.S. ...
How is your brother who is
an apparition of mine.

Delightful reminiscence!
Ruskin card I know. you

Steed's today is certainly an event!
and now what he'd look like
I don't suppose so. So
just so long as the one
for cheer — more
like the perhaps-
tattoo? that only you
can no longer with
justice call me
a beardless boy
(so while he been) tattooed up
I have developed a thick stubble

Steed always
was fat though
he must be a
remarkable object
now
I expect to see
something like this.

returned, the problems were still waiting for him, so he immediately set off again, this time for Liverpool with his sister Winifred, who was sailing to America. Once he had put her on board, he combed the town for old friends, finding none. 'The Town proved most inhospitable,' he complained to the Rani. ' . . . I had hoped to see Sampson – but alas! his house proved nothing but a silent tomb of memories with those wonderful blinds drawn gloomily down.' The Rani herself was away in the country, though her elusiveness, he admitted, was stimulating in a disappointing sort of way. 'Curiously enough 'tis to a dream I owe my most vivid, most tender recollection of you. (And they call dreams vague . . . hazy . . .). It happened in Liverpool the last night I spent there. (Heaven knows how I spent the next!)' The following day he 'fled down Brownlow Hill to the station and so home again'.

A letter Ida sent Alice Rothenstein about this time indicates some of the changes that were taking place in the John household. From her mother Ida had got a few pieces of furniture, including their bed; on the walls of each room she had put plain white paper, and suspended buckets of roses from the ceiling. To do the cooking she had employed a rabbity young girl named Maggie – tempted, she maintained, by 'friendly lettuce' – and a maid called Alice whom David insisted on calling 'Aunt Alice'.

Her day began at 5.30 a.m. and ended at 7.30 p.m. Between day and night there were three delightful hours of idleness: then at 10.30 p.m. the night work began – 'it is the hardest part,' she told the Rani. 'I am breaking the baby of having a bottle at 3 a.m., and it entails a constant hushing off to sleep again – as he keeps waking expecting it. Also he has not yet begun to turn himself over in bed, and requires making comfortable 2 or 3 times before 3 a.m. This is not grumbling but bragging.' Nevertheless, it was a tremendous relief to her to get rid of the children for short spells. That summer they went down with Maggie to stay at Tenby, and Ida felt almost guilty at her sense of liberation. 'It is most delightful without them,' she admitted to Alice Rothenstein.

As soon as their flat was emptied of children, it filled up again with 'aunts' – models for Augustus. Esther, magnificently attired in expensive dresses almost bursting at their fastenings, came and posed, while Ida, who was not Mrs Nettleship's daughter for nothing, set to work creating clothes for herself so as 'to have at least one pretty feather to Esther's hundred lovely costumes. I shall have to come down naked in my fichu, for how can one wear grey linen by her silks and laces?'

But while Ida was anxious at being outshone by Esther, Esther was

about to be eclipsed by another girl. In the same letter to Alice Rothen-
stein, Ida mentions that 'Gus and the beautiful Dorelia McNeill are
here . . . Gus is painting Dorelia'. He was, she adds, feeding Dorelia
up for her portrait. This is the first mention of the legendary Dorelia,
who was to remain at the very centre of both Ida and Augustus's lives
until each died, and to play a short intense part in the life of Gwen John.

Who was Dorelia? To anyone acquainted with the work of Augustus
John she is a very familiar figure. Over a period of sixty years, he drew
and painted her obsessively, and her likeness can be seen in galleries
all over the world. Yet what these pictures convey is not her identity
but her mysteriousness. They never seek to analyse her character but to
enshrine the aura of mystery that Augustus spun about her, like a
cocoon. The most celebrated portrait of all, 'The Smiling Woman',[116]
has often been likened to the 'Mona Lisa', for in both cases the artist
himself seems ignorant of the smile's genesis and meaning, is content to
be its captive. Another picture,[117] at least as fine though in a quite
different style, is more mellow and depicts her as a dream creature who,
on our waking, continues to haunt and baffle us.

In this sense, Dorelia was a creation of Augustus's. He made her
enigmatic; he made her his ideal woman. What he desired from women
was at once very simple and very difficult to achieve: it was the un-
known, timelessly preserved intact; it was fantasy blended with reality.
Though he felt a romantic reverence for high birth – 'you darling little
aristocratic love', he used to call the Rani – he disliked sophisticated
women on the whole, and avoided women famous for their intellect
and wit. Great physical beauty and fragrant simplicity were what
exercised his spirit to the utmost, for behind these qualities seemed to
lurk the ultimate secret, the wonder of life. Cleverness he could find
elsewhere, if he needed it: he could find it in men. But in some women
he could behold the inscrutable moving in step with his moods,
magically deceiving tedium. For some men, stupidity mixed with a
powerful dose of beauty produces this paradox, this undying, spell-
binding awe. For Augustus this was not so – stupid women, especially
when good-looking, he had noticed, were inclined to talk too much.
What he wanted was something rarer: silence.* Silence was freedom.
Into silence, physically eloquent, he could read everything and nothing;
like Nature herself, it defied explanations, soared above them, held
him entranced.

All that Augustus aspired to is suggested by the fantasies he wove

* 'Beauty is best silent, though the birds belie me,' John wrote in a copy of
Chiaroscuro which he gave to Addyer-Scott. 'Speech may interrupt its spell: the
eternal mother may smile indeed but hardly laughs aloud, and if it speaks it will
surely be in a whisper . . .'

around Dorelia. In his pictures of her, we see Dorelia as tall, with a swan's neck and perfectly-proportioned head, often the mother-figure. In truth she was rather short, with a larger head and no more the conventional mother than Ida. He dressed her in broad-rimmed straw hats, their sweeping lines like those of the French peasants'; and in long skirts that reached the ground, with high waistlines and tight bodices, like the costumes of the peasant women of Connemara: but she was not a peasant, French or Celt. He laid a false trail across the life of a gypsy girl called Dorelia Boswell, so that many concluded that his Dorelia was probably a Boswell and certainly a gypsy: she was neither. He called her 'Ardor'; he called her 'Relia' and he called her Dorelia, and finally he called her 'Dodo': but none of these were her real names.

Dorothy McNeill had been born on 19 December 1881 at 97 Bellenden Road, Camberwell. Her father, William George McNeill, was a mercantile clerk, a position he held unwaveringly, neither sinking nor rising from it until eventually promoted, through age, to the rank of retired mercantile clerk. Son of the stationmaster at Peckham, he had married a local girl, Kate Florence Neal, the daughter of a dairy farmer.* They were a forgettable couple. He cultivated a nondescript appearance and a presence largely unobservable: she made lace. Together they earned the collective nickname of 'Mr and Mrs Brown'. But all their seven children (of whom Dorothy was the fourth) were extraordinarily handsome – mostly small with very dark complexions, prominent mouths curving downwards, and soft voices gentle and low, blue-black hair and large eyes that were brown and brooding.

Each of the four daughters had been taught some profession. Dorothy learnt to type. Her first job, at the age of sixteen, was for the editor of a magazine called *The Idler*. Then, for a short time, she worked for an author; but by 1902 she had become a junior secretary copying legal documents, in the office of a solicitor, G. Watson Brown, in Basinghall Street. She did not appear discontented, but her personality was very passive and she was not communicative, so it was difficult to know what she really felt. Another young typist in the office, Muriel Alexander, remembers that Dora, as everyone there called her, always dressed very 'artistically' in a style entirely of her own, wearing long full-skirted dresses and having her hair parted in the middle and drawn in a knot at the back of her head. Quiet and unassuming, she was a mutely sympathetic presence in the office. Everyone liked her; no one knew much about her. On the surface, it seemed, she had accepted a secretarial career, to be followed in the ordinary way by one as housewife. She was not ambitious in the usual sense; but deep

* They were married on 31 August 1870 at the Register Office in Camberwell, when he was twenty-two and she eighteen.

within her, unobserved by others, lay the utter certainty that she belonged to the world of art. How this was she could not say; nor did she ever speak about it. But instinctively she knew it to be true, and accepted it as her destiny. However illogical, she would follow this instinct wherever it led. It was her secret, her means of emancipation. It was Dorothy who typed each day; but it was Dorelia who dreamed.

And it was Dorelia who, in the evenings after the office closed, went off to the late classes at the Westminster School of Art. Here she got to know a number of artists and began to be invited to their parties, at one of which she met Gwen John. She had already seen Augustus once at an exhibition of Spanish paintings at the Guildhall near her office, but they had not spoken and he did not see her. Yet the sight of him riveted her and she remembered this first glimpse till the end of her life. It was almost as if, in that moment and without words or contact of any kind, she had chosen him as the vehicle of her destiny.

There are many stories of how they met. A popular one was that Augustus overtook her in a London street one day, looked back, and was unable to avert his eyes for almost the rest of his life.* However it really was, they must have met early in 1903 while she was living in a basement in Fitzroy Street. By the summer he was already writing her passionate love letters: 'The smell of you is in my nostrils and it will never go and I am sick for love of you. What are the great beneficent influences I owe a million thanks to who have brought you in my way. Ardor my little girl, my love, my spouse whose smile opens infinite vistas to me, enlarges, intensifies existence like a strain of music. I want to look long and solemnly at you. I want to hear you laugh and sigh. My breath is upon your cheek – do you feel it? I kiss you on the lips – do you kiss me back? Yes I possess you as you possess me and I will hear you laugh again and worship your eyes again and touch you again and again and again and again . . . your love Gustavus . . .'

She was, of course, hypnotically beautiful – almost embarrassingly so, Will Rothenstein found: 'one could not take one's eyes off her'.[118] An early drawing[119] Augustus did gave her a sultry look, with high rounded cheek bones, slanting eyes and an air of devastating refinement. A painting entitled 'Ardor'[120] shows a full dimpled face, eyes that solicit, rouged cheeks and mouth. It is the portrait of a seductress, a

* 'I had tea with him [Augustus], and then we went to all those Belgian Cafés in Fitzroy city,' Carrington wrote to Lytton Strachey (8 March 1917). 'He was most interesting, as he gave me a complete history of his life, and parents, the mysterious sister who lives in Paris, a brother, and yet another sister. You know it wasn't the Strand where he met Dorelia. I have ever since you told me (walking across N. Wales from the Dante Lake) thought when I was in the Strand, near Adelphi, of John looking back at Dorelia in a Black Hat and now it was all a false vision, as he met her in Holborn.'

comparable subject in some ways to 'Merikli', though by contrast Ida seems too wholesome for the part. In his portraiture, Augustus was like a stage director, assigning his subjects all sorts of short dramatic roles. Dorelia, it seemed, acquiesced in them, fitted each of them to perfection – mother, mistress, little girl, phantasm, goddess, seductress, wife. She became all things to him; she was everywoman.

It was not by her looks alone that she stimulated him. Beauty is not so scarce. What was uncommon about Dorelia was the enigmatic power and the magneticism that gave her beauty its depth. Rarer still, her serenity – something he so conspicuously lacked and the source of which, in her, baffled and attracted him. She was no intellectual; she was not particularly witty or articulate; and certainly not sentimental. It was her *presence* that was so powerful, above all her magical peace-giving qualities. People who were unhappy, agitated, could come to her, relax, share something of her extraordinary calm. Disasters, tragedies, crises appeared to shrivel up within the range of her strong personality. She seemed nourished by some distant source, and at all times guarded her secrets well, like a cat. Like a cat, too – a panther – she moved, with a smooth rhythmic action, intensely feminine.

Augustus did not conceal from Ida this sudden flare-up of love for Dorelia: concealment did not come easily to him – it was something he would learn, rather inadequately, later on. Besides, he might as well have tried to hide a forest fire – he simply could not do it. He presented Ida with the fact of his new love; he introduced her to Dorelia; and he left her to decide what should be done. Of the three of them, Ida was always the most likely to take a positive decision about the future. Augustus and Dorelia acted on impulse in a way that could appear decisive, but which was mainly a reflex to the present.

The upheaval of Ida's feelings was deep and very painful. Upon the decision she had to make depended the fate of their marriage. She knew Augustus better than anyone – 'our child-genius' as she was soon to call him with more than a shade of sarcasm – and she had to accept that alone she could not hope to confine his incendiary passions within the grate of married life. He maddened her, but she loved him. And she *liked* Dorelia. When the two women were together – it was strange – Ida's difficulties seemed less acute: she was almost happy. Reason therefore told her that, if Augustus's feelings persisted, some form of ménage-à-trois was the only practical solution. She must not object to his having a love-affair with Dorelia – that would drive him mad. Reason told her all this; but sometimes, like some tidal wave, a violent red jealousy would surge through her drowning reason, urging her on to pain and destruction. She felt useless, ugly. Marriage, which had imprisoned her, had left Augustus free, since her love for him

excluded all other emotions, while his for her did not. But she steeled herself not to give in to the conviction that life was unfair. The quasi-religious advice she had poured forth in earlier days on her aunts and sisters she now turned upon herself. Her moral duty was to follow the sensible course of action and accept these awkward complications as a part of her love for Augustus. Whatever happened she must fight against jealousy, since that, like wounded vanity, was the very voice of the devil. So, for the time being, she appeared philosophical: 'Men must play,' she quoted, 'and women must weep.'

With Augustus infatuated and Ida raising no objections, Dorelia now moved into their married life. At first the part she played, though a very vital one, was intermittent. She never lived in their flat, though she visited Augustus most weeks to be drawn and painted by him. He loved to dress her up, to buy her bright petticoats up to her knees, gay ribbons to tie in her hair, and curious costumes that took his fancy. And he relied on Ida to help him choose such stuffs. 'Don't forget to come on Sunday,' he reminded Dorelia. 'I want to get a new dress made for you, white stockings and little black boots and lots of silly little things for your hair . . . Sleep well Relia and don't forget me when you go to sleep.' But sometimes, without warning, she did not turn up, and he would grow frantic with worry. 'In the devil's name! Why did you not come? Are you ill? . . . or did you dance too much the night before, so you were [too] tired to come up here . . . A true young wife and a lady you are . . . Are your new clothes made [yet]? I should like to see you on the high road all dressed in fire-red. Are you coming next Sunday?' But already by Monday he found he could not wait till next Sunday. 'I went last night down to Westminster to find you but you were not there. When are you going there again? as I would like to see your pretty eyes again. If you'll believe me my girl, I liked more than I can say sitting with you on the grass on the ferns. As you say, you are a young wild tree, my Relia. I love to kiss you just as I love to feel the warmth of the sun, just as I like to smell the good earth. One gets used to the afterwards, my girl, and then they need not be so very damned. My wife and I have been ransacking shops to find a certain stuff for your picture . . . I am getting excited over the picture. I will do it better now after I have kissed you several times.'

He longed, also, to paint her in the nude, but she seemed unwilling. 'Why not sit for me in your soft skin, and no other clothes – are you ashamed? Nonsense! It is not as if you were very fat.' But still she would not.

At each point his excitement was matched by her imperturbability; his passion by her elusiveness; his doubts and speculations by her unastonished compliance. She had cast a spell on him, and he began to

weave one for her, a Romany spell. 'How would you like yourself as a Romany lady?' he asked. To Dorelia, who was rather dismissive of her anonymous parents, here was an intriguing question. Under Augustus's tuition she began learning the language. All these early letters he sent her were written in Romany,* mixed with odd English words, and to them he attached careful word-lists. He was delighted how swiftly she learnt, how eager she was to enter his make-believe world. 'Sit and write down another letter for me,' he urged her. 'Put in it all the Romany words you know, then a little tale about yourself, and send it to me.' So she wrote and told him about an old woman who drank whisky and had fallen in love with her – and he was enchanted.

So his love grew. He could think of almost nothing else, could scarcely endure being parted from her. 'Dear sweetheart Dorelia,' he wrote to her early that summer on a short visit to Littlehampton. 'Now I am going to bed, now I am under the blankets, and I wish that you were here too, you sweet girl-wife. I want to kiss you again on the lips, and Eyes, and neck and nose and all over your bare fiery body. When our faces touch, my blood burns with a wild fire of love, so much I love you my wild girl. I don't speak falsely. If you laugh you cannot love. Now I see your white teeth. Why are you not here with me? I hear the sea that sings and cries in the old way, my own great sad mother. Send me word very soon – Tell me that you love me a bit. Yours Gustavus Janik.'

It was not long before rumours of Augustus's love-affair began to be whispered among his friends – and among Ida's. 'I have come to the conclusion that it is very difficult to deceive anyone,' Ida wrote to Alice Rothenstein, 'and that people know one's own business almost as well as one knows it oneself. I suppose you know that, as you know most things (I am not sarcastic). In a certain way you are a very wise person.' This was Ida's difficulty: she had no one to whom she could confide. Alice was a loyal friend, but perhaps not a very understanding one. Her own life was so different, so safe. There was about her a suspicion of vicarious living, of looking with great relish and disapproval through keyholes at other people's goings-on. The smell of high-principled gossip clung to her. Whatever one did, she already knew about it and knew one had done wrong. No one could doubt that she had Ida's interests sincerely at heart, but the two of them could seldom agree how those interests were best served; and Ida, who grew

* They are written partly in the inflected Romany, like the so-called 'Welsh Romany' which is really an older form of English Romany, partly in the broken English Romany, and partly in English. The versions quoted here have been done into English by the gypsy scholar Ferdinand G. Huth who writes that 'I have made the translation as near as possible to the actual Romany words'.

discouraged by Alice's conventionality, tried to avoid sharing with her too many of her problems. Besides, in all circumstances, Alice invariably counselled prudence, now that she had left the stage and married Will. 'I ask you why should a healthy young woman be particularly "prudent",' complained the Rani to Ida, ' – or was Alice herself ever – such rot!' On the whole Ida preferred Will's counsel and companionship – they warmed her more. He too could lecture one, but when he addressed himself to young women his romanticism quite dissolved his moralizing. They were a strange couple, Alice and Will – she still beautiful, blooming, a faintly overblown pink rose 'large and fair and cushiony and sleepy', as Ida once described them; he 'a hideous little Jew with a wonderful mind – as quick as a sewing-machine, and with the quality of Bovril'.

Partly because of Alice, Ida was shy of disclosing many secrets to Will. To Augustus himself it was always difficult to speak of anything personal. One had to overcome the great silent well of his disapproval. When he did talk, it was usually to deliver some laconic sentence that effectively put an end to all further discussion. She was aware of becoming less attractive in his eyes when she tried to speak to him seriously. It was as if he believed that any talk about their problems could only exacerbate them, and that the only natural thing to do was to close one's eyes to them. This was one of the reasons he sometimes drank – to be rid of his problems: to be rid of himself.

Although she would have preferred a man to talk to, Ida probably confided most to the Rani. To her she felt she might occasionally 'grumple' without disloyalty. She could trust her, being closer to Ida than to Augustus – 'my heart's blood to you', she ended one of her letters, 'and my liver to Augustus'. Her vitality and humour was infectious, and the world was a brighter place after one of her letters. She never set herself up as a paragon mother – 'Yours is the proper way to have babies,' she told Ida, 'one after the other without fuss and let them roll around together and squabble and eat and be kissed and otherwise not bother.' She would write of the entertaining disasters that had befallen her, such as poisoning her family with mushrooms; she sent her appalling photographs of herself 'looking like the Virgin Mary with indigestion'; she told her how common and conventional her own children were becoming – born parents, every one of them; and she fulminated against the Liverpool middle-classes, 'all bandy-legged and floppy nosed and streaky haired', with their 'jocky caps and sham pearls and bangles and dogs and three-quarter coats' – they made her ache and roll and scream with anger, causing 'the glands behind my ears to swell'. And finally she would apologize for failing, despite everything, to be discontented. 'I am sorry I am so happy and you so

much the reverse – I think I really am too stupid to be anything else. You must pay the penalty for having the intelligence, I suppose – The lady Dorelia is a strange creature.'

Dorelia's strangeness – 'her face is a mystery', Ida remarked, 'like everyone else's' – and the uneasy partnership to which she had been admitted was increasingly the subject of speculation. Almost the only people, it seemed, who were aware of nothing unusual were the participants themselves. Their friends were very alert to the situation, and many of them began

> *to take each other unawares*
> *With moralizings manifold.*

'I saw John last week and he doesn't seem to have been pulling himself together as he should have done,' lamented Will Rothenstein to his brother Albert (3 June 1903), ' – he seems as restless as ever, and looks no better than he should do. Ida has gone off to Tenby for a month with her babes, so he is alive just now.'

A few weeks after Ida returned, Albert Rutherston went to dine with them at Fitzroy Street one evening and, unclouded by disapproval, was able to give a clearer picture of them all. 'They are well,' he told Michel Salaman (9 August 1903), 'and John showed me some exceedingly good starts of paintings – they have bred at least a dozen canaries from the original twain which fly about the room – perch on the rafters and sit on one's head while one dines – it really was amusing ... Miss MacNeill came after dinner – she ... seems to be a great friend of all the Johns – I think John must have a secret agreement with that lady and Mrs J – but not a word to anyone of this – it is only my notion and a mad one at that.'

Others who saw the crowded rough-and-tumble household, with its multiplying flock of canaries, women and children, were sadder and more confident in their opinions. 'Really matrimony is not a happy subject to talk about at present,' Tonks wrote to Will Rothenstein (15 September 1903). 'The John establishment makes me feel very melancholy, and I do not see that the future shines much.'

But Augustus loved Fitzroy Street. Before Whistler died that summer, he would occasionally meet him there and they would have lunch together. He had always been amused by Whistler's panache, but in retrospect no longer had quite the same reverence for him as at the Slade. Whistler had been a man of cities; his curiosity 'stopped short at dockland to the east and Battersea to the west'.[121] He was almost the founder of the urban cult of English Decadence, against which Augustus had now started to rebel.

Augustus had loved Fitzroy Street, but the flat there was obviously

too small for them all. He felt confined, unable to breathe in that bricked-in atmosphere. He dreamt of hills and fields, of 'the broad, open road, with the yellowhammer in the hedge and the blackthorn showing flower'.[122] As the summer wore on, this feeling grew more acute, reaching a peak while on a visit to Charles McEvoy * at Westcot, near Wantage in Berkshire. 'I have fled the town and my studio; dreary shed void of sunlight and the song of birds and the aspirant life of plants,' he told Will Rothenstein. 'Nor shall I soon consent to exchange the horizons that one can never reach for four mournful walls and a suffocating roof – where one's thoughts grow pale and poisonous as fungi in dark cellars, and the Breath of the Almighty is banished, and shut off the vision of a myriad world in flight. Little Egypt for me – the land without bounds or Parliaments or Priests, the Primitive world of a people without a History, the country of the Pre-Adamites!'

The difference between town and country was like that between sleep and waking life. 'Don't get up so much,' he advised Dorelia from Fitzroy Street, 'it's better to sleep. What beautiful weather we are having – it makes me dream of woods and wind and running water. I would like to live in any wooded place where the singing birds are heard, where you could smoke and sleep and stop without being stared at.'

The best plan, he decided, was to find some house in the country not far from London that would serve to accommodate as many as might reasonably find themselves there – women, children, animals, friends, family, servants and, perhaps more intermittently, Augustus himself. Ida, who had recently completed her decorations to Fitzroy Street, agreed. It was a scheme that should advance all their interests: in any event it seemed inevitable.

But Dorelia, meanwhile, had other plans.

5. CANDID WHITE AND MATCHING GREEN

The Carfax Gallery, in the spring of 1903, had held a joint show of Gwen and Augustus's pictures. 'I am devilish tired of putting up my exhibits,' Augustus complained to Dorelia. 'I would like to burn the bloody lot.' Of the forty-eight pictures – paintings, pastels, drawings and etchings – forty-five were by Augustus. Nevertheless, he told Rothenstein, 'Gwen has the honours or *should* have – for alas our smug critics don't appear to have noticed the presence in the Gallery of two rare blossoms from the most delicate of trees. The little pictures to me are almost painfully charged with feeling; even as their neighbours are empty of it. And to think that Gwen so rarely brings herself to paint! We others are always in danger of becoming professional and to

* Charles McEvoy (1879–1929) was the brother of Ambrose McEvoy. Described as a dramatic author, he was a village playwright and gifted clown.

detect oneself red-handed in the very act of professional industry is a humiliating experience!'

The pain that Gwen had absorbed over Ambrose McEvoy was now disappearing. She had closed down her feelings for him, though keeping open a strong antipathy for Mary McEvoy. Until very recently she had continued living at the McEvoy family home in Colville Terrace, while Ambrose and Mary moved down to Shrivenham in Berkshire, where they were joined by Gwen's former friend Grace Westry. It was possibly at this time that Gwen transferred to a cellar in Howland Street – 'a kind of dungeon', as Augustus described it, ' . . . into which no ray of sunlight could ever penetrate'. Indifferent to physical discomfort, she seemed filled with a strange elation. 'I have never seen her [Gwen John] so well or so gay,' Albert Rutherston told Michel Salaman (9 August 1903). 'She was fat in the face and merry to a degree.'

The source of Gwen's upsurge of happiness was Dorelia. On an impulse, she proposed that the two of them should leave London and walk to Rome – and Dorelia, once she was certain Gwen was not joking, calmly agreed. There was nothing, no one, to hold Gwen in England. It was fitting that she should celebrate the opening of this curious new chapter in her life with such an odd adventure, that she should want to cut off geographically, physically and emotionally her past. But for Dorelia the decision is less immediately understandable – after all, it meant abandoning Augustus, perhaps for months, at a critical stage of their relationship. With a man so volatile, what guarantee was there he would feel the same when she arrived back? Yet Dorelia's mind did not work like this. If Fate intended her to live with Augustus, then that was how it would be – and nothing on earth could alter this. There was therefore no risk in going away. However it might turn out, her future was certain if unknown; only the present could be shifting, complicated. Although she seldom revealed her thoughts, there can be little doubt that she was feeling the strain of being a visitor to Augustus's life, and not integrally part of it. Once Augustus and Ida had settled into their house in the country perhaps everything would be different. All she knew was that her life, whatever form it took, would be involved with art, and that there was nothing inconsistent with this in going off with Gwen.

The two girls were as excited as if it were an elopement. But Augustus found himself manoeuvred into a parental role, advising caution, good sense, second thoughts. Their plan was impossible,* he promised them:

* 'Miss McNeill came after dinner – she and Miss John were about to start for Boulogne from whence they intend walking to Rome!!!!!!!! it is true all roads lead to that city but methinks they have chosen a long one.' Albert Rutherston to Michel Salaman (9 August 1903).

it was also mad. But Gwen brushed aside his objections, would not even listen to his arguments – 'She never did'.[123] Finally, he came round, gave them a little money and some cakes, and they set off 'carrying a minimum of belongings and a great deal of painting equipment'.[124] Boarding a steamer in the Thames, they landed at Bordeaux and began trudging up the Garonne from village to village. 'I am sitting on the side of a road,' Gwen wrote to Ursula Tyrwhitt (2 September 1903); 'there are no hedges but great trees, on the side of the road there are fields of white grass with white flowers in it – it looks like spring. On the other side are vines we gather and grapes when we want them but they are not quite ripe yet.'

From this time onwards, though there were occasional good days, they found the going hard. Once they travelled in a motor car – 'till it broke down'; and more than once they were offered lifts in carts – 'every lift seems saving of time and therefore money too so we always take them', Gwen explained to Ursula Tyrwhitt. At each village they would try to earn some money by going to the inn and either singing or drawing portraits of those men who would pose. But their appearance provoked much astonishment, and their motives were sometimes mis-construed. At night they slept in the fields, under haystacks or, when they were lucky, in stables, lying on each other to feel a little warmer, covering themselves with their portfolios and waking up encircled by curious little congregations of farmers, gendarmes and stray animals. Between the villages, bowed beneath bundles of possessions that seemed larger than themselves, they would practise their singing. They lived mostly on grapes and bread, a little beer, some lemonade. There were many adventures; losing their tempers with the women, out-witting the men, dying of fright, crying with laughter.

By the end of November they reached Toulouse where they hired a room 'from a tiny little old woman dressed in black . . . she is very very wicked'. Here they stayed and worked. 'We shall never get to Rome I'm afraid', Gwen wrote to Ursula Tyrwhitt, 'it seems further away than it did in England . . . the country round is wonderful especially now – the trees are all colours – I paint my picture on the top of a hill – Toulouse lies below and all round we can see the country for many miles and in the distance the Pyrenees. I cannot tell you how wonderful it is when the sun goes down, the last two evenings we have had a red sun – lurid I think is the word, the scene is sublime then, it looks like Hell or Heaven.'

Augustus watched their progress with a mixture of amusement and irritation. 'I congratulate you both on having thus far preserved body and soul intact,' he wrote to them when they were about halfway to

Toulouse. 'But with all my growing sedulity I find it difficult to believe you are really growing fat on a diet of wine and onions and under a burden of $\frac{1}{2}$ a hundredweight odd.' He also congratulated them on having escaped the importunities of an old man in a barn 'with true womanly ingenuity', and he enclosed five pounds for Dorelia – 'a modest instalment of my debt to you'. But already small misunderstandings had begun to creep into their exchanges. Perhaps Dorelia was affected by a vein, in Gwen's character, of puritanism. In any event she decided she did not want random gifts of money accompanied by jokes she did not care for – and wrote to tell him so; at which Augustus excused himself indignantly.

But he was mainly concerned, at this stage, with Gwen's pictures. He himself was contributing half-a-dozen works to the Winter show of the N.E.A.C., including portraits of Mackay, Rothenstein and Sampson: he was eager for Gwen to submit at least one of her own so that she should not be forgotten. 'The day for the N.E.A.C. is Nov. 9,' he reminded both girls. 'I hope Gwen will do a good picture of you, and that it will contain all the genius of Guienne and Languedoc. I hope it will be as wild as your travels and as unprecedented.' But Gwen refused to be rushed. 'The New English sending day is next Monday,' Augustus wrote again more urgently, 'and Gwen's picture doesn't seem to arrive.' When it did arrive – a wonderful glowing portrait of Dorelia entitled 'L'Etudiante' – it was almost exactly six years late, and was shown at the N.E.A.C. Winter exhibition of 1909.

Meanwhile there was plenty to occupy Augustus at home. He and Ida had taken a two-year lease on what seemed a perfect house, with a large garden, orchard and stables, at Matching Green in Essex. 'It is lovely here,' Ida wrote to the Rani, ' . . . to go out into the quiet evenings and see the moon floating up above and feel the cold air.' They moved in with a lawnmower and a dog called Bobster during late November. Elm House, as it was called, stood next to a pub, had a studio but no telephone or electric light, and overlooked the village green. 'Several gypsies have been already,' Ida informed Mrs Sampson. 'Our house is one of the two ugly ones. Inside it is made bearable by our irreproachable taste.' Four-and-a-half miles from Harlow, their nearest town, and twenty from London, Matching Green stood in a tract of land, Augustus told Will Rothenstein, 'abundant in such things as trees, ponds, streams, hillocks, barns etc. . . . Pines amaze me growing stiff and lofty like Phallic symbols. I get dangerous classic tendencies out here I fear. London is perhaps on the whole a safer place for me.'

London meant money, and money was – or ought to be – security. Since leaving his Liverpool job, Augustus's income had grown erratic,

while his responsibilities steadily mounted. It was this state of affairs –
'living as I do in such insecurity' he described it [125] – that now per-
suaded him to collaborate in a scheme of Orpen's. 'I have committed
myself to one day a week teaching at a school Orpen initiates with
Knewstub as secretary,' he informed Will Rothenstein. 'We hope to
make pocket-money out of it at least. It is a very respectable under-
taking with none of the perfection you had insisted on. It is Knewstub
who makes things feasible with his capacity for organising and letter
writing.'

Jack Knewstub was the brother-in-law of both Orpen and Will
Rothenstein. Nicknamed 'Curly' Knewstub, he had fair permanently
wavy hair, very boyish good looks and a rather rough North Country
manner. For a time he had acted as secretary to a Welsh Member of
Parliament and it was presumably here that he learnt his skills as letter-
writer. In his organizing capacity he was certainly superior to Augustus,
but he was no business man: he was a romantic. His father had been
both pupil and assistant to Rossetti – old Knewstub, it was said, could
draw but not colour, and Rossetti, a superb colourist, could not draw:
it was an ideal partnership. But Curly Knewstub, brought up in this
Pre-Raphaelite world, could neither draw nor colour. He was an
artist *manqué*, a dreamer with ambitious cultural fantasies to which this
new school now acted as a focus. In the firmament of his imagination,
Augustus shone like a star. He was infatuated with him and over the
years schooled his own six children to draw precisely in the John
manner, until they came to loathe John's very name.

If Knewstub worshipped Augustus, Augustus tolerated Knewstub.
He was an agreeable drinking-companion, mercifully unintellectual and
not arty, useful in countless little practical ways – the paper and sealing-
wax of life. His dreams and aspirations effectively misted over any lack of
business competence – of which, in any case, Augustus was no judge.

The Chelsea Art School, as it was called, opened in the autumn of
1903 at numbers 4 and 5 Rossetti Studios in Flood Street. On the
prospectus, a highly respectable document,* Augustus and Orpen
were named as its principals. Knewstub, who began by using 18 Fitzroy
Street as his office, acted as secretary and general manager. The sexes
were properly segregated into separate rooms, Gwen Salmond con-
scripted as 'lady superintendent' and various other 'Sladers' drafted
to give occasional lectures. Everything began reasonably well. 'They
have 35 students – but need to double that number to make it pay,'
Ida wrote to Winifred John (January 1904). 'They have fine studios in
Chelsea. Gwen Salmond is the chief girl and looks after the women's
affairs. Isn't it mad?'

* See Appendix Two.

One person who thought the whole arrangement dangerously mad was Alice Rothenstein. Did Ida, she wondered, know *nothing* about men? It was inviting trouble, this burying herself away in the country and permitting a man like Augustus to roam the streets of London alone. Her head swam at the pure folly of it. So strongly did she feel, that she might personally have intervened – had she not been weightily pregnant at the time. As it was, the very least she could do, from her bed of confinement, was to pepper Ida with her warnings. Of course, it was none of her business, but then what were friends for? She owed it to Ida to volunteer the advice that everything she was doing was absolutely fatal. Alice *knew* what Gus was like – had she not been on the stage before she married Will? Ida had had so sheltered an up-bringing, was such a curiously innocent creature – she must be protected at once by post. Ida endured her reprimands stoically, then retaliated (12 December 1903):

'You are quite quite wrong, but I will not scold you now as you are just going to have a baby. In the first place I prefer being here. And healthy or no, Gus enjoys being in London alone.

'Think it pride if you will, but the truth is I would not come back if I had the chance. You do not understand, and you need not add my imaginary troubles to your worries. If I had not known it was alright I should not have come here. *I always know*. So there. Cease your regrets and all the rest of it. Yrs Ida.'

Alice was shocked. This was the last thing she had expected. Was it not right for her to speak openly to a friend? She was not hurt, she was *disappointed* by Ida. But the temptation to appear more offended than she actually felt was almost irresistible. Ida, however, was having no nonsense. She refused to be seen as forlorn, abandoned, irresponsible – it was simply Alice's theatrical imagination, she declared. For Alice's way led only to self-pity. 'Dear Alice, I was not in the least vexed,' she replied, 'and you know I was not. And please always say exactly what you feel. Only I can't help doing the same and disagreeing. And I know it is such a good thing we came here, and you say it is a bad thing.'

Thereafter, whenever Alice's flurry of questions, counsels and in-vitations grew too intensive, Ida turned a deaf ear to them. She would counter all this probing attention with observations of her own about the local weather; about the countryside – had Alice observed how lovely the trees were looking just now? – about the two piebald pigs she owned ('they grunt very nicely') – and about the terrific number of black-and-white cats* Gwen had left with them which by now, Alice

* 'We now have 10 in all,' Ida wrote to Mrs Sampson, but 'only' 6 birds. She later bought 4 additional birds to even up the population. 'Domesticities amongst the birds are going on all around me.'

would be interested to know, had had two sets of kittens and eaten all but one of them. Sometimes she would post her 'several pages of nothing'; at other times she would reveal that, with many disheartening interruptions, she was struggling to learn the piano or to make a hat. She sent flowers and embroidery and lists of 'scattered visitors – all very pale' to Elm House: her mother and sisters, Mrs Sampson, the Rani – 'we have giggled and been stupid and feminine all the time'. Alice must visit her too – it was so beautiful looking out of the window on to the elm trees, the green, the open skies: 'The geese still cackle and waddle on the green, and the bony horses graze. All the buds are coming out, and birds beginning to sing long songs.'

But by far the best method of deflecting Alice's formidable pity was to introduce the ever-interesting subject of children. Since both women were producing babies at pretty well the same speed, it was a natural topic about which to correspond. Besides, Alice, who was extremely proud of her children, simply could not resist it. Ida's letters to her reveal something of her character, her family and their way of life at Matching Green. She is careful to establish, and thereafter to remind Alice, that David and Caspar are in no way comparable to the magnificent Rothenstein offspring. Both boys, she assures her, 'have violent tempers'. David, who 'is spoiled – or at any rate he is difficile', howls whenever the sun comes out, loves nursery rhymes with any mention of dying in them, says 'NO' a great many times each day and has taken to drawing, making their lives terrible with his ceaseless demands for pictures of hyenas, cows and 'taegers'. Caspar is enormous, struggles with a free style action on his tummy across the floor exclaiming 'Mama' as if it were some kind of joke, is perfectly toothless at ten months old, but has developed two fat and rosy cheeks from perpetually blowing a trumpet – 'his first and only accomplishment'. He is strong as a bull and has achieved a 'long dent in his forehead from a knock . . . [which] really must have dented his skull as it still shows after several weeks'.

But sometimes her stream of entertaining trivia runs dry, and we catch sight of deeper aspects of Ida's life. 'Dear Alice, I have nothing to say – do forgive me. I am very tired.' The children dominated her night and day, sucked all energy out of her body. Never, it seemed, could she escape from them, from their noise, their eternal need for food and attention. 'I am getting a little restive sometimes,' she admitted (15 February 1904), 'but what I chiefly long for is 2 or 3 quiet nights. Not that they are restless in the night – but as you know they require attention several times.' She was a conscientious mother, determined to make the best of what, between the lines, emerges as a pretty bad job. Motherhood was a medicine she had to swallow, and which must – to judge from its bitter taste – do her character much

good. 'All my energies go to controlling my own children's passions,' she explained to Alice. 'I do get angry and irritable sometimes, but I am getting slowly better, and it is a discipline worth having. I have been so used to looking upon life as a means to get pleasure, but I am coming round to another view of it. And it is a limitless one.'

Intermittently this glow of moral optimism would fade and she envied the two Gwens their painting. There was no chance of returning to her own. 'I get very little time for contemplation now-a-days – and if I do get half-an-hour I am certain to tear my dress and have to mend it, or spill a box of pins, or something.' She enjoyed too little of Augustus's company and too much, much too much, of his children's. 'For the first time in my life Matching Green bores me – to extinction almost. I wish it did quite,' she confessed to the Rani after several months there. 'It would be quite a pleasant way of dying – to be bored away into nothing.' During the long days she prayed for the children to go to sleep, to be off their 'Mummy's hands and nerves'. Perhaps, she reflected, it was all due to her poor powers of organization, but 'I am beginning to wonder if my head will stand much more of the babies' society.'

From the nursery she began to escape into the kitchen. She was not alone at Matching Green. Though Alice, their maid at Fitzroy Street, had left them, Maggie their young cook, by now very 'fat and attractive' and nicknamed 'Minger', had come with them to Elm House. As the weeks went by, Ida did more cooking and Maggie more looking after the boys. 'I have begun to learn to cook,' she announced triumphantly (15 February 1904), 'and can make several puddings and most delicious pastry.' Cooking was so much quieter than children, so much more restful and satisfactory, so much – despite what everyone said – more creative. 'I have been cooking and cooking and cooking – and have been so successful. I want to try and make Maggie nurse, and be cook and odd woman [myself]. . . . And cooking is so charming – and if Maggie will – However, it is not settled yet.' By the spring it was settled: 'Maggie is Nurse entirely now – and I am Cook General. It is so much less wearing.'

She also took up gardening, became a 'scientific laundress', grew 'mad on polishing furniture', involved herself in the manufacture of loud check coats – all to escape from the children and avoid guilt. Guilt, springing from a sense of inadequacy, often stabbed at her. She was better off than many others. Besides Maggie, she employed from time to time 'a very large and conscientious child of 14' called Lucy Green to act as housemaid. Yet still she seemed to suffer from overwork. 'Matching Green is quite drunk to-day,' she wrote to Alice at Easter. ' . . . soon the woman who lives on our other side will be

helping herself home by our garden railings. It is remarkable the way they all make for the pub. Overwork. I know the necessity. I go to domestic novels – quite as unwholesome in another way. For my part I could not be really at leisure and able to follow my own desires with less than 4 servants. So what can these poor people do without *one*? And yet how gorgeous life is.'

Then again this glow would darken and a terrible cloud of apathy sweep over her. 'I should like to have gone to Michel [Salaman]'s marriage feast but they will do well enough without me, and nothing matters.'

But one thing still mattered to her at all times: Gus. All winter he had been subject to dark moods, and when spring came these moods began to grow blacker and more frequent. His temper affected her as the weather affects a barometer, and her failure to pull him out of these depressions was a perpetual source of self-reproach. She lost confidence – perhaps she was the wrong person to help him; perhaps only Dorelia could do that – help both of them. Her exhaustion was added to his listlessness, and together they seemed oddly will-less, like two ships becalmed, waiting.

The Chelsea Art School absorbed much of Augustus's energy during its first two terms. For his own work he used a studio above the school, and would often spend a full week, or even a fortnight, in town. 'London is very beautiful,' he wrote to Dorelia, 'it becomes more like home every day.'

Orpen's chief contribution to the school was a series of lectures on anatomy. All pupils had to draw from the model, then 'skin him' and draw the muscles employed in his posture.

As at Liverpool, Augustus stressed the value of observation. He discouraged the use of red chalk because it tended to make a bad drawing look pretty. Every line should carry meaning, nothing be left vague. Students were taught to cultivate precision, to keep their drawings broad and simple avoiding too much detail, to use a hard piece of charcoal, to draw with the point and to perfect what he called 'the delicate line'.

Perhaps because it diverted his attention from personal worries, Augustus rather enjoyed his teaching.* 'He never despised nor dis-

* The draft of a rousing notice by John to the students of the Chelsea Art School with special reference to the Sketch Club compositions that were submitted for monthly criticism, reads: 'How is it there is so little work done for the Sketch Club? The neglect of composition makes drawing negligible, and is madness. How is it students are timid when they know Design demands Courage? How is it they are indifferent when they know that Art calls for Emotion? Why are they speechless while creation is a statement???'

couraged a sincere, though unskilful, beginner,' one student remembered. 'But he was scathing about any kind of showing off.' On one occasion he called forth what Knewstub described as 'a flood of tears' by suggesting that some of the ladies would probably be better occupied at home with a little domestic work, such as nursing a baby. His most severe criticisms, however, were usually softened afterwards by an invitation to a drink or sometimes to a day trip up the river on a steamer from which, in his most rumbling bass, he would decant Romany verses: a sound very bold and incomprehensible.

The division of his life between town and country seemed to suit him: he never quite had time to grow tired of either. In London he was meeting many people for the first time – Gordon Craig, Arthur Symons, Charles Ricketts, also Lady Gregory.* In March he dined at Hugh Lane's house, and Lady Gregory noted: 'John was there, and other artists. Martin Wood was there and kept saying "this is a very remarkable gathering". We went upstairs after dinner to look at the Titian – Philip II, and I speaking to John for the first time said "How can the wonderful brilliancy of that colour keep its freshness so long?" And John said "Ah-h-h".'

From remarkable exchanges such as this, he would return with relief to the freshness of Essex. 'It has been wondrous fine in the country these last few days – a white frost over everything, our humble garden transformed; every leaf and twig rimed with crystal; in the moonlight things sparkled subtly and any old outhouse became the repository of unguessable secrets,' he wrote to Will Rothenstein. 'To-day all changed into the dreariness of mud – the green a morass – the sky all gone, and grey expressionless vapour instead. . . . I am bent on etching now and mark me Will I will have a new set out before it is time to think of potato planting. This bald little house is becoming trim and homely and you will not find it inhospitable when you seek its shelter.'

Armchairs and green baize tables, a light oak bureau and a cottage

* In May 1904 Lady Gregory sent Augustus a copy of her *Poets and Dreamers*, an 'astonishing book', he called it. In a letter to Lady Gregory (25 May 1904) he wrote: 'Mr John Sampson of Liverpool know[s] more than any man about the Tinkers. He has collected a considerable vocabulary of their words besides tales and rhymes, and was the first to solve the mystery of their language and its origins. I have only known some English Tinkers whose language is but a debased and impoverished derivative of the Irish Tinkers'. Your book proves how much original feeling there is in the Irish peasant; he does not indeed take his impressions or pleasures at secondhand. If you would care I would willingly send you the hundred words or so I know of English Shelta but I feel it is the richer Irish dialect you ought to come across and Mr Sampson is its custodian.' (Berg Collection, New York Public Library.)

piano had made their appearance in the house. Augustus's pipes and slippers littered the rooms; breeding cages for the canaries were raised upon the walls, each suspended by a single nail – 'they are charming and make an awful mess', the Rani wrote when she came to stay. The little brown bookshelves in the chimney corners were filled with Turgenev and Borrow, Darwin, Balzac and de Maupassant, elaborate works on Italian painters, cookbooks, domestic novels and books about Wales. The white-papered walls of the drawing-room were covered with rows of Goya and Rembrandt etchings 'and part of a Raphael cartoon in one corner'. But his own work was subject to fitful delays. He saw everything in copper lines, but when depressed he could not work, and there seemed no controlling these attacks of depression. 'Rumbling home in a bus in a state of blank misery I found myself opposite a perfect queen among women, a Beatrice, a Laura, a Blessed Virgin!' he wrote to Will Rothenstein that winter. 'The sight of her loveliness, the depth of her astonished eyes, her movements of a cap-tured nymph dispelled the turgid clouds from my mind, leaving an exquisite calm which became by the time I got to bed a condition of almost religious exaltation. Would I could repay my debt to the en-chantress! Would that I too were a wizard!'

But he could summon up no spells to control his own emotions. New people, new visual experiences affected him as a switch controls an electric light: and he affected other people. Alone, he was nothing. The clouds of his 'blank misery' rushed in to fill the vacuum. They came and went again, forming and dissolving according to no obvious laws, but each time massing more densely, taking longer to evaporate. For Dorelia, like a sun beyond the horizon, was out of sight: and he was cold and miserable without her.

He had hoped she would return for their belated house-warming party at Matching Green; and he longed to finish his portrait of her. 'Your fat excites me enormously and I am dying to inspect it,' he wrote to her. 'I am itching to resume that glorious counterfeit of you which has already cost me too many sighs. I have a feeling that the solitude of Matching Green will do much towards its perfection. The thought of this picture came upon me with an inward fluttering and I am fond to believe that the problem will now find its final solution in your newly acquired tissue. When are you two going to turn your backs on Pyrenean vistas? How is it you are not going to assist at the warming and consecration of Elm House? I imagine new papers in the ladies smoking room with ribbons and roses on it and new chintz on the chairs and sofa again with roses and ribbons. Ida has commissioned me to paint a silk panel for the piano, and the front door is already a pure and candid white behind which no hypocrisy can harbour.'

He asked to be told of their exploits, but all he received was a package of out-of-date Christmas presents – bonbons and beautiful toys for the children, and elaborate cakes for him and Ida. 'Gwen is still in Toulouse I believe,' Ida told Alice (January 1904), 'painting hard – and anxious as soon as her 5 pictures are finished, to go to Paris.' 'They have a dog who is naughty *always*, Gwen says,' she wrote to Winifred the same month. And that, it seems, was all they knew.

Even before the end of the year Augustus had been growing impatient at their prolonged absence. The weeks went by; he heard almost nothing, and what news did trickle through only tantalized him. He grew cantankerous, self-pitying. He was being neglected. 'It was a bloody long time before I heard from you,' he burst out in a letter from the Chelsea Art School. 'Gwendolina says that you get prettier and prettier. . . . When are you coming back again? You are tired of running about those foreign places I know. . . . I have stayed up here now for many days, laudably attempting to get things done, but these models, drat them, don't give a man a chance with all this employment. However I am getting into a weedy condition. My studio is grimey, my bed is unmade, my hair uncombed, my nails unpared, my teeth uncleaned, my boots unblacked, my socks unfresh, my collar unchanged, my hose undarned, my tie unsafety pinned (I wish you'd send me some safety pins, it's not too much to ask) – lastly, my purse unlined.'

It was true that Gwen and Dorelia were by now growing tired of Toulouse. Their room was bare; they bathed, when it was not too frigid, in the river; and subsisted mainly on a diet of old bread, new cheese and middle-aged figs – though there were also some light-hearted evenings over a bottle of wine and a bowl of soup. Gwen, Dorelia observed, was becoming very puritan in some of her attitudes. She disapproved of the theatre and spoke with disgust of the 'vulgar red lips' of a girl they used as a model. Yet she was not unattractive to men, and never careless of her appearance – 'in fact', Dorelia noted, 'rather vain'.[126] To maintain themselves the two girls made portrait sketches in the cafés for three francs each. The rest of the time Gwen worked at her five paintings, three of which appear to have been portraits of Dorelia.[127] 'I look forward to a little time in which I can try to express in some way my thoughts,' she wrote to Ursula Tyrwhitt. 'I am hurrying so because we are so tired of Toulouse – we do not want to stay a day longer than necessary – I do nothing but paint – but you know how slowly that gets on – a week is nothing. One thinks one can do so much in a week – if one can do a square inch that pleases one – one ought to be happy – for after all to do in a year something beautiful – "a joy for ever" would be splendid! . . .'

By the end of February the five pictures were presumably, for the

time being, finished. Bundling their possessions on to their backs again
they made their way north, in the direction of England.

Augustus was overjoyed: but a month later he had sunk back into the
most terrible lassitude. Gwen and Dorelia* had got as far as Paris: and
stopped. The Rani, who was staying at Elm House in the last week of
March, describes what the atmosphere was like in a letter to her
husband (24 March 1904):

'Mr Augustus's habits are really remarkable. He came on Tuesday
with a bad cold and all Wednesday morning he stayed in bed and played
the concertina and we had to take turns to provide him with gossip.
All afternoon he read Balzac – never moved from his chair – went out
for a walk just before supper in piercing cold – read all evening including
meals – said "I want to make some more sketches of you" and dropped
the subject. All Thursday (yesterday) he stayed in bed and asked for no
one – played the most melancholy tunes on his concertina and got up
at tea time – very silent, read his book but as good as gold and ready to
nail up bird cages or anything – after tea went out – at tea he said "Good
God is it Thursday? – I thought of doing that sketch to-day." At 6.15
he appeared with a block and some red chalk and began to draw me as
I sat by the fire. I said "I hope you are not doing it unless you feel
inclined" to which a growl and "I do feel inclined – that is I shan't
know if I do until I've done." He drew furiously by firelight and the
last glimmer from the window and fetched a lamp and drew by that
until supper – 7 o'clock – three sketches – I didn't ask to see them
knowing better – at supper we both took our life in our hands . . . and
asked to see the sketches he had done. He produced them . . . each
more charming than the other. . . . He worked with the tension and
rapidity of ten Shannons rolled into one – scraped and tore away at it
in the most marvellous way and did I should think fully six more of
which I only saw one – too exquisitely squirrelly and funny for des-
cription but beautiful. They were mostly put in the coal scuttle as he
did them but preserved all right. It must have been about 12 when he
suddenly stopped, said "thank you for sitting" and went off to bed.'

The next day, 25 March, the Chelsea Art School officially ended its
term. Augustus now began to spend more days at Matching Green;
and time hung very heavy. The tension went out of his life; he lan-
guished. For a while he stayed mild and listless, only half-aware, it
seemed, of the terrible cacophony of children, canaries, chickens and
other cattle that reverberated through Elm House.

'Mrs John is beating the baby to sleep which always amuses me and

* 'I have ordered a mighty canvas against your coming,' Augustus wrote to her.
'. . . so better go in for Ju-jitsu at once, dear, for you will have to fill it spread-
eagle wise.'

appears to succeed very well – she is so in earnest over it that the baby seems to gather that she means business,' the Rani wrote to her husband a few days later (27 March 1904). '. . . The baby is simply roaring its head off and no one paying any attention – it is in another room . . . You would hate to be here. Mr Augustus looks sometimes at the baby and says "Well darling love – dirty little beast" at the same time. He is the sweetest natured person in the world. It is all indescribable and full of shades and contrasts and the whole is just like his pictures. He looks so beautiful and never takes a bath so far as I can make out. At least I know he is not three minutes dressing but always looks clean. He has cut his hair by the way a good deal – Ida likes it, I haven't made up my mind yet – I think she must have sat on the baby – it has suddenly stopped crying.'

The sweetness slipped out of his nature soon afterwards on learning what Gwen and Dorelia were up to in Paris. At La Reole, on their way to Toulouse the previous autumn, they had met 'a young artist who gave us his address in Paris, so that we can be models if we like in Paris'. On reaching Paris in the early spring of 1904 they put up in a single room at 19 Boulevard Edgar Quinet. 'I am getting on with my painting, that makes me happy,' Gwen wrote to Alice Rothenstein. She had been followed from Toulouse by a married woman who, falling under her spell, had abandoned her husband to be with Gwen. But in Paris Gwen, happy now with her painting, would have nothing to do with the woman. 'She was extremely queer and hard,' Dorelia reflected,[128] always attracted to the wrong people, for their beauty alone. But her work was more important than anyone.

In their spare time the two girls made clothes. 'The room is full of pieces of dresses – we are making new dresses,' Gwen told Alice. 'Dorelia's is pink with a skirt of three flounces. She will look lovely in it. Our two painters will want her as a model I am sure when we go home.' But the news that enraged Augustus was that for one artist in Paris Dorelia was posing in the nude – something she had never consented to do for him. He was filled with an Othello jealousy. 'Why the devil don't I hear from you, you bad little fat girl?' he reprimanded her. 'You sit in the nude for those devilish foreign people, but you do not want to sit for me when I asked you, wicked little bloody harlot ["lũbni"] that you are. You exhibit your naked fat body for money, not for love. So much for you! How much do you show them for a franc? I am sorry that I never offered to give you a shilling or two for a look at your minj. That was all you were waiting for. The devil knows I might have bought the minj and love together. I am sorry that I was so foolish to love you. Well if you are not a whore, truly tell me why not. Gustavus.'

Dorelia's reply, when it arrived, was little more than a scribble. In the heat of the moment, Augustus had forgotten to enclose his usual word-list, so much of his invective had gone astray. Certain phrases in his letter puzzled Dorelia. Carried away by linguistic curiosity, she questioned him. What, for example, did lŭbni mean? But Augustus already felt rather ashamed of his outburst and refused to answer such questions. Instead he wrote to apologize. All this letter-writing was getting him nowhere. He needed to *see* Dorelia. It was over eight months since he had last seen her. What was he to do? Curiously, it was Ida who decided, suggesting that he spend ten days in Paris – he could see the show of primitives there at the same time. As soon as she had spoken, he acted. He was like a dynamo – one that needed some-one else to turn the switch before it came to life.

What exactly happened during his stay in Paris is not now known, but something may be deduced from the developments that followed his visit. A week before he arrived, Gwen had written to Alice Rothen-stein: 'We are getting homesick I think, we are always talking of beau-tiful places we know of beyond the suburbs of London and Fitzroy St. and Howland St. seem to me more than ever charming and interesting. We shall be going home in the Autumn I think or before.'

This, apparently, was their intention just before Augustus turned up in the second week of May. What they did afterwards was altogether different. That another man might take his place in Dorelia's life had not seriously occurred to Augustus. But this was what was happening in Paris while he lay lugubriously playing the concertina at Matching Green. His rival was a very young artist – half artist and half farmer – probably the man she and Gwen had met at La Reole. His name was Leonard, and from Dorelia's point of view he possessed certain ad-vantages over Augustus: he was not married; life with him, while not contradicting her sense of destiny, might involve a farming back-ground that appealed to her, and would certainly be calmer, more assured.

A contest now developed in Paris as a result of which Dorelia left Boulevard Edgar Quinet – not with Augustus back to England, but to Belgium with Leonard. She fled with him secretly, telling no one, leav-ing no address. She had gone, they discovered, to Bruges, was living with Leonard and for the time being could only be reached through a *poste restante* there. She would stay with him at least three months, at most a lifetime: it depended how things worked out. It was, she after-wards remarked, 'one of my two discreditable episodes'.[129]

Exasperated, almost beside himself, Augustus hung on in Paris, doing nothing. He was completely deflated, reduced once more to writing letters – not mere prose ones this time, but page after page of

poems, ballads and sonnets, odd rhymes running in his head, scraps of verse Shakespearian, which he stored up and subsequently sent her.

> *But for the woman I hold in my heart,*
> *Whose body is a flame, whose soul a flower,*
> *Whose smile beguiled me in the wood, the smart*
> *Of kisses of her red lips every hour*
> *Branding me lover anew, is she to be,*
> *Being my Mistress, my Fatality?*

In the full stream of his romantic passion there are already oddly shaped pebbles of pedantry that, in time, would grow into veritable boulders. At one point, for example, he interrupts one of his most anguished letters in order to instruct Dorelia that 'the word "ardent" in the first sonnet I sent you should be changed to "nodding". Kindly make that correction.'*

So prolific were these poems that there seems to have been one left over for Ida who, he learnt, was now pregnant again. Possibly on Gwen's advice, he does not appear for the time being to have written anything except poetry for Dorelia; but to Ida he explained very frankly all that was happening. Upon Ida's reaction the whole course of their future hung. Since Augustus's happiness depended on Dorelia, and Ida's on him, she too longed for Dorelia to return. How happy the three of them might be! The last months had been miserable. She felt she had lost even the power of sitting to Augustus – and she would rather have lost her child. Every day, it seemed to her, she became more subordinate to him while he moved further away from her. They could only come together again if Dorelia were at the centre – of that she was now convinced. In a state of almost religious exaltation she sent to Gwen and Augustus two letters that were dramatically to alter the whole course of events. To Dorelia herself she did not write, but Gwen at once communicated the extraordinary developments:

'Dorelia, something has happened which takes my breath away so beautiful it is.

'Ida wants you to go to Gussy – not only wants but desires it passionately. She has written to him and to me. She says "She [Dorelia] is ours and she knows it. By God I will haunt her till she comes back."

'She said also to Gussy, "I have discovered I love you and what you want I want passionately. She, Dorelia, shall have pleasure with you eh?" She said much more but you understand what she means.

'Gus loves you in a much more noble way than you may think – he will not ask you now because he says perhaps you are happy with your

* She did.

artist and because of your worldly welfare – but he only says that last – because he knows you – we know you too and we do ask.

'You are necessary for his development and for Ida's, and he is necessary for yours – I have known that a long time – but I did not know how much. Dorelia you know I love you, you do not know how much. I should think it the greatest crime to take with intention any-one's happiness away even for a little time – it is to me the only thing that would matter.

'I point out your happiness and the highest happiness. I know of course from one point of view you will have to be brave and unselfish – but I have faith in you. Ida's example makes me feel that some day I shall be unselfish too.

'I would not write this if I knew you have no affection for Gussy. You are his aren't you?

'You might say I write this because I love you all – if you were strangers to me, I would try to write in the same way so much I feel in my heart that it [is] right what I say, and good.

'I am sorry for Leonard, but he has had his happiness for a time what more can he expect? We do not expect more. And all the future is yours to do what you like. Do not think these are my thoughts only – they are my instincts and inspired by whatever we have in us divine. I know what I write is for the best, more than I have ever known anything. If you are perplexed, trust me. But I know you know what I do. Gussy is going home to-night. Come by the first train to me. I shall be at the gare to meet you. When you are here you will know what to do and Ida.

'Do not put it off a minute simply because I shall then think you have not understood this letter – that it has not conveyed the truth to you. I fear that, because I know how weak words are sometimes – and yet it would be strange if the truth is not apparent here in every line.

'You will get this to-morrow morning perhaps – I shall be in the evening at the gare du nord. I would not say goodbye to Leonard. Your Gwen.'

It was not simply that Gwen wanted Dorelia to return to Augustus, but that she believed Dorelia belonged to the John tribe and that by running away she had contradicted her nature, committed a sin against some natural law. Her letter, and the others she wrote over this period, are remarkable for their urgent, intimate involvement with Dorelia's future. The anxiety which consumed her was like that of a dedicated priest witnessing a brother being tempted by mammon: only this is no ordinary religion, it is the religion of love for art's sake. Were not art and religious experience much the same thing? Was not Dorelia an idol in the temple of art?

But it is the tone as well as the content of what Gwen wrote that is so strange – that dogmatic certainty in her own rightness which, like a faith in some divinity shaping all their ends, shall not be denied. The other side of this moral conviction was a callousness that shows itself in her attitude to Leonard – 'what more can he expect?'

Just as remarkable was the subtle way in which Gwen took over and organized everything. It was, judged objectively, a most effective piece of practical politics that she, and not Augustus (whose obedient silence is interpreted as altruism), should communicate with Dorelia. This avoided any hint of a sexual tug-of-war, of a man-versus-man situation. Nor was Gwen acting for herself – after all she would have no place in Augustus's home when Dorelia returned. What her letters do not reveal is that she had just begun her love affair with Rodin, that she was full of joie de vivre, happy and self-confident in a way that was unique for her. It was this that gave her such sureness, made Dorelia the counterpart in Augustus's life of Rodin.

If Dorelia was subject to anyone's will, it must have been Gwen's, whose hard queer company she had kept over the last eight months, who, alone of all the John tribe, knew Leonard, and who probably also knew Dorelia best. The timing and occasion of her first letter, too, was excellent: no appeal until Ida's sanction had been obtained. Finally, she called upon the one strain stronger than any other in Dorelia's character, one that Gwen understood well: her sense of destiny. There was only one weakness in Gwen's position, and that was inevitable: while she could only send 'weak words' on a piece of paper, Leonard was with Dorelia in person. It was her words against his physical presence. But what she could do to offset this disadvantage she did, recommending Dorelia to tell Leonard nothing, to leave him in the same furtive way as she had left Augustus. For this too was in Dorelia's character, and to have a weakness recommended as one's duty can be irresistible.

When Gwen went to the Gare du Nord the following evening, Dorelia was not there. She had written a letter. To go back, she claimed, would be for ever to curtail her freedom. With Leonard she was free. Therefore she must not act selfishly, but think of Leonard's interests too, help him to develop his talent. Gwen had written her letter in 'an ecstasy': it was not cool reason. Whatever happened Gwen must not come and seek her out in Bruges.

If Gwen had not won as easily as she appears to have expected, she already sensed victory in Dorelia's reply. In her answer she brushed aside all these objections, asserting that whereas she understood Dorelia's position, Dorelia did not understand hers. To assist in this

understanding, she returned to the attack, reiterating and elaborating
her previous arguments:

'I must speak plainly for you to know everything before you choose.
Leonard cannot help you, he would have to know Gussie for that and
Ida and you a long, long time, he never could understand unless he
was our brother or a great genius.

'Strength and weakness, selfishness and unselfishness are only words
– our work in life was to develop ourselves and so fulfil our destiny
And when we do this we are of use in the world, then *only* can we help
our friends and develop them. I *know* that Gussie and Ida are more
parts of you than Leonard is for ever. When you leave him you will
perhaps make a great character of him – if he has faith in you that you
are acting according to your truest self – and what good could you do
him if he had no faith in you – by being always with him? But faith or
no faith he would know some day the truth – and that is the highest
good that can happen to us. To "wholly develop" a man is nonsense –
all events help to do that. I know as certainly as the day follows the
night that you would develop him and all your friends as far as one
human being can another by *being yourself. That is what you have to think
of,* Dorelia. To do this is hard – that is what I meant by saying you
must be brave and strong. I am sorry for people who suffer but that is
how we learn all we know nearly – and that is the great happiness –
knowledge of the truth!

'You know you are Gussy's as well as I do. Did you do wisely in
going away like that without telling him? Do you dare spend a week
with him or a day, or a few hours? Forgive me for speaking like this
darling Dorelia – I only want to help you to know yourself. I love you
so much that if I never saw you again and knew you were happy I
should be happy too. Oh don't be too proud to think much of all these
facts. You are unselfish but it makes it simple to know all we have to do
is to be true to the feelings that have been ours longest and most
consistently.'

While Gwen was writing this to Dorelia, Leonard had posted an
answer to her first letter which, disobeying Gwen's instructions,
Dorelia had shown him. Written in halting English, by now partly
indecipherable, combining pathos with dignity, it is couched as a rebuke
yet struggles to maintain a sense of fairness in grappling with the
questions posed by Gwen's lofty philosophy:

'Dear Miss John,

'Dorelia got your letter to-day and showed it to me. Your letter
forces me to explain to you several things you forgot, as well as I can
do.

'Of course you don't know me neither do you know my sentiments

to Dor; but this is the other side of the facts, at which you did not like to look, anyway it exists and it is as true as your words, if I allow myself to talk a little bit of myself.

'You say L. has had his happiness for a time, what more can he expect? Do you really think [— —] feelings are so [—] am constant [—] of hapiness, do you really think that Dorelia's feelings are small enough to love a man like this? People like me don't love often and a woman like Dorelia will not pass my way again; you would better understand, if you would know my life.

'Your letter is full of love, the love of a woman for another one, now imagine mine if you can. I am no ordinary man as you may think, who loves a girl because she is beautiful or whatever. I tell you and you are Dory's friend so you must understand it, I am an artist and cannot live without her and I will not live without her – I think this is clear. Very right if you say "it is the greatest crime to take with intention anyone's happiness". You might say as you did I had my hapiness. Do you think hapiness is a thing that you take like café after dinner, a thing that you enjoy a few times and something you can get sick of? Not my hapiness by God; I suffered enough before and I don't let escape something from me that I created myself with all my love and all my strength. Well, all those words are only an answer to yours, but something else that you forgot.

'We cannot force the fate to go our ways, fate forces us. This [—] that. Dorelia is not free dis[—] then she was mine as [—] with soul and body [—] understand.

'That's all I have to tell you, compere now my fate with that of John and his family perhaps you will see where it is heavier. My words seem hard to you, but they are the expression of my feelings as well as I can say it. I think it is not necessary to talk about Dorelias feelings and thoughts. I did *not* tell her what to do, I told her she might do what she thinks right and naturel, but remember your words of the crime and think that there are greater crimes which are against the rules of nature.

'If you want wright to me your thoughts about everything and dont get mad against me, you must see that there is no world that [is] absolutely right.

L – – – ard Bruges kplaass 5.'*

* It appears that Leonard unintentionally gave a clue here to their address. By a process of elimination (there is, for example, only one square or 'plaats' in Bruges that begins with the letter K), one can establish that they were probably living at Kraanplaats, 5, a large and beautiful dolls' house very near the Théâtre Royal Communal. This house belonged to a certain Lodewyk Van den Broucke and his wife Leonie (née Huys). He was evidently a man of some means, having 'no profession'. The records, that might have confirmed Leonard to be his son were destroyed

Wisely Gwen did not accept this invitation to write to Leonard. She was not interested in an academic discussion of 'thoughts about everything', but in outcomes; not in fairness, but rightness. Besides, it would have been a bad error of tactics to descend from her philosophic stratosphere to debate points of detail with him. His letter arrived in Paris before Gwen had posted her second letter to Dorelia, so she slipped into the envelope an extra page, quite pitiless, and not for Leonard but Dorelia. In this, she neatly deflects his arguments to her own ends. His letter, she confesses, had disappointed her, had made her 'more certain if certainty can be more certain of everything I have told you'. Leonard's love was, after all, nothing better than possessiveness. She had supposed it to have been finer – perhaps he'd climb to better things in time, given the adversity. He loved her of course, no one denied that. But his love was selfish, like that of the Pebble of the brook in Blake's *The Clod and the Pebble*, while Augustus's, 'much more noble', resembled the little Clod of Clay's.* For, whatever his faults, Augustus was an artist; while Leonard, as yet, was a part of the bourgeoisie.

'I have just read Leonard's letter. In self-justification I must answer a few things to you. I don't know what he thinks I mean – he does not understand certainly. I *never* thought he does not love you, I thought he loved you in a much finer way than his letter shows. When a person loves another they are only happy if the other one is – I don't see how they could be happy otherwise. He talks about his happiness and seems to think I want to take it away! He should be glad of everything I have said if it helps to show you how things stand and to be free, but he says "you are not free anymore you are his, his body and soul". He says there

'Love seeketh not itself to please,
 Nor for itself hath any care,
 But for another gives its ease,
 And builds a Heaven in Hell's despair.'

So sang a little Clod of Clay,
 Trodden with the cattle's feet,
 But a Pebble of the brook
 Warbled out these metres meet:

'Love seeketh only Self to please,
 To bind another to its delight,
 Joys in another's loss of ease,
 And builds a Hell in Heaven's despite.'

by fire in 1947. However, from other letters, we know that Leonard's surname began with a B, so it seems possible that he was (christened after his mother)' Leonard Broucke.

are greater crimes than breaking another's happiness that is to do things against the rules of nature.

'He limits the laws of nature. You are bound to those whome you are in sympathy by laws much stronger than the most aparent ones. The laws of nature are infinite and some are so delicate they have no names but they are strong. We are more than intellectual and animal beings we are spiritual also. Men don't know this so well as women, and I am older than Leonard.

'He said "I *could* not live without her and *will* not live without her – this is clear." Well a man who talks like that ought to be left to walk and stand and work alone – by every woman. Only when he can will he do good work.'

Gwen's shock tactics exploded powerful doubts within Dorelia. And to Gwen's philosophy were now added Augustus's poetry, and letters of simple entreaty from Ida. This pressure by post built up steadily to a bombardment. Ida had already dispatched Augustus back to the front line of combat in Paris so that, when the critical moment came, he could advance upon Bruges with all haste. 'Aurevoir,' she wrote to him, 'and don't come here again alone. Mrs Dorel Harem must be with you.'

From Dorelia herself little or nothing was heard. Before the west wind of passion that blew upon her, she was floundering, quietly, hopelessly, without comment. Then, suddenly, she seems to have capitulated. 'I have given in and am going back with Gus soon,' she wrote to Gwen. How and when she was going back was still left vague; hers was a conditional surrender of which no one quite knew the conditions. It was now that Augustus, reinforcing his advantage, moved from France into Belgium. And still, from further back, the John artillery kept up its unremitting hail of letters. Ida was particularly insistent that Dorelia should return, not just to England or London, but to Elm House itself. The three of them must live together in Augustus's Essex harem – 'a wonderful concubinage'. This would be infinitely preferable to a dreary segregation, with its periodic loneliness, dangers, dullness, incompleteness – almost respectability. If Dorelia were elsewhere, Ida feared she might never see Augustus, that he might actually leave her. She could never be sure. This at least was part of her reason for welcoming Dorelia into the home. But the prospect of it also excited her curiously. She had begun to identify her feelings for Dorelia with Gwen's, and to suspect that in some extraordinary way she loved her. She was certainly attracted to her passionately, yet vicariously and with symptoms that at moments were like those of a voyeur.

'Darling Dorel,' she wrote. 'Please do not forget that you are coming

back – or get spirited away before – as I should certainly hang myself in an apple tree. Whenever I write to you I think you will be annoyed or bored – I seem to have written so often and said the same thing. But for the last time O my honey let me say it – I *crave* for you to come here. I don't expect you will and I don't want you to if – well if you don't. But I do want you to understand it is all I want. I now feel incomplete and thirsty without you. I don't know why – and in all probability I shall have to continue so – as of course it will probably be impractical or something and naturally there are your people – and Gus will want you to be in town.

'But I want you to know how it is Mrs Harem – only you needn't come for 10 days as I am curing freckles on my face and shall be hideous until I blossom out afresh.

'I heard from Gwen "Dorelia writes she has given in". Were you then holding out against Gus, you little bitch? You are a mystery, but you are ours. I don't know if I love you for your own sake or for his. Aurevoir – I wish I could help that Leonard. It is so sad.'

It seems probable that Leonard still did not know what was happening. Dorelia kept everything secret – in a sense even from herself. She did not make an exact decision, she merely put herself in the path of the greatest current of energy, and let events take their course. By this time Augustus had reached Antwerp where he halted, expecting some news from Dorelia. 'I am getting to know every stone of Antwerp,' he wrote. '. . . The Devil keeps you away from me Ardor McNeill. Sometimes I talk to you while walking along and laugh so heartily all the people stare. All night I have strange dreams . . . You have only written once and how many letters have I sent you. You make me feel like Jesus Christ sometimes. I sit and sip and call for paper and ink – I wonder if you call for my letters. Yes you must . . . I think of the portrait I shall paint of you – there is a painting here by Rembrandt of little Saskia – a wondrous work – it is the repository of the inmost secret in the heart of a great artist. It is like the Cathedral here only more intimate more personal more subtle. In it is the principle of man's love of woman. You call me pirino – beloved, but do you love me enough to kiss me and laugh to me when I am dying? Beloved Beloved your hands are laid on my head and everything fades. Beloved do I not stand strong and stark upon the world with the wind of ages about my thin white body? Yes my feet clutch the rock of time and my arms are outstretched to the fingertips to polar stars – Target to the Firmament. I shall not quail. Butt of meteors I shall know how to smile. Ardor thou sylph with a secret for me let me hear you breathe. **Gustavus.**'

Dorelia

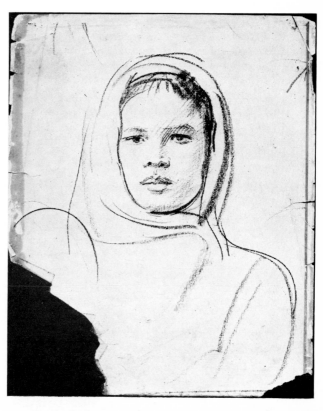

Ida

A Slade School picnic, April 1899. Seated on the horse from left to right are William Orpen, Augustus John and Gwen John. Seated with foot on shaft, Albert Rutherston. Standing without hat in centre, Edna Waugh. Seated to right, Alice Rothenstein and behind, William Rothenstein.

Jury of the New English Art Club at the Dudley Gallery, 1904. Left to right (standing) Walter Russell, David Muirhead, Alfred Rich, Ambrose McEvoy, Henry Tonks, Augustus John, D. S. MacColl, P. Wilson Steer, Muirhead Bone and Francis Bate; (seated) Fred Winter, Fred Brown, Roger Fry and William Rothenstein.

By nature inarticulate, Dorelia found it more than usually difficult to reply to these romantic outpourings. They impressed her, but she was swamped* by them. They were music – and how does one answer music? They were complete in themselves. During the whole of this dramatic episode on which their lives would pivot, while everyone else was discharging his very soul on to paper, she confined herself to the odd postcard – a time, a place, a piece of luggage, some weather, part of a dream, sometimes simply nothing at all but the picture on one side, her signature on the other. Augustus dashed from place to place – Antwerp, Brussels, Ghent – endeavouring to catch these cards, endeavouring to discover in them some clue as to what was going on. 'I hope you haven't sent word to Antwerp now that I have left,' he wrote from Ghent – but how would he ever know without travelling back again to Antwerp?

It appears that Dorelia had consented to see him, but only outside Bruges, presumably because Leonard still did not know she was going to leave him. Augustus himself hardly knew. 'I can come then on Tuesday morning?' he asked, perplexed, exasperated. 'Why come here, this isn't the way home, at least not the shortest. Beloved tell me where to find you – but if you can come here before *come in the name of all the Gods* – wait for me here opposite the station.' They met, almost by accident it seemed, certainly by good luck, but even now nothing was irretrievably fixed. Dorelia needed more time: a week. Allowing her to return was a torture to Augustus. It was not natural. 'What am I to do these last days?' he demanded. She did not reply. 'The time is nearly up – Ardor,' he wrote again. 'Gand is very near Bruges. I am to rejoin you on Tuesday morning. So be it.'

They set off on their return journey from Bruges station on

* 'Miss Dorelia Ardor. Pirini, I must keep writing,' he wrote from Antwerp. 'I found this evening a letter to you I had not posted. I wrote it the day I came – I have sent you many letters. Have you taken the trouble to go to the Post Office for them? You have not written to me yet. Do you not believe you are precious to me, invaluable one! I am alone and what can I do but think, and thoughts of all sorts come to me. I know if I don't hear from you to-morrow I will come to find you again. I can always claim you; I will have you for myself. Why did you desert me before – why, I cannot think. Don't trouble to find an impossible answer. If anyone can understand you I can. Love I know you – Know me – Know me. I have tears of love for you and yet I am not drunk. Sweet I have met you on the high-way and I have recognised you and kissed you and you have fled into the woods and I have followed you at last and found you again. My girl, my sweet friend whom I love so much can you withhold your lips your eyes and your heart and your mind from me your lover – he who will take no denial – no denial. No denial is valid with him henceforth. It is useless – my lady, sybil, Dryad, form without circumference, incomprehensible simplicity, earth and air –
Ardor McNeill, it is you I love – Gustavus.'

1 August 1904. They were to travel, not via Paris, but direct to London. Before leaving, Augustus wrote to Gwen arranging for Dorelia's belongings in the Boulevard Edgar Quinet to be sent to Flood Street. On the platform, waiting for their train, Dorelia also wrote to Gwen, finally breaking her long silence. Her postcard reads: 'How is the cat? Dorelia.'

Whether Leonard ever knew, until after she left, that Dorelia had 'given in' and chosen Augustus, is not certain; but it seems unlikely. He returned to Paris, imagining perhaps he was following Dorelia. But he only saw Gwen, who told him nothing. His name does not appear in their correspondence again: except once that autumn. 'Leonard came up to me a few days ago,' Gwen wrote to Dorelia. 'I should write him a nice letter if I were you. He will get very ill otherwise I think.' After this he vanishes, leaving just the echo of his letter to Gwen – 'I will not live without her.' The rest of Gwen's letter to Dorelia is about the complexities of making a skirt, about some 'earrings like Gussie's' she had mislaid. There is a mention of Rodin 'with some millionaires', and a description of four 'Toulousians' with umbrellas they knew. That was all.

Gwen had won the day – but thereafter she was to see little of Dorelia, Ida* or Augustus, and she moves out of the story of their lives. Deliberately. Despite the homesickness for England, even Wales, to which she had confessed less than three months ago, despite her intention to return 'in the Autumn I think or before', she never went back for any length of time. 'Stronger than a man, simpler than a child, her nature stood alone' – Charlotte Brontë's words about her sister Emily suggest a comparison with Gwen. Both of them were solitary and withdrawn, yet capable of passionate love; both of them deeply rooted in this life yet straining towards the perfection that implies another; both, after suffering, reconciling the will with the spirit. Gwen's certitude finds its parallel in Emily Brontë's 'Strange Power! I trust thy might: trust thou my constancy.' In a letter to Michel Salaman,[130] Gwen was to write: 'I don't think we change, but we disappear sometimes.' From the life she had known up till this time, she was about to disappear. She had renounced large ambitions of the kind towards which she felt Augustus was always tempting her; she had renounced her background and created another; she had renounced pleasure and risk and to some extent she had apparently renounced love. In Emily Brontë, too, there is the renunciation out of which certitude grew, but it seems infinitely

* A letter Ida wrote to Alice Rothenstein reveals that Gwen did not get back to painting until December of this year.

more tender – until one compares it to Gwen's portraits of solitary*
women.

> *This summer wind with thee and me*
> *Roams in the dawn of day;*
> *But thou must be where it shall be,*
> *Ere evening – far away.*

In the day-to-day world there was little left but triviality – those bits
and pieces of wood by which we keep afloat. Gwen's letters are full of
this. It was an art at which Dorelia, too, excelled – but it achieved
epidemic proportions once Ida also succumbed. 'They are putting up a
hen run in the garden here,' she wrote to welcome the returning couple.
'It will be much nicer – we shall be able to see them now. The hammock
is up and there are some canvas chairs and we are becoming quite like
a "country house" – and now the rain has come.'

From some correspondence he wrote to Charles Rutherston, it
appears that early this autumn Augustus took a private studio on the
other side of the King's Road from the Chelsea Art School – No. 4
Garden Studios, in Manresa Road. But Dorelia did not live with him
there. Instead, as Ida had desired, she went down to Elm House.

Ida had desired it, but now that it was actually coming to pass she
was beset by fears. After the great strain of the past months she felt
exhausted, and for a time this summer came near to a nervous break-
down. Compared with Gwen who, she imagined, had no one at all
now, she considered herself dreadfully feeble – she knew nothing of
Gwen's new happiness with Rodin. She had planned to visit Gwen in
Paris for a few days but was forced to abandon this 'for all sorts of
reasons' – her pregnancy, a child's sickness, the portrait of her that
Augustus promised urgently to do. Worried by the tone of her letters,
Gwen came instead to Elm House for three days in September, and
this fortified Ida.

But Augustus was happy. Everything would turn out for the best.
Ida was 'ready to play up', he told Dorelia, and 'only wants rest'.
Even if Paris was beyond her, she could still enjoy 'little journeys to
London'. He looked, and saw that everything was good. 'Never have
the beauties of the outer world moved me as of late,' he wrote to Will
Rothenstein from Matching Green.

'Our poultry run I conceive to be the most wonderful thing. So re-
mote from human interestedness, so paradisiac, so unaccountable it
seems under the slanting beams of the sun in the triumphant afflatus of
a long day's chant of love. The hens moving about their simple

* 'My solitude (which sometimes seems a sort of obstinacy).' Gwen John to
Michel Salaman (3 June 1926).

concerns, ever with them a strange note from the East (subdued now, their wild flight forgotten on the way from India), dappled gold under gilded alders, moving among medicine bottles, the broken pots and pans, crockery, meat, cans, old boots and ancient dirt and indescribable debris – the uncatalogued tales of a human abode.

'I have worked at my woman painfully, laboriously, with alterations of achievement and failure, impotence and power – you know the grinding see-saw – under a studio light, cold, informal, meaningless – a studio – what is it? a habitation – no – not even a *cow-shed* – 'tis a box wherein miserable painters hide themselves and shut the door on nature. I have imprisoned myself in my particular dungeon all day to-day for example – on my sitters' faces nought but the shifting light of reminiscence and that narrowed and distorted by an atrocious "sunlight" – let me not speak of the result – to work thus tho' manfully is to be foredoomed, 'tis to kick against the pricks. Now, mark you, this evening at sundown I escaped at last to the open, to the free air of space, where things have their proportion and place and are articulate – so by the roadside I came upon my women and my barking dog seated on the dark grass in the dusk, and sitting with them I was aware of spirits present – old spirits, ancient, memorable, familiar spirits, consulted in boyhood – insulted in manhood – bright, good, clear, beneficent spirits, ever-loving and loved spirits of Beauty and Truth and Mystery. And so we are going for a pic-nic to-morrow – and I will make sketches, God-willing. I wish we might never come back to dust-heap-making again. The call of the road is on me. Why do we load ourselves with the chains of commodities when the trees live rent free, and the river pays no toll?'

There are gleams of beauty in this letter, though they are clouded by the convolutions of his style. Yet this was the man. The simple animal-and-vegetable world for which he longs is glimpsed from a distance – a vision of natural happiness, native to him, from which he has somehow been parted. But as each woman in her ideal landscape is seen as the custodian of this happiness, so he becomes more involved in the world of 'human interestedness' from which he is seeking to escape. All his life he would inhabit this purgatory, an in-between world where he was neither free nor sophisticated, but enveloped by an atmosphere that seems permanently transitional, and where he can never rest. So, with ominous foreboding of what was to come, he signs his letter: 'Yours with the Unrest of Ahasuerus in his bones, "John".'

Men Must Play and Women Weep

It was more circumstances than anyone's fault.
 Ida John to Alice Rothenstein (August 1905)

It is more difficult at first to be wise, but it is infinitely harder afterwards *not* to be.
 Ida John to Mrs Sampson (May 1905)

1. DU CÔTÉ DE CHEZ ROTHENSTEIN

'My baby is getting so heavy I do not know how I shall bear him (or them) by October,' Ida had written to Alice Rothenstein (August 1904). 'The two outside are splendid and well,' she added, but 'I am such a size I think I am going to have a litter instead of the usual.'

The usual, another boy of heroic proportions eventually called Robin (or Robyn), was born at Elm House on 23 October. He was so punctual that everyone was taken by surprise. 'I had to race across the green for the wise woman,' Augustus told Mrs Sampson. 'The doctor, with truly professional promptitude, arrived in his express 16 horse motor car immediately after the event was successfully accomplished.' Yet despite these emergencies 'there was less fuss than usually accompanies the advent of an ordinary hen's egg,' he assured the Rani. '. . . Of course it's staggering to be confronted with a boy after all our prayers for a girl. Ida started the life of Frederick the Great last night which I think must have determined the sex of the infant. It was very rash . . . Ida has just remarked "Tell her she can have it if she likes." '

'Come down any day,' Ida was soon urging Alice. 'I am *quite* well enough to bear it. I will not get up too soon but I am awfully strong I think. The baby is still splendid.' By December he had swelled to so enormous a size that he was already '6 months in appearance. I never saw such a giant.' Luckily he was very obedient, 'and sleeps all the time'.

The new unconventionality of her married life cut Ida off more than ever from her family and from a number of her friends. What she called her 'blundering career' had left her curiously isolated 'like a bird sitting on its eggs'.

'I have arrived at the point of eating toasted cheese and stout for supper,' she darkly confessed to the Rani. 'It is a horrible thing to do, but shows to what a pitch animal spirits can arrive in the country.' It was not especially for love, she explained, that 'I am hungry and

thirsty, but for ethics and life and rainbows and colours – butterflies and shimmering seas and human intercourse'. She prized her friends very highly, even when they did not always approve of her Matching Green ménage. 'As you know,' she wrote to Will Rothenstein, 'the communicable part of my life is very narrow, and I have nothing to tell you about it. As to the other, you must understand that without telling or you would never count me one of your "dearest of friends" – a privilege of which I am only worthy in my most silent moments.'

The extent of what she felt able to communicate to her family is defined by a letter she wrote in the spring of 1905 to her aunt, Margaret Hinton:

'Robin is quite a man! he crawls about and eats bread and butter, and this evening he sat on the grass in the front garden and interviewed several boys who stopped on their way from school to talk to him. He makes so many noises, and laughs and wags his head about. You say you wonder what we do all day. About 6.30 Robin wakes, and crawls about the floor, and grunts and says ah and eh and daddle and silly things like that. About 7 D[avid] and C[aspar] wake and say more silly things, and get dressed, and have a baked apple, or a pear or something, and play about with toys and run up and down. Breakfast about 8.30. Go out in the garden, Robin washed and put to bed about 9.30. D and C go out for a walk, or to the shop, and to post. Bring in letters at 11. We have dinner about 1. and they wake up about 2., have dinner, go out, and so on and so on till 7 when they're all in bed, sometimes dancing about and shouting, sometimes going to sleep. Robin now joins in the fray and shouts too.'

And so on and so on through a life of loud and blameless exhaustion. It was an Allen and Hanbury world, with no time ever for anything else. But what Ida's letters also reveal is the increasing need she felt to share with others – other women, perhaps, especially – something more than this cooking-and-children routine. Triviality necessarily devours most of our lives – and in a civilized world triviality often comprises the mere business of keeping oneself and others alive. But, apart from this, there was also 'something that is behind the ordinary aspect of things,' Ida wrote. 'I think it is reality.' Triviality one could document; the reality which lay barricaded behind it one could only allude to with imprecision. For Ida, reality was coming to terms with the facts of her life as they now existed.

'Some days the curtain seems to lift a little for me,' she told her aunt, 'and they are days of inspiration and clearer knowledge. Those days I seem to walk on a little way. The other days I simply fight to keep where I am . . . I can understand the saints and martyrs and great men suffering everything for their idea of truth. It is more difficult,

once you have given it some life – to go back on your idea than to stick to it. It torments you and worries you and tears you to pieces if you do not live up to it . . .

'. . . it must sound mad to you, especially talking of fighting.

'It's wonderful what a different life one leads inside, to outside – at least how unknown the inside one is.'

It was impossible, in England in 1905, for people to understand, or to admit they understood, her true life – as yet she hardly comprehended all its aspects herself. By admitting her husband's mistress into the home she had, in the popular view, either made the supreme sacrifice for love; or else acted with inexcusable weakness. And on the whole, in England in 1905, people would tend to believe the latter. Why, even in Paris, men and women were hardly so brazen! Her unknown life, therefore, had generally to stay unknown – especially to the Nettle-ships. In defiance of the social conventions, Ida believed – was deter-mined to believe – that she lived a natural life: natural for her. But, as her reference to saints and martyrs implies, it was not easy and she embraced with some warmth the notion of self-sacrifice. Unfortunately, triviality would keep on breaking through in a way that drove her almost to distraction. Her days were full of problems about the chil-dren's tadpoles, the canaries' eggs. What infuriated her was her habit of growing infuriated – often over the most petty matters – when she had plainly settled for a manner of ruthless gentleness, of almost aggressive sympathy with everyone. 'What with babies, toothache and a visitation of *fleas* (where from we do not know) I am fast losing my reason,' she exclaimed to Alice.

Alice had grown curious again, but she was dismayed when even-tually Ida, in a dignified, faintly exasperated letter, went some way to satisfying her curiosity. 'Gus and Dorelia are up in town,' she wrote this winter, 'from which you may draw your own conclusions, and not bother me any more to know "where Dorelia sleeps" – You know we are not a *conventional* family, you have heard Dorelia is beautiful and most charming, and you must learn that my only happiness is for him to be happy and complete, and that far from diminishing our love it appears to augment it. I have my bad times it is only honest to admit. She is *so* remarkably charming. But those times are the devil and not the truth of light. You are large minded enough to conceive the amazement [? arrangement] as beautiful and possible – and would not think more of it than you would of any other madness which is really sanity. You will not gossip I know as that implies something brought to light which one wants hidden. All this we do not wish to hide, though there is no need to publish it, as after all it is a private matter.

'This letter is intended to be most discreet. It really expresses the

actual state of affairs and you need not consider there is any bitterness or heartache behind, as, though there *is* occasionally, it is a weakness *not to be tolerated* and which is gradually growing less and will cease when my understanding is quite cleared of its many weeds . . .'

The response from Alice was an unprecedented silence. 'Alice Rothenstein has at last shut up,' Ida reported triumphantly to Augustus. But to Alice herself she wrote: 'You and Will both ignore my letter but I suppose you don't know what to say – and really there is nothing. I hope you showed it to Will . . . Write again and tell me about someone – anyone – and all the horrid gossip you can think of.'

But, of course, the only gossip Alice could think of was Ida's. How could it be otherwise? It took her breath away – she could think of nothing else. What Ida really needed from her friends were stories about their own lives, or other people's, so irresistible that they would draw her out of the shell of her own existence, focus her attention elsewhere. She wanted particular details to brood over; she wanted her friends' letters to be like chapters from a serialized novel, so absorbing, so full of suspense, that they supplied a wholly new fabric, uncontaminated by self, to the pattern of her life. What she got was something different; from the Rani a sweet exuberant amusement, eccentrically mistyped,* proclaiming that Ida's situation was far too interesting for her to leave for a second. This was some comfort – 'only one is apt to drown the interest in tears', Ida confided to her – 'how natural and how foolish this is you will know'.

The Rani's letters were an invitation to enjoyment – almost as if they were two spectators at the Matching Green theatre. But Ida could not see it that way – if only she *could* be a spectator instead of taking everything with such 'pudding-like gravity'. Yet the darling Rani was the best of her friends: 'Your letters make green places in my life,' she told her. It was only that, in moments of crisis, she plummeted beyond their reach 'like a stone falling down a well'.

From Alice she received advice, cautionary advice, reproachful advice, advice that ran contrary to everything she had already done. Such advice was stirred in with a curiosity so persistent that it sometimes drove Ida frantic. 'She [Alice] is so – oh I don't know – she wants to know *why* and *how* – as if Chinese Ladies had answers to their riddles,' Ida complained to the Rani. 'The only nuisance about a riddle is its answer. Riddles are most fascinating by themselves.' Yet although she was always *gênée* by Alice – and Alice by her – somehow they

* Most mistypings were of a single letter that drastically changed the meaning of a word – such as a reference to the 'diving room' in her house. But there were also delightful misspellings. 'The spelling of "tomorroe" is quite too sweet,' Ida told her, 'and I shall adopt it.'

maintained a 'tremendous admiration of each other' so that, worse than all Alice's reproaches, were no letters at all. That had the ring of death. Alice's sudden silence was like an echoing wall, deafening Ida with her own doings – everything she wanted to escape from. 'Your silence is chilling,' she wrote to her. 'I do not think, if it is caused by displeasure, that it is fair. . . . Please to write at once, and tell me you adore me and everything I do is right . . . Oh Alice Alice Alice why don't you write and tell me all your Nurse's faults and all about Johnnie – and how you hope I am well and are longing to see me – *Darling* don't be cross – I can't help it. My heart is a well of deep [un]happiness and this makes me malicious.'

What bewildered Alice was Ida's attitude. Otherwise everything was as clear as a Victorian melodrama: Ida was the victim, noble but misguided; Dorelia the culprit who, if she had any decency, would take herself off; and Augustus was the man, an artist traditionally unconventional whom Ida must skilfully control as Alice controlled poor Will. She knew the plot well enough. Will, however, disagreed and blamed Augustus. 'Ida is simply an angel,' he wrote to Alice (19 October 1905), '– I think you are most unjust to Dorelia, who is looking after the children all the time and helping everything on, – Heaven knows she gets little for doing so.'

The friendship between the Johns and the Rothensteins was by this time developing symptoms of burlesque. Ida, being especially fond of Will, was besieged by Alice; Augustus, much attracted to Alice, was fêted by Will. It was as if each Rothenstein sought to protect the other from these explosive Johns. Ida's correspondence to 'darling Will' holds what are almost love-letters and these would be dutifully answered – by Alice. But when Alice herself sat to Augustus, Will strongly objected to her expression – the head flung back, the eyes closed – and would turn up at Augustus's studio to escort his wife home so punctually that on occasions Alice had not yet arrived there.

'You are a dear good friend to Gus,' Ida had written to Will – but Augustus, though he could not disagree, sometimes wished it were otherwise.

> *Thy friendship oft has made my heart to ake :*
> *Do be my Enemy for Friendship's sake.*

The trouble was that Augustus could not feel what he knew he was expected to feel. He could not even pretend to. Of course he appreciated very well that he should feel grateful – Will needed to be kept well-oiled with gratitude – but usually it was irritation that swarmed through him. His fate was to be helped, with extreme magnanimity, at every twist and crisis of his career, by someone whose personality

he increasingly disliked. Whichever way he turned he seemed unable
to avoid the rigours of Rothenstein's generosity, and his reaction, as he
was only too well aware, seemed very mean. A number of times he tried
to end their relationship – 'I have broken with Rothenstein by the
bye which of course is base ingratitude,' he once wrote to Lady Ottoline
Morrell (8 February 1909), '– in extenuation I must say the sensation so
far has been quite tolerable' – but breaking with Rothenstein was no
easy matter: he kept coming back for more. He was like a boxer for
ever turning the other cheek to his assailant, yet never to be knocked
out, a nightmare figure eventually wearing his opponent down with
these blows of his chin.

'It is more difficult to receive than to give,' Augustus once wrote,[131]
and this was the lesson so many of Rothenstein's beneficiaries had
bitterly to learn. Epstein, for example, who once assured him: 'Your
help so freely given me has been of the greatest service to me,' wrote
later (20 June 1911):

'Dear Rothenstein –

'I want no more of your damned insincere invitations.

'This pretence of friendship has gone on far enough.

'Yours etc Jacob Epstein.

'It is the comic element in your attitude that has prevented me
writing the above before this. I did not believe till now you could have
gone on with it.'

Augustus's hostility was almost exactly parallel to Epstein's. 'I have
had enough of him [Rothenstein], in spite of all his enthusiasm,' he
wrote to Ottoline Morrell (23 March 1909). 'How I wish someone
would record the diverting history of Rothenstein's career – it would
be the most ludicrous, abject and scurrilous psychological document
ever penned. He is I think . . . Le Sale juif par excellence de notre
siècle. There is I think one man only who could write adequately about
him and that's [Wyndham] Lewis . . .'

According to his son, John Rothenstein, 'no-one among his con-
temporaries had shown such perceptive generosity towards his brother
artists of succeeding generations from Augustus John and Epstein to
Henry Moore and Ceri Richards'. This is completely true, yet he never
became a popular figure. Many of the artists he helped turned on him
and, in an uncharacteristic moment of exasperation, Max Beerbohm
once revealed to him that he had no friends at all.* What, then, was the
secret of this gift for unpopularity? It seems to have depended upon
several qualities. He had begun his career as a promising artist, but as

* One of the guests at a dinner in honour of Will Rothenstein remarked: 'We
ought really to have been at a dinner composed of his enemies.' To which his
companion replied: 'They'd be precisely the same people.'

the years went on found himself more and more enclouded by ethical art-politics. 'For myself I want to paint my pictures and live within my means,' he once wrote to Alice (4 September 1923). 'I am slow and unproductive; but I am above all things an artist and I dread the growing complexities of life.' Yet the loneliness of painting never entirely suited him, and the complexities of public life spread like a sea over his artistic career. Like so many British painters of this period he apparently failed to fulfil his early potential, and his dissatisfaction seems to have been contagious. He grew into a figure somewhat similar, in the literary world, to Hugh Walpole, increasingly the patron rather than the creative painter, fixing his personal ambitions on the performance of his protégés. It was as if he sought to ride to immortality on their backs. His two prize rebellious steeds were Augustus and Stanley Spencer, whom he entered against the rival stables of Roger Fry. But of all his string, Augustus was the greatest disappointment to him, winning in brilliant fashion so many of the minor races, running under false colours, starting favourite for the classics, finishing last but one.

Already, by 1905, disillusionment had set in. 'I am sorry John has no success,' Will wrote to Alice that year (19 October 1905). 'I slid some advice in on the subject before the Puvis decoration at the Sorbonne, and I still think he may do great work – at any rate he feels it, and can do it.'

Will's advice, like Alice's, was a formidable and didactic commodity. A Max Beerbohm multiple caricature shows him advising poets how to write poetry, playwrights how to stage their plays, painters how to paint.* Augustus, unfortunately, was not susceptible to advice. He needed Rothenstein, intermittently, for one thing: money. 'I had a letter from John – not one I cared for much, for there was a hint of further pecuniary needs,' Will complained to his brother Albert (10 September 1908), '– he writes as though he were entirely neglected, but this is scarcely the case – one sees his drawings about everywhere,

* At the centre Will is looking into a mirror, lecturing himself on modesty. *Upper left*: lecturing Oscar Wilde on deportment, while Wilde casts his eyes heavenwards. *Upper right corner*: lecturing Lord Coleridge on law, who looks down benevolently at Will standing on tiptoe on a law book. *Upper right*: skewering with a pen Pinero, who postures on its point like a ballet dancer while Will lectures him on playwriting. *Middle right*: lecturing the Prince of Wales on 'dress', Will very tiny in white tie and tails down to his heels. *Lower right*: lecturing Aubrey Beardsley on decadence, and Mr Furse on 'folly'. *Lower middle*: advising Lord Rosebery (simply a bald and faceless dome rising out of a winged collar) on 'la partie politique'. *Lower left*: lecturing George Moore on 'caution' – he looking very spindly and stunned. *Middle left*: lecturing Mr Stratton on Art. The drawing is owned by Will Rothenstein's niece, Mrs Powell.

doesn't one?' What Will traded in, what he purchased, was gratitude. But Augustus had none to give – it was not a feeling he liked to entertain. 'I have not found him [Augustus] the most grateful of men in the days of his splendour,' Will sorrowfully confided to the Rani years later (19 August 1933). But then, who was properly grateful? One was always being shortchanged. The inverted gratitude he unerringly drew down upon himself was partly due to the ill-will of the competitive art-world, since the law of the jungle persists most strongly in cultural and academic circles. But it was also due to certain peculiarities in his character. He felt he lacked charm. 'The Gods who made me energetic & gave me a little passion & a little faith did me an ill turn when they made me ugly & charmless,' he confessed once (28 July 1915) to Rabindranath Tagore.[132] He wanted above all things to be loved, yet was fatally attracted to the wrong people – those who had no love to give – and he was often thrown on the defensive. The gratitude he squeezed out of people was a substitute for the love he felt he could never command. He had been brought up in the Whistlerian tradition where even the slightest whisper of criticism was intolerable. To this sensitivity was added an exceptional sanctimoniousness as he grew more and more exercised over good causes. He became known as 'the parson', and Augustus went out of his way to shock him: he could not resist it. Will's tone, too, varied disconcertingly between the lofty and the obsequious; he was suspected of chasing celebrities; everything he seemed to view through a mist of high-mindedness. The discreet ebullience of his bachelor days gradually gave way before advancing austerity. In the rather racialist climate of Edwardian England, he started off with obvious disadvantages, and improved on them to fashion for himself a positive handicap. What Augustus objected to was his ugliness. Will was aesthetically reprehensible to him and the marriage of this dark monkey-like creature to the refulgent Alice, the pink rose, went against all his notions of propagating a masterfully beautiful race. If anything was immoral, that was.

Then there was the embarrassing problem of Rothenstein's praise. Augustus needed praise, as he needed drink, as he needed later on to associate with the aristocracy. But he was not so susceptible as to think more highly for any length of time of those who provided such props. Recognizing weakness in himself, in black moods he would assail those very people whom, in other states of mind, he had encouraged to indulge him. He would imbibe praise for a time: then suddenly it sickened him.*

* An article Rothenstein wrote about the Slade celebrated Augustus for many of those buccaneering qualities that clustered round his weaker side and fed the John legend. But Augustus strongly objected to this. 'Your all too picturesque

It was partly because Will had placed an aesthetic investment in Augustus's future that, unlike Alice, he welcomed the presence of Dorelia. The visual inspiration which Augustus originally found in Ida had begun to fail; but, in 'the matchless Dorelia', Rothenstein later rhapsodized,[133] 'in her dazzling beauty, now lyrical, now dramatic, John found constant inspiration. Who, indeed, could approach John in the interpretation of a woman's sensuous charm? No wonder fair ladies besieged his studio, and his person, too; for John had other magic than that of his brush; no one so irresistible as he, nor with such looks, such brains, such romantic and reckless daring and indifference to public opinion.'

The winter show of the New English Art Club at the end of 1904 included two paintings of Dorelia. 'This year for the first time Mr John gives promise of becoming a painter,' Roger Fry wrote in the *Athenaeum*.[134] '. . . at last he has seen where the logic of his views as a draughtsman should lead him . . . he has already arrived at a control of his medium which astonishes one by comparison with the work of a year or two back. . . . One must go back to Alfred Stevens or Etty or the youthful Watts to find its like. . . . People will no doubt . . . complain of his love of low life, just as they complain of Rubens's fat blondes; but in the one case as in the other they will have to bow to the mastery of power. . . . In modern life a thousand accidents may intervene to defraud an artist's talents of fruition, but if only fate and his temperament are not adverse, we hardly dare confess how high are the hopes of Mr John's future which his paintings this year have led us to form. . . .'

With supporters like Fry and Sickert, 'an amusing and curious

treatment of me, leaves me in any posture but that of the penitent. Tho' you have been good enough to clothe me in "Bravest green", I find myself much more comfortable in my own less operatic habiliments and much more likely to face with fortitude and detachment the kind of music you bring to bear on me; – I have heard such strains before – but never! oh never! did I expect to find you in the position of band master – you my dear Will, whose flair and vision have been among the conditions which make life tolerable in this island. Your picture of me hurling bombs at mankind is lurid but inaccurate; – had I bombs to throw, mankind would not be my objective . . . I am not enough of a business man ever to hope to become "an asset to our country"; "purely and divinely inspired" as I may be by "the beauty and grandeur of the world"; I trust however that "our country" will prove something of an asset to me – otherwise why should I stop in it? . . . Differing with you, I think that the artist may *not* without shame join with his fellow men. His isolation indeed grows more complete as his art becomes more pure, nor is it the "ultimate usefulness" of the art which ever inspires him. His goal lies within himself – nor in his audacity is he deterred or terrified or bewildered for more than one sickly moment by the clamour and bustle and siren voices that come to him from without.'

character – amiable withal',* who came down to Matching Green to look at his drawings; with his income from the Chelsea Art School and from occasional exhibitions at the Carfax Gallery, he could afford to dispense with Rothenstein's favours. He had further strengthened his position when, late in 1904, he was elected as one of the original members of the Society of Twelve, a small group of British draughtsmen, etchers, wood-engravers and lithographers. The Honorary Secretary and leading spirit of this group was Muirhead Bone, who organized its exhibitions at Obachs in New Bond Street. For Augustus this was another valuable outlet for his work; for Rothenstein, who was also an original member, it was a new arena in which to display, like an inverted Iago, his motiveless generosity. His methods of alienating everyone were on this occasion particularly adroit. To the Society of Twelve he proposed electing a thirteenth member, Lucien Pissarro, who, not being British, was ineligible for membership. It was a masterstroke. Inevitably, when Pissarro failed to gain the necessary votes, Will resigned. Augustus, who hated being dragged into these affairs, was persuaded to use his influence to bring him back, and this, somewhat improbably, he achieved. But no sooner was Will re-elected than he was at it again, returning undaunted and unavailing for three years in succession to the same charge, resigning again, and throwing the whole group into confusion. 'I was tenacious,' he later owned, 'and many letters passed between Bone and myself, until Pissarro was admitted.' By which time the society was so shaken with squabbles it did not long survive Will's quixotic triumph.

Five years after Rothenstein died, Augustus wrote an Appreciation of him in the catalogue to the Tate Gallery Memorial Exhibition.† In this he paid tribute to him as a man 'always intransigent and sometimes truculent', subject to a rare disease, 'madness of self-sacrifice', and bound therefore to make enemies. But he also called him 'a generous, candid and perspicacious soul', and while walking round the exhibition the day before it opened his eyes filled with tears and he admitted that he had often been unjust to his old friend. Yet if Will had come tripping through the door just then, Augustus would soon have strode out, infuriated by his admirer. Both, to an unusual degree, were at the mercy of their temperaments, and however much they wished it

* 'Sickert is certainly an amusing and curious character – amiable withal. But it offended me to hear him cast off his old master so lightly and perfunctorily the other day – after all, Whistler wasn't a bad artist. Sickert probably never saw his real merits, but he is singularly inept at times, for instance having once and for all disposed of poor Whistler he goes on to discover Robert Fowler Esq! But anybody who has served on a Jury with him must know he is quite futile . . .'

† Sir William Rothenstein Memorial Exhibition. Tate Gallery, 5 May–4 June 1950.

otherwise their temperaments did not mix. One of the strongest features of Augustus's character, arising from his antipathy to Edwin John, was an allergy to anyone who assumed the role of father-figure. Rothenstein, who came from a very authoritarian family, was infatuated with the father-figure, feeling a need both to promote others* in that part, and to leapfrog into it himself – especially in relation to his brother Albert whom he smothered with admonitions concerning the high seriousness of art to the extent of stopping him painting altogether. Augustus would neither play the parent, nor swallow the well-meaning reprimands. In a word they were incompatible. Yet each still felt he needed the other. Despite his success, a new strain had been placed on Augustus's financial resources by the birth of Robin that autumn. By the New Year, he was even more susceptible to Rothenstein's help. For Dorelia was now pregnant.

2. KEEPING UP THE GAME

For several months Dorelia seems to have kept her pregnancy a secret – an index probably that things were not going well. Already, by the end of 1904, scenes of unimaginable violence had broken out between them. Shortly after Robin's birth, Ida had made one of her 'little journeys' up to London for a few days, avoiding her friends, feeling strangely hysterical. 'I simply drifted – from one omnibus to another – without aim or intention,' she admitted to Alice (December 1904). Yet the sudden flow of freedom, release from duty appeared to have 'done me worlds of good'. She returned to Matching Green shortly before Christmas, only to find that a double portrait Augustus was painting of her and Dorelia had gone wrong; that, in her absence, Augustus had altered the design so that, by the time she arrived back, there was no room on the canvas for Ida at all. Instantly she was plunged, beyond anything this incident seemed to warrant, into misery. Her unhappiness was so acute, so rankling, she could not contain it, and 'there was a black storm'. What bit into her was the *unfairness*. Being left out of the picture symbolized what was increasingly becoming her position in the household. After the storm was over and, rather to their surprise, they were still afloat, Ida felt easier and 'there was a fair amount of sunlight'. But the tension in the atmosphere had not been dissipated and over the rest of this winter, almost daily, there were bitter quarrels. To these there seemed no logical consistency. One morning Augustus and Ida would take sides against Dorelia, and Augustus would volunteer that she could leave whenever she liked – he

* Henry Woods was one, Herbert Fisher another, and to some extent Robert Bridges a third.

had only rescued her in the first place, he added, because he felt sorry for her; but the following morning it was Ida who was invited to leave – 'pack up your luggage and take your brats with you!' Next day Augustus would suddenly announce that *he* was leaving for 'the Blue Danube'; after which it was the turn of Ida (who threatened to leave for Amsterdam); then Dorelia. Finally: 'We are all thinking of going to the tropics,' Ida told Mrs Sampson, '– don't you think it would be a good plan?' But still no one left.

Unhappiness, like an epidemic, spread from one to the other. It seemed impossible to operate the ménage successfully. Augustus felt doubly confined, conscious of the women's critical eyes watching him, especially Ida's, infuriated by these cloudy human complications that he would not admit existed, that he felt *should* not exist. That winter shut him away in Elm House like some prison. It was unendurable, and largely of his own making. He went roaring from room to room driving the children before him, like cattle.

But Ida's pain went deeper. She had invited Dorelia to Matching Green, because the two of them had a better hold on Augustus than Ida by herself would have had. But then she was consumed by dreadful jealousy and doubt. For Augustus made no attempt to conceal his infatuation for Dorelia; while to Ida he seemed blind. 'Have I lost my beauty altogether?' she once asked Dorelia. Sometimes she felt ill with depression, and in fact was subject to a succession of minor ailments that conspired to make her look in her own eyes more ugly still. 'I have *an eye*,' she proclaimed in a letter to the Rani. 'Dr. says due to general weakness! it has a white sort of spot in it and runs green matter in the evening – which during the night effectually gums down the eyelids so that they have to be melted open! Isn't it too loathesome?' The *eye* was followed by a *throat* – 'dear me what next? Varicose veins probably.'

Doubt and jealousy infected everything. Since Dorelia had come, Maggie had taken herself off, disapproving of their immoral ways. It was natural that, to some extent, Dorelia should take her place. But Ida seldom allowed her to do anything for the children or in the house, partly, it seems, because Augustus was quick to criticize her for treating Dorelia like a servant. Nor could she bring herself to speak about Dorelia's unborn baby; and she began to hate herself for this apparent meanness of spirit. Envy of Dorelia; sexual jealousy; self-hatred for harbouring such passions; frustration, anger, disenchantment so buffeted her during these dark months that she emerged from the winter a changed person, her love for Augustus impaired, her attitude to herself and to Dorelia altered.

It was to the Rani she confessed most. 'I feel simply desperate,' one of her letters begins; and another: 'My depression is so great as to be

almost exhilaration.' As the days went by this depression deepened
dangerously. 'I feel utterly – like this □ – square as a box and mad as a
lemon squeezer. What is the remedy?' she asked her friend. '. . . Do
you know what it is to sit down and be bounced up again by what you
sat on, and for that to happen *continuously* so that you can't sit *anywhere*?
Of course you do – I am now taking phenacetin to keep the furniture
still.' Up till this moment she had preserved the detachment and energy
of humour. But the effect of her phenacetin tablets appears to have been
to reduce this detachment. Depression now engulfed her – she was too
weary to fight it off, and for the first time contemplated suicide. From a
distance the Rani sometimes knew more of what was happening than
Augustus and Dorelia, from whom Ida camouflaged her emotions.
She did not complain, but explained: 'I live the life of a lady slavey. But
I wouldn't change – because of Augustus – c'est un homme pour qui
mourir – and literally sometimes I am inclined to kill myself – I don't
seem exactly necessary.' She still admired him – but she was no longer
intimate with him. Also he was 'impossible', and so life itself had
become impossible. Her thoughts of suicide sprang from no wish to
die, but from a disappointment over living. 'I long for an under-
standing face,' she told the Rani. 'I am surrounded by cows and
vulgarity here. Isn't it awful when even the desire to live forsakes one?
I *cannot* just now, see any reason why I should. Yet I feel if I tide over
this bad time, I shall be glad later on. What do you think?'

The Rani thought Ida must not be left alone – and wired Augustus
who was then in London with Dorelia, to return home at once. She
also wrote to Ida urging her to shake off such ill-thoughts of death.
'As to suicide,' Ida responded, 'why not? What a fuss about one life
which is really not valuable! . . . Am I not a fool to make such a fuss
about a thing I accepted, nay invited, but I have lost all my sense of
reason or right. All that seems far over the sea and I can only hear
sounds which don't seem to matter. It's so funny not to *want* to be good.
I never remember to have felt it before. It is such a nice free feeling –
animals must be like that.' But the crisis lifted, and she confessed: 'You
know *I was very near* the laudanum bottle – somehow it seemed the next
thing. Like when you're tired you see an armchair and sit down in it.
Now you "know all" I feel a sort of support – it is funny. Others
know, but no one has given me support in the right place as you
have. One held up an arm, another a leg, one told me I wasn't tired
and there was nothing the matter . . . With you I have something to
sit on!'

Though she showed little, and said nothing, Dorelia too was not
happy. She felt responsible for the bickering, the guilt, the deep
dissatisfaction that pervaded the house. There were times, she knew,

when Ida must have wished her at the bottom of the sea. She began to think it had been a mistake coming to Matching Green. Then, early in 1905, while Augustus was painting her portrait, she told him categorically that once this picture was finished she would leave. There was nothing to stop her; she had no wish to stay. Augustus was furious. Their life together, of which he had had such clear and splendid dreams, was failing. It should have been so natural. Angrily he blamed Ida. After all, it was she who had urged Dorelia to join them at Matching Green instead of living with Augustus in London; and it was her hostility that was driving her away, pregnant, and without any place to return to. Because she had felt unnecessary to Augustus, Ida had made Dorelia feel unnecessary to Elm House, to the children and general running of the place.

The turmoil of emotions following Robin's birth had worn Ida out, and she had gone to stay with the Salamans at Oxford for a short holiday. But her imagination still stalked the rooms of Elm House, remembering and reliving her reactions to so many sights and sounds she had never wanted to witness. Unlike Augustus, she could not persuade herself that none of it had happened; she lingered over everything, imprisoning the details in her mind. No matter what her intelligence advised, she was affected biologically by this poison. In a remarkable letter she now sent privately to Dorelia, very long, but written hurriedly in pencil still curiously unfaded, she set down the conclusions she had come to over the winter they had endured together.

'. . . I tried not to be horrid – I know I am – I never hardly feel generous now like I did at first – I suppose you feel this through everything – I tried to be jolly – it is easy to be superficially jolly – I hate to think I made you miserable but I know I have – Gus blames me entirely for *everything* now – I daresay he's right – but when I think of some things I feel I suffered too much – it was like physical suffering it was so intense – like being burnt or something – I can't feel I am entirely responsible for this horrid ending – it was nature that was the enemy to our scheme. I have often wondered you have not gone away before – it has always been open to you to go, and if you have been as unhappy as Gus says you should have told me. I do not think it likely Gus and I can live together after this – I want to separate – I feel sick at heart. At present I hate you generally but I don't know if I really do. It is all impossible now and we are simply living in a convention you know – a way of talking to each other which has no depth or heart. I should like to know if it gives you a feeling of relief and flying away to freedom to think of going . . . I don't care what Gus thinks of me now, of course he'd be wild at this letter. He seems centuries away. He puts

himself away. I think he's a mean and childish creature besides being the fine old chap he is.

'I came here in order to have the rest cure, and I am, but it makes things seem worse than if one is occupied – but of course it will all come all right in the end. I know you and Gus think I ought to think of you as the sufferer, but I can't. You are free – the man you love at present, loves you – you don't care for convention or what people think – of course your future is perilous, but you love it. You are a wanderer – you would hate safety and cages – why are you to be pitied? It is only the ones who are bound who are to be pitied – the slaves. It seems to me utterly misjudging the case to pity you. You are living your life – you chose it – you did it because you wanted to – didn't you? Do you regret it? I thought you were a wild free bird who loved life in its glorious hardships. If I am to think of you as a sad female who needs protection I must indeed change my ideas – and yet Gus seems to think it is all your sorrow. I do not understand. It was for your freedom and all you represented I envied you so. Because you meant to Gus all that lay outside the dull home, the unspeakable fireside, the gruesome dinner table – that I became so hopeless – I was the chain – you were the key to unlock it. This is what I have been made to feel ever since you came. Gus will deny it but he denies many facts which are daily occurrences – apparently denies them because they are true and he wants to pretend they aren't. One feels what is, doesn't one? Nothing can change this fact – that you are the one outside who calls a man to *apparent* freedom and wild rocks and wind and air – and I am the one inside who says come to dinner, and whom to live with is apparent slavery. Neither Gus nor I are strong enough to find freedom in domesticity – though I know it is there.

'You are the wild bird – fly away – as Gus says our life does not suit you. He will follow, never fear. There was never a poet could stay at home. Do not think I consider myself to be pitied either. I shudder when I think of those times, simply because it was pain . . . It has robbed me of the tenderness I felt for you – but you can do without that – and I would do anything for you if you would ever ask me to – you still seem to belong to us. I.'

What Ida had overlooked was that, during the first few months of 1905, Augustus had grown rather less attentive towards Dorelia. The wild bird was caged and, no longer on the wing, looked less attractive. For Augustus love was like fire, and he was drawn to it for much the same reasons that society feared it. Confined within the grate of marriage, it could smoulder safely, drearily, giving out little heat or light, endangering no one. But its smoke sidled up and choked him and its dying ashes were cheerless. He wanted to spread it about, let it take

light where it would, to burn it wastefully if need be, to make a splen-
did conflagration – rather than sit fixed before its sinking embers. And
now Dorelia, whom he had once likened to a flame, was diminished by
this domestic chill. His poems dried up, his gaze unlocked itself; of
course he was still aroused by her sexually, still needed her as a model –
yet he seemed less responsive. Idealism was petering out into sensuality
which, by itself, never satisfied him. What he needed from Dorelia,
and even more from Ida, was less of them. He needed distance to get
his romantic view in focus. Except in bursts he was not a demonstra-
tive man and felt impatient over homely displays of affection, so that
Dorelia, confused by this sudden heating-and-cooling of emotion, grew
defensive. Ida had hardened towards her; Augustus, at moments,
appeared indifferent; neither of them ever mentioned her unborn baby,
and this, from Augustus, hurt her. She confessed as much to Ida who,
contradicting her avowed loss of tenderness, her general hatred for
Dorelia, wrote back most sensitively to reassure her:

'My dear, men always seem indifferent about babies – that is, men of
our sort. You must not think Gus is more so over yours than he was
over mine. He never said anything about David except "don't spill it".
They take us and leave us you know – it is nature. I thought he was
rather solicitous about yours considering. Don't you believe he came
over to Belgium because he was sorry for you. He is a mean skunk to
let you imagine such a thing. If ever a man was in love, he was – and is
now, only of course it's sunk down to the bottom again – a man doesn't
keep stirred up for long – and because we can't see it we're afraid it's
not there – but never you fear.'

Such consolation was even more applicable to Ida herself, and was
soon to form the basis of a new bond between the two women. The
catalyst which would help to bring this about was Dorelia's baby. But,
for the time being, it was just one more factor confusing everything.
Like a lake, swollen by the rivers of their mixed feelings that ran into
it from every direction, their confusion rose. At times, it was the only
thing the three of them shared. Augustus's pronouncements certainly
sounded unmixed, but then they were so quick, and so quickly suc-
ceeded by other pronouncements equally strong and utterly different.
Ida, for all her disenchantment, still harboured a deep affection for him
– 'he's a mean and childish creature besides being the fine old chap he is'
– still exonerated him, as Dorelia was to do, because he was an artist.
Admiration and anger, jealousy and tenderness for Dorelia curdled
within her. Amid all this turbulent eddying of emotion, it was up to
Dorelia to steer a firm course. But for her pregnancy, it seems likely
that, as before in Paris and Bruges, she would have slipped away,
without a word. Words were not her *métier* – words, explanations, all

this indulgence, this lavish outpouring of passion, was not in her line. She was, so she always insisted, 'a very ordinary person', blessed with the vicarious gift of inspiring an artist – and that artist need not be Augustus. Yet she had little talent for making independent decisions: she excelled at making the best of other people's, and when, as now, no one made any decisions whatsoever, she drifted without a compass. Hoping that Ida might decide for her – for the two of them had never been so intimate as by post – she wrote expressing her confusion. But when Ida replied, it was faithfully to mirror this confusion back:

'About your going or not *you* must decide – I should not have suggested it, but I believe you'd be happier to go . . . Yes, to stay together seems impossible, only we know it isn't – I don't know what to say. Only I feel so sure you'd be happier away . . . I know I should be jolly glad now if we all lived apart – or anyway if I did with the children. Don't you think we might as well? – if it can be arranged.

'I don't feel the same confidence in Gus I did, nor in myself.

'Yes I know I always asked you to stay on, but still I don't see why you should have – you knew it was pride made me ask you, and because I wouldn't be instrumental in your going, having invited you – also because I didn't see how I could live with Gus alone again. All, all selfish reasons.

'. . . I have often felt a pig not to talk to you more about the * baby, but I couldn't manage it. Also I always feel you *are not* like ordinary people and don't care for the things other people do. Gus says what I think of you is vulgar and insensible – I don't know – I know I'm always fighting for you to people outside, but probably what I tell them is quite untrue – and vulgar. I know I admire you immensely as I do a great river or a sunny day – or anything else great and natural and inevitable. But perhaps this is not you. I don't feel friendly or tender to you because you seem aloof and like some calm independent animal – you don't seem to need anything from me, or from any woman – and it seems unnatural and a condescension for you to do things for me. Added to all this is my jealousy. This is a true statement of why I am like I am to you . . .

'As to Gus he's a poet, and knows no more about actual life than a poet does. This is sometimes everything, when he's struck a spark to illumine the darkness, and sometimes nothing when he's looking at the moon. As to me, we all know I'm nothing but a rubbish heap with a few buried treasures which will all be tarnished by the time they come to light.

'This mistake I make is considering Gus as a man instead of an artist-creature. I am so sorry for you, poor little thing, bottling yourself

* Ida crossed out the word 'your' and substituted 'the'.

up about the baby. Shall we laugh at all this when we're 50? Maybe –
but at 50 the passions are burnt low. It makes no difference to now does
it?'

But so much of Ida's analysis, it seemed to Dorelia, made 'no dif-
ference to now'. Dorelia needed to simplify things in order to act, not
to investigate them more minutely. So far as action was concerned,
there was only one new simplifying factor in Ida's letter: she was no
longer asking Dorelia to stay. Dorelia therefore wrote back briefly and
cryptically, stating that she would 'treat it as an everyday occurrence'
and, she implied, just wander off. But Ida, fearing that Dorelia would
vanish before she got back, and that she would have to return to Elm
House alone with Augustus, replied urgently:

'Do not go till we all go, it would be so horrid . . . I want to go out
from Matching Green all together and part at a cross roads – don't
you go before I get back unless you *want* to . . . We shall have dinner
all together – no slipping away.'

As an inducement for Dorelia to remain until she arrived back, Ida
promised 'a bottle of olives . . . 2 natural coloured ostrich feathers and
some lace!'

Whether it was the lure of these items or the fact that Ida appeared at
last to have issued firmer instructions, Dorelia was persuaded to wait.
Augustus had by this time gone up to yet another new studio* in
London, and the two women joined him there in the last week of
March. This was to be the crossroads, the parting of the ways. He did
not know that they had been corresponding, and even seems to have
imagined that the crisis of Dorelia's departure had passed: after all, no
one had said anything. What then happened was unexpected to every-
one.

'We had a *terrific* flare up,' Ida afterwards (27 March 1905) told
Alice Rothenstein. '. . . and the ménage was on the point of being
broken up, as D[orelia] said she would not come back, because the
only sane and sensible thing for us to do was to live apart. But I
persuaded her to, for many reasons – and we settled solemnly to keep
up the game till summer. Lord, it was a murky time – most sulphurous –
it gave me a queer sort of impersonal enjoyment. After it we all three
dined in a restaurant (which is now a rare joy) and drank wine, and then
rode miles on the top of a bus, very gay and light hearted. Gus has been
a sweet mild creature since.'

The 'many reasons' for Ida's change of attitude are nowhere specified.
Certainly it must have taken Dorelia by surprise and, so it appears, was
not completely understood even by Ida herself. The 'queer sort of

* He moved from No. 4 to No. 9 Garden Studios in Manresa Road, Chelsea,
during the spring of 1905.

impersonal enjoyment' she felt may have been the exercise of power. For however flamboyant or romantic the others might appear, from them the secret of making decisions had been withheld. Where Ida led, Augustus and Dorelia followed, overtook – and the knowledge of this must have afforded her some measure of satisfaction. To some degree she seems to have taken the Rani's advice and been able to treat the whole affair as some sort of theatre, where whatever dramatic speeches the principal characters might deliver, they moved about on her directions.

But one of the 'many reasons' was Ida's dread of living alone with Augustus. If she remained with him, as she might have to, then he would take other mistresses, and none of them was likely to match Dorelia. It had been Ida's love for Augustus that had drawn all three of them under the same roof; but it was her affection for Dorelia that now held them together.

So far as the baby was concerned, Ida made some attempt to interrupt her own silence, to offer some diffident flourish of help and participation. 'If you would like me to help you over the baby's birth or if you'd rather I kept out of the way – I meant to of course, but probably you'd much rather not. I'd like to and I'd hate to. I would rather come, probably only because I don't like to be away from things'.

In the event Ida was not with Dorelia when the baby was born – and nor was anyone else. Apart from the fact that it was a boy, eventually to be called Pyramus, and that he was born on bleakest Dartmoor, what happened, and exactly when, is difficult now to ascertain. For the occasion Dorelia assumed the name of 'Mrs Archibald McNeill', wife of a naval officer long at sea, while Augustus on his arrival posed as her solicitous brother. Later on their identities changed. 'I'm quite certain there is no penalty attached to having a bastard in the family,' Augustus wrote to reassure her from a Liverpool pub called 'The Duke'. 'So better register him as my son – provided of course it isn't published next morning in the Daily Mail or Express – as your family and my father no doubt take in one of those journals and such advertisement would be very disturbing. Have you stuck to that list of names? A sensation takes possession of me that Pyramus may be omitted or Alastir . . . The parish of Lydford wasn't it?'*

Pyramus was born during late April or early May, in a caravan that

* Dorelia was deeply allergic to certificates, and in the end the birth was never registered. In a letter that would make any biographer's heart sink, Augustus reassured her: 'There is no need to register Pyramus at all – or anybody else – you *may* register him for *nothing* within 6 weeks but after that you pay so much to do so. But you are not bound to register him. Sampson told me this. He has not registered Honor. So you can write to the registrar and tell him you have decided not to.'

Augustus was buying from Michel Salaman.* Dorelia was alone (except for a large herd of cows), though not far from an inn owned by a friendly landlord and his wife, Mr and Mrs Hext, who saw to it that a doctor and nurse visited her. Both Augustus and Ida had planned to be there, but Augustus 'wearing my new suit so of course I cannot think very composedly' was fastened in committee work at Liverpool where Charles Reilly 'keeps at me about his scheme of a school of 10 picked pupils and walls and ceilings to decorate – and £500 a year'. Ida, meanwhile, was held at Matching Green in polite talk with her mother who had decided to stay with her over Whitsun. In their absence they both sent down money, advice of diet ('don't live on potatoes'), and plenty of unanswered inquiries – though most of these seem to have been about the Hexts.

As soon as the telegram – in Romany – arrived at Elm House saying Dorelia's baby was born, Ida abandoned her mother and hurried down, travelling through the night by train and arriving at the camp by eleven next morning. She found Dorelia lying along the caravan shelf which served for a bed, with her infant – 'a boy of course,' – beside her. Augustus, 'suave and innocent as ever', turned up the following day 'to kiss the little woman who is giving up much for love of him', Ida wrote to the Rani. 'The babe is fine, a tawny colour – very contented on the whole – we have to use a breast pump thing as her nipples are flat on the breast.'

A few days later the children flocked down, shepherded by Minger who had returned for the emergency, and they all settled down to graze upon the moor for two months, Augustus coming and going at intervals. 'It is adorable and terrible here,' Ida wrote. 'We work and work from 6 or 7 till 9 and then are so tired we cannot keep awake – at least I can't. Dorelia is more lively – owing perhaps to an empty belly.' All day they were out of doors, wearing the same clothes, going about barefoot, growing very sunburnt – 'at least the women and children are – the Solitary Stag does not show it much' – and eating double quantities of everything.

Ida seemed transformed in this new climate. The old depression evaporated into the open air as if it had never been. 'I do all the washing in the stream,' she told the Rani, '– the water is soft as honey and strong as wine – I can work all day – with joy – and you know I hate it as a rule – in a bloody house. Here there is about 10 square yards to keep clean and tidy, and beyond the moor and the sky.'

It was not simply the setting that had transformed her, but a change in

* Michel Salaman had started off his honeymoon in this caravan, and sold it in the spring of 1905 to Augustus for thirty pounds, paid punctiliously over a period of thirty years.

Augustus's attitude. 'Gus is a horrid beast,' she eulogized in another letter to the Rani, 'and a lazy wretch and a sky blue angel and an eagle of the ranges. He is (or acts) in love with *me* for a change, it is so delightful – only he *is* lazy seemingly, and when not painting lies reading or playing with a toy boat. Then I think well how could he paint if he has to be on duty in between – duty is so wearing and tearing and wasting and consuming – only somehow it seems to build something up as well which is so clever.' Ida hardly knew how to interpret this change in Augustus. At the very moment one might have expected him to give his fullest attention to Dorelia, he had turned back to her. She had lost confidence in herself to such an extent that she could not believe he really loved her. But then what was Augustus's love? 'We had one flare up – nearly 2,' she confided to the Rani. '. . . owing to Gus's *strange* lack of susceptibility – or possibly by some human working, his being too susceptible. It is a difficult position for him. He is so afraid of making me jealous I believe – and he was not wildly in love with her – nor with me, only quite mildly. With the result that he appeared indifferent to her, while really feeling quite nice and tender, had I not been there. But Lord – it *is* impossible but interesting and truth-excavating.'

Despite the difficulties, and odd flare-ups, these were marvellous months for Ida. She adored living in the van. Yet even in her topmost hours with Augustus, she was assailed by doubts – thoughts of Dorelia, lying near by. Was *she* happy? Could they both be happy at once? She was painfully aware of Dorelia's mute disappointment. They would have to work out something better than this.

For Augustus too this was a good spring. He was free to work, and work went well. May was productive of many etchings – romantic pieces entitled 'Out on the moor' and 'Pyramus and Thisbe' and there is an excellent study of Dartmoor ponies. Close by their camp was a spring for washing and drinking, which the women and children used; while in the evenings Augustus would stride off out of sight to the Hexts, sit in their plain flagged kitchen and warm himself before the peat fire. Back at the camp he erected a tent of poles and blankets after the gypsy fashion and, like the Hexts, lighted peat fires – but they were 'usually all smoke'. At night they would retreat into the tent to sleep 'and you can hear the stream always and always'.

The rest of this summer Ida and Dorelia passed together at Matching Green, while Augustus roamed the country between his school in London and his prospective school in Liverpool. In his absence the two women grew extraordinarily close. The whole basis of their friendship was shifting. They managed the house, looked after the children, made each other clothes and in the evening played long games

of chess which Ida always won.* Towards Augustus, it appeared, they now occupied very similar positions. 'A woman is either a wife or a mistress,' Ida had written to Dorelia. 'If a wife, she has (that is, her position implies) perfect confidence in her husband and peace of mind – not being concerned about any other woman in relation to her husband. But she has ties and responsibility and is, more or less, a fixture – and not free. If a mistress she has no right to expect faithfulness, and must allow a man to come and go as he will without question – and must in consequence, if she loves him jealously, suffer doubt and not have peace of mind – *but* she has her own freedom too. Well here are you and I – we have neither the peace of mind of the wife nor the freedom (at least I haven't) of the mistress. We have the evils of both states for the one good, which belongs to both – a man's company. Is it worth it? Isn't it paying twice over for our boon?

'Our only remedy is to both become mistresses, and so at any rate have the privileges of the mistress.

'Of course I have the children and perhaps, being able to avail myself of the name of wife, I ought to do so, and live with G[us]. But I shall never consider myself as a wife – it is a mockery.'

The need to free herself from being Augustus's wife ran very strong in Ida. As a sign of the new role she intended to assume, she relinquished for a time the name Ida, calling herself Anne (or Ann),† the third of her Christian names; and then, to escape further from her past self (and much to the initial confusion of this biographer) signed some letters Susan.‡ Her previous reaction against Augustus was invaded by a mounting attraction to Dorelia which, in a curious way, drew her closer to Augustus again. Like Gwen, she was fascinated by Dorelia romantically. 'I know it makes you mad to hear me rave on about her [Dorelia],' she teased Alice Rothenstein. 'Dear old darling pure English Alice – I can't help loving these fantastics however abnormally their bosoms stick out. As to Dorelia – she is a little water lily § – and, as Gus says, she has the gift of beauty.'

Alone with Dorelia, Ida was as happy as she had been for a long time. Envy and jealousy melted into love: she disliked their being apart even for a few days. 'Darling D,' she wrote while on a short visit to

* 'Except once,' Dorelia positively remembered.

† A number of Augustus's etchings of Ida call her Anne; for example, 'Anne with a feathered Hat' (C.D. 59) and 'Anne with a lace shawl' (C.D. 46).

‡ She also began renaming her friends – the Rani, for example, who became Lady Polly. 'Lady Polly is such a much more suitable name for you than Rani,' she explained. 'You are quite like lots of Lady Pollies in cheap novels . . . of course you will think it atrocious.'

§ In a letter to the Rani, Ida described Dorelia as 'the queen of all the water-lilies'. Her correspondence with both the Dowdalls is in the Liverpool City Libraries.

her mother, 'Love from Anna to the prettiest little bitch in the world
. . . I was bitter cold last night in bed without your burning hot, not to
say scalding, body next me – . . . Yours jealously enviously and
adoringly Ida Margaret Anne JOHN.'

To establish their new regime on a more solid foundation, Ida now
came out with the proposal that she and Dorelia should leave England
and, with their children, set up house together in Paris. It was a most
startling suggestion, but one that had many advantages, she argued.
Their lease of Elm House was up that autumn, so that in any case they
would have to move. She had loved Paris while living there with the
two Gwens, and the Parisian atmosphere, she was convinced, would
accommodate their ménage far better than anywhere in England. It was
a new start. They would find an inexpensive studio for Augustus who
could divide his time making little journeys between London and
Paris. They would all see one another – not too much of one another.
Money would certainly be a difficulty, but Ida would practise the
severest economies and earn money from modelling again: for she
was determined to go and to take Dorelia with her. She had already
written a letter to Augustus, telling him she wanted to live apart – not
because she didn't love him but because on a day-after-day basis they
were incompatible. And he, still 'a sweet mild creature', had not sought
to excuse himself, but blamed his 'nervous aberrations' for all their
troubles. Although, in his politeness, he did not say so, he wanted
something new as much as she did.

'Dearest of Gs,' she had replied, 'With people one loves one does not
suffer from "nervous aberrations". And peace with Dorelia would
never bring stagnation, as you know well. For a time that spiritual
fountain, at which I have drunk and which has kept me hopeful and
faithful so many years, seems dried up – I think lately I have taxed it.
I think it would be a good thing, when it can be arranged, for us all to
live quite apart, anyway for a time. You will not mind that – you know
we never did intend to live together. I shall have to sit – there's no
other means of making money – mais tout cela s'arrangera.

'Yes, there is in those letters [to Dorelia] something you never did
and never will write for me – I think it is because I love you that I see
it. And I think if I had known it before I should not have wanted us all
to live together. It has been a straining of the materials for you and I
ever to live together – it is nature for you and her.

'I am quite sure you will visit me and I will receive you, oh my love
. . . By rights Dorelia is the wife and I the mistress. *Is it not so?* Ar-
ranged thus there would be no distress . . . Tu me comprends comme
toujours parce que tu es bon et doux. Aurevoir – we will see later on
what can be arranged –

'Ever yours Sue.'

What Ida now arranged was a variation of this plan. The 'two mistresses' scheme at first sounded less flatteringly in Augustus's ears, but suited his nature far better – 'You know you will be happy alone,' she told him. They would not detail things mathematically between them, but simply see how everything sorted itself out. 'Dodo says we can't trouble about "turns",' she told Augustus. The centre of this French plan, there can be no doubt, was Ida and Dorelia's closeness. 'I do not know rightly whether Ardor and I love one another,' Ida explained to Augustus. 'We seem to be bound together by sterner bonds than those of love. I do not understand our relationship, but I feel it is necessary for us to live [together].' Whether or not they loved each other, they both, in their fashion, loved Augustus who, at one time or another, loved one of them or the other. With so much love surging between them surely it must be possible, if only accidentally, to hit upon some system that satisfied everyone? But Ida's proposition, once it was finally revealed to him, left Augustus out in the cold, he suspected. Certainly he did not appear to be at the centre of it, and his first response was to tell Ida that he did not think it would work, that they would soon come scuttling back to England. But Ida was adamant. 'We *must* go,' she insisted. And as always her decision plunging, through the general ocean of indecision, was conclusive.

As always, too, everyone began by trying to make the best of anything new. Dorelia's silence was an enthusiastic one; while from the north of England Augustus exuded amiability and sweet reasonableness. Unless some ungovernable mood was on him, Augustus felt nervous of opposing Ida. He had been genuinely shocked by her contemplated suicide, and all the more alarmed at having to be told this by the Rani. The news had sobered him. 'My imagination is getting more reasonable and joyous now,' he wrote, 'I wish to God it would be one thing or the other and stay! I have longings to sculp – it's been coming on for years. Paris! ! ! . . . I hope to paint two orange girls if I can get them. Before actual life at any rate moods and vapours vanish. Suppose I came back to the Green soon . . . I look to you, Ardor, to restrain Ann's economical fury.'

But Ida would not allow him back just then. His moods were so strong, so destructive, so – as he admitted – unreasonable that the best-laid schemes might be exploded by them. She wanted to fix everything unalterably before meeting such risks. She wrote off to hotels, made detailed travel arrangements, gave the servants notice, contracted to sell all the furniture they could not take with them. She did more: she told the Rothensteins. 'I expect you'll think we're mad,' she assured Alice (July 1905). 'We are going to live all together for a

time again – it is pleasanter really and much more economical. We shall only need one servant. We shall do the kids ourselves – meaning Dorelia and me. Her baby is weakly, but a dear little thing – not much trouble. Gus of course will live mostly in London . . . I feel this living [in] Paris is inevitable, and though there are 10000 reasons in its favour I will not trouble you with them. The reason really is that we're going.'

Alice's reaction, predictably, was one of extreme horror. She wondered whether Ida had taken leave of her senses. Paris! So it had come to that – it was shipwreck! She ought to return to London at once. It was not fair to do anything else: not fair on Augustus.*

Confined to the communicable part of her life, Ida despaired of making Alice understand. 'I'd rather stay here [Elm House] than live in London again,' she replied (27 August 1905). 'So it isn't the boredom of Matching Green that is driving me. I'm not bored here – merely in a foreign land. So sorry I appear such a selfish beast about Gus – I do to Mother, taking away her heart's delight. Can't be helped. Give us up – or me.'

But it was not the way of the Rothensteins to give people up, and in this instance Will appears to have agreed with Alice. Indeed it may have been his opposition to the Paris scheme that helped to reconcile Augustus to it. 'It is mostly on your account that they [Will and Alice] are so against Paris,' Ida told Augustus. 'Alice says "you do not quite realise what it means to a man!" Does she mean in the nights? Anyway I cannot, dare not, allow her ideas of comfort etc to influence me at all . . . If anything would keep me it would be Mother.'

Unlike Augustus and Dorelia, Ida was encumbered by her family. 'It *is* selfish,' she admitted to the Rani, 'because of my Mother – but I can't help it.' Mrs Nettleship's strong sensible middle-class standards were like chains to Ida's freedom, and she had resolved to cut them. For, since they had once more settled to 'keep up the game', nothing could be concealed from Mrs Nettleship any longer – even that Dorelia had a baby of her own. Their departure called for drastic explanations, and as soon as everything was organized Ida broke the news.

The attitudes of Alice Rothenstein and Mrs Nettleship, representing those of society and the family, were very close. They harmonized their horror. But to all Mrs Nettleship's objections Ida returned one answer: that it was unreasonable to blame her for not placing her mother's

* 'Alice Rothenstein is simply indescribable,' Ida complained to the Rani. '. . . She and I always feel quite opposite things. Lord! She wants us to take a "cheap flat" in London! – as if there were such a thing possible to live in . . . I can't think of the tight smiling life which London means for me now. Were I alone it would be different.'

welfare above that of her husband, or even, for that matter, above her own. Since her daughter's marriage Mrs Nettleship had begun to get on quite well with Augustus. At least he was not so *absolutely awful* as she had once feared. He amused her; and appreciating this he had kept everything on an easy bantering level. 'They get on quite well in a queer way,' Ida had noted with surprise. '. . . What an instinct many – I suppose most – people have for keeping "on good terms". It necessitates such careful walking – and fighting would be so much more amusing – or perhaps not.' Now she had a real fight on her hands. Mrs Nettleship blamed Augustus for his lack of control; and she blamed Ida for countenancing it; and finally she blamed both of them for exposing this wretched state of affairs to the public gaze. Why couldn't Dorelia live a little way off, if such things must be? Why make themselves a subject for squalid gossip – had Ida given no thought how it would affect her sisters and all the family? To which Ida could only reply that this was one of the reasons they were leaving the country. It was a good debating point, but no more. Exasperated, Mrs Nettleship declared that it was against the law to have two wives, and that she intended to institute legal proceedings. But no one took this seriously, and for Augustus ('my only husband' as Ida ironically called him) it added to the comedy.

The struggle continued with daily remonstrances and cajolings even after they had reached Paris, right up to the end of the year. The pull that Mrs Nettleship exerted on Ida was ingenious. She did not complain, she asserted, on her own account, but in the interests of her other two daughters, Ethel and Ursula, who now joined in with their own appeals. To them Ida was obliged to justify herself all over again. Her letters, extraordinary for their tone of forbearance injected with small shots of scepticism, are a good index to her state of mind over this crucial period.

'Dearest angel,' she wrote to Ursula (6 December 1905). 'It is quite unnecessary for you to feel miserable about us unless of course your sense of morality is such that this ménage really shocks you. But as you say you know nothing of actual right and wrong in such a case I suppose you feel bad because you think I am unhappy or that Gus does not love me. I think I've got over the jealousy from which I suffered at first, and I now take the situation more as it should be taken. . . . I don't know how they told you, but I suppose from your letter they made it pretty awful. As a matter of fact it is not awful – simply living a little more genuinely than would otherwise be possible – that is to say accepting and trying to digest a fact instead of hiding it away and always having the horrid consciousness of its being there hidden. . . . I know in the end what we are doing will prove to be the best thing to

have done. It is not always wisest to see most. Do you understand. Oh do you understand? I think really if you were left to yourself you would understand better than almost anyone – instinctively. If you were to begin to think of the reasons against our arrangement I should be afraid . . . It is a beautiful life we live now, and I never have been so happy – but that does not prove it is right. It seems right for us – but is it for the outside world? doesn't charity begin at home? and at most we only make people uncomfortable . . . do believe I no longer grudge Gus his love for Dorelia – I never did, but he was so much "in love" that no interested woman could have remained calm beholding them. But now that is over, and though he loves her and always must it is different – and we live in common charity, accepting the facts of the case – and she, mind you, is a very wonderful person – a child of nature – calm and beautiful and patient – no littleness – an animal if you will, but as wholesome as one – a lovely forest animal. It is a queer world.'

These patient, understanding letters called forth no sympathy from her sisters, since both of them were under their mother's control. Ursula even added a strange new ammunition to the moral bombardment. If their ménage persisted, she wrote, then she would never be able to come and see Ida again and never be able to give herself in marriage. Ida's immorality was like a blight, she declared, withering her own chances of fruitfulness – and those of Ethel.

Ida was stunned by this accusation. She could not believe it, did not know even whether Ursula herself believed it. In the past Dorelia had always left the house when any of Ida's family came to stay, but if they would not continue to come then Ida would simply have to go and visit them. 'As you can't accept her [Dorelia], I suppose it would be better,' she wrote. 'It *is* a queer world. . . . As to your prospects of marriage – that is the one unsurmountable and unmeltable object – till you are both happily married! Do write again after thinking about it a bit – I mean the whole affair.'

Ursula needed no prompting from overseas. She wrote again the same week announcing that, since Ida was unrepentant, she, Ursula, hereby renounced marriage and resolved to live a spinster all her life.* Ida's reply (12 December 1905), the final letter in this exchange, blended irony and tenderness but contained none of the guilt that the Nettle-ships had sought to implant within her.

'Darling Urla,

'I was very glad to have your letter – I do think it was a little heroic. You have no business to feel so heroic as to be willing to give up marriage – or to say "what would it matter". Of course it might not matter – but dearest I understand you when you say that – it is like

* She did, and so did Ethel.

my painting – there are some things that seem so important which really
don't matter in the least. It has cost me much pain to give it up – but it
doesn't matter! It is a part of the artist's life to do away with things that
don't matter – but, as you say, it is unlikely you would love a man who
couldn't at any rate be made to bear with our ménage. He needn't know
us. You do astonish me with your idea of uncleanness – I can't ap-
preciate that – I am differently constructed. It seems to me so natural –
and therefore not unclean. . . . To me your thinking it so appears ab-
surd and almost incredible – as if you'll grow out of it. A bit too
"heroic". As to "doing away with the whole thing" you might as well
say you'd like to do away with the sea because of wrecks and drowning.'

The long struggle now seemed at an end. But throughout all Ida's
difficulties of persuading Augustus and of resisting the Nettleships,
there had been one factor which helped to blunt opposition, and gave
added point to the new ménage: she was pregnant again.

3. FROM A VIEW TO A BIRTH

'Don't you too sometimes have glimpses so large and beautiful that
life becomes immediately a jewel to prize instead of a burden to be
borne or got rid of?' Ida had once asked the Rani. Regularly the dark-
ness of her life was shot through by these lyrical searchlights. Painting
had been one; marriage another. 'What great work is accomplished
without a hundred sordid details?' she demanded shortly after David's
birth. 'To have a large family is now one of my ambitions.' But already,
by the time Caspar was born, the night of disillusion had begun to
close in, and her ambition, still heroically proclaimed, sounded more
hesitant. 'I should say more than I meant if I launched into explanations
of why I want a large family,' she wrote again to the Rani. 'I know I do,
but it may only be because there's nothing else to do, now that painting
is not practicable – and I must create something.'

Babies, as a substitute for art, had failed even before Robin's birth,*
and for a time the surrogates had become cooking, gardening, even
hens. Yet still the babies kept on coming, and her disenchantment
deepened: 'We are all such impostors!' she exclaimed. Then, in a letter
from Paris (April 1906) to the Rani, Ida revealed that she had made
'violent efforts to dislodge' her fourth child during early pregnancy.
Her ambition to have a large family had died completely, to be replaced
by something altogether different.

Even before Dorelia had arrived at Matching Green, Ida had written
to the Rani: 'It suddenly strikes me how perfectly divine it would be

* 'As soon as I am up,' she wrote to Mrs Sampson after Robin's birth, 'I am
going to climb an apple tree – and *never* have another baby.'

Ida

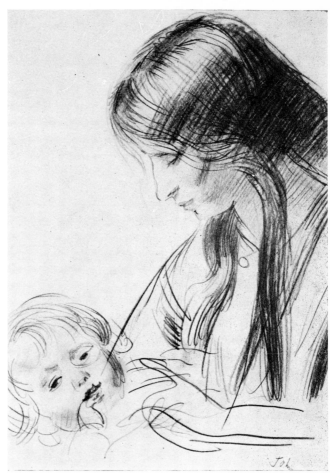

Dorelia

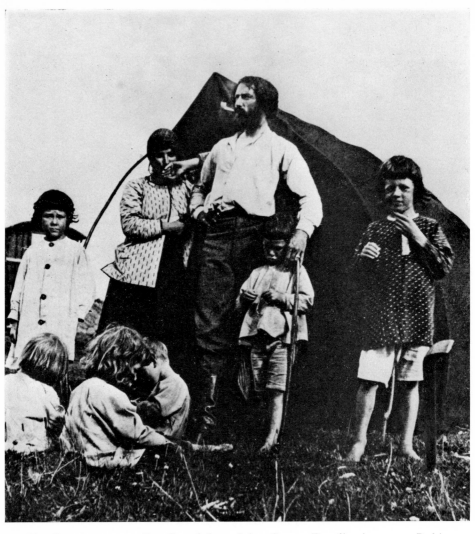

Family encampment. Standing, left to right: Caspar, Dorelia, Augustus, Robin, David; sitting: Edwin, Romilly and friend.

if you and I were living in Paris together. I can imagine going to the Louvre and then back to a small room over a restaurant or something . . . think of all the salads, and the sun, and blue dresses, and waiters. And the smell of butter and cheese in the small streets.' Conceived as fantasy, her romance had come to life as fact. It represented for Ida an entirely new attitude to the world, and to her proper place in it. 'I should like to live on a mountainside and never speak to anybody – or in a copse with one companion.' she wrote.[135] 'I think to live with a girl friend and have lovers would be almost perfect. Whatever are we all training for that we have to shape ourselves and compromise with things all our lives? It's eternally fitting a square peg into a round hole and squeezing up one's eyes to make it look a better fit.'

The girl friend was different, but the philosophy was the same. In her experience, men were of two conditions: the artists and poets, who were wild, beyond good or evil, and with whom one fell in love; and the others who were mostly fools and who bored her. Both, as husbands, were equally impossible. With girls, however, she could develop an enduring closeness, even an intimacy. 'I wish I'd been a man,' she confessed to the Rani. 'I should then have felt at home in this infinitely simple world.' To some extent, it was the man's part she intended to play in Paris.

Augustus, Ida and Dorelia, with David and Caspar, Robin and Pyramus and Bobster their dog, set sail for France at the end of September 1905. The sea was rough, the boat rolled and Caspar (who was violently sick) declared in some alarm: 'We'd better go back.' Ida had taken two rooms for them all at a small hotel near the School of Medicine where specially reduced prices were offered to adults accompanied by children. 'The hotel people are very kind and the food lovely,' she assured her mother. 'Children *perfectly* well and Tony [David] especially cheerful . . . [he] asked last evening if all the people in Paris talked nonsense.' Robin, however, seemed to pick up the new language astonishingly fast, and very soon was calling everyone *fou*, *sot* and *nigaud* in the most threatening manner.

From the hotel they at once set out to find a flat or some studio with living rooms, and very soon came across what they wanted, near the Luxembourg Gardens. By the middle of October they had moved into 63, Rue Monsieur le Prince, and engaged a maid, a young girl called Clara, to look after them while they looked after the children. 'She [Clara] cleans a room thoroughly in the twinkling of an eye,' Ida informed Alice, 'cooks exquisitely, is clean to a fault, and can remember the exact mixture and amount and time of food for 3 babies under 1

year.' This beauty for work and competence was, moreover, not physically beautiful. She seemed ideally suited to them.

Ida's fourth child, confidently referred to as Suzannah since its conception, was born on 27 November. As usual it was 'another beastly boy – a great coarse looking bull necked unpoetical unmusical commercial snoring blockhead', she told Mrs Sampson. Yet he was the weakest of all her children and for over a year lived only on bread, milk and grapes. 'He is called Quart Pot – as being a beery fourth,' Ida wrote to the Rani. '. . . After my experience I have quite given up the belief in a good god who gives us what we want. To think I must make trousers to the end of my days instead of the dainty skirt I long to sew . . . he is a difficult child like David was . . . Poor little unwelcome man.' Later called Jim, he finally settled down, after gigantic difficulties in registering his birth, to the name of Edwin.

The world was fuller than ever of babies, but in these new surroundings, and fortified by her new outlook on life, Ida was not submerged by them. 'I almost think it worth while to live in this little world of children,' she confessed to the Rani. 'We are sometimes convulsed with laughter.' Laughter was the new ingredient in her life. 'Things mostly get worse in this world,' she had once written to Mrs Sampson from Matching Green. Now, from Paris, she wrote to her: 'I've come to the conclusion that laughter is the chief reason for living.' Things might still get worse, of course, but with detachment one could enjoy plenty of happiness. 'One is not bound to be too serious,' she informed Mrs Sampson. This was her new discovery, and with it rose 'those bubbles inside' that made her feel 'like a champagne bottle that wants to be opened'.

Dorelia was the centre of this happiness and strength. She looked after Ida during her confinement and after Edwin's birth; she coped with crises ranging from burst hot-water bottles to outbreaks of measles. Difficulties dwindled in her presence like weeds starved of nourishment: it seemed ridiculous to get worked up over such trivial affairs. 'My dear, you have no idea of the merits of Dorelia,' Ida confided to the Rani. 'Imagine me in bed, and she looking after the 4 others – good as gold – cheerful – patient – beautiful to look upon – ready to laugh at everything and nothing. She wheels out 2 in the pram, David and Caspar walking, daily, morning and evening – baths and dresses them – feeds them – smacks them.'

Their new life contained many aspects of the old, but the two mothers were better able to deal with it all. Ida, in particular, had regained her self-confidence. 'This place is divine,' she wrote to Mrs Sampson, 'and one can do everything – one feels so strong.' Outside the flat, their routine achieved the air of almost bourgeois respectability. 'Time was

spent taking the children out in a pram to the Luxembourg Gardens and in the evenings sitting in cafés or sometimes going to concerts, art shows, museums,' Dorelia remembered.[136] 'How attractive Paris was in those days, separate tables outside the cafés and discreet lighting.' On the surface, life was 'fairly ordinary'. But those who called upon these bourgeois-bohemians at Rue Monsieur le Prince saw something fairly extraordinary. There was only one bed between the lot of them – the children sleeping in boxes on rollers, the babies in baskets – and almost no furniture. 'Here is a picture of our life in one of its rarely peaceful moments,' Ida wrote to Alice early in 1906. 'Imagine a long room with bare boards – one long window looking on to a large courtyard and through an opening in the houses round to the sky and a distant white house, very lovely and glowing in the sun, and trees. In the room an alcove with a big wooden bed in it. At a writing table David doing "lessons" – on the floor two baskets – Pyramus intent on a small piece of biscuit in one – Edwin intent on his own hands in another. Robin in a baby chair with some odd toy – Caspar on the ground with another. The quiet lasts about ten minutes at ·the outside. Unless they are asleep or out there is nearly always a howling or a grumbling from one or more – unless a romp is going on when the row is terrific.'

Will Rothenstein, who visited their flat on his way to Venice shortly after they moved in, was deeply shocked by what he witnessed. The Johns seemed like a slum family with Augustus, a fearful figure, stamping about at its head. 'He is very impatient with his children and they are terribly afraid of him – the whole picture is rather a dark one,' he reported to Alice (19 October 1905). '. . . I felt terribly sad when I saw how the kiddies were brought up, though anyone may be considered richly endowed who has such a mother as Ida. Ours seem so clean and bright compared with them just now.'

But in Augustus's eyes it was the children who terrorized him. They needed money, but prevented work; wanted to be entertained, got on his nerves. One day, amid the uproar, losing his temper with David and Robin, he slapped both their faces very hard: and was suddenly consumed with remorse. 'They will never really forget my having clouted them in the face like that,' he told Dorelia. 'I have never forgotten my father (whom I would give you for 2d) kicking me upstairs once – when I was almost Tony's age. Tell Tony I want him to enjoy himself – but to be somewhat useful and intelligent at the same time.' Since it was impossible to work in such a hurly-burly atmosphere, he returned after a fortnight to England.

Ida was now free to construct the sort of life of which she had dreamed. Liberated from the man-dominated world, she struggled to

free herself so far as was practicable from the domination of children by eventually employing, in addition to Clara, another servant – 'which is why we can saunter out, and spend money to an outrageous extent... and we come in again, after an absence of 4 hours and find absolute tranquillity – babies everywhere asleep in cots (literally 3) and 2 virtuous little boys looking out of [the] window at the rain from a house built of chairs – too sweet for words. Life is pleasant and exciting.'137

At last Ida seemed to have won that great luxury, time: time in which to read Balzac, Dostoievsky, Emerson and the *Daily Mail*; time to buy straw hats and cashmere shawls, to make clothes for pictures which Gus would some day paint; time for music – Beethoven and Chopin – of which she and Dorelia were especially fond; time to fill with talk and dreaming and sensuous laziness. They were not gregarious, the two of them: it was a secret life they led. 'It is, for 2 or 3 reasons, impossible to know people well here – so I keep out of it altogether,' Ida explained to the Rani. '. . . And it is just as nice in many ways not knowing people.' Not knowing people was part of Ida's detachment, her freedom. 'How delightful not to care what the neighbours think!' she had once exclaimed to Mrs Sampson at Matching Green. 'My utmost is to tell myself and others that I do not care – I do all the time.' In Paris she no longer cared so much. She had escaped from her family and the neighbours. She could be free as Dorelia now: she felt sure she could.

Almost the only person they saw at all regularly was Gwen John – 'always the same strange reserved creature', as Ida described her.138 They would dine with her on eggs and spinach and charcuterie in her room in the Rue St Placide where she lived with her 'horrid' cat and where they would meet Miss Hart, an ex-pupil of Augustus's at Liverpool 'who has attached herself uncomfortably to Gwen'.139 Gwen gave them three beautiful pictures for their bare flat: also, Ida wrote to Augustus, 'there was a head of Gwen by Rodin in the Salon'.

To be free, to be as irresponsible as she could allow herself, 'as gay as possible under the circumstances' – this was Ida's ambition. Dorelia took to wearing bright jerseys and short velvet skirts; Ida cut her hair short but did not look *very* 'new womanish, because it curls rather'. Then David, presumably pursuing this fashion, cut off for the second time all his own and all Caspar's hair so that they were almost unrecognizable when Ida and Dorelia returned home. Released from the aweful presence of their father – the eyes that stared, the voice that roared – the children had never been more boisterous. David imitated wild beasts, bears and baboons; Caspar, in a sealskin cap, danced fantastic jigs, turned somersaults, and boasted that he was a king; Robin was constantly teased by David and Caspar, constantly teasing the beautiful Pyramus; while Edwin, a long thin cross creature, howled

independently in toothless rage. But though the 'acrobats' as Ida called
them had never been more lawless, yet 'I lose my temper less than of
yore – Dorelia never did lose hers. We take it in turns to take them
out.'

Other people's tempers were less shock-proof. After three months,
the neighbours, unable to endure the continuous red, wet tumult of
sound any longer, demanded their eviction. 'We shall probably take a
small house,' Ida wrote (12 January 1906) to Alice who, in the confusion
of breeding, had sent a bonnet for Pyramus, mistaking him for Ida's
baby. Not living on a mountainside or in a copse, it seemed impossible
to avoid compromise. Responsibility, compounded of habit and anxiety,
cause and effect, was ever at their heels, and in January they began house-
hunting once again in the quarter beyond Rue de la Gaieté. After
exploring 'millions of studios' and a number of houses, they pro-
visionally decided on 77 Rue Dareau, where Augustus had already
booked a studio for the spring. 'The concierge of your studio showed
us his rez de chaussée,' Ida wrote to Augustus (January 1906). 'Do
you think it would do?' There were many advantages: a garden, and
the studio to sit in during the evenings, besides three living-rooms, a
kitchen and scullery; the rent was low, they could take it on a quarterly
basis, and they would still be near the Luxembourg Gardens. Best of
all 'your concierge says there can be no objection to the kids – he says
he understands "qu'ils crient – qu'ils ne chantent pas!" He was in-
credulous when I said the neighbours would object – and if they do
they can go and we'll take their places.' Both Ida and Dorelia were
convinced they would not 'find anything so good in every way as the
R de C'. Their only doubt was Augustus's attitude. 'If you dread having
the kids and all at your place – if you think it will interfere with your
work – we will find something else.' Ida's letter reached Augustus (who
had just sold a number of his pictures) in a jovial mood and he urged
them to take the *rez-de-chaussée* at once. The clamour of the children
seemed no great impediment now he could no longer hear them. 'I
trust the family is well to the last unit,' he replied (February 1906). 'I
hope to get everything done in a week and then back again my hearties!
. . . Feed up well . . . and circulate the money.'

The new apartment would not be ready till April. Meanwhile Ida
proposed taking the three eldest children to the South of France. Mrs
Nettleship had not been well and after a month's rest in London was to
descend to Mentone for three weeks' recruitment. To accompany her
she invited Ursula and Ida with her children. It was, in part, an act of
Talleyrand diplomacy. 'I cannot refuse can I?' Ida asked Augustus.

They set off early in March and spent the rest of the month at 'a
highly respectable hotel' crowded with British gentlewomen of

'comfortable means' attended by their very correct daughters – prim little moppets in muslin. To Ida these people seemed violently dull; but the beauty of the country was intense, the change in atmosphere total. 'Shall I tell you of the mountains?' she inquired of the Rani (29 March 1906), '– their grand grey forms right upon the clouds, the lower parts covered with trees – fir trees – and the lowest with Olive trees – and up at the top streaks of snow in the cracks (as seen from here) in reality masses of snow in the ravines and crevasses. And the town of Mentone all built up in piles against the hill and the sea – good old sea, ordinary old sea – spreading out at the bottom, with the steam yachts of the rich and the fishing boats of the poor and the eternal waves – so stupid and so graceful. And the mongrel population – selling in silly sounding French. They're really all Italian or half Italian.'

In the hotel garden among the tulips and the wallflowers, the pansies, stocks and daffodils, Ida would sit reflecting on how strange it all was and how happy she ought to have been, but wasn't. Instead she fretted impatiently, sucked back into that awful sense of exclusion that had devoured her at Matching Green. Augustus had returned to Paris not long after she had left for Mentone: she longed yet dreaded to be back. These blue and cushioned hotel days with all their luxurious discomfort, their expensive inconvenience, were a terrible waste of time. She felt like some general witnessing a battle swinging away from him, powerless to do anything about it. Good manners and an English sense of duty – all she had endeavoured to escape from by coming to France – held her in check. If only she had been a different kind of person! 'I crave to go to school,' she told the Rani. 'Not quite literally, but to set about learning from the beginning – Lord, how I long to. The 3 kids are here, and very brave and jolly. Edwin is left in the care of the loveliest girl in the world God damn her. And I believe Gus has gone back to Paris to-day; so they'll all have a good time together, especially as his Poet Friend [Wyndham] Lewis is there, and great friends with Dorelia, and Gus has found a new creation called Egmont Hake whom he names "a jewel of a man". So they'll be so happy and perfect, damn and I am here biting my nails with rage and jealousy and *impotence*. Because if I were there it would spoil the fun don't you see? Oh why was I not born otherwise?'

This was Ida's first set-back since coming to France. Early in April she returned to Paris, and she, Dorelia and the children moved into the Rue Dareau.* Again hope rose in her, hope for her resurrection into a

* In a letter to his mother, Wyndham Lewis primly reported John's move 'with his families' to this new home. 'He [John] has an apartment, garden and studio all together, parterre. The elder of his children, that I hadn't seen for some time, are becoming excessively interesting personalities: but their conversation, although

new person and a new life. With Dorelia she re-papered the walls of
their new home, and covered them with sketches, pictures, photo-
graphs: it was a fresh start, but again, inevitably, it had many ingredients
of the old life. Augustus came and went; the children ('it makes them
all look very interesting') all caught colds; and Dorelia ('it's her turn')
'is decidedly enceinte', Ida informed Augustus. 'It is depressing.'

4. CHANNEL CROSSING

'About to embark shortly for England,' Augustus had written to
Wyndham Lewis, 'I would be encouraged to the adventure by a word
from you as to your welfare and whereabouts.' No sooner had he
settled on a studio for his work in Paris than the work began to flow
in – but from London. 'We had £255 in about ten days ago, to my
amazement,' Ida wrote to him from Paris. 'You do make a lot.'

Augustus had hoped by this time to sell the Chelsea Art School to a
Mrs Flower, a cousin of Ida's, so that he would be free to live in Paris,
but the negotiations grew more and more involved and it was not until
the summer of 1907 that they staggered to some finality. This delay
and the infinite complications it entailed exasperated Augustus. 'I am
sick of the school and tired of Orpen,' he wrote to Dorelia (1906). 'The
lady can't buy the school just yet. I think of chucking it – even if I have
to pay off debts.'

That he did continue teaching at Rossetti Studios was partly due to
an exciting new development that had grown out of the school early
that winter. This was the acquisition of a gallery next to the Chelsea
Town Hall in the King's Road. Orpen, who largely financed it at the
start, persuaded Knewstub to open the Chenil Gallery, as it was called –
a small town house ideally suited, Knewstub saw, for accommodating
his cultural dreams. Downstairs were two small rooms: one he con-
verted into a 'shop' selling canvases, paints and all manner of artists'
equipment; the other he established as an etching press room for artists
wishing to prove or print from their own plates. Upstairs there were
two exhibition rooms, one of which held a permanent collection of
work by the regular platoon of Chenil painters: Ambrose and Mary
McEvoy, David Muirhead, William Nicholson, Orpen, James Pryde

sparkling, is slightly disgusting to a person of pure mind – which is the more dis-
tressing since it be so edifying, to the more urgent exigencies of the intellect. – They
call me a "smutty thing" and a "booby" because I insisted that a lion could climb
up a beanstalk, nay, *had* done so, in my presence! – and one of the first wife's
children has contracted the indelicate habit of spitting at one of the second wife's
children while having his bath: – by the way, Miss MacNeill is producing another
infant.'

and Augustus himself. At the back was a large studio which Augustus was often to use in the years to come.

The first one-man show at the new gallery, in May 1906, was of Augustus's etchings, which acted as a stimulus to great productivity over the early months of this year. 'I have to spend days seeing to my etchings,' he explained to the pregnant Dorelia as the weeks passed and still he did not return to Paris, '– a man has ordered a complete set. I find to my astonishment I have done about 100.' This man was Campbell Dodgson who, on 20 February 1906, had written to Will Rothenstein asking him to approach Augustus and find out whether he would let the British Museum have a selection of his etchings and drawings. Rothenstein put Dodgson directly in touch with Augustus and a week later they met. 'I went to see John yesterday and looked through his etchings which interest me very much,' Dodgson reported to Rothenstein (28 February 1906). 'He is quite willing to give me specimens of his drawings hesitating only on the grounds that he hopes to do better, and would not like us to have things that he would wish to tear up some years hence; but there is not much fear of such a fate befalling certain things that I saw yesterday and would like to secure. But [Sidney] Colvin will go himself in a few days and settle the matter.'*

This interest from the British Museum had quickly spread to the Chenil Gallery, where Knewstub at once set about arranging this first large show of Augustus's etchings. It was not an easy exercise. Once his first interest in the plates had passed, Augustus was often careless about their preservation, allowing them to be scratched, battered and corroded by verdigris. So when Knewstub stepped forward to rescue these plates from further harm, and superintend their printing and publication in a methodical manner, he found himself confronted by a vast salvage operation. He cleaned, he scraped, he searched and, as many plates as he could find (whether in sufficiently good condition to yield editions, or so badly treated that they had to be destroyed) he took over and numbered, together with all such early proofs as he could discover in Augustus's studio.

The Chenil exhibition was a great success, and many came to see his etchings.† In a letter to Charles Rutherston, Augustus wrote: 'I am

* Campbell Dodgson (1867–1948) had entered the Print Room of the British Museum in 1893, and in 1912 he succeeded Sir Sidney Colvin as Keeper of Prints and Drawings. He became particularly well known as an expert on early German art and a collector of nineteenth-century prints and drawings. His catalogue of Augustus's etchings appeared in 1920. He married in 1913 the artist Frances Catharine Spooner, daughter of W. A. Spooner, of Spoonerism fame.

† The Chenil exhibition catalogue lists eighty-two etchings, the number of prints varying but never exceeding twenty-four. A significant quantity of these plates, Dodgson noted, mostly nudes, were etched 'somewhat hurriedly and in

of course very pleased with the results of the Chenil show, which far exceeded what I expected.' His enthusiasm, springing to some extent from an artificial stimulus, lasted another three years during which he continued to use needle and copper, though on a gradually diminishing scale. After 1910 he produced, over the rest of his career, only about half-a-dozen more etchings – a small group of portrait studies of a girl's head; a head of John Hope-Johnstone recovering from measles; and two self-portraits. His later work shows a real advance from the sometimes rather laboured earlier efforts, with their ample use of dry-point, to the pure etched line of his most successful plates. But the medium did not suit his temperament: it was too slow, too small. The paraphernalia of needles and plates, of nitric and sulphuric acid, which had captured his interest at first, finally bored him to extinction.

Augustus's treatment of his copperplates was similar to that of his friendships: neither were kept in a state of good repair. He liked to keep an army of acquaintances in reserve, upon any number of which he could call when the mood was on him. He wanted fair-weather friends; he wanted them to be, like some fire brigade, in a permanent state of readiness for his calls; and he enjoyed summoning them fitfully. Among the etchings at the Chenil Gallery were several portraits of friends who had already sped out of his life: Benjamin Evans who had shot down the drain; Ursula Tyrwhitt and Esther Cerutti who had been outshone by later models. And there were others, too, of whom he saw only little now. Michel Salaman who had graduated from an art-student into a fox-hunting squire; 'little Albert' already partially eclipsed by little Will; the monkey-like Orpen who had grown attached to a gorilla in the Dublin zoo – 'perhaps the only serious love affair in his life';[140] and Conder who in June 1906 had become so seriously ill he was forced to relinquish painting.*

* 'It is sad about Conder,' Augustus wrote to Will Rothenstein (19 September 1906). 'I hope he is still capable of work.'

several cases without genuine inspiration', in order to be ready for the show. About fifteen were produced in the early months of this year, sometimes more than one plate being etched on the same day. It seems possible, too, that several numbers were added to the exhibition after the catalogue was printed: about seven are dated precisely (though possibly without accuracy) as having been done in the last week of May; while three excellent portraits of Stephen Grainger which Augustus appears to have completed that spring are not listed. Among those shown, some of the portraits, and a few of the groups in a landscape setting, are striking. Others in which the contorted forms are hastily drawn have little meaning to express. Many of the numbers in the exhibition were a frank act of homage to Rembrandt, and one of them was actually a translation on to copper of a Rembrandt pen-and-ink drawing.

There were two motives behind all Augustus's friendships: inspiration and entertainment. Either they stimulated him as an artist, or they induced self-forgetfulness. But none of them could live up to his veering idealism. He knew this himself, and mocked himself for it. 'I am in love with a new man,' he once (16 March 1906) told Dorelia, 'Egmont Hake – a bright gem!' Such mysterious gems – and there were many of them – would glitter for a day, grow dull and be lost for ever. His most consistent relationships were, in some sense, the most tenuous – those which were held together by humour or, more simply, cemented by long periods of absence. He welcomed the retreating back, the cheerful goodbye, the disappearing companion whose tactful vanishing trick saved in the nick of time their comradeship from the cancerous contempt that grew with familiarity. He relished people such as John Sampson whom he could abandon 'in the Euston Road while he was immobilized under the hands of a shoe-black', and then meet again, their feelings charged with nostalgia; or even Will Rothenstein, oscillating violently between romanticism and austere morality, on whom, in spite of everything, Augustus still depended for financial support; and Gwen too, for whom, though she could not work under her brother's shadow, he continued to feel an admiration shot through with exasperated concern.

What Gwen had felt about Augustus, others, such as Wyndham Lewis, were beginning to discover for themselves. 'I want also to do some painting very badly, and can't do so near John,' Lewis complained to his mother (1906).[141] '. . . near John I can never paint, since his artistic personality is just too strong, and he much more developed, naturally, and this frustrates any effort.' Because of this frustration, Lewis turned to his writing, being known by Augustus as 'the Poet'. Now that Augustus was jostling between Paris and London, he was able to see far more of Lewis, then on the move between England, France and Germany while brewing up his Dostoievsky cocktail, *Tarr*. Their relationship over-ripened rapidly. Augustus's romantic admiration for his disciple soon began to evaporate and what was left mingled curiously with lumps of more indigestible matter. They would go off to night-clubs together, or sit drinking and talking at a café in the Rue Dareau* recommended by Sickert for its excellent *sauerkraut*. 'Not that I find him absolutely indispensable,' Augustus conceded,[142] 'but at times I love to talk with him about Shelley or somebody.' Lewis himself preferred to talk about Apaches and 'to frighten young people' with tales of them. But what chiefly amused Augustus were Lewis's extraordinarily ineffectual romances. These formed part of his material

* Brasserie Dumesnil Frères, 32 Rue Dareau.

for *Tarr* whose theme became sex and the artist, displacing the stated one of the hero's spiritual progress. If the artist, Lewis seems to argue, finds much in his work that other men seek in women, then it follows that he must be particularly discriminating in his love-affairs, scrupulously avoid sentimentality and all other false trails that lead him away from reality. It was a theme nicely attuned to Augustus's own predicament, and almost certainly it formed part of their regular conversations. Augustus understood very well the conflict between artistic integrity and appetite for life, knew that overlapping territory between inspiration and gratification. 'I am like a noble, untaught and untainted savage who, embracing with fearful enthusiasm the newly arrived Bottle, Bible and Whore of civilization, contracts at once with horrible violence their apoplectic corollary, the Paralysis, the Hypocrisy and the Pox . . . So far I have been marvellously immune.'

Lewis's immunity, however, appeared even stronger. Prudence, suspicion and an aggressive shyness ringed him about like some fortress from which he seldom escaped. His love-affairs often seemed to be no more than word-affairs, though the words themselves were bold enough. 'Lewis announced last night that he was *loved*!' Augustus reported to Alick Schepeler. 'At last! It seems he had observed a demoiselle in a restaurant who whenever he regarded her sucked her cheeks in slightly and looked embarrassed. The glorious fact was patent then – l'amour! He means to follow this up like a bloodhound. In the meanwhile however he has gone to Rouen for a week to see his mother, which in my opinion is not good generalship. He has a delightful notion – I am to get a set of young ladies during the summer as pupils and of course he will figure in the company and possibly be able to make love to one of them.' But when not in the vein to be amused by Lewis's eccentricities, Augustus would quickly get needled. It was almost as if his own romanticism was being caricatured. 'The poet irritates me,' he admitted, 'he is always asking for petits suisses which are unheard of in this country and his prudence is boundless. What a mistake it is to have a friend – or, having one, ever to see him.'

Even so, Augustus could not be alone. Without an audience he lost confidence, began to disintegrate. This was why the luminous caverns of the pubs and cafés attracted him. One sauntered in as if on the spur of the moment, chose one's companion for an hour or two, a Juliet for a night: then it was over. Such encounters were marvellously invigorating. There was no long shadow of duty cast upon one, no tedious hangover of personal relationships to endure. If friends were God's apology for families, it followed they should be as unlike one's own family as possible. But perfection could not be found in a single

man, for perfection must suit all weathers. 'I cannot find my man,' he told Alick Schepeler, '– hence I have to piece him together out of half a dozen – as best I can.'

Upon the construction of this composite friend Augustus spent much haphazard energy. A little less McEvoy, for example, was quickly balanced by more Epstein and the introduction of a new artist into his life, Henry Lamb. In his correspondence, Augustus sometimes makes fun of Epstein, feeling for him an amused sense of admiration. 'Epstein called yesterday and I went back with him to see his figure which is nearly done,' Augustus wrote to Dorelia (1907). 'It is a monstrous thing – but of course it has its merits – he has now a baby to do. The scotch girl [Margaret Dunlop] was there – she is the one who poses for the mother – he might at least have got a real mother for his 'Maternity'. He is going about borrowing babies. He suggested sending the group to the N.E.A.C.! ! Imagine Tonks' horror and Steer's stupefaction!'

Augustus did a number of etchings of Epstein. Common to all of them is a rather petulant expression, whether the look is wild and lachrymose, or calmer though still 'difficult'. Most revealing of all is a red pencil drawing which Epstein himself much liked. By using the point of a very hard pencil Augustus gives this portrait a taut quality, a tightness of face and mouth indicating both intellect and a sort of temperamental force. The rhetorical pose of the head bends a little to the romantic conception of genius, but the drawing[143] also emphasizes the 'closed to criticism' nature of Epstein's personality.

He had, of course, much criticism to close his mind to. The 'monstrous thing' Epstein was working on in his studio in Cheyne Walk early in 1907 was almost certainly one of the eighteen figures, representing man and woman in their various stages between birth and death, that were to embellish the new Medical Association Building in the Strand. These figures, mostly nudes, caused a whirlwind of moral outrage when, in the spring of 1908, they began to be thrust upon the public gaze. 'They are a form of statuary which no careful father would wish his daughter, or no discriminating young man, his fiancée, to see,' one newspaper[144] informed its readers. Other experts, including clergymen, policemen, dustmen and the secretary of the Vigilance Society were soon adding their voices to this hymn of vituperation. The statues were called 'rude' and vulgar; they exerted a 'demoralizing tendency' and were said to constitute 'a gross offence'. They were indecent and a nuisance and would 'convert London into a Fiji Island'. Who could doubt that these objects must surely become a focus for unwholesome talk, the meeting place for all the unchaste in the land? Many artists defended Epstein, but in his autobiography he does not

mention Augustus who privately did much to assist him,* and who saw clearly that artistic support was irrelevant to moral indignation and would never impress the public. 'Epstein's work must be defended by recognised moral experts,' he wrote to Robert Ross. 'The Art question is not raised. Of course they would stand the *moral* test as triumphantly as the artistic, or even more if possible.

'Do you know of an intelligent *Bishop* for example?

'To-morrow there is a meeting to decide whether the figures are to be destroyed or not. Much the best figures are behind the hoarding which they *refuse* to take down. Meanwhile Epstein is in debt and unable to pay the workmen.'

Augustus's advice was quickly taken up, and the Bishop of Stepney, Cosmo Gordon Lang, later Archbishop of Canterbury, was persuaded to mount the ladders to the scaffolding, from where he inspected the figures very intimately and, on descending, declared himself positively unshocked. His imperturbability did much to reassure the British public and soothe the Council of the British Medical Association which instructed the work to proceed.

Though he admired Epstein's sculpture, Augustus was impatient with his personality. This milk-drinker from America excelled in blowing

* For example, he wrote to the poet Arthur Symons: 'Perhaps you may not have seen or heard of the sculptured figures on a new building in the Strand by a man called Jacob Epstein, which are in imminent danger of being pulled down or mutilated at the instigation of the "National Vigilance Society" of sexual maniacs, supported by tradesmen in the vicinity – and the police. These decorations seem to me to be the *only* decent attempt at monumental sculpture of which the streets of London can boast. A few of the nude male figures however have been provided by the artist with the indispensable apparatus of generation, without any attempt having been made to disguise, conceal, or minimise the features in question. This flagrant indelicacy has naturally infuriated our susceptible citizens to such an extent that without the most sturdy exertions of the intelligent lovers of Art and truth, the figures will be demolished.

'So after having been *sweated* physically and morally outraged for some 14 months by commercial close fistedness and prurient timidity our artist is left now penniless and inarticulate to face the last ignominy. Being a foreigner Epstein is quite innocent of the parochial sentiment which is the breath of our metropolis, he has merely contrived to inform his figures with a World-Passion to which we are strangers over here. If you would view the works, or those which are visible, for the hoardings are not yet all down, I feel sure you will share some of my feelings and will do something in defence of Epstein and Art itself – Yrs Augustus E. John.'

To Dorelia, Augustus wrote: 'Epstein wrote to me in despair, his figures are being threatened by the police! It is a monstrous thing . . . I sent him a fiver on account of Rom[illy]'s portrait and have written to a few people. On comparing his figures standing in their austere nakedness above with the squalid horde that pullulate beneath, leering and vituperative, one is in no doubt *which* merit condemnation, sequestration and dismemberment. I stand much in need of air air air – and you you you!'

his own trumpet.* 'I hope Epstein will find his wife a powerful rein-
forcement in his studio,' Augustus wrote to Will Rothenstein (19
September 1906) on learning of his engagement to Margaret Dunlop.
'Perhaps she will coax him out of some of his unduly democratic
habits.' As proud and touchy as Augustus was truculent, Epstein
appeared determined to attract hostility, and with Augustus found no
difficulty in doing so. Though Augustus did a lot to help Epstein,
their friendship was continually put upon the rocks by Augustus's
mercurial success and Epstein's long periods of poverty and was finally
sunk by an astonishing fancy-dress flare-up during the First World
War.

But in these early days they got on well. Epstein needed encourage-
ment; Augustus could afford to give it. Often they would be joined by
McEvoy in whose gentle company neither felt disposed to quarrel.
Epstein used to drop round to the Chelsea Art School occasionally,
and there would be black periods of silence as he and Augustus leant
against one of its walls: then a remark from Epstein – 'At least you will
admit that Wagner was a heaven-storming genius.' And from Augustus
an ambivalent grunt.

A witness to these exchanges, and much impressed by them, was
Henry Lamb. Lamb had recently thrown up his medical studies in
Manchester and, in a desperate bid to become an artist, turned up in
London. Here he at once started at the Chelsea Art School, and, having
nowhere to live, used to sleep there on the model's throne. On coming
in each night he would discover a fresh cartoon done by Augustus
during the evening – large works of many almost life-size figures, which
dazzled him. Sometimes Augustus would discuss one of them with him.
'I think of taking out that figure and introducing a waterfall,' he would
say. Lamb felt himself to be in the heavy atmosphere of genius. The very
silence was saturated with this property, and Lamb soon began to affect
it himself as part of the artist's equipment – a sort of cloak. As a draughts-
man he modelled himself on Augustus's work, and in his style and
manner of life, his very looks, he schooled himself to emulate Augustus's
example. Inevitably, Augustus was flattered by this handsome,
gifted follower. What could be more proper than a young man wishing

* But he was always a good subject for anecdotes. 'I don't believe in the modern
ideal of living in a cow-shed and puddling clay with somebody else's wife concealed
in a soap-box, like our friend Epstein,' Augustus wrote to Alick Schepeler (sum-
mer 1906). A few days later he amended this in an explanatory passage: 'The soap-
box or packing-can is well known in Bohemia as a substitute for a bed – and if
turned over might very well be used to conceal somebody else's wife, provided she
were not too fat – I was wrong however to provide Epstein with this piece of
furniture. I forgot that he used to keep somebody else's wife in his *dustbin* – I hear
recently that he has married her – so it's all right.'

to act apprentice to him? It was a concept he had always understood and wanted to benefit by himself. He responded generously. 'I hope you are doing designs lightheartedly,' he wrote (24 October 1906) '– What is so becoming as cheerfulness and a light heart? I think the old masters are apt to presume upon our reverence sometimes – one is always at a disadvantage in the society of the illustrious dead – perhaps it would be high time to bid them a reverent but cheerful adieu! since we have invented umbrellas let us use them – as ornaments at least.'

Lamb was not slow to respond to this message and at once elected Augustus as a new master among the illustrious living. Augustus was delighted. Confidence swelled within him – confidence, but not conceit. If people believed in him, he believed in himself. He needed other people's faith to fortify his own will. 'Your letter thrills me somewhat,' he replied to Lamb (5 November 1906). 'I am not quite a Master – yet. I keep forgetting myself often. But I am learning loyalty. We must have no rivals – and no fickleness. I feel ashamed to go to sleep sometimes. I am learning to value my own loves and fancies and thought above all others. But Life has an infernal narcotic side to it – and one is caught napping and philandering – – – alas! alas! if one had some demon to whip one! I hardly believed you had faith in my possibilities – in my will. I am so glad.

'One must have the tenderness of a lover and the recklessness of a warrior. Well – hurrah.'

No friendship yet had begun on such a lofty note – none would lead to such complications or remain so long and with such embarrassment a thorn in the flesh of both artists.

'I think I shall be a supernaturalist in Paris, and in London a naturalist,' Augustus wrote to Alick Schepeler. In London he had found work and a few people to inspire him; in Paris entertainment and the promise of inspiration to come. Something of the awe and wonder that had possessed him when he first went up to the Slade now re-entered his life. Paris he described as 'a queen of cities' and 'so beautiful – London can't possibly be so nice'.[145] No atmosphere, surely, was ever more favourable to the artist. On the terraces of the Nouvelle Athènes or the Rat Mort it was not difficult to conjure up the ghosts of Manet, Camille Pissarro, Renoir, Cézanne, Degas – figures from the last enchanted epoch, laughing and arguing across the marble tables. But the real heart of Paris lay further back: it belonged to the Middle Ages. Malodorous, loud with bells, its architecture full of passion, of the cruelty and splendour of ancient superstition, Paris seemed more dangerous than the carbolic climate of London. It was closer to Nature, to the earth itself and man's strange evolution from that earth. The murmur of the boulevards, deep and vibrant; the view of the city seen at dusk

from Sacré Cœur as the light began to pinpoint between the emanations of a hundred thousand chimneys; the landscape of the Île de France with its opulent green as if depicted through mediaeval windows: such beauty seized him with a kind of anguish, confronted him with un-answerable questions: 'What will become of us? What could all this mean?'

For hours he would sit in the Rue de la Gaieté, watching, talking, drinking, listening to the infernal din of a mechanical orchestra, and not wishing to go home – not going home. There was more dreaming of painting than pictures painted.

'They are playing in this café just now – so I expect I shall get rhetorical presently,' he declared in a letter to Alick Schepeler. 'Yes, I shall paint yet; it is more like fighting than anything else for me now – it will be triumphant though . . . Civilization keeps getting in my way and making a dreary hash of things – and wasting time. I'ld like to be kept by a prince. It's not safe to let me loose about the place in this way – and then send me bills to pay.'

The heady cosmopolitan world of Montparnasse intoxicated him – yet it was a literary world he had very largely entered. The talk was of Huysmans and Baudelaire, of Turgenev and Nietzsche and the newest Dostoievsky in bad French. Almost the only painter, living or dead, who is mentioned in his correspondence is Puvis de Chavannes. His Parisian friends were mostly writers, in particular the circle that gathered round the monocled, top-hatted figure of Jean Moréas at the Closerie des Lilas and which included Apollinaire, Colette, Paul Fort the wandering poet who, with his brother Robert, ran the journal *Vers et Prose*, and André Salmon the literary spokesman of *Les Jeunes*.

Of all this group his most valued friend was Maurice Cremnitz. Late at night, after the group had dispersed from the Closerie des Lilas, Cremnitz would lead Augustus off to louche, out-of-the-way areas of Paris. He introduced him to a Swedish lady famous for her exercises – 'yes, she was not to be sneezed at, as vulgar people say', Augustus conceded,[146] 'her crystallization would take the form of the purest amour physique I thought with no corrupting element of physical passion'. At other times they would explore the old quarters of the city, 'visiting the wine shops where the *vin blanc* was good – and cheap';[147] and they would go to the little Place du Tertre, to the Moulin de la Galette and the Bal Tabarin where such delightful songs as 'Petite Miette' and 'Viens pou-poule' were all the rage and where Cremnitz would sing, in amazing Cockney English, 'Last night down our alley came a toff.' 'I observed the true gaieté française that night,' Augustus wrote after his first visit there with Cremnitz, 'a little femme de mauvaise vie had a new song she kept singing and teaching everybody

else – no one could have been more innocently happy – and the song – ! !'[148]

Innocent, too, at least in name,* was an obscure subterranean *bouge* near Les Halles into which they descended one night, 'and, I must admit, drank great quantities of white wine. A drunken poet joined us there and declaimed Verlaine and his own verses at great length. As he had the impudence to take exception to my style of Beauty I said "Voulez vous venez battre avec moi, Monsieur l'Antichrist?" He got up and, having put himself into a pugnacious attitude, sat down again. Afterwards he was very affectionate, informing me that he and I had fought side by side in the Crimea – frères d'armes!' This robust shadow-boxing was marvellously congenial to Augustus. Paris seemed to unite those two aspects of his personality that could, in his work and his attitude to people, so easily diminish each other: a romanticism that was idealistic, nostalgic; and his wry, rather satirical humour.

So, for a while, Paris diverted him. 'I've been damnably lazy this summer,' he admitted to Will Rothenstein (19 September 1906), 'but am happily unrepentant. I fancy idleness ends by bearing [more] rare fruit than industry. I started by being industrious and lost all self-respect – but by now have recovered some dignity and comfort by dint of listening to the most private intimations of the Soul and con-temning all busy-body thoughts that come buzzing and fussing and messing in one's brain.'

All his life Augustus lived under the influence of an impossible ideal. What he sought in men – inspiration and entertainment – he also looked for in women, though in a different form. Men inspired him by reason of the poetry in them, by what they achieved, and many of his finest portraits are of writers and artists: Hardy, Wyndham Lewis, William Nicholson, Shaw, Matthew Smith, Dylan Thomas, Yeats. Other men – Trelawnay Dayrell Reed and Chaloner Dowdall – enter-tained him by their eccentricities. The inspiration of women sprang from the simple fact that they were closer to Nature and to the mystery of birth; and this he celebrated most lyrically in a number of small glowing panels depicting young mothers and children as part of a bare landscape. But women also entertained him simply and obviously by their sexuality; for sex, which had so worried him while he was an adolescent, had now become 'the greatest joke in the world':[149] and Augustus loved a joke.

His ideal was impossible because it was unrealizable in any perma-nent or material condition into which he tried to transform it. As symbols of the miracle of life, women must be seen and not heard,

* Caveau des Innocents.

must be inaccessible, unknown, inviolate: they must guard their secret well, hint at it only with their eyes, convey it by the slow rhythm of their movements, their quiet. Yet the miracle of life, of which women were the custodians, depended upon the joke of sex. Inspiration and entertainment were oddly harnessed together, often pulling in different directions, sometimes failing to drag him past sentimentality.

No one, perhaps, catches his attitude to women so well as a new woman he had recently met in London. Her name was Alick Schepeler and, next to Dorelia herself, she became for a few years his finest model. But as the embodiment of Augustus's romantic ideal, she was almost a parody. No one, it seemed, knew who she was. 'Are you a Pole?' Augustus demanded – but in reply she could only smile secretly, without meaning. In *Chiaroscuro* he refers to her – 'Alick Schepeler, to whose strange charm I had bowed' – only once, and declares her to have been 'of Slavonic origin', adding that she 'illustrated in herself the paradox of Polish pride united to Russian abandon'. By naturalization she was in fact British, her mother Sarah Briggs being Irish and her father, John Daniel Schepeler, German. The facts of her life were unusual, though not extraordinary. Her real name was Alexandra, she was an only child and had been born on 10 March 1882 at Skrygalof, near Minsk in Russia, where John Schepeler worked as an industrialist. Her father died when she was five and she was taken by her mother to live in Poland. Here Sarah Schepeler found employment with a Polish family as 'English' governess, while Alexandra was boarded near by with a Mrs Bloch and her daughter Frieda. After some ten years in Poland Sarah Schepeler died, and not long afterwards Alexandra, who had by now become part of the Bloch family, travelled to London with Frieda. The two girls, who were about the same age and had become great friends, lived together at 29 Stanley Gardens in Chelsea. Frieda attended the Slade but Alexandra, who appeared to have no promise of talent in any direction whatever, took a course in typing and went to work as a secretary for the *Illustrated London News*. In her letters to Augustus she hints at leaving this paper and taking on grander work. In fact she never left, nor sought promotion. Her unsettled upbringing seemed to have implanted within her an allergy to change, even change for the better. She lived in Chelsea and typed at the *Illustrated London News* for over fifty years.

In the extent of her ordinariness lay her single extraordinary quality. Her mind was a polished vacuum where the imagination of the artist was free to roam unimpeded. She had nothing to hide, but from the very presence of this nothing arose a mystery none could penetrate. In her relationships with men, this was her asset. She had no cards to play, yet her hand seemed full of trumps which she trembled on the

verge of revealing. Her talk was of her cat, her clothes and her office. She was unbelievably uninteresting – and no man could quite believe it. Augustus, in his anxiety to avoid *intellectual* passion, could scarcely have chosen anyone with finer qualifications.

Yet she lived for passion. Love – physical and romantic love – was her escape from a destiny of unimaginable dullness, and in this she was very intense. Rootless, she had nevertheless come in contact with a kind of reality that Victorian and Edwardian young ladies never knew. She had avoided the hockey-and-inhibition of a British education, and unlike some young girls in London then she was eager for love-affairs. So her life took on a strange dichotomy. She gained something of a reputation as a coquette, abandoning herself anxiously to every sort of pleasure, and staying out at parties till late at night. Day came, and she was translated once more into a pale, contented secretary.

What she lacked in confidence she made up for with tedium. Yet she was not unattractive, and it is easy to understand why Augustus found her so striking. Five feet five inches tall, she had sumptuous brown hair and eloquent, pensive blue eyes. She was highly strung, easily pleased, equally easily offended, and at both extremes intensely feminine. She walked in beauty like a mist impregnated by all those notions English people associate with Poles and Russians. But to many, her most bewitching quality was her gurgling voice, rich and soupy and full of flattering inflections when speaking to those she liked.

It was through Frieda Bloch and her Slade friends that Alick, as everyone called her, got to know Augustus and subsequently many other writers and artists from Wyndham Lewis to W. B. Yeats. Some of them treated her badly, though she never complained or explained. When questioned, for instance, about Yeats, she simply gurgled, her voice like hot air bubbling through lemonade: 'Ah Yeats – he was a won-derful man!' And Lewis? 'Yes – won-derful!' And Augustus? 'Won-derful!'

For all eminent artists and manly men her admiration was unfettered. But like Augustus she was incapable of planning or scheming. Spontaneously, without premeditation, while Ida and Dorelia were tucked up together in Paris, Augustus and Alick had begun to see a great deal of each other. For once, inspiration and entertainment were well married.

'You are one of the people who inhabit my world,' Augustus wrote to her, '– a denizen of my country, a daughter of my tribe – one of those on whom I must depend – for life and beyond life. I am subjected to you – be loyal to your subject.' Almost nothing became Alick so well as her absence, and since Augustus had to spend much of his time in Paris, his infatuation for this 'jeune fille mystérieuse et gaie' deepened.

Their relationship developed partly through a correspondence that was voluminous, purple, and of astonishing tedium. It is not that their love letters achieved this pitch of tedium gradually: they bored both of them at once. Augustus even owned that he had to have a constant supply of brandy in order 'to continue this correspondence which bores me so much'. Boredom was, indeed, one of the gifts they shared. They were experts in the subject, scholars, connoisseurs; they were competitors. In almost every letter he asks her urgently: 'Let me know if you are badly bored?' And in almost every answer she is able to boast of some new territory conquered by ennui. This ennui was an object of fascination to Augustus, who measures it wonderingly against his own so that it spreads into their most significant shared quality, becomes part of the very fabric of their love-affair, reaches pathos. 'Do you know I long to see you again,' he writes from France. 'You are such a love – your smile is so wonderful and nobody cries so beautifully as you. How bored are you Alick? I get quite desperate at times – really yesterday I caught myself in the act of beating my brow! All alone and quite theatrically – I tell you I was angry!' To paper up these areas of boredom, he begs her to 'cover six sheets with an embroidery of pretty thoughts and interesting information', and send them to him at once. 'Wrap yourself in the sheets, so to say, and leave the imprint of your adorable self behind for me.' But such an accomplishment is quite beyond Alick; she has nothing to say. To escape from himself, and assume another character part, Augustus then begs her: 'Do re-christen me!' But this feat too is beyond her; she can think of no names, her head is empty – and so Augustus remains inescapably Augustus, bored and bewildered.*
Nevertheless, by a fraction, she was more bored than he, if only because he wrote more letters than she did. 'Ah, Alick – writing so often as I do how can one avoid being a bore?' he demanded. 'I know what risks I run but still persist – it means talking to you vaguely, unsatisfactorily and blindly, but still some attenuated converse with you. I can't see the expression on your face nor hear the sound of your voice – it is worse than the telephone – and more open to misunderstandings. It is a kind of muffled dumbshow with hands tied.

'How is it you mean so much to me – you are like a woman found on an island by one happily shipwrecked, who shows him the cave where she sleeps and the berries she eats and the pool in which she bathes herself – and in kissing her his soul flies to the moon henceforth his God as it is hers.'

Boredom was to be outwitted by the most extreme rom-antics. As

* He called her 'Undine', meaning female water-sprite or elemental spirit of the water in Paracelsus's system.

hypochondriacs of the soul, their search for new and extraordinary sensations with which to drive off the dreaded accidie must be un-remitting. With great zeal, with inventiveness, they quarried after the purely superficial, and from time to time, as a remedy against tedium, they would add some *nouveau frisson* to their medicine chest. 'I can tell you how to procure a new sensation,' Augustus prescribed in one of his letters. 'First of all get hot – undo your waistband – indeed it is better to remove your outer dress, then, seated on your bed, pour white wine very slowly down your neck, breathing regularly the while. But you must be at the proper temperature to commence with. If this doesn't please you I will tell you another method.'

Alick's letters almost always disappointed Augustus; but the posts that brought no letters from her stirred him up very wonderfully.

'Alick – why don't I hear from you – won't you write even if you don't love me? Do not wait till you love me – it might take days to come on. What else can I say – nothing till I hear from you, my moon, my tender dove, rose of my soul. – John.'

Their correspondence was enclosed, at Alick's insistence, within a paraphernalia of espionage secrecy that artificially flavoured the masquerade between them. Augustus never kept letters, he merely failed to lose them. Alick, who sensed this, is always rousing him to the point of destruction. 'Yes I burn your letters,' Augustus assured her. 'Even the last, than which nothing less compromising could have been written, I took away to a lonely spot and consumed. I hope you dispose of mine with equal thoroughness. In case you are still without a cigarette I send you one – to be smoked with this letter.' But still Alick was not satisfied. She seemed to detect a bantering tone in this assurance, and on at least one occasion asked for her own letters to be returned to her through the post. 'Here are your letters – you see I have destroyed many. My habit (an evil one of course) is to put them in my pocket where they remain safely till it gets too crowded – when I weed out a few . . . There is nobody here who would read *your* letters or understand them . . . Yes – you may trust to my honour to *burn* all letters I get from you in future *instantly* and if you like I will eat all the ashes as a further precaution. You don't realise what depths of discretion I am capable of, and I am improving in this respect – under your tuition.'

Alick distrusted flippancy. If Augustus had a fault, it was this disconcerting humour of his – for she was desperately anxious to conceal that she had nothing to hide. Unasked, she swore most earnestly and without any trace of humour that she consigned each item of his correspondence to the flames. It may now be read in its entirety at the library of the University of Michigan.

In his strangely muted world, isolated, swept by melancholia, Augustus welcomed Alick Schepeler as a fellow being. His instinct was not wrong. She mitigated his bouts of loneliness by being inexplicably lonely herself. She was, he told her, 'Keltic' like himself. Besides social shyness and physical passion, they had in common a background from which their adult life was divorced. With their quick perceptions they combined a curious amalgam of boldness and timidity; both were polyglots and read widely, though mainly as a refuge from solitude; both took their mental colouring from their friends. As revealed by their correspondence, the one taste they had in common absolutely was a sartorial obsession. Their intense excitement over clothes was often the only stimulus to quicken the movement of their blood. When Alick commanded him to write and tell her all he was doing in France, he replied: 'I would rather talk about you and your beautiful under-clothing.' At other times he would question her: 'Tell me, Undine, how are your shoes wearing? It seems so *fitting*, that you – a soulless, naked, immortal creature, come straight out of the water, should take to *shoes* with such passion!' She would fill the page with detailed descriptions of her dresses, and he, in his answers, would ponder over which had demoralized him the most, the blue, the pink or the black-and-white.

Clothes are the clue to the two most significant aspects of this correspondence. 'I have bought a new hat and an alpaca coat,' Augustus announced, 'to give me confidence.' His clothes were like those in an actor's wardrobe, for he changed his personality with them. It has been said that he modelled his appearance on Courbet, but in fact he had no single model in mind, and many transitory moods and influences claimed him. Parental disapproval was always a strong recommendation. One morning about this time old Edwin John read in a newspaper a description of his son's appearance as being 'not at all that of a Welshman, but rather a Hungarian or a Gypsy', and at once sent a letter of reproof which Augustus had no difficulty in treating as Alick Schepeler was always imploring him to treat hers. But the reproof did not go unheeded and, to caricature his father's wishes, he secured a complete Welsh outfit with which to flabbergast Montparnasse. Edwin John's real wish was for gentlemanly inconspicuousness, and this perhaps was the starting point of his son's melodramatic uniforms. Especially in these early days, Augustus's clothes, like his handwriting and the style of his pictures, were always changing in the search for his real self – or the successful avoidance of it. 'I am so mercurial,' he confessed. 'Really I must cultivate a pose. It is so necessary so often.' It was necessary to steady him, to bring consistency to his attitudes and direction to his rudderless progress. So he experimented.

'Méfiez-vous des hommes pittoresques,' warned Nietzsche. Augustus quotes this in *Chiaroscuro*, but adds that, though weary of his extreme visibility, he was unable to achieve unobtrusiveness. At times he despised himself for this failure. 'I have half a mind to get shaved and assume a bowler,' he told Alick. 'My life seems more amazing every-day.' So he trimmed his beard and for a short time did wear a bowler – with the result that he grew more noticeable than ever: a victim of his own appearance, as Princess Bibesco later described him.

The correspondent who wrote Alick Schepeler so many letters during 1906 is every inch a costume actor – but detachment and humour kept pulling the mask a little from his face. 'The thought haunts me that in a gross state of satisfaction I have allowed myself to utter the most abominable sincerity,' he tells her. 'I ask you in your turn to make allowances.' But these letters are not insincere; they are elaborately undeceiving. They expose, perhaps more clearly than anything else he wrote, the fluidity of his character, with its hectic cross-currents of whim and temper. They show the urge to cover up his uncertain inner being with the hats and coats and hand-made shoes of the confident outer man. But they also illustrate the unhappy paradox by which he dressed to attract the sort of attention that, once he commanded it, disgusted him.* What he intended to be a means of self-escape often made for agonized self-consciousness. He was embarrassed by his past self which, in a new mood, would seem to him false, full of sickening sentimentality. In just such a mood he later destroyed most of his letters to Ida, telling the Rani that 'they made me almost wither up in disgust'.

Clothes also form a natural part of this correspondence because they are essential to Augustus's pictures. His infatuation with Alick Schepeler had at its source the certain knowledge that, for whatever reason, her face and figure could summon from him great art. For this paragon of boredom was Lady Enigma to him: and that was enough – no need to question further. In the years 1906 and 1907 he drew and painted her numerous times. By all accounts his finest portrait in oils, entitled 'La

* For example: 'An English fool, whom I had observed eyeing me in Rouen Cathedral to-day, rushed up to me outside, and started addressing me with extreme nervousness in lamentable French. He asked me if I were a Russian. I said "Mais non monsieur". He then began excusing himself so painfully that I invited him to speak English. He was thunderstruck and asked if I were a socialist. "No, are you?" "Er, no, I'm a Chrstian – first of all etc." He explained he was so struck by my appearance, the ass! He was a pitiable sight. His deplorable condition when I left him made me almost *feel* Christlike. Indeed I was about to make him the repository of the newest Beatitude. "Blessed are the ridiculous, for they shall entertain the Lord," when he oscillated confusedly and disappeared in a pink mist.' John to Alick Schepeler, undated.

Seraphita', he accidentally set alight in the 1930s during one of his cigarette fires. But there are at least half a dozen remarkable drawings in galleries and private collections.* Almost all of them have in common a Slavonic strangeness, a foreignness, and the suggestion that he had caught sight of depths in her not visible to others. Alick herself is said to have remarked that she had never noticed she was beautiful until Augustus drew her. Yet the drawings are in no way prettified. They show a face which, though it may have some characteristic John features – a slight slanting of the eyes or high prominence of the cheek bones – is unique. It is a face that haunts one. The eyes drill through the spectator with a peculiar insistence; the hair, like great flying fingers, has a curious wildness about it; the expression varies between animation, mischief and serene secrecy. Always enormous strength is conveyed – a reflection of the force of Augustus's feelings – without the cosiness occasionally present in his portraits of Ida and even Dorelia. Sometimes, as in a drawing entitled 'Study of an Undine', there is a hint of insanity. The face emerges out of soft contours and shadow, with its wispy strands of hair, like the head of Medusa. She is a cross between a witch and nymph.

The letters he wrote to Alick Schepeler form a perfect commentary on these portraits. In the spring of 1906 he writes from Paris: 'Am I painting? – why yes – and I have burst certain bonds too that bound my brain with iron and now my bewildered eye mixes dream with reality – and weeps with joy and pain.'

To mix dream with reality was his ambition.† He saw in Alick Schepeler a perfect focus for this ambition since she lived most intensely in

* At the FitzWilliam Museum, Cambridge, there is 'Study of an Undine' (P.D. 155), dated 1907, and 'Portrait of Alexandra', 1906 (P.D. 154–1961). At the Manchester City Art Gallery there is 'Study for Undine' (1182) and 'Miss Schepeler'. 'Alick Schepeler', a black-pencil portrait on grey paper owned by Mrs H. Alexander is reproduced as No. 18 in *Augustus John: Fifty-two Drawings*. A full-length drawing ($5\frac{3}{8}'' \times 13\frac{1}{2}''$) described as 'A lady with left hand raised to her cheek' – a very deliberately enigmatic pose – is probably a study for the burnt oil painting 'La Serapita'. It was owned by Mrs Charles Hunter and later bought by Vita Sackville-West. It is now in the collection of her son Benedict Nicolson. 'I have a certain tenderness for this drawing,' Augustus wrote on 9 June 1938. 'It is of Miss Alick Schepeler.'

† Another letter he wrote to Alick Schepeler at about this time catches something of John's artistic philosophy. 'If I write anything I am bound to disagree with it. Truth can never be stated definitely. Let us be satisfied, sweet, to make allusions. A truth grasped escapes through the fingers. Even lying is unreliable. For me the delicate and contradictory whispers of perambulating spirits are alone oracular, and the mischievous insinuations of marauding devils cause my soul to flutter with a vague and delighted anticipation – no less than the unimaginable touch of an angel's fingers on my head leaves my brain busy with some celestial project.

'The veils lift over the mountains, the shadows become luminous, and in the gloomy wood voices are heard talking and singing.'

his imagination. He observed her and painted her in England; but it was in France that his portraits were conceived.

'I see you standing on the summit of a sea-hill and, turning towards the sea with a gesture divinely nonchalant, project me a surreptitious yawn which, carried by the waves is at length deposited moistly yet merrily on my shore,' he wrote to her from across the Channel. 'I picture you extended, partly in and partly out of the water like an Undine hesitating between immortality and love, or like some sweet reptile of old discovering the first dry land or like some formerly aquatic species at the moment of differentiation. And how brown you are – O pray – retain the bloom till I come. Do not wash till I see you.'

On land he saw her, thought of her, as a witch:

'It is regrettable that I have not persevered with my occult studies, otherwise I might appear to you personally which would be a much better plan than writing a dull letter,' he wrote in the summer of 1906. 'I used to wonder whether you were a young witch . . . given to broom-stick riding and Sabbats of a Saturday. Perhaps if I surprised you astrally at this moment I should detect you in the act of performing some diabolical incantation or brewing a hellish potion or suchlike. Sweet one! More probably I should find you sleeping soundly and I would be able to see how many kisses one required to wake you up.'

Dream and reality, the very mainspring of his art, seemed by June 1906 to have moved to the Sleeping Beauty of Stanhope Gardens. Paris, which was to have given him the impetus for so much new work, had already begun to lose its lustre. He could find in France only actuality and, during the crucial last six months of the year, this actuality was turning into nightmare.

5. A SEASIDE CHANGE

'A sojourn at Ste Honorine-sur-Mer, near Bayeux, was memorable for little save the birth of my son Romilly,' Augustus recorded over thirty-five years later.[150] In his voluminous correspondence at the time, and in that of Ida, there is much that is memorable, though no mention of Romilly's birth.*

Within two months of moving to the Rue Dareau, though living there only intermittently, Augustus was grumbling to Alick Schepeler (June 1906): 'So far rather gloomy here – I am decidedly sleepy and feel the dullest of all the devils.' His depression worsened until he resolved to reconnoitre a long holiday by the sea for himself and for

* Romilly John was never informed of his exact birthday. His birth, like that of his brother Pyramus, was not registered.

what Wyndham Lewis had called 'a numerous retinue, or a formidable staff – or a not inconsiderable suite, – or any polite phrase that occurs to you[151] that might include his patriarchical ménage.'

'I am off to-night,' Augustus wrote to Alick Schepeler one June evening, 'to find a place by the sea, somewhere in Normandy I think. First of all I mean to go to Caen. The poet [Wyndham Lewis] is coming with me . . . I shall be moving about . . . Cher ange – why don't you come over too, as you thought of doing? I will find a place. I will arrange everything . . . I have had a spell of complete sterility lasting several days, but now I see nothing but beauty. I refuse to see anything else.'

Rather irritably he roved the Normandy coast until he came to Ste Honorine des Perthes where, falling in with a band of Piedmontese Gypsies * – about a hundred vans packed with grand men and women and some beautiful children – his spirits suddenly veered upwards. 'They spoke very good Romany,' he told Alick Schepeler, 'and played very badly, alas. At Port-en-bessin, near Ste Honorine, there are wonderful sea-women who collect shellfish – they are very tall and quite pre-historic – just the sort you'd hate. I suppose I want to do a painting of them all the same.' His mind was now made up. He would lead his families to Ste Honorine, and station Alick Schepeler just off the coast on Jersey. She could wear her beret and her splendid new pink dress – and she could bring her friend Frieda Bloch too. It would be a terrific summer. A 'glorious bathe in the sea' at Ste Honorine confirmed that this was the correct decision, and he hurried back to Paris to fetch everyone.

'Gus has just come back from finding a little house by the sea for all of us to go to,' Ida wrote to Mrs Sampson. 'The kids ought to enjoy it.' Her implication that the adults might not enjoy it was to prove drastically right. From July to the end of September they lived 'chez Madame Beck' at Ste Honorine. 'It is a tiny village,' Ida told Alice Rothenstein. '. . . We are between Cherbourg and Caen. Bayeux is the nearest town, and we only get there by cart and steam tram.'

Since flight was so difficult, Ida had to rest content brooding over the 'patriarchical ménage'. As Dorelia had looked after her during Edwin's birth, so now she looked after Dorelia. But the children, with whom Dorelia had dealt so calmly, rasped on her nerves and her inability to overcome this irritation enervated her. She was imprisoned: the place of her captivity was fuller than ever of these children, and 'I don't care for them much.'[152] David, who was 'very silly and not very interesting',

* A large charcoal drawing he did of these gypsies, 'Wandering Sinnte', is now in the Manchester City Art Gallery. Though the figures are unrelated psychologically, they have a compositional unity and a community of feeling that makes it one of the best of Augustus's groups.

seemed in the last year to have advanced not at all: either he would make cheeky jokes or noises like an engine. Caspar, '*very* fat and solid', spent his time dashing in and out of the water – up to his ankles; Robin did nothing but climb and jump; Edwin, who now looked like a huge swollen doll – 'very ugly with tiny blue eyes' – had developed so red a face that 'we bathe him in sea weed';[153] Pyramus appeared more Wordsworthian than ever and, as ever, did nothing; and so on.

As at Matching Green, Ida's 'formidable staff' comprised two girls – Clara, who had joined them when they originally came to Paris, and Félice, a very ladylike and refined woman who made disagreeable noises in her nose and suffered from persistent palpitations. She screamed at mice, had fearful starts when failing to spot people approaching her, and yawned all day – huge, lionlike yawns. Yet she worked very well, though no one liked her, least of all Clara who could not endure the least shade of interference. The two of them were seldom on speaking terms – either it was ear-splitting peals of abuse rivalling the children's, or a disdainful silence. Their bad humour contributed much to the tenseness of this holiday.

Ida felt she had not the energy to control these domestic politics – the confidence, the strength, even the humour of Paris were ebbing. 'We are in a village miles from the railway and by the sea,' she wrote to the Rani (August 1906). 'It is very relaxing and we all, except the children, feel awful.' What had gone wrong? Everything, it appeared – and for all of them. At first it had promised so well. 'It's a lovely place,' Ida had written happily to Mrs Sampson. The sun shone, and Augustus would lead off his troop on bathing parties, on long walks to pick blackberries for jam and 'English puddings', and on picnics – 'there is a lovely place on the cliffs where we slide down. Gus goes head first.' They encountered several battalions of gypsies – 'glorious chaps' – and Augustus bought Ida a guitar which she promised she would 'learn to play well'. Gwen John came for five days with her cat and surprised everyone by bathing twice a day. And then there was the poet Wyndham Lewis – 'a nice beautiful young man', Ida called him – who stayed for five weeks, grew a beard, let off cheap fireworks and made everyone cry with laughter* over his plans.

* 'The poet astonished the beach by appearing in a Rugby blazer and a cholera belt,' Augustus reported to Alick Schepeler. '. . . He came back full of the beauties of sea-bathing – that is to say: he had been viewing the girls frolicking in the water from a prominent position on the beach. He assures me there were at least 10 exquisite young creatures with fat legs, and insists on my accompanying him tomorrow . . . He wants me to go to Munich in January for the Carnival – he assures me I will dance with the Crown Princess.'

Lewis's more laconic description of this long vacation was simply: 'I wrote verse, when not asleep in the sun.' See *Rude Assignment*, p. 120.

Then, abruptly, the sun went in; the gypsies vanished; Gwen John
left; Wyndham Lewis, after sitting for his portrait, failed to amuse any
longer; and Augustus was 'plunged into gloom by a thousand trage-
dies'.[154] These thousand tragedies sprang from one central disap-
pointment. Instead of turning up in Jersey, Alick Schepeler had drifted
north to, of all places, Cumberland, giving as her reason the need to
sketch for two months; and she had taken with her Frieda Bloch.
Augustus's reaction was extreme. He shut himself away, refused to
paint out of doors, refused even to bathe except after dark. 'I have had
most horrible spells of ennui,' he wrote. 'I sat in a garden the other day
and wondered what there was in the world at all tolerable. I examined
a tree attentively to discover any beauty in it – without success. The sky
seemed an awful bore and I wondered why it should be blue. It if had
been dark indigo and the trees gold perhaps I should have been rather
pleased.' The beauty which he had refused not to see at the beginning
of this holiday was now extinguished without trace. He could not paint,
he could not stop trying to paint; he could not rest, he had no energy.
His melancholia was not just the absence of high spirits: it was a
positive disease, a cancer that consumed his very talent. The one cure
was a stimulus for his work, and the one stimulus just then was Alick
Schepeler. Now that she was further off than ever, her attraction re-
doubled. She began to obsess him.

'I have awful fits of boredom – *awful*,' he confided to her. 'I dreamt
such a dream of you last night – and you had at last actually consented
to take off your clothes – at any rate you were quite naked and quite
beautiful. Why are you so – "nice"? . . . I would love to lie about with
you – no, I mean walk long walks with you – and perhaps have a bathe
now and then. The people I see on the beach don't please me . . . I am
horribly restless – I wonder why the Devil I came here now. I curse
myself – and calculate the maximum of years I have to live . . . Kiss me
Alick – if you love me still a bit – darling you strange one. It is time I
went on with that portrait. I believe I shall do nothing before – almost.
I am expecting a letter from you – Alick – I kiss your knees and eyes
and mouth.'

He lived for her disappointing letters, wrote to her almost nightly,
and composed poems to her including a sonnet which discovers
(with apologies) her Christian name rhymes with 'phallic'.

Maddened by frustration – and insect bites – he could not wait to be
out of 'this sea-side hole', and begin to paint 'Whitmanic' pictures.
'Just write, beloved,' he urged Alick, 'and keep my spirits up. I foresee
dismal things if you don't. The sea is beautiful all the same – I would like
to lie in the sun with you and let the water dry on us.'

The other side of these generous love-letters was a meanness to those

around him. He could not help himself. For day after day Ida and the others were subjected to a highly-charged apathy, a death ray of pessimism. Deprivation – if only as a conjecture – always affected Augustus violently because it restored the chief condition of his childhood: deprivation of a mother; deprivation of love. He reacted in a 'spoilt' manner, grew surly, then aggressive. So now, after many dangerous days of simmering, he could hold himself back no longer. 'I have been dissecting myself assiduously here,' he informed Alick, 'and as a consequence have thrown overboard all self-respect and feel infinitely more comfortable and free and on excellent terms with the Devil.'

This allusiveness concealed a crisis that split apart the love molecule Ida, with Dorelia's collaboration, had so carefully prepared. Augustus had no wish to hurt either of them, but misfortune moved in his blood like a poison, and he had to expel it or die. 'How I hate causing worry!' he exclaimed to Alick. And how much he caused! For he hated even more being 'unnatural', and he was allergic to secrets, which were claustrophobia to him. But his melancholy had grown so painful that it stupefied him, making him, so he admitted, 'careless of other people's feelings'. What he now did was bluntly to tell Ida and Dorelia the truth – the unstable truth of the moment, the truth he felt under the influence of his evil mood. He told them that domestic life, even of the unorthodox variety with which they had experimented, smothered him; he told them of his feelings for Alick, that his painting could not advance without her, that he needed her. There was nothing too personal in all this – but he could not be restricted; he would explode. Boredom, guilt, frustration, sterility: to such morbid sensations had their ménage led him. They stifled his work, and he could countenance them no longer. At the same time he wrote to Alick: 'I think I have about done with family life or perhaps I should say it has done for me – so there is nothing to prevent us getting married now.'

But marriage to Alick was only another fantasy escape he indulged largely because 'I wish to remain as respectable as possible in your eyes.' What in fact he proposed was something less original: to duplicate the arrangement he had with Ida and Dorelia in Paris, with a similar arrangement, also in Paris, with Alick and Frieda Bloch. His letters to Alick are full of plans for her to join him. 'If I had a wish for the fairies to fulfil it would be that you would come to Paris with Miss Bloch before long and collaborate with me,' he begins; and later: 'I begin to see very plainly that Miss Blocky will never get on unless she comes to Paris and brings you with her. I will find her a studio – and I will show her things I'm pretty sure she never suspected.'

Only now, for the first time, did Ida and Dorelia acknowledge that,

even between them, they could not contain Augustus. He was not proposing to leave them, simply to add to their number. He made no secret of it. 'John is taking a studio in Montmartre, where he thinks of installing two women he has found in England,' Wyndham Lewis confided to his mother;[155] 'and I think John will end by building a city, and being worshipped as sole man therein, – the deity of Masculinity.'

It was Dorelia who first resolved that she wanted no place in this city. She secretly decided that once Romilly was three or four months old, she would quietly 'buzz off'.[156] Ida too would have liked to leave. Her predicament is set out lucidly and poignantly in a letter she wrote from Ste Honorine to the Rani:

'Dearest, daily and many times a day I think I *must* leave Augustus. Isn't it awful? I feel so stifled and oppressed. If I had the money I think I really should do it – but I can't leave him and take his money – and I can't keep the kids on what I have – and if I left the kids I should not find peace – you must not mind these confidences, angel. It is nothing much – I haven't the money so I must stay, as many another woman does. It isn't that Aug is different or unkind. He is the same as ever and rather more considerate in many ways. It's the mental state – I don't understand it and probably I should be equally slavish – *No* – I know I am freer alone. However one has lucid moments anywhere. Don't think me miserable. All this is a sign of health. But it's a pity one's got to live with a man. I shall have to get back home sooner or later – not meaning 28 Wigmore Street – and it doesn't matter as long as I don't arrive a lunatic. It's awful to be lodged in a place where one can't understand the language and where the jokes aren't funny. Why did I ever go there? Because I did – because there lives a King I had to meet and love. And now I am bound hand and foot – darling how will it end? By death or escape? And wouldn't escape be as bad as bondage? Would one find one's way – . . .'

They had spun a web for their own delight, and now found themselves most unhappily glued to it. This was not only the plight of unliberated women, but of unrefined human nature: they were all entangled. It was as if they had lovingly prepared an ambush into which they had somehow fallen and which now lay open for others to fall into.

At the end of September they left Ste Honorine all together and returned to the Rue Dareau. The atmosphere between them was black. 'I am very maladif I regret to say – that is I get fits of depression about every two hours – alternately intervals of malign joy,' Augustus confessed to Alick. Like a butterfly struggling out of its chrysalis, he felt it was time to fly off to new places, places remote and unknown. 'Paris

is a queen of cities but I think Smyrna would suit me better.' Next moment he hankered after Italy – the Italians were surely the finest people in the world, and besides, he would be able to see in Italy 'my darling Piero della Francesca'. Genoa might suit him best, or 'Shall we go to Padua?' he asked Alick. But even before his invitation had arrived, another brainwave was upon him: 'I am inclined to take refuge in Bucharest at the nearest, to seek serenity in some Balkan insurrection, or danger in a Gypsy tent, or inevitable activity in Turkistan . . . I am horribly aware of the power of Fate to-night.' This self-destructive urge quickly passed and, in a more hibernating mood, he suddenly inquired: 'Perhaps I may depend on you for warmth this winter. . . . I feel that once back in London I shall never leave it.' By now Alick was thoroughly confused. What *was* happening? Augustus was astonished at her question. Surely everything was perfectly clear! 'As to my coming to London, is it not already definitely arranged?' he demanded. 'Haven't I said jusqu'à l'automne a dozen times? And is not my word unimpeachable – am I not integrity itself?'

He did return to London, and to Alick, that October, while Dorelia prepared to move off elsewhere the following month. Only Ida was to stay on at the Rue Dareau – with her pack of boys, and two quarrelling women. Her bondage there was tighter than ever now, for to add to the complications, Clara had become pregnant.

And, as if that were not enough, Ida herself was again pregnant.

6. 'HERE'S TO LOVE!'

For the next six months, between October 1906 and the spring of the following year, Augustus, Ida and Dorelia struggled to establish lives which, though inevitably they overlapped, would be essentially separate.

For Augustus the first taste of this new regime was sweet. His depression lifted like a cloud at evening, and a bewildered exhilaration blazed through. The world was one marvellously mixed metaphor and he stood, in superb uncertainty, at its centre. 'I feel recurrent as the ocean waves,' he boasted[157] on arriving in London, 'blue as the sky, ceaseless as the winds, multitudinous as a bee-hive, ardent as flames, cold as an exquisite hollow cave, generous and as pliant as a tree, aloof and pensive as an angel, tumultuous as the obscenest of demons. . . .'

It remained to be seen how long this combination of feelings would persist. Augustus himself was as confident as a boy. 'I no longer suffer from the blues,' he told Alick, 'and my soul seems to have returned to its habitation. I think you are more adorable than ever.' All that summer he had been damnably lazy but, as he explained to Alick, 'it is

when I am not at work enough that I get bored'. Once again the un-controllable volatility of his temperament had swung him above gloomy vapours up to elegiac ecstasies, and the will to work throbbed through him. Seldom had he felt so vigorous.

But first there were some small practical matters to attend to. For while his soul had found its true habitation, there was still no proper place to house his body. He required a new studio in London – a fine new studio to match his mood – and, while he was about it, another new studio in Paris. Then he would be free at last to paint. 'I am going to take a new studio in Paris,' he proclaimed[158] (September 1906) '– remote and alone – in some teeming street – where I can pounce on people as they pass, hob-nob with Apaches and maquereaux and paint as I can. Then of course the studio in London – the new one – in your neighbourhood.' He had found nothing in Paris before leaving, so he now took up the search in London. 'I hope the Gods will provide me with a good studio in London,' he wrote to Alick, 'a studio I can live in and where you can come and sit without being spied on.' But the Gods, and estate agents, led him a merry dance – to Paddington, Bermondsey and the East End: all without success. For the time being he still used Rossetti Studios which Knewstub offered to lease to him for a further year. But independence meant freedom from the Knew-stubs, Orpens and Rothensteins, and so he refused it – while con-tinuing to use it *faute de mieux*. For a short period he rented another studio in Manresa Road from the Australian painter George Coates. It seemed a splendid place – Holman Hunt had painted his 'Innocents' there – but Augustus did not stay long. Dora Coates noted with dis-approval that he had 'a compelling stare when he looked at a woman that I much resented'. She also resented his treatment of the studio – soiled socks and odd clothes lay thick upon the floor amid the dust of weeks, and by the time he left it was as 'dirty as a rag and bone shop' and had to be scrubbed with carbolic soap. He found no other place so good as this, and by February 1907 was reduced to a 'beastly lodging' at 55 Paulton's Square, owned by Madame Herminie Considerant, corset maker.

The only virtue of such a place was that it was near Alick. They saw a lot of each other that winter, and a lot of the mystery began to leak out of their relationship. Quite regularly their meetings ended rowdily: she is always striking him in the face with her 'formidable fist', he apologizing too late for being 'so damnably careless'. Sitting, she soon discovered, like almost everything else, bored her excessively. Yet he had to paint her. 'You have not come to-day – but, dear, come to-morrow – You know I am not stable – my moods follow, but they repeat themselves – alas – sometimes – I must paint you dear – to-day –

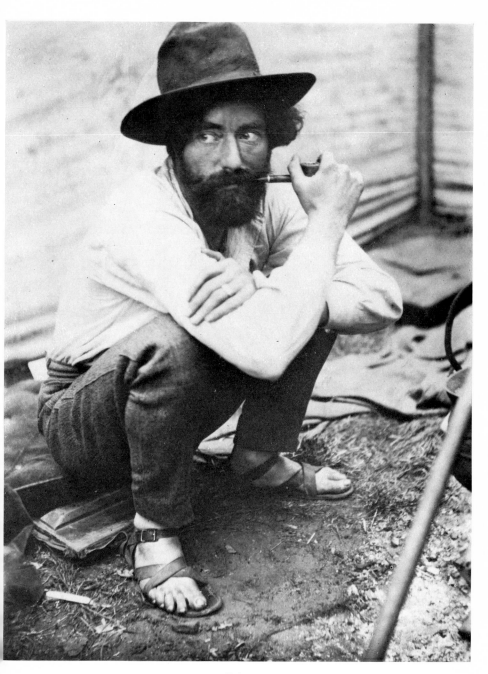

John

John Quinn
and
John Sampson

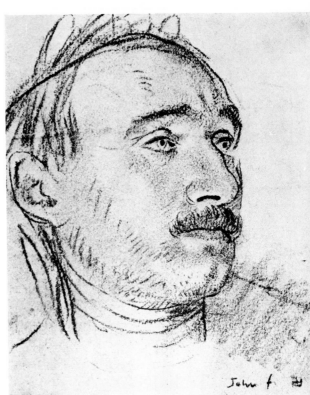

John J.

probably you don't quite like me – but do come to-morrow. Who knows? – You may find me less intolerable to-morrow . . . à demain, n'est-ce-pas bien chère, petite Ondine souriante. Soyons intimes – franches – connaissants – alors amants.' By the end of the year, feeling 'I want to wash myself in the Ocean', Augustus returned to Paris.

It was desperate work looking for studios, but in Paris he was luckier, finding a vast room off the Boulevard St-Germain, in an old hotel belonging to the famous Rohan family. 'I have taken a studio – with a noble address. Cour de Rohan [3], Rue du Jardinet,' he told Alick. By February the workmen were busy converting it – 'my studio commences to be magnificent' – and by March he had moved in – 'I will be about doing things in it soon'. But by March it was too late.

As soon as Augustus had returned to London, Dorelia made her move. Ida sub-let the studio at Rue Dareau, and the two women set off to find a *logement* for Dorelia. By the beginning of November they had found what she wanted at 48 Rue du Château. 'It has 2 rooms and a kitchen and an alcove – one of the rooms is a good size,' Ida informed Augustus (10 November 1906). 'It is in a lovely disreputable looking building – very light and airy, the view is a few lilac trees, some washing hanging up and a railway – very pleasant – and to our taste . . . The logement is 300frs (£12) a year. It is rather dear in comparison with ours, but we couldn't find anything better or cheaper, and there will be room to store all your things in it . . . Dodo and I had an amusing interview with the landlord and his wife of the logement last night at 9. We had to go down to his apartment near the Madeleine – a real French drawing-room with real French people – Very suspicious and anxious about their rent and Dodo's future behaviour – D. was mute and smiling. I did my best to reassure them that she was très sage and her man (they asked me at once if she was married or not and didn't mind a bit her not being) was "solvent". We said she was a model (she's going to sit again) and the wife wanted to know if the artists came to her or she went to the artists! The husband kept squashing the wife all the time though he had called her in for her opinion of us. He was small and concise and sensible, and she was big and sweet and stupid.'

French opinion being favourable, Dorelia moved in with Pyramus and Romilly almost at once. But Augustus was not pleased. It had all happened so fast and while he was away. He did not want Dorelia disappearing again to Belgium. After all, it was not impossible that he had exaggerated Alick Schepeler's importance to him. There was nothing exclusive about it. Besides, it was easy to overvalue the significance of what he called his 'physical limitations'. At Matching

Green when Ida had been suicidal over Dorelia, Augustus had explained his behaviour in a letter to the Rani – and in essence nothing had changed now that Dorelia was angry about Alick.

'One [i.e. Ida] must grow accustomed to the recurrence of these perhaps congenital weaknesses – which you must remember have not appeared with Dorelia's arrival only but date in my experience from the first moment of meeting Ida – which are indeed included in her system as a mark of mortality in one otherwise divinely rational. Don't please ever think of me as a playful eccentric who thinks it necessary to épater les bourgeois; things take place quite naturally and inevitably – one cannot however arrest the invisible hand – with all the best intentions – to attempt that is pure folly.'

But Dorelia was less tractable than Ida – she had entered the web less deeply. She saw no folly in his attempting to 'arrest the invisible hand'; she doubted his best intentions; she doubted even his motives in writing to her now. Augustus was quick to protest. 'My beloved Relia, I don't write to you without loving you or wanting to write. Believe this and don't suspect me of constant humbuggery. Who the Devil do you think I'm in love with? If you think I'm a mere liar, out goes the sun. I've been thinking strongly sometimes of clearing back over the Channel to get at you, you won't believe how strongly or how often.'

And it was true: she didn't. But at Christmas he arrived and there was a great party in the Rue Dareau. Gwen John turned up and Wyndham Lewis and Dorelia with her children. They ate 'dinde aux marrons', plum pudding and 'wonderful little cakes'; and they drank quantities of 'punch au kirsch'. For the six children, instead of a plodding white-bearded Father Christmas, they had 'le petit noël' who, though he descended the chimney, had 'a delicacy of his own entirely French'.[159] It was the last happy time they would spend together. 'The shops are *full* of dolls dolls dolls – it is so French and ridiculous and *painted*, and yet it doesn't lie heavy on the chest like English "good cheer",' Ida wrote to the Rani (December 1906). 'One can look at it through the window quite pleasantly instead of having to mix in or be a misanthrope as at home. Perhaps because one is foreign. It is delightful to be foreign – unless one is in the country of one's birth – when it becomes génant.'

The holiday was delightful, but it solved no problems, brought no reconciliations: it was simply a holiday. After it was over, Augustus returned to finish his portrait of Alick Schepeler; and Dorelia went back to her *logement*. Gradually she was growing more independent. Her sister Jessie came for a few weeks to help with the children; she began dressmaking; got a cat of her own from Gwen John; started to model

again. 'Dodo has just been to déjeuner, washed herself (1st time in 3 days) and gone off to sit at "Trinity Lodge",' Ida wrote to Augustus. 'I'm afraid she's forgotten to take her prayer book. She says for her last pose she didn't have to wash – it was such a comfort. But for Trinity Lodge the outside of the platter must be clean.' Soon Dorelia had established a routine of life very largely separate from Ida and Augustus. 'Dodo has only been once to déjeuner since she left,' Ida sadly observed. 'She is quite 20 minutes away. She poses in the afternoons and has a woman to mind the kids. Gwen gave her 100 francs for the black velvet coat she made. I think she is enjoying herself a bit in leaving the babies. Romilly is getting on.'

By March it seemed as if Dorelia had succeeded in achieving her independence.

'I am alone again – and alone – and alone.' From Augustus, with his permission, Ida was content to live apart – 'it is so easy to love at a distance,' she reminded him. And from a distance she still worshipped him. 'I say Mackay is 2nd rate,' she had written to the Rani. '. . . I have always known it, but the other day it flashed on me. So is Sampson. There is no harm in being 2nd rate any more than being a postman. It is just a creation . . . Augustus has not that quality – he is essentially 1st rate . . . As to a woman, I know only one first and that is Gwen John. You and I, dear, are puddings – with plums in perhaps – and good suet – but puddings. Well you perhaps are a butterfly or an ice cream – yes, that *is* more suitable – but we are scarcely human . . . This sounds tragic, but I have been living with exhausting emotions lately and am – queer – Yours in a garden Ida.'

Augustus was still first rate – she was disappointed only in herself, in what she thought of as her 'utterly 10th rate' self. In all aspects of her life, it now seemed to her, she had failed. She had failed as an artist – even as a musician; she had failed as a friend – she never saw her friends now; that she had failed with Augustus was obvious; and, what was more painful still, her relationship with Dorelia had failed – they were still friendly, but that first sweet intimacy had gone. And she had failed too – was in the very process of failing – as a mother.

If Augustus's world that winter was a huge mixed metaphor, for Ida it had become a mixed bowl of cough mixture, dill water, cod-liver oil, milk of magnesia. The eldest children were getting to an age when they demanded more attention but she had no more to give them. Their future seemed bleak with such a mother. David, she told Mrs Sampson, was 'such a queer twisted many-sided kid. Horrid an[d] lovely – plucky and cowardly – cruel and kind – thoughtful and stupid, many times a day. He needs a firm wise hand to guide him, instead of a bad tempered

lump like me.' She had begun to arrange their education, sending David and Caspar to the Ecole Maternelle of the Communal School – 'there are about 300 all under 6', she told Augustus, 'and they do nothing but shriek little ditties with their earless voices, and march about in double file'. But both boys were so unhappy she had to remove them: another failure.

She was imprisoned during the children's pleasure, for so long as the mind could tell, the eye could see. 'Life here is so curious – not interesting as you might imagine,' she wrote to the Rani. 'I crave for a time when the children are grown up and I can ride about on the tops of omnibuses as of yore in a luxury of vague observation. Never now do I have time for any luxury, and at times I feel a stubborn head on me – wooden – resentful – slowly being petrified. And another extraordinary thing that has happened to me is that my spirit – my lady, my light and help – has gone – not tragically – just in the order of things – and now I am not sure if I am making an entrance into the world – or an exit from it! . . . As a matter of plain fact I believe my raison d'être has ended, and I am no more the inspired one I was. It seems so strange to write all this quite calmly. Tell me what you can make of it when you have time. My life has been so mysterious. I long for someone to talk to. I can't write now – another strange symptom!'

It was a sickness of living from which she suffered – quite different from the suicidal troughs of Matching Green. Then there had been dreadful jealousy; now, though she often dreamed of Augustus and Alick Schepeler, they were absurd dreams, never tortured. 'Last night you were teaching her [Alick] french in the little dining-room here while I kept passing through to David who had toothache and putting stuff on his tooth.' It was as if she was too tired to feel anything positive now. On hearing that Augustus was coming over at Christmas, she had remarked to the Rani: 'Funny – I haven't been alone with him for 2½ years – wonder what it will be like – boring probably.'

In Ida's letters, especially to the Rani, there is a fatalistic flirting with the idea of death: 'Oh Rani – Are you in a state when the future seems hopeless? I suppose things are never hopeless really are they? There is always death isn't there?' There was nothing new, except death, under the sun. She lived in a kind of pale stupor, numb and pointless. 'The only way to be happy is to be ignorant and lie under the trees in the evening,' she had told the Rani. Never again could she recapture such green ignorance. Life was a limbo of impassiveness, all grey, where nothing could surprise her.

But she had not counted on Augustus. Now that he had finished his portrait of Alick, and now that Dorelia had coldly moved away, he suddenly proposed returning to live with Ida. What else was there for

him? Ida was dismayed. She knew of course that he was temporarily feeling dissatisfied with the present arrangement, but he would not 'regret it later on I swear'. Had he considered the implications? What about the children, for instance – 'Can you really want to see them again?' she asked him. 'You know they worry you to death.' But Augustus complained he had no home. He could find nowhere to live in London, and he could not work. Was his request really so extraordinary? After all, they loved each other still; they'd come through a lot together – why should they not settle down in London and be happy? Without a proper home he seemed quite lost. Besides, he had given her scheme a long trial. It did not sound unreasonable. 'It may be I should come back to London,' Ida reluctantly agreed. 'You must tell me. I will come – only we get on so much better apart. But I understand you need a home. Dis moi et j'y cours. As to the love old chap we all have our hearts full of love for someone at sometime or other and if it isn't this one it's the other one over there.'

Her real feeling at the prospect of returning to live with Augustus is explicitly stated in a letter she sent to the Rani: 'Gus seems to hanker after a home in London, and I feel duties beating little hammers about me, and probably shall find myself padding about London in another ½ year – Damn it all.'

What still tied her to Augustus, as she had explained at Ste Honorine des Perthes, was financial dependence. Throughout the autumn and winter she had saved exorbitantly. 'If I live long in France,' she remarked, 'I shall become a real terror for the pence.' Her mother often enclosed quite large sums to be put into savings for her. To Augustus she represented such thrift as an art, parodying his own: 'Am still trying to take care of the pence with great pleasure in the feeling of beauty it gives – like simplifying an already beautiful, but careless and clumsy, work of art.' But the real impetus behind this economic fury was her desire to shore up some possibility of independence against the future. Now this hope was suddenly crushed, not so much by Augustus's appeal that they should live together once more, but by her response to this appeal. The little hammers of duty were banging nails into the coffin of this last dream. For however much money she saved, duty would always scale the walls of her independence. She had complained in the past of her own selfishness, but she was not selfish enough. She hated the idea of returning to London, but was at once resigned to it.

In a letter to Alice Rothenstein, she wrote: 'It chills my marrow to think of living back in England.' The Rothensteins had become increasingly concerned about her life with, and without, Augustus; and wrote to inquire, complain, praise and comfort her.

'My only treasure is myself,' Ida insisted to Will, 'and that I give you,

as I give it to all men who need it, every time I really live . . . as to
Gussie, he is our great child artist: let him snap his jaws. What does he
matter? It is *you* who matters, and you dare not be frightened except
at your own self.

'I am glad to have your letter: it is such a comfort to hear a voice.
Life is a bit solemn and silent in the forest where I live, and the world
outside a bit grotesque and difficult. Certainly there are always the gay
ribbons you talk of but they are only sewn on and are there to break the
intolerable monotony, for which purpose, darling Will, they are *quite
inadequate* . . .'

Such gloomy letters greatly worried the Rothensteins, who blamed
Augustus for her depression. But Ida would not allow this. 'I must
write to say it is not so,' she firmly answered Will. The devil, she ex-
plained, was in herself – 'and as soon as you wound it, it heals up and
you have to keep on always trying to find its heart.' This devil had so
many names: first it was jealousy; then a vanity which masqueraded as
duty; finally sloth. Would she ever kill it? 'When one fights a devil
does one not fight it for the whole world? It is the most enchanting
creature, it is everywhere. God, it seems to spread itself out every
minute. Sometimes I do find its miserable fat heart and I give it a good
stab. But it is chained to me. I cannot run away.'

The three of them were in Paris during February: Augustus moving
into his new studio; Dorelia in her *logement*; Ida still at the Rue Dareau.
'Let's go up the Volga in the sun,' Augustus entreated Alick. But it was
no more than a gesture: he could not run away any more than Ida. He
would have liked to. Paris nauseated him. In letter after letter he
complains that 'I find the bourgeoisie here quite hateful'. As always
when depressed he petulantly externalized the cause: 'I am much
depressed to-day by the aspect of civilization – never was human society
so foully ugly, so abysmally ignoble,' he declares '– and I have also had
a cold which doesn't improve matters.' He revisited all the places
which had so delighted him less than a year ago – the Louvre, the
Luxembourg Gardens, the Panthéon ('to encourage myself with a view
of Puvis's decorations') – but everywhere was filled with ugly crowds
which 'brought my nausea to a climax'. The whole French nation
oppressed him like an allergy whose symptoms were incurable sadness
and cynicism. 'A good deed, I think, shines with great difficulty in a
naughty world,' he wrote to Alick. 'I went into the morgue and saw 4
dead men; they looked *awfully well* really – the only thing impressive I
found today . . . These four unknown dead men, all different, seemed
enlarged by death to monumental size, and lacking life seemed divested
only of its trivialities.'

To be reborn was what he longed for – not through death, but in the birth of Ida's fifth child. 'Oh for a girl!' she had written to him – but she confidently 'expected a boy. The contemplation of another baby, which could still excite Augustus, only caused her heartache. 'In 3 weeks – si on peut juger – a new face will be amongst us – a new pilgrim, God help it,' she wrote to the Rani. 'What right have we, knowing the difficulties of the way, to start any others along it? The baby seems so strong and large I am dreading its birth. How pleasant it *seems* that it would be to die.'

Wyndham Lewis – whom Augustus now accused of 'the worst taste', but whom Ida claimed 'I love' – had spent much of his time recently at the Rue Dareau. 'Mrs John and the bonne will have their babies about the same time I expect,' he wrote to his mother, '– I suppose beneath John's roof is the highest average of procreation in France.'

As it turned out neither of these babies – nor yet a third one that Wyndham Lewis had so far failed to spot – were born under Augustus's many roofs. After some hesitation Ida decided to have her child in hospital. 'It is much simpler and I don't pay anything,' she explained to Mrs Nettleship. 'I just go when it comes on without anything but what I'm wearing!'

Clara and Félice had by now both left,* and Ida engaged a new nanny called Delphine for the children. 'Gawd knows if she's the right sort,' she reported to Augustus, '– one can but try. She's fairly handsome 22 years old.' Under these circumstances Ida was obliged to ask Dorelia whether she would return to the Rue Dareau while she was in hospital; and Dorelia, in agreeing, walked back into the web.

'Augustus is well in his studio now and a beauty it is – and he has plenty of models just at present . . . Dorelia – and all the kids – to say nothing of me in spreading poses,' Ida wrote to the Rani late that February. Although the writing of letters made her feel 'pale green', she continued her correspondence right up to the time of her confinement. To lighten the black humour of some of these letters, she had told the Rothensteins: 'we shall come up again next spring you know'. And then, she promised, all their worries 'would melt away like the mist when the sun comes out'. But to the Rani, with whom she felt less need to dissemble, she confessed that it was not to the spring she was looking forward, but 'to the winter for some inexplicable reason'. She was

* 'Clara is enceinte and will have to leave end of January,' Ida had written to Augustus. 'It is so disappointing. She is such a good nurse. Félice is going to snort over needles and thread and be a dressmaker – I bravely gave her notice and had to bear a scene of tearful reproach – but within the week she found a genteel place as mender to a school . . . Poor old Clara is cheerful over her affair but she would much rather not have it, and says had she been in Paris when she found out she would have gone and had it destroyed.'

suffering from an 'egg-shape[d] pessimism' and, in her last letter to the Rani, she writes: 'I am dreadfully *off* babies just now . . . Awful nuisance considering in a fortnight or so the silent weight I now carry will be yelling its head off out in the cold.'

There was one further item of recurring news after Christmas that seemed to promise, for all their hectic efforts over the last months, that the entangled pattern of their lives would go on as before. Dorelia was again pregnant. 'Dorelia is decidedly enceinte,' Ida noted, '– it is depressing. Aurevoir.'

In the first week of March, Ida walked round to the room she had engaged at the Hôpital de la Maternité, ten minutes away in the Boulevard du Port Royal. Nothing, as she had written, could have been simpler. The baby was born in the early morning of 9 March: it was a boy.

The complications began immediately afterwards. Mrs Nettleship, who had gone over to Paris partly for business and partly to see Ida, explained to Ethel and Ursula what had happened:

'My dears, Ida is to have a slight operation. It is serious but not very dangerous. In 48 hrs she will be quite out of danger. It will be to-night – I can't come home for a few days . . . They think a little abscess has formed somewhere and causes the pain and the fever. She has to go to a Maison de Santé and one of the best men in Paris will do it. I am glad I was here as I could help . . . I have been running about all day after doctors and people.'

Augustus seemed paralysed by these events. The waiting, the suspense, above all the stupefying sense of powerlessness unmanned him. It was a nightmare, and he like someone half-asleep within its circumference. 'Apart from my natural anxieties,' he wrote,[160] 'I was oppressed by the futility of my visits, by my impotence, and insignificance.' Every decision was taken by Mrs Nettleship from her headquarters at the Hotel Regina. It was she who selected a specialist and arranged to pay him sixty pounds – 'I would have paid him £600 if he had asked it'; it was she who organized Ida's move to the new hospital and paid sixteen shillings a day for her room there (each sum scrupulously noted); it was she who wrote each day to family and friends keeping them informed of the latest developments. She was particularly reassured that the specialist, besides being 'the best man in Paris', was well-connected and had attended several diplomats at the embassy. When not busy at the hospital she would inspect the children at the Rue Dareau, interview Delphine and Dorelia, replant the entire garden there, and conduct David to his new school. 'He talks about "the boys in my school" just like an Eton boy might,' she noted with approval.

Between times she managed to keep her business affairs going, sending off satisfactory messages to various titled clients. Her energy was prodigious, and in complete contrast to Augustus's stupor. 'Gus looks quite done up,' she confided to Ursula. 'He has the grippe and he is terribly upset about Ida. He does everything I suggest about Doctors and things, but has not much initiative – he has no experience.'

The Maison de Santé to which Ida had been removed was a light, airy and spacious building in the Boulevard Arago. Somehow the atmosphere here engendered more hope. 'The place is the very best in Paris,' Mrs Nettleship reported. ' . . . The nuns who nurse her are the most experienced and so quiet and pleasant. If it is possible for her to recover she will do it here.'

The crisis, which so galvanized Mrs Nettleship and demoralized Augustus, was observed by them at each stage differently. Where she is hopeful, he is pessimistic. 'Ida has got over her operation better than we expected,' she writes to her daughters, while Augustus the same day tells John Sampson that Ida 'is most seriously ill after an operation'. While Mrs Nettleship busied herself with complicated plans for Ida's convalesence, Augustus would scribble out wan messages to the Rani: 'She is a little worse to-day.'

But on one subject they were agreed: the baby. Augustus indeed was the more enthusiastic: 'The new baby is most flourishing so far. I really admire him,' he told Mrs Sampson. ' . . . He has a distinct profile. We called him Henry as it was the wish of Mother Nettleship to memorialize thus her great friendship with Irving.' But on Dorelia and on Mrs Nettleship Henry imposed an additional strain. 'He sleeps all day and cries all night,' Mrs Nettleship wrote to Ursula. 'Someone has to be awake with him every night.' He was, she added, 'a great beauty'; but 'I hope he will turn out worth all this trouble and anxiety.' This pious hope was to echo down his life, like a curse.

Ida was suffering not from 'a little abscess' but puerperal fever and peritonitis. 'It all depends on her not giving way,' Mrs Nettleship explained. 'She is no worse to-night than she was this morning and every hour counts to the good – but she might suddenly get worse any minute.' The main hope of her pulling through lay with what Mrs Nettleship called her 'natural vitality', but this had been worn away through the years to a degree that her mother could not appreciate, and it was Augustus who saw what was happening more clearly. To Mrs Nettleship her daughter's recovery was, once the doctors had done their best, a matter of character, of plain determination. It did not occur to her that Ida might not want to live, that she could consent to die.

She was in pain and fever for much of the time. Except while under

the anaesthetic, she did not sleep at all, night or day, following Henry's birth. Mrs Nettleship insisted that a whirl of cheerfulness be kept revolving round her beside, almost a party spirit, so that she should not realize the full gravity of her illness. But Augustus had little heart for such a charade. 'I do everything that is possible,' Mrs Nettleship assured Ursula. 'She is very unreasonable as usual and wants all sorts of things that are not good for her. I have to keep away a good deal as she always begs me to give her something she must not have and I can't be always refusing.' Augustus could refuse her nothing. She made him ransack Paris for a particular beef lozenge; she demanded violets; asked for a bottle of peppermint, a flask of eau de mélisse: he got them all. She seemed to understand that any definite activity, however improbable, came as a relief to him, and when she could invent nothing else for him to be doing she made him go and have a bath. To Mrs Nettleship it sometimes seemed as if he were acting quite irresponsibly, but she made no move to stop him. Perhaps Ida sensed some friction between them. 'Either you're all mad or I am,' she told them.

But on the morning of 13 March she demanded something that even Augustus could not act upon. Sitting up in bed, she declared her determination to leave the hospital and return to Dorelia in the Rue du Château. Here she was going to cure herself, she said, 'with a bottle of tonic wine, Condy's, and an enema'. Augustus, in a panic, 'got the doctor up in his motor car' and at last he managed to dissuade her. But this was a bad day for Ida, and having relinquished the hope of joining Dorelia, her spirit seemed to give up the struggle.

'I adore stormy weather,' she had once written to the Rani. On the night of 13 March there was a violent storm, with thunder and lightning, lasting till the early morning. Lying in her hospital bed, Ida longed to be out in it, imagined at certain moments she was. 'She wanted to be a bit of the wind,' Augustus wrote to the Rani. 'She saw a star out of the window, and she said "advertissement of humility". As I seemed puzzled she said after a bit "Joke".'

The hospital staff tried to remove him, but Augustus stayed with her the whole of that night. At times she was very feverish, 'her spirit making preparatory flights into delectable regions',[161] but there were periods of contact between them. He rubbed her neck with Elliman's Embrocation and, at her special request, tickled her feet. She pulled his beard about. To the sisters she remarked: 'C'est drôle, mais je vais perdre mon sommeil encore une nuit, voyez-vous.' In a delirium she spoke of a land of miraculous caves, then, with some impatience, demanded that Augustus hand over his new suit to Henry Lamb. Despite the fever, her pain had vanished and she felt strangely euphoric. 'How can I speak of her glittering smiles and moving hands?' Augustus

wrote afterwards to the Rani. And to Mrs Sampson he wrote of that
night: 'Ida felt lovely – she was so gay and spiritual. She had such
charming visions and made such amazing jokes.'

In the morning, after the storm was over, she roused herself and
gave Augustus a toast: 'Here's to Love!' And they both drank to it in
Vichy water. It was a fitting salute to a life that had steered such a brave
ambiguous course between irony and romance. Mrs Nettleship arrived
shortly afterwards with Ethel her daughter, just come from England.
'We are just waiting for the end,' Ethel wrote to her sister Ursula. 'Ida
is not really conscious, but she talks in snatches – quite disconnected
sentences. Mother just sits by her side – and Gus stands the other side
and sometimes holds her hand – she has some violets on her bed. I am
just going to take the children for a walk – they are not going to see her
as they would not understand, and she cannot recognize them.'

She died, without regaining consciousness, at half-past three that
afternoon. 'Ah well, she has gone very far away now, I think,' Augustus
wrote to Mrs Sampson. 'She has rejoined that spiritual lover who was
my most serious rival in the old days. Or perhaps she is having a good
rest before resuming her activities.'

The relief was extraordinary. As he rushed out of the hospital on to the
Boulevard Arago, Augustus was seized with uncontrollable elation. 'I
could have embraced any passer-by,' he confessed.[162] He had had enough
of despair. It was a beautiful spring day, the sun was shining, the Seine
looking 'unbelievable – fantastic – like a Chinese painting'.[163] He
wanted to divest himself of the immediate past, escape the domination
of death; he wanted to paint, but first to get drunk. 'Strange after
leaving her poor body dead and beaten I had nothing but a kind of
bank holiday feeling and had to hold myself in,' he told the Rani.

Many of his friends were mystified, shocked. 'John has been drunk
for the last three days, so I can't tell you if he's glad or sorry,' Wyndham
Lewis reported to his mother.[164] 'I think he's sorry, though.' Not
everyone was so charitable as this. They blamed Ida's death on Augus-
tus, hinted at suicide, and attributed his 'Roman programme' to
justifiable guilt. Guilt there must often be with death – guilt and ag-
gression. Augustus's drinking was a desperate bid for the sort of
optimism he needed to keep him from the descent into paralysing
melancholia. When John Fothergill wrote to express sympathy, adding
that one had only to scratch life and underneath there was sorrow,
Augustus at once replied: 'Just one correction – It is *Beauty* that is
underneath – *not* misery, which is only circumstantial.' This he *had* to
believe; it was his lifebelt. What particularly confused and agonized
him about Ida's death, in addition to his natural grief, was that it had

come through childbirth, and that his children had been deprived of a mother just as he had been. It seemed he was no better than his father. He tried to keep the tide of melancholia from advancing. But as the days passed the spirit of elation was more difficult to sustain, and he drank more.

Ida was cremated on the Saturday following her death at the crematorium of Père Lachaise. Almost no one was there – certainly not Augustus. A number of people had written from England offering to come, but Augustus, who disliked formal exhibitions of sentiment, refused them all. What was the use? Friends, with their long faces, irritated him at a time when it was crucial he did not succumb to depression. 'People keep sending me silly sentimental lamentations,' he complained to the Rani. 'I really begin to long to outrage everybody.' By far the worst offender was poor Will Rothenstein who 'never forgave'[165] himself for not having gone out to Paris, and in meticulous expiation wrote long letters which Augustus found 'unintelligible'.[166] To the Rani he confided: 'That Will Rothenstein is an unhappy mortal – he's given to Uriah Heep-like manifestations. He implored me not to give way to remorse which was very Biblical of him, I'm sure.'

One man defied Augustus's instructions and, much to his surprise, arrived in Paris on the morning of the cremation. This was Ambrose McEvoy who 'had the delicacy to keep drunk all the time and was perfectly charming'.[167] He had come for the day, intending to go back to London the same night, but got so drunk he was incapable of going anywhere for a week. 'He will lose his return ticket if he doesn't pull himself up within a day or so,' Wyndham Lewis predicted.[168]

Henry Lamb, who was now living in Paris and who had taken Ida to a music hall the night before she entered hospital, also attended the cremation. When the coffin and the body were consumed, and the skeleton drawn out on a slab through the open doors of the furnace, Lamb and McEvoy were still able to recognize the strong bone structure of the girl they had known. An attendant tapped the slab with a crowbar, and the skeleton crumbled into ashes. The ashes were then placed in a box and taken back to Augustus. Later a memorial service was held in Lamb's rooms.[169]

One of the few people who understood Augustus's feelings after Ida's death, partly because she shared some of the same manic-depressive tendencies, was Gwen John. For a short time she came to look after him at his new studio in the Cour de Rohan. 'She was one of those who *knew* Ida,' Augustus explained to Mrs Sampson; one who understood that 'Ida was the most utterly truthful soul in the world.'

It had been to Gwen that Ida had once admitted: 'Our marriage was, on the whole, not a success.'[170]

Buffeted by Fate

God knows, I am buffeted mightily by fate.
 Augustus John to Alice Rothenstein

1. THE BATTLE OF THE BABIES

Ida was dead: but in many ways her influence was still alive. 'Ida keeps teaching me things,' Augustus told Alice Rothenstein. It seemed to him that she was teaching him at last who he was, solving the everlasting problem of his identity. 'I don't know that I feel really *wiser* through my sorrows, perhaps, yes: but at any rate I feel more "knowing" – I also feel curiously more myself,' he wrote to Alick Schepeler. ' . . . I also feel still greater admiration for my view of things as an artist and at the same time my modesty is redoubled.'

His artistic aims had not altered, but he saw them more clearly and was to pursue them with more determination. 'I still feel extremely confident that given the right woman in the right corner I shall acquit myself honourably,' he had written to Will Rothenstein. 'This implies conditions which one must certainly seek for oneself – which do not follow one about like a nimbus above all solitude – optional, if you will, but freedom!

'I went to see Puvis's drawings in Paris. He seems to be the finest modern – while I admire immensely Rodin's later drawings – full of Greek lightness. Longings devour me to decorate a vast space with nudes and – and trees and waters. I am getting clearer about colour tho' still very ignorant, with a little more knowledge I shall at least begin . . .

'O for crystal purity and definition! O for divinely deliberate, smilingly contemplative creation! O for knowledge enough to be gay! O for final deliverance of all filthy compromises, humbugging turpitudes, contemporary cob-webs.'

Ida's death acted upon him as a catalyst, and very many of his finest paintings were done in the following eight years. 'It is so difficult to realise that Ida has gone so far away,' he told Mrs Nettleship. ' . . . If she could only just come and sit for me sometimes. I've never painted her – I thought I had so much time, and began by getting at sidelights of her only, counting on doing the real thing in the end – she was such a big subject.'

It was this sense of time lost that accelerated his urge to paint, to seize every opportunity of doing so, to simplify life in order to do so. But there was a difficulty. Robbed of Ida's 'economical fury', with seven

children to support, almost as many studios and perhaps Dorelia (at least while she was pregnant), how was he to start? His predicament was complicated by a new belief in his children. While Ida was alive, he had tended to look at them as deafening interruptions to his work. But because of what he had lost, and perhaps too because they were older, he began to see them as the very subject-matter of his work. He could imagine Ida's voice mocking him: 'Now you've got them, and can't get rid of them, run them for what they're worth.' The trouble was they were not worth anything – not financially. In order to paint them he must have them around him; but to have them around him he needed money; and to get money he would have to paint commissioned portraits which were in any case a very hit-or-miss business. However this conundrum was to be worked out, he did recognize in what direction his painting must advance. 'I must tell you how happy thoughts fill me just now,' he confided to Alice Rothenstein. 'I begin to see how it is all going to come about – all the children and mothers and me. In my former impatience and unwisdom I *used* to think of them sometimes as accidental or perhaps a little in the way of my art, what a mistake – now it dawns on me they are, must be the real material and soul of it.'

But if he had 'knowledge enough to be gay', never it appeared was he in greater need of 'final deliverance' from 'filthy compromises, humbugging turpitudes, contemporary cob-webs'.

The sort of gossip from which Ida had partly shielded him now reached him with lapidary intensity. He heard it everywhere – ill-informed, sentimental, full of malicious well-meaning.

Lady M. F. Prothero to Alice Rothenstein:

'I have been so much grieved to hear of Ida John's death. It sounds terribly sad, – and all those babies left behind! I hear that Mrs Nettleship was with Ida, so I feel she must have had care in her illness. But I wonder if she had been worn out lately in one way or another. The thought of her quite haunts me, – and her heroic conduct all through – I should so much have liked to hear something about her from you, and what is likely to become of those infants. – I suppose John is quite irresponsible and it will fall to Mrs Nettleship to mother them. She, poor soul, has already had a hard struggle, and this responsibility is a heavy one for her to bear . . .'

It was nevertheless a responsibility Mrs Nettleship had resolved to shoulder. The fight between her and Augustus opened up the very moment Ida had died. On the following day (15 March 1907) she reported the outcome to her daughter Ursula:

'Gus is quite willing for me to take them [the children] for the present but we have not made any plans for the future. I think he wants to get

away to the country. I want to get a Swiss nurse for the children . . . They are very pleased to be coming with us.'

Three days later she returned to Wigmore Street, carrying off the three eldest children. She was warm with plans for them – what they should precisely wear, what eat. The two babies, Edwin and Henry, she left in Paris, on the misunderstanding that they were to be looked after not by Dorelia but Delphine, who 'is a very good nurse'.

Augustus had not been 'quite willing' for his mother-in-law to take the children even on this temporary basis. He just had no alternative. 'I am nearly bankrupt at the moment,' he confessed to Will Rothenstein. It was out of the question to saddle Dorelia with more squatters just as her own, Pyramus and Romilly, were 'beginning to get wise'; and so he was grudgingly forced to concede this first round in the child contest. 'Mrs Nettleship and Ethel N. took David and Caspar and Robin back to London,' he announced to Mrs Sampson, '– leaving us the incapables.'

He was determined to 'get them away again'.[171] To the Rani he confided: 'I have tried to make it clear that I shall kidnap them some day.' His plans were legion. All worked on the principle of an unofficial adoption. His friends, none of whom lived so bourgeois an existence as his mother-in-law, could each take a kid or two and Augustus would then rent some small studio or flat in their houses throughout the country. It was not ideal, perhaps; but as a temporary solution it was, he flattered himself, pretty good. 'It is a pity to scatter them so,' he agreed with his outraged mother-in-law, '– one will know what to do a little later.'

At first this notion was greeted with acclaim. 'Everybody is asking for a baby and really there aren't enough,' he calculated, '– but I should like Mrs Chowne to have a little one *if I can find one.* . . . I wonder if Mrs Chowne can make Allenbury's and whether she understands the gravity of dill-water.'

The Chownes chiefly recommended themselves as prospective foster parents – probably for Henry – because she was good-looking and he, besides being 'a nice chap', had 'painted some charming flower pieces'.[172] They had no children, lived in Liverpool where Augustus would enjoy occupying a studio, and had known (if only slightly) Ida. It was a perfect pilot scheme for the whole exercise of adoption. But it failed, and for the most inconsequential of reasons. Both the Chownes welcomed the idea – *but never at the same time.* As an example of political diplomacy it was expert. 'I should hate to disappoint Mrs Chowne,' Augustus admitted to the Rani who was acting as a sort of broker in the arrangements. Goodwill, like an unending stream, flowed between them without interruption or consequence: but afterwards there was no more talk of adoption.

The other practical matter that engulfed Augustus over the six months following Ida's death was the future of the Chelsea Art School. The business negotiations had been prolonged and for the most part unintelligible to all parties. This had been due to Knewstub's business methods, which involved muddling the money from the school with that of the gallery in such a way that at both places his cheques were invariably returned to him. 'It is a great pity that Knewstub is such a tactless idiot,' Augustus had acknowledged to Trevor Haddon (4 February 1907). But he still aimed at using the school as a makeweight in the complicated balance between art and finance. He wanted from it the maximum dividend of money for the minimum investment of time. He proposed giving it the use, for advertisement purposes, of his name and, if it provided him with a studio, he guaranteed to be on the spot – from time to time. As his understudy, elevated with the name of Principal, he recommended Will Rothenstein, whose support was crucial. The goodwill of the school had apparently been purchased for two hundred pounds by Mrs Flower, who intended removing it to Hampstead Heath and paying Augustus one guinea for each of his appearances there – provided his understudy turned up when he did not. The trouble was that Will would ask such damned pedagogic questions: What was the exact constitution of the school? Could he have more details of his personal status there? Was it 'honourable', of the first rank, and established on a proper footing? Augustus would meet such inquiries at a more personal level: Mrs Flower was 'a very nice woman – rather remarkable. I think one of those naked souls, full of faith and fortitude'; she therefore merited Will's collaboration. 'Knowing her pretty well,' Augustus added, 'I have not thought it necessary to treat her too formally – she would be perfectly ready to fall in with any views you or I held . . . The worst of being friendly with a person – one's practical sense suffers . . . Mrs Flower, I think, is a good girl – without being half weighty enough; she would give no trouble and understand she takes financial responsibility.' This responsibility embraced a fine new studio 'she will erect for me, which will be an immense boon'; plus another, in a neighbouring pine grove, where select young ladies could pursue their studies under his tuition. Here too he would invite his friends, Lamb, Epstein, even Lewis 'to roost among my trees'. Mrs Flower, he concluded, 'should consider herself lucky'.

Yet it was not to be. 'The school we might make of it is too good to let slip too hastily,' he urged Will Rothenstein (28 July 1907) as it began to fade. But truthfully he was not interested in teaching; only painting. It was a School in Spain, and as such floated gracefully out of their lives and was lost to view.

Without money from the school he had to rely more than ever on 'the

asphyxiating atmosphere of the New English Art Club . . . Its corrupt-ing amenities – its traitorous esprit de corps – its mediocre excellen-cies even – !' he complained. 'I always want to slough my skin after the bi-annual celebrations and go into the wilderness to bewail my virginity for another reason than that which prompted Jepthah's daughter.'

Over these next years there would seldom be a time when his work was not being exhibited in London: at the Carfax and the Chenil, the Goupil and Society of Twelve shows, at groups, academies, clubs. Any new movement or gathering – the Camden Town, the Allied Artists – any mixed show of modern work automatically invited him, however foreign its aesthetic programme might be. He was untouched by these movements and counter-movements – their interest for him was, like art-teaching, financial. But he was not hostile to them and they wel-comed his co-operation. Fry and Tonks, Rothenstein and Rutter – these and other painter-critic-politicians wooed him. He bowed to their solicitations to exhibit, to sit on hanging committees, to become presi-dent of societies: but he was above art-politics, or at least to one side of them. They were a means to an end when other means failed. 'I am longing to borrow money so as to work till my show* comes, un-disturbed by Clubs and Societies,' he hinted to Will Rothenstein (22 June 1907). It was the uncertainty of his life that forced him to rely so much on these institutions:

'Pendulous Fate sounds many a varied note on my poor tympanum – my darkness and lights succeed one another with almost as much regu-larity as if the sun and the Planetary system controlled them; and the hours of *moonless* nights are long dismal unhallowed hours. My life is completely unsettled; I mean to say the circumstances of my existence are problematic; but my art, I believe I can say, does not cease to develop . . . I shall set about a composition soon – with a motive of action in it, controlling all – as in a Greek play.'[173]

If the means were more than ever complicated, the ends were simpler. Art historians sometimes write of painters who fail to be swept up by the newest movements of their day as having lacked 'courage'. This was not true of Augustus: he was an authentic throw-back. Nothing could have been easier for him, with his dexterity, than to copy with trivial variations the post-impressionists in Paris. But to have done so would have involved a real loss of integrity. He was not blind to their merits. 'I want to start something fresh and new,' he told Will Rothenstein (April 1907). 'I feel inclined to paint a nude in cadmium and indigo and

* 'Drawings by Augustus E. John' at the Carfax Gallery, December 1907. 'Knewstub's peculiarities have ended by tiring me out,' he had written to Trevor Hadden (11 February 1907), 'and I have arranged for my next show to be else-where.'

orange. The "Indépendants" is effroyable – and yet one feels sometimes these chaps have blundered on something alive without being able to master it.'

From the way in which he writes of pictures he wants to paint, of subjects that excite him, there seems little to connect him with his near-contemporaries in France or England – Gauguin alone would seem to be within hailing distance.

'I should like to work for a few years entirely "out of my head", perhaps for ever. To paint women till their faces become enlarged to an idiotic inanimity – till they stand impassively, unquestionably, terrifyingly fecund – fetiches of brass with Polynesian eyes and dry imperative teeth and fitful craving bowels that surge and smoke for sacrifice – of flesh and flowers. How delightful that sounds! Can you* imagine the viridian vistas, can you hear the chanting in the flushing palm tree groves and the thumping of the great flat feet of ecstatic multitudes shining with the sacred oil. The "Ah Ah Ah" of the wild infant world?'

Primitive inspiration was not to be found in Paris. Parisian women were what Delacroix once described as 'on stage'.[174] There are those who say that, by leaving Paris, Augustus turned his back on everything exciting that was happening in modern painting; that had he stayed he would have painted good pictures as did Derain, who had something of the same panache. But his instinct was sure. He wanted to find a place, untouched by the twentieth century, where the inhabitants still lived the life of their ancestors. His instinct was sure – but his thinking was weak : he did not plan to live in such a place, but to spend a holiday there.

He set off in April, patrolling the north coast – 'I have been right across the top of France,' he reported to Will Rothenstein. Finally he came across what he was looking for: Equihen, a village of primitive fisher-folk not far from Boulogne. 'The fish women are simply magnificent,' he wrote to Dorelia. 'I must get a studio or shed here soon and paint 'em – there's money in it!' It was good to get away from the 'steam music, literary society, bugs and other embêtements' of Paris. At Equihen one could see the marins getting the fish out of the sea and the matelots selling them – 'and the women go about in wonderful groups. Just the stuff for me. They resemble a community that live on the river by Haverfordwest distinct from their neighbours – in a village called Langum. The women go all over Pembrokeshire selling oysters in a peculiar costume and the men are supposed to mind the babies. When I think of them I burn to go and see them. It seems to me more wonderful than Spain and Italy, this little colony whom nobody knows anything about . . .'

In this 'desolate little place'[175] he found a studio and summoned

* i.e. Will Rothenstein.

Dorelia and the four babies Pyramus and Romilly, Edwin and Henry.
Since there were 'nice soft sand dunes' for the children to crawl on, he
proposed, after they had settled in, sending for Ida's other sons. 'I am
working pretty hard,' he assured Will Rothenstein, 'now and then.
Having a little studio here is a boon. I like the wenches here and the
clothes they wear and I wish I had more money to spend on them . . .
Pyramus grows more lyrically beautiful every day. He is like a little
divine phrase from Shelley or Wordsworth. He is more flower-like and
"meaningless" than any child I know. He is the incarnation of the daisy.
I think I must try to do a "Mother and Child" of him and Dorelia.'

But there were obstacles. The Mother was now trying to bring about
a miscarriage and for much of the time feeling too ill to sit to Augustus.
Once more he experienced 'those submarine days when one begins to
wonder what manner of beings live above the air'.[176] The frustration
that had consumed him at Ste Honorine began again to smoulder.
'Meet me at Boulogne next Saturday will you?' he suddenly invited
Alick Schepeler. But she, unchanged, absconded to Cumberland. 'As to
my work, I haven't got at it really,' he admitted to Henry Lamb (13 June
1907). 'But my "head" still yields enchanting suggestions. In fact call it
what you will it is my best friend, tho' I have other loyal parts. Some-
times I feel myself as if slowly and surely settling down on some scrap
heap.'

At this critical moment when, set in his viridian paradise, inspiration
failed to ignite, an invitation arrived from Lady Gregory. She asked him
to come over to Ireland, to stay with her at Coole, and to do a portrait
of her other guest that summer, W. B. Yeats. Augustus hesitated – then
accepted. 'It may be that I shall draw Yeats' portrait,' he wrote to Alick
Schepeler, '– I am so hard up.'

2. IMAGES OF YEATS

The invitation to Coole Park had emanated from Lady Gregory's son,
the artist Robert Gregory, at whose marriage Augustus was invited to
be best man. He had helped Gregory with his work in London, and this
invitation was in the nature of a repayment for his kindness. Appro-
priately, it was a business proposition. Yeats was then revising his
collected works in preparation for A. H. Bullen's edition of the follow-
ing year. The edition was to contain a portrait by some contemporary
artist. Yeats had wanted Charles Shannon to do an etching for the
frontispiece, but 'Shannon was busy when I was in London,' he ex-
plained to John Quinn (4 October 1907), 'and the collected edition was
being pushed on so quickly that I found I couldn't wait for him.' It was
then that Robert Gregory had put forward Augustus's name, to which

Yeats rather nervously agreed: 'I don't know what John will make of me,' he faltered.

Augustus, too, was nervous – financially, 'I should like very much to visit you – and perhaps Yeats' drawing would make it possible,' he wrote from Equihen to Robert Gregory, 'but just now it is difficult for me. How much will the publishers pay, do you think? I would be glad to do the drawing. But as you see I am a long way off. . . .' In reply, Lady Gregory sent him a fee of eighteen pounds in advance, plus a suggestion that should he wish to draw some of the family, then they might well wish to buy some of his drawings. The deal thus tentatively struck, Augustus sailed for Galway and the beginning of an illuminating new chapter in his career.

He arrived at Lady Gregory's big plain house in September. He had met Yeats before at the Nettleships' and at the Rothensteins', but never studied him as a subject. 'Yeats, slightly bowed and with his air of abstraction, walked in the garden every morning with Augusta Gregory, discussing literary matters,' he later remembered.[177] 'With his lank forelock falling over his russet brow, his myopic eyes and hieratic gestures, he was every inch a twilight poet.' It is as this not altogether youthful embodiment of Celtic poetry that Augustus portrays Yeats. The flat, dense colour areas of the oil portrait* suggest some comparison with Gauguin; and the design and colour are strong. Yeats, dressed in a white shirt and black smock, wears a loose cravat tied in a bow at the neck. The flesh-tones are wonderfully pale – a whitish-yellow; and this poetically consumptive complexion is enhanced by a backcloth of green meridian that isolates and freezes the poet by its density and airlessness. It is every inch a romantic portrait: this is what inspired Augustus; this is what he did best. For a moment Yeats fulfilled Augustus's ideal of a poet, and this ideal, in an unpassing moment, has been beautifully caught. Apart from the oil portrait, Augustus did numerous other studies† from which to work up his etching. But this final etching seems rather spoilt by the slowness of the medium. It has a pudding quality, the facial muscles solidified by laboured cross-hatching with the needle into india rubber.

'I felt rather a martyr going to him [Augustus],' Yeats had reported to Quinn (4 October 1907). 'The students consider him the greatest living draughtsman, the only modern who draws like an old master. But he makes everybody perfectly hideous, beautiful according to his own

* Now in the Manchester City Art Gallery. An unfinished study, one of several, is in the Tate Gallery (5298).

† One of these, in pencil and wash on tinted paper, is at the National Portrait Gallery, London. It has what appear to be spots of Beaujolais on it. Yeats is wearing a macintosh.

standard. He exaggerates every little hill and hollow of the face till one looks a gipsy, grown old in wickedness and hardship. If one looked like any of his pictures the country women would take clean clothes off the hedges when one passed as they do at the sight of a tinker.'

Having glimpsed his studies with pen and brush, Yeats was certain at this stage that Augustus's 'best work is etching, he is certainly a great etcher with a savage imagination'. Shortly afterwards, to his horror, the etching arrived. It made him, he complained to Quinn, 'a sheer tinker, drunken, unpleasant and disreputable, but full of wisdom, a melancholy English Bohemian, capable of anything, except living joyously on the surface'.

Part of the trouble lay with Lady Gregory's reaction. 'John has done a terrible etching of Yeats,' she had written to Quinn (22 December 1907). 'It won't do for the book but he may do another, he promised to do two or three. Meanwhile I am trying to get Shannon to draw him. It is rather heartbreaking about John's for he did so many studies of him here, and took so much of his time. . . . But if they are not like Yeats, and are like a tinker in the dock, or a charwoman at a prayer meeting they and the plate shall go into the fire.'

About her reaction Augustus seems to have remained philosophical – at any rate his confidence was unshaken. 'Lady Gregory, much as I love and admire her, has her eye still clouded a little by the visual enthusiasms of her youth and cannot be expected to *see* the merits of my point of view,' he explained to Alick Schepeler, 'tho' her intelligence assures her of their existence. Painting Yeats is becoming quite a habit. He has a natural and sentimental prejudice in favour of the W. B. Yeats he and other people have been accustomed to see and imagine for so many years. He is now 44 and a robust, virile and humorous personality (while still the poet of course). I cannot see in him any definite resemblance to the youthful Shelley in a lace collar. To my mind he is far most interesting as he is, as maturity is more interesting than immaturity. But my unprejudiced vision must seem brutal and unsympathetic to those in whom direct vision is supplanted by a vague and sentimental memory. It is difficult also to assure people that my point of view is not that of a particularly ill-natured camera – but on the contrary that of a pro-foundly sympathetic and clairvoyant intelligence. Another thing is I never paint without admiring.'

It was almost impossible for any artist to see Yeats as Lady Gregory saw him. If Augustus had portrayed him in her eyes as an ugly ruffian, Shannon, by an unlucky chance, made him look damnably like Keats; Jack Yeats, of course, could only see him through a mist of domestic emotion; Mancini turned him into an Italian bandit; Sargent into a dream-creature. And so on. Yeats flirted with the idea of introducing the

lot of them into his collected works, one after the other, 'and I shall write an essay on them and describe them as all the different personages that I have dreamt of being but never had the time for. I shall head it with this quotation from the conversation of Wordsworth: – 'No, that is not Mr Wordsworth, the poet, that is Mr Wordsworth, the Chancellor of the Exchequer''.

Such flights of fancy were firmly censored by Lady Gregory, and in Bullen's edition a Sargent drawing took the place of Augustus's etching. But in subsequent editions it is almost always one or other of Augustus's portraits that have been chosen as the frontispiece.* Yeats himself had never really been so opposed to Augustus's interpretation of him as Lady Gregory. On leaving Ireland, he wrote to John Quinn (7 January 1908): 'I would like to show you Augustus John's portrait of me. A beautiful etching, and I understand what he means in it, and admire the meaning, but it is useless for my social purpose.' It took time before he appreciated the portrait. Years later he wrote: 'Always particular about my clothes, never dissipated, never unshaven except during illness, I saw myself there an unshaven, drunken bar-tender. And then I began to feel John had found something that he liked in me, something closer than character, and by that very transformation made it visible. He found Anglo-Irish solitude, a solitude I have made for myself, an outlawed solitude.'

Though fearing his 'savage imagination', Yeats was greatly taken with Augustus. His attitude, like Augustus's towards him, mingled romance with an amusing perception of character.

'He is himself a delight,' Yeats wrote to John Quinn (4 October 1907), 'the most innocent, wicked man I have ever met. He wears earrings, his hair down to his shoulders, a green velvet collar and had two wives who lived together in perfect harmony and nursed each other's children on their knees till about six months ago when one of them bolted and the other died. Since then he has followed the lady who bolted and he and she are gathering the scattered families. Of course, nobody round Coole knew anything of these facts. I lived in daily terror of some benevolent gossip carrying on conversation with him like this,

' "Married, Mr John? Children?"

* 'The portrait was painted in 1907 at Coole by Augustus John,' Yeats wrote to Olivia Shakespeare on 13 November 1933, the year after Lady Gregory died. 'I am using it as a frontispiece for my collected volume of lyrics which you will get in a day or two.' When the etching was rejected, Yeats had written privately to his publisher A. H. Bullen (March 1908): 'The Augustus John is a wonderful etching but fanciful as a portrait. But remember that all fine artistic work is received with an outcry, with hatred even. Suspect all work that is not.'

' "Yes." "How many?" "Seven." "You married young?"

' "Five years ago." "Twins doubtless?" – after that frank horrifying discourse on the part of Augustus John, who considers himself a particularly good well-behaved man. The only difference is in code. He told me how he tried to reform an old reprobate professor [John Sampson] who is an authority on gipsy lore. The old professor had a series of flirtations unknown to his wife, but one day when he was in a half-intoxicated state in a Welsh tavern where he had been studying gipsies he was plunged into deep depression because a gipsy told him he was getting bald at the top of his head. "What shall I do?" he said to John. John replied sternly "Return to your innocence", by which he meant sin openly and scandalise the world. He is the strangest creature I have ever met, a kind of fawn . . . a magnificent-looking person, and looks the wild creature he is.'

Dressed impeccably, according to his own standards, in an old Victorian coat, Augustus was on his very best behaviour. He was as charmed by Yeats as Yeats was by him, and the two of them would sit up late in intimate talk. 'He is most delightful,' Augustus told Alick Schepeler, 'nobody seems to know him but me – unless it is the Gregorys, but that is my conceit no doubt.' Except for these late-night conversations, Augustus spoke little, worked hard and would wander off for long solitary walks in the wooded park round Coole where he had located 'a region which is obviously holy ground'. Often he needed to escape out-of-doors and spent many evenings rowing idly on the lake, with only the swans, which Yeats had celebrated, for company. Then, to the apprehensive admiration of Robert Gregory and the astonishment of everyone else, he would surge indoors, do wonderful athletic things on the drawing-room floor, stride out again and climb to the top of the tallest tree in Coole garden, where he carved a mysterious symbol. Poets, playwrights and patrons struggled among its lower branches, but 'nobody else has been able to get up there to know what it is, even Robert stuck halfway'.[178]

By the time he left, Augustus had seen enough of Ireland to know that it was rich in motifs for him as a painter. Already he had vague vast schemes to paint all Galway. He would return, several times; and at the last time he would again paint Yeats.

3. ALL BOYS BRAVE AND BEAUTIFUL

At Equihen Augustus had left a situation full of passionate uncertainties.

Attended by one of her sisters – 'voluptuous Jessie'[179] – Dorelia had enjoyed a successful illness culminating, to the satisfaction of all, in a

miscarriage. Nothing could be wrong with this unless it was the timing, which coincided with the arrival of Mrs Nettleship, bringing with her Ida's three eldest boys.

Augustus had wanted to encircle himself with all his children this summer, and to spend his time happily at work over them and the admirable sea-girls. He had not reckoned on Mrs Nettleship's presence, nor on the unpaintable school clothes with which she had decked out her grandchildren. It was a shock – but he was determined to prove the optimist. 'This is a jolly place,' he wrote to Ursula Tyrwhitt. 'My numberless kids are all here now. I have a dilapidated studio to work in. The fish people here are very amusing. The girls look fine in their old costumes. Multitudes of children teem in the gutters together with the debris of centuries.'

Such cheerfulness died hard. He was resolved not to put up with the children's noise, but to *enjoy* it. After all, it was natural: did he therefore not have a moral duty to enjoy it? Enjoyment was necessary to work – it accelerated his perceptions: but it was elusive. Everything seemed to rub away at this quality of enjoyment at Equihen and, because of the company of Mrs Nettleship, in the most abrasive manner. Before her commanding presence, the very beauty of Nature seemed to hesitate and retreat; even alcohol could no longer 'stimulate those delightful sensations old Debaucheries used to procure me . . . angelic glimpses secreted like pearls in piggeries.'[180]

In a letter to Henry Lamb (5 August 1907) he wrote: 'I wish this house were on wheels.' It was the stationary quality of life which prompted, even in the midst of beauty, such terrible ennui, like the spider in a flower. Wherever he was he wanted a place of escape – like the magic lake or *Turlough* at Coole, islanded, and mysteriously rising and subsiding. What he desired now was an encampment that contained all possibilities, that moved yet rested, that congregated the right people – artists and comedians, women and children – but that had hidden places into which he could retire. In such a community he saw the solution to that war between involvement and solitude which confronts most artists.

'I understand that solitude is not always and ever good for a man,' he wrote to Henry Lamb. 'Are we not much too solitary? It's only those who live much among men and women who can preserve and develop that internal independence which belongs to a warrior. We are not made to do battle with spirits and demons of the desert. I think company is better medicine than loneliness. Let us see new faces, lest the old ones grow old under our tiring eyes, and damn it we are artists not misanthropists. Anthropology is our business. Solitude be damned. One seeks solitude – with one's woman only.'

These were brave-sounding words, but they trumpeted a virtue of what, for Augustus, was becoming a necessity. His real problem was how to adjust his uncharted personality to the disciplines of the artist's life. He needed more solitude, if possible, not less; more opportunity to train his memory in recapturing the fleeting moment; more emphasis on sustained imagination. But this gypsy way to artistic fulfilment was new and needed to be worked out.

Henry Lamb was by this time his new star. 'He is no ordinary personage,' Augustus was to assure Ottoline Morrell (20 September 1908), 'and has the divine mark on his brow.' Lamb had taken his apprenticeship to Augustus very seriously, and very far. His drawings, though more clinical, resembled Augustus's, and so did his clothes. He let his hair grow long; he failed to shave; he fastened on gold ear-rings. If he could have added a cubit to his stature, he surely would have done so. He was spectacularly handsome. With his hypnotic deep-blue eyes he fascinated men and women alike, and his entrance into any gathering was almost as striking as that of his master. Like his master, too, he had married a Slade girl, Euphemia, the very model of a John model. When the Chelsea Art School went into a decline – or rather when Augustus's attendances there declined – Lamb quitted it and followed him to Paris. By the beginning of 1907 he was living in the Rue Cels and studying at La Palette under Jacques-Emile Blanche.

Ida had liked Lamb: they had shared a literary intelligence and would discuss the French translations of Dostoievsky. Dorelia liked him too: they were both musical and played the piano together. After Ida's death, Dorelia and Lamb drew closer. 'Dorelia will I hope buck up under your sunny influence,' Augustus wrote to Lamb (13 June 1907), '– yours is evidently the touch. My person is like a blight on the household.' Meanwhile Augustus was doing countless studies of Euphemia. The mercurial presence of this girl, with her pale oval face and heavy honey-coloured hair, had already provoked rather a sharp inquiry from Alick Schepeler. 'I have never had time or inclination to consider her very seriously,' Augustus airily defended himself. 'I have simply taken her for granted. It is true I have thought her rather eccentric . . .' Then, in Paris, immediately following Ida's death, time and the inclination had been amply provided. She was comedian and model to him: he admired her body, was amused by her exploits. Warm, passionate and impetuous, the proprietor of a most generous temper, there was something wild and heroic about her. So the two households, the Lambs and the Johns, mingled, amoeba-like, revolved and came together again as in some complicated dance. But one partner was hurt – Euphemia, who fell into the arms of another British painter then studying at La Palette, Duncan Grant. 'That Lamb family sickens me,' he complained to Lytton

Strachey (7 April 1907), 'and that man John. I'm convinced now he's a bad lot. His mistress, Dorelia, fell in love with Henry and invited him to copulate and as far as I can make out John encouraged the liaison and arranged or at any rate winked at the arrangements for keeping Nina [Euphemia] out of the way, although Henry didn't in the least want to have any dealings with Dorelia. However it was apparently all fixed up that they should "go on the roads" together when Nina was (according to her own story) found with a loaded revolver ready to shoot herself (and Henry as far as I could gather). So Henry was left by himself . . . Dorelia and John seem to be the devils and the others merely absurd . . .'

This account, which suffers from being tied to Euphemia's version of the truth, nevertheless indicates how Augustus, and such artists as Innes and Derwent Lees, were always separated from Fry's group of Bloomsbury painters. It was not that they failed to admire one another's talent: they did. But Augustus was ill-at-ease in their tidy, educated presence, and he mistrusted their bloodless theories which, like an eiderdown, seemed to suffocate all growing life. And they were disconcerted by his deliberate thoughtlessness, his irrationality. There was no common ground between his pursuit of 'meaningless' beauty, and their imposition of 'significant form'. To Bloomsbury, Augustus was a meteor, dazzling and self-destructive, a phenomenon that attracted their alarmed gaze but from which, after a covert glance, all wise men must, they judged, avert their eyes. 'Oh John! Oh . . . what a "warning"! as the Clergy say,' Lytton Strachey exclaimed to Duncan Grant (12 April 1907). 'When I think of him, I often feel that the only thing to do is to chuck up everything and make a dash for some such safe secluded office-stool as is pressed by dear Maynard's [Keynes'] happy bottom. The dangers of freedom are appalling! In the meantime it seems to me that one had better immediately buy up every drawing by him that's on the market. For surely he's bound to fizzle out; and then the prices!'

The entanglements in which Augustus wrapped himself, while inviting all sorts of damage, were fundamentally unserious. That was how it appeared to Bloomsbury, and this was the burden of their complaint. He lived a life (could there be anything more shocking?) based upon the casual whim! Their judgement was precisely logical, totally unpsychological. For Bloomsbury could not know the annihilating force of solitude upon him, did not sense the panic.

Of course Augustus never subscribed to any theoretical rules of behaviour and, since he did not trade in words, never defended or explained his philosophy. It was based, however, upon a natural law of self-interest that did not necessarily exclude the interests of others, but

did not put them first. The ideal collective sphere where 'each man shift for all the rest, and let no man take care of himself' he considered absurd and against human nature. If some desire swept through you, then you must give expression to it with all your being – physically, vocally, at once and until it was exhausted and you were left empty or filled by another desire. Those who acted upon their emotions lived longer because they lived by a biological reality not just social convention. However admirable your motives for bottling up feelings might be, this was wrong because the contents of the bottle turned to a poison that seeped into your unconscious – hence the fact that those with the most exquisite consciences and elevating philosophies could spread the most unhappiness. There was a danger in modern society of the animal in man being neglected. But, however polished by tea-time veneer, the principle of the survival of the fittest still ruled our existence. Therefore give expression to it openly – not in a thin trickle of financial self-interest, but as a nourishment and expansion of the soul-and-body. Lock antlers with the men; copulate with the women; scatter your image through the land. There will be wounds given and received; but there will be no deception or the sour sediment of regrets and frustrations taken to the grave. The wounds will be honourable and will heal, not fester. This was how life should be lived.

Yet it was surprisingly difficult to achieve the simple life. What could be more simple, for example, than to invite Henry Lamb to Equihen? And what, in the society of Mrs Nettleship, could be more unwise? 'I hope you will come and bathe here,' had run his innocent invitation. But instead of Henry, Euphemia came, dressed rather improbably as a young man and followed by an enthusiastic, but bankrupt, Swede. Having relieved Augustus of some of his Irish money, the Swede hurried off to Paris, while Euphemia, falling ill with a mysterious disease, was condemned for a week to bed. 'She makes an irresistible boy,' Augustus admitted to her husband, '– I feel, myself, better after assisting at her recovery.'

Although she was not to allow him a divorce until the late 1920s, Euphemia had already walked out on Lamb and, amid much determined talk of divorce, embarked on an extraordinary career that was to be much caught up with other artists. Describing her in his mammoth *Confessions* under the pseudonym of 'Dorothy', Aleister Crowley, the Great Beast 666, wrote that she 'would have been a *grande* passion had it not been that my instinct warned me that she was incapable of true love. She was incomparably beautiful . . . She was capable of stimulating the greatest extravagancies of passion.' For Augustus, who gave her the name 'Lobelia', these extravagancies were wonderfully comic. 'She has made the acquaintance of a number of nations,' he assured Lamb

(5 August 1907); and he told Dorelia (April 1908) that 'Lobelia had 6 men in her room last night, representing the six European powers, and all silent as the grave.'

Dorelia had not seduced Lamb; he had fallen in love with her. For him it was almost inevitable, fulfilling his role as Augustus's *alter ego*. Since he was an artist, it also made destiny-sense to Dorelia. Already they had begun a love-affair – the second of Dorelia's two 'discreditable episodes' – that was to continue, with intervals, for twenty years.

For the time being their affair had no unpleasant repercussions: except with Mrs Nettleship. Mrs Nettleship had never liked Dorelia, and everything she learnt this summer confirmed her in this dislike. Obviously she was quite the wrong person to whom to entrust Ida's boys. It was not simply a matter of immorality: it was incompetence – an incompetence so superlative it made Mrs Nettleship perfectly dizzy. It was out of the question for the children to be brought up in this lunatic way. They were decked out in fanciful rags, never washed, brushed or combed, and never properly superintended. Their bedrooms were full of unchecked frogs, absurd grasshoppers and other atrocities: it was bedlam. Even Augustus was forced to own that 'this crêche-like establishment is a little too heroic – in the long run'.[181] Within a week of arriving at Equihen, the boys had almost been drowned *en masse*, being uniquely rescued in the last second by a local fisherman who 'was getting food for his rabbits on the cliff when he heard their screaming,' Mrs Nettleship explained to Ursula (19 July 1907). 'He has never saved anyone before and he hopes to get a medal.'

So different was the atmosphere from what Mrs Nettleship had created at Wigmore Street, she felt as if she had landed on some distant world where no one knew what was right or wrong, and no normal standards applied. The amoral beauty of it all drove her frantic. 'There never seems time for anything here,' she complained to Ursula, '– the weather is so lovely, we are out all day and in the evening we are too sleepy to do anything. It is almost irritating that this place is so lovely – I hate it all for being so placid and "only man is vile" . . . Something must come to relieve this tension.'

What came tightened the tension to breaking-point. Dorelia had succeeded in not telling anyone that her children this summer had suffered from ophthalmia, a painful eye disease. She had even forgotten it herself and, by arranging for all the children to share a single sponge and towel, had successfully spread the infection first to Edwin, then to Robin. Mrs Nettleship was appalled. Here was actual proof that Dorelia could not be trusted. She at once herded Ida's untainted sons together and drove them out of the infected area. 'I should like to bring them back right away,' she told Ursula, 'but Gus does not think it matters!

. . . He says the village children get over it all right and so will ours! He is nearly driving me mad . . . I have never known anyone so impossible to deal with.' At the same time, for fear of losing the boys altogether, she had to remain outwardly friendly. Nor could she leave while the ophthalmia persisted, since no one did anything to cure the disease unless she personally insisted on its being done – Dorelia preferring what she called 'natural methods'. At first, Mrs Nettleship's monumental diplomacy seemed to be effective, especially when Augustus, responding to the strain of the holiday, remarked that the two families could never be brought up together. 'If either of our boys [David or Caspar] get ophthalmia I shall use it as a weapon,' Mrs Nettleship promised.

Twelve days later, diplomacy had disappeared for ever. 'It is war to the knife,' declared Mrs Nettleship. Each side had marshalled a team of doctors with strongly opposing advice. 'Gus is hopeless – just one mass of selfishness – not thinking of anyone, but his own desires – and so surly and cross,' Mrs Nettleship explained to Ursula. 'How Ida can have endured it I can't imagine – he has no heart at all.'

Another twelve days and Mrs Nettleship had returned to Wigmore Street, triumphantly taking with her David, Caspar, Robin and, if that were not enough, the urn containing Ida's ashes. It was less her victory than Augustus's defeat. For the time being he had nowhere for them to live, and it affected him keenly.

'I am saddened to realise that I have allowed an immoral and bourgeois society of women to capture my 3 eldest boys,' he acknowledged to Henry Lamb (27 July 1907). 'It will be the devil to get them back again but it must be done when opportunity offers. Perhaps I may ask you to assist me one day in recovering them. Can you shoot? I cannot stand finding those chaps in the hands of people among whom I shall always be a stranger, and no longer in the brave and beautiful attire their mother gave them to wear. I cannot leave them with people who although they are Ida's mother and sisters did not even know her.'

Mrs Nettleship was used to getting her own way and, once back in Wigmore Street, she set about consolidating her advantage. She knew that Augustus did not want to prolong the present arrangement, yet sensed he was somehow in two minds. His uncertainty was contagious and, untypically, she could not make up her own mind as to what her best tactics should be. If she wanted to mollify him she would approach him via her daughter Ursula; if she wanted to frighten him she would appeal to Edward Nettleship – 'Uncle Ned of Nutcombe Hill', said to be a dragon of a man. Finally she did both, in addition to canvassing opinion among various aunts and cousins. Ursula acted at once, writing to assure Augustus that, if the children were left with the Nettleship

family, she would see to it that their education was not old-fashioned and would look after them herself. In his reply, Augustus set down his feelings with unusual explicitness:

'Be sure that if any consideration could induce me to part with the children it would be the fact that *you* alone would have them. The *immediate* future has an unsettled aspect for me. Homeless, penniless and lawless I present a pretty spectacle of a paterfamilias! But thanks to you things begin to look much more tractable. I want badly to retain the children as Ida's and mine – to keep them in the atmosphere they were born in – a delightful atmosphere and not at all dreadful you know – and to think of them being educated into ordinary little early Victorian bourgeois prigs is a horrid thought! You have eased me of that apprehension at least. I'm sure you would do your best to train them into men brave, intelligent, gay – like heroes: and you would have some of Ida's sublime gigantic composure in dealing with them – I really was beginning to fear I shouldn't recognise them in a year or so, or they me. I was preparing myself for the moment when they would approach me and earnestly implore me to get my hair cut! In addition to these perhaps morbid fancies the spirit of opposition was kindled somewhat on finding my section of the family treated to a kind of super-discreet aloofness – and the three kids in question hardly to be viewed and that only under formidable escort: indeed one had the sensation of extraordinary and almost painful privilege that malefactors must experience when permitted to interview for a few brief moments their more fortunate relatives on the other side of the bars, attired, one seems to see them, in their Sunday best! Now I know that prejudice alas! is the most natural thing in the world, and meanness the commonest, and error the most universal. Yet it is natural enough too to seek to remove these weeds, at any rate when they come your way; and I must have a try at getting people to know that Dorelia is a Person and a very rare and respectable being, to wit full of sense and sensibility, having no shams in her being, indeed a kind of feminine genius I fancy. I would like to mention that had she been only my "mistress" we would not be together now. Had she not been a worthy soul, do you think I could have stood it so long? I say this as no superior person, believe me – I might say like Hamlet "I am myself indifferent honest, but yet I could accuse myself of things it were better my mother had not borne me. I am proud, revengeful, ambitious, with more offences at my back than I had thought to put them in, imagination to give them shape, or time to act them in. What should such a fellow as I do, crawling between heaven and earth!" But Dorelia was loved of Ida and her very good friend in spite of appearances and all great mistakes not withstanding. Barring their mother she had more to do with the children than anyone else;

and because Ida happened to die it doesn't strike me as indispensable to hurry D. out by the back stairs. In a word she has been and so far remains part of my family and I should like her always to continue to give the children the benefit of her honesty and simplicity and affection, and help to dress them bravely too – as she knows how to. For without brave attire I can't put up with them. It would be a frightfully difficult thing to take them away from you even now: but I don't want to. They can always pay you visits, especially as you have an anti-Wig-morian plan – and heaven knows I may have a house in London – but wait till after my show when I hope to see my way better. Perhaps you will say you must have them altogether or not at all – Alas! But I suppose it's not impossible that you may have babies of your own some time, and you might think that better than having other people's babies . . . since my proposal to reassume the parental responsibilities sooner or later – friendliness and Patience have become established . . .'

While Augustus was writing this letter to Ursula, Uncle Ned was sharpening his pen at Nutcombe. With long-drawn-out relish he was preparing himself of 'a good slapping letter' for Augustus. It was congenial labour. He lingered lovingly over the vituperative phrases, savouring them, hardly liking to let them go. He was still remorselessly chewing over all this when he received from Ursula Augustus's letter and, as he read through it, it occurred to him that his carefully-charged time bomb fell, quite suddenly, 'rather flat'. It was a sad waste, but at least a little of his invective could be discharged vicariously. The letter he now (28 September 1907) wrote to Ursula is a good measure of the antipathy between the two sides of the family, and shows between what bewildering changes of background some of Ida's sons were to pass their formative years. At first, Uncle Ned allowed, he had thought the fellow must have been mad drunk when he wrote, 'but on re-reading, there is too much essential coherence for that. He [Augustus] whines that he is penniless and homeless and lawless (the last evidently, like the other two, from his misfortune doubtless, not from any preventable fault!). He wants to keep the children for himself and Dorelia, but he wants you with your gigantic composure to carry on their Bohemian Education when in the intervals of their home life they pay you visits in some place where the atmosphere is "anti-Wigmorian".' Such a re-sponse, Uncle Ned urged, called in question the whole policy of concili-ation. Instead, he would like to hear that Augustus was being instructed 'in quite simple words that it is his business to put his back into his work to maintain his children', that no Nettleship worth the name would be a party to brave attire – if '"brave" means (as I am told it does) squalid or dirty or gutter-snipe attire'; and that to talk of the inhabitants of Wigmore Street as bourgeois prigs was 'impudent nonsense' for which an

instantaneous apology was required. This, like music, was what Uncle
Ned would like to hear – but it would have to come now from Ursula,
since she had opened the negotiations. She must change the tune – but
he, if called upon, would conduct her playing. It must, however, be a
solo programme – they couldn't have every aunt and cousin chiming in.
So the dragon roared his last paragraph of flame:

'I think that subtle, absolutely selfish and introspective as he is, and
morose and bad tempered to boot, he is a coward at any rate when
dealing with women; and that hard hitting, at any rate now, is at least as
likely to succeed with him and Dorelia (who of course is doing her best
as wire-puller) as any other plan . . . Dorelia wants to keep him; she
does not really want Ida's children.'

So with both sides convinced of the other's immorality as parents, the
autumn passed; and, for their winter quarters, they took up entrenched
positions in this war to the knife. 'We are rather harassed by babies,'
Augustus admitted to Henry Lamb (5 August 1907). 'We ought to have
a few vigorous old women to attend to them.'

4. OR SOMETHING

In one respect at least Uncle Ned had misunderstood the situation. He
had attributed logic, even calculation, jointly to Augustus and Dorelia,
and in so doing had, from the very start, mixed in with his reasoning an
untruth that reliably falsified almost any deduction he cared to make.
His generalship behind the Nettleship lines was therefore of incalculable
value to Augustus. 'Wire-pulling' or any other species of long-term
cunning had no part in Dorelia's make-up. Her gift was for taking
things as they came – and when they didn't come, but hung around
some distance off, she had no talent for advancing on them by a subtle
route. The present suspended state of affairs did not stimulate her best
qualities. To a degree, her desires were the very opposite of what
Uncle Ned had represented: she did not inevitably want to keep
Augustus, but she did want one or two of Ida's children. Her point of
view was beyond the comprehension of the Nettleships.

Over the summer, over the autumn, Dorelia and Augustus debated
the situation as fully as two inarticulate people could. They evolved all
manner of schemes for taking care of the future, but without Ida they
were strangely undecided and, despite much activity, made little pro-
gress in any direction. Basically there were two plans: first that they
should continue living together; and secondly that they should not. The
first plan came in many forms. One night, for example, Dorelia dreamt
of 'a lovely country . . . terrific mountains and forests and rivers – the
people were Russians but I think it must have been Spain';[182] and next

The Dowdalls

His Honour the Lord Mayor of Liverpool, and Smith (1909)

day they were hot for setting off to discover this place. Then, changing
their minds, they thought of settling for a house in England. 'We must
have an aquarium in the country,' Dorelia affirmed.[183] 'We might get
one in exchange for a baby or something.' It was that continual 'or
something' that foxed them.

Dorelia's difficulty was Henry Lamb, whose influence was like that of
a magnet upon a compass. Her sense of destiny could no longer guide
her, and she did not know what to do. At times she was almost passion-
ately indifferent. 'I haven't the faintest wish to get married,' she informed
Augustus (September 1907). 'I think it would be best if I went on the
road and left you in peace which I should be only too glad to do if you
would let me have one of the children – Caspar or Robin – he would be
better with me than in that virginal atmosphere [Wigmore Street].'

Lamb, who was to walk through Brittany from inn to inn the follow-
ing summer with Caspar on his shoulders, had already been approached
by Augustus in connection with the children. The argument was simple.
Since Lamb was apprenticed to Augustus, what could be better than
apprenticing one of Augustus's sons to Lamb? It was a merry scheme.
'I found Robin overwhelming!' he recommended. 'When one sings or
even whistles to him, he lies back and closes his eyes luxuriously. It is he
who should be your pupil . . .'

During the next two or three years, the relationship between Augustus
and Dorelia was to be more fluid and circumstantial than at any other
time. Sometimes they lived on wheels together; sometimes the Channel
flowed between them. Sometimes they were close; sometimes they
seemed to float apart, carried this way and that by currents they could
not control. 'Don't worry,' Dorelia reassured him this autumn, 'as I
think either plan extremely desirable.' There were indeed times when
any plan seemed desirable – but still they could not decide. Yet whenever
Dorelia drifted too far away, Augustus would all at once grow resolute :
'Beloved, of course it's *you* I want.'

One thing at least had been agreed: they could no longer afford,
scattered through two countries, quite such a multitude of unsuitable
flats and studios. On returning to London, Augustus wrote to Lamb
('mon cher Agneau') asking him to sell the lease of his studio in the
Cour de Rohan. Though he would make other parts of France his
second home in the future, he was never again to live in Paris. Ironically,
perhaps, this parting was to coincide with his meeting with Picasso.
'I saw a young artist called Picasso whose work is wonderful in Paris,'
he had written that summer (5 August 1907) to Lamb. And two months
later, once his studio was let and all connections with Paris severed,
(4 November 1907) he had become convinced that 'Picasso is a wonder'.

The two painters had visited each other at their studios, and Augustus was greatly impressed by Picasso's work, chiefly because, like his own, it was steeped in the past, drew part of its inspiration from Puvis de Chavannes and revealed 'elements derived from remote antiquity or the art-forms of primitive peoples'.[184] Some of Augustus's paintings done at this time, and perhaps even earlier, show a striking resemblance to Picasso's Blue Period, and indicate the direction his work might have gone had the geography of his life been different.

But only in London could he sell his work. Lack of money was the Nettleships' best weapon and he was determined to disarm them. However, for the first few days, having nowhere else to go, he was obliged to put up in, of all places, Wigmore Street.* Shortly afterwards he moved to Whistler's old studio at 8 Fitzroy Street where he stayed, intermittently, for almost a year. It was his sole foothold in London, from where, at the prompting of his spirit, he would wander off to pubs and music halls, to the Café Royal or, in some painted wagon, to remoter spots.

'I'm thinking of raising a little money with a preliminary show of drawings alone,' he wrote to Lamb on 11 November 1907. The results of this exhibition at the Carfax Gallery that December were encouraging. 'The show opened most successfully,' he told Dorelia. 'I sold about £225 worth the first morning. 'Twas a scene of great brilliance. Epstein and his wife looked grand.' After it was over he wrote to Lamb: 'I hope now to paint pictures for the rest of my life.' But he had other plans too. 'I *must* have a press,' he told Dorelia. 'I long to bring out a book of etchings. It might be called "etchings of Innocence" or "Phantasmagoria" or "The Simple Way". . . .'

Over the next months there were plenty of opportunities to sell his work: etchings and drawings at the Society of Twelve into which he was planning to elect Lamb; drawings and paintings at the N.E.A.C., which had opened that winter with the 'paltriest of shows'. He was arranging a one-man summer show at the Chenil Gallery and hoped to send in something big to the celebrated 'Exhibition of Fair Women' to be held early in 1909 at the New Gallery.† It was the field work for this last affair, at which he would exhibit one of his acknowledged masterpieces, that gave him the most trouble. He had been presented with a huge canvas by William Nicholson: the problem was how to fill it.

* 'I took a small studio here (28 Wigmore Street) which I now see is quite impossible,' he wrote to Henry Lamb (25 September 1907). After a short period of 'perfect hell' he went to stay with Charles McEvoy at 132 Cheyne Walk before settling into 8 Fitzroy Street – 'it is a fine place' he told Dorelia.

† The exhibition was held by the International Society of Sculptors, Painters and 'Gravers, at the New Gallery during February and March 1909.

'I have a scheme for a picture of fair women in which Lobelia ought to figure,' * he instructed Lamb (24 December 1907). But Euphemia had temporarily vanished and he had to look elsewhere. 'I just passed Bertha in the street (the girl in black tights),' he wrote hopefully to Dorelia. But she, unlike Ida, was determined to be absolutely firm with him. 'That barmaid has disappeared from my ken,' he reassured her. Next he unearthed 'La Seraphita', his still unfinished (as he now thought of it) portrait of Alick Schepeler, named after Balzac's ambiguous novel. 'Having changed the background it now looks rather remarkable,' he wrote to Lamb (10 January 1908), '– her face embodies all that is corrupt, but the thing has a monumental character and the pose is perfect I think.' The picture showed Alick in a tight black dress, standing on a mountain top with strange ice-floes growing at her feet. It needed only a few more sittings. 'Seraphita still stands upon her crest and smiles her smile of specious profundity to a nervous and half-credulous world,' Augustus assured Alick. 'I hope you will come and see me here . . . when I will show you some things.' But again Dorelia, who particularly disliked Alick for her public demonstrations of emotion, put her foot down; and again Augustus yielded: 'I have written to the Schepeler and said goodbye so now you cheer up and get well, there's an angel.' Finally it was a superb picture of Dorelia herself, 'The Smiling Woman', which he submitted to the Exhibition of Fair Women. †

Though he himself was doing good work, the English art world depressed him. Of many of his fellow artists, such as Bone and Dodd, he held no high opinion. In his letters over this period he seems to have been most excited by some drawings of Alfred Stevens, and some 'reproductions of wonderful pictures by Gauguin'. Of his contemporaries, Gwen was still the best. He had persuaded her to exhibit two pictures at the N.E.A.C. show in the spring of 1908: her portrait of Chloë Boughton-Leigh and 'La Chambre sur la Cour'. ‡ 'Gwen's pictures are simply staggering,' he told Dorelia. 'I have put up the prices to £50. They will surely sell.'

As for his own work, 'I seem to make millions as usual,' he told Lamb (10 January 1908) to whom, out of the blue, he sent a present of five

* The virgins of Damascus suing Tamburlaine for mercy.

† Originally called 'Woman Smiling', it reversed its title in 1910 when it was shown at the Manchester City Art Gallery in a loan exhibition of John's work. It was the first picture bought (for £225 at Manchester) by the Contemporary Art Society, founded that year to acquire works by living artists for loan or gift to public galleries. It was also the first picture presented by the Society to the Tate Gallery (3171).

‡ Both pictures are now in the Tate Gallery, the latter having changed its name to 'A Lady Reading'.

pounds. But although no one exhibited more than he, no one in certain moods disliked it more. 'Would that I could leave exhibiting alone for years and years,' he confided to Lady Ottoline Morrell (20 September 1908). 'Perhaps some day I may be able to buy back the rubbish I have sold and have a grand auto-da-fé.'

The English art scene was dim, but there were some bright stars. 'It is surprising to find men in England apparently alive to the tendency of modern art to symbolism,' he wrote (17 January 1908) to Lamb, who had recently been telling him about the work of van Gogh. 'I met [Roger] Fry the other night and he is quite a lively person – on the other hand "Impressionism" is still lectured on as the new gospel by certain persons of importance. I feel utterly incompetent to cope with problems outside art – without my wife, whom I want. Terrible glooms and ennuis visit me in the evenings when I can think of no one I want to see and am yet tormented by solitude. Sometimes I have tried seeing how much I can drink in one night but it's a dismal experiment. At any rate I have nearly done a large painting which I think is lovely – a nude virgin by a lake. I am thinking of giving up models altogether.'

His letters during this winter resound with vigorous complaints. 'My hypochondria comes and goes – and comes again,' he reported to Lamb (6 February 1908). 'It is a beshitten society. I know no man in London.' He suffered very energetically from the great malaise of the times: Edwardian neurasthenia – and treated it with complex diagnoses. 'I am myself a prey to chronic pulmonary bronchial and stomach catarrh but occasional spells of country air keep me going.' His symptoms were often valiant; he was the very battleground for giant contests between his phagocytes and every marauding macrophag. 'My macrophags are having a fight for it,' he cabled back from the front line of this war. But the real culprit was that malign monster, London. 'The London people are sickening,' he informed Ottoline Morrell (20 September 1908). On fine days he was suffocated in his dingy studio as in some dark hull of a ship; and gloomy days depressed him unutterably wherever he was. He had taken up riding, and this stirred his blood about a bit. 'You must come and ride over the downs with me,' he invited Lamb (14 December 1907). But then he got so hot riding, and afterwards so cold – it could not be good for his 'corpuscles'.

After the banishment of Alick Schepeler he felt more hemmed in than ever. He was seeing Dorelia only intermittently: it was an impossible situation. So he turned to, of all people, Ida's friend the Rani: 'La plus chère de toutes les dames!!' he greeted her in his wildest handwriting. 'Let me have a word, please – I live here [8 Fitzroy Street] now. They tell me you are coming to London for the Slade dance – if that's true – mightn't I see you – yourself. I have heard with incredible joy how

much better you are for Canary carryings-on. Let me then assure my-self – formally – visually – tangibly of your well-being . . . After the ball come and rest under my lofty roof – there's a little angel.'

Like a Colossus chained, he seemed incapable of independent action except under the impulse of tremendous forces; while by others, for a while, he could be led as simply as a child. Only at present he had no one to lead him, no one opposite whom to play a new Augustus. Self-escape, by one means or another, was like a drug for which, in his languishing solitude, he craved. 'For the moment dreadful glooms blot out the glittering vistas of life – even debauch would afford me no illusion,' he confessed to Lamb (14 December 1907), ' . . . nor bring back a sense of triumphant reality. In a word I am in a sorry state. Perhaps the fog will lift before to-morrow. But meanwhile this hideous envelopment of dullness . . .'

He was about to meet, however, a woman quite different from any he had known before who would dispel this fog, and to whom, for special reasons, Dorelia could not object.

5. ETHICS AND RAINBOWS

Lady Ottoline Morrell had already encountered Augustus at Conder's studio in Chelsea three years before. Tall and mysterious-looking, intensely silent and with an air that was somehow *méfiant*, he seemed to her a strangely memorable person. Gold ear-rings he wore, and a sweater polo-necked and very black; his hair was shaped like that of some figure in a Renaissance picture, and he watched everyone with a curious intentness. It was the eyes that first mesmerized her – his eyes, then his voice, then his hands.

'They were remarkably beautifully-shaped eyes,' she recalled,[185] 'and were of that mysterious pale grey-green colour, expanding like a sea-anemone, and more liquid, more aesthetically and poetically perceptive, than any of the darker and more definite shades. His voice, when he did speak, was not very unlike Conder's, only rather deeper and more melodious, but like Conder's hesitating – and he also had the same trick of pushing his hair back with one of his hands – hands that were more beautiful almost than any man's hands I have ever seen.'

Lady Ottoline was every inch as striking a figure as Augustus. When they met again early in 1908 at a smart dinner party in Lowndes Place, he felt very self-conscious in his uncomfortable dinner-jacket, shy and rather aggressive, until he caught sight of Ottoline: then he forgot himself. Tall, with deep mahogany red hair, a prognathous jaw, swan's neck and bold baronial nose, she had the external force to command his self-forgetfulness. In a magnificent half-length portrait,

painted nearly a dozen years later, he depicts her as some splendid galleon in full sail, triumphantly breasting the high seas. Her head, under its flamboyant topsail of a hat, is held at a proud angle and she wears, like rigging, string upon string of slightly moulting pearls (painted with the aid of tooth powder) above a bottle-green velvet dress. Her eyes are rolled sideways in their sockets like those of a runaway horse and her mouth bared in a soundless scream – almost as if the prototype of Bacon's portrait of Pope Innocent X. This portrait when first exhibited produced a furore, and people asked themselves how Lady Ottoline could possibly have allowed the artist to paint such a freakish likeness of her. Even Augustus grew rather nervous about her reaction to all this Press comment. 'I would like you to have that portrait but I don't think it's one you would like to hand down to posterity as a *complete* representation of you,' he told her (10 February 1922). He need not have worried.* She brushed aside the paper storm, went on to buy another portrait of Augustus's and hung it for all to see over the mantelpiece in her drawing-room. 'Whatever she may have lacked it wasn't courage,' Augustus acknowledged in *Chiaroscuro*; 'in spite of a dull and conventional upbringing, this fine woman was always prepared to do battle for Culture, Freedom and the People.'

Lady Ottoline was a unique personality and she inspired Augustus as vividly as she did many other writers and artists: Aldous Huxley and D. H. Lawrence; Simon Bussy and Duncan Grant. To stimulate the

* 'I am delighted you snubbed those stupid and impertinent journalists,' Augustus wrote to her (14 March 1920). 'I have kept them at bay as far as possible but they are very persistent. Even if one is induced to express an opinion it is sure to appear in a distorted form and minus the points.' Two years later, on 1 February 1922, he wrote in answer to a letter from Ottoline about the picture: 'I still have your portrait. People don't often buy other people's portraits. It's rather a cruel predicament as you know and yet I like it. I think I had priced it at £500 at the show but you can have it for much less. Would £200 be too much?' Ten days later he is hedging: 'In the meanwhile I have collected some pictures for a show at Pittsburgh U.S.A. and I thought of including your portrait among them as I think with all its deficiencies (and tooth-powder) it is one of my best in some ways. Would you mind letting it go for the show, and then we could decide later if you really wanted it, or try another.' On 9 January 1925 he informs her: 'The price I have put on your portrait is £400. Is that too much?' Eight months later (2 September 1925) he writes: 'I am delighted that on seeing the portrait again you still think well of it. It isn't good enough but I think it has distinction. I am sorry the price I put on it is too much – but I would not part with it to anyone else for less than twice that sum – and I know I shall be able to get it or more one day.' The following month, some seventeen years after he had begun this portrait, their transactions were at an end – and at once he suggested beginning another picture. 'Oh yes – your portrait is full of faults and I know I should love to do another.' By now Ottoline was middle-aged, and feeling perhaps that there was not enough time left for another portrait, she did not accept this offer.

imaginations of such men was her talent – almost her genius. She had crossed over from her aristocratic homeland to this country of art and letters, and she offered those painters and authors whom she admired excursions to her native country. At her house in Bedford Square – a symphony of pale grey walls and yellow taffeta curtains – Augustus first came into contact with the smart world, for which, in years to come, he would develop a gourmet's taste. It was like some extraordinarily rich food that melted in the imagination but, in large quantities, sickened the stomach. Yet in 1908 this drawing-room world was brilliantly new to him. Fashionable society appealed to him for much the same reasons as did the society of gypsies and anarchists: it offered him an attractive theatre where he could assume a different role. To avoid claustrophobia he needed to move from one self to another, to play many parts in succession like a travelling mummer. It was probably a sign of recognizing this ability that he wanted more than one of his sons to go on the stage – as comedians. Augustus too could play the comedian, though he often took the straight part opposite a troupe of Café Royal clowns. But just as some actors can only give fine performances when the lines they deliver are good, so Augustus needed to come under the strong influence of someone he could admire.

Ottoline provided just such a potent theatrical influence. Sitting next to each other at dinner in Lowndes Square they talked of troubadours and Romanies; and then, abruptly, Augustus demanded: 'Will you sit to me? Come and see me tomorrow in my studio.' This signalled the beginning of a friendship, important to each of them, that was to last until Ottoline's death in the 1930s. The very next morning she went round to Fitzroy Street chaperoned by her husband, the member of Parliament for South Oxfordshire. 'We knock, and John himself appeared – in his usual clothes: a greyish suit, the coat long and full in the skirts, and with a bright green velvet collar, a large silk handkerchief round his neck. He waved us in.'[186] After inspecting his pictures and making arrangements for sittings, they were introduced to Clive and Vanessa Bell. 'Vanessa had the beauty of an early Watts portrait,' Ottoline recorded,[187] 'melancholy and dreamy. They stood in front of the picture of the lake, Clive Bell gesticulating in an excited way, showering speechless admiration, Vanessa, head bent, approving.'

Augustus fulfilled Ottoline's pictorial notion of genius, and she was soon deeply in love with him. The impression she gives of his appearance speaks eloquently of her romantic attraction:

'His dark auburn hair was long and cut across the front like a fringe, and with a square beard, his curious pale face and sea-anemone eyes, he might have been a Macedonian king or a Renaissance poet. He had a power of drawing out all one's sympathy.'[188]

Over these first months he did many watercolours and drawings of her; and she grew more deeply hypnotized by him. Each visit to Fitzroy Street sent her into a turmoil of emotions. With every step along the short walk from Bedford Square what tension there was, what fear and pain! Before advancing, she would bombard him with a heavy artillery of gifts – fine editions of Wordsworth and Goethe, Browning and Plato, even Euripides, the works of Synge and eventually of Strachey. Augustus fell back. 'You keep giving me things,' he remonstrated (8 June 1908). But she could not stop, and the first trickle of presents soon became a torrent. There was about their relationship a curious reversal of roles: it is Ottoline who plays the masculine part, bold and despairing, almost aggressive at times. Augustus is shy, rather coyly flattered by all these attentions, sometimes embarrassed, always cautious. She invites him to concerts of love music, and to tragic melodramas. She sends him a little watch which keeps breaking – a kind of stop-watch; she sends him rings for his fingers and assorted jewellery including a magnificent opal. By every post the presents pour in – lilies (which Romilly ate) for his studio, and lotions for his hair; various scarves and cloaks for his hypochondria, a green shawl and a capacious wool cover for his bed which, he claims, will keep his whole family warm. If Augustus created the John-girl with her characteristic tight bodice, long-waisted full skirt and broad-brimmed peasant hat, Ottoline must have contributed generously to Augustus's own appearance. Her most triumphant adornment was a large replica of Carlyle's hat which 'is stupendous', he proclaimed (24 May 1909). 'It reduces even the rudest street gamin to speechlessness. But it is not a hat for every day of the week.'

Nor was their love-affair for every day of the week. His intense mobility and hibernating illnesses ('acute compound neurasthenic hypochondria – at least that's my diagnosis')[189] made him an elusive lover. Yet this elusiveness only scalded her imagination the more. Wherever she went she was haunted by thoughts of him: his poverty, his vagabond freedom, the simplicity of his life, the poetry in his paintings; those mesmerizing eyes, long fine sensitive hands, and his deep resonant voice echoing in her mind. At parties she would introduce his name into the conversation for the pleasure of hearing, like distant music, people talking about him. But so often what they said distressed her. Most conventional Englishwomen looked on her as affected or even amoral for knowing such a raffish creature. Even other artists and writers failed to hit the right note – Henry James, for example, who produced an off-key *mot*: 'John paints human beings as if they were animals, and dogs as if they were human beings'; or Lytton Strachey, who likened him to the cruel and sophisticated Byron.

But Ottoline knew him better. Despite her intoxication, there is a shrewdness in her observations about him. Her heart might beat for the legendary Augustus, but her intelligence comprehended the man.

'Engagements were intolerable to him. Luxuries, possessions, responsibilities were alien to him. When I mixed in an ordinary London life, the figure of this man, so unquestionably remarkable, living a life so completely different from anything I saw around me, haunted and disturbed me. He would appear to me in my imagination as if he passed through the room, suddenly making the conventional scene appear absurd.'[190]

Mysteriousness, which he so highly prized in women, she had discovered in him. It was like a grain of love-powder that itched and irritated, that stimulated and would not leave her in peace. Above all, it was his melancholia that affected her, the silence that alternated with his flashing high spirits, the sudden boldness that interrupted his old-fashioned courtly manner with women – so abominated by the new breed of feminists. His life might seem simple and free, but he was complicated, locked within himself.

Perhaps the most astonishing aspect of their relationship was that they never quarrelled. His moodiness and her possessiveness made for difficulties, and many of their other friendships were split by bitter arguments. Their stamina lay perhaps in their awareness of this incompatibility. She could not get past his melancholy and her possessiveness had little to feed on. Often he would speak of her with reverence, call her 'an angel' – yet with the knowledge he could not walk in step with an angel very far. They remained on friendly but still quite formal terms until 30 May 1908. That day Ottoline sailed across to his studio alone, and suddenly confessed her painful love for him. The same night, after she had left, he wrote to her:

'When you were in my studio to-day I wished I could cry – I should have felt more intelligent – perhaps – with the delicatest and noblest woman loving me so infinitely beyond my deserts. Do you know what a horror I have of hurting a hair of your head and bringing a shadow into your thoughts . . . and you are trying to assure me you are just like others are!

'Is it not something to realise that change and development is possible still – that one is not yet altogether finished and one is still young! still adolescent! still living . . .'

Four pages he wrote that night, and he ended with a sentiment that might have drawn a rueful smile from Ida: 'Since my wife's death there have been few opportunities of excitement or intoxication that I have let pass . . .' Nevertheless, he concludes: 'We *can't* go on thus, darling that you are . . . Good-night, angel.'

But, in a mood of reluctant passion, the affair did go on. Like the little

watch she gave him, it was always stopping: then starting again. So far as was possible, Augustus acted honourably. He discouraged her quite gently, and from reasonable motives. 'You must know that I do care for you,' he told her (17 June 1908), '. . . and how I hate to pain you . . . but I see the inevitable . . . Forgive me Ottoline.' It is possible, of course, that he was not attracted to her, but some of his letters suggest the contrary. It is also possible that, seeing her as a patron for his work and as someone who would introduce him to prospective purchasers, he was at pains to avoid a situation that, by promising too much, might alienate her. But again his correspondence does not corroborate this. It is true he did benefit a little through Ottoline's friendship,* but those letters in which he writes of pictures invariably petition help for his friends, particularly Epstein and Lamb.† As his later dealings with the American collector John Quinn would confirm, he was secretly a generous man but, rather in the style of Bernard Shaw, tried to avoid a reputation for generosity because it complicated life.

Like money, love-affairs were a means to an end. They were explorations within himself of new continents, symbolized by his request to each woman to re-christen him.‡ They discovered aspects of himself he had never imagined before; they taught him to get away from the dull old stamping grounds, to become another person. This was their fatal charm. For when the new continent had been thoroughly explored, the new self mapped and assimilated into the central empire of the self, there was no more mystery: and interest died.

Love-affairs gave Augustus energy – without them he was passive. They involved his vanity, compensated for his lack of conceit. But once the passion had flown and the empty husk of the relationship remained, it would depress him dreadfully. It is this he sees so clearly as the inevitable outcome of his affair with Ottoline – unless, that is, they could end it while it was yet unfinished. It is a contest between the fleeting present and the long waste of the future, with its quagmires of guilt,

* 'How good of you to get the Duke of Portland to buy my drawings,' Augustus to Ottoline Morrell (7 July 1908). The 6th Duke of Portland was Ottoline's half-brother.

† 'My friend Lamb has just 40 francs left to carry him through the summer . . . Epstein is slowly being killed in London. It seems to be a general superstition that artists can live on air – whereas the truth is their appetites, like their other capacities, are exceptionally good,' Augustus wrote to Ottoline (20 September 1908). Later that month he wrote: 'You were good sending that cheque to my friend Lamb . . . Epstein is I think still very hard put to it . . . It would be grand if Portland or anyone else gave him a commission.' With characteristic generosity Ottoline gave Epstein an order for a garden statue and took likely clients to visit him, including W. B. Yeats and Lady Gregory, who commissioned him to do a bust of herself.

‡ Ottoline called him Elffin. When he no longer signs himself Elffin their love-affair (but not their friendship) is at an end.

responsibility and unevenness of feeling. It was this hangover of love that sapped his energy.

He warns her as clearly as he can that contact between them can only lead to disenchantment. He needs her – as a model. 'I am aware of my brutalities – and all my agonies and joys, and will continue as God made me,' he writes (28 July 1908), ' . . . and will do yet the work that no one else can do *quand même*.' For any unhappiness his character is to blame. 'I should be called Legion and you know only one or two of me yet.' Some of these selves were not attractive: they were melancholic-aggressive or inert – and he had no control over their comings and goings. 'I felt I was *fated* to cause you in the long run more pain than happiness – and that I could not acquiesce in,' he writes in another letter (21 December 1908). 'I dislike sailing under colours none of my hoisting . . .

'With every wish to be honest I suppose I cannot escape those notorious disabilities which I must share with all true Welshmen . . .'

Truth gradually gives way before a curious rigmarole of romantic assumptions tenaciously held by each of them on behalf of the other. 'You are the most generous soul in the world and I the mouldiest,' he asserts (June 1908). But Ottoline maintains that it is *she* who is worthless – worthless without him. He is a genius: what do her petty pains and cares matter beside his needs? She will come to him tomorrow. Her letter awaits him when he gets back very late at night to Fitzroy Street, and at four in the morning (4 June 1908), in some panic, he replies: 'Ottoline. Don't come to-morrow. I'm not able – yes you are too great for me, vulgarly tragical or unhappy.' But Ottoline only wants to serve him. She feels humbled before his goodness, his concern and tenderness for her. If only she had *more* to offer him. The postman hurries back and forth with their bits of paper, delivering questions, answers, counter questions, often whole conversations on a single day. Even so, in their haste, they cannot always wait for him but must dash out to convey some vital postscript by hand. 'It is you who crush me with your goodness – no, exalt me!' Augustus contradicts her (3.45 p.m. 4 June 1908). 'Never will I cease to love and honour you, dear Ottoline. It is you have genius. Otherwise our meeting would have been inevitably calamitous . . . I am necessarily miserable and feel myself abject and unable to face people I respect. Daughter of Heaven that you are – I can only *really* approach you spiritually. Do you know I have just seen how I should paint you . . . Elffin.'

Truth gives way: but it never disappears altogether beneath the haze of protective romanticism, for other people are involved. One of these is Ottoline's husband, Philip Morrell. Augustus's attitude to him had commenced jocular: 'Keep Philip happy,' he counsels her (9 June 1908),

'and make him blow up the houses of Parliament.' But Ottoline, who by now is infatuated with Augustus, cannot conceal her feelings and soon the situation grows awkward. 'I think it evident that your husband don't like me,' Augustus protests (8 January 1909). The possibility of a scandal that, since it involved a member of Parliament, would hit the headlines alarms him to the point of pomposity. 'I was not really surprised that Morrell should have been out of humour,' he informs Ottoline (18 December 1908). 'I felt I was cutting rather an offensive figure in your house. I should be very sorry to disturb so admirable a personage as your husband. I have nothing but respect for him and would never question his right to object to me . . .'

The other person involved was Dorelia, whom Augustus was very anxious to avoid offending by this new liaison. Whenever he sees Dorelia, he reassures Ottoline: 'Do *not* harbour the thought that I am going to forget you'; or 'I hope you will never suspect me of indifference'. But there is never any doubt that Dorelia comes first – about this he is specific: 'I love no one living more than Dorelia, and in loving her I am loyal to my wife and not else,' he explains to Ottoline – then adds: 'You are certainly wonderful – Ottoline . . . There *will always* be that infinitely precious cord between us – so fine, so fragile that to strain it would break it. And you will not continue to suffer too much, you will have the fortitude of great hearts and unconquerable souls – and the sweetness of the music of heaven will teach you to smile at last with the sweetest smile of all, and the profoundest. Bless you, Ottoline. Elffin.'

Although Dorelia was very strict at this time, and very suspicious, there were several reasons why she did not object to Ottoline. There could be no doubt that their relationship was partly a business one. Besides which, Lady Ottoline Morrell was utterly unlike the barmaids, actresses and models Dorelia had so far come up against. Then, until March 1909, she had never met Ottoline.

They met for the first time in Augustus's studio one day while Ottoline was sitting for her portrait. Dorelia seemed to take little notice of Ottoline; but Ottoline studied Dorelia very keenly. 'She had the dignity and repose of a peasant from a foreign land,' Ottoline noted in her diary.[191] '. . . nonchalance and domination towards the children, a slightly mocking attitude to John, and shyness, *méfiance*, towards me, which melted by degrees. Between my sittings we sat round the large table for tea, the children eating slices of bread and jam, John looking a magnificent patriarch of a Nomad tribe, watching but talking very little. I saw that in every movement Dorelia made there was such grace and rhythm that she was indeed a stimulating model for any painter.'

From this day Ottoline set out to make a friend of Dorelia. It was uphill work. The two women were utterly different – Ottoline sophisti-

cated and histrionic; Dorelia simple and laconic. To complement
Augustus's Carlyle, Ottoline bought Dorelia a large Leghorn hat. She
put it on without a word, but with her special smile, looking secretly
beautiful. Yet despite all Ottoline's overtures of friendship, Dorelia
remained strangely unforthcoming, and when Ottoline invited her with
Augustus to a dinner party to meet the stars of Bloomsbury, Virginia
Stephen,* Roger Fry, Clive and Vanessa Bell, she received a dis-
concerting refusal:

'Dear Lady Ottoline, Thank you very much for your invitation but I
cannot come as I think it rather ridiculous to be introduced to people
as Mrs John. I do not know the Bells.

'John asks me to say that he will be pleased to come. I'm afraid you'll
think I'm rather ungracious.'

But, being simple, Dorelia saw clearly what so many clever men of
Ottoline's acquaintance obscured: that she was essentially a generous
woman. To this generosity Dorelia naturally responded, adding to the
letter: 'I wonder if you would care to come here? I should be very
pleased to see you. Yours sincerely Dorelia McNeill.'

For all this diplomatic skirmishing, the position threatened to become
more complicated. In any solution between the four of them, there were
several differences that could never be dissolved. But by a sudden
unthinking act of genius, Dorelia averted trouble. She took Ottoline
one day to meet Henry Lamb. He was the perfect understudy to
Augustus. By the summer of 1909 he even occupied his studio in Fitz-
roy Street, Augustus having moved back into Chelsea. Arrayed in
tobacco-coloured frock-coat and breeches, looking like some marvel-
lous lackey, Lamb had flowered into an astonishing figure. Ottoline
could not take her eyes off his slim visionary silhouette, tinged with
khaki, and by the end of the year he had very largely replaced Augustus
as an emotional figure in her life. 'Elffin' was no more; but to Augustus
and Dorelia, Ottoline remained a loyal friend. Not the least of her uses –
and the one that first melted Dorelia – was to the children. And with
these they needed all the help available.

6. FIGHTING THE PHILISTINES

Like a pair of skilled jugglers, Augustus and Dorelia had kept revolving
in the air every one of the schemes they had first introduced into their

* 'The age of Augustus John was dawning,' Virginia Woolf had written. When
she met him and Dorelia – 'figures as beautiful and almost as improbable as' Otto-
line – she and her friends 'were all swept into that extraordinary world where such
odd sticks and straws were brought momentarily together. There was Augustus
John very sinister [?] in a black stock and a velvet coat . . .' See Quentin Bell's bio-
graphy of Virginia Woolf, Vol. I, pp. 124, 144–5.

act at Equihen. To be or not to be married; to live together, or apart, or both – and where or anywhere: the range of alternatives spun before their faces ever more fantastically.

For much of the winter of 1907–8 Dorelia had stayed on in France. There were many matters for her to attend to: sorting out 'clothes, curtains, cushions etc.' from the studios – 'and then there is the accordion and various musical instruments' including the gypsy guitar Ida had never learnt to play. She gave up her apartment and, with Pyramus and Romilly, moved through a series of hotels. She was seeing much of Lamb who, in Augustus's words, had finally 'lost his dear little wife. I think he wants a change – his letters are getting a bit pompous in style.' But most of her time was spent 'making clothes for the kids' of the most anti-Wigmorian cut. She wrote to Augustus for supplies of wool, money and tobacco: and she waited.

Augustus meanwhile bent his mind to grappling with their problems. 'It's a damn puzzle what to do just now,' he admitted. ' . . . It seems pretty evident we ought to have a house somewhere in the country on account of the multitude of children, and the expense of a London house. In a couple of years I'll be pocketing thousands but just now is the fix,'

He could not, however, get unstuck from his work long enough to investigate very much of the country, and this was the reason, he explained to Dorelia, why he began to 'look for a house about London'. To Lamb he wrote (10 January 1908): 'I'm trying to get a house in Hampstead on the heath – which is much better than most country I seem to find in England – in fact the heath is incomparably lovely.' What his method relied on for success was a coincidence between what he happened to find and what his dreams of the perfect life happened to be. But coincidence was made difficult by his dreams flashing past so swiftly – no house seemed able to catch them. While exploring Hampstead, for example, he dreamed fervently of Toulouse. Wyndham Lewis thought of going there, and anything Lewis could do . . . But then a brilliant new notion seized him. Spain! A young friend, the celebrated practical joker Horace de Vere Cole who, in the guise of Sultan of Zanzibar had ceremonially inspected Cambridge, now (with a perfectly straight face) recommended a castle in Spain. 'I met the Sultan of Zanzibar in Bond Street yesterday,' Augustus reported to Dorelia. 'He said he was going to Spain with Tyler.' Royall Tyler,* he added was 'my latest friend', a Bostonian and a

* Royall Tyler was the author of *Spain: A Study of her Life and Arts*, 'a capital straightforward business-like book . . . My only objection is to the title, as I think Spain is a neuter noun,' A. E. Housman wrote to the publisher Grant Richards (6 July 1909). Richards himself had more to object to, since Tyler then ran off with his wife, a woman in the high Spanish style.

profound student of Spanish matters. 'He is going to go mad one day,' Augustus predicted, '– I saw it in his hand and he knows it.' The more he thought of Spain, the less attractive Hampstead or even Wantage (which he had previously scrutinized) appeared. Despite rumours, there seemed nothing specially improbable about the Spanish scheme. After all, as he once boasted to Ottoline (13 January 1909), 'I am, by nature, clearly intended for the bull-ring.' Wyndham Lewis further kindled his imagination by declaiming pages of Spanish poetry to him. 'I found myself in a perfectly dangerous state of health . . . I wrestled with [John] Fothergill and nearly killed him.'

In April 1908, inflamed by poetry, he set off in pursuit of some Spanish gypsies, picking up Dorelia in Paris on the way. From the Hôtel du Mont Blanc in the Boulevard Edgar Quinet, he wrote to Ottoline (28 April 1908):

'Spain is cruel – but I have blood-thirsty moments myself . . . Have you ever found it necessary to strangle anybody – in imagination? There is indescribable satisfaction in it. At other times I feel more like bringing people to life. My Variability is rather disconcerting and hardly makes life easier. I must learn discipline and consistency.'

Spain, which had seemed for a few moments a likely winner among his many schemes, now began to fall back. He got no nearer the Spanish border on this occasion than Paris itself, and it took him almost another fifteen years to complete the journey. 'I am perturbed by the spectacle of Spring and the green leaves seem to cover the branches all too guiltily,' he told Ottoline (4 May 1908). He was staying at the same hotel as Euphemia, and wondering whether he shouldn't after all 'shut myself up in my studio – and do something – not merely contemplate'.

His indecision was helped by Dorelia who had now determined to 'wander about' France with some of the children, in preference to settling down with Augustus. 'It would I think be out of the question to allow her to take Edwin for the reason that her own two boys are quite enough to keep her busy,' Augustus appealed to Mrs Nettleship, 'although she would cheerfully take charge of the whole lot . . . I know no princess with maternal instincts unsatisfied, unfortunately, who would open her gates to my poor boys. Perhaps I may meet one . . .'

Where Dorelia would wander and for how long was, like most other things, unsettled. Once again, and with several later entries, it was neck-and-neck between all their schemes. But some final decision was becoming urgent. 'Travel as we may,' Augustus wrote to Dorelia, 'we want a pied-à-terre *somewhere*.' In the interval there was nothing for Augustus to do but turn his back on Spain and go back to Fitzroy Street. 'I haven't taken the house yet – it seems to me sometimes quite unpractical without Ida,' he wrote to Mrs Nettleship. 'Just now I really

don't know what to do – apart from painting. The house I looked at is lovely and the heath of course.'

So far as the children were concerned, Augustus was considering farms. He bundled them along to stay with various friends in the country, in particular to Westcott in Berkshire where Charles McEvoy lived,* and where they all went a number of times before deciding against it. 'There are grand backgrounds in Berkshire for noble decoration,' he reported to Lamb. 'It is unfortunate that the peasants have taken to motor caps and bicycle shirts.' Then, on his way back, he fell in with a man who told 'me about the country near Naples [where] he used to live,' Augustus wrote to Dorelia. 'I asked him how much one could live there for with a family – he said £250. I have ordered a pass-port. It will be ready the day after to-morrow . . .'

A real decision could only be wrung out of Augustus by some crisis, and it was Dorelia who now presented him with this sense of crisis, as he began to suspect she might never return from her wanderings.

'You know very well I want to live with you and no one else,' he wrote to her after she had left, 'but it seemed pretty clear you were too dissatisfied with me – and even found me repugnant at times. You were often enough talking about going off – as to making a beast of myself you alone can stop that. I wish you were here – if you want to be absolutely independent I don't want to be dependent . . . Will you come over? or will I come back? Doing nothing is killing me. I wish you would come south with me. I can't stand the thought of separating – only if you *want* to I can do nothing.'

The danger of losing Dorelia altogether concentrated Augustus's mind wonderfully. It was a kind of death. 'C'est bien que toi que je désire – mon ange,' he declared, '– c'est bien que toi.' When Augustus was decisive, Dorelia fell in step with him. Between their various schemes it was now a photo finish, which revealed – a dead heat! For they agreed to marry, and yet not to marry: to marry, so far as the Nettleships were concerned, almost at once; but not to translate this

* 'Charlie McEvoy nearly killed me in the evening by his drolleries,' Augustus wrote to Lamb (24 August 1907) after an early visit to Westcot. 'He has recently had a play put on by the Stage Society which was a great success, the most enlightened critics combining in a chorus of praise. He sketched me the plot of his next play which also endangered my life. It is regrettable I am at the mercy of these comedians.' In 1907, McEvoy had written 'David Ballard' and he was also the author of 'The Village Wedding', which was performed by the village players at Albourne. In 1908 Augustus had done an etching of him (C.D. 20) described by Campbell Dodgson as 'a wonderful example of direct and unprejudiced portraiture, a perfect likeness and a masterly, though by no means beautiful, etching, which ranks by general consent as one of the best of Mr. John's plates'. It was first shown at the fourth exhibition of the Society of Twelve in 1908.

policy very urgently into fact. Augustus promised 'to raise the wind' in Wigmore Street 'which is quite willing to blow just now', and added: 'I'm beginning to feel myself – ten times as efficient as anybody else.'

This policy of marriage was partly to make it clear to the Nettleships that they proposed taking away the children and making a home for them. Believing that his life was falling apart, Mrs Nettleship had recently swung into the attack, apprising Augustus that 'a woman who kills an unborn child is not fit to have the care of children'. In a heated exchange between the two of them Augustus felt able to answer that, in accusing Dorelia of bringing about a miscarriage, she was condemning Ida, 'who had tried the same thing'. He himself took the other view – that by 'annihilating a mass of inchoate blubber without identity at the risk of her life to spare me further burdens', Dorelia had proved 'her unusual fitness for the bringing up of children'. Was it not Mrs Nettleship herself who had first 'instructed Ida in the mysteries of child-prevention? – mysteries which she was evidently not quite equal to mastering, thank God! . . . I would have killed many an unborn child to keep her [Ida] alive – and even have felt myself perfectly fit to take charge of children.' The outcome of this row was that both of them lost their tempers and Augustus finally notified Mrs Nettleship he 'was taking all the children away and was at last happy at the thought of resuming our ménage where it left off – with Ida there in spirit and in the blood of her kids.'[192]

Realizing that by treating Augustus in the way Uncle Ned had prescribed she had committed a bad error of tactics, Mrs Nettleship now sent him a conciliatory letter in which she allowed that to marry Dorelia was 'obviously the correct thing to do'. But Augustus was only exacerbated further:

'It is by no means from a desire to be "correct" that I am going to marry Dorelia. It is precisely because she is the only possible mother to Ida's children now Ida has gone, since I love her, knowing her to be such. And for no less reason would she consent to marry me, or I her. She is entirely and absolutely unselfish as Ida was and as their life together proved, with such proofs as stagger the intelligence. She is besides the only woman who does not stifle one in domesticity and who is on my own plane of intelligence (or above it) in a word the one woman with whom I can live, work and still be a father to all my children. Without her I would have to say good-bye to the children, for I cannot recognise them or myself in a house and an atmosphere which will ever be strange and antipathetic to me as it was to their mother . . .

'If I were not supremely confident that Dorelia and I are able to bring up the children immeasurably better than you or anybody else, I would not hesitate to leave them where they are. But as I distinctly object to the way they are being brought up with you, as I see quite

clearly it is *not* a good way, nor their mother's, Dorelia's or my way, I am going to take them away at once . . .'

Privately, to Dorelia, he confessed some doubts 'as we can't hamper ourselves too much'. But by now events seemed to have gained a momentum of their own which, like a whirlpool, pulled in Dorelia, who 'suddenly turned up here [8 Fitzroy Street] to help with the children', Augustus told Ottoline (26 June 1908). Together they would roam France with four kids, two of Ida's and Dorelia's two, he explained. 'They are not going to be brought up by Philistines any longer. I tell you I had to fight to come to the point.'

From Mrs Nettleship, however, he received literally more than he bargained for. At the end of June he had written to her outlining his plans: 'I am off to France in a few days and want to take David and Caspar with me – I would *like* to take them all of course – but am not quite ready for that. I think we may go to Brittany for the summer . . . I hate the thought of leaving Robin behind – and Edwin – and Henry!' Events now followed each other with what he called 'admirable briskness'.[193] Mrs Nettleship at once replied that she was holding on to the children, and that if Augustus attempted to abduct them she would have him committed to prison. As for Dorelia, she would prefer to see her dead than in charge of Ida's sons. To this, Augustus sent back an ultimatum: '*Take your proceedings at once, but deliver up all my children in your charge by to-morrow morning.*'

Next morning no children arrived at his studio, and Augustus marched round to Wigmore Street. What then happened he described in a letter to Wyndham Lewis (28 June 1908). Mrs Nettleship, he narrated, tried 'to take refuge in the zoo with my 3 eldest boys and only after a heated chase through the monkey house did I succeed in coming upon the guilty party immediately behind the pelicans' enclosure. Seizing two children as hostages I bore them off in a cab and left them in a remote village for a few days in charge of an elderly but devoted woman. The coup d'Etat was completely successful of course. Dorelia appears on the scene with almost miraculous promptitude and we take off the bunch of 4 to-morrow morning . . .'

Henry, who was only fifteen months old, missed this escapade and was exempted from the bargaining. For all of them, the results of that morning's manoeuvres round the zoo were to be permanent. Though they visited Wigmore Street in their holidays, Ida's four eldest boys were brought up by Augustus and Dorelia; while Henry, the odd one out, remained with the Nettleships, with consequences that were strange and tragic.

7. IN THE ROVING LINE

'Paris is amazingly beautiful and brilliant . . . Was it not mad of me to abduct my children in this way?' Augustus asked Ottoline (1 July 1908). 'But I was provoked to the point of action.' Even so, too many children and too little money was a worrying predicament – to be relieved slightly by landing Caspar on Lamb's shoulders and extracting money owed to him in England via the ever-faithful Will Rothenstein. 'The evil worm of distrust had begun to tickle me with the cold sweat,' he wrote to Rothenstein (July 1908), 'inducing suspicion that I had bitten off more than I could chew. But a few days en plein air renewed my courage . . .'

After a week in Paris, Augustus led his troupe off to Rouen, and from there they sailed to Cherbourg, the appearance of which 'pleased me well'.[194] He had money to last them all three months, but confidence enough to take them anywhere – Italy, southern France or beyond through the delightful country of La Mancha. Leaving Dorelia and the six boys in Cherbourg, he set off on foot. 'If my stars prove favourable I shall, I hope, start some beasts and vehicles and what not,' he announced to Wyndham Lewis.

From the first his stars shone dully. At Les Pieux he was seized by the police and interrogated on suspicion of loitering with intent, though he had been plainly walking without any intent whatever. Later he was robbed of his money in a restaurant and, without funds, refused a bed – 'so I stole into the country by bye-ways and slept under a hedge,' he told Lamb (July 1908), '– got down to a place called La Royel in the early morning, bathed my poor sore feet and . . . was refused milk and coffee'. It was not before he reached Flamanville that his luck began to turn. Here he caught up with a fête, 'a modest circus and a number of revellers keeping it up, was recognised by a charming circus man I met at Bayeux 2 years ago. . . . There was also a little Gypsy girl black as night who did the fil de fer. An intoxicated man conducted me down to Dielette where I finished him off with a bottle of wine. In the evening the crazy band drove round in a kind of box emitting gusty strains from various base instruments, the aged philosopher still capering and kissing his hand to the girls – a very wonderful company this – a very wonderful meeting.'

Next day he was again stopped by the police, and it became clear that any crime committed in the neighbourhood would quickly be credited to him. For the rest of his journey he 'took tortuous ways to avoid the police', he told Dorelia, sleeping in ditches and fields, under bridges and hedges, and often walking through the night. In a most revealing letter

to Dorelia, written from Dielette (to which, in his efforts to throw off
the police, he had secretly doubled back) he confessed:

'My love of my kind had already vanished and I was becoming a
rooted pessimist – as for J. F. Millet, he seemed to me a damned
blagueur – a bloody romanticist and liar – as he was in fact. But Dielette
renews me – it is astonishing – it is even better than my native town
where I ought to have stopped . . . The place is lovely – so varied –
sandy beaches, rocks, harbours and prehistoric landscapes behind. I
wish to God I had the sense of figures. My *watch* has stopped even, out
of sympathy I suppose.

'I shall probably be about here all to-morrow, so send me some calcu-
lations, I pray you, to guide me a little . . . You have only to lose your
temper to gain everything you want with people.'

To Will Rothenstein he had written: 'I don't want to fix myself long in
hired rooms.' Yet his designs to gather beasts and vehicles together and
follow a vagabond life through Europe had been hit hard by the police
hostility, and he reluctantly decided to postpone his pilgrimage and
settle down in seaside apartments. 'I don't see how we can all get on
wheels this summer,' he confessed to Lamb (July 1908). 'There are too
many children and too little experience. Besides a van is requisite and
my funds are low. All I can think of doing at present is to take some
rooms at Dielette for a month – (and they are dear enough) and then go
somewhere else.'

They moved into the Maison Delort late that July and stayed there
until the end of September. 'The boys are exceedingly well,' Augustus
reassured Mrs Nettleship, 'so don't be anxious.' They looked, so he
boasted to Ottoline (September 1908), 'like healthy vagabonds'. He
himself was anxious about Henry. 'I trust he is not over-clothed,' he
warned Mrs Nettleship. 'It is wonderful how children can stand cold if
they wear few things.'

The sun shone and he worked hard and happily. 'The days are
wonderful here,' he wrote to Ottoline (20 September 1908), 'and I am
working up to colour at last. Do you know Cézanne's work? His
colours are more powerful than Titian's and searched for with more
intensity.' His own colours he was now restricting to the three primary
ones represented by ultramarine, crimson lake and cadmium, with green
oxide of chromium. It was with these that he painted 'Girl on the Cliff',
better known by its Buddhist title 'Nirvana' * – a state of perfect beati-
tude where all passions are dissolved and individual existence absorbed
into the Supreme Being.

He profited much by his season at Dielette – 'I have got, it seems to

* A pencil and watercolour study of this, which served as a sketch for the oil
painting, is in the Tate Gallery (3198).

me, much further,' he told Ottoline – but the prospect of a dingy London studio and dingy London streets was not alluring. 'I wanted to get to the Pyrenees or further instead of lingering in the chilly north, but I lack the necessary millions. So back again to the horrors of a Cockney winter. Are there no millionaires of spirit?' he asked Will Rothenstein. 'It would be cheaper and infinitely better to have a few houses about the place to go to,' he told Mrs Nettleship. 'I am more than ever convinced of the necessity of having at any rate one fixed roof not too far from London.'

He returned to London with Dorelia and his six sons early in October, and within a month he had found a house[195] 'in Chelsea with a big studio'. This was 153 Church Street, off the King's Road – 'a good house',[196] Dorelia described it. They took a two-and-a-half year lease and, after various delays, moved in shortly before Christmas. 'There is plenty of room and a piano,' Augustus invited Lamb (23 December 1908). ' . . . I hope you will come at once. You'll have a room to yourself.'

London that winter seemed 'very hostile and the English sillier than usual'.[197] Unemployment was rife, jobless men roamed the towns in their thousands, and members of Parliament warned one another that blood would soon be flowing in the streets. 'I hope blood will flow as nothing good can happen without,' Augustus declared.[198] Meanwhile, despite his mood of anarchy and the usual number of conflicting plans – for another studio in Liverpool, a flight to Naples, and a country house on the north coast of Wales – he settled into the shell of his new home as if for protection against storms to come. 'Perhaps the Epsteins may come to dinner to-day,' he wrote to Ottoline (26 December 1908), '– now that we are bourgeois folk with carpets and front doors and dining-rooms.'

> *Wanderers, you have the sunrise and the stars;*
> *And we, beneath our comfortable roofs,*
> *Lamplight and daily fires upon the hearth,*
> *And four walls of a prison, and sure food.*
> *But God has given you freedom, wanderers!*[199]

A broken collar bone partly accounted for Augustus having consented to turn bourgeois for the winter. But, with the coming of spring, mended and eager, he resolved to abandon his carpets and comfortable roof, and break out into Gypsydom – that way of life best suited to horrify the bourgeoisie. For three months he chafed within his prison walls, but found some relief in reading Dostoievsky's *Les Possédés*, 'a wonderful book', and in submitting himself to be 'overhauled' by a new

doctor. 'I am tired of nerves and glooms,' he told Ottoline* (13 January 1909), 'and one could certainly surmount them, unhandicapped physically.' By February he was already feeling 'dangerously healthy', the proper condition in which to take the road.

During this gloomy period of waiting, while he dreamt only of the freedom into which he would soon plunge, he threw off a masterpiece – a wonderfully dandified and belligerent portrait of the painter William Nicholson. 'I have started Nicholson,' he wrote to Ottoline on 8 January 1909, '– as a set off to his rare beauty I am putting in a huge nude girl at his side. This will add to his interest, I feel . . .' But eventually he put in one of his own paintings – a girl, fully-clothed, against a mountainous landscape at the right-hand corner of the composition, where his signature would have been. He showed similar restraint throughout the picture, which is executed in sombre, throbbing colours.† 'William, overcoated, yellow-gloved, the picture of a Georgian buck, glares from the corner of an overdark eye at the beholder,' wrote Marguerite Steen: 'a superb piece of coloratura painting, ranking with the Suggia as one of the finest of John's portraits, though not quite convincing as a likeness of the sitter. Still, perhaps in those days William did look like a gentleman pugilist, or perhaps this aspect of his personality was called out by their mutual fondness for the ring.' For several years Augustus himself believed this to be his best portrait. He had recognized in Nicholson a superb subject, but unless commissioned he could not afford to paint him. So Nicholson himself commissioned the painting for a small fee which he nevertheless forgot to pay and for which Augustus forgot to ask.‡ When, some years later, the Fitzwilliam Museum at Cambridge bought the portrait for a thousand pounds, the two painters happily pocketed five hundred each.

Even before this portrait was finished, there came over him the absolute necessity to travel. Ever since the birth of Pyramus, the caravan

* Ottoline had recommended one of her own doctors who, Augustus told her (6 February 1909), 'was evidently a celestial emissary in disguise'.

† Mostly brown and ochre. The head is done in slightly paler tones of the same colours, and leads the eye gently into the composition, while the black hair links the face and the figure to the rest of the composition. The portrait is completely self-contained and achieves a perfect harmony. There is a static, almost Hockney-like quality to Nicholson. The line of the curtain conducts the eye downwards towards him, is continued in Nicholson's raised finger, his legs and cane, and finally the sedate figure itself, halting its progress. It is a cast-iron composition, worked out to the last detail. The impasted highlights on the shoes connect with the creamy impasto on the cushion, the white gloves, whites of eyes – the stages linked by the white cane. The curtain pattern is echoed by the colours in the John painting in the right-hand corner. There is an effect of space and atmosphere without the use of chiaroscuro.

‡ But which was nevertheless paid eventually. Probably one hundred pounds.

which Augustus was buying from Salaman had lain gently disintegrating on Dartmoor. But recently he had moved it up and anchored it at Wantage with Charles McEvoy, where it was given a lick of fresh paint. A brilliant blue, it stood ready for adventurings. On his first expedition, he took along John Fothergill, architect and innkeeper, as companion. They trundled off on the first of April. 'I called on [Roger] Fry at Guildford and found him in a state of great anxiety about his wife who has just had another attack,'* Augustus reported to Ottoline (8 April 1909). 'He sent off his children that day. I was sorry as I wanted to take them on the road a little. Fry came down and we sat in the caravan awhile. Next day I hired a big horse and proceeded on through Dorking and up to a divine Region called Ranmore Common . . . I called at the big house to ask for permission to stop on the common and was treated with scant courtesy by the menials who told me their man was out. So on again through miles of wild country to Effingham where, after several attempts to overcome the suspicion attaching to a traveller with long hair and a van, I got a farmer to let me draw into one of his fields. At this time the horse was done up and my money at its last.' So he left his van in the field, along with the sleeping horse and the sleeping Fothergill, and caught the milk train up to London. He had covered eighty miles on the road and it had all been highly satisfactory. But this was a mere beginning, a mere flexing of muscles. The summer would be spent with all his family away from front doors and dining-rooms; with the wind in the night outside and the stars in the wind; with the sun and the rain on his cheek.

Ever since the market days in Haverfordwest, since his first visits to the circus and his sight, on the wasteland outside Tenby, of the raggle-taggle gypsy encampment with its wagons and wild children, its population of hard, high-cheekboned men and women, their faces dark as the earth, he had felt attracted to travellers and show people. Destiny had drawn him closer to them after meeting John Sampson when he had begun to learn their language. Since leaving the art sheds at Liverpool, he had often revisited Cabbage Hall on 'affairs of Egypt'; and elsewhere, encounters with such people as W. B. Yeats, with his addiction to tinkers as well as countesses, and Lady Gregory, with her studies of local myth and dialect, had helped to widen his knowledge. But it was not until 1908 that he began to dream of living as one of them. Two things that summer had contributed to this dream. While in Paris he had met several new friends in the luxurious apartment of Royall Tyler. Among these was the gypsy guitarist Fabian de Castro. The two of them entered into a deal whereby Augustus taught the guitarist to paint,

* Helen Fry suffered from an incurable thickening of the bone of her skull and in 1910 was consigned to a mental home until her death in 1937.

while de Castro passed on to Augustus some of the songs from his voluminous repertoire. During these reciprocal classes, de Castro told Augustus something of his background. Now forty, he had been born at Linares in the Province of Andalusia. While still a lad he was seized with the *Wanderlust*, forsaking his respectable family to take up with *gâjos* and other gypsies, like himself, in the roving line. His conviction that he was of noble descent from the Pharaohs was fierce and unalterable. He had travelled alone and in strange company, on foot and otherwise, through many lands plying many trades and practising many arts, to which he now intended to add the art of painting. Augustus was enchanted by his stories told with that serious self-mocking gypsy humour which found fun in the most unexpected places and was seasoned with a philosophy of which these wandering Bohemians, it seemed to him, alone possessed the secret. After a day spent in talk, song, paint and laughter, towards evening they would be joined by other cronies, 'Drummer' Howard, Tudor Castle, Horace de Vere Cole, and together they would set off to see La Macarona and El Faico, the celebrated Flamenco artists. This was Augustus's introduction to the Flamenco tradition of music and dancing, and it moved him extraordinarily deeply. The intricate rhythms seemed to stir up undercurrents of anguish and regret that astonished him by their force. The harsh outcry of the singers, rising convulsively from the very bowels, merged with the insistent humming of strings into a heart-breaking ululation, suggesting the lamentations of beings thrust out of heaven and debarred from all tenderness and hope: all but the hunger, the irony and bitter passion of the damned. While the dancers themselves illustrated, with superb precision, the pride and glory of the flesh.

After this week was up, Fabian de Castro left for Toledo, where, having painted after Augustus's prescription a huge and unorthodox Crucifixion, he was rewarded with imprisonment in the *Estaripel* for committing an act subversive of law and order. Augustus took something of a vicarious pride in his pupil's accomplishment, though imprisonment in Spain, he admitted, (even for *lèse-majesté*) was a thing that might happen to anyone, like lunching in England.*

By this time Augustus had reached Cherbourg, where he had fallen in with a raucous band of Russian coppersmiths from Baku. 'I was thrilled this morning – and my hand still trembles – by the spectacle of a company of Russian Gypsies coming down the street,' he had illegibly written to Will Rothenstein. 'We spoke together in their language –

* 'Let us hope that Fabian will soon be released to sell the notorious work at an increased price,' Augustus wrote, 'and add one more chapter of accidents to those amazing Memoirs, the publication of which may be eagerly looked to by Gypsy students.' *Journal of the Gypsy Lore Society*, Vol. 5, 1910, pp. 135–8.

wonderful people with everyone's hand against them – like artists in a world of petits bourgeois.' At once he set about compiling word lists of their beautiful, fragmentary vocabulary, and taking down their songs. This data he sent back to Liverpool. 'It was a difficult job getting the songs down,' he reported to Scott Macfie (11 August 1908), '– everybody shouting them out, with numerous variations – but they showed the greatest satisfaction on my reading them out . . . I don't like extracting words by force from Gypsies – it is too much like dentistry. I prefer to pick them up tout doucement.'

Back at Liverpool, the gypsy scholars had dug up an international plot legally to expel the gypsies from Europe. This hideous news, reaching Augustus, lodged in his imagination and eventually sired there a mammoth sentence:

'The concept of Sophisticated Europe rejecting the wisdom of Babes and the Light from the East,' he wrote to Scott Macfie (16 March 1908), 'produces in me a sensation of mortal sickness; I feel *myself* personally outraged and assailed by a horrible and inhuman monster – a monster begotten by brute Stupidity upon terrified Ignorance, weaned in the lap of Hypocritical Conceit and sponsored by Vulgarity Triumphant – in other words the hideous Dragon of Democratic, Altruistic, Authoritative, Purblind, Pragmatical, Grand-motherly Legislative Force – and impregnable like some monumental masterpiece of Victorian Sculpture, this monster hermetically garbed in the spot-less and refulgent broadcloth of undetected Turpitude – stands – as my vision presents him – in an attitude expressive at once of an almost overburdened consciousness of moral responsibility and an immediate readiness to *protect* at all hazards the indispensable activities, the hard-earned and taste-fully amassed belongings and the super-refined sensibilities of the blameless and disciplined rate-paying myriads he "represents" – with one hand holding, say, a copy of the "New Theology", the other raising towards his lips a Policeman's Whistle . . .'

The very quality that the police feared and prosecuted, Augustus exulted in: it was the *unexplained* – to them merely the misunderstood – to him the mystical. His pursuit of this pilfering, unprotected race, his attempt to become a part of their wandering community, to be admitted as a *rai* (a non-blood brother) stemmed from his preoccupation with the lost, primitive world from which we all derive. In taking to the road he was not just following an isolated whim. He was reacting, as others were beginning to, against the advance of industrialized society, with its inevitable shrinking of personal liberty, its frontiers barbed-wired by a rigmarole of passports and identity cards, rules, regulations and Thou-Shalt-Nots, by the paraphernalia of permits, licences, censuses, forms in triplicate. This urge to escape from the city was the obverse of his

longing to reawaken an intuitive response to the natural world. Since he dared not be alone, a gypsy community seemed the best method of achieving this. By consorting with these quick, strong, vital and deceitful people, by mastering their ancient tongues, by penetrating behind the false glamour and living, like them, round bonfires under the dark prehistoric night in tense harmony with Nature, Augustus was searching for his own soul, for a way of holding in equilibrium all the contradictory impulses in his temperament. He was not alone in seeking a solution to such problems in the Gypsy cult. His obsession recalls that of Jacques Callot, but it was also finding a parallel in contemporary literature from Arthur Ransome's *Bohemia in London* (1907) to the pastoralism of the Georgian poets and the chunky anthologies in paper-boards produced by the Poetry Society.[200] No wonder the chief ornament of the Georgians, Eddie Marsh, lost sleep wondering whether he could afford a second John for his collection; and Rupert Brooke, beholding a John picture at the New English (1909) felt 'quite sick and faint with passion'.[201] To such poets and impresarios, no less than to student painters, Augustus, 'with his long red beard, ear-rings, jersey, check-suit and standing six feet high, so that a cabman was once too nervous to drive him', as Edward Thomas reported[202] to Gordon Bottomley, seemed a natural leader. But where could they expect him to lead, except backwards? Their movement, which was to be shattered by the First World War, sought as if by some gypsy spell to freeze the uniform march of industry across the country. But the best they could hope to win was a little extra time:

> *Time, you old gipsy man,*
> *Will you not stay,*
> *Put up your caravan*
> *Just for one day?*

Already, with his comings and goings, Augustus had grown 'so damned Gypsy like,' in the words of Scott Macfie, 'that unless one writes at once one runs the risk of missing you'. On his return to London in the autumn of 1908, harried by the French police, an event occurred which persuaded him that he had penetrated, if not to the heart, at least to the body of the gypsy world. In fact it was a sign of the one aspect that most gypsies, however great their liking for him, resented: his freedom with their women.

'This morning I find a parcel which opened – lo! the ear of a man with a ring in it and hair sprouting around lying in a box of throat pastilles,' he wrote to Wyndham Lewis, '– nothing to indicate its provenance but a scrawl in a mixture of thieves' cant and bad Romany saying how it is the ear of a man murdered on the highroad and inviting

me to take care of my Kâri = penis, but to beware of the dangers that
lurk beneath a petticoat. So you see even in England I cannot feel secure
and in France the Police are waiting for me, not to speak of armed
civilians of my acquaintance.'

His broken collar bone that winter and removal to Church Street
had enabled him to pursue his gypsy studies at a more bookish
level. The *Journal of the Gypsy Lore Society*, first born in 1888, though
issuing songs transcribed by John Sampson 'on the highroad between
Knotty Ash and Prescot', had ceased to sing only three years later. But
now, like some sleeping beauty, she was being re-awakened by the kiss
of scholarship, enthusiasm and, what she had so lacked before, the
oxygen of money. They were, as the Devil is said to have remarked
when he looked down the Ten Commandments, 'a rum lot', these
Edwardian gentlemen who in company implanted this kiss of life: a
cosmopolitan band of rogues and idealists led by the portly and pontifi-
cating Sampson and assisted by various willing girls indispensable, in
Sampson's view, to serious gypsy studies. Folklorists, philologists and
phoneticians, professors both Celtic and Scotch, zealous bibliographers
from Columbia drew together to investigate the gypsy question. Under
such learned attentions, the arms of the society stretched out to reach
anthropologists in Switzerland and linguists in India, embracing on the
way such odd bards as Arthur Symons, that living entombment of
'English Decadence', and (still at No. 2 The Pines) Theodore Watts-
Dunton, author of the sultry best-seller *Aylwin*, now, in his middle
seventies, about to be released from tending the sexually blighted
Swinburne and – a final brilliant touch – married to a girl of thirty.
Most prominent among these scholars and comedians whom Augustus
discovered to be his colleagues was an intimidating vegetarian, 'Old
Mother' Winstedt, John Myers, the finest scientific authority on gypsies'
poisons, and, from Lincolnshire, the Very Reverend George Hall,
expert poacher and approver of plural marriages, whose sport was
collecting pedigrees. Sampson had hoped that the presence of a parson
might give a collar of respectability, so far absent, to the gang's Borro-
vian adventurings – instead of which, his general appearance, tattered
clerical coat, huge bandage over one eye (he having fallen head first off a
cart) and habit of smoking a short pipe while drinking beer, produced
quite the reverse effect.

All this was made possible by the new honorary secretary of the
Gypsy Lore Society, Robert Andrew Scott Macfie, in truth the most
endearing of men: and rich. Now in the prime of life, tall, dark and
modest, of rueful and compassionate charm, he displayed an old-
fashioned chivalry counted upon by the others – and not in vain – to
bring in more lady members. He possessed the talent for getting on

with absolutely everyone, the gift (much exercised by Augustus) of tact. His interests were wide and his abilities various. A skilful musician, expert in typography and well-known bibliographical scholar, he was also a fluent linguist and had soon learnt the Romany tongue. He also claimed authorship of an authoritative and absolutely unobtainable work on Golden Syrup and, after the First World War (during which he served as regimental quartermaster-sergeant), a military cookbook, everywhere lit up by flashes of his quaint humour.*

Macfie had been the head of a firm of sugar refiners in Liverpool before being seduced by Sampson into his gypsy career. Boarding up his large house near the cathedral, he moved to 6 Hope Place, which now became the headquarters of the society. Augustus, on his many trips to Liverpool, would often call on him there and was usually relieved of some frontispiece or article for the journal.[203] Fired by Macfie's tact and enthusiasm, he was soon transformed into a vigorous recruiting officer in the ranks of the society. Patrons, dealers, private collectors, Café Royalists and society hostesses who wished to preserve diplomatic relations with him were obliged, as an earnest of their goodwill, to keep up their gypsy subscriptions. All manner of Quinns and Rothensteins found themselves enrolled, and some, for extraordinary feats, were decorated on the field.†

By April, Augustus was ready to penetrate beyond this screen of scholars into the fastnesses of Surrey, Cambridge and East Anglia. He had made what passed for the most elaborate preparations, obtaining letters of introduction 'from puissant personages to reassure timid and supercilious landowners, over-awe tyrannous and corrupt policemen and non-plus hostile and ignorant county people in general'.[204] He had done more. To the sky-blue van still stationed at Effingham he added another of canary yellow and a light cart, a team of sturdy omnibus horses, a tent or two and eventually Arthur, a disastrous groom. They mustered at Effingham – a full complement of six horses, two vans, one cart, six children, Arthur, a stray boy 'for washing up', a broken-down wagon, Dorelia and her younger sister Edie. 'We are really getting a

* For example: 'It is well known that putting jam or sugar on porridge, like wearing braces with a kilt, is one of the few crimes that definitely exclude a man from the Scottish suburb of Heaven.'

† 'I have recently taken it upon myself (with what share of justification I know not) to confer the title Rai upon a friend of mine – one Percy Wyndham Lewis – whose qualifications – rather historical or anthropological than linguistic viz. – the having coupled and lived in a state of copulation with a wandering Spanish romi in Brittany – seemed to me upon reflection to merit the honourable and distinctive title of our confraternity,' he informed Scott Macfie (6 November 1908). '. . . I may add that my friend appears fully to appreciate the value of his new dignity. He remarks: "Henceforth, my brother, my seed is implicated with that of Egypt".'

step nearer my dream of the Nomadic life,' Augustus told Ottoline. 'The tent we have made is a perfect thing and the horses I bought are a very good bargain. The children are naturally all the better for so much fresh air. I would like all the same a few little girls running about. Will you lend me Julian [205] for one?' Their camp was like a mumper's, only, he boasted, more untidy. Undeterred by the scorn of the local gypsy, the convoy moved off to Epsom, where Augustus hit the headlines by protesting against the exclusion of gypsies from the racecourse on Derby Day. Then, the race lost, he set his black hunter's head towards Harpenden, which they reached on 9 July. Augustus was exhilarated by their progress. 'It's splendid . . . I ride sometimes by the side of the procession, but for the last two days I've been drawing the big van with two horses. It's always a question of where to pull in for the night. Respectable people become indignant at the sight of us – and dis-respectable ones behave charmingly . . . I'm acquiring still stronger views regarding landlords.' [206]

His next stop was Cambridge, where he had secured a commission to paint a portrait of the classical anthropologist Jane Harrison, 'a very charming person tho' a puzzle to paint'.[207] He had been offered this job on the recommendation of D. S. MacColl who described him as 'the likeliest man to do a really good portrait at present', and who gave him preference over Wilson Steer 'whose tastes lie in the direction of young girls'. With this opinion Jane Harrison appears to have agreed, writing to Ruth Darwin, the promoter of the portrait: 'I personally should take his advice . . . he [Augustus John] seems to me to have a real vision of "the beauty of ugliness" . . . What I mean is that he gets a curious beauty of line: character, I suppose it would ordinarily be called, that comes into all faces however "plain" that belong to people that have lived hard; and that in the nature of things is found in scarcely any young face. Now this interests some people – I don't think it ever did interest Steer. If I were a beautiful young girl I should say Steer . . .'

Augustus's painting, 'the only existing humane portrait of a Lady Don' as David Piper described it,[208] pleased its sitter, in particular because Augustus used Steer's 'Yachts', which Jane Harrison owned, as part of the background. To D. S. MacColl she wrote (15 August 1909) in praise both of the picture and the artist:

'Thank you for finding Mr John. He was delightful. I felt spiritually at home with him from the first moment he came into the room: he was so quiet and real and sympathetic too. . . . He was perfect to sit to; he never fussed or posed me, but did me just as I lay on the chair where I have mostly lain for months. I look like a fine distinguished prize-fighter who has had a vision and collapsed under it. . . . It seems to me beautiful, but probably as usual I am wrong!' [209]

Augustus and his retinue had encamped in a field by the river at Grantchester, and every day he would drive to Newnham, 'working away in utter oblivion',[210] while Jane Harrison smoked cigarettes and chatted with Gilbert Murray. 'Although a complete dunce,' he recalled,[211] 'I enjoyed their learned conversation while I was painting, for in no way did it conceal the beautiful humanity of both.' Even so, he felt little need to advance further into Cambridge and, apart from a visit to James Strachey at King's to spread the word of Dostoievsky, he made almost no contact with the university. 'The atmosphere of those venerable halls standing in such peaceful and dignified seclusion seemed to me likely to induce a state of languor and reverie,' he wrote in *Chiaroscuro*,[212] 'excluding both the rude shocks and the joyous revelations of the rough world without.'

His presence, however, had already provided in itself a rude shock to Cambridge life. 'John is encamped with two wives and ten naked children,' Maynard Keynes inaccurately reported from King's College (23 July 1909). 'I saw him in the street to-day – an extraordinary spectacle for these parts.' Two days later he was writing to Duncan Grant: 'All the talk here is about John . . .* Rupert [Brooke] seems to look after him and conveys him and Dorelia and Pyramus and David and the rest of them about the river. . . . According to Rupert he spends most of his time in Cambridge public houses, and has had a drunken brawl in the streets smashing in the face of his opponent.'

The talk reverberated round the colleges to such an extent that special parties of Raverats, Verralls and the like would arrange expeditions to the field to catch a glimpse of them, watching Dorelia make a pair of Turkish trousers, or the children gnawing bones for their supper then falling asleep on straw round the camp fire – and other marvels. 'We cause a good deal of astonishment in this well-bred town,' Augustus observed.[213]

The resurrection of the 'two wives' legend seems to have arisen not only because of Edie McNeill, but the more improbable presence of Ottoline Morrell who, dressed in her finer muslins, had gaily accepted an invitation to their field. 'Come any day,' Augustus had wired. '. . . In case of any mistake our field is at Grantchester . . .'. Her experiences there over twenty-four hours were a demonstration of the curious fact that the pleasures of the natural life are not naturally accessible to everyone. Augustus met her at the station with a horse and high gig.

* 'He [John] seems to have painted Jane Harrison at a great rate – 7 sittings of 1½ hours each. She is lying on a sofa in a black dress with a green scarf and a grey face on cushions of various colours with a red book on her lap' (Maynard Keynes to Duncan Grant, 23 July 1909).

'Directly I climbed up into the cart the horse, which was a huge ungainly half-trained animal, began to back, slipped and fell down,' Ottoline recalled.[214] 'John rapidly descended from our high perch; he stood calmly smoking a cigarette, looking at the great brute kicking and struggling, but made no attempt to help. However, station loafers came to the rescue, and we adjusted the horse and harness. Up we got again, and slowly trotted through Cambridge to a meadow . . .

'How damp and cold and cheerless and dull it seemed. John was morose, with a black eye, the result of a fight . . . Dorelia and her sister, absorbed in cooking and washing, treated me with indifference and taciturnity, and made no friendly effort to make me feel at home. But after all it would have perhaps been a difficult task to be at home in a melancholy, sodden meadow outside a caravan.'

For her dinner, Ottoline was thrown a crust of bread and some fruit, while the children munched bread and jam. Next day she hurried back to London 'chilled and damp and appreciative of my own home and Philip'.

Augustus's famous fight had been against Arthur, the groom, who, the previous evening, had been flung into a pugnacious attitude by the notion of leaving Cambridge. It fell therefore to Augustus to correct him, and between pub and trap. they rained blows on each other, Augustus eventually carrying the day. Once recovered from their wounds they set off and gained a piece of waste ground near Norwich, where Augustus suddenly abandoned the lot of them. His next port of call was Liverpool and he had originally thought of travelling there in the vans. But 'it'll take me 3 weeks to get to you by road,' he told the Rani (July 1909), 'so I fear I must give up the plan and come by train'. So, leaving his women and children with instructions 'to come on steadily' or not at all, he walked into Norwich and caught a train on his way to paint one of the most notorious portraits of his career.

It was the custom in Liverpool for members of the city council to raise a private subscription of one hundred guineas and to present the retiring lord mayor with a ceremonial portrait. The mayor in 1908-9 had been Augustus's friend Chaloner Dowdall. Usually the chairman of the Walker Gallery was invited to choose the artist, but Dowdall, as whip of the Conservative party in the council, had so often collected the money for previous incumbents and knew so much about it all that, when the deputation came to see him and mentioned something about an artist, he at once asked it to let him handle the matter 'and you will have the biggest gate the Autumn Exhibition has ever had – and I shall have a picture worth five hundred guineas within five years time'. He then offered the commission to Augustus, who willingly consented:

'I'ld like very much to stay with you,' he wrote to the Rani. 'I believe Chowne has a studio for me if I want it. Don't let Silky [Chaloner Dowdall] worry any more. Tell him I'm coming . . .'

Augustus was full of ideas for this portrait, and proposed to Dowdall, as they went together to buy the canvas, painting not only the Lord Mayor but his whole retinue of attendants which went with him on State occasions. Dowdall, slightly alarmed, demurred on the grounds that his house, though large, could hardly contain so monumental a work of art. Augustus, while nodding his head in agreement, nevertheless bought the biggest canvas available. 'I was an ass not to agree,' Dowdall afterwards claimed.[215]

That afternoon Augustus made a rapid watercolour sketch, about 24 inches by 18, and next morning when the canvas had arrived he set to work, beginning with the two lines – the wand and the sword – on which the design was based. By lunch it was all drawn in. 'He worked like a hawk on the wing,' Dowdall observed,[216] 'and was white, sweating and exhausted.' The two of them repaired for 'a good lunch' which was served by Smith, the Lord Mayor's footman. Noticing that Smith and Dowdall got along very well, Augustus suggested that the footman should be included in the picture, and to this Dowdall and Smith agreed. 'The whole thing was drawn in on the canvas at a single sitting,' Dowdall recalled, 'and painted with extraordinary rapidity.'

What struck Dowdall as being so remarkably rapid lasted an eternity for Augustus.* At first it went 'without a hitch', he wrote to Dorelia, 'and it'll be done in a few days. It's great sport painting jewels and sword hilts etc. My Lord sits every day and all day and I've been working like a steam engine.' The town hall itself made 'a devilish fine studio', and he predicted that the portrait would be 'a shade better than Miss Harrison's'.[217] His only trouble was the background, 'which I didn't have the foresight to arrange first'. After a week this trouble had spread to the foreground, mainly because Dowdall would assume 'such an idiotic expression when posing'. This spirit of idiocy seemed to fill the town hall during his second week. 'It was frightful there,' he complained to Ottoline (9 September 1909), 'made all the more impossible by his lordship's inability to stand at ease. No more Lord Mayors for me. I used to be so glad to get out of the town hall that I roamed about the whole evening not returning till very late. I had but one desire: to submerge myself in crude unceremonious life.' Augustus had found he was expected to spend every evening and night with the Dowdalls, and to voyage back and forth with his subject in an official carriage and pair. The Liverpool police had appealed to Dowdall never to let Augustus out of his sight lest his excursions after dark be made a 'subject of comment

* In objective terms, about a fortnight.

Alick Schepeler

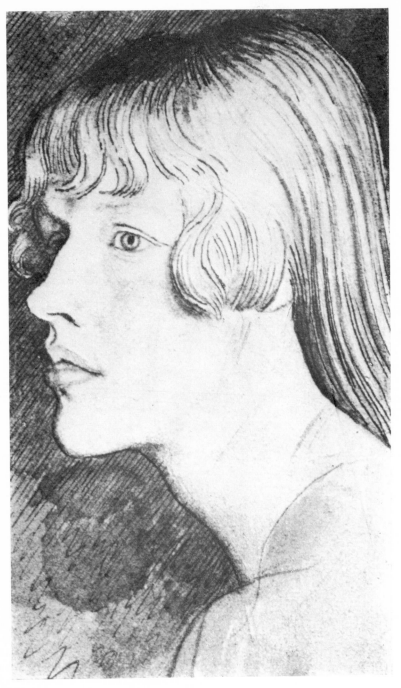

Euphemia Lamb ('Lobelia')

in the town, and . . . be held to prejudice in some way the dignity of his Office'.²¹⁸ After tasting the freedom of the road, Augustus found this atmosphere intolerable. He was seized with impatience, the result of which, in terms of paint, was an inspiration: the portrayal of Dowdall as a civic Don Quixote attended by his doubtfully obsequious Sancho Panza, Smith.

Near the end of the portrait, feeling he could endure the municipal strain no longer, Augustus absconded to Wales. His friend Sampson had recently rediscovered the celebrated gypsy story-teller and great-great-grandson of Abraham Wood, King of the Gypsies: one Matthew Wood who, since 1896, had vanished from the face of the earth. To Sampson he was invaluable as the last of his race to preserve the ancient Welsh Romany dialect in its purity. Like some hedgehog, he had been quietly grubbing along in a remote village 'at the end of nowhere'²¹⁹ and seven miles from Corwen, called Bettws-Gwerfil-Goch. Having triumphantly tracked him there, like an 'old grey badger to his lair', Sampson resolved not to lose such a valuable creature again till he had got to know him 'as well as his own boots'. He therefore rented two semi-detached cottages on the spur of Bron Banog, overlooking the village, knocked them into one, and now moved in with two imposing pantechnicons of goods and chattels, with Margaret his wife, a dwarf maid named Nellie, their sheepdog Ashypelt, and their three children, Michael, Amyas and Honor in the charge of two young 'secretaries', the fair Kish and the dark Dora. And Augustus.

He arrived one evening 'in the best of spirits', determined to profit by his freedom from Liverpool town hall.

'Matthew Wood with his fiddle and I with my voice entertained the company till late – and there was great hilarity,' he wrote to John Quinn (September 1909). 'There were two young ladies present, secretaries of the Rai. After going to bed I became possessed of the mad idea of seeking one of them – it seemed to me only just that they* should do something in the way of entertaining *me*. I sallied forth in my socks and entered several rooms before I found one containing a bed in which it seemed to me I discerned the forms of the two girls. I lay down at their sides and caressed them. It was very dark. Suddenly a voice started shrieking like a banshee – it might have been heard all over Wales. I thought then I had stumbled upon Sampson's boys instead of them I sought. I told the voice not to be silly and went away. On the landing appeared the two girls with a candle and terror in their eyes. I scowled at them and returned to bed.'

Next morning at breakfast, the maid Nellie entered and demanded an

* The words 'one of them' have been crossed out, and 'they' more accurately substituted.

explanation for his presence in her bed that night. Augustus, who had not seen her before, was horrified to observe that she was some four feet tall. He explained, with honesty, that it had been a mistake due to the peculiar pitch of Welsh darkness and the odd character of the house which together had left him entirely dependent on his sense of touch. But Nellie, very dignified, remarked that this hardly explained the nature of the caresses he had lavished upon her – and the little girl with whom she slept, Miss Honor. Each revelation seemed to make the business worse, and Augustus could only fall back on the claim that he must have been dreaming. By lunch, the atmosphere in the house had grown so constrained that he decided to slip away. His exertions to make a joke of the matter by suggesting it might have been worse – after all, supposing it had been Sampson's arms he had blundered into! – were met with silence.

He left after lunch without a word, walking down to the village to see about a horse and trap. Here Sampson overtook him to volunteer the advice that he should not return to the house, and upon Augustus assuring him that 'nothing could have been further from my thoughts'[220] and that he was even then on his way, Sampson relented and proposed a drink. 'We passed several hours with drinks and gypsies,' Augustus told the Rani. The inn resounded to the melodious din of richly inflected Romany, but after a while a discordant note was introduced by Matthew Wood's half-brother Howell, a hefty degenerate brute who began provoking Sampson, trying to pick a quarrel with him. 'We got outside the Inn and Sampson was shouting that he'ld have this dog turned out of the village.' Feeling he might owe his friend a good deed, Augustus offered to re-enter and, for a start, turn him out of the pub. 'This I did and shot him into the road. Then ensued a bloody combat.' Within the sunlit square each stripped to the waist and, in the style of the old-fashioned prize fight, began battle. After two long rounds Augustus had him on the ground 'but he was biting my legs. Up came the others, Sampson vociferating blood and death! And the poor Gypsy was led off streaming with gore, howling maledictions in three languages.'

It was well past midnight when Augustus arrived back in Liverpool to find the Dowdalls' house, out of which he had been so eager to escape, impossible to enter. 'I climbed over the fence and tried all the windows at the back. I tried to pull down one of those damn lamps,' he told the Rani. 'Your house is like a fortress. So I went into Sefton Park and lay under a laurel bush till dawn . . . about 6 [I] went and washed my gore and grime in the Central Station.'

Though much revived by experiences that would have half-killed another man, Augustus was in no frame of mind to do justice to his

model, the Lord Mayor, and despite the head not being quite all there to his satisfaction,* he got off that same day back to Norfolk.

The reception given to the portrait when it was first shown that autumn was as extreme in its way as that shortly to be accorded Roger Fry's show: 'Manet and the Post-Impressionists'. The press called it 'detestable', 'crude', 'unhealthy', 'an insult', 'a travesty in paint' and the 'greatest exhibition of bad and inartistic taste we have ever seen'. The art critic of the *Liverpool Daily Post* (18 September 1909) felt able to describe it as 'a work worse painted and worse drawn than any modern picture we can remember', and suggested that it was 'an artistic practical joke' which gave Smith grounds for legal action. Another critic (19 September 1909) detected moral danger on the canvas. It was, he declared, 'an attenuated specimen of what Mr John chooses to call a man, over 20 heads in length, all legs, the pimple of a head being placed on very narrow shoulders and by his side, in a ridiculous attitude, a figure that I fancy I have seen before in a Punch and Judy show. All painted in rank, bad colour and shockingly badly drawn . . . The public have none too great knowledge of art as it is; to publicly exhibit this work is calculated to do immense amount of harm to the public generally and the young art students who go to galleries and museums for guidance and help.'

'You are being pounded and expounded (which is worse) in the *Liverpool Post* just now,' Scott Macfie informed Augustus (21 September 1909). To combat the public objection a strong body of supporters had quickly assembled, calling up phrases such as 'crystallized rhythm' to the defence. *The Liverpool Courier* (25 September 1909) interpreted it as a 'topical allegory' which had a 'symbolic value as representing the characteristic relationships of the Labour-Socialist Party and the Liberal Government'. While in the *Western Daily Press* T. Martin Wood, who described Augustus as 'the most revolutionary' of 'all the revolutionaries who are now alive', reflected upon the 'expression of countenance, in which a soul is to be seen'.

Liverpool was sent into an extraordinary hubbub by this controversy, echoes of which were to last many years. Day after day the Walker Art Gallery was packed with people coming to ridicule or admire this 'Portrait of Smith' as it was now called. Letters of anonymous indignation were everywhere posted in haste, and feelings of fury, adulation and merriment were kept at a high level by all manner of Tweedledum cartoons, satirical verses and stories to the effect that Dowdall had

* He later reversed this opinion. In 1911, when he had an opportunity to add to the head, he decided against doing so. 'I sent your portrait to the N[ew] E[nglish],' he wrote to Dowdall. 'I couldn't decide to touch it, merely gave it a thin coat of varnish. I think it looks well.'

commissioned a gang of burglars to make off with it, only to find they had taken the valuable frame and left the canvas. Augustus himself did not immediately help his symbolic supporters by stating that he had introduced Smith into the picture 'for fun' [221] – and at no extra cost! But he was obviously taken aback by the venom of some attacks which he described as 'stupid, disgusting and unnecessary'.

After leaving Liverpool, the picture toured the country, always followed by a wake of argument, and was shown at the winter exhibition of the N.E.A.C. in 1911. 'There is nothing to justify the indignation expressed by the Liverpool worthies,' one paper proclaimed. But the *Athenaeum* (2 December 1911), as at some new Bonnard, could still 'marvel somewhat at Mr John's innocence of the science of perspective', while other critics invoked the names of Gainsborough, Sargent, Velasquez and Whistler.

One man who had stood up for the portrait from the beginning was Dowdall himself. On all public occasions he announced that it was splendid, and went so far as to supplement Augustus's honorarium out of his own pocket. 'I consider it a great picture, and for what my opinion is worth, I am prepared to go nap on it,' he was reported [222] as saying. Nevertheless it was to prove something of a white elephant to the Dowdall family, following them from house to house in its atrocious golden frame and dominating their lives. 'You will have to build a special room to hold it,' advised a friend. [223] Such friends had to enter through the back door at Liverpool because the portrait blocked the entire entrance hall. It also cost a fortune to insure, the hiring of a special railway truck to move and, when stationary, attracted crowds of Augustus's devotees who would call round and demand to view it, making the Dowdalls' lives a torment. Eventually, in 1918, Chaloner Dowdall decided to sell it. Liverpool, despite its hostility, still felt a proprietary right in the picture and was critical of Dowdall. But Augustus took a different line: 'I'm glad to hear you found the old picture useful at last,' he wrote to him (14 October 1918), 'and that it fetched a decent price. It was really too big for a private possession of course, failing the possession of a palace to hold it. I don't forget how well you acted by me at the time.'

The National Gallery had offered Dowdall six hundred and fifty pounds, but E. P. Warren, a private collector who lived with John Fothergill at Lewes House in Sussex, topped this with an offer of one thousand four hundred and fifty pounds. Dowdall asked the Rani whether their son (then aged ten) would prefer to see his father enshrined in the National Gallery at a fairly nominal price or enjoy the proceeds of the full market price – to which she simply replied: 'Don't be a fool!' So the portrait went to Warren's beautiful eighteenth-century

house where it joined a Lucas Cranach, a Filippino Lippi and, in the garden, Rodin's 'Baiser'. With his money Dowdall then bought a house, Melfort Cottage, in Oxfordshire with three acres of land where he lived for the next thirty-five years. But the picture still had not come to rest. When Warren died, his heir Asa Thomas lent it back to the Walker Gallery. It was exhibited there in 1932, but Liverpool was still dead set against it, and the director refused to buy it. Not for another six years was it bought. 'I have now to make a confession,' Sydney Cockerell then wrote to Dowdall (2 June 1938). 'As London Adviser to the Felton Trustees of the National Gallery of Victoria I am guilty of having caused the banishment to Melbourne of your magnificent portrait by Augustus John. It is really too bad as it is perhaps his masterpiece and it certainly should have remained in England. How mad your fellow citizens of Liverpool were to allow it to go out of their hands!'

The price this time had risen to two thousand four hundred pounds – twenty-four times the original fee. It was shown at the Tate Gallery for a month, then left for Australia. Another sixteen years later it returned to Liverpool, and to the Walker Art Gallery where, for six weeks in 1954, it was the centrepiece of an Augustus John show having Liverpool connections. 'It may well be that something of this conflict, aligned in the same way, will divide Liverpool again now,' wrote Hugh Scrutton with a nostalgia for the aggressive past. '. . . At all events visitors to the Walker Art Gallery can now see this stormy petrel of a picture returned to its original place of showing. And it may be their last chance. For the picture will return to the National Gallery of Victoria, Melbourne, in September and it is anybody's guess whether it will return again within their lifetime from Australia.'*

* In July 1911 Augustus painted another Liverpool portrait that, amid much controversy, was exiled overseas. This was of the Celtic scholar Kuno Meyer. It shows him lolling in a chair, his waistcoat thrown open (and part of his trousers) to display a large expanse of shirt and a claret-coloured tie. It is a strong and weighty piece of portraiture, very robust and effective in style. Presented, through subscription, by some two hundred Liverpool friends, and shown at the N.E.A.C. (winter 1911) and the National Portrait Society (spring 1915), it was much admired by Sir Hugh Lane who, Lady Gregory told Quinn (16 March 1912) 'hopes to buy John's picture of Kuno Meyer for the Gallery [Irish National Gallery]. The Liverpool people don't like it, and he could sit to someone else for them. It is a fine thing.' But once again, though Liverpool did not like it, it did not especially want others to enjoy it elsewhere. Then, at the beginning of the First World War, Kuno Meyer came out on the side of the Germans, and left Britain for America. The portrait continued to hang at the Liverpool University Club, greatly to the embarrassment of the authorities who, by way of compromise, turned its face to the wall. Though it still belonged to the absent professor, Liverpool in its anxiety now to be rid of the traitorous object tried to remove it to the care of the public trustee as the property of an alien enemy. As the war continued, Ireland, England, America

Returning, via London, to camp, Augustus found that everything was
not well. Arthur had again misbehaved, and in a sudden fury Augustus
fired him on the spot. They were now, with their various caravans,
carts, animals and boys, immovable. In desperation, Augustus wired
his friend Charles Slade,* who lived not far off at Thurning. The
muddled wording of his S.O.S. admirably conveyed the emergency:
'*Have fired Arthur can you come help love conveniently at once John*'. Slade
quickly rode over and shepherded the convoy back to his farm. But the
romantic life had already taken a heavy toll of them. A number of
photographs which Slade took during September show in detail the
brave equipment with which they had encumbered themselves. The
vans, still bright, were in the 'cottage' style, with ornate chip-carved
porch brackets projecting at the front and rear, and steps which, when
the horses had been unharnessed and put out to graze, fitted between
the dipped shafts. The tents, to judge from Augustus's drawings, were
of the traditional gypsy construction – a single stout ridge-pole
carrying five pairs of hazel-rods shaped into a cartwheel, over which
framework blankets could be fastened by skewers or pinhorns.[224]
There are no horses in the photographs, possibly because they had, at
an alarming rate, begun to die off. One stumbled and fell *en voyage*,
projecting Augustus over its head; another fell while standing in the
shafts 'and I sold it to a knacker for a sovereign'. Photographs of
Dorelia and Edie suggest that they too were almost on the point of
death, worn out by the rigours of road-life. The boys, while at Thurn-

* Charlie Slade, whose brother Loben had married Dorelia's sister Jessie, was
known as 'the half-a-potato man' on account of his fantastic mystical experiences
which, Romilly John explains, 'originated in an experience of his own nothingness
in the ruins of Pompeii, and the revelation that came to him that the cut surfaces of
a potato sliced in half, however asymmetrical in shape the potato, were exactly
similar. He was subsequently promoted to station master at Cambridge, when I
became deeply involved in his ideas and was urged (in vain) to produce a book on
the subject.' Romilly John to the author, 28 July 1972.

and even Germany fought for the right not to have it, and it remained in a state of
suspended ownership. 'I have been thinking that I ought to sell John's portrait of
me,' Kuno Meyer innocently wrote to Quinn on 3 November 1915, 'although this
is not the best time to do so. Besides, John wouldn't like it, and I should be very
sorry to hurt his feelings. For, unlike most of my English friends, he is one
who will not put politics – and such dirty politics – above friendship . . . the por-
trait (which my English friends no longer care for) is unsuited to my small flat and
– entre nous – not liked by my family as a portrait, while it is one of John's master-
pieces, as everybody admits.'
 The portrait which Augustus had begun at Dingle Bank a 'Rotten' place and
finished in two sittings at 4 Colquitt Street, went after the war to where Lane had
originally wanted to send it: the National Gallery of Ireland in Dublin.

ing, all caught whooping-cough, which they communicated to the Slade children; and gradually the general discomforts of their camp, which resembled those occupied by prisoners-of-war, penetrated as far as Augustus himself. 'I shall be damn glad to get on with my own work,' he wrote to John Quinn (September 1909). He had agreed to decorate the Chelsea house of Lady Gregory's nephew, Hugh Lane, and he returned thankfully to Church Street. He would not repeat such a rough-and-tumble journey, but it was not long before he began wondering about agreeable variants. 'I don't suppose we shall return this summer,' he admitted to Slade, with whom he had left a number of his vans and sons. 'I wish I had the vans in France. Do you know how much it would cost to heave them over the Channel?'

8. FATAL INITIATIONS

'I have been seeing a lot of Arthur Symons lately,' Augustus wrote to Ottoline (1 October 1909). 'I'm afraid he's about to break down again and that will be the end. He reads me poems that get more and more lurid.'

On the face of it, poet and painter were an ill-assorted pair. The son of a puritanical Wesleyan minister, Arthur Symons had been brought up along nervously conventional lines and indoctrinated with a vast dose of the Knowledge of Evil. Against the effects of this upbringing he had later received a partial vaccination at the hands of Dr Havelock Ellis who, during a week's visit to Paris, introduced him to the debauchery of cigarettes and wine. Upon such weeds and fruit was Symons's celebrated *Knowledge of French Decadence* brought to birth. He was a man, in George Moore's words, 'of somewhat yellowish temperament', who, according to Will Rothenstein, 'began every day with bad intentions . . . [and] broke them every night'. His spirit was eager enough, but his body, undermined by those chronic and persistent illnesses which afflict men who will outlive all their contemporaries, was weak. Though much obsessed with notions of sex, he was not a passionate man but something different: a passionate believer in passion. The rhyme was preferable to the deed, and he would dizzy himself, in verse, with visions of belly-dancers, serpent-charmers and other exotic temptresses. More prosaically, he had married Rhoda Browser, a strong-willed scatterbrain who seems to have been a better performer off stage than in the various theatres where she occasionally acted. But he needed about him people who were strong, people who had an appearance of strength greater than his father's had been: it was this quality that had first attracted him to Augustus.

They had met in Gordon Craig's studio in Chelsea in 1902 – 'one of

the most fortunate events of my life', as Symons described the meeting.
The following spring, when Augustus held his show at the Carfax
Gallery, Symons wrote a long appreciation of it in the Anglo-French
paper, *Weekly Critical Review* (2 April 1903):

'I have just been to the Carfax Gallery, in Ryder Street, to see some of
the work of a young man who, if he does not become a notable painter,
will owe it entirely to his own fault. Mr Augustus E. John is, pictorially
speaking, a man of substance; grave people say he is squandering his
substance in riotous painting; but I contend he is living within his
means, he need have no fear of using up his capital.'

Many years later, in an article entitled 'The Greatness of Augustus
John', in which he selected Augustus as 'the greatest living artist',
Symons recalled his first reaction to the Carfax exhibition. Two sen-
tences from Baudelaire had occurred to him: '*Je connais pas de sentiments
plus embarrassant que l'admiration*'; and '*L'énergie c'est la grâce suprême*'.
These two sentences sum up very well the commerce of their relation-
ship. Symons traded his admiration in exchange for Augustus's gener-
ous encouragement. He set out to please Augustus, sitting for him,
dedicating books to him, deferring to his literary taste, assailing him
with congratulatory poems; and he set out to take from him something
he badly needed: energy. Wilde had once described him as 'an egoist
without an ego'. It was Augustus whom he now elected to supply this
ego from the dynamo of his overcharged personality. It was not difficult
for Symons to identify himself with Augustus. In his article he had
written that John's pictures 'revealed to me at once his primitive genius
and his startling originality, and I knew that he, like myself, was a
Vagabond, and that he knew the gypsies and their language better than
anyone else.' In his letters and diaries he sometimes makes this identifi-
cation between them quite explicit: 'I was born at Milford Haven in
Wales,' he once wrote to John Quinn (30 January 1914) '– oddly nine
miles along the coast from where Augustus was born.' Were they not
blessed then, or afflicted, with the same Celtic blood? And had they not
endured very similar upbringings? In his diary he noted:

'John's fascination is almost infamous; the man, so full of lust and life
and animality, so exorbitant in his desires and in his vision that rises in
his eyes.

'His mother, who died young, was artistic, did some lovely paintings
his father still keeps in Tenby. There he got some of his gift – as I did
from mine. I for verse, he for painting. Our fathers never really under-
stood us . . . John's father hated art and artists; the mother, imagin-
ative. So was mine: both imaginative: one derives enormously from
one's mother.'

They seldom saw each other before 1909, but Augustus lived

vividly in Symons's imagination. 'Arthur Symons has sent me a poem he had dedicated to me – all about bones and muscles and blatant nakedness', Augustus wrote to Alick Schepeler. 'I ask myself what I have done to merit this?' The poem, 'Prologue for a Modern Painter: To A.E. John' is a hymn to vitality, a declaration of his faith in the kind of life he could never make his own, except through someone else:

> *Hear the hymn of the body of man:*
> *This is how the world began;*
> *In these tangles of mighty flesh*
> *The stuff of the earth is moulded afresh. . . .*
>
> *Here nature is, alive and untamed,*
> *Unafraid and unashamed;*
> *Here man knows woman with the greed*
> *Of Adam's wonder, the primal need.*
>
> *The spirit of life cries out and hymns*
> *In all the muscles of these limbs;*
> *And the holy spirit of appetite*
> *Wakes the browsing body with morning light.*[225]

The rather embarrassed question which this poem prompted from Augustus was valid. What, after all, *had* he done to merit such rhapsodic rhymes? For one of the paradoxes of their friendship was that where Augustus dreamed, Symons, in his tireless search for 'impressions', had often acted. He had breathed in the fantastical air of Dieppe far deeper than Augustus, stopping impatiently for a night while in pursuit of some fish-women, could ever have done. And he had actually gone to many of the places, especially in Italy, that had been the unreached destinations at the end of Augustus's rainbow plans. Yet because Symons dreaded action 'more than anything in the world',[226] he was determined to see Augustus as a great man of action. What mesmerized him was the apparent lack of that guilt which so weighed down his own actions wherever he went.

The flow of poems persisted and was for some years their main line of communication. It formed, for Symons, a kind of umbilical cord attaching him to a creative source of life. 'Dear Symons,' Augustus wrote from Church Street, 'To-day I've just come back to find another beautiful poem for me! I would have written columns of gratitude for the others you sent, only the words, not the will, failed me.'*

Then, in 1908, a terrible disaster had overtaken Symons: he had gone mad in Italy. From Venice, urged on by a sense of extreme exasperation,

* Yet the words, so failing in gratitude, were more forthcoming in parody, and John wrote a number of verses in the Symons style. See Appendix Three.

he fled to a hotel in Bologna where Rhoda, dressed like a dragonfly, hurried to his side. She found him racked by terrible imaginations, but her concern seemed only to sharpen his torment. For repeatedly she would demand, as if in pursuit of medical symptoms: 'Do you *really* love me, Arthur?' One night he disappeared: he had given his answer. 'So it has come at last!' she soliloquized. 'He no longer loves me!' Next morning, however, Symons returned and created some dismay by failing to recognize his wife, and then, with foul curses filling his mouth, rushing off chased by horrible shapes and shadows. The hotel manager then explained to Rhoda: 'Madam, your husband is mad. He has bought three daggers.' In hysterics she ran back to England to be arraigned by a herd of Browsers for having deserted her husband. Symons, meanwhile, had lost himself, drifting day after day in ever-increasing fatigue from one ominous spot to another. 'I walked and walked and walked – always in the wrong direction.' At last he was arrested in Ferrara, manacled hand and foot, and thrown into a mediaeval goal. It was only with great difficulty that his friends and family got him released and dispatched back to England where, in November 1908, he was confined to Brooke House, a private mental home.

The doctors there were confident they could not cure him. They had diagnosed 'general paralysis of the insane', which could proceed, they confirmed, through hopeless idiocy to death. They spoke matter-of-factly. They were kind, but firm: all hopes, they promised, were ignorant and vain. Symons (who lived thirty-six more years in perfect sanity) had, they declared, a life-expectancy of between two months and two years – it could not be more. His manner of life at Brooke House, though described by the specialists as 'quiet', seems to have been unusually active. He assumed the title of Duke of Cornwall, and took off all his clothes; he frequently dined with the King and kept forty pianofortes upstairs on which he composed a prodigious quantity of music. He rose each morning at 4 a.m., and worked hard on a map of the world divided into small sections; he also wrote plays with the greatest frenzy and illegibility, devoted endless time to the uplifting of the gypsy, and, when not occupied as Pope of Rome, involved himself in speculations worth many thousands of pounds. But his main duty as a lunatic was to arrange for Swinburne's reception in Paradise, and when Swinburne died a month later the pressure of these delusions began to ease. 'Had it not been for John,' he wrote later, 'whose formidable genius is combined with a warmth of heart, an ardent passion and will, at times deep, almost profound affection, which is one of those rare gifts of a genius such as his, I doubt if I could have survived these tortures that had been inflicted upon me.'

Already, by the summer of 1909, Symons was being allowed out from

Brooke House in convoy, followed by a Miss Agnes Tobin, a West Coast American lady bitten with a passion for meeting real artists, and, at some further distance, a hated 'keeper' from the asylum. This procession would make its slow serpentine way to the home of Augustus who, after losing the keeper 'without compunction or difficulty', would set them high-stepping to the Café Royal, where he prescribed for Symons medicines more potent than any administered at Brooke House. 'At the Café Royal, between five and eight, we each drank seven absinthes, with cigarettes and conversation,' Symons wrote excitedly to John Quinn (20 June 1914). 'In spite of that we got a few sensations.' There were many of these splendid occasions: visits to the Alhambra and to the Russian ballets; glorious luncheons at the Carlton and sumptuous suppers with young models in Soho: all for the sake of what Symons called '*la débauche et l'intoxication*'. Augustus had become the Sun in Symons's life, whose absence betokened a dismal day: 'Alas I never saw John. Worse luck for me then.' [227]

Augustus was extremely good to Symons. Under the impression that the poor man was very shortly to die, he set out lavishly to entertain him and make his last few weeks enjoyable. 'I have seen Symons a good deal,' he told Quinn (25 October 1909) '– he keeps apparently well but one can see all the same that he is far from being so. The doctors give him 2 or 3 more months. He is entirely engrossed in himself, his only other preoccupation being to get me to listen to him while he reads out his latest poems – which are all hell, damnation and lust.'

What Augustus had not calculated was that, a dozen years later, he would still be entertaining Symons 'a good deal', and that Symons would still be counting on him to be (14 April 1921) 'as wonderful as ever'.

Egocentricity is a condition of all illnesses, and what Augustus did for Symons, almost literally, was to dissipate his egocentricity. He blew into his life and kept blowing, ventilating it with humour, filling it with people, elbowing out Symons's introspection. The delusions melted into nothing before the heat of actual events. But part of Symons's recovery was due, Augustus maintained,[228] 'to the kindness and devotion of Miss Tobin'. The presence of Miss Tobin, like that of a jester at Court, was entirely appropriate to their meetings. She was forty-five with the light behind her, hailed from San Francisco, had translated Petrarch, and now lived in the Curzon Hotel. She was a woman of the right instincts but the wrong clothes, and had been observed to be 'a little bit flighty'.[229] Conrad (who dedicated *Under Western Eyes* to her) called her Inez; Francis Meynell, however, called her Lily 'because of the golden and austere delicacy of her head and neck'; and she called Augustus 'my poor butterfly'. He stood up to it well. Something of his attitude to their

tripartite meetings is conveyed by a nautical description he gave to John
Quinn (18 December 1909):

'I've been seeing Symons and Miss Tobin now and then. Symons is
still held up in Brooke House nor will he be released in a hurry I think.
He keeps pouring out verses.* He has developed a tremendous affection
for me which I find as embarrassing as it is undeserved. He never
suspects that there can be no complete understanding between us, and
one can't be frank with an invalid.

'The other night occurred a row as we came out of a restaurant. In
order to cope more successfully with the exigencies of Symons' society,
I had before meeting him, taken on board a considerable ballast in the
way of drink and was thus, although the more sea-worthy in respect to
plain sailing on an even keel, rendered less competent to oppose the
squall that followed . . . when we got outside, some man started
buffooning me, holding out his hat and asking for alms. I regarded him
for about a minute then gravely and neatly knocked his hat halfway
down the street upon which I was set upon by his companions, a man
and a woman armed with an umbrella, and the first man returning I was
in the thick of an ignominious struggle in which I stumbled and knocked
myself, or was knocked, senseless on the curb. Miss Tobin was holding
in Symons and she got some of the assembled multitude to put my limp
body into a four-wheeler. She drove me home. I had regained con-
sciousness very soon and my first words were "Has anybody got a
cigarette?" I still have an aching jaw from that encounter. I think Miss
Tobin enjoyed the affair on the whole.'

The three of them had been brought together, while Augustus was
briefly in London following his escape from Liverpool's Lord Mayor, by
John Quinn, the New York lawyer, who has been called 'the twentieth
century's most important patron of living literature and art'.[230] Quinn
had arrived in England this summer to buy some pictures by Charles
Shannon, Nathaniel Hone and 'Augustus John, the artist who is so
much discussed in London now'.[231] He had heard tell of both Symons
and Augustus from W. B. Yeats and, with American enthusiasm, had
not been content to see each of them separately, but seen to it that they
saw one another too. There appeared to be advantages in this for
everyone. Miss Tobin, who was coming into contact with more artists
and authors than once she could have dreamed possible, made the
suggestion, full of consequences, that Quinn acquire manuscripts by
Symons and her friend Conrad. 'Your bringing A.S. and Mr John
together was a miraculous success and will, I think, be an immense
solace to A.S.', she informed Quinn (16 September 1909). 'Mr John told

* 'You keep pouring out poetry while I flounder in charcoal.' John to Symons
(1909).

me he would keep up the friendship – and wants A. S. to sit for him.'
Augustus's portrait of Symons was delayed until the autumn of 1917
when, though advertised by Frank Harris* as showing 'a terrible face –
ravaged like a battlefield', it was warmly welcomed by the Symons
family. 'John has done a fine portrait of A[rthur],' Rhoda confided to
Quinn (29 October 1917), '. . . What an odd fish he is; but he has great
personal qualities. He has been true to A[rthur] all thro' these years, and
it's few who have . . . he's a great artist, isn't he? . . . A[rthur]'s port-
rait is very El Greco-ish!'

Of Quinn Augustus did a number of drawings (one of them described
by a friend as 'the portrait of a hanging judge') † and a large formal
portrait in oils – all during a single week in August. On the fifth and
final sitting, just as Augustus was about to take up his brushes, Miss
Tobin (who was in attendance with Symons) stepped forward and
exclaimed that the canvas was perfect – 'at the razor's edge'. Augustus at
once laid down his brushes and began drinking – so the picture was
perforce finished. ‡

* '[Augustus John] has painted Symons with the relentless truth we all desire in
a portrait,' Harris wrote: 'the sparse grey hair, the high bony forehead, the sharp
ridge of Roman nose. The fleshless cheeks; the triangular wedge of thin face shocks
one like the stringy turkey neck and the dreadful claw-like fingers of the out-
stretched hand. A terrible face – ravaged like a battlefield; the eyes dark pools,
mysterious, enigmatic; the lid hangs across the left eyeball like a broken curtain.
I see the likeness, and yet, staring at this picture, I can hardly recall my friend of
twenty-six years ago.'

† It was probably this drawing which was used on the dust jacket of B. L. Reid's
The Man from New York: John Quinn and His Friends. The drawing, which is attri-
buted to no one, is certainly by John.

‡ In a letter to his wife (25 August 1909) Symons gives rather a different account
of this afternoon. 'We went to John's studio at 3. The Quinn was finished: a very
fine living portrait: 5 days! Then I turned over heaps and heaps of designs, and he
gave me a delightfully sensual nude, with a sketch of a head on the back. Then –
in half an hour (I sitting as still as a statue) he did a magnificent drawing of me –
almost more living than myself – the eyes marvellous! – and what fat cheeks! –
mouth! etc. It is full face. I crossed my knees and put my left hand around my chin.
His eyes went up and down every minute – his hand went and went with a pre-
cision that I never believed any human being could do. He sat on a stool in shirt and
trousers, the sleeves turned up, holding the block between his knees with his left
hand. I sat on the edge of the platform. Then, a few minutes after, I sat on the chair,
upon it half-sideways with my eyes turned to his. He sat on a high stool. Another
half-hour – another totally different – but both magnificent – the latter gave, in a
few strokes, my left hand with the rings on it. Then John said: "I am going away
for three weeks or so, and when I come back I will do a portrait of you" . . . Then
Hugh Lane's, then Carlton for dinner, then the Empire where Lydia Lopokova, a
Polish dancer, was . . . Then we went back to the Carlton and had a few drinks (I
mean the three of us). Then I put on a red silk tie and John said: "I must do another
drawing." He seized Quinn's bill and dashed off a diabolical half face of me!!!'

At the end of their week, everyone was thoroughly delighted with one another. Miss Tobin wrote ecstatically to thank Quinn for his 'wonderful and royal kindness . . . 7 taxis in a day . . . Your visit remains with us something glorious – in the atmosphere of the Decameron. Really – *everything* we did with you came off.' And Quinn wrote to Miss Tobin (21 December 1909): 'I don't know when I have been so taken with a man as I was with John. He is a splendid fellow: nothing morbid, or introspective or posing about him . . . a man of action, as I am fated to be, gets close to a man like John.'

Yet even now, in the very honeymoon of their friendship, there was a sign of what was to come: Quinn's portrait. Although he affected to think well of it – 'I liked the portrait John made of me,' he assured Lady Gregory (21 December 1909). 'And I liked John himself immensely' – it was not an engaging likeness. When it was exhibited that autumn at the N.E.A.C. under the title 'The Man from New York', the critic of the *English Review* (January 1910) wrote:

'The peculiar note of hardness which Mr A. E. John has could not have found a better subject than "The Man from New York". It shows exactly that hardness which we look for and find in this type of American.'

Quinn insisted that, on reading this, 'I howled out loud with glee'.[232] There are few more doleful sounds than the hearty laughter of a man without humour. Quinn's lack of humour was a very positive quality. Uninhibited by any sense of the ludicrous, he enjoyed drawing attention to it by cracking jokes.* His response to Augustus's portrait † was indeed partly the result of its being a very funny picture. It presents him at three-quarter length, seated with his left hand on his hip and his right hand extended, resting on a cane. The shape of his figure is, unmistakably, that of a tent and upon a face of pimple proportions at the apex of this design there sits an expression of the sternest vacancy. Quinn, his biographer B. L. Reid tells us, 'felt baffled and unhappy about it',[233] though Symons, Pissarro and others considered it 'extremely good'.[234] Bravely, he hung it over his mantelpiece for as long as he lived, but would indignantly protest that Augustus 'painted me as though I were a referee or umpire at a baseball game or the president of a street railway company with a head as round and unexpressive and underdeveloped as a billard ball. Thirty or forty years of life in school, college, university

* A fair example may be taken from a letter Quinn wrote to James Huneker, the American art critic (4 February 1913): 'In my cable to Fry I expressly said that I bought the picture on your recommendation only so that if you have any fish to fry or bones to pick with Roger of the same name, then why not fry Fry. Personally, I never take fries; I always go in for roasts or broils . . .'

† The portrait is now in the New York Public Library.

and the world has I hope put a little intelligence into my face. Intelligence is not predominant in the John painting of me, but force, self-assertion and a seeming lack of sensitiveness which is not mine!'[235]

Quinn's interpretation of the portrait was perfectly accurate: Augustus had depicted his hopes of intelligence, so aggressively held, as vain. 'Do not expect any subtle intelligence from him [Quinn] or any other Yankee,' he warned Will Rothenstein (20 September 1911). 'They are a disconcerting people . . . I fear you will find New York a terrible place: money has literally taken the place of brains and character, and the American mind is a metallic jungle of platitude and bluff.'

In an earlier letter to Rothenstein Augustus had lamented the dearth of 'millionaires of spirit'. In Quinn he had found, quite simply, a millionaire of the purse. He would have liked to like him, and he described him, after their first few meetings, as 'a pleasant, jocular and open-handed Irish-American', adding hopefully: 'We became very friendly'.[236] But this is, very precisely, what they never became: they valued each other for qualities other than friendship. 'He's a treasure,' Augustus told Dorelia (August 1909). 'He's offered me £250 a year for life and I can send him what I like. He's a daisy and will do much more than that.' It seemed to Augustus that so liberal a patron, and one tactful enough not to inconvenience him by living in the same country, was the ideal solution to his problems. This extra money would enable him to live where he wished, travel where he liked; it would release him from a lot of commissioned work and allow him to paint imaginative pictures. He believed too that Quinn's interest would encourage self-discipline: 'I can tell you honestly you did me a lot of good that week in London,' he wrote in his first letter[237] to Quinn (September 1909), 'and that quite apart from pecuniary considerations. You will help me to keep up to the scratch.'

The figure of Quinn, hopelessly beckoning, stood at the end of a long straight road lavishly paved with good intentions. When Quinn, for example, asks for a complete set of his etchings, Augustus willingly consents, adding (4 January 1910): 'I mean to methodize my work more and put aside say one or two months every year to etching – it can't be done every day or any day.' In another letter (25 October 1909) he tells Quinn: 'I am extremely anxious to study Italian frescos as I am fired with the desire to revive that art . . . I am quite ready to say goodbye to oil painting after seeing the infinitely finer qualities of fresco and tempera.' But when Quinn replies with dismay, Augustus hurriedly gives way (18 December 1909):

'What you say about my remarks on fresco and oil-painting are words of wisdom – I wrote under the enthusiasm of the moment. But I have

had time to realise that oil-painting has its own virtues and have given up despising my own past – a thing one is too apt to do, when struck with a fresh idea. I suffer from being unduly impressionable – and often forget the essential continuity of my own life: the result being I am as often put back on my beam ends rather foolishly. What you say is true that one is apt to despise one's own facility – whereas one should recognise it as the road to mastery itself. I shall keep your letter and read it over whenever I feel off the track – *my own track*. It will be medicine for me who am occasionally afflicted with intellectual vapours.'

But Quinn, like many medicines, had a bitter taste. To appreciate the full flavour of a relationship that was crucially unsatisfactory to both of them, it is necessary to understand Quinn's psychology as patron and collector. One of the contradictions of his character was that, while being financially generous, he was a triumphantly mean man. His letters to Augustus and other artists and writers are always business letters, and almost always interchangeable – except for the odd quirk that what is quoted in one has been the main body of another. Essentially this correspondence is a form of memoranda for his files; it is endless, pitted with headings and sub-headings, listings and elaborate recapitulations of earlier correspondence. He is not afraid of recounting events out of which he comes extremely favourably and everyone else greatly to their disadvantage. He confesses being partial to (like cheese) 'juicy girls', but at the same time he is a sexual Puritan much given to amatory philosophizing, for which Augustus seemed an obvious target. He is a loud believer in 'guts'. And finally, he is full of yarns that always open with the rhetorical challenge: 'Have you heard the latest story?'

To lack of humour he prudently added lack of charm, and equipped with such powerful machinery he perfected the art of boredom. Dullness by itself, like patriotism, was not enough. He ensnared his victims in the web of his money and inflicted on them his terrible jokes, appalling lectures, his deathly political harangues. Many of his 'friendships' disintegrated under this treatment and always, on Quinn's part, with a sense of moral relish. There were many precedents for his eventual break-up with Augustus – his split, for example, with W. B. Yeats. 'I think he [Yeats[needed a lesson,' Quinn told T. W. Rolleston (5 August 1910), 'and he got a good one.'

He fed greedily on malicious gossip, like one parasite upon another, extracting confidences and, 'in confidence', passing them on. It continually amazed him how extraordinarily stupid everyone else was – and sometimes he wrote to tell them so; though more often he preferred telling their friends. His personal dislike of people extended to those he did not personally know: 'If there is one man I loathe it is [Ford Madox] Hueffer,' he once told James Huneker (2 July 1914). 'I do not

know him from Adam, but if I were an artist I would draw him with a
hare lip.'

It is difficult to resist the diagnosis that Symons's 'fatal initiation of
madness' had been swiftly cured at some mental expense to his com-
panions. It was not long before Miss Tobin was seeking to employ
Quinn for legal advice about her nightmares. 'I had a frightful dream
which told me efforts were being made to make me out mentally un-
balanced at some time or other,' she informed him (24 July 1911). 'This
is a dreadful stigma. But at last I have come to feel that no credence can
be given to it by anyone who knows me – and the only side of it that is
of importance is the legal side. Can you find out for me if I have been
found "incapable" at any time for any cause – that is the legal term
("incapable") isn't it? Irresponsible, I mean.' This was a subject upon
which Quinn found some difficulty in taking instructions. Miss Tobin
was at once sympathetic. Of course it was awkward commenting legally
across salt water. She would therefore cross the Atlantic and call at his
office. She would travel, he must understand, with an English nanny
who, she argued, would be seasick. So would he please 'have a man sent
out on a pilot-boat'. There is real pathos when Quinn suddenly cries
out: 'I am a dreadfully driven man!' But in his legal opinion to Miss
Tobin can be detected the seeds of his own lunacy: 'My conviction [is]
that the origin of most dreams is in the stomach or intestines.'

Quinn had rapidly diagnosed Symons's complaint as venereal disease.
Symons might 'fool them all yet,' he guessed, but Quinn himself would
not be fooled. His duty was clear and indirect: CABLE FIFTY
POUNDS PLEASE WARN FRIEND AGAINST DANGER VEN-
EREAL INFECTION ITALY.

Such cables, which were intended specifically for Augustus and no
'friend', reached him wherever he travelled – the sweet smell of money
rising from a nauseous draught of cautionary advice. However far he
went, however fast or uncertainly, by van or train or simply on foot, the
venomous torrent of Quinn's goodwill, choked with the massive
boulders of punning and unintentional *double-entendres*, overtook him.
At Arles, for instance, Augustus read (February 1910):

'For God's sake look out and protect yourself against venereal disease
in Italy. Remember the Italians aren't white people. They are a rotten
race. They are especially rotten with syphilis. They don't take care of
themselves. They are unclean. They are filthy. Whatever their art may
have been in the past, to-day they are a degenerate, filthy, diseased race.
They are professional counterfeiters, professional forgers, habitual per-
jurers, blackmailers, black-handers, high-binders, hired assassins, and
depraved and degenerate in every way. I know two men who got
syphilis in Naples and who, as a result of syphilis and drink, both got

paresis and died horrible deaths . . . I know another man who got
syphilis in Rome. Therefore for God's sake take no chances. Better
import a white concubine than take chances with an Italian. The white
woman would be cheaper in the end . . . Your future is in your own
hands, my dear friend. I am convinced you have the intellect to keep the
rudder true.'*

In time, Quinn's medical lunacy took a deeper hold on him, spreading
from venereal disease to diseases of the feet and teeth. He became a
specialist in sciatica ('sciatica is a term of ignorance and a disease arising
from ignorance'); in lumbago ('lumbago is a term of ignorance and a
disease arising from ignorance'); and in the relationship between forni-
cation and eye-strain. The cure for such distempers was soup, eight
glasses of water a day and, of course, plenty of x-rays. In dentistry,
which he proclaimed as a new American science 'like chiropody', lay the
secret of 'healthful' life. To all writers and artists he was generous with
his medico-legal expertise – and particularly on teeth, which were his
first love. Whether they had bad eyesight or bad feet, he would urge
them to visit their dentist. 'I think I wrote to you two years ago I told
[James] Joyce that the trouble with his eyes was due to his teeth,' he
reminded Symons (15 November 1923). 'I could see it.'

What was common to both Symons's and Quinn's relationship with
Augustus was the quality he extracted from many people and from
which derived the substance of his legend: a form of vicarious living.
In Symons this vicariousness is plain: 'What I am certain of is that
John – of all living men – has lived his life *almost* entirely as he wanted
to live it,' he once (21 October 1915) wrote to Quinn. 'So – he is the
most enviable creature on earth.' Symons sincerely believed the truth of
this, and would have felt almost a loss of religion had he been per-
suaded otherwise.

The vicarious quality in Quinn is more complicated. He led two lives
which were separate and simultaneous. In the present he worked hard as
a lawyer and amassed a considerable fortune; and with this fortune he
bought his paintings for the future. He had a good eye for pictures, but
he neither enjoyed them aesthetically as credit in some spiritual bank,
nor treated them primarily as financial investments. He collected them

* In a letter sent the previous day (31 January 1910) Quinn had written: 'Syphilis
is the national disease of Italy. Before a white man has intercourse with an Italian
woman or a white woman with a "dago" (our word for an Italian) male or female
should be examined by a physician, a non-Italian of course, to see there is no
gonorrhoea or syphilis and an affidavit by the dago of no connection since the
medical examination, and even *then* there is danger. For Heaven's sake, if you do
go to the rotten place look out for this. Whisky and syphilis are two of the greatest
enemies of the human race and the latter often follows indulgence in the former
. . . Youth is a precious thing.'

in order to shore up a kind of second-hand immortality; this was his motive. It was right, he believed, to enjoy hell for the present to undergo heaven in the future. But the unshrinking distance between his parallel lives is measured by a sentence of angry pathos he once (25 March 1912) wrote to Will Rothenstein: 'All my life, or rather for twenty years, it seems to me I have been doing things for others.' The thought gave him no pleasure.

Augustus was one of those for whom, he later came to believe, he had done too much – for he had hoped Augustus would do much for him. In his attitude to money and art there was a pagan fanaticism, defying logic, that cast Augustus as an angel on whose back he would ride heavenwards – only to discover that this was not Augustus's destination. By 1910 he had arranged to pay him three hundred pounds a year for the pick of his own work, and a further two hundred pounds to select, on Quinn's behalf, work by other British artists. In short, Augustus was to act as his patron's agent. Quinn's delusion, almost as fundamental as Symons's, was that Augustus possessed the sort of character which responded well under such an arrangement, that a man who, by his own admission, was inconsistent, temperamental and whose tastes were not the same as Quinn's, would be his top choice as representative. Nevertheless, held together by mutual advantage, the plan worked reasonably well for a few years, and it was the lunacy of Augustus, amply aided by such improbable characters as Mrs Strindberg, which killed it before it could die a natural death.

Augustus's lunacy was compounded of two ingredients. Of these the first was lack of common sense. Between his promise and the fulfilment of that promise fell an almost endless pause. His practical incompetence over small matters tuned Quinn up to a marvellous pitch of exasperation. What should have been simple was, again and again, made complicated with radiant ingenuity: paintings were sold twice, or painted over, set fire to, sunk, never begun, or lost for ever. But there was a second reason, a motive, for all this purposeless perversity. Augustus was allergic to patron-and-artist dealings: they reminded him horribly of father-and-son arrangements, and he felt an incurable itch to behave irresponsibly. Then, there was something else. Quinn, at first, obviously worshipped him, and implanted within him seeds of guilt. By those who built for him a pedestal, he was invariably contaminated with the dry-rot of disappointment. He attracted hero-worship – then punished it. For there was no core to him: other people were transplanted to become that core until he rejected them, merged with someone else. His friends and patrons he made temporarily a part of himself, but what seemed to them a most selfless generosity was his own need: the filling of emptiness.

So, from among the four of them – Augustus, Quinn, Symons and Miss Tobin – bound together by ties of reciprocal expediency, it was Symons, protected by an official certificate, who was least 'afflicted with intellectual vapours'.

9. ITALIAN STYLE, FRENCH FOUND

An epidemic of ambitious schemes infected the last three months of 1909. 'I am overwhelmed with work just now,' Augustus wrote to Alick Schepeler, 'and have to scorn delights (or pretend to) and live laborious days.' He had it in mind to prepare a catalogue of all his etchings, and to make a book about the gypsies of Europe; he would exhibit some paintings at the N.E.A.C. and drawings at Chenil; and then he would paint all his children, separately and together. He had already started a large new portrait of Dorelia – 'it ought to be one of the best portraits of a woman in the world', he told Quinn (4 January 1910), '– the woman at any rate is one of the best'. Newest and best of all were two other enterprises. 'There's a millionairess from Johannesburg [Mrs Lionel Phillips] who proposes sending me abroad to study and do some decorations for a gallery at Johannesburg which she is founding,' he wrote to Quinn (25 October 1909). 'If she is sufficiently impressed by what I will show her all will be well.' This opportunity had almost certainly come through Sir Hugh Lane, who was then forming the collection at the Johannesburg Municipal Gallery. Augustus had started work this autumn decorating Lindsay House, Lane's home in Cheyne Walk – 'exciting work', he told Ottoline Morrell (1 October 1909).

Suddenly, at the beginning of December, he was attacked by the most dreadful melancholia. Clouds of lethargy engulfed him and the excitement with which he had begun painting in Lane's house was blotted out, as if for ever. 'I have been working at little Lane's walls,' he explained to Ottoline (4 December 1909). 'It is an absolutely futile thing to undertake that kind of work in a hurry. I should like to have years to do it in – and then it might *last* years. Lane himself is a silly creature and moreover an unmitigated snob. It seems my fate to be hasty but I have serious thoughts of quitting this island and going somewhere where life is more stable and beautiful and primitive and where one is not bound to be in a hurry. I want absolutely to grasp things plastically and not merely glance at their charms, and for that one needs time. – As for these commissions such as Lane's or Phillips', they are misleading entirely – one is not even asked to do one's best – merely one's quickest and convenientest.'

He continued to be misled for another fortnight of deepening gloom:

then came the inevitable storm. 'I have made a drastic move as regards Lane's decorations,' he confided to Quinn (18 December 1909). 'I found doing them in his hall impossible, subjected to constant interruption and inconsequent criticism as I was. Lane himself proved too exasperating in his constant state of nervous agitation – he resembled more some hysterical old lady than a man. So I exploded one day and told him I'ld take the canvases away to finish – which I have done.'

Lane's 'snobbishness', 'agitation' and 'inconsequent criticism' had not been provoked by anything Augustus had done on his canvases. They arose from another source altogether which Augustus glosses over. In a letter Dorelia sent to her sister Ursula Slade about this time, she reveals that Augustus had spotted 'a lovely gypsy girl and asked her to sit for him'. This sitting took place next day at Lane's house where the two of them were soon joined by 'a whole band of ruffians' who made merry in every room and 'nearly frightened Lane out of his wits'. When the danger had passed and they were gone, Lane 'was very angry and said it wasn't at all the thing to do'. It was after this protest that Augustus erupted with his reprimands against 'this island' and carried off his canvases; while Lane himself, in high dudgeon, descended into Monte Carlo.

Dissatisfaction spread everywhere. There was no light in England, and no space in Church Street. 'Il me faut de l'air, de l'air, de l'air,' he cried out to Wyndham Lewis. By Christmas, Robin had fallen ill with scarlet fever. He sat quarantined in one corner of the room with Dorelia's sister Edie, while the rest of them huddled in the opposite corner. When the Rothensteins, with implacable timing, called round bearing the compliments of the season they were shooed from the door. 'Our house', Augustus apologized (4 January 1910), 'was more hospital than hospitable, I fear.'

Now that he was no longer working at Cheyne Walk, Augustus was thrown back deeper into this heavy atmosphere. Their crowded life began to tell on all their nerves. Even Dorelia's air of cheerful detachment faltered. She felt unwell and, to Augustus's fury, refused to see a doctor. It seemed almost as if she cherished her symptoms, like a list of unspoken complaints. In retaliation he developed catarrh: but as an argument it was hardly satisfactory. Dorelia's unnatural lethargy drained all energy from him, as if she were an electric current and he a mere bulb, growing dimmer. She had no spirit for anything, he began to think, except opposing him – which she did with a fine flair of contempt. 'The days are leaden as a rule,' he confided to Quinn (18 December 1909). '. . . I don't seem to be cut out for family life. I can't help being convinced that the wear and tear on my nervous system is diminishing my activity by about half. The crisis which takes place at

least weekly leaves me less and less hopeful as regards this ménage. It is a great pity as I am very fond of the missus and she of me.'

Despite all they had come through together, Augustus now felt that they must part. He would take a studio and live in it; she could remain at Church Street. They must see each other, but not live together. 'I think it would be fairer on us both to avoid the day to day test,' he wrote,[238] 'and I should work with less preoccupation. You would scarcely believe the violence of the emotional storms I go through so often – and worst of all those gloomy periods that precede them.'

Dorelia did not argue. In her strangely weakened condition, all manner of doubts had begun to invade her. Ida and the past were resurrected in the most torturing way; and during the exhausted intervals of calm they tried to flounder towards some formula she might have devised. Perhaps, instead of parting, they should marry at once? It was Augustus, however, who now demurred. 'I don't know that to "regularize our union" would be of any practical advantage whatever,' he wrote to her, '– we might find life all the more difficult. It's such a delicate affair.'

Doubts redoubled, threatened to come between them, yet, with a curious adhesiveness, somehow kept them together. The discord was often loud but always it was resolved with tenderness, forgiveness to the point of forgetfulness. For it was not as though they were against each other: it was a common enemy they fought seeking to divide them.

'It was a horrible pity we got into that state,' he wrote to her after one row. '. . . I don't know what precisely brought it on. It was a kind of feeling you were tugging in the wrong direction or exhibiting a quite false aspect of your nature – not the real one which never fails to bowl me over, but like the moon suffers an occasional eclipse.

'By living together too casually our manners deteriorate by degrees, "inspiration" ceases to the natural accompaniment of irritation and dissatisfaction till at last the awful storms are necessary to restore us to dignity and harmony and equilibrium. You know very well that "expression" in you or state of mind I shall always love as the most beautiful thing in the world and hate to see supplanted by something less divine and you know how mercurial I am, veering from Heaven to Hell and torn to pieces by emotion or nerves or thoughts – is it any wonder we can't always be happy? I acknowledge my grievous short-comings as I acknowledge your superior vision to which I owe so much (that's what I meant by "being useful"!). I never liked any "tart" as a "tart" but for some suggestion of beauty – and even some faint delusive charm is a concrete fact to a poor artist (!). I can't help thinking we *can* go on better than we have been by using our wits.'

The explanation for Dorelia's 'false aspect' tugging 'in the wrong direction' was another pregnancy. Augustus needed all her devotion, faith, energy; he needed her as mother as well as mistress. But during pregnancy it was not biologically possible for her to provide all this. By the end of the year they had come, somewhat hesitantly, to the conclusion that during the second month of another pregnancy that December, she must have had a miscarriage.

'I have an ineradicable cold and am as discontented as a bear in a pit,' Augustus had complained to Ottoline (28 December 1909). But the New Year promised new hope. Quinn, who attributed their matrimonial difficulties to bad dentistry, had sent a Christmas cake to Dorelia and, to Augustus, his first cheque – a magic remedy. 'I feel by no means dreary now,' he replied (4 January 1910). '. . . Frank Harris has written me from near Naples [239] asking me to come out for a spell – I think I may manage a few weeks off profitably.'

By the second week of January they had drawn up a new plan. They would part – but only for a month or so. Augustus would plunge south to escape the winter darkness and, putting Quinn's money to good uses, explore the French and Italian galleries. Edie, it was arranged, would mind the children, and Dorelia would have an eye kept on her by her friend Helen Maitland. Then, once she felt really better, Dorelia would leave with Helen and some children to join Augustus – while Edie, as a substitute for her sister, went to stay with Lamb. Celebrating with a long French holiday, they would all then enter a happier phase in their lives.

The nine months Augustus spent abroad were to be of the greatest significance. He set out by train in the middle of January to discover the classic land of Provence of which he had long dreamed. In bright sunlight he descended at Avignon and 'as if in answer to the insistent call of far-off Roman trumpets . . . I found myself, still dreaming, under the ramparts of the city by the swift flowing Rhône'.[240] To Dorelia he sent his first vivid impressions of the place (10 January 1910): 'This is a wonderful country and a wonderful town Avignon. I'm beginning to feel better. . . . The people are certainly a handsome lot on the whole. I see beautiful ones now and then. . . . We could camp under the city walls here.'

Everything conspired to delight him. Across the Rhône the white town of Villeneuve-les-Avignon shone like an illumination from some missal; and in the distance, as if snow-covered, *Le Ventoux* unexpectedly raised its creamy head. Near by, like a noble phalanstery rising straight and 'functional', stood the Popes' Palace where Augustus would go to admire the fragmentary frescoes of Simone Martini. But it was not

the indoor works of art that excited him most: it was the country and
the people. The sun would not be denied. 'I get tired of museums,' he
wrote to Dorelia (17 January 1910). 'The sun of Provence is curing me
of all my humours.' Of wonderful naïvety and charm were the 'gypsy
children playing – Gitanos, I never saw such kids – one of them especi-
ally broke my heart he was so incredibly charming, so ceaselessly active
and boiling over with high spirits. He was about Robin's age, but a
consummate artist. I went down first thing this morning to see them
again but I fancy they have disappeared in the night for one of their
hooded carts had gone. It's so like them to vanish just as you think
you've got at them.'

He did no work and his travels took in more encampments than art
galleries. 'Nothing so fills me with the love of life as the medieval –
antique – life of camps,' he had once (2 October 1909) told Scott Macfie,
'it seems to shame the specious permanence of cities, and tents will
outlast pyramids.' Already he was feeling miraculously restored. 'I was
in the last extremities of depression before getting here,' he wrote to
Arthur Symons (January 1910), 'and now I begin to feel dangerously
robust. The country is full of beautiful women.' From Avignon he
advanced to Nîmes and then hurried on to Arles, once celebrated for the
special beauty of its girls, where he was detained longer. 'The restaurant
cafe where I am stopping here would not be a bad place for us to put
up,' he told Dorelia. He was missing her. 'I can't sleep alone,' he
complained, 'and when I do I dream of Irish tinkers and Lord Mayors.'
Surely she would have to rescue him soon? 'What do you think about
coming down here with P[yramus] and R[omilly]? I would love it. We
would be quite warm in bed here.'

He made Arles his headquarters for the rest of this month. 'Arles is
beautiful – Provence a lovely land,' he wrote to Ottoline Morrell
(18 January 1910). '. . . What a foetid plague spot London seems from
this point of vantage. It takes only this divine sunlight to disperse the
clouds and humours that settle round in England. I never want to stop
there again for all the winter.' But wherever he went in Provence he
was tempted to stop – and would write to Dorelia telling her so. At
Paradou he noticed 'an excellent bit of land to stop on, but we must
have light wooded carts and tents – no heavy wagons please.' There
were many such places in France. 'There's plenty of sand one could
camp on all over the Camargue which is as flat as a pancake and mostly
barren,' he reported to Dorelia (27 January 1910). 'I've been talking to a
young man, a cocker, about getting a cart to move about in.' Mean-
while he walked huge distances – 'I have bought the largest pair of
boots in the world' – and sometimes, in bourgeois fashion, travelled
by train.

One village that enchanted him was Les Baux – 'an extraordinary place', he wrote, 'built among billows of rocks rather like Palestine as far as I remember. The people of Les Baux are pleasant simple folk – a little inclined to apologise for their ridiculous situation. We could have a fine apartment there cheap. There are plenty of precipices for the boys to fall over.' It was at Les Baux that he met Alphonse Broule, 'a superb fellow' who claimed to be a friend of the great Provençal poet Mistral whose statue, overcoat on arm, reared itself at Arles – 'a man singularly like Buffalo Bill'. This man – 'a poet', Augustus first hazarded: 'an absolute madman', he later concluded – offered to introduce him to the master, and a few days later they met near Maillane.

'The country I saw on the way made me wild,' he wrote to Dorelia, '– so beautiful – a chain of rocky hills quite barren except for olives here and there . . . finally we came to Mistral's house; by this time my host was getting very nervous. But we found the master on the road, returning home with his wife . . . and he was so feeble as to receive us into his house. Mrs Mistral was careful to see that we wiped our feet well first. My companion talked a lot and wept before the master, a large snot hanging from his nose. Mistral listened to him with some patience. On leaving I asked him if he would care to sit two seconds for me to draw him when I passed that way again. He refused absolutely and recommended me to go and view his portrait at Marseilles. I . . . was enchanted with his answer which showed an intellect I was far from being prepared to meet.'

Mistral later regretted having forbidden Augustus to do his portrait, he told Marie Mauron,[241] but their meeting had horrified him. First there was this man Broule with his voice-and-tears like some ceaseless breaking of waves in the depths of a hollow cavern; and then there was his companion, an extraordinarily flamboyant and forbidding fellow from whom Mistral shrank in alarm. Let a man like this begin to draw you, he had reflected, and you would find him living with you for the rest of your life. It was either a firm goodbye at the start, or goodbye to work.

'I don't see how Italy could be much better than this,' Augustus wrote from Arles. Nevertheless, with regret, he decided to 'go off to Marseilles to-day, and so to Italy and get through some of the galleries studiously'. The first stage of this journey was to yield a marvellous discovery. Leaving Arles for Marseilles, the railway skirts the northern shores of the vast blue Etang de Berre, bordered by far-off amethyst cliffs. As he travelled along this inland sea, through the pine and olive trees, the speckled aromatic hills, he saw from the window, in the distance, the spires of a town appear, built as it seemed upon the incredible waters. The sensation which this sight, now gliding slowly

away, produced on him was like that of a vision. He made up his mind
after Italy to return, and find out what this mysterious city might be.

At Marseilles another surprise awaited him: the town was teeming
with gypsies. From the *terrasse* of the Bar Augas he watched groups of
Almerian Gitanos lounging at the foot of the Porte d'Aix, staves in
their hands, their jet-black hair brushed rigidly forward over the ears
and there abruptly cut, like nuns from some unknown and brilliant
order. His attention was particularly caught by one remarkable figure –
a tall bulky man of middle age wearing voluminous high boots, baggy
trousers decorated at the sides with insertions of green and red, a short
braided coat garnished with huge silver pendants and chains, and a hat
of less magnificence but of greater antiquity upon his shaggy head,
puffing at a great German pipe. Recognizing him as a Russian gypsy,
Augustus accosted him in Romany. He had just received from Quinn
another fifty pounds and with some of this he proposed celebrating their
meeting, in return for which he was invited back to their camp. They
arrived, with a certain *éclat*, in a cab, ate supper round an enormous
bonfire and ended the evening amid songs and dances in the Russian
style. Augustus, who had come for dinner, stayed a week at this camp.
'I cannot tell you how they affect me,' he wrote to Ottoline Morrell
(February 1910). '. . . I have an idea of dying myself chocolate pour
mieux poser à Gitano.' But after this week he was already less of a
damn gâjo.

'Last night Milosch and Terka, my hosts, showed me all their wealth
– unnumbered gold coins each worth at least 100 francs, jewels, corals,
pearls. This morning came 3 young men, while we were still lying a-bed
on the floor, bearing news of the death of a Romany. Terka wept and
lamented wildly, beating her face and knotting her diklo round her
neck and calling upon God. At the station we found 20 or 30 Romani-
chels seated on the floor drinking tea from samovars. Beautiful people –
amongst them a fantastic figure – the husband of the deceased – an old
bearded man, refusing to be comforted.'[242]

Augustus did not draw much, feeling he gained more simply from
watching. 'I tried to draw some of them,' he told Dorelia, 'but they
never look the same when they're posing. All the same it's worthwhile
trying.' What he hoped to do was to make very rapid sketches from
which to work later. 'When people notice they are being drawn,' he
explained to Ottoline, 'they immediately change expression and look
less intelligent.'

He was learning more Romany every hour, and sending copious
word-lists and notes on songs in the direction of Liverpool. What he
jotted down in a few hours was enough to keep the best gypsy brains
there at work for months. Scott Macfie was particularly gratified by the

demoralizing effect of Augustus's researches. 'This new dialect seems pretty stiff stuff to work out,' he wrote gleefully, 'and it is a pleasure to see signs of exasperation in Winstedt's remarks. He complains that in consequence of the strain his morals, his habits and his manners have become disgusting.'

Augustus was happy – but Italy seemed as far off as ever. 'I'm not particularly impatient to do Italy,' he wrote to Dorelia. 'Already I've seen a good many sights, but no pictures it is true, except the Avignon ones.' It is possible he would never have crossed the border but for the fact that the gypsies had elected to go there themselves.

'I may get off to-night to Genoa,' he eventually informed Dorelia, 'as the Gypsies are going to Milan I shall see them again. They also mean to come to London.* They could give a good show in a theatre. Terka, the woman in whose room I am staying, has a baby 10 months old who I think may die to-night. We went to a doctor to-day who seemed anxious to get rid of us. The little creature bucked up a bit to-night but was very cold. I'm going back now with a little brandy, all I can think of . . . I might take a room in Milan for a few weeks and try and paint some of these folk.'

He travelled by night to Genoa, his head still full of gypsies, his bearded and bedraggled appearance itself very gypsylike. 'Why was I not warned against coming here,' he immediately complained to Dorelia. '. . . Wonderful things happened at Marseilles the last two days. I haven't had my clothes off for a week. . . . I'm sick of Italy.' But it was really Genoa he disliked. Though it had *sounded* warm, it was a cold place – 'a place to avoid'.[243] The streets crawled with people, like lice, and 'the pubs are horrid little places mostly art-nouveau'. Of course the country was better, and the Italian lower classes had wonderful faces – the faces of peasants, virile, martial, keen as birds. But the bourgeois, as elsewhere, were not fit to be mentioned: and they swarmed everywhere. 'I took a second class ticket – hoping to get along quicker,' he told Ottoline (11 February 1910), 'but I couldn't put up with the second-class people (not to speak of the first). I had to take refuge in the third class – and was happy then. The 3rd class carriages have a hard simplicity about them which was infinitely comfortable.' He aimed to 'get through' Italy as fast as he could – a week, he calculated, should do the job.

Since he intended rejoining the gypsies at Milan, he continued to cultivate a gypsy appearance – 'as to my handkerchiefs I have two with me, simply foul; socks I have given up; you could grow mushrooms in

* They turned up in the summer of 1911 at Liverpool and were infiltrated by several members of the Gypsy Lore Society in costume.

my vest'.[244] All this contributed to his Italian difficulties. His whirlwind flight, pursued everywhere by Quinn's venereal imprecations, lasted (owing to the slowness of Italian trains) a full fortnight, but had an effect out of all proportion to this time. Though he hated the big towns which, after the roughness of Marseilles, struck him as 'overcultivated', he loved the country. There were hillocks of brown earth on the way to Siena – 'things one might invent', he described them to Ottoline, 'without ever expecting to see'. The Tuscan landscape seemed not to have changed since the fourteenth century. 'You know those earthen mounds, gutted with the rains,' he wrote to Arthur Symons, '– and those mountains, like women in bed, under the quilts? What a lusty land it is!' From Siena, where he was greatly attracted by the work of Pietro Lorenzetti, he came to Orvieto – 'do you know it?' he asked Symons. 'Splendid! The frescoes there break your heart – so beautiful, so magnificent.' He sped on – to Perugia,* and then to Florence which, he told Ottoline (11 February 1910) was 'magnificent and uncomfortable for a vagrant like myself – and too much to see – too many masterpieces to digest at one meal'. All the same, simply because of the rush, he was seeing things with an extraordinary intensity that would keep these first impressions vividly before him all his life.

He had decided to postpone Rome, turning north and travelling through thick gloomy mountains with half-melted snow on them, a grey mist hiding the sky, to Ravenna. 'The mosaics here are superb,' he wrote to Dorelia. 'Westminster Cathedral ought to be done in the same manner.' He had intended only to change trains at Ravenna, but it was difficult to relinquish the Court of Justinian and Theodora, and he stayed there several days. The Tomb of Theodoric evoked pre-natal memories of Gothic heroes – a semi-barbaric splendour compared with which the modern world seemed pale. Padua, his next halting place, and the paintings of Giotto also slowed down his progress. He had seen so much he was growing confused. 'Was it here I saw Piero della Francesca's majestic Christ rising from the tomb?' he wondered.[245] 'I think not.'

But what did it matter, the provenance? Italy, he was discovering, represented for him the great, the authentic tradition to which, un-dismayed by its splendour, he meant to dedicate himself. It was in Provence that he was to find another home – 'I love that patch of ground,' he told Symons – and it was to the Provençal landscape, and the landscape of North Wales that he would look for his finest pictures. In such an atmosphere, less charged with the accumulated glory of the

* 'I went to Perugia this morning – no shape of a place. I did the whole shoot in an hour; nothing but some Perugino frescos, and Perugino as you know was rather a soft growth.' Augustus to Dorelia (February 1910).

past and where there were no masterpieces to overawe him, Augustus would set to work: but enriched by what he had seen during these two brilliant weeks in Italy. For to Giotto of Padua, to Duccio, Masaccio and Raphael, to Piero della Francesca wherever exactly his resurrected Christ might be, and to Botticelli whose *Primavera*, lovely beyond compare, was the brightest jewel of Florence, he would ultimately trace his own cultural beginnings.

And so to Milan. A vast assembly of gypsies – twenty tents of pleasure – had occupied a field outside the city. Work was in progress when Augustus approached, and the air rang with the din of hammering and the cries of these wild tribes. To his astonishment he found not only his Marseilles friends but also the coppersmiths he had met two years previously in Cherbourg – and there was a grand reunion. That evening a party was held in the principal tent. Black-bearded, wild-eyed, fierce and friendly, the men, many of them as handsome as Romans, were dressed in the costumes of stage brigands. They carried long silver-bedecked staves, and their white-braided tunics were decorated with silver buttons as large as hens' eggs. The women were mostly in scarlet, and each had threaded twenty or more huge gold coins in her hair and on her blouse – a total, in sterling, of at least a hundred pounds. As the great celebration proceeded, these young girls were called upon to dance to music of accordions, while the men lifted up their voices in melancholy song. The dancers, without shifting their position on the carpet, agitated their limbs, hips and breasts in a kind of shivering ecstasy. Cross-legged at a low table, Todor, the elderly chief next to whom Augustus sat, beat time until the bottles leapt, sometimes in a sudden frenzy shattering his great German pipe – immediately to be handed another. Solid silver samovars littered the floor, and on the tables stood elaborately chased silver flagons a foot high and filled with wine and rum. A troop of old men were seated round them in a state of Bacchic inspiration, while outside the tent a crowd of *gájos* looked on as if in some hypnotic trance. 'The absolute isolation of the Gypsies seemed to me the rarest and most unattainable thing in the world,' Augustus wrote to Scott Macfie (14 February 1910). 'The surge of music, which rose and fell as *naturally* as the wind makes music in the trees or the waves upon the shore affected one strangely. It was *religious* – orgiastic. I murmured to my neighbour "Kerela te kamav te rovav" ["It makes one want to cry"].'

Late that night, while the festivities were in full swing, he tore himself away and, returning the next morning to annotate some songs, found the party still going strong – together with the rattle of twenty hammers beating out copper vessels, and the yelling of youths with

shining eyes swaying together in a multi-embrace. 'If ever my own life becomes insupportable I know where to turn for another,' he wrote to Quinn (3 March 1910), 'and I shall be welcomed in the tents.'

Back to Marseilles. 'In some respects it beats Liverpool even,' he wrote to Chaloner Dowdall. The roughness of the place reflected the other side of his romanticism, and he began to relish it. 'You ought to let me take you round Marseilles one day,' he offered the Rani. 'There are things there to raise the hairs on Rothenstein's back.' Now he knew the night spots 'I feel ready to live here,' he told Dorelia. 'One sees *beautiful* Gitano girls about with orange, green and purple clothes . . . Hundreds of people to paint . . . One of the women, without being very dark, is as splendid as antiquity and her character is that of the Mother of God.'

But his letters to Dorelia were filled with anxiety. However urgently he wrote, she did not answer him. When, for example, he asked for a bundle of postal orders and blank cheques to be sent, a registered envelope arrived at the *poste restante* which, since he still travelled without a passport, could not be released to him. After summoning two stalwart gypsies to swear in strange tongues as to his identity, he was eventually allowed to open the envelope which was found to contain a dentist's bill meticulously forwarded by Dorelia. Soon he began to besiege her with telegrams. 'As you don't answer my three telegrams I conclude you have had enough of me.' What trickle of news had arrived worried him. 'You had better see a doctor about your poor tummy,' he had written near the start of his journey, '– and so leave nothing undone that might be good for you. Tell him you thought you had a fausse couche the other day. *Now do!*' The only information he had received since then was a note telling him she was suffering from mysterious pains in her side. 'Your belly is very enigmatic,' he replied. 'You'd better come this way at the next period and make sure. You'd don't want to have any more babies just yet. I don't suppose you'ld better Pyramus and Romilly. Don't forget to write . . . Au revoir, my love, I wish you were here.'

Finally she wrote. 'I was overjoyed to hear from you,' he answered. 'I was steeling myself for another disappointment.' The news itself was bad – and good. She *was* pregnant again: it had been a 'false miscarriage'. She would join him in Provence, together with Helen Maitland and a detachment of family. 'This is splendid news!' Augustus wrote back cheerfully. 'I hope it'll be another boy! Glad your belly has settled down to proper working order. I wonder what part of the babe will be missing. Its kâri perhaps, in which case it may turn out to be a girl after all.'

Dorelia herself seemed neither happy nor unhappy. Pregnancy was no mighty matter. 'The terrible thing is I am going to have another infant in August (I don't really mind),' she wrote to Ottoline (February 1910). '. . . It is sure to be another boy'.

In view of what was to happen, and of the criticism voiced by Henry Lamb and others to the effect that Augustus endangered Dorelia's life, as he had done Ida's, it is important to establish some facts. An unusually intimate letter ('to no one else could I write so intimately') which Augustus sent Quinn (3 March 1910) gives a view of what happened that, because he seldom spoke of such things, was not appreciated by many who were close. It also reveals a concern over this new pregnancy that he was careful to keep veiled from Dorelia.

'The infernal fact is that she [Dorelia] is in for another baby sometime this summer. God knows I've got plenty of kids as it is, and worst of all Dorelia is not in robust health. Her inside bothers her. I tried my best to avoid this – but she hates interfering with nature. All I hope is that she will at least get strong here. She insisted on bringing 3 of the youngest kids here; 3 remain in London and go to school.'

But he was delighted she was coming. In his fashion he had been faithful to her. 'I went through Italy without sampling a single Italian female,' he gravely reassured Quinn. 'I saw, however, many with whom I slept (with my eyes open) in fancy.' He was to rejoin Dorelia at Arles. Travelling up there slowly from Marseilles, he wrote to Ottoline: 'These really barren hills round here *enchant me* . . . I visited this evening two bordels here . . . the ladies were not very beautiful, strictly speaking – but I found them very aimable . . . There was a mechanical piano which my acquaintance played with the utmost dexterity. I was thoroughly interested and lost more money than if I had been a "client sérieux".

'At Avignon also I introduced myself into a bordel – "une maison très sérieuse". The ladies of those establishments are absolute slaves. The patron took all the money and the travailleuses are not allowed to quit the house without permission. However they don't complain –si le patron est gentil et pour une qu'il y aurait beaucoup de clients. They are excessively simple.'

Two days later, 'looking incredible with some white veil over her head',[246] Dorelia arrived.

She came with Pyramus, Romilly and Edwin; and with Helen Maitland. Helen was now her closest friend and much influenced by her. She was a striking girl, with clear grey-blue eyes, a rosy complexion and finely formed features. Rather small, she held herself very upright and

moved with a slow, trailing, purposeful stride that conveyed great dignity. The set of her face expressed a somewhat daunting determination; her tone of voice, flavoured with irony, was sometimes harsh: and she had a hard energy within. But it was her smile, radiant and welcoming, that was remarkable, softening her expression, sending out a challenge, a flattering air of complicity. And it was this smile, which she offered like a bouquet of flowers, that made people pour out their troubles to her. For herself, she hated sympathy and seldom spoke of her own difficulties. Like Dorelia, she was the most stimulating listener, the cause of good conversation in others.

Like Dorelia, too, she saw her life as a vocation to be fulfilled among painters. She was a woman who preferred, in a maternal fashion, to give love than to have the responsibility of receiving it. She was to marry, eight years later, the brilliant and burly Russian artist in mosaic, Boris Anrep – reputed to be the only man in London capable of standing up to Augustus in a fist fight; and in 1926 she was to leave him to live with Roger Fry,* many of whose ideas on modern art she 'invited' out of his head. But now, again following Dorelia, she was deeply in love with the satanic Henry Lamb.

Between her and Augustus, Lamb was the barrier.† It was galling to Augustus that, even though Helen's love might not primarily be a thing of the senses, she should prefer his understudy to himself. Besides, she was very loyal to Dorelia and, anxious that she should not be treated badly, over-ready to be critical of him. His sense of the ridiculous often reduced her to tears of laughter – but then she could not altogether take him seriously, being so serious herself. It was certainly galling for him. For though she laughed, she was not happy. Her love-affair was going badly and she blamed this on Lamb's philosophy which, she believed, he had picked up from Augustus. A strong feminist, she disapproved of an attitude that appeared to treat women simply as raw material for art. It was, she felt, merely another outpost of masculine self-assertion, and

* Like Augustus, Boris Anrep had landed himself with two wives in the same house – number two being useful for selecting books from the public library for Helen on the infallible principle of their not being the sort she would choose for herself. But he disappointed Helen 'by his literary philistinism and preference for legshows to those concerned more with the head', Romilly John remembers (29 July 1972). '. . . It was rumoured that she came from California which might account for her devotion to Culture and her eventual rejection of Boris and Hampstead in favour of Roger Fry and Bloomsbury.'

† In the first draft of his autobiography, Augustus referred to Helen as 'censorious', adding: 'I have always disappointed her, being somewhat earth-bound and unable to rise to the lofty stratosphere, where, without oxygen, she seems most at home. . . . For, feeling myself accursed, her strictures left me subdued but with an inkling at least of higher things beyond my grasp.' Dorelia, however, considered these observations to be sarcastic and they were dropped from *Chiaroscuro*.

it provoked her own most aggressive streak. Men she treated as children, and children as nonentities. And she preferred men who were weak or in difficulties to those who seemed self-reliant. They sustained her belief that women, being by far the more practical sex, should run most things. It was a belief shortly to be tested.

They assembled, the six of them, at Arles and caught the same train south Augustus had taken the previous month along the Etang de Berre. Like a jewel in a chain changing colour and extending between the barren hills, the great lake seemed to mesmerize them all. 'I have seen this Etang de Berre looking wonderful,' Helen wrote to Lamb, 'it has these pale brown hills all around and it's small enough to get perfectly smooth the moment the wind is down and then the colours are lovely – very brilliant green one evening with a blue sky. All the way from Arles I was ecstatic with delight . . . simply speechless with astonishment at the curious light blue of one Etang we passed. It was so bright that it made the sky look dull and dark. They had planted cypresses all along the line so we only saw it for a moment or two now and again through a break in them. But I doubt if any mortal could have stood such loveliness much prolonged. On the other side was a vast stony plain, quite limitless and bare except for sage bushes and sheep.'

They were en route for the town whose spires Augustus had briefly seen rising from the waters on his first journey into Marseilles. At Pas des Lanciers they descended, ate their food squatting in a circle on the platform, then changed to the little railway line that leads to Martigues. Their train skirted the Etang, passing close under hills of extraordinary shape, some very thin with jagged edges stacked one behind another and all bare except for aromatic grey herbs in patches – thyme, lavender and sage. At every orchard, at almost every cowshed, the train would stop. But at last they came to Martigues. There was no need to seek further.

'An enchanting spot this, situated in the water at the mouth of an island sea where it joins the Mediterranean,' Augustus wrote to Ottoline. '. . . The population are handsomer than the country folk. I have seen so many powerful women whose essential nudity no clothing can disguise. In the little port at hand are found sea-farers from all the shores of the Mediterranean.'

For several days they stayed at a hotel, then moved into 'an admirable logement unfurnished and unwallpapered, with a large room in which to paint'. This was the Villa St Anne, a house they were to keep, using it intermittently, for the next eighteen years. On the outskirts of Martigues, along the route to Marseilles, it stood upon a steep yellow

bank overlooking the blue waters of the lagoon. From the terrace
stretched a plantation of pine trees, and all around were trackless stones,
and rocky grey hills interfused with heather and a million sweet-smelling
herbs. To Dorelia's delight, they had a large wild garden with olives,
vines, almonds, figs and 'weeds all over the ground which is covered in
pale coloured stones'.[247]

For the time being they shared the villa with its proprietor, a hawk-
faced Huguenot named Albert Bazin. He was a prime example of that
breed of eccentrics who clustered round Augustus for most of his life,
and he possessed one single frustrated passion: for flying. Over twenty
years of ruthless experiments he had constructed, to some secret ornith-
ological recipe, a squadron of aeroplanes, all of which *flapped their wings*.
From time to time, while Mme Bazin delivered a narrative of proceed-
ings from the shore, he would launch his latest model, like some enor-
mous gnat, across the waters where at a desperate rate it would rise
fractionally from the waves, sweep through a wide arc, then plunge into
the bosom of the lake. Although these machines were reduced to mere
salads, Bazin himself was always miraculously unhurt. In such pursuits
he had grown old, ill, bankrupt but undismayed; for with the arrival of
Augustus his aviation fantasies soared to their highest altitude. He at
once recognized in him the perfect 'jockey' for his machines, and a
vicarious source of revenue with which to continue his inventive
industry. Augustus was delighted with this philosopher of the air and
promised to sound out various art patrons on his behalf. Bazin needed,
initially, a mere two hundred pounds to take off and 'it must be found',
Augustus told Ottoline (May 1910), since he was the 'finest man and
aviator in France'. But it was Quinn who, through many months, bore
the brunt of Augustus's enthusiasm. In letter after letter he was buried
under information about this 'real savant as regards flying matters',
flooded with journals that contained articles by Bazin proving that he
'has got ahead theoretically at least of the other men', such as Blériot.
Augustus's appeals took many forms. Would Quinn like 'to collaborate
with him and his machine No. 8 which ought to be ready in the autumn,
if he finds the cash?' Could some 'American energy' be harnessed for
'my bird-like neighbour'? Perhaps someone from 'the Land of Enter-
prise' might investigate his 'case'. 'I wrote to you lately as longwindedly
as I could about Albert Bazin,' Augustus reminded him (23 May 1910).
'. . . Do not be bored with Bazin yourself but bore your friends as
much as you can.' Quinn alternated between physical alarm on Augus-
tus's behalf – 'don't you attempt to go out on Bazin's machine' – and
financial alarm on his own: 'Personally I can't afford to "take a flyer"
now myself.' Although any appeal to bore his friends was irresistible, he
disliked such methods when applied to himself. 'Say at once if you are

not interested in the matter,' Augustus would beg him like someone stone deaf, 'and I will cease to bore you.' 'I am afraid it is hopeless!' cried Quinn. But Augustus, approaching the problem from a different angle, urged: 'He[Bazin]'s got a fine young daughter of 18 summers. The fact might as well be mentioned – in view of the collaboration.' 'I'd rather collaborate with his daughter than I would with the old man,' Quinn conceded – adding however that 'Marseilles seems to be far off'. But though the geography might be poor, the biology was strong enough, he insisted: 'I may tell you that not eating much meat and not drinking lessens the strain on the testicles . . . I have doubled my efficiency since I quit eating so much and since I stopped drinking. If only I could cut out smoking entirely, I would treble my efficiency.'

The pattern of life at the Villa St Anne, though confused a little by good intentions, was straightforward. 'I am installed in this little house with a batch of family and hard at work,' Augustus promised Quinn (2 April 1910). 'The weather has been glorious and we have been out of doors all day for weeks.' They had bought a boat and spent many days dreamily rowing across the glasslike surface of the lake. 'From time to time, as with dread I looked down into the bottomless void beneath us,' Romilly John recalled,[248] 'an enormous jellyfish of a yellowish grey colour sailed by, trailing in gentle curves long streamers decorated with overlapping purple fringe: it seemed to emphasize the spatial quality of the blue depths.'

From a Catalonian gypsy Augustus also bought a donkey and cart, and while Dorelia took the children off to the sea, he would go on long sketching expeditions. 'One sees much more by these means,' he told Quinn (2 April 1910), 'and one doesn't go to sleep.' At night, while Dorelia cooked and the children eventually tumbled into bed, Augustus would read: gypsy literature from Liverpool, Provençal masters such as Diderot and Mistral, poems from Symons and Wyndham Lewis, the works of Léon Bloy, and old copies of the *New Age*.

Gypsies would often pass the door, be invited in for a drink and a talk, and stay several days. Somehow there was always enough food for them, and Dorelia enjoyed their company too. 'We had the house full of gypsies for about a week,' she wrote to Ottoline (May 1910). '. . . It was great fun. They would dance and sing at any hour of the day.'

At intervals, when the supply of gypsies grew scarce, Augustus would take himself off to Marseilles and seek sanctuary with 'some Gitano pals' who were teaching him to play the guitar. From here he could keep watch on a waste piece of ground outside the town over which passed a strange procession: bear-leaders from the Balkans; wagon-loads of women; Russians 'fresh from Russia'; a pantalooned

tribe of Turkish wanderers from Stamboul, 'in little brown tents of ragged sacking far from impervious to the rain', waiting for a boat to Tangier; a whole lot of Mumpers from Alsasce – 'a low unprofitable company'; Irish tinkers, Dutch nomads, French Romani-chels, gypsies from southern Spain, Bosnians, Belgians, Bohemians, Bessarabians – 'the travelling population of France is enormous'.[249] If only he could import some into Surrey, and let them breed!

His word-lists grew longer and his calligraphy more fevered. Of everyone he inquired about Sainte Sara and the gypsy pilgrimage to Saintes Maries de la Mer. 'This pilgrimage may be the last of the old pilgrim mysteries of the gypsies,' he assured Scott Macfie (14 May 1910). He ransacked the library at Aix; he reverently inspected the bones of the Egyptian saint at Saintes Maries. But beyond various stories of miraculous cures he could discover little. It did not matter. For though Sainte Sara was a problem to be solved by the Gypsy Lore Society, to Augustus she remained a symbol, and the annual fête at Saintes Maries a renewed act of faith. As such, it presented itself to him as a picture by Puvis de Chavannes, and was to dominate, tragically, the last years of his life.

Not all his pursuits were so scholarly. His letters to Scott Macfie intersperse gypsy investigations with exploits of another kind among the 'inveterate whores of Marseilles'[250] whom he now thought of introducing into his decorations for Hugh Lane. They were everywhere, like an army of occupation. To run the gauntlet of what he called 'this fine assortment of Mediterranean whores',[251] he resorted, Wyndham Lewis-style, to the protection of a voluminous cloak – 'a cloak albeit of stout fabric' – like a bandit. 'Why does the employment of a prostitute cause one's last neglected but unbroken *religious* chord to vibrate with such terrifying sonority?' he suddenly demanded (16 March 1910). From Liverpool came little response to these Dostoievsky rumblings, and Augustus was obliged to answer himself.

'As to whores and whoredom, considered from the purely practical point of view (never really pure) as a utility it is an abomination which stinks like anybody else's shit,' he volunteered (30 March 1910); 'considered morally it is a foul blasphemy which must make Christ continually sweat blood: but without either point of view, there is an aspect of beauty to be discovered – which indeed jumps at one's eye sometimes – whores, especially at 20 sous la pusse, have often something enigmatic, sacerdotal about them. It is as if one entered some temple of some strange God, and the "intimacy" really doesn't exist except to reveal the untraversable gulfs which can isolate two souls.'

To 'know' someone in the Biblical sense, and to know them otherwise not at all; to preserve the stranger-element in a physical union;

this symbolized, without speech, the loneliness of human beings exiled on earth, and fitted his own isolation into a universal pattern, mystical and inexplicable. Everyone *knew*, no one said anything, and nothing was expected. The relationship was a single act with no long descent into tedium, no race for disenchantment, no ugly clash of wills or accretion of personal knowledge to bewilder. It was the implications of the act rather than the act itself that lived in the imagination. A number of times this spring and summer Augustus took off for Marseilles, drank whisky, 'misbehaved', and returned to Martigues much the better for it all. But it was, he wrote to Scott Macfie (3 April 1910), 'a dangerous subject'.

Two expeditions this summer were of particular interest. One of these was to Aix-en-Provence where Augustus and Dorelia travelled in their donkey cart from dawn to dusk to see Ottoline. She found them sitting outside a café, Dorelia very beautiful in a striped cotton skirt, a yellow scarf covering her head; Augustus, his square-cut beard now pointed in the French manner,* 'which made him look like a dissipated Frenchman, as his eyes were bloodshot and yellow from brandy and rum'.252 Together they went to Cézanne's house on the outskirts of Aix, which still contained a number of his pictures including the murals of the four seasons mysteriously inscribed 'Ingres'; and the next day they explored the town, looking at churches and the tomb of Joseph Sec. Augustus, Ottoline observed,

'. . . was a bored and weary sightseer. In the afternoon when we returned we found him sitting outside a café drinking happily with the little untidy waiter from the hotel and a drunken box-maker from the street nearby. In his companions he requires only a reflecting glass for himself, and thus he generally chooses them from such inferiors. He seems curiously unaware of the world, too heavily laden and oppressed with boredom to break through and to realize life.'253

Augustus's other expedition, to Nice – 'a paradise invaded by bugs (human ones)'254 – involved what he called 'some mighty queer days' with Frank Harris. He had first met Harris in Wellington Square, Chelsea, with Max Beerbohm, Conder, Will Rothenstein and others. With his booming voice, baleful eye and hardy wit, Harris imposed himself upon the distinguished company by sheer force of bad character – or so it appeared to Augustus, whose attention was much taken up with the stately figure of Constance Collier, the flamboyant actress somewhat improbably engaged to Max Beerbohm. While Harris was holding the floor, Augustus suggested to this 'large and handsome lady'

* 'I am living the simple life here. My missus has just snipped the best part of my whiskers off, and wants to finish the job.' John to Quinn (2 April 1910).

that she sit for him, adding, perhaps somewhat tactlessly, that he would have to find a bigger studio. 'Why not take the Crystal Palace then?' boomed Harris, suddenly exploding into their conversation: and everyone laughed. He was, Augustus rather sourly observed, very much the *pièce de résistance* of the party, a position Augustus preferred to occupy himself. Like Augustus, Harris presented a bold front to the world. 'Stocky in build, his broad chest was protected by a formidable waistcoat heavily studded with brass knobs,' Augustus wrote.[255] 'With his basilisk eyes and his rich booming voice he dominated the room. Hair of a suspicious blackness rose steeply from his moderate brow, and a luxuriant though well-trained moustache of the same coloration added a suggestion of Mephistopheles to the *ensemble*.'

Harris took an apparently very friendly and flattering interest in Augustus, claiming in return that 'he praised my stories beyond measure' – the sort of high-flown approval he regretted being just unable to accord Augustus's paintings. This was a preliminary exercise in a most subtle piece of psychological outmanoeuvring that would have delighted Stephen Potter. In fact Augustus had not greatly admired Harris's fiction, but praised *The Man Shakespeare* as 'a wonderful book'. To this literary judgement Harris responded with a burst of artistic criticism: 'The quality of his [John's] painting is poor – gloomy and harsh – reflecting, I think, a certain disdainful bitterness of character which does not go with the highest genius.' Then, describing Augustus as 'a draughtsman of the first rank, to be compared with Ingres, Dürer and Degas, one of the great masters', he bought a drawing, persuaded Augustus fulsomely to inscribe it to him, then sold it for a nice profit to a dealer where, to his irritation, Augustus later stumbled across it.

In an unfair world, where it was always necessary to turn the tables on those who were over-gifted, Harris saw Augustus as a potentially superior version of himself – a superb Celtish actor, a lover of women and a lusty drinker, a creature of fantasy and of talent, and a rebel artist who disdained the social successes that Harris had once coveted. Lunching at the Café Royal at the time *The Man Shakespeare* was published (autumn 1909), Harris was greatly struck by Augustus's height, beauty and 'great manner' which, he wrote,[256] 'swept aside argument and infected all his hearers. Everyone felt in the imperious manner, flaming eyes and eloquent cadenced voice the outward and visible signs of that demonic spiritual endowment we call genius.'

Harris was then considering himself in the role of prosperous gallery owner, and it must have been partly owing to this new career that he acted quite so hospitably to Augustus. His blandishments, mixed in with pious references to Jesus Christ, continued to arrive by post that winter, first from Ravello, then from Nice. And it was here that Augustus

succumbed to an invitation to stay with him. Their encounter was to strike sparks that illumine odd corners in both their characters.

Augustus arrived at Nice station dressed in corduroys and with his painting materials in a small handbag. On the platform he was met by Harris decked out in full evening dress, apparently disconcerted by his guest's lack of *chic*, yet determined to carry him off to the Opera House where he had a box lent to him by the Princesse de Monaco. Here his wife Nellie awaited them 'attired for the occasion in somewhat faded and second-hand splendour'. The composer of 'the infernal din' to which they were subjected soon joined them and, taking a dislike to Augustus on sight, restricted his compliments to Harris. Augustus, who particularly resented exclusion from such exchanges, noticed that they 'vied with each other in mutual admiration', and 'I gathered that I was assisting at a meeting between "the modern Wagner" and "the greatest intellect in Europe".'[257]

What then happened later that night and on subsequent nights back at Harris's home was very peculiar. 'I was shown my room which, as Frank was careful to point out, adjoined Nelly's, his own being at a certain distance, round the corner . . . Before many hours passed in the Villa, I decided I was either mad or living in a mad-house. What I found most sinister was the behaviour of Nelly and the female secretary. These two, possessed as it seemed by a mixture of fright and merriment, clung together at my approach, while giggling hysterically as if some desperate mischief was afoot.' Ten years later Nellie Harris hinted to Hesketh Pearson[258] that she had repulsed Augustus's advances during this visit. Whatever the actual facts, there is no doubt that Augustus came to interpret his unsatisfactory three days there as a fortunate escape from some deeply laid Harris plot.

'On the night of the third day our understanding came to an end, or rather I should say perhaps reached perfection. By this time I came to loathe the sight of this monster, and he knew it. I, it seems, had failed him, and his resounding eloquence was wasted on Nellie, who responded but with nervous giggles to the grandiose prospect her husband painted of a "European Courtesan's career".'

What is so strange in testing for the truth of this episode is that Harris was extremely possessive over Nellie; while Augustus, though he often gets details wrong (such as Harris's house at Nice) and embroiders facts with malice, had no gift for invention. It seems he had come to suspect that, by taking advantage of Nellie's night time propinquity, he would lay himself open to Harris's 'requests' for money. Thank God he – or perhaps Nellie – had failed! That Harris was keen on raising funds is undeniable, yet Augustus's interpretation of what was in his mind must almost certainly have been wrong. A man of liberal instincts,

initially, Harris was, in the view of J. D. Fergusson, a new Robin Hood robbing the rich in order (in due course) to reimburse the poor. His vendetta was carried on against the socially successful for the ostensible benefit of the writer and artist. That he himself was poor and a writer enabled him to begin and end many of these charitable exercises at home. But he would never have used an artist for blackmail. So although Augustus, swelling himself up with optimism, could congratulate himself on having 'failed' Harris, it seems more likely that he played up perfectly.

From Carlyle onwards, Harris sought to humiliate, usually in some sexual context, those he admired. Such men pointed the way to all that Harris prized – power and the love of women – but at their own risk, for Harris's route was paved with their exposed lives. He resented that his own fame should depend upon that of other men, that it should be a corollary to theirs. Shakespeare was beyond his reach, if only in time; but his books on Shaw and Wilde, and his series of contemporary portraits, ring loud with this rival-complaint. His novels and short stories demonstrate two other qualities: a lack of literary talent and Harris's hopes of self-greatness. In *Undream'd of Shores*, for example, there is an account of Akbar, the great Mogul ruler, curiously similar to Harris. At one point he tells the girl he loves that there are many men handsomer and stronger than he. But she denies this hotly, asserting that he is the most splendid man in the Court, for 'though he was only a little taller than the average' there was, she reminds him, his 'black eyes and hair and his loud deep voice'. Harris sought to lose the view of himself as he really appeared behind this vision of himself (here put into the girl's mouth) as he wished to appear. The smoke screen he used was puffed up with the fumes of competitive reassurance. In his writings and his life he set up situations which allowed him to score off those who were publicly acknowledged to be handsome, talented and romantic. Augustus unwittingly presented himself as a perfect example: a sitting target. How conscious Harris was of what he did it is impossible to say, but his Contemporary Portrait of Augustus reveals his attitude of attraction-and-resentment quite unashamedly.

'It was Montaigne who said that height was the only beauty of man, and indeed height is the only thing that gives presence to a man. A miniature of Venus may be more attractive than her taller sisters, but a man must have height to be imposing in appearance, or indeed impressive.'

Harris then goes on to portray Augustus as the perfect example of the male species.

'Over six feet in height,* spare and square shouldered, a good walker

* Augustus was just under six feet, but walked tall.

who always keeps himself fit and carries himself with an air, John would draw the eye in any ground. He is splendidly handsome with excellent features, great violet eyes and long lashes . . . he is physically, perhaps, the handsomest specimen of the genus homo that I have ever met.'

Yet this was the man who, three nights in succession, had been rejected by Nellie; who had failed precisely where Harris was successful. Throughout his pen portrait, he constantly returns to emphasize Augustus's fine looks together with 'his wonderful power of drawing and his weird and defiant looseness of living'. Such accomplishments apparently form a crescendo of praise, yet at the end we are suddenly turned against him – or rather what his physique represents – by an acrobatic moral twist. His pitfall, Harris insists, 'is not drink'. Jesus drank. No: if he fails 'it will be because he has been too heavily handicapped by his extraordinary physical advantages. His fine presence and handsome face brought him notoriety very speedily, and that's not good for a man. Women and girls have made up to him and he has spent himself in living instead of doing his work.'

Augustus brought up the full force of his boredom to meet Harris's challenge. But by the third night he had had enough and, shouldering his belongings, stole out at dawn and made his way down the hill to Nice harbour where he laid up in a sailors' café. 'Ah! the exquisite relief! To be alone again and out of that infected atmosphere, that madhouse! To be among common fellows and free to go as I pleased.'* It was an instance of that 'certain abruptness of manner' without which, Harris gleefully noted, 'he would be almost too good-looking'.

In his amusing and urbane descriptions of Harris thirty years later, Augustus attempts to get something of his own back by taking it out of him *visually*. Harris, he observes, 'was looking his ugliest' by the third day; while Nellie (then in her thirties and not unattractive) is converted into a middle-aged matron. But when, in 1929, Augustus first read Harris's Contemporary Portrait of him, his tone was far from urbane: it was outraged. In a letter to Elmer Gertz[259] (25 May 1929) he explains that he had left Harris's villa 'because I found the moral atmosphere of the place unbearable. . . . I could not consent to stay as the guest of a cad and bully posing as a man of genius.' Besides, he went on, his host's habit of dragging the name of Jesus Christ into any

* 'I WENT TO NEECE TO STAY WITH SOME PEOPLE BUT I FOUND THEY WERE SO HORRIBLE I RAN AWAY ONE MORNING, EARLY, BEFORE THEY WERE UP NEECE IS A LOVELY PLACE FULL OF HORRIBLE PEOPLE.' Augustus to David John (March 1910).

conversation or piece of writing was obnoxious to him 'coming from a man of Harris's moral standards'. Here, unmistakably, is the pompous humourless tone of Edwin John, his father. He refused to let Gertz use these letters in his biography[260] to refute Harris's inaccuracies, partly because they revealed the extent to which he had been discomfited and partly because, Harris still being alive, he wished at all costs to avoid public controversy. His dealings with Harris, especially his sudden fear of blackmail, mark the first hereditary pull towards that caution and inflated air of authority with which, in later years, he sought to protect himself from a hostile world. 'It seems hopeless for me ever to attempt to conceal even the secrets of the water-closet from the outside world,' he complained to Wyndham Lewis (July 1910). 'There will still be an industrious person with a rake stationed at the other end of the sewer. It is true that I don't put myself out for secrecy . . .' – but the cuticle of secrecy, which would eventually cover and distort his life, had already begun to grow.

The effects of his visit to Nice lingered with Augustus like a bad hangover. 'I expect he would be less gloomy with just his Family,' Helen Maitland confided to Lamb. Soon afterwards she left Martigues to join him, having assured herself and Lamb that Dorelia 'seems better. She doesn't get a pain in her side anymore.'

A few weeks later, in the early morning of Monday, 1 May, Dorelia gave birth prematurely to a dead child. Throughout that day her life hung agonizingly in the balance. 'She *nearly* died afterwards of loss of blood and was really saved by having sea-water injected into her body,' Augustus wrote to Quinn (5 May 1910). '. . . The child, which was a girl, would have been welcome 3 months hence. It had got displaced somehow.' Very pale and weak, Dorelia kept to her bed for a month. 'Happily she has more common sense than would be needed to fit out a dozen normal people and doesn't worry herself at all, now that she is comfortable.'

Augustus was less calm. The hideous threat of puerperal fever terrified him – 'I know that demon already too well.' He was seized with a panic of guilt and helplessness. Now that his family was so scattered – three children in France, three in London, and one, Henry, in Hampshire – he needed more than ever a strong centre to his life. If Dorelia died, everything fell apart. Being 'totally without help except for the neighbours', he immediately wired Helen Maitland who, to his consternation, returned bringing with her Henry Lamb. 'We made an amnesty for these peculiar conditions,' Lamb explained to Ottoline. With Dorelia and Helen in the house, Lamb assumed a very John-like role, and it was difficult for Augustus to object, though he feared, in

Lamb's wake, a long line of gossip.* Only when it was clear that Dorelia was 'on the high road to recovery' did Lamb leave, after which Helen kept him informed by letter. 'Her lips are dreadfully pale but I think she's getting better really' (19 May 1910). In another letter she observed: 'Dorelia, you know, doesn't care for herself and if she thinks she does for other people I am sure it's a mistake and it's something else that she minds.'

Though she had brought a packet of tea with which to combat the crisis, Helen was handicapped by being unused to children and cooking.† Her meals may well have helped to subdue the boys, for they began to tell even on Augustus's redoubtable constitution. 'He is very saintly the way he eats the strange food put before him and even finds ways of pretending to like it,' she wrote to Lamb (May 1910).

By 25 May, Augustus reported that Dorelia 'is getting strong. She is gay to ravishing point.'[261] They had emerged at last from their 'awful adventure' but, anxious to avoid any possibility of a relapse, Augustus planned to import 'a sturdy wench' into the house to do the work as soon as Helen left. 'We have an abominably pretty housemaid,' he was able to complain a little later that summer.[262]

Dorelia's illness, which put a temporary halt to his work, partly overshadowed the rest of that summer at Martigues. For a time Augustus took a studio in Marseilles – 'an astonishing town,' he assured Quinn (28 May 1910), 'probably the dirtiest in Europe'; but he grew ill with a series of stomach disorders cheerfully diagnosed by Dorelia as appendicitis, cancer and ulcers – 'this is encouraging', he remarked to Quinn. Personally he blamed the climate which was alternately too hot, too dry and too windy. By July the other four children arrived – something Augustus strongly welcomed in theory – and their complaints were added in chorus to his own. 'I have my whole family over here now, and it's a good deal,' he conceded.[263] Regular cheques from Quinn and Hugh Lane arrived: but he was more resistant to this medicine now.

* 'I wired to a young woman to come and assist,' he gruffly explained to Wyndham Lewis (July 1910), 'Lamb accompanied the young woman and spent 2 or 3 days in this town; possibly with the object of making himself useful or perhaps with some purely sentimental motif or both.' In fact Lamb seems to have spent about ten days there.

† 'One evening Helen experimentally served up an untried Greek vegetable which I rashly pronounced delicious. A deathly silence ensued. It was as if I had praised Alma Tadema. Such are the pitfalls of associating with aesthetes!' Romilly John wrote (29 July 1972). 'She was unable to leave children well alone to get on with their insignificant lives, and one felt bound to come out with some deep remark and continually to show promise. . . . A tremendous believer in talking things out, after a trying day with her little boy she would go upstairs, wake him up, and reason with him about his conduct, finally leaving him in tears to reappear wreathed in smiles.'

He was a martyr, suddenly, to homesickness. 'There are no green fields here,' he noticed[264] (5 August 1910), 'scratch the ground and you come to the rock . . . a green meadow smells sweet to me . . . This place doesn't succeed in making me feel well – but I have intervals of well being.' A curious longing for the west of Ireland swept over him, and for the people of Ireland with their wry, ramshackle ways, so much more appealing than the complacent natives of Provence. 'These people are too bavard,' he told Ottoline (5 August 1910), 'too concrete – too academic even. They all look as if they've solved the riddle of the universe and lost their souls in the process.'

In this mood he decided to return to London before the end of September and, though he at once regretted this decision, it gave a zest to his last month there. He was working once more against time, and this suited him. Although little finished work had been possible – or so he believed – he had made a good many studies that would, he calculated, be useful for his Hugh Lane decorations. After a spell of defeat, he had begun something entirely new 'with all the lust and keenness of a convalescent'.[265]

'What I have been about here is rapid sketching in paint,' he told Quinn (25 August 1910), 'and I can say (with some excitement) that it's only during the last week or two that I have made an absolute technical step . . . I want to live long!'

That November the fruits of Augustus's nine months abroad were shown at the Chenil Gallery in a one-man show entitled 'Provençal Studies and Other Works'. At the same time, a mile away, another exhibition had just opened: Roger Fry's 'Manet and the Post-Impressionists'.

Revolution 1910

I wish to God I was born with more method in my madness –
but it's coming.

Augustus John to Arthur Symons (March 1910)

I. WHAT THEY SAY

There can have been few more unfortunate times for a British painter to
have been born than in the 1870s. At home, he would have passed his
youth in an atmosphere of genteel tranquillity and then, at the onset of
middle age, been overtaken by changes unprecedented for their speed
and significance. It was almost impossible for such a painter not to be
at some period out of step with his age. For even in 1910 it was still easy
to believe one was living in the middle of the Victorian era. Nothing
much had changed – nothing that affected one. Victorianism had
hardened into a tiny Ice Age of its own, splendidly impervious to the
intellectual fires that were consuming the Continent. Like a massive iron
gate, rusted, half-buried in the earth, it stood blocking the way, needing
the detonation of a World War eventually to uproot it.

Fear was the artificial stimulant that had kept Victorianism alive so
long beyond its natural life span: fear of national decline and the rise of
the degenerate lower classes; fear of sex and the spreading knowledge
of birth control; fear that the very implements of fear, poverty and
religious superstition, were losing their power; fear of foreigners.

Then, 'in or about December 1910 human character changed'. The
date was not arbitrary. Announcing[266] this change fourteen years later,
Virginia Woolf chose it so as to make 'Manet and the Post-Impression-
ists' a symbol of the way in which European ideas entered battle with
English conservatism. Since then art- and social-historians have some-
times tended to convert this symbol into a reality. Time is a magnifying
glass and through it, as things recede, we seem to see them muc hmore
sharply. At over sixty years' distance we have no difficulty in under-
standing what happened. 'Manet and the Post-Impressionists' was a
watershed, and in or about December 1910 the character of British Art
changed: indeed, it disappeared. The Second Post-Impressionist
Exhibition which, two years later, admitted British artists, signalled the
last opportunity for them to choose the path they would follow and the
view posterity would take of them.

Like gossip for biographers, journalism is a rich but dangerous source
material for historians. The 'awful excitement' which erupted after

'Manet and the Post-Impressionists' was a journalistic freak diagnosed
by Roger Fry as another outbreak of British philistinism, more extreme
than anything since Whistler's day. It was historic. The *Times* critic
declared a state of anarchy;[267] Robert Ross warned readers of the
Morning Post[268] that the exhibiting artists were lunatics, and Charles
Ricketts wrote to congratulate him on his percipience. Doctors were
called in publicly to pronounce on the pictures to the sound of applause;
Philip Burne-Jones saw in the show 'a huge practical joke organised in
Paris at the expense of our countrymen', though Wilfrid Blunt could
detect 'no trace of humour in it', only 'a handful of mud': and he
summed up the exhibits as 'works of idleness and impotent stupidity, a
pornographic show'. It was left to a Royal Academician, Sir William
Richmond, to strike a note of pathos: 'I hope that in the last years of a
long life,' he wrote,[269] 'it will be the last time I shall feel ashamed of
being a painter.'

It is when artists forget their own work and expend their energies on
abusing other artists that art is most easily transformed into art-history.
Historians pronouncing on this tempting subject, using it as a thread in
their historical pattern, have an authority scarcely less extraordinary
than doctors or psychiatrists. The special danger of the historical
panorama (as opposed to the mosaic of history) is that it tends to widen
the gap between appearance and reality. It is not necessarily the job of
the artist to fix the destiny of kingdoms or to mirror social conditions,
but to practise his art to the best of his ability wherever it may lead. The
Post-Impressionist shows, which in their historical context have been
used by some critics as a simplifying device, in fact greatly complicated
the condition of art in Britain. That Sir William Richmond should find
these exhibitions 'unmanly'; that Tonks would come to recognize in
Fry the counterpart of Hitler and Mussolini; and that Fry himself
should emerge as the leader of a number of young and rebellious painters
was all perhaps predictable. But the repercussions from these shows
were felt most keenly by those artists who were embedded in their own
times. Those whose work belongs to all time were generally less
affected; while among others who, like Augustus, were half-in and
half-out of their times, the reaction was highly unpredictable. 'The sheep
and the goats are inextricably mixed up,' Eric Gill observed to Will
Rothenstein.

Augustus is the prime example of an artist whose true position cannot
clearly be defined in the perspective of an historical pattern. Within any
general survey of the twentieth century it is impossiblet o place him
neatly – unless he is depicted as a transitional figure in an age of transi-
tion, but moving diagonally. He was admired by Roger Fry and dis-
missed by Clive Bell, and he returned those feelings exactly; he was a

pupil of Tonks, Fry's enemy, but provoked in the breast of Sir William
Richmond, who called him 'loathesome', feelings of moral shame and
outrage very similar to those stirred up by Fry himself. He admired
Cézanne, was influenced by Gauguin, and disliked Matisse. Though he
had seen and been impressed by Picasso's work and had travelled much
in Europe, he could still in 1907 ask Henry Lamb who Van Gogh was.
He exemplified nothing in British art that he could not just as well be
made to contradict, and it is only when we examine him in relation to
the particular, not the general, that a comprehensible likeness may be
traced – that of a solitary figure occupying on the stage of British art a
prominent position, yet to one side from the main events. It is an
oblique view, and curiously revealing.

2. WHAT THEY SAID AT THE TIME

In the years before the First World War, Augustus's place in contem-
porary British art was unique. If Steer was the old king about to enter
retirement, Sickert occupied the role of Regent: and Augustus was heir
apparent. Whatever he did was news, and whatever he did added not so
much to his achievement as to his promise. 'Promise' was the word that
was invariably applied to his work; he was credited and debited with it;
it hung round his neck like a label, and eventually like a stone. Ever
since the Slade days, it was said, he had been dogged by an enviable and
excessive facility. His admirers were encouraged to detect in his paint-
ings signs of infinite potential. However good a particular painting
might be – his *William Nicholson*, *Yeats*, *The Smiling Woman*, or his finest
dream picture of Dorelia – it seemed only to add to the weight of his
future. He was overburdened with promise.

For the last dozen years he had been constantly in the public mind,
associated with something indefinably romantic, brilliant and slightly
scandalous. The criticism and appreciation he attracted revolved round
endless anecdotes that had little to do with his art. 'He is the wonder of
Chelsea,' exclaimed George Moore in 1906, 'the lightning draughtsman,
the only man living for whom drawing presents no difficulty whatever.'
Two years later (10 June 1908) Neville Lytton was actually praising
him for not allowing 'style to interfere with the spirit of life which is the
one and only really essential thing for art'. Referring to him as 'an
anarchistic artist', he told Will Rothenstein: 'I think John's daring and
talent is an excellent example for us and shows us in which direction it is
expedient for us to throw our bonnets over the windmills.' Some indica-
tion of the kind of fame he had achieved before 1910 is provided by an
exhibition of Max Beerbohm's caricatures during May 1909 at the
Leicester Galleries. One of these, as described by Max himself,[270] shows

Augustus 'standing in one of his own "primitive" landscapes, with an awfully dull looking art-critic beside him gazing (the art-critic gazing) at two or three very ugly "primitive" John women in angular attitudes. The drawing is called "Insecurity"; and the art-critic is saying to himself "How odd it seems that thirty years hence I may be desperately in love with these ladies!"'* ·

Max's ambiguous attitude to Augustus almost exactly reflects that of his contemporaries as a whole. At the Leicester Galleries his caricatures had been interspersed with pictures by Sickert and other artists – and 'John has a big (oils) portrait of Nicholson,' Max told[271] Florence Beerbohm, '– a *very* fine portrait, and quite the *clou* of the exhibition.' Four months previously Augustus and Max had dined with the Nicholsons and Max afterwards described Augustus as 'looking more than picturesque . . . [he] sang an old French song, without accompaniment, very remarkable, and seemed like all the twelve disciples of Christ and especially like Judas!' Admiration for his personality, admiration for his painting: but both were shot through with suspicion. If his appearance suggested some betrayal, his painting often caused bewilderment. 'He [John] has a family group at the Grafton,' Max wrote to Florence (April 1909), '– a huge painting of a very weird family. I wish I could describe it, but I can't. I think there is no doubt of his genius.' Max considered *The Smiling Woman* 'really great',† but many of Augustus's paintings, especially of women, struck him as crude and ugly. At the same time he believed, like his art-critic, that he would be 'converted' by them and that future generations would acknowledge them to be of lasting value. The 'promise' which he attributed to Augustus was therefore in a sense vicarious: it was the age that had not adjusted its focus yet to his particular vision.

To what extent this faith in Augustus's visionary power was buoyed

* 'Max has done a very funny caricature of me – dozens of awful art students in the background,' Augustus wrote to Dorelia. Besides 'Insecurity' (now owned by the National Gallery of Victoria, Melbourne), Sir Rupert Hart-Davis has 'run to earth' another five Beerbohm caricatures of Augustus, including one (1909) protesting against the fashions for the coming spring; one as a war-artist in uniform coming across three barefoot gaily-clad women working on a farm; one leading a headless Lord Leverhulme by the arm; and one in the series 'The Old and the Young Self' (Ashmolean Museum, Oxford).

In 1942 Augustus became a member of the Maximilian Society, writing to Alan Dent: 'I like best old and seasoned things. Max is old and seasoned. He was born so. Hence his endurance and indestructability and the inviolable innocence of his genius.'

† 'In the Fair Women Show, by the way, John has a portrait in oils – a full length – of "A Smiling Woman" – which seems to me really great – quite apart from and above anything else there; and you behold in me a convert.' Max to Florence Beerbohm, March 1909.

up by an overflow from his personality to his painting is impossible to say. Paul Nash, who did not know him personally and had 'a deep respect for John's draughtsmanship especially when it was applied with a paint brush', observed[272] that 'technical power rather than vision predominated'. To swell the confusion, his work was extremely erratic, consistent only in its absence of dates: and he obeyed impulses that often provoked the public to fretful reactions – like that which had greeted his 'Lord Mayor of Liverpool'. By the young he was generally wor-shipped and, until the 1920s, remained a cult figure among art students. C. R. W. Nevinson, for instance, to whom Augustus was quite simply 'a genius', noted[273] that 'though I am always called a Modern, I have always tried to base myself on John's example'. To some other painters, and especially in retrospect, it appeared that he had achieved an instant and extraordinary success. Already, by 1900, at the age of twenty-two, he was comfortably sharing a long notice with Giorgione. And in 1907, in an article[274] entitled 'Rubens, Delacroix and Mr John', Laurence Binyon wrote:

'Mr John has shown such signal gifts, and has such magnetic power over his contemporaries, that he might to-day be the acclaimed leader of a strong new movement in English painting; only he seems to have little idea as to whither he is himself moving. Does he lack faith in himself? . . . he will never know the fullness of his own capacities till he puts them to a greater test than he has done yet, till he concentrates with single purpose instead of dissipating his mind in easy response to casual inspirations of the moment . . .'

The tone of this notice, mixing morals with aesthetics, was very typical. No one questioned that here was a great draughtsman – but was he husbanding his talent as he should? – would he succumb to his own waywardness? – was he not more anxious to scatter than to build? By almost everyone his work was felt to be very 'unconventional'. It was not 'normal' to search for distortion as he persistently did. What was this 'affectation' that made him deliberately misplace 'the left eye in the "Girl's Head"?' asked the *Magazine of Fine Arts*;[275] '. . . it is difficult to follow the aim of the artist'. The critic of *The Times* (3 December 1907) expressed, in a genial way, what many established art critics thought about his work:

'The artist, as is well known, is a favourite among the admirers of very advanced and modern methods; and, if he were a dramatist, his plays would be produced by the Stage Society. That is to say he is very strong, very capable, and very much interested in the realities of life, the ugly as well as the beautiful. Most of these drawings display the qualities mentioned, but it is only fair to add that in some of the pencil heads, especially the portraits, Mr John shows he can on occasion condescend

to the taste of those old fashioned people who believe in beauty and charm.'

Another critic of the same show, heralding what was to come, announced: 'One must go to Paris to see anything approaching the nightmares that Mr John is on occasion capable of.'[276]

By 1910 the Americans were discovering him.* When Quinn sent him a batch of notices from Philadelphia for Dorelia's 'scrap-book', Augustus replied (4 January 1910) that 'she don't keep one – when she *does* read my notices, it's with a smile'. She had begun, he added, to complain that they were no longer rude enough, and therefore not fun, and this coincided with his own feeling that during the previous year or two (1908–9) his work had started to tail off.

'I've never kept any of my press notices yet,' he wrote to Quinn (23 May 1910), '– doubt if I could find storing room for them, but I have a habit of sending some of them to my father, who likes it; reserving the scornful and abusive ones for my own delectation till I light my pipe or otherwise utilize them. I used to enjoy getting these latter kind but lately they are getting confoundedly dull and appreciative. It must be my fault of course; – Blague apart I am pleased as Punch when anybody admires my work *genuinely* and with *understanding* but the run of "critics" are merely diplomatic journalists and even then "admiration" would be unwelcome. The only ones who count are the inspired critic-clairvoyant and fearless – and the conscientious and equally fearless Philistine – and praise and blame from either are equally welcome and stimulating.'

In another letter to Quinn that month (25 May 1910) Augustus admitted: 'I realise I have been fearfully constipated mentally for the last two years or so – in a thorough bad state and it has made my work dwindle and paralysed my activities.' It was during this period of constipation that his place in British art had apparently been sought and was to be defined. He now dominated the New English Art Club to an extent where even his failure to send in work to their exhibitions itself became headline news. Though still assailed by older critics for the wilful pursuit of ugliness – an opinion that seems incredible today – he was generally considered to be the most progressive artist in the country.

'There are two artistic camps in England just now,' W. B. Yeats advised Quinn in 1909, 'the Ricketts and Shannon camp which carries on the tradition of Watts and the romantic painters, and the camp of Augustus John which is always shouting its defiance at the other. I

* His portrait of William Nicholson was 'undoubtedly one of the strongest paintings' (John Beatty) at the International Exhibition held by the Carnegie Institute at Pittsburgh in 1910. Following this, a number of American critics became interested in his work and several American galleries offered to show it. At the famous Armory Show of 1913 he was strongly represented.

sometimes feel I am divided beween them as Coleridge was between Christianity and the philosophers when he said "My intellect is with Spinoza but my whole heart with Paul and the Apostles".'

Quinn's intellect too, supported by his purse, was with Augustus, and as late as 1914 the wisdom of his investment was confirmed by the distinguished American critic James Huneker who declared that the three biggest talents among living artists were Matisse, Epstein and Augustus John.

If such estimates read strangely today it is partly because the reverberations that have echoed so loudly down the years from the two Post-Impressionist shows have deafened us to what was actually happening at the time. Many of the art critics who had written favourably of the impressionists and who, up to the autumn of 1910, had counted themselves among the progressives, now agreed with Wilfrid Blunt that the Post-Impressionist daubs were like 'indecencies scrawled upon the walls of a privy'. To us, therefore, it can easily appear that, in the last weeks of this year, the enlightened elite of Britain had been reduced to half-a-dozen Bloomsbury intellectuals drawn up about the frail but defiant figure of Roger Fry. It was not so. To many people Augustus's pictures at the Chenil Gallery in these weeks seemed more exaggerated than those of 'the Frenchmen at the Grafton'. Reviewing his show, which he summed up as being 'a mystery', The *Times* critic asked (5 December 1910): 'What does it all mean? Is there really a widespread demand for these queer, clever, forcible, but ugly and uncanny notes of form and dashes of colour? . . . for our part we see neither nature nor art in many of these strangely-formed heads, these long and too rapidly tapering necks, and these blobs of heavy paint that sometimes do duty for eyes.' In notice after notice, critics linked him to the concurrent show of Post-Impressionists and, considering that the Chenil was situated far deeper within the territory of libel than the Grafton, the tone is often quite as hostile. 'At his worst he can outdo Gauguin,' wrote a critic in *The Queen* (10 December 1910), '. . . uncouth and grotesque . . . It is unfortunate that Mr John should go on filling public exhibitions with these inchoate studies, instead of manfully bracing to produce some complete piece of work.' Two years later, when the Second Post-Impressionist Exhibition coincided with the showing of Augustus's 'Mumpers' at the N.E.A.C., it was the latter which was seen by many critics to be the turning-point in British painting. Public opinion in these two years had changed towards Post-Impressionism, but not in its placing of Augustus's work as more 'advanced' and, in some cases, more incomprehensible than the standard Post-Impressionists. For many he was the last word in modernity. 'After Picasso,' wrote one critic, 'Mr John.'[277]

In 1909 Augustus was *avant-garde*; by 1912 he had been relegated to
the rearguard of British art: that, with the foreshortening of time, is
how it can now appear. The younger artists had formed up behind him,
but he had had nowhere to lead them and they turned instead to Fry.
This is the judgement of history, and it has been influenced by the
misinterpretation of two facts. The first of these was Augustus's des-
cription of 'Manet and the Post-Impressionists' as 'a bloody show'; the
second was his refusal to send in any work to the Second Post-Impres-
sionist Exhibition. Both are true. But they form only a small portion of
the truth.

The very year that he had begun to fulfil his much-trumpeted
promise is the year that contemporary critics renewed their hostility to
him and that, in retrospect, art-historians have removed him from the
forefront of British art. For in 1910, working independently in France
and taking his inspiration from Italy, he had launched a private
revolution of his own.

3. WHAT HE SAID

Deep within the Castle Insularity, encircled by a narrow moat called the
Channel, the once lovely Princess of English art had been locked up for
over a quarter of a century. The picture, *circa* 1910, is well known: it
belongs in spirit to the Victorian literary tradition of painting that, in
artists like Frith and Alma Tadema, had degenerated into pure illus-
tration.

But the insularity that is blamed for this static nature of art in late-
Victorian and Edwardian England could never, in strict geographical
terms at least,* have applied to Augustus John. From an early age he
had travelled widely in Europe; he had lived in France, met Picasso,
seen the work of Cézanne in Provence and of Matisse in Paris. He had
even read the novels of Dostoievsky before they had been Garnetted.
Yet in two respects insularity held him back. He had been trained in a
climate so regulated that it admitted only two schools of rival art: the
academic art taught by Tonks and Brown based on classical and Renais-
sance models; and the academizing process carried on by the Royal
Academy 'by which', Harold Rosenberg has written, 'all styles are in
time tamed and made to perform in the circus of public taste'.[278]
Augustus had learnt his lessons well and it had taken him time to 'see' a
non-academic form of art that matched his talent.

* 'Is it that the atmosphere of England is oppressive?' Augustus once asked
Quinn (25 May 1910). 'Stendhal said a man lost 50% of his genius on setting foot
on that island.' Almost fifty per cent of Augustus's post-Slade work had been done
in France.

Artistic insularity is a gift not peculiar to the British. When there are
no natural language barriers, the custodians of art in each country erect
extra high tariff walls of fashion and national interest partly on the
grounds of preserving some manageable simplicity. When the best
artists happen to be working in one's own country, probably there is
little deprivation. But a foreigner in that country can still encounter
difficulties.

Despite all the time he had spent there, Augustus had remained
something of a foreigner in Paris. But in Provence he had come home.
There was something of Wales here, he felt, something to which he
responded deeply and intuitively. The country was rooted in a past to
which he himself belonged and with which he could connect the work
of Puvis de Chavannes and the great Italian masters he had been
studying. He saw himself, quite suddenly, as being part of a tradition in
painting, of being able to add to that tradition; and this feeling of
belonging gave him new stamina. Everything seemed to fall into place;
what he had seen, where he was, who he was.

'I am certain I have profited greatly by my visit to Italy,' he told
Quinn on reaching Martigues (3 March 1910). 'My imagination and
sense of reality seems to me just twice as strong as it was before – and no
exaggeration . . . I tell you frankly and sincerely, I feel *nobody* dead or
alive is so near the guts of things as I am at present – and it's devilish
hot. And, *what is surprising*, together with this infallible *realism* my sense
of beauty seems to: *has*, grown simultaneously. All this remains to be
proved of course. I give myself till the end of the year to prove it up to
the hilt. And this comes, it seems to me, from being suddenly *alone* for
some months, and seeing – and rubbing against (without committing
myself too far) new people and also seeing certain pictures which
crystallize the overwhelming and triumphant energy of dead men – like
Signorelli for instance.'

At such moments of confidence the air was thick with resolutions. 'I
have never really been captured by alcohol,' he admitted to Quinn on
this occasion, 'and I'm not going to run after it. I think any sport can be
overdone: and I'm taking a real pleasure in dispensing with that form of
entertainment. In a short while I shall be able to get as drunk as I like on
green tea. Besides I'm beginning to take a really miser's interest in my
own value – and will grow less and less inclined to dissipate my
savings.' It is easy to be too sceptical of such good intentions, often
repeated, to his puritan, health-mad patron. There were, inevitably,
events that confused this stern programme: drunken days with gypsies;
the irrelevant sorties of his bird-like neighbour and the air-machines;
the distressing ambush of hospitality prepared for him by Frank Harris;
Dorelia's illness and interminable family troubles. Yet this season there

was more optimism, more courage to say the word no. He admits to 'floundering'* at times, but returns stubbornly to his proper work and makes genuine progress. One of his problems is that, in periods of mounting enthusiasm, he is inclined to turn away from his past to pursue anything new. 'I think little of my etchings so far,' he confided to Quinn (28 May 1910) who had bought almost all of them, '– but I'm keen to do a set of dry-points soon.' Temptation came to him in the form of an invitation to South Africa, where he was asked to found a school, decorate Parliament and paint ten portraits of South African celebrities – Joubert, Botha and others – for one thousand pounds. These offers he turned down.

He was helped in his resolution by a book that Quinn had sent him early in May: James Huneker's *Promenades of an Impressionist*. He had been prepared at first sight to dislike it intensely. There were too many Parisian anecdotes, too many picturesque phrases, too many eulogies of bad artists such as Fortuny and Sorolla. But it was characteristic of his new seriousness this year to get beyond first sight. He persevered and began to find it more and more stimulating. Huneker's large, genial, comprehensive outlook, his gargantuan appetite, might not be profound, but it was better than that: it was useful.

'He [Huneker] reminded me of many a thing I used to know but had, to my shame, forgotten,' he explained to Quinn (25 May 1910). 'His fresh and unfailing enthusiasm for a crowd of merits lesser minds think mutually destructive, is splendid and unheard of . . . it is the gesture of a generous and hearty man – who seems to overflow with intellectual energy and does not husband it like poorer men. . . . This book gives me the courage and humility of my boyhood. It is strong crude air after the finicking intellectuality of London which drives a sensitive spirit into subterranean caverns where thoughts grow pale like mushrooms. I have been assailed with manifold doubts and have taken refuge in dreams when I should have sharpened my pencil and returned to the charge. An artist has no business to think except brush in hand.'

'I am keen on a good show in the autumn,' Augustus had told Quinn (19 May 1910). There were delays, but not serious ones. The show which opened in December contained thirty-five drawings and etchings in the upper rooms at Chenil's, and downstairs fifty small 'Provençal Studies' in oils. It was the drawings upstairs that tempered the hostility of critics with a tone of regretful wonder; but it was the oils that represented his new field of achievement. In certain moods he saw these panels as preliminary studies for a set of complete fresco works on a

* 'I have been working hard lately and I think to good purposes. I seem to have got *on* to the job after months of floundering.' Augustus to Quinn, 19 May 1910.

very large scale. In this he had been misled by the generous criticism of Roger Fry who, the previous year, had declared[279] that 'it is quite evident that Mr John should have a great wall in some public building and a great theme to illustrate. In Watts we sacrificed to our incurable individualism, our national incapacity of co-operating for ideal ends, a great monumental designer. A generous fate has given us another chance in Mr John, and I suppose we shall waste him likewise. What would not the Germans do for a man of his genius if they ever had the chance to produce him?' Such stirring words rang sweetly in Augustus's ears; but they were blind to his lack of consistency, the fact that he painted best when in the grip of some intense but fleeting mood – the intensity arising from its very transitoriness. Fry, in many ways the greatest and most influential critic of his age, had little idea of individual talent in relation to particular theories. Augustus was the last person to co-operate, publicly and for any length of time, for ideal civic ends. But Fry's appreciation had a heroic tone that echoed in Augustus's imagination for the rest of his life. In 1939, when opening an exhibition of photographs of contemporary British wall paintings at the Tate Gallery, Augustus said sadly: 'When one thinks of painting on great expanses of wall, painting of other kinds seems hardly worth doing.' And shortly afterwards, in a restaurant, he remarked to John Rothenstein: 'I suppose they'd charge a lot to let Matt Smith and me paint decorations on these walls.'[280] He was outraged when, in 1952, John Rothenstein referred to him as a great 'improvisor' because this reflected adversely on his capacities as a painter on a monumental scale.

His oil sketches at the Chenil Gallery revealed, for the first time, a gift for colour. The pale hills of Provence with their olives and pines and their elusive skies, the summer light across the Etang mysteriously moving with sun and shade, seemed to have brought him into a more vivid contact with nature. These jewelled impressions tell no story: they are simply landscapes, or figures or groups of figures in a landscape setting who reflect life as in a ballet – the girl on the sea's edge poised like some dancer, her hand on the bar of the horizon. The colour is clear and untroubled, brushed on with hasty decision – there is no niggling detail: they are austere, these panels, in their simplicity – and often shamelessly unfinished. 'The technique appears to be, at its simplest, to make a pencil drawing on a small board covered with colourless transparent priming,' commented David Piper;[281] 'then the outlines are washed in with a generous brush loaded with pure and brilliant oil colour – and there's a happy illogicality about it, for the lines of the drawing . . . are those of any John drawing, subtly lapping and rounding the volume they conjure up, but they are obliterated by the oils, and the result for effect relies on the inscape of vivid

colour, on contrasting colour, and the broad flattened simplified pattern.'

Never in his work had the tension between dream and reality, the ideal and the actual, been presented so directly by means so simple; never had the content been raised so superior to mere imitation of nature. His method seemed far removed from the ordinary language of British art, and most critics argued that he was using a shorthand which was quite unintelligible. The most appreciative was Laurence Binyon, who wrote: [282]

'Somehow everything lives. Even the paint, rudely dashed on the canvas, seems to be rebelling into beauties of its own. Mr John tries to disguise his science and his skill, but it leaks out, it is there . . . I do not know how it is, but these small studies, some of them at least, make an extraordinary impression and haunt one's memory. A tall woman leaning on a staff; a little boy in scarlet on a cliff-edge against blue sea; a woman carrying bundles of lavender: the description of these says nothing, but they themselves seem creatures of the infancy of the world, aboriginals of the earth, with an animal dignity and strangeness, swift of gesture, beautifully poised. That is the secret of Mr John's power. He is limited, obsessed by a few types . . . his ideas are few . . . But in it there is a jet of elemental energy, something powerful and unaccountable, like life itself.'

In the course of this review Binyon compared Augustus's instinct and the simplicity of his technique to that of Gauguin. Other critics compared this new work to that of Matisse,[283] Van Gogh[284] and Jules Flandrin,[285] all of whom were then exhibiting at the Grafton Gallery. This coincidence points to a parallel development that had been taking place in Augustus and Roger Fry. In the very month that Augustus had discovered the wall paintings of Luca Signorelli, Fry was writing of Signorelli as 'one of the family of the great audacious masters'.[286] The names of both Fry and Augustus had, in the past, been primarily associated with those of the Old Masters: they had been wary of the modern movement. But by the end of 1910 they were seen to be, quite separately, at the head of all that was most *avant-garde* in England. In neither case did this involve a rejection of what they had believed in before, for what they had discovered was the *modernity* of certain Old Masters, such as Masaccio and Signorelli, whose work was akin to the greatest of the Post-Impressionists. Their sudden flowering of enthusiasm for modern French painters sprang in each case from their new understanding of the Italian Primitives.

Augustus thought of Fry as a very skilful writer, a poor artist and a man of the most credulous disposition. He feared where this credulity might lead people in the future, but he saluted the 'wonderful things'

Fry had seen which, by 1910, had brought him so close to his own con-
clusions.* Quentin Bell has written that it was 'remarkable' for a man of
Fry's temperament and training to have realized that 'Cézanne and his
followers were not simply innovators but represented also a return to
the great tradition of the past, for such a conviction, which does not
seem wonderful to-day, required an extraordinary effort of the mind in
the year 1910'. Even more remarkable was for Augustus to have made
an identical discovery at exactly the same time.

4. WHAT HE SAID ABOUT THEM

'A bloody show!' These shocking words have reverberated down the
decades and, reaching the ears of art-historians, have been hailed as the
first cry of the future Royal Academician.

He did say them – to Eric Gill who reported them by letter to Will
Rothenstein, thus ensuring their immortality. They represented his first
reaction, not so much to the pictures themselves but to the sense-
less chatter and vulgar journalistic outcry to which the show had
given rise. From this time on he was to become increasingly touchy
about publicity. It seems almost certain, from the date Gill must have
written to Rothenstein, that Augustus had roundly denounced the
exhibition before actually going to it. Certainly his first sight of it
was distorted by all he had heard and read which, like a film, seemed
to come between him and what he saw. He did not visit the Grafton
until early December, after the show had been running a month.
'There is a show of "Post-Impressionists" now on here,' he noted
in a letter to Quinn (December 1910), 'and my post-impression of it is
by no means favourable.' That was all. But in the last week of the
exhibition, when all the noise had died down, he went again. His true
reaction to the pictures is set out in a long letter to Quinn (11 January
1911):

'I went to the "Post-Impressionists" again yesterday and was more
powerfully impressed by them than I was at my first visit. There have
been a good many additions made to the show in the meanwhile – and
important ones. Several new paintings and drawings by Van Gogh
served to convince me that this man was a great artist. My first view of

* It is this parallel course, as well as his own independence, that Augustus signi-
fied in a letter to Quinn (10 February 1911): 'I don't think we need Fry's lead: he's
a gifted obscurantist and no doubt has his uses in the world. He is at any rate alive
to unrecognised possibilities and guesses at all sorts of wonderful things.' Else-
where in this letter he writes: 'If you sent him [Fry] a gilded turd in a glass case he
would probably discover some strange poignant rhythm in it and hail you as a
cataclysmic genius and persuade the Contemporary Art Society to buy the pro-
duction for the Nation.'

his works disappointed and disagreed with me. I do not think however that one need expect to be at once charmed and captured by a personality so remarkable as his. Indeed "charm" is the last thing to talk about in regard to Van Gogh. The drawings I saw of his were splendid and there is a stunning portrait of himself. Gauguin too has been reinforced and I admired enormously two Maori women in a landscape. As for Matisse, I regard him with the utmost suspicion. He is what the French call a fumiste – a charlatan, but an ingenious one. He has a portrait here of a "woman with green eyes" which to me is devoid of every genuine quality – a vulgar and spurious work. While in Paris the other day I saw a show of paintings by Picasso which struck me as wonderfully fine – full of secret beauty of sentiment – I have admired his work for long . . . I forgot to mention *Cézanne* – he was a splendid fellow, one of the greatest – he too has work at the Grafton.'

As the example of Matisse shows, the work of some of these artists struck for him a dumb note. Later on (July 1913) he helped Quinn to buy a Gauguin ceiling he much admired, and he recommended (3 December 1912) work by Manet and Degas. But of Maurice Denis he wrote with discrimination to Quinn (17 May 1912):

'I have known Mr Denis's work for long and have admired it from time to time . . . I think Denis has a certain talent. I know he has, but I don't find it leads to much or is in the great sense, exciting. I think him an intelligent, ingenious, and sincere man who makes the most of his gifts within the contemporary field. He doesn't go beyond it. He is a well known and probably prosperous person and his recent works at Marchants have impressed me less than earlier ones. He is not, in my opinion, great by any means. Picasso now has genius, albeit perhaps of a morbid sort . . .

'Your feeling about Renoir is just. A wonderful man! That unfinished thing we saw at Durand-Ruels impressed me enormously. I may have said that "Impressionism" was of the past – dead – but *impressionists* no!!! Renoir, Degas, Toulouse-Lautrec – etc – will always be live artists. I wish we had gone to see Anquetin while in Paris. A man of immense gifts. Bye-the-bye if you come across a painting by Daumier, freeze on to it! One of the great Frenchmen. El Greco too is now coming into his own. A terrible, mysterious Spaniard – or rather Greek.'

Certainly this is not the letter of an Englishman infected with the virus of insularity. Yet he was also extremely interested by his British contemporaries, writing copiously about their work to Quinn so that, in this vicarious way, he could help them without reprisals of gratitude. Such methods appealed alike to his generosity and secretiveness, and accurately reflected his attitudes from 1910 until the 1920s. His taste was not at all what might be surmised. For himself he bought examples of

work by, among others, Epstein, Wyndham Lewis, William Roberts and Christopher Wood. But about Ricketts and Shannon, artists who seem to have more in common with himself (such as a reverence for Puvis de Chavannes), he was lukewarm:

'I have never succeeded in feeling or showing any great interest in *his* [Shannon's] work tho' I have remarked that personally he shows himself a man, one would say, of character,' he once (25 August 1910) wrote to Quinn. 'He has a reserve which contrasts with the funny effervescence of Ricketts – who is the cleverer chap; but as for him, he has lost his innocence, he is corrupt – and I doubt if even a good wash in Jordan would restore his pristine purity. I mean that a man of his intellectual parts should keep himself straighter – at the risk of being stupid even.'*

Since Quinn relied on Augustus for judgement and information about what was going on in the London galleries, their correspondence over the next half-dozen years gives much evidence of Augustus's opinions. The first artist whose work he recommended was naturally his sister Gwen. In her dealings with Quinn she is, in many respects, the very reverse of Augustus. From Quinn's point of view, it was like looking towards their pictures from across the Atlantic through opposite ends of a telescope: his seemed so near, hers so remote. And while Augustus is perpetually anxious for her to retain Quinn's goodwill, it was he in the end who forfeited it.

* Another artist about whose pictures his feelings were mixed was Mark Gertler. He had recommended his early work – which hung alongside his own at the Chenil Gallery – but by 16 February 1916 he is telling Quinn that 'Mark Gertler's work has gone to buggery and I can't stand it. Not that he hasn't ability of a sort and all the cheek of a Yid, but the spirit of the work is false and affected.'

With Eric Gill it was the other way about. On 10 February 1911, he is advising Quinn against buying his work. 'Personally I don't admire the things and feel pretty certain that you wouldn't neither. I admit that Gill is an enterprising young man and not without ability. He has been a carver of inscriptions till quite recently when he started doing figures. His knowledge of human form is, you may be sure, of the slightest and I feel strongly that his experience of human beings is anything but profound. I know him personally. He carves well and succeeds in expressing one or two cut-and-dried philosophical ideas. He is much impressed by the importance of copulation possibly because he has had so little to do with that subject in practice, and apparently considers himself obliged to announce the gospel of the flesh, to a world that doesn't need it. Innes calls him "the naughty schoolmaster", Gore calls him the "precious cockney" and I call him the "artist of the Urinal" . . . I'll let you know when I see a thing of Gill's which I can really respect and desire. His present things are taking at first glance as they look so simple and unsophisticated – but, to me at least, only art at first glance.' Three years later his opinion of Gill's work has risen. 'I also ordered you one of Gill's things, a dancing figure in stone,' he wrote to Quinn (26 January 1914). '. . . Gill has made good progress and his things are admirable now, both in workmanship and idea.'

Among other artists he recommended were John Currie,* Epstein, Jacob Kramer, Harold Gilman, Charles Ginner, Spencer Gore,† Walter Greaves,‡ Derwent Lees, C. R. W. Nevinson and Wilson Steer. Often he would write persuasively about painters working in styles very different from his own. Alvaro ('Chile') Guevara he described as 'the most gifted and promising of them all' (16 February 1916), but he was also very impressed by Gaudier-Brzeska, who, he wrote (3 April 1915), 'is a man of talent. His things look as if they have been sat on before they got quite hard. Some of them look like bits of stalactite roughly resembling human forms. But they are wittily conceived.' Most of all he wrote about David Bomberg. 'You ought to get more Bombergs,' he advised Quinn§ (26 January 1914), 'he is full of talent.' Following the lead of Marinetti – 'a common type of the meridional; naif, earnest, and ignorant. But we are very friendly' – Bomberg's painting took a 'Futurist' course that was ultimately unsympathetic to Augustus. But, with reservations, he continued to praise him (in company with 'another

* John Currie, who appears as 'Logan' in Gilbert Cannan's novel *Mendel* (1916), shot himself and his mistress in a fit of jealousy. 'You remember Currie, some of whose works you bought?' Augustus asked Quinn (10 October 1914). 'He shot his mistress dead yesterday and then himself. He has since died of four bullet wounds in the chest. The girl was staying here [Alderney Manor] lately carrying on a futile love affair with another young man. We all got sick of her. She was an attractive girl or used to be when I knew her first, but seemed to have deteriorated into a deceitful little bitch.

'It is a terrible affair and it's a good thing I suppose that Currie died. He was an able fellow and would have had a successful career.'

† Spencer Gore, 'whose work I think good and promising', Augustus recommended to Quinn and continued to admire. In 1928 (*Vogue*, 25 July) he wrote: 'The work of Spencer F. Gore, although [attracting] the admiration of a small body of genuine picture-lovers, undoubtedly failed to reach its deserved favour with the general public on account of the war following so soon after his death, which befell when he might be said to have arrived at the prime of his accomplishment. But this unconscious injustice was repaired by the April [1928] exhibition [at the Leicester Galleries], when it was realised that Gore was one of the most notable landscape painters of his time.' And again in 1942 (*Horizon*, Vol. VI, No. 36, December 1942, p. 426) he wrote: 'The industrious apprentice is a type to be admired rather than loved. In Spencer Gore's case, however, immense industry was coupled not only with a rare and ever-ripening talent: he possessed in addition an amiable, modest and upright nature which elicited the deep affection and respect of all those who knew him.'

‡ 'He [Greaves] is a real artist-kid, with Chelsea in his brain. I shall never cease to appreciate his work – *so* unlike Whistler's at bottom.' John to Quinn, 17 May 1912.

§ On 29 December 1913, Augustus had written to Quinn urging him to buy a Bomberg drawing 'extremely good and dramatic representing a man dead with mourning family, very simplified and severe. I'ld like you to have it.' Quinn bought it for fifteen pounds.

Futurist called Balla who is good') – specifically his famous *Mud-Bath*.[288]
'Would you like to invest in the unfathomable?' he invited Quinn in a
style suitably patronizing for a patron (24 June 1914). 'Bomberg has
talent and ingenuity, but frankly his latest things are too, too inhuman to
provoke my whole-hearted enthusiasm. Still he is an amusing little type,
and you might be amused to have some of his inventions.'

There is no mention of Bomberg in *Chiaroscuro* or in *Finishing
Touches*; and none, or almost none, of the other artists upon whose
behalf he had secretly exercised himself. He had taken to writing only at
the end of the 1930s, and by the time his fragments of autobiography
were put together as books it was too late. He had become introverted,
unwilling to study the unfamiliar, distrustful of his own good nature, a
prey to disappointment and melancholia. His tone as well as the content
of what he wrote is affected. Of Picasso, for example, he joked: 'Such
ceaseless industry, leading to a torrent of *articles de nouveauté*, may seem
to some, capricious and rootless, but it undoubtedly deserves its reward
in the greatest snob-following of our time' – a sentence that was itself
rewarded by Picasso's classification of Augustus as: 'The best bad
painter in Britain.'

It can therefore be misleading to reconstruct the young man from
what the older man wrote a long time in retrospect. Fortunately there
exists in *Vogue* eight long articles[289] he wrote during 1928 on modern
French and English painters – a series subsequently forgotten yet far
more authentic as a guide to his artistic taste. These articles help to
reconcile the old and the young man, and demonstrate how catholic and
near-contemporary his taste still remained up to his early fifties – though
he had grown resentful of the power of fashion in art, for which he
blamed the dealers. The value of the French tradition was a thing be-
yond the ephemeral whim of fashion and depended upon 'the unceas-
ing enthusiasm of French painters towards a personal expression'. The
French painters he singled out as having created a climate that favoured
modern innovations were Manet, Monet ('in the entrancing waterlilies
of his later years'), Sisley and Camille Pissarro – 'these are the pioneers
who led painting from the halting deliberation of David to the coura-
geous or even risky contact with the open air. Monet, Renoir, Degas
not tentatively, but with conscious authority, released that long-
confined expression of instant response to the aspect of the visible
world.' The battle of the Impressionists had long ago been fought and
won, but he deplored the labelling of Post-Impressionism applied to the
later romantics Van Gogh, Gauguin and Emile Bernard because 'their
work and their own individuality was much more significant than, and
much more distinct from, the work of the Impressionists themselves'.
After the muscle-bound paganism of Gauguin, the reverent Christianity

of Van Gogh, the next painters in the grand line of French art were
rather less to his liking. The atmosphere had become too cultured, too
sophisticated. He praises, with reservations, the work of that lazy giant
Derain, but deprecates his pedantry; while the developments since 1912
in the styles of Picasso and Matisse seem almost completely to have
reversed his attitude to them. Picasso, whose Blue and Rose periods he
had loved, appeared to be growing metaphorically false. 'Matisse
remains the best, the most sensitive, of French painters, for Matisse
having abandoned his early essays in imbecility, has by dint of assiduity
and method achieved the foremost place in his generation as an exquisite
paysagist and painter of *genre*.'

Among senior contemporary painters he singles out 'three old
gentlemen', Bonnard, Forain and Rouault as being above competition –
'individual and isolated examples of the glory of French painting'. And
among the younger ones he chooses Chagall for 'his admirable handling
of paint', Antral, in whose best pictures 'one discovers a pure and
architectural vision refreshingly distinct from the vinous romanticism
of which Utrillo is the acknowledged master', Othon Friesz and, above
all, Segonzac, who 'conceived the landscape in its fundamental unity
and basic rhythm; escaping from a too direct naturalism, he rebuilds the
essential structure, revealing the form in its organic fullness, and setting
free its deep burden of emotion in low and thrilling cords of colour'.

These opinions are not borrowed but give evidence of someone who
could still look at new paintings and have reactions to them.* His
criticism of British painters is more confused since it sews together
paragraphs of friendship with passages of objective appreciation – the
two sometimes embroidered with a skein of *double entendre*:

'With Mr Henry Lamb we have another type of mind, more self-
conscious but less free [than Matthew Smith's]. He seeks, with an almost
mathematical ingenuity, to invent new harmonies of colour in combina-
tion with a most searching analysis of character. This passionately
serious painter, for whom any intellectual concession is an impossibility,
remains still insufficiently recognised. For to many amateurs, an easy
and comforting facility is more attractive than Mr Lamb's *intransigence*
and the almost moral integrity of his art.'

The theme which emerges from the body of Augustus's art criticism
is a belief in individual accomplishment entirely independent of art

* Over ten years earlier (10 February 1917) Roger Fry had written to Vanessa
Bell: 'John turned up at the Omega t'other day and looked at our show. He seemed
to me almost entirely stupid – to have no reaction whatever to pictures, but I don't
know of course.' It is after this date that a note of disapproval enters Fry's criticism
of Augustus's work. And it was after the war that Augustus began popularly to be
represented as an embodiment of the past, without any active response to the
present or curiosity over the future.

trends. It was, he reflected, a comforting thought that posterity amended the injustices of contemporary neglect, that no effort of real creative merit could fail to be recognized in the course of time: but he did not believe it. There was no sign, for instance, that the work of Paul Maitland or W. E. Osborn would ever be revived. Nor did Augustus expect his writing to dent this impervious system. Yet there was a certain luxury in protesting against the inevitable – a satisfaction of the soul.

His protest lay against Paris: not as a symbol and repository of the great French tradition of painting by which he himself had profited, but as a forcing house of the international picture-*bourse*. Paris had become the world's greatest stock-exchange for art, the Mecca of the amateur, the student, and above all the dealer. A great machinery for the encouragement of the young was centred there and people arrived from all over the world in search of revelation. That a great tradition had made Paris famous was taken to imply that it was Paris which had made the tradition. Yet many painters had had a bitter struggle to establish themselves in the city of which they were, after their deaths, the pride. Constantin Guys had been in Baudelaire's words 'le peintre inconnu'; Daumier a political suspect and journalist-illustrator to the end of his life. And so on. The Post-Impressionists found it no easier. Biographies of Cézanne, Gauguin and Van Gogh all told a similar story of derision, lack of understanding. Rousseau 'le Douanier' and Modigliani, whom in great poverty Augustus visited a few years before his death, were two recent victims of incomprehension on the part of 'the great art city of the world'. By the late 1920s their pictures all fetched enormous prices, and Paris, on their posthumous behalf, did herself great honour. Since there could be no guarantee that the centre of creative activity in painting still rested at Paris, the huge combination of studio and dealer's shop that had been constructed there, like some monument of piety or penance, was probably little better than an empty shell: the goddess of art had paused – and now moved on.

From this serious misreading of the past, Augustus suggested, there had arisen a dangerous contemporary mystique:

'It is possible seriously to question the wisdom of establishing a cosmopolitan usine d'art, however well equipped it be. For a French painter, to whom his own land is a natural source of inspiration, it doubtless affords considerable advantages, and, it is to be hoped, may save such lamentable examples of failures of appreciation . . . But for painters of other countries, especially those who have a strongly defined native tradition, like England, there is a danger of the individual and national voice being lost in an international lingua franca.'

This became the basis of his complaint against Roger Fry, and it may be overheard in his criticism of the Bloomsbury Court painters Vanessa

Bell and Duncan Grant, whose natural decorative gifts, he felt, had
been misappropriated. Grant, for instance, had 'an innate sense of
decoration [and] . . . exhibits a natural lyricism in his work which
appears to owe less to definite calculation than to irrepressible instinct
for rhythmical self-expression'. But his instinct had been subjected to
other people's calculation in such a way that his versatile temperament
had absorbed 'with an ease nearly related to genius the most disconcert-
ing manifestations of the modern spirit'. It was a case of a good artist
being, as it were, rogered by Fry.

The right course, Augustus believed, was exemplified by another
artist whose work had something in common with Duncan Grant's:
Matthew Smith. He too had been influenced by the modern spirit, but
had taken from it only what was germane to his special talent:

'French influences are inevitably to be noted in his work, but the
fulness of form which characterises so many of his figures has a distinct
relationship with Indian and Persian drawings. With a cataract of
emotional sensibility he casts upon the canvas a pageant of grandiose
and voluptuous form and sumptuous colour, which are none the less
controlled by an ordered design and a thoroughly learned command of
technique. This makes him one of the most brilliant figures in modern
English painting. Aloof and deliberately detached from the appeals of
ordinary life, he sits apart and converts what to other men are the ever-
partial triumphs of passion into permanent monuments of profound
sensory emotion. In flowers, fruit and women he finds the necessary
material for his self-expression, and from them he has evolved a kind of
formula which represents his artist's inner-consciousness. And he has
never risked the danger which threatens those who make bargains with
society by attempting the almost impossible task of combining fine
painting with satisfactory portraiture.'

Of all Augustus's feelings for modern artists, this wonderful
appreciation of Matthew Smith was by far the most consistent,
lasting for over thirty years until his death. The nature of his
admiration, suddenly revealed here, was partly a stick with which to
beat himself. For he saw Matthew Smith's career as an example of the
isolated and independent path the artist must climb in order, through
long study, trial and many a failure, to release the secret of his talent.
The source of his own natural inspiration was South Wales, but he was
temperamentally denied access there by the occupation of his father.
Now he had found in Provence, and very soon would find in North
Wales too, a landscape that absorbed his personality and, through a
mysterious process of self-identification and self-abandonment, liberated
his imagination. He had found also, in Primitive art, a means to escape
from the boredom that overwhelms the half-civilized animal in the face

of nature. Then, finally, he discovered an artist, another Welshman, whose imagination cross-fertilized with his own and with whom he now entered a brief period of mutual apprenticeship, radiant, and unique in his career.

5. WHAT HAPPENED

During 1910, that year of exceptional artistic ferment, the first of Augustus's Slade contemporaries, William Orpen, quietly joined the Royal Academy. This was the dull side of that brilliant Post-Impressionist symbol Virginia Woolf had coined. With extraordinary precision art-history was repeating itself and, to the rhythm of its thrilling monotony, the *enfants terribles* of a decade ago were starting on their journey to become Grand Old Men. Their rebel headquarters, the New English Art Club, was now twenty-four years old. French-built to withstand the assaults of British Academicism, it now stood, a British fortress against the advance of French Post-Impressionism. What was needed, apparently, was a new, or still newer *Salon des Refusés* to oppose the old *Salon des Refusés* whose tyrannical rule was felt by the younger artists far more acutely than the remote hostility of Burlington House.

The first cumbersome expression of this need had been Frank Rutter's Allied Artists Association, a self-supporting concern modelled on the Parisian *Société des Artistes Indépendants*. All artists, by paying an annual subscription, could exhibit what works they pleased without submitting them to a censorious jury. Founded in 1908, in July of which year it held its first mammoth show at the Albert Hall, it soon gave birth to 'the Camden Town Group' and the 'London Group' which in 1914 was to swallow them both up. Augustus was a founder member of the Allied Artists Association, though he never exhibited with them. This paradox, which arose from the cross-currents of laziness and generosity, was explained by Rutter:[290] 'John never does exhibit anywhere unless you go and fetch his pictures yourself . . . He joined because, like the good fellow he is, he thoroughly approved of the principles of the A.A.A., and knew it would help others though he had no need of it himself.'

The idealism of the Allied Artists Association soon descended into combative art-politics. On Saturday nights they would meet at a little hotel in Golden Square – usually Augustus, Bevan, Gilman, Ginner, Gore, Lucien Pissarro, Rutter and Sickert – and go on afterwards to the Café Royal. And almost always, at some hour of the evening, the talk would turn, and return, to the question of whether they should capture the New English Art Club or secede and set up a rival society. Augustus was what Rutter called 'consistently loyal' to the N.E.A.C. In several respects his position was closest perhaps to the Protean figure of

Sickert. Both were opposed to 'capturing' the New English, and
Augustus believed furthermore that any other group they might found
must be truly independent rather than a rival. Only in that way could it
faithfully represent their ideal of exhibiting freely, and steer a course of
tolerance and diversity between the various rocks of art-fashion. The
result of these talks was the formation in 1911 of the Camden Town
Group, dominated by Gilman, Ginner, Bevan and Gore, and watched
over by the benevolent eye of Sickert. Though unconnected with
Camden Town, Augustus was admitted to this group which marked an
important defection from the New English whose original aims it
nevertheless almost exactly reproduced. He exhibited only once with
them, though he liked to look in on their weekly meetings at 21
Fitzroy Street, and surreptitiously buy pictures both for himself and
for Quinn.

Then, in 1912, two things happened: he turned down Clive Bell's
invitation to show work at 'The Second Post-Impressionist Exhibition';
and, in the words of Quentin Bell, he left the Camden Town Group and
'flew back to the New English'. Both actions have been interpreted as
retrogressive steps marking his end as an imaginative artist. When, in
1914, the London Group emerged as the spearhead of modernity,
Augustus's name was, for the first time, not among Britain's *avant-
garde*.*

Because of Augustus's circumstances, which at this period were
unique, it is easy to draw from these two acts a wrong conclusion. He
was prolific; he had a wealthy American patron; he had the use of a
London gallery where he could show his pictures at any time. Although,
with his large family, he needed more money than most other artists,
his work was now fetching good prices – the small oil panels at Chenil's
had sold for forty pounds each and some of them were soon changing
hands for seventy and eighty. The considerable trade union spirit he
felt for his fellow artists was uncorrupted by art-politics – he saw no
reason why the Vorticist should not lie down with the Omega. He
would have liked as many alternatives as were practicable to be available
for all of them, involving numerous exhibitions where, irrespective of
style, they could display and sell their paintings. But the Camden Town
Group – named, in deference to Sickert, after the drab working-class
area which provided subject matter for many of the members' pictures –
though it might contain better painters, was narrower than the untidy
pell-mell of the New English. Besides, the theme of his landscapes
represented everything that was remote from suburbia and was quite
out of place in a Camden show. In fact he had never broken with the

* He was, however, elected with Oscar Kokoschka and Jack B. Yeats as an
honorary member of the London Group in the Second World War.

New English – his tepid relations with them were still intact. The decision to show nothing at their two exhibitions in 1910 had not been one of deep art-policy but simple geography: no one could 'go and fetch his pictures' while he was abroad almost all that year. The year had ended with his one-man show at Chenil's for which he reserved all his recent work; but in 1911 he was again exhibiting with them. Nor had he broken with the Camden Town painters, whose work, as we have seen, he continued to recommend to Quinn. For him these various clubs and societies were not exclusive alternatives but additional platforms from which all artists might perform.

Yet behind his decision to withhold work from the 'Second Post-Impressionist Exhibition' there lay Augustus's involuntary involvement in a sudden clash between Roger Fry and Will Rothenstein. The enmity which flared up between these two didactic painter-politicians seems partly to have arisen from Rothenstein's attitude to the new power Fry was exercising on behalf of contemporary artists, especially the younger ones. Fry had been given temporary control of the Grafton Gallery which, he innocently told Rothenstein, 'seemed to me a real acquisition of power'. He planned to stage there a large exhibition by living British artists and, very late in the day, invited Rothenstein to submit – adding by way of inducement: 'John has promised to send.'[291] This invitation, however, was not only delayed but also restricted to Rothenstein's recent Indian work which Will knew in his heart was far from being his best. Worse still, he himself had been pondering upon a similar plan; but while he pondered Fry had gone ahead with his own arrangements without benefit of Rothenstein's collaboration. Many years later (27 July 1920) he admitted[292] to Virginia Woolf that 'I used to be jealous of Prof. Rothenstein, who came along about four years after me and at once got a great reputation, but,' he added triumphantly, 'I wouldn't change places with him now.' From all sorts of people – Desmond MacCarthy, Eric Gill and others – Rothenstein was hearing rumours of Fry's schemes, and he was deeply offended by this neglect. 'I have heard no details of your Grafton schemes at all and was waiting to hear what it is you propose,' he pointed out to Fry (30 March 1911) '. . . You have been too busy to tell me of a thing which is of some importance.' Fry, however, seems to have been anxious to establish his Grafton Group to a point where Rothenstein, once admitted, could not influence it. 'Do let us, however, get rid of misunderstandings,' Rothenstein pleaded under the threat of being left out altogether (4 April 1911); 'we are both of us working for the same thing and it seems absurd that there should be anything of the kind . . . But I don't think you realise how ignorant I am of your intentions and of your powers.'

It was the fact of their 'working for the same thing' that drove them

apart. Rothenstein felt that if Bloomsbury was sponsoring the Grafton group, he would be at a disadvantage. He therefore sought, with some success, to discover a point of principle with which to misunderstand Fry's intentions. Since Steer and Tonks had already refused to let their pictures be shown in company with those of younger artists, there seemed a good chance that, by laying down enough barbed wire of high principles, Fry's rival scheme could be halted altogether. The particular point of principle that Rothenstein turned up concerned the selection of the show, which apparently was to be made by Fry alone. In place of such dictatorship, Rothenstein suggested an 'advisory committee of artists', and recommended the sort of people – Augustus, Epstein, Eric Gill, Ambrose McEvoy – who might sit on it. These were all artists friendly to Rothenstein whose work Fry wanted to include. By refusing this suggestion Fry ran the risk of alienating them altogether. In his reply to Rothenstein (13 April 1911) he insisted that it was 'inevitable that I should appeal to various artists to trust me with large powers since I have the actual control and responsibility on behalf of the Grafton Galleries. Now you know me well enough to know that I am not unlikely to listen to advice from you and that I should give every consideration to any suggestions which you or John or McEvoy might make and I should be delighted if you would co-operate; at the same time I could hardly go to the other groups of younger artists, who are quite willing to trust me personally, and say to them that their work must come before such a committee as you suggest for judgement; nor can I possibly get rid of my responsibilities to the Grafton Galleries.'

The tone and language of this letter declare it to be a political document; but it was not a document of diplomacy. Rothenstein resented being made, as it were, a mere minister without portfolio in Fry's new government: he wanted at least a cabinet post – preferably that one occupied by Clive Bell. Was it not he, Will Rothenstein, who had first established lines of communication between France and England while Fry was merely pottering through the galleries? And was he now, summarily, to be ousted? Although, in the past, Fry had written generously in praise of his work, Rothenstein refused to trust his judgement.[293] Didn't everyone know how naïve he was, how credulous? It was impossible to serve under him in only a minor advisory capacity. Fry, with some intransigence, maintained he was at a loss to account for Rothenstein's non-co-operation. 'I gather you are very much annoyed with me,' he wrote to him (13 September 1911), 'but I simply can't disentangle the reason. No doubt it is all quite clear in your mind, but I haven't a clue.'

Rothenstein's tactics over the next months helped completely to alter the nature of Fry's 'Second Post-Impressionist Exhibition' which

eventually included only a small British group among French and Russian sections. If McEvoy seems to have been a pawn in the complicated chess game that now developed between these two painter-impresarios, Augustus was a knight who found himself being moved strongly about the board forwards and sideways on behalf of Rothenstein's team. Great efforts were made to capture him. As late as the summer of 1912, Fry was writing to Clive Bell: 'I'm delighted that John wants to show'; but in the event he did not do so, and his absence from the exhibition was remarked upon by some as being an index of its absurdity. Rothenstein, in winning this battle, lost a war in which, among the casualties, Augustus was to be seen as having sustained injuries on the wrong side. His letter of refusal had been sent not to Fry but to Clive Bell:

'Dear Bell,

'I received your very enigmatic letter. I am sorry I cannot promise anything for the "Second Post-Impressionists". For one reason I am away from town, and for another I should hesitate to submit any work to so ambiguous a tribunal. No doubt my decision will be a relief – to everybody.

'Yrs truly, Augustus John.'[294]

It was a relief, primarily, to Augustus himself. 'I am conscious that the various confabulators find the question of my inclusion embarrassing,' he had confided to Wyndham Lewis, 'and I would wish to liberate their consciences in the matter if I could find adequately delicate means of doing so.' Once he was clear of the whole bloody show he felt marvellously disencumbered. He had owed some loyalty to Will Rothenstein in the same sense that he was 'consistently loyal' to the New English Art Club – though in spirit he might feel closer to Fry and some of the Camden painters. He was not, however, close to the 'highbrow' critic Clive Bell, who after a long interval of silence was to launch upon his pictures a most bitter and brilliant attack,* evaluating

* 'Seriousness' by Clive Bell, *The New Statesman and Nation*, 4 June 1938, pp. 952–3. 'If only Augustus John had been serious what a fine painter he might have been . . . in my opinion "the latest paintings of Augustus John" at Tooth's gallery in Bond Street are almost worthless.

'They are not serious: in the strict sense of the word they are superficial. The painter accepts a commonplace view and renders it with a thoughtless gesture. And even that gesture is not sustained . . . the picture crumbles into nothingness. Nothingness: at least I can find nothing beneath the general effect . . . there is less talent than trick; and there is no thought at all . . . the master has preferred carelessly to dash on the canvas a brushful of colour which at most indicates a fact of no aesthetic importance. . . .'

Elsewhere in the article, which refers to John's talent, charm, personal beauty, detestation of humbug and, perhaps optimistically, his sense of decency and magnanimity, and calls him 'a national monument', his work is unfavourably compared to that of Paul Nash, Xavier Roussel and Claire Bertrand.

them, with care, as 'almost worthless'. Perhaps this was one of those examples of Clive Bell's journalism that, Fry complained,* 'have done me more harm than all the others'. In any event, Augustus reflected, with Bell as his lieutenant Fry might be pushed anywhere. It seemed to him ironical to insist, as an Allied Artist, that no censor should come between the painter and his public and then, as a 'Post-Impressionist', to sanction Fry's censorship. In fact he admired a number of painters exhibiting among the English group which included Spencer Gore, Henry Lamb, Wyndham Lewis and Stanley Spencer. But the best way he could help such painters was via Quinn; otherwise he could only join them at the expense of Will Rothenstein, the New English and his own independence – and with the uncomfortable feeling of having betrayed a part of his past.

He needed, too, the right background. Fry's habit of herding artists together into groups, societies and clubs, always with the finest motives, did not fit Augustus. Since he could not work within such closely knit units, he began to feel that probably he should not be identified with them. It was as much a matter of instinct as of reason: he was simply out of place. His right place was far away from the metropolitan art world, in North Wales or southern France, not alone, but with his new friend, the painter J. D. Innes.

James Dickson Innes was nine years younger than Augustus.† His parents were said to be 'old-fashioned folk' addressing each other, when they spoke at all, as Mr and Mrs Innes. But from the earliest days 'Dick' Innes was a romantic. 'Born and bred in Wales,' Augustus wrote,[295] 'to which country he felt himself bound by every tie of sentiment and predilection', he had nevertheless practised eating black ants at school in order to establish his French ancestry.[296] In 1905, from the art school at Carmarthen, he won a scholarship to the Slade and by the autumn of 1907, when he first met Augustus, was living in Fitzroy Street.‡ He presented at this time a remarkable looking spectacle: 'a Quaker hat,

* Roger Fry to Jean Marchand, 19 December 1921. *The Letters of Roger Fry*, Vol. II, p. 519. 'I do not exactly find him [Clive Bell] spiteful. He hasn't much personal judgement and he's a terrible snob . . . it is not by personal antipathy that he castigates a painter but rather by his over-preoccupation to show himself in the forefront of the trend. And since he is an admirable journalist and expresses himself forcefully he inflicts much distress without exactly meaning to.' Later in this letter, Fry suggests that Bell was not fundamentally a 'serious' art critic – 'he does not make a serious effort to understand it but collects hearsay and remarks from other artists etc.'

† He was born on 27 February 1887, one of three sons.

‡ At either 8 or 9 Fitzroy Street, to which he had moved from 125 Cheyne Walk in order to be near the Slade.

coloured silk scarf and long black overcoat set off features of a slightly cadaverous cast with glittering black eyes, wide sardonic mouth, prominent nose, and a large bony forehead invaded by streaks of thin black hair. He carried a Malacca cane with a gold top and spoke with a heavy English accent which now and then betrayed an agreeable Welsh sub-stratum.'[297]

His early paintings reflect his admiration for Wilson Steer. Working *en plein air*, in the suppressed light of evening or dawn, and using luminous colours, he would explore the blurring of detail caused by a wide variety of atmospheric effects. But it was during his first visit to France with John Fothergill* that his short painting life really began. The impact of southern light upon him increased his awareness of colour and intensified his romantic involvement with Nature in a manner very close to Augustus's experiences two years later in Provence. But this trip also sounded his death-knell. Having fallen ill, apparently with spots encouraged by his failure, over a long period, to wash, he returned alone via Dieppe and was found to be suffering from tuberculosis. It is not easy now to understand the significance of such a diagnosis: probably it meant death. The 'White Scourge', as it was called, was one of the great killers; there were no antibiotics and almost the only recommended treatment was unending rest. Innes was not the person to accept such passive medical advice and from this time on he grew increasingly restless. The T.B. had attacked his teeth so that he could not masticate properly: but he could drink, and in the intervals between intense activity, he did so heavily. One other pleasure at least the disease did not quench (as a romantic adventure with a young Algerian carpet weaver was to demonstrate): tuberculosis is said to fortify potency.

Early in 1909 Innes had visited Paris with Matthew Smith, but does not seem to have been particularly interested in the French painters who (some of them posthumously) were about to invade England. Once again illness cut short his visit and he was sent to convalesce at St Ives. But in the spring of the next year he was back in Paris and it was here, in a café,† that he met and fell passionately in love with Euphemia Lamb. Together they made their way, largely on foot, to Collioure, revisiting the places Innes had first seen with Fothergill – Euphemia dancing in the cafés to help pay for them.

As with so many British artists, this year, 1910, was crucial for Innes. He had returned to the Slade as a teacher, but finding himself in

* Innes was in South Wales early in 1908. Then, during April and May, he travelled with Fothergill to Caudebec, Boxouls and Collioure where Matisse and Derain had worked in 1905–6.

† At 25 Boulevard du Montparnasse in May 1910.

disagreement with Tonks and Brown, had looked for guidance to John
Fothergill. Now, early in 1910, he broke with Fothergill. The reasons
for this break, which had serious consequences on Fothergill's short
book[298] about Innes, have never been explained, but certain factors in
Fothergill's temperament were shockingly out of keeping with Innes's
wild post-tubercular adventures. It seems clear that Fothergill's relation-
ship with Innes was to some degree possessively homosexual. A misfit
in modern civilization, Fothergill prided himself on his elaborately
civilized manners, but seems to have derived most satisfaction from
ticking off, and being abused by, the uncivilized. There was almost a
self-destructive aspect to this artist, gallery proprietor and classical
archaeologist's decision to take up, of all occupations, innkeeping. Such
a masochistic vein Innes, with his violent Swiftian imagery, was the
perfect man to exploit; and there was soon much for Fothergill to
lament:

'[Derwent] Lees tells me strange things about Innes,' he complained
to Albert Rutherston, '– in short – [Euphemia] Lamb off – (sounds like
11 o'clock P.M. at a nasty eating house) and also his allowance from
mother – gone to Paris, his savings gone also. Knocked a bobby on
the head and arrested. He was also wounded in the head in a back
street in Chelsea along with John in a fight. What stupidities some
people allow themselves to indulge in because they call themselves
artists.'

And the company he kept! Bohemians, drunkards, practical jokers,
known eccentrics. No wonder his mother had cancelled his allowance –
Fothergill knew just how she must be feeling. Even worse goings-on
were to follow. One day, for example, when Innes, Horace Cole and
Augustus were in a taxi they:

'bethought themselves of the rite of "blood brotherhood", and at
once put it into practice. They mingled their blood freely enough. Innes
drove a knife right through his left hand. One of the others [Augustus]
stabbed himself in the leg and was laid up for some time afterwards.
Cole made a prudent incision, sufficient to satisfy the needs of the case.
The driver was indignant when he saw the state of his cab and its
occupants, but the rite had been performed and no lasting damage
was done.'[299]

Fothergill's place in Innes's life was 'for a season' taken by Albert
Rutherston who, in 1909, had suffered some sort of nervous breakdown.
Something, perhaps, of Rutherston's delicate tracery may be detected in
his later work, but already the most important living influence on him
was that of Augustus. According to Charles Hampton, Innes particu-
larly admired the lyricism of his nude figures. As early as 1909 some
John-like figures – nudes disporting themselves in a sandy pool – have

made their appearance in Innes's imaginative pictures, though they tend
to be much more primitive and awkward.

It is often assumed that Innes influenced Augustus by his example of
flattening landscape in his use of colour so as to escape the strait-jacket
of Nature; while Augustus taught Innes how to work in figures so that
they appeared to grow out of the landscape. There may be some truth in
this, but Augustus was certainly employing the flat-colour technique
and non-figurative design in 1910 before there is any biographical
evidence to suggest that Innes's work was well known to him; while,
on the whole, the least successful parts of Innes's pictures are his
figures, since in his passionate involvement with Nature, the landscape
itself became, as it were, a woman, and the human form a tautology.

What is perhaps more interesting is the extraordinarily similar posi-
tion each had achieved. As John Rothenstein has noted,[300] both were
obsessed 'by a highly personal conception of the ideal landscape which
also haunted the imaginings of Puvis de Chavannes'; both, in the
Mediterranean light, had rediscovered what they had first known as
children in Wales; both observed and sought, using more primary
colours, to reproduce the poetry of Nature. Yet there were differences.
Augustus searched for a lyrical simplicity that would convey in essence
and by the most direct means, his feelings for the wild and barren
country into which he sowed his fertile mothers-and-children. Innes
was more formal in his methods. His structural principles of composi-
tion were strongly influenced by Japanese prints, and the foregrounds
of his landscapes (often designed against a naturalistic distance) are, in
their bold rhythmical manner of foreshortening, almost abstract
patterns.

It was in the autumn of 1910 that Innes and Augustus began to see a
lot of each other. Augustus's exhibition at Chenil's in December 1910
was followed by a one-man show of Innes's work, and Augustus imme-
diately wrote to Quinn advising him to buy some of them.

'He's a really gifted chap and shows a rare imagination in his land-
scapes. It is true he has not done much yet, being quite young, but if he
can keep it up there can be no doubt about his future. London doesn't
do for him and he's off to Wales and later to the south.'[301]

Innes preferred the country but visited London for exhibitions and
would sometimes stay on, obeying what he called the 'stern call of
dissipation'. He was by now a bearded, unkempt figure, still with his
wide black hat, but permanently covered with paint, permanently ill
and permanently out-of-doors – he preferred even to sleep in the open.
Wandering one night upon the moors of North Wales between Bala
and Blaenau Ffestiniog, he had come upon the lonely inn of Rhyd-y-fen
and, though destitute and forlorn, had been cared for by its landlord,

Washington Davies – a playboy of Northern Wales – who fed him on Welsh mutton and, in the evenings, danced Welsh jigs. It was then that Innes had seen the mountain of Arennig, and made it his own. On and around this rock of porphyry he did his most inspired pictures. 'His passionate love of Wales and the mountains of Wales was the supreme mainspring of his art,' Augustus wrote,[302] 'and though he worked much in the south of France, mostly in the neighbourhood of Mount Cagnion, Mynedd Arennig remained ever his sacred mountain and the slopes of the Migneint his spiritual home.' Upon the summit of this mountain, under the cairn, he was to bury a silver casket containing his letters from Euphemia, whom he always associated with Arennig. He did not paint her poised against its precipitous contours as Augustus might have done; she *was* Arennig and Arennig her. Though emotional storms might sometimes shake and agitate him, here was the magnetic point to which, like the needle of a compass, his heart would always turn.

Compelled, like a lover, to broadcast his feelings, Innes confided to Augustus about Arennig, and the two of them made a plan to meet at Rhyd-y-fen that March. 'Our meeting was cordial,' Augustus remembered,[303] 'but yet I felt on his part a little reserved, as if he felt the scruples of a lover on introducing a friend to the object of his passion.' Behind the inn rose the slopes of Arennig Fach, and beyond the little lake of Tryweryn they could see in the distance the peaks of Moelwyn. It was an ideal place,* and they decided to look for a cottage near by. At last Innes came across one, about three miles from Rhyd-y-fen on the slopes of the Migneint by a brook called Nant Ddu.† They furnished it sparsely and moved in when Augustus returned during May. 'I think Innes was never happier than when painting in this district,' Augustus recalled.[304]

'But this happiness was not without a morbid side for his passionate devotion to the landscape was also a way of escape from his consciousness of the malady which then was casting its shadow across his days, ignore it as he might appear to do in an effort of sublime but foolish self-deception. This it was that hastened his steps across the moor and lent his brush a greater swiftness and decision as he set down in a single sitting view after jewelled view of the delectable mountains he loved

* 'This is the most wonderful place I've seen,' Augustus wrote to Dorelia (March 1911). '. . . The air is superb and the mountains wonderful . . . We are now off for a week to see a waterfall that falls 400 feet without a break.' This was possibly the subject of Innes's waterfall picture done the previous autumn and now in the Tate Gallery (3804).

† 'Innes is here too working at the mountains and working well. We have taken a little cottage on the moor for £10 a year, it will be a useful place to work from.' John to Quinn (from Nant Ddu, Cwmprysor, North Wales, 19 May 1911).

before darkness came to hide everything except a dim but inextinguishable glow, perceived by him as a reflection of some miraculous and eternal City of the West.'

Innes's activity was prodigious. Rarely did he return at dusk without at least two panels completed. Though rapidly done, they had often entailed long expeditions over the moors in search of that magical moment of illumination which would suddenly burst upon him through the ever-changing procession of clouds. Like a man condemned, he worked with feverish speed: he simply did not have the time for mistakes. The effect of this upon Augustus was extraordinary. Never before had he met someone whose swiftness and decision exceeded his own. What he had once done at the Slade for others, Innes, acting as a pacemaker, could now do for him.

But there was another way in which Innes helped. 'He was an original, a "naif",' Augustus wrote[305] – and in a letter to Quinn (15 June 1911) he describes him as an 'entirely original chap and that's saying a lot. He is not the sort who learns anything. He will die innocent and a virgin intellectually which I think a very charming and rare thing.' Augustus did not copy Innes or seek to learn from him any very painterly secrets. It was Innes's example that inspired him. He had felt recently that his own innocence, the quality which W. B. Yeats had found so remarkable in him, was in jeopardy. Innes encouraged him to re-establish it – so much is evident from his letter to Quinn in which, passing from Innes to himself, he adds: 'I am on my way I think to get back (or forward) to a purely delightful way of decorating which shall in no way compete with the camera or the coal-hole. But one has a lot to unlearn before the instinct or the soul or what you call it can shine out uninstructed.'

It was ironic, therefore, that their sole disciple should be a copycat of genius, Derwent Lees. He could paint McEvoys, Inneses* or Johns[306] at will and with a fluency that sometimes makes them almost indistinguishable from their originals – though his figures with their great dense areas of cheek and chin do have originality. An Australian, he had come from Melbourne, after a duty stop in Paris, to London, and now taught drawing at the Slade. A strange, fair-complexioned man, rather thin, he somehow – possibly it was the way he dressed – gave the impression of plumpness. But he was chiefly remarkable, in the days when artificial limbs were still unusual, for a fine and exciting false right foot,† complete with wooden toes in which, amid much giggling, a Slade girl once got her finger caught.

The paintings which these three did in the four or five years before

* 'I tire of seeing my own subjects so many times,' Innes once wrote of Lees's pictures.

† He had mislaid his foot in a riding accident.

the war mark a unique phase in British painting which, though it has been generally labelled 'post-impressionist' belongs more properly to the alternative tradition of the symbolist painters.

The war signalled the end of this visionary period of landscape painting. It was during the war that Lees succumbed to an incurable mental disease which terminated his painting career. And it was on 22 August 1914 that Innes died of his tuberculosis. In his first draft of the introduction to an Innes Memorial Exhibition at the Chenil Gallery in 1923 Augustus laments not just the death of so promising a talent but, by implication, the fading of his own which, he sometimes suspected, would have been better served by a fate like Innes's.

'In his short lifetime, though handicapped and tortured by the remorseless disease which finally put an end to him, he managed by heroic effort to make a name for himself as one of the foremost figures of his time in the art of landscape painting. He cannot be said to have fulfilled himself completely; he died too young for his powers to have reached their full maturity – and for that matter does not everyone? But by the intensity of his vision and his passionately romantic outlook, his work will live when that of many happier and healthier men will have grown, with the passing years, cold and chill and lifeless.'

6. WHAT NEXT?

'It was cruel to leave Provence,' Augustus had complained to Ottoline on his arrival back in England in September 1910. Only a month before, in France, he had started to feel homesick – but for what home? London suited neither Dorelia, nor himself, nor the children who (especially David) fell far too readily under the sway of Mrs Nettleship. 'Dorelia (my missus) is very keen on a house in the country,' Augustus reminded Quinn (December 1910), 'and we shall have to look out for one soon. She tends to get poor in London.'

He had at once recommenced work on Hugh Lane's decorations – but no longer in Lane's house. Instead he had taken a studio for himself at the Chenil Gallery. 'I think you will find Chenil's quite a good place now,' he reported with some optimism to Will Rothenstein, 'and Knewstub is improving.' Determined to get Lane's pictures done by the spring 'or perish', he several times gave up 'touching a drop of liquor' and admitted feeling 'exceedingly good'.

Having Chenil's as his office brought some alleviation to their Church Street problems, but it fell far short of solving them. All the old difficulties and irritations crowded in and it seemed possible once more that they could not continue living together very long. 'Do you want a ring,' Augustus suddenly asked Dorelia: but answer came there none.

Like some General, he had moved up his squadron of caravans to Battersea 'so that we may turn into the van any hour'. As soon as the winter was done with they could trek all over England: the possibilities were endless.

These next twelve months were feverish. Augustus spent more and more time at his office and it was there, rather than at home in Church Street, he would entertain his friends. Some days he would leave for Chenil's in the morning – a distance of at least five hundred yards – and not return that night at all. Next day Dorelia would receive a note from Essex, Berkshire or Brittany: 'The country is so beautiful – you wouldn't believe – I suddenly quitted London.' In October he had gone to France; in November he took off to see Eric Gill at Ditchling, discussing there the question of a New Religion and a co-operative scheme (which came to nothing) for taking a house from which their work could be sold independently of the dealers. In December he hurried off twice to Charlie McEvoy's 'pig-stye' at Wantage: 'Mrs McEvoy frequently wishes you were here,' he wrote to Dorelia – adding hastily: 'So do I.'

A family Christmas at Church Street being obviously unsupportable, he once more set off for the Chenil and arrived this time in Paris. 'I have been so embêté lately and have taken refuge in Paris and have neglected all my pleasures,' he explained to Ottoline (27 December 1910). '. . . I found London quite deadly and think of going south again till England becomes more habitable. I hear Lamb has been doing your portrait* – le salaud!' He dined with Royall Tyler off stuffed pigs' trotters and met his new wife – 'a horror'; saw Epstein and Nevinson, and squared up to Boris Anrep;† searched in vain for Gwen;

* 'My immense picture of Ottoline is to begin: so my respiration may be audible in Dorset,' Henry Lamb to Lytton Strachey, 10 April 1910.

† Boris Anrep recorded this first encounter with Augustus (in a letter to Henry Lamb) thus: 'If you could creep in my heart and memory which you honoured by some particulars of your relation to John's – you would feel sike and poisoned by the byle which turns round in me when I first saw John. That was a night-mare, with all appreciation of his powerful and mighty dreadedness, and some ghotic beaty, I could not keep down my heat to some beastly and cruel and vulgar look of brightness which I perceived in his face and demeanour. . . .' Augustus relished Anrep's personality and admired his work. In 1913 he persuaded Knewstub to arrange an exhibition of Anrep's drawings at the Chenil Gallery, and in later years put him in the way of several commissions, from Lady Tredegar and others, for his mosaics. Once, in 1928, he suddenly telephoned Anrep in a highly emotional state to say: 'Boris, you are a great artist. I want you to know that I think so' – and then rang off. This must have been at the time he was writing 'Five Modern Artists' for *Vogue* (3 October 1928), in which he said of Anrep: 'In those works with which he has adorned our public buildings he has performed a permanent and most signal service to the life of our time. Alone among living artists he has practically restored

attempted to teach Lobelia to ride a bicycle; was chased by an Austrian tiger woman from whom he eventually escaped through a smoke-screen of Horace Cole's practical jokes (including, apparently, a mock-operation for appendicitis), and in all devastating innocence concluded: 'Paris is certainly preferable to Chelsea. I think I'd like to live here.'[307] It was as if the past had never been.

For most of this time he stayed at 40 Rue Pascal with Fabian de Castro, the Spanish guitarist who, with the cunning of the devil, had outwitted his gaolers in Madrid and was now writing his autobiography. 'He has wandered all over Europe,' Augustus warned Quinn, 'and even across the Caucasus *on foot* and speaking only Spanish – and has done everything except kill a man.'

It was almost in parody of himself that, having determined to go south to Marseilles with a Miss George* who, he consoled Dorelia, 'might be useful, posing', Augustus straightway returned to London leading, like small deer behind him, a troupe of his cronies right up to the front door of Church Street. What with the cook's two children to reinforce Augustus's six, and the intermittent appearances of Helen Maitland and Edie McNeill to reinforce that of Fabian de Castro and other friends, the place was crowded as for war. One packed night during the first week of January 1911, fire broke out in the house, and Augustus, wakened by screams, 'leapt out of the room half-crazy and found our servant on top of the stairs burning like a torch. I happened to have been sleeping in a dressing-gown by some happy chance and managed to extinguish the poor girl with this. But it was a terrible moment . . . fortunately her face, which is a good face, was untouched. She was burnt about the arms, legs and stomach . . . She had come up the stairs from the dining-room, blazing – the smell nearly made me faint afterwards. It was the hottest embrace I've ever had of a woman.'[308] They summoned a 'smart little doctor' to do the repairs both to the girl and to Augustus himself, whose left hand and leg and more pertinent areas had got severely toasted without, he was anxious to demonstrate, putting him 'out of action in the slightest degree'.[309] He was, however, ordered to stay in bed. 'This will mean keeping quiet for a few days,' he told Quinn (5 January 1911), 'after which I want to take

* Possibly Teresa George who, he tells us in *Chiaroscuro* (p. 17), called on him in London and told him that his father was seeking her hand in marriage. 'He and I had something in common after all, then!' Augustus concluded.

a lost art, and revived the traditions of the golden age of Christian art in this particular medium. Affected both by the early Byzantine traditions still surviving in Russia, together with the magnificent examples to be seen in Sta. Maria Maggiore in Rome, and those of Ravenna and Palermo, he has succeeded in expressing modern conditions in terms which have too long been considered obsolete.'

one of my vans on the road for a week or so and then get back to work
with full steam up.'

It was less these conflagrations than the convalescences that were, for
Dorelia, most arduous; not the rows but the periods of 'keeping quiet'.
She, who could enjoy-and-endure so much of the heroic found herself
strangely vulnerable to the trivial. A small thing it was that finally
cracked her cheerful detachment: spitting. By all accounts Fabian de
Castro was a splendid guitarist, but he *would spit in the bath*. This
accomplishment infuriated Dorelia beyond reason. She lay awake
thinking about it, and finally she put up a notice: PLEASE DO NOT
SPIT IN THE BATHROOM. And when he took no notice of it, she
left.

She left for Paris, and she left with Lamb. It was a casual business.
'Dorelia is in Paris for a few days and I in London,' Augustus remarked
in the course of a letter to Michel Salaman about the more pressing
matter of ponies. But it was not casual for Lamb. 'I stayed more than a
week,' he wrote to Lytton Strachey (1 February 1911): 'seeing for the first
time the city in all its glamour of history, art and romance. But I should
explain Dorelia was there and that I came back with her in a motor car
belonging to an American millionairess [Mrs Chadbourne]. Now I am
completely rejuvenated and working with tenfold industry.' Invariably
Dorelia would have this inspiriting effect on him, but she caused him
much pain that, though he bore it uncomplainingly, may itself have
contributed to the pain he inflicted on those who fell in love with him,
and eventually on Dorelia herself. On the evening of their return, after
they had parted, Lamb wrote to Ottoline:

'I arrived about 6 this evening having travelled since very early on
Sunday with Dorelia, Pyramus and Mrs Chad. in her motor. The excite-
ments of Paris came in an unusually trebled dose, and the final shaking
of the journey have reduced me too low . . . I have lived too giddily
these last days to give them the thought they must have. It is an odd and
desolate sensation to spend the evening alone. I must turn into bed
immediately in the hope of a braver morning moral.'

By the time Dorelia arrived back in Church Street, 'full steam' was
up. Augustus and his friends had journeyed into Essex for a gypsy
evening during which Lobelia executed a fantastic belly dance, writing
her name and address on the shirt fronts of those she took to as she
whirled past them; and Augustus got 'mad drunk' after a long spell of
total abstinence; and Fabian de Castro lost himself. Then, on their
return, Horace Cole charged his motor car into a cart-load of people
injuring many, one severely. Innes, too, had 'been doing la Bombe lately
by all appearances', Augustus advised Dorelia; and McEvoy, in her
absence, had sprouted 'a moustache like an old blacking brush'. And

now there was the Gauguin Ball in London; and after that Lady Gregory had invited him back to Coole. But first, he decided (10 February 1911), 'I want to go south again and work in the open'. This was his way of announcing the expedition to meet Innes in North Wales. After he returned, Dorelia again left, joining Lamb at the Dog Inn at Peppard and then in London. 'Dorelia did come the last day at Peppard,' Lamb wrote to Strachey (11 May 1911); 'we walked through divine woods and lunched in an exquisite pub with the politest of yokels and I . . . got of course quite drunk. Then I had another evening with her all alone at Bedford Square. It was more than the expected comble.'

In a letter to Ottoline, Lamb had once suggested (10 May 1910) establishing 'a discreet form of colony'. With an amoeba-like drawing he outlined a community of Johns, Maitlands, Morrells and himself, adding: 'I could double myself no doubt and general reunions could be arranged at suitable intervals.' It was a fantasy that had nearly been translated into fact. Like a rock-pool by the sea, the colony was sometimes teeming, sometimes almost empty. Innes and Lobelia and Epstein; Alick Schepeler and Wyndham Lewis and Mrs Strindberg – all these, and others – countless others – would float in and be carried out from time to time, causing a little ripple. But for Lamb there was no one so important as Dorelia. In his letters he does not gossip about her, but writes in a tone – rueful, tender, oblique – he reserves for no one else. He saw and heard far too little of her; but he felt, formidably and hopelessly, in her debt.

When Augustus returned to North Wales in May he took Dorelia with him. But the journey was not a success and she came back alone. 'We are getting restless about moving,' Augustus had confided to Quinn (10 February 1911). For Dorelia this had by now become a matter of urgency. Cut off from the country she seemed to lose strength. Their sardine-life together held no nourishment for her. She felt it was wrong, that her true being had been uprooted and was withering, dying. There was no sun in London, no air, no time, no involvement with real things that made sense by multiplying and returning the energy you put into them. The very atmosphere was clogged with 'important' matters that people confused with reality. She had to get away.

They had written to a number of friends asking them to look out for a house in the country, but so far their investigations had been worse than unsuccessful. Pursuing a house in the west with Charlie Slade, Augustus tripped, fell, damaged his leg and returned home a convalescent again. 'Please get me a house. John,' he had desperately cried from bed to his friends the Everetts. In reply he received a list of questions with intervening spaces, which he loyally filled in and sent back. Shortly afterwards, Katherine Everett came upon Alderney

Manor, a strangely fortified bungalow larger than most houses, that had been built by an eccentric Frenchman. It was set in sixty acres of woodland near the Ringwood Road outside Parkstone in Dorset, included a walled garden, cottage and stables – all for an incredible rent of fifty pounds a year. Lady Wimborne, the landlord, a keen Liberal and Evangelical leader, insisted in conversation with Katherine Everett that 'we should be pleased to have a clever artist for a tenant'.[310] Dorelia was so desperate to leave London she was ready, it seemed, to take the house sight unseen, but Augustus, in the guise of a practical man, advised: 'The house is no doubt lovely in itself, but it must be seen – so much depends on the placing of it.' They therefore went down to spend a few days with the Everetts, who lived some three miles from Alderney.

'I can still visualize the group coming up our pine-shaded, sun-dappled drive,' Katherine Everett wrote.[311] 'Mrs John, who was leading a grey donkey with a small boy astride it dressed in brilliant blue and another equally vivid small boy at her side, wore a tight-fitting, hand-sewn, canary-coloured bodice above a dark, gathered, flowing skirt, and her hair very black and gleaming, emphasized the long silver earrings which were her only adornment.'

Augustus and Dorelia took to Alderney Manor at once. 'It's a good find,' Augustus informed Quinn,[312] 'any amount of land with pine woods goes to it, and inexpensive.' Some repairs and alterations were needed and while these were being arranged, the Johns camped in the Everetts' grounds, amusing themselves by decorating the small empty gardener's cottage where they ate, painting the walls black and the furniture scarlet.

'One afternoon,' Katherine Everett remembered,[313] 'the children decided to get the red and black paint off their persons, so they all undressed and, with turpentine soap and scrubbing brushes, set to work to clean themselves up. It was while they were so occupied that Lady Wimborne paid her first call.'

For a moment Alderney seemed to tremble in the balance, but Lady Wimborne, her liberal principles fully extended, sailed past this test and everything was quickly settled. Over these summer months, Dorelia spent much of her time preparing for their move to the house. 'D. has gone to live for ever near Poole,' Lamb wrote in despair to Lytton Strachey. But already, in the second week of July, he had joined her there for what he called 'a supreme time'. In a letter to Strachey (24 July 1911) he described what was to become for him a second home.

'She [Dorelia] lives in an amazing place – a vast secluded park of prairies, pine woods, birch woods, dells and moors with a house, cottages and a circular walled-garden. And, pensez, all these you could have possessed for £50 a year – *we* could have possessed them!! It was

very hot when I was there and lovely naked boys running about the woods. John was away. In the course of some almost endless conversations with D. I thought her as superior as ever, but in danger of becoming overgrown in such isolation.'

On leaving Alderney, Lamb crossed over to France, a sudden enterprise inciting him to carry off with him Dorelia's sister 'poor picturesque Ede' – a scheme he almost instantly regretted.

While Lamb lingered at Alderney, Augustus had been in Liverpool finishing his portrait of Kuno Meyer. 'Funny things continue to happen,' he told Ottoline (14 July 1911). Charles Reilly, the architect, was roused from sleep by the figure of Augustus, in flight once more from the Austrian tiger-woman or 'Walking hell-bitch of the Western World',[314] climbing through his bedroom window; Granville-Barker was surprised at finding himself cross-examined over dinner on the subject of 'a horse and trap'; Innes was infuriated on being joined at Nant Ddu by Albert Lipczinski and his beautiful Doonie, sent expressly from Liverpool – 'they are incredibly poor', Augustus explained; the Sampsons and Dowdalls were visited, and Susan their maid. And all Liverpool was praised and blamed: 'The Mersey is a grand thing. The ordinary Li-pool population is awful – hopeless barbarism.'[315]

Though nothing appeared to have altered, Alderney marked the positive beginning of a very different pattern in Augustus and Dorelia's lives. They moved in during August, though Augustus still kept on his studio at the Chenil Gallery. 'We have left Church Street for this place which does well for the kids,' he announced to Quinn (16 August 1911). '. . . My studio here is still unfinished and this has lost me a lot of work. My missus is well and gay but I very much fear she is in for something rather unnecessary.'

They had, it seemed, solved their problems by altering the very geography of their lives together. A new phase in Augustus's career was about to start. Though composed of the same parts as before, it would increasingly re-arrange the kaleidoscope of his life; and, as with all change, he responded optimistically to the prospect.

But to Henry Lamb the future seemed black: 'One of the chief temptations,' he confessed,[316] '[is] to succumb to the general pressure of the news that Dorelia is enceinte again, which means she may die at any minute.'

DESECRATION OF SAINT PAUL'S
To the Art-Students of London

Since the so-called decorations of Saint Paul's have been encroaching actually on the substructure of the mighty Dome itself, a great feeling of indignation has arisen. The atrocities of the design, the meanness of the patterns, the crudity of the colour, and the vulgarity of the whole is too evident to those who have inspected the results of Sir William Richmond's scheme of decoration. Even *good* decoration would be out of place, superfluous, and utterly contrary to the expressed wish of Wren.

But what are we to say to the treatment in Romanesque Style of a Renaissance building, the Petroleum Stencilled Frieze (already condemned), the false accentuation of architectural features nullifying the Master's intended effect, but, above all, the audacious demolishing of the stonework of the structure itself to provide a bed for these detestable Mosaics?

We feel assured none who have at heart the preservation of the Masterpiece can submit to see the glorious memory of its illustrious Author thus insulted, or can do less than their utmost to avert what can only be regarded as a National Calamity.

The initiators of this movement call upon the Students of the various Art Schools in London to send their representatives to join with them in determining the most effective means of making their protest.

A Meeting will be held to that end at Mr. A. Rothenstein's Rooms, No. 20, Fitzroy Street, Fitzroy Square, W., on Saturday May, 6. from 5. P.M. till —

Secretary, MAX WEST,
Slade School, Gower Street.

THE CHELSEA ART SCHOOL
ROSSETTI STUDIOS
FLOOD STREET, CHELSEA EMBANKMENT

PRINCIPALS:
AUGUSTUS JOHN
WILLIAM ORPEN

YEAR 1904
FIRST TERM: MONDAY, JANUARY 11th TO FRIDAY, MARCH 25th.
SECOND TERM: MONDAY, APRIL 11th TO FRIDAY, JUNE 24th.
THIRD TERM: MONDAY, OCTOBER 3rd TO FRIDAY, DECEMBER 18th

THE STUDIOS SEPARATE TO EACH SEX WILL BE OPEN ON WEEK DAYS (SATURDAYS EXCEPTED) FROM 10 TO 5. AND MODELS WILL BE POSED DAILY. A LADY SUPERINTENDENT WILL BE PRESENT. SEATS AND EASELS WILL BE FOUND, BUT SUCH OTHER MATERIALS AND APPLIANCES AS MAY BE NECESSARY MUST BE PROVIDED BY THE STUDENTS.

FEES
FOR FIVE DAYS PER WEEK. SEVEN GUINEAS PER TERM, OR NINETEEN GUINEAS PER YEAR.
FOR THREE DAYS PER WEEK. FOUR GUINEAS PER TERM, OR ELEVEN GUINEAS PER YEAR.
ALL FEES MUST BE PAID IN ADVANCE. CHEQUES SHOULD BE DRAWN IN FAVOR OF THE SECRETARY AND CROSSED.

COMMUNICATIONS SHOULD BE SENT TO THE SECRETARY.
J. KNEWSTUB,
18 FITZROY STREET, W.

IT IS TO BE UNDERSTOOD THAT MR. JOHN AND MR. ORPEN WILL FIND THEIR PART IN STIMULATING, BY ADVICE AND SUGGESTION, THE MOST PERSONAL ARTISTIC AIMS, AND THEY ARE BOLD TO HOPE THAT BY SYSTEMATIC DISCOURAGEMENT OF THE CHEAP AND MERETRICIOUS AND HEARTY PROMOTION OF THE MOST REAL AND SINGLE-MINDED VIEW OF LIFE, NATURE AND ART, THEIR EFFORTS WILL NOT TEND OTHERWISE THAN TO THE BEST PROGRESS OF THEIR STUDENTS IN ART, IN NATURE AND IN LIFE

Mr. AUG. E. JOHN and Mr. WILLIAM ORPEN desire to bring to your notice the ART COURSES to which they propose to give their assistance during the forthcoming year.

The CLASSES will consist of Drawing and Painting from Life (figure, portrait, and costume), Painting from Still Life, Figure Composition, Landscape and Decorative Painting, together with the usual Elementary Subjects where required

The STUDIOS will be situated in Chelsea; classes will be held for ladies and gentlemen, and every arrangement will be made to meet the convenience of individual students. A Lady Superintendant will be present daily.

The SPRING TERM of Session 1904 commences on the 11th January, and intending students should give prompt notification as the numbers are strictly limited, and no application can be considered later than the 31st December.

The FEES are moderate, and particulars and all other information can be obtained by writing to

<div style="text-align:center">

THE SECRETARY,

18 *Fitzroy Street,*

London, W.

</div>

To Iris [Tree]. A poem in parody of Arthur Symons

To her foul breathing maw I hold
The guttering candle of my lust,
That smoketh like burnt offerings
Upon the altars of that old
Intoxicate goddess of the bust,
Multiple and indeterminate,
The fume whereof waxes and wanes
As spew upon the floor of Hell,
That bubbles with the heat of it;
Red lips that smack of carrion
And the faint penetrating smell
That comes of eating onions
That grow beside the lake of Sin;
And eager cloven tongue that laps
The froth from off the jaws of Shame;
(Ah God, ah God, the Joy thereof!)
Beneath the fulsome beaded paps,
Her devastated belly quakes
With the unmentionable aches
And agonies without a name,
As used to ravage and lay waste,
The carcase of Lucrezia,
When she lay panting with the Pope.
And thro' her burning violet veins,
The corpuscles of passion chased
The Molecules of virtue out;
Her heavy eyes quite glazed with Dope
And fume of the abominable wine,
That sinners serve to sinners, shine
With the extraordinary desire for trout
Caught by lost souls in Acheron;
The issue of her riven loins,
As evil monsters pullulate
About the shadow of her groin's
Unholy sanctuary; ululate
Like Hell's spawn unredeemable,
Brought forth to torment, damnably
And writhe and twist and turn again.

Simple Symon

Notes

1. *Horizon*, Vol. III, No. 14, February 1941, pp. 98–9.
2. *Chiaroscuro*, p. 28.
3. Letter to the author, 18 October 1968.
4. *Chiaroscuro*, p. 25.
5. *Chiaroscuro*, p. 36.
6. op. cit.
7. *Chiaroscuro*, p. 37.
8. *Chiaroscuro*, p. 19.
9. *Chiaroscuro*, pp. 31–2.
10. Letter to the author from Darsie Japp, 13 December 1968.
11. *Chiaroscuro*, p. 12.
12. Gwen John to Jeanne Foster, 11 August 1924.
13. William Rothenstein to Max Beerbohm, 24 July 1941. Quoted in Robert Speaight's *William Rothenstein*, p. 402.
14. *Evening Standard*, 19 January 1929.
15. *Horizon*, Vol. XIX, No. 112, April 1949, p. 295.
16. op. cit.
17. *Chiaroscuro*, p. 35.
18. *Evening Standard*, 19 January 1929.
19. B.B.C. talk first transmitted on 17 November 1967.
20. 'The Slade School of Fine Art' by George Charlton, *The Studio*, October 1946.
21. See Randolph Schwabe, *The Burlington Magazine*, June 1943.
22. *Men and Memories*, Vol. I, pp. 22–5.
23. 'The Slade School of Fine Art' by George Charlton, *The Studio*, October 1946.
24. *Horizon*, Vol. III, No. 18, June 1941, p. 394.
25. *Chiaroscuro*, p. 41.
26. *Chiaroscuro*, p. 42.
27. *Chiaroscuro*, p. 44.
28. *Finishing Touches*, p. 29.
29. Letter to the author, 1969.
30. Letter to Ursula Tyrwhitt.
31. Famous People, No. 31 of a series of 50. Illustrated by Angus McBride and described by Virginia Shankland.
32. *Evening Standard*, Saturday, 19 January 1929, p. 18.
33. 'Face to Face' television interview, B.B.C., 15 May 1960.
34. *Finishing Touches*, p. 30.
35. *Rude Assignment*, pp. 118–19.
36. *Chiaroscuro*, p. 49.
37. *Chiaroscuro*, p. 249.
38. See catalogue of the Gwen John exhibition 1968. The Arts Council. Introduction by Mary Taubman.
39. Gwen John to Ursula Tyrwhitt, 4 April 1928.
40. Gwen John to Ursula Tyrwhitt, 22 July 1936.

41. Undated letter from Gwen John to Ursula Tyrwhitt.
42. Gwen John to Ursula Tyrwhitt, July 1927.
43. Gwen John to Ursula Tyrwhitt, 6 June 1925.
44. *Modern English Painters*, Vol. I, 'Gwen John', pp. 160–1.
45. *Modern English Painters*, Vol. I, 'William Orpen', p. 227.
46. *Men and Memories*, Vol. I, p. 334.
47. See *The Listener*, 23 November 1967.
48. *Men and Memories*, Vol. I, p. 333.
49. See John's Introduction to the Catalogue of Drawings by Ulrica Forbes, Walker's Galleries, 118 New Bond Street, London, 17 October 1952.
50. 'A Note on Drawing', p. 10. From *Augustus John: Drawings* edited by Lillian Browse (Faber and Faber, October 1941).
51. *Chiaroscuro*, p. 46.
52. *Chiaroscuro*, p. 48.
53. *Rude Assignment*, p. 119.
54. *Men and Memories*, Vol. I, p. 333.
55. See John Russell's obituary in *The Sunday Times*, 5 November 1961.
56. *Chiaroscuro*, p. 36.
57. *Chiaroscuro*, p. 27.
58. At the Cornell University Library.
59. Ethel Nettleship to Caspar John, 29 June 1951.
60. *Autobiographies* by W. B. Yeats, p. 271.
61. *Autobiographies* by W. B. Yeats, p. 193.
62. ibid., loc. cit.
63. *Chiaroscuro*, p. 48.
64. op. cit.
65. *Finishing Touches*, p. 40.
66. *Chiaroscuro*, p. 147.
67. Undated letter from Ida Nettleship to her mother.
68. *Chiaroscuro*, p. 250.
69. Introduction to the William Rothenstein Memorial Exhibition Catalogue, Tate Gallery (May–June 1950).
70. *Men and Memories*, Vol. I, p. 348.
71. *Horizon*, Vol. III, No. 18, June 1941, p. 400.
72. Oscar Wilde to William Rothenstein, 4 October 1899. See *The Letters of Oscar Wilde* edited by Sir Rupert Hart-Davis.
73. *Men and Memories*, Vol. I, p. 352.
74. ibid. loc. cit.
75. John to Michel Salaman, February 1900.
76. *Horizon*, Vol. III, No. 18, June 1941, p. 401.
77. Undated letter from John to Michel Salaman.
78. *Horizon*, Vol. III, No. 18, June 1941, p. 401.
79. *Chiaroscuro*, p. 38.
80. *Men and Memories*, Vol. I, p. 358.
81. *Chiaroscuro*, p. 49.
82. *From Stomacher to Stomach*, the unpublished autobiography of E. Fox Pitt.
83. *Men and Memories*, Vol. II, p. 1.
84. From an essay Osbert Sitwell did not include in *A Free House*. It will be found in André Theuriet, *Jules Bastien-Lepage & his Art* (1892) pp. 139–40. See also Malcolm Easton, *Augustus John* (The University of Hull, 1970).
85. *Fifty Years of the New English Art Club* by Alfred Thornton.

86. *Cambridge Review*, March 1922.
87. *Victorian Artists* by Quentin Bell, p. 91.
88. *The English Review*, January 1912.
89. *Burlington Magazine*, February 1916.
90. *New Age*, 28 May 1914.
91. Letter from Augustus John to Lady Ottoline Morrell, 5 August 1910. This correspondence is now at the University of Texas, Austin.
92. This and other unpublished Orpen letters are owned by Miss Miriam Benkovitz, the biographer of Ronald Firbank.
93. *My Gipsy Days* by Dora E. Yates, p. 74.
94. Most of John's letters to Will Rothenstein are at the Houghton Library, at Harvard, Cambridge, Mass.
95. *Chiaroscuro*, p. 60.
96. *Letters of Sir Walter Raleigh*, Vol. II, p. 333.
97. John to Will Rothenstein. See *Men and Memories*, Vol. II, p. 9.
98. C.D. 14.
99. One of his subjects, for instance, was 'A Rabbi Studying', from a drawing by Rembrandt. C.D. 73.
100. Lord David Cecil, *52 Drawings*, p. 12.
101. To Will Rothenstein, 9 March 1902.
102. To Will Rothenstein, undated.
103. In his preliminary synopsis for an autobiography, 1923.
104. One impression, at least, is dated 1902. C.D. 47.
105. Unpublished diaries of Arthur Symons.
106. Ethel Nettleship to Sir Caspar John, 27 June 1951.
107. Unpublished diary of L. A. G. Strong, in the possession of Mr B. L. Reid, biographer of John Quinn.
108. *Men and Memories*, Vol. II, p. 4.
109. 'I Speak for Myself', B.B.C. recording. Far Eastern Service, 10 September 1949.
110. ibid.
111. Walter Pater, *The Renaissance*.
112. *Finishing Touches*, p. 26.
113. The painting was bought by Charles Rutherston and now hangs in the Manchester Art Gallery.
114. *Modern English Painters*, Vol. I, p. 179. The picture is in the Manchester City Art Gallery.
115. Called simply 'Esther'. C.D. 1903.
116. Tate Gallery, London, 3171.
117. Reproduced in *Augustus John*, British Painters series (1962) by John Rothenstein. Plate No. 8. Owned by the Pitman family.
118. *Journal of the Gypsy Lore Society*, Vol. XLIX, 3rd Series, parts 1–2.
119. 'Miss McNeil', Manchester City Art Gallery.
120. Now in the Manchester City Art Gallery.
121. *Augustus John* by Malcolm Easton (1970), p. 43.
122. *Bohemia in London* by Arthur Ransome (1907) 2nd edn., 1912, p. 89. See also *Augustus John* by Malcolm Easton (1970).
123. *The Burlington Magazine*, No. 475, October 1942, p. 237.
124. Gwen John, Retrospective Exhibition Catalogue (Arts Council, 1968). Introduction by Mary Taubman.
125. In an undated letter to Mrs Hugh Hammersley.

126. Dorelia to John Rothenstein (19 January 1951). See *Modern English Painters* (1962 edn), 'Sickert to Grant', p. 187.

127. 'Dorelia by lamplight, at Toulouse' (in the collection of Romilly John); 'The Student' (City of Manchester Art Gallery); and 'Dorelia in a Black Dress' (Tate Gallery, 5910).

128. Dorelia's actual words, spoken to the author, while describing this time.

129. Dorelia to the author, 3 July 1969.

130. 19 January 1926.

131. John to Ottoline Morrell, 30 November 1908.

132. See *Imperfect Encounter* by Mary Lago (1972), p. 207.

133. *Men and Memories*, Vol. 2, p. 166.

134. *Athenaeum*, 19 November 1904, p. 700.

135. In an undated letter to the Rani.

136. Letter to the author, 23 November 1968.

137. Undated letter from Ida to the Rani.

138. In an undated letter to Mrs Sampson.

139. Extract from an undated letter from Ida to Augustus.

140. John to Ulick O'Connor. See *Spectator*, 10 November 1961.

141. *The Letters of Wyndham Lewis* edited by W. K. Rose, p. 39, where this letter is wrongly guessed as *ca.* 1908.

142. John to Alick Schepeler, undated (1907).

143. Now in the National Portrait Gallery, London, No. 4119.

144. *The Evening Standard and St James's Gazette*, 19 June 1908.

145. Letter (undated, *ca.* autumn 1906) to Alick Schepeler.

146. Undated letter to Alick Schepeler.

147. *Chiaroscuro*, p. 68.

148. Undated letter to Alick Schepeler.

149. *Chiaroscuro*, p. 26.

150. *Horizon*, Vol. V, No. 26, February 1942, p. 125.

151. Anne Stuart Lewis, his mother. See *The Letters of Wyndham Lewis*, p. 12.

152. Letter from Ida to Mrs Sampson.

153. Letter from Ida to Alice Rothenstein.

154. Undated letter to Alick Schepeler.

155. *The Letters of Wyndham Lewis*, p. 31.

156. Dorelia John to the author, July 1969.

157. To Alick Schepeler.

158. Undated letter to Alick Schepeler.

159. Letter from Ida John to the Rani, December 1906.

160. *Finishing Touches*, p. 45.

161. Letter from Augustus to the Rani, March 1907.

162. *Finishing Touches*, p. 46.

163. Letter from Augustus to Mrs Sampson, March 1907.

164. *The Letters of Wyndham Lewis*, p. 36.

165. See *Men and Memories*, Vol. II, p. 90.

166. Letter from Augustus to William Rothenstein, 20 March 1907.

167. Letter from Augustus to the Rani, March 1907.

168. *The Letters of Wyndham Lewis*, p. 36.

169. Information from 'Augustus John', an unpublished typescript by Alan Moorehead, whose source was Henry Lamb.

170. Unpublished diaries of Arthur Symons: 'Gwen and Doulia' (*sic*).

171. John to Alice Rothenstein.

172. John to Chaloner Dowdall.

173. John to Will Rothenstein.

174. Delacroix to Félix Guillemardet, 1 December 1823.

175. John to Will Rothenstein, April 1907.

176. John to Alick Schepeler from Equihen.

177. *Horizon*, Vol. IV, No. 22, October 1941, p. 289.

178. W. B. Yeats to John Quinn, 4 October 1907.

179. John to Henry Lamb, 24 August 1907.

180. John to Henry Lamb.

181. John to Henry Lamb, 25 June 1907.

182. Letter (undated, but probably September 1907) from Dorelia to Augustus.

183. ibid.

184. *Chiaroscuro*, p. 69.

185. *Ottoline : The Early Memoirs of Lady Ottoline Morrell* edited by Robert Gathorne-Hardy, p. 141.

186. *Ottoline*, p. 157.

187. ibid.

188. ibid., p. 158.

189. Augustus to Ottoline Morrell, 10 March 1909.

190. *Ottoline*, p. 159.

191. *Ottoline*, p. 163.

192. Augustus to Dorelia.

193. John to Wyndham Lewis, 28 June 1908.

194. John to Ottoline Morrell, 7 July 1908.

195. John to Ottoline Morrell, 11 November 1908.

196. Letter to the author, 25 November 1968.

197. John to Lamb, September 1908.

198. ibid.

199. From 'The Wanderers' by Arthur Symons. *Amoris Victima*, 1897.

200. See *Augustus John* by Malcolm Easton (1970).

201. *Edward Marsh* by Christopher Hassall (1959), pp. 145, 148.

202. *Letters from Edward Thomas to Gordon Bottomley* edited and introduced by R. George Thomas (1968), p. 144.

203. John's contributions to the J.G.L.S. are: *New Series*, Vol. 2; 'Wandering Sinte' (frontispiece), pp. 197–9; *Russian Gypsy Songs*, Vol. 3, pp. 251–3; *French Romani Vocabulary*, Vol. 4, pp. 217–35; *Russian Gypsies at Marseilles and Milan*, Vol. 5, pp. 135–8; *The Songs of Fabian de Castro*, pp. 204–18; *O Bovedantuna*, 'Calderari Gypsies from the Caucasus' (frontispiece). *Third Series*, Vol. 7, 'Portrait of Dr. Sampson' (opp. p. 97); Vol. 17, 'Self-Portrait' (frontispiece), p. 136; *Le Château de Lourmarin*, Vol. 23, pp. 120–2; *Portrait of a Russian Gypsy*, Vol. 27, pp. 155–6; *Keyserling on Hungarian Gypsy Music*, Vol. 36, pp. 81–2; *Miss Jo Jones's Frontispiece*, Vol. 39; 'Les Saintes Maries de la Mer, with Sainte Sara, l'Egyptienne, and a Child' (opp. p. 3), pp. 3–4, *Dora E. Yates*.

204. John to Ottoline Morrell, 8 April 1909.

205. Ottoline's daughter.

206. John to Ottoline Morrell, 9 July 1909.

207. John to Ottoline Morrell, 22 July 1909.

208. 'Augustus John – the pattern of the painter's career', B.B.C. Radio 3 (15 April 1954).

209. *Jane Ellen Harrison: A Portrait from Letters*, pp. 129–30.

210. Jane Harrison to D. S. MacColl, 15 August 1909.

211. John to Jessie G. Stewart, October 1957.
212. *Chiaroscuro*, pp. 64–5.
213. John to Ottoline Morrell, 22 July 1909.
214. *Ottoline*, pp. 181–2.
215. Chaloner Dowdall to Vere Egerton Cotton, 6 November 1945.
216. ibid.
217. Augustus to Dorelia.
218. *Chiaroscuro*, p. 154.
219. *My Gypsy Days* by Dora E. Yates, p. 71.
220. John to the Rani.
221. *Daily Dispatch*, 4 October 1909.
222. *Scotsman*, September 1909.
223. Albert Fleming in a letter to Dowdall, 16 December 1911. Liverpool Public Library.
224. See *Augustus John* by Malcolm Easton, p. 52.
225. *The Fool of the World* (1906) by Arthur Symons, p. 69.
226. Arthur Symons to Rhoda Bowser, 6 May 1900. See *Arthur Symons: A Critical Biography by Roger Lhombreaud*, p. 175.
227. Symons to Quinn, 5 April 1915.
228. See *Agnes Tobin: Letters, Translations, Poems. With some account of her life.* Grabhorn Press for John Howell. San Francisco 1958, p. xii.
229. Quinn to Joseph Conrad, 12 April 1916.
230. By Alice B. Saarinen, *The Proud Possessors* (1959), p. 206.
231. Quinn to Josephine Huneker, 10 April 1909 and 14 July 1909.
232. Quinn to John, 31 January 1910.
233. B. L. Reid, p. 73.
234. B. L. Reid, p. 76.
235. B. L. Reid, p. 77.
236. *Horizon*, Vol. IV, No. 20, August 1941, p. 125. This description and comment were omitted from *Chiaroscuro* twelve years later.
237. This letter is not in the Quinn Collection at the New York Public Library, but belongs to the author.
238. John to Quinn, 18 December 1909.
239. From, in fact, Lord Grimthorpe's villa at Ravello.
240. *Chiaroscuro*, pp. 104–5.
241. Interview with Marie Mauron, September 1971.
242. John to Dorelia.
243. John to Ottoline Morrell, 11 February 1910.
244. John to Dorelia.
245. *Horizon*, Vol. VI, No. 36, December 1942, p. 422.
246. Helen Maitland to Henry Lamb, 23 February 1910.
247. Dorelia to Ottoline Morrell, February 1910.
248. *The Seventh Child* by Romilly John, p. 8.
249. John to Scott Macfie, 2 May 1910.
250. John to Arthur Symons.
251. John to Scott Macfie.
252. *Ottoline*, p. 199.
253. *Ottoline*, p. 200.
254. John to Chaloner Dowdall.
255. *Horizon*, Vol. VI, No. 32, August 1942, pp. 135–8.
256. *Contemporary Portraits: Third Series.*

257. *Chiaroscuro*, p. 128.

258. *Extraordinary People* by Hesketh Pearson, p. 212. Also private information.

259. The Gertz papers are in the Library of Congress, Washington, D.C.

260. *Frank Harris* (1931) by Elmer Gertz and A. I. Tobin, a dentist.

261. John to Quinn, 25 May 1910.

262. To Quinn, 25 August 1910.

263. John to Quinn.

264. John to Ottoline Morrell.

265. John to Quinn, 25 May 1910.

266. In her lecture 'Mr Bennett and Mrs Brown' delivered on 18 May 1924 at Cambridge.

267. *The Times*, 7 November 1910, p. 12.

268. *Morning Post*, 1 November 1910, p. 3.

269. *Morning Post*, 16 November 1910, p. 3.

270. In a letter dated March 1909 to Florence Beerbohm. David Cecil Transcripts, Merton College, Oxford.

271. 22 May 1909.

272. *Outline* by Paul Nash, p. 167.

273. *Paint and Prejudice* by C. R. W. Nevinson, p. 189.

274. *The Saturday Review*, 7 December 1907, pp. 694–5.

275. *Magazine of Fine Arts*, May–August 1906.

276. *Augustus John – the pattern of the painter's career* by David Piper, B.B.C. Radio 3 (15 April 1954).

277. See 'Mark Gertler. A Survey' by John Woodeson, 1971.

278. 'The Academy in Totalitaria', *Art News Annual*, 1967.

279. *Burlington Magazine*, Vol. XV, No. 73, April 1909, p. 17.

280. *Modern English Painters* by John Rothenstein (rev. edn 1962), Vol. I, 'Sickert to Grant', p. 207.

281. 'Augustus John – the pattern of the painter's career', B.B.C. Radio 3 (15 April 1954).

282. *The Saturday Review*, 10 December 1910, p. 747.

283. *Pall Mall Gazette*, 11 December 1910.

284. *The Queen*, 10 December 1910.

285. *Daily Graphic*, 10 December 1910.

286. *Burlington Magazine*, February 1910, p. 267.

287. John to Quinn, 24 June 1914.

288. The Tate Gallery (T. 656).

289. *Vogue*, 11 January 1928, 'The Paintings of Evan Walters'; 7 March, 'The Unknown Artist'; 18 April, 'The Woman Artist'; 27 June, 'Paris and the Painter'; 25 July, 'Three English Artists'; 22 August, 'Some Contemporary French Painters'; 3 September, 'Five Modern Artists'; 31 October, 'Interior Decoration'. The series was originally intended to comprise twelve articles but, even with the encouragement of T. W. Earp, Augustus could not get beyond eight.

290. *Since I was Twenty-five* (1927) by Frank Rutter, pp. 191–2.

291. Roger Fry to Will Rothenstein, 28 March 1911. *Letters of Roger Fry* edited by Denys Sutton, Vol. I, p. 344.

292. 27 July 1920. See *Letters of Roger Fry*, Vol. II, p. 486.

293. See *Imperfect Encounter*, pp. 10–13.

294. The Library, King's College, Cambridge.

295. 'J. Dickson Innes', an unpublished essay by Augustus John in the possession of Mr William Gaunt.

296. Information from Mr Charles Hampton, to whom I am indebted for many facts concerning Innes's career.
297. 'Fragment of an Autobiography' by Augustus John, *Horizon*, Vol. XI, No. 64, April 1945, p. 255.
298. *James Dickson Innes* by John Fothergill, 1946.
299. 'Reminiscences of Fellow Students' by Randolph Schwabe, *The Burlington Magazine*, January 1943, p. 6.
300. *Modern English Painters*, Vol. II, 'Innes to Moore', p. 25.
301. Augustus John to John Quinn, 10 February 1911. This letter was in answer to one of Quinn's agreeing to buy some Innes watercolours.
302. Rough draft for his Introduction to the Innes exhibition of 1923 at the Chenil Gallery.
303. *Horizon*, Vol. XV, No. 64, April 1945, p. 255.
304. William Gaunt holograph.
305. 'The Late J. D. Innes. A Short Appreciation' by Augustus John A.R.A.
306. For a Derwent Lees 'John' see 'The Round Tree' at the Aberdeen Art Gallery, which may be compared with John's own 'Gipsy in the Sandpit' at the same gallery.
307. John to Dorelia, from the Hotel Corneille. Probably January 1911.
308. John to Quinn, 5 January 1911.
309. John to Quinn, 11 January 1911.
310. *Bricks and Flowers* by Katherine Everett, p. 232.
311. ibid, pp. 232–3.
312. 15 June 1911. 'It's an excellent place for the boys and I think we are pretty lucky to have got it. The towns near by are perfectly awful, being horrible conglomerations of red brick hutches.'
313. *Bricks and Flowers*, p. 232.
314. John to Quinn, 16 August 1911.
315. John to Dorelia, July 1911.
316. Henry Lamb to Lytton Strachey, 18 October 1911.

Index

John, Ida—*cont.*

Club, 111; measles and a return to Wigmore Street, 113; her pregnancies, 120–1, 136, 169, 208, 239; etchings by Augustus, 123; gifts for baby from professors' wives, 128; nightmares about her baby, 128–9; birth of a baby boy, 129; need for sympathetic companionship, 132; isolation and a trip to London, 133; not made for a mother, 135; death of her father, 135; birth of her second son, 142; Augustus's portrait of her at the New English Art Club, 143; changes in the John household, 145; and Dorelia McNeill, 149; ménage-à-trois, 149–50; discouraged by Alice Rothenstein's conventionality, 152; Alice Rothenstein's reprimands, 159; way of life at Matching Green, 160; envy of the two Gwens' paintings, 161; learning to cook, 161; birth of her third son, 181; toasted cheese and stout, 181; life of blameless exhaustion, 182; defiance of social conventions, 183; enjoyment of the Rani's letters, 184; symptoms of burlesque in friendship with the Rothensteins, 185; 'little journey' to London, 191; doubt and jealousy, 192; severe depression, 193; conclusions over the winter she endured with Dorelia, 194–5; new bond with Dorelia, 196; change of attitude, 198; affection for Dorelia holding the ménage together, 199; dread of living alone with Augustus, 199; living in the caravan, 201; need to free herself from being Augustus's wife, 202; decision to live in Paris, 203; preparations, 204–5; encumbrance of her family, 205; ambition of a large family, 208; impressions of men, 209; departure for France, 209; birth of her fourth son, 210; struggle to free herself from the domination of children, 212; eviction from Rue Monsieur le Prince, 213; dullness of the people at Mentone, 214; move to Rue Dareau, 214, 238; brooding over the 'patriarchical ménage', 234; 'formidable staff' at Matching Green, 235; unable to contain Augustus, 238; alone again, 243; sickness of living, 244; financial dependence on Augustus, 245; dread of her expected baby, 247; birth of her fifth son, 248; puerperal fever and peritonitis, 249–50; death, 251; cremation, 252

Appearance: 75, 134–5, 212

John, Pyramus (Augustus's and Dorelia's son, 1905–13): birth, 199

John, Robin (Augustus's and Ida's son, b. 1904): birth, 181; appearance, 235; scarlet fever, 325; quoted 339

John, Romilly (Augustus's and Dorelia's son, b. 1905): quoted, 80 n.; birth not registered, 233

John, Thornton (Augustus's brother): his endurance, 15–16; ambitions, 16; prospecting for gold in Canada, 16 n.; at Greenhill School, 22; sent to boarding school at Clifton, 23; endorsing Augustus's treatment of their father, 27; 'skeleton in the cupboard', 27–8; Sunday afternoons with Augustus, Geraldine de Burgh and friends, 73

His letters to Augustus: 17 n., 33

John, William (Augustus's grandfather): assigned the lease of No. 50 Rope Walk Field, 1; speechless children, 6; marriage, 7; his library, 7; travels through Italy, 8; ambitions as an author, 8; early moves in married life, 8; admission as a solicitor, 8; Lord Kensington's agent, 8; obituary, 8 n.; career comparable to that of Thomas Smith, 11; death from 'water on the brain', 12, 29; souvenirs from his European wanderings, 13; 'skeleton in the cupboard', 28; confusion over his identification in the parish records, 28; rumours surrounding his final illness and death, 28; cerebral softerina, 29

John, William (Augustus's great-grandfather), musical talents, 7 n.

John, Winifred (Augustus's sister): abilities as a violinist, 7 n.; touch and facial expression language, 14; French lessons, 15; appearance, 16; travels in Canada and America, 16 n.; marriage to Victor Lauder Shute, 17 n.; education, 21–2; criticism of Augustus's description of their father, 27; outrage at her father's matrimonial skirmishes, 29; sharing a flat with Augustus and Gwen in London, 58; Augustus's affinity with, 72; sailing to America, 145

John's Music Hall Sketches, 43 n.

Joking Apart (Mary Dowdall), 117

Jones-Lloyd, Alice, Edwin John's engagement to, 29

Journal of the Gypsy Lore Society, 299

Jowett, Benjamin, 75 n.

Joyce, James, 322

Jungle Book (Rudyard Kipling), Ida and its characters, 75–6

Kapp, E. X., 63 n.

Katerina, Maria: Augustus's fascination for, 101–2; gift of a ring, 102; Augustus's letters intercepted by Mrs Everett, 104

Kensington, Lord, William John acting as his agent, 8

Keynes, Maynard: reference in Strachey's letter to Grant, 266; reports of Augustus's behaviour in Cambridge, 302

Kingsley, Alice: painting party at Vattetot-sur-Mer, 91; with Oscar Wilde in Paris, 95

Kipling, Rudyard, Ida and the *Jungle Book* characters, 75–6

Knewstub, Grace, painting party at Vattetot-sur-Mer, 92

Knewstub, Jack: appearance, 158; Orpen's

Schepeler, Alick—*cont.*
 Augustus's letters to: 101, 222 n., 228–9, 231, 232, 253, 261, 263, 313, 324
Schepeler, John Daniel, 226
Schwabe, Randolph: quoted 42 n.; cut off the New English Art Club jury, 48 n.
'Scotch-Wells', excursions to, 3
Second Post-Impressionist Exhibition: admission of British artists, 349; Augustus's refusal to submit any work, 356, 370–1, 373
Settlands, stone used for Edwin John's house, 6 n.
Sex Disqualification Act 1919, 10
Shakespeare, Olivia, 262 n.
Shankland, Virginia, description of Augustus, 53
Shannon, Charles, 259, 316, 363
Shaw, George Bernard, 54–5, 225
Shute, Victor Lauder, marriage to Winifred John, 17 n.
Sickert, Walter: interpretation of Legros's art instruction, 40; meeting with Augustus, 82; manager of the Carfax Gallery, 91; leading figure in the New English Art Club, 110; respect for Augustus, 112; at Alice Rothenstein's parties, 139; an amusing and curious character, 190 n.; opposed to 'capturing' the New English Art Club, 370
Signorelli, Luca, 360
Simpson, F. M., 131
Simpson, Miss, Augustus's invitation to her wedding, 99
Sisley, Alfred: Augustus's appreciation, 365
Sistine Chapel, 69
Slade, 1871–1960, The (Andrew Forge), 39 n.
Slade, Charles: rescue of Augustus's camp, 310; looking at houses in the west with Augustus, 384
Slade, Felix, 38
Slade School: Augustus's entry, 37; influence of its atmosphere on Augustus, 38; teachers, 38–41; firmly established principles of teaching, 40; Mediaeval-Renaissance workshop, 40; austere regime and segregation of sexes, 42; ties formed with the National Gallery by Walter Russell, 48; new spirit of comradeship centred around Augustus and Gwen, 61; Mrs Everett and the skeleton room, 64–5; effect of Whistler's arrival, 69–70; chief nursery of young talent for the New English Art Club, 111; and the desecration of St Paul's, 387
Smith, Leah: influence of the John children's upbringing, 4; proposal of marriage, 4; travels in America, 13 n.
Smith, Matthew: marriage to Gwen Salmond, 62; Augustus's appreciation, 368; visit to Paris with Innes, 375
Smith, Rosina: influence on the John children's upbringing, 4; and religion, 5; travels to Switzerland, Japan and

America, 13 n.; marriage to Owen H. Bott, 13 n.
Smith, Thomas: second marriage to Mary Thornton, 10; career comparable to that of William John, 11; his will, 11; death from a stroke, 12, funeral, 12
Smith, Zadock, 10
Society of Twelve: original membership, 190; exhibition of Augustus's work, 257, 274
Southampton Street, No. 39, 106
Southbourne, Edwin John's move to, 68
South Cliff Street, Edwin John's move to, 68
Spain: a Study of her Life and Arts (Royall Tyler), 286 n.
Speaight, Robert, 92 n.
Speakers' Corner, 44
Spencer, Stanley, 49, 69, 187
Spread Eagle, 91
Stedelijk Museum, Amsterdam, 67 n.
Steen, Marguerite, description of Augustus's portrait of Nicholson, 294
Steer, Wilson: at Slade School, 46–8; 'the shearing of Mr Steer', 47; appreciation of Augustus's drawings, 56 n.; leading figure in the New English Art Club, 110; Augustus preferred for Jane Harrison's portrait, 301; recommendation of Augustus, 364; Innes's admiration for, 375
Stephen, Virginia, 285
Stevens, Alfred, Augustus's excitement over his drawings, 275
Strachey, Lytton, 266, 381 n., 384, 385
Stumping, Augustus taught the art of, 34
Symons, Arthur: Augustus's letter to him in support of Epstein, 221; study of gypsies, 299; meetings with Augustus, 163, 311; appreciation of Augustus's Carfax show in *Weekly Critical Review*, 312; 'Prologue for a Modern Painter: Augustus John', 313; madness in Italy, 314; dissipation of his egocentricity, 315; Augustus's portrait, 317; letters from Quinn, 322
 Augustus's letters to: 313, 316, 328, 332
Syphilis, Quinn's warnings to Augustus, 321
Systems of Art Education (Edward Poynter), 39 n.

Tagore, Rabindranath, 188
Tate Gallery: Walter Russell made a trustee, 48; Sir William Rothenstein Memorial Exhibition, 92 n., 190; Conder's views of Swanage, 100 n.; study of W. B. Yeats, 260 n.; exhibition of photographs of contemporary British wall paintings, 359
Te Deum, Edwin John's setting for, 12
Temple-Allen, Francis, marriage to Clara John, 29 n.
Tenby: arrival of Edwin and Augusta John, 1; Augustus's love for the harbour and bay, 18; the beach a fashionable plot, 18;